THE PHILOSOPHY OF
DONALD DAVIDSON

THE LIBRARY OF LIVING PHILOSOPHERS

PAUL ARTHUR SCHILPP, FOUNDER AND EDITOR 1939–1981
LEWIS EDWIN HAHN, EDITOR 1981–

Paul Arthur Schilpp, Editor
THE PHILOSOPHY OF JOHN DEWEY (1939, 1971, 1989)
THE PHILOSOPHY OF GEORGE SANTAYANA (1940, 1951)
THE PHILOSOPHY OF ALFRED NORTH WHITEHEAD (1941, 1951)
THE PHILOSOPHY OF G. E. MOORE (1942, 1971)
THE PHILOSOPHY OF BERTRAND RUSSELL (1944, 1971)
THE PHILOSOPHY OF ERNST CASSIRER (1949)
ALBERT EINSTEIN: PHILOSOPHER-SCIENTIST (1949, 1970)
THE PHILOSOPHY OF SARVEPALLI RADHAKRISHNAN (1952)
THE PHILOSOPHY OF KARL JASPERS (1957; AUG. ED., 1981)
THE PHILOSOPHY OF C. D. BROAD (1959)
THE PHILOSOPHY OF RUDOLF CARNAP (1963)
THE PHILOSOPHY OF C. I. LEWIS (1968)
THE PHILOSOPHY OF KARL POPPER (1974)
THE PHILOSOPHY OF BRAND BLANSHARD (1980)
THE PHILOSOPHY OF JEAN-PAUL SARTRE (1981)

Paul Arthur Schilpp and Maurice Friedman, Editors
THE PHILOSOPHY OF MARTIN BUBER (1967)

Paul Arthur Schilpp and Lewis Edwin Hahn, Editors
THE PHILOSOPHY OF GABRIEL MARCEL (1984)
THE PHILOSOPHY OF W. V. QUINE (1986, AUG. ED., 1998)
THE PHILOSOPHY OF GEORG HENRIK VON WRIGHT (1989)

Lewis Edwin Hahn, Editor
THE PHILOSOPHY OF CHARLES HARTSHORNE (1991)
THE PHILOSOPHY OF A. J. AYER (1992)
THE PHILOSOPHY PAUL RICOEUR (1995)
THE PHILOSOPHY OF PAUL WEISS (1995)
THE PHILOSOPHY OF HANS-GEORG GADAMER (1997)
THE PHILOSOPHY OF RODERICK M. CHISHOLM (1997)
THE PHILOSOPHY OF P. F. STRAWSON (1998)
THE PHILOSOPHY OF DONALD DAVIDSON (1999)

In Preparation:
Lewis Edwin Hahn, Editor
THE PHILOSOPHY OF SEYYED HOSSEIN NASR
THE PHILOSOPHY OF MARJORIE GRENE
THE PHILOSOPHY OF ARTHUR C. DANTO
THE PHILOSOPHY OF MICHAEL DUMMETT
THE PHILOSOPHY OF JAAKKO HINTIKKA
THE PHILOSOPHY OF HILARY PUTNAM
THE PHILOSOPHY OF RICHARD M. RORTY

THE LIBRARY OF LIVING PHILOSOPHERS
VOLUME XXVII

THE PHILOSOPHY OF
DONALD DAVIDSON

EDITED BY

LEWIS EDWIN HAHN

SOUTHERN ILLINOIS UNIVERSITY AT CARBONDALE

CHICAGO AND LA SALLE, ILLINOIS • OPEN COURT • ESTABLISHED 1887

To order books from Open Court, call toll-free 1-800-815-2280.

THE PHILOSOPHY OF DONALD DAVIDSON

Open Court Publishing Company is a division of Carus Publishing Company.

Copyright © 1999 by The Library of Living Philosophers

First printing 1999

Printed and bound in the United States of America.

Library of Congress Cataloging-in-Publication Data

 The philosophy of Donald Davidson / edited by Lewis Edwin Hahn.
 p. cm.— (The Library of Living Philosophers; v. 27)
 Includes bibliographical references and index.
 ISBN 0-8126-9399-X (pbk. : alk. paper). — ISBN 0-8126-9398-1 (cl.
: alk. paper)
 1. Davidson, Donald, 1917– . I. Hahn, Lewis Edwin, 1908– .
II. Series.
B945.D384P45 1999
191—dc21 99-39735
 CIP

The Library of Living Philosophers is published under the sponsorship of Southern Illinois University at Carbondale.

GENERAL INTRODUCTION
TO
THE LIBRARY OF LIVING PHILOSOPHERS

Founded in 1938 by Professor Paul Arthur Schilpp and edited by him until July 1981, when the present writer became editor, the Library of Living Philosophers is devoted to critical analysis and discussion of some of the world's greatest living philosophers. The format for the series provides for setting up in each volume a dialogue between the critics and the great philosopher. The air is not refutation or confrontation but rather fruitful joining of issues and improved understanding of the positions and issues involved. That is, the goal is not overcoming those who differ from us philosophically but interacting creatively with them.

The basic idea for the series, according to Professor Schilpp's general introduction to each of the earlier volumes, came from the late F.C.S. Schiller, who declared in his essay on "Must Philosophers Disagree?" (in *Must Philosophers Disagree?* London: Macmillan, 1934) that the greatest obstacle to fruitful disussion in philosophy is "the curious etiquette which apparently taboos the asking of questions about a philosopher's meaning while he is alive." The "interminable controversies which fill the histories of philosophy," in Schiller's opinion, "could have been ended at once by asking the living philosophers a few searching questions." And while he may have been overly optimistic about ending "interminable controversies" in this way, it seems clear that directing searching questions to great philosophers about what they really mean or how they think certain difficulties in their philosophy can be resolved while they are still alive can produce far greater clarity of understanding and more fruitful philosophizing than might otherwise be had.

And to Paul Arthur Schilpp's undying credit, he acted on this basic thought in launching in 1938 the Library of Living Philosophers. It is planned that each volume in the Library of Living Philosophers include preferably an intellectual autobiography by the principal philosopher or an authorized biography as well as a bibliography of that thinker's publications, a series of expository and critical essays written by leading exponents and opponents of the philosopher's thought, and the philosopher's replies to the interpretations and queries in these articles. The intellectual autobiographies usually shed a great deal of light on both how the philosophies of the great thinkers

developed and the major philosophical movements and issues of their time; and many of our great philosophers seek to orient their outlook not merely to their contemporaries but also to what they find most important in earlier philosophers. The bibliography will help provide ready access to the featured scholar's writings and thought.

With this format in mind, the Library expects to publish at more or less regular intervals a volume on one of the world's greater living philosophers.

In accordance with past practice, the editor has deemed it desirable to secure the services of an Advisory Board of philosophers to aid him in the selection of subjects of future volumes. The names of eight prominent American philosophers who have agreed to serve appear on the page following the Founder's General Introduction. To each of them the editor is most grateful.

Future volumes in this series will appear in as rapid succession as is feasible in view of the scholarly nature of this library. The next volume in the series will be devoted to the philosophy of Seyyed Hossein Nasr, and it will be followed by ones on Marjorie Grene, Arthur C. Danto, Michael Dummett, Jaakko Hintikka, Hilary Putnam, and Richard M. Rorty.

Throughout its career, since its founding in 1938, the Library of Living Philosophers, because of its scholarly nature, has never been self-supporting. We acknowledge gratefully that the generosity of the Edward C. Hegeler Foundation has made possible the publication of many volumes, but for support of future volumes additional funds are needed. On 20 February 1979 the Board of Trustees of Southern Illinois University contractually assumed sponsorship of the Library, which is therefore no longer separately incorporated. Gifts specifically designated for the Library, however, may be made through the Southern Illinois University Foundation, and inasmuch as the latter is a tax-exempt institution, such gifts are tax-deductible.

LEWIS E. HAHN
EDITOR

DEPARTMENT OF PHILOSOPHY
SOUTHERN ILLINOIS UNIVERSITY AT CARBONDALE

FOUNDER'S GENERAL INTRODUCTION*
TO
THE LIBRARY OF LIVING PHILOSOPHERS

According to the late F.C.S. Schiller, the greatest obstacle to fruitful discussion in philosophy is "the curious etiquette which apparently taboos the asking of questions about a philosopher's meaning while he is alive." The "interminable controversies which fill the histories of philosophy," he goes on to say, "could have been ended at once by asking the living philosophers a few searching questions."

The confident optimism of this last remark undoubtedly goes too far. Living thinkers have often been asked "a few searching questions," but their answers have not stopped "interminable controversies" about their real meaning. It is nonetheless true that there would be far greater clarity of understanding than is now often the case if more such searching questions had been directed to great thinkers while they were still alive.

This, at any rate, is the basic thought behind the present undertaking. The volumes of the Library of Living Philosophers can in no sense take the place of the major writings of great and original thinkers. Students who would know the philosophies of such men as John Dewey, George Santayana, Alfred North Whitehead, G.E. Moore, Bertrand Russell, Ernst Cassirer, Karl Jaspers, Rudolf Carnap, Martin Buber, et al., will still need to read the writings of these men. There is no substitute for first-hand contact with the original thought of the philosopher himself. Least of all does this Library pretend to be such a substitute. The Library in fact will spare neither effort nor expense in offering to the student the best possible guide to the published writings of a given thinker. We shall attempt to meet this aim by providing at the end of each volume in our series as nearly complete a bibliography of the published work of the philosopher in question as possible. Nor should one overlook the fact that essays in each volume cannot but finally lead to this same goal. The interpretive and critical discussions of the various phases of a great thinker's work and, most of all, the reply of the thinker himself, are bound to lead the reader to the works of the philosopher himself.

*This General Introduction sets forth in the founder's words the underlying conception of the Library. L.E.H.

At the same time, there is no denying that different experts find different ideas in the writings of the same philosopher. This is as true of the appreciative interpreter and grateful disciple as it is of the critical opponent. Nor can it be denied that such differences of reading and of interpretation on the part of other experts often leave the neophyte aghast before the whole maze of widely varying and even opposing interpretations. Who is right and whose interpretation shall he accept? When the doctors disagree among themselves, what is the poor student to do? If, in desperation, he decides that all of the interpreters are probably wrong and that the only thing for him to do is to go back to the original writings of the philosopher himself and then make his own decision—uninfluenced (as if this were possible) by the interpretation of anyone else—the result is not that he has actually come to the meaning of the original philosopher himself, but rather that he has set up one more interpretation, which may differ to a greater or lesser degree from the interpretations already existing. It is clear that in this direction lies chaos, just the kind of chaos which Schiller has so graphically and inimitably described.[1]

It is curious that until now no way of escaping this difficulty has been seriously considered. It has not occurred to students of philosophy that one effective way of meeting the problem at least partially is to put these varying interpretations and critiques before the philosopher while he is still alive and to ask him to act at one and the same time as both defendant and judge. If the world's greatest living philosophers can be induced to cooperate in an enterprise whereby their own work can, at least to some extent, be saved from becoming merely "desiccated lecture-fodder," which on the one hand "provides innocuous sustenance for ruminant professors," and on the other hand gives an opportunity to such ruminants and their understudies to "speculate safely, endlessly, and fruitlessly, about what a philosopher must have meant" (Schiller), they will have taken a long step toward making their intentions more clearly comprehensible.

With this in mind, the Library of Living Philosophers expects to publish at more or less regular intervals a volume on each of the greater among the

1. In his essay "Must Philosophers Disagree?" in the volume of the same title (London: Macmillan, 1934), from which the above quotations were taken.

world's living philosophers. In each case it will be the purpose of the editor of the Library to bring together in the volume the interpretations and criticisms of a wide range of that particular thinker's scholarly contemporaries, each of whom will be given a free hand to discuss the specific phase of the thinker's work that has been assigned to him. All contributed essays will finally be submitted to the philosopher with whose work and thought they are concerned, for his careful perusal and reply. And, although it would be expecting too much to imagine that the philosopher's reply will be able to stop all differences of interpretation and of critique, this should at least serve the purpose of stopping certain of the grosser and more general kinds of misinterpretations. If no further gain than this were to come from the present and projected volumes of this Library, it would seem to be fully justified.

In carrying out this principal purpose of the Library, the editor announces that (as far as is humanly possible) each volume will contain the following elements:

First, an intellectual autobiography of the thinker whenever this can be secured; in any case an authoritative and authorized biography;

Second, a series of expository and critical articles written by the leading exponents and opponents of the philosopher's thought;

Third, the reply to the critics and commentators by the philosopher himself; and

Fourth, a bibliography of writings of the philosopher to provide a ready instrument to give access to his writings and thought.

PAUL ARTHUR SCHILPP
FOUNDER AND EDITOR, 1939–1981

DEPARTMENT OF PHILOSOPHY
SOUTHERN ILLINOIS UNIVERSITY AT CARBONDALE

ADVISORY BOARD

ACKNOWLEDGMENTS

The editor hereby gratefully acknowledges his obligation and sincere gratitude to all the publishers of Donald Davidson's books and publications for their kind and uniform courtesy in permitting us to quote—sometimes at some length—from Professor Davidson.

LEWIS E. HAHN

#Added to Board after the subject of this volume was chosen.

TABLE OF CONTENTS

PREFACE

Donald Davidson (born 6 March 1917), now emeritus from the University of California at Berkeley, is still quite active as a philosopher and a world traveler. An original thinker, one of the best and broadest of the analysts, and a helpful interpreter of the history of philosophy, he has a happy facility for interacting fruitfully with philosophers of many persuasions as well as with representatives of numerous other disciplines. Fifteen or more conferences on his thought have been held in various parts of the world, and more than twenty books have been published on his work. Davidson has been the recipient of more than two score visiting professorships, lectureships, prizes, research grants, and other honors in many countries, and some of his papers have been reprinted at least two dozen times in nine or more languages. For more information on his publications please see his bibliography in this volume.

His intellectual autobiography provides a helpful summary of his visiting professorships and prestigious lectureships as well as the context of some of the major conferences on his work, and some interesting background on many of his major theses. His comments in the autobiography concerning his relations to Spinoza, for example, shed fresh light on both philosophies. The reader may also find interesting his comment that had he known more about the history of philosophy he would have avoided some of the tempting errors to which he succumbed.

I am grateful to Professor Davidson and his diverse set of able critics for making this volume possible.

I am happy to acknowledge once more the warm support, encouragement, and cooperation of our publisher, Open Court Publishing Company, especially M. Blouke Carus, David R. Steele, Kerri Mommer, Jeanne Kerl, and Jennifer Asmuth. And I also very much appreciate continued support, understanding, and encouragement from the administration of Southern Illinois University.

As always, moreover, I am grateful for the friendly and unfailing help in a variety of ways from the staff of Morris Library. It is invaluable for my work and that of my fellow scholars. My warm gratitude also goes to Christina Martin, Loretta Smith, and the Philosophy Department secretariat for help

with numerous projects; and my special thanks go to Sharon Langrand, recently retired secretary, and Frances Stanley, who now carries the ball, for help with manuscripts, proofs, and correspondence and all they did and do to keep our office functioning efficiently.

Finally, for warm support, stimulation, and friendly counsel I am most grateful to my able and resourceful pluralistic colleagues who from diverse perspectives make common cause for philosophy and a better university.

<div align="right">

LEWIS EDWIN HAHN
EDITOR

</div>

DEPARTMENT OF PHILOSOPHY
SOUTHERN ILLINOIS UNIVERSITY AT CARBONDALE
SEPTEMBER 1998

PART ONE

INTELLECTUAL AUTOBIOGRAPHY OF DONALD DAVIDSON

Intellectual Autobiography

By the time I was born, on March 6th, 1917, in Springfield, Mass., my parents were married. My father's paternal granfather emigrated from Scotland to this country; the Davidson clan comes from around Inverness. Shortly after moving to America, my greatgrandfather deserted his wife and disappeared into the west. He was never mentioned in my presence except once when I asked my father about him. Herbert Clarence, my grandfather, was a sweet old man when I got to know him, quiet, good-natured and generous. He lived with my grandmother in the Bronx near the Pullman Company railroad yards, for he was a Pullman Car conductor, the "captain" of a car, until he retired. When he died he left me the gold Waltham watch he received on retirement; that was about all he had to leave. His wife's maiden name was Yale, and I think she was a descendent of Elihu Yale, the benefactor of the university. My grandmother made clear she thought she had married beneath her.

My mother's maiden name was Grace Cordelia Anthony, and for years I was under the ~~impression~~ misapprehension that she, and therefore I, was a direct descendent of Susan B. Anthony, the early suffragette. This was not the case, but the error was understandable, for my mother's half-brother, Holcomb Anthony, was directly related to Susan B. The situation is more

Donald Davidson

INTELLECTUAL AUTOBIOGRAPHY

B y the time I was born, on March 6, 1917, in Springfield, Massachusetts, my parents were married. Here is what I know about my forebears. My father's paternal grandfather emigrated from Scotland to this country; the Davidson clan comes from around Inverness. Shortly after moving to America, my great-grandfather deserted his wife and son and disappeared into the West. He was never mentioned in my presence except once when I asked my father about him. Herbert Clarence, my grandfather, was a sweet old man when I got to know him, quiet, good-natured, and generous. He lived with my grandmother in the Bronx near the old Pullman Company railroad yards, for he was a Pullman car conductor, the "captain" of a car, until he retired. When he died he left me the gold Waltham watch he received on retirement; that was about all he had to leave. His wife's maiden name was Yale, and I think she was a direct descendant of Elihu Yale, the benefactor of Yale University. My grandmother made clear that she thought she had married beneath her.

My mother's maiden name was Grace Cordelia Anthony, and for years I was under the misapprehension that she, and therefore I, was a direct descendant of Susan B. Anthony, the early suffragette. This was not the case, but the error was understandable, for my mother's half brother, Holcombe Anthony, was directly related to Susan B. The situation is more complex still. Susan B. was a seventh generation descendant of John Anthony, who was born in England in 1607 and settled in Portsmouth, Rhode Island. Susan B.'s paternal grandfather had a brother, Elihu, who was the great-grandfather of Hiram J. Anthony. Hiram J. married Alida Anthony, to whom he was not related as far as anyone knows; meanwhile Alida's brother, James Wallace Anthony, married a Carrie Holcombe. James Wallace and Carrie begat my mother; if you have followed this far, you will see my mother was not in the line descending from John Anthony. But now: Alida and James Wallace died and their surviving spouses married each other. This new couple begat Holcombe Anthony, my mother's half brother, and a genuine descendant of the original John Anthony. (Holcombe had a daughter named Susan B. Anthony.)[1]

Another myth I picked up, or invented, was that I was somehow related (through my mother) to "the last witch burned on Boston Common". At best,

if that is the right phrase, I was related to Mary Dyer, who was the next to last Quaker to be executed (hung, not burned) on Boston Common for having repeatedly broken the Massachusetts laws by "inciting rebellious sedition".

My mother's family lived in Gloversville, New York. My mother had three sisters, and they, along with their first cousin, Marion, and half brother, Holcombe, remained in close touch all their lives. I liked them all, and I deeply admired and envied Holcombe (whom everyone called "Tony"). He was playful and fun, like my mother, and I wished I could be like him. My mother's stepfather, Hiram J. Anthony, owned a foundry in Gloversville which mainly made, by hand, the iron stamps used to cut out the pieces of leather from which gloves are assembled. One of my early memories is of this shop with its exciting bustle and strong pleasant odors.

A year or less after I was born my father undertook the wartime task of supervising the construction of two large concrete piers in Manila Harbor, and our little family moved to the Philippine Islands for a three-year stay. My impression is that both my parents enjoyed this period. Pictures show a handsome young couple in clothes considered appropriate to a tropical setting. My father liked playing tennis in the humid heat; for years afterward he used the steel racket with steel strings which was the only thing then available that would hold up in that climate. My mother loved the romance of a colonial setting; she appreciated having servants, and she learned the smattering of Spanish that was needed for communicating with them. In the summers my mother and I, in imitation of the British in India, took to the hills for relief from the heat. My father joined us when he could. Baguio, a mile higher than Manila in Igorot country, was reached only by a torturous road. One day I was running along a sidewalk made of sharp slabs of slate brandishing a toy airplane when I fell and cut open my forehead. According to family tradition, the primitive clinic to which I was rushed had only a bent needle and a rusty needle available to sew up the wound. The bent needle was straightened, but broke; the rusty needle finished the job while four strong adults did their best to hold unanaesthetized me. This story has some of the marks of hero legends, but I still have the scar for whatever that proves. (An even better myth: my birth was a difficult one requiring high forceps. The doctors were asked which one they should save, my mother or me. Having received the only reasonable answer, the doctors set me aside as a lost cause while they attended to my mother. I attracted attention by yelling. This is a story I told for years thinking my mother had told it to me. When I finally asked her she said there was no truth in it. I guess she meant no literal truth.)

On December 4, 1919, while we were still in the Philippines, my sister Jean Elizabeth was born. Her birthday became very special to me, for my own daughter, my present wife, and one of my oldest friends, John Goheen, were all born on the same day of the year. In spite of repeated efforts, I never

succeeded in getting all these people together on a December 4.

Soon, probably in 1920, my mother and her children returned to the mainland, and holed up with her family in Gloversville. I remember those as pleasant days, surrounded by the large Anthony families. Presently my father returned, and we moved to Amherst, Massachusetts, where my father had a job teaching mathematics at the University of Massachusetts, then an agricultural school. We lived first in one and then another attractive house, my mother breezing about doing the voice exercises thought necessary for acting; she was excited by the local amateur theatricals in which she had a part, and by the director.

Next year my father was hired by the McClintock Marshall Steel Company (later to be swallowed up, along with my father, by the Bethlehem Steel Corporation) as an engineer-salesman. This was the sort of work he had trained for at Cornell, for he had a civil engineering degree. In practice, he hired and directed the engineers who did the figuring and the blue prints; his job was to sell the steel, and the steel was sold along with the detailed engineering that architects were unwilling to do themselves. The new job required moving once more, this time to Collingswood in the outskirts of Philadelphia. A year later we moved to another suburb of Philadelphia, Swarthmore. My memories of this period are a bit more distinct, and what I remember is not all agreeable. We were so briefly in each place that my parents didn't get around to sending me to school; my mother taught me to read and write to whatever extent teaching was involved. One day my father brought home a kit, consisting of a Quaker Oats box wound with a fine reddish-brown wire, a crystal with a cat's whisker, a pair of earphones and a few other parts, and we assembled our first radio. I was fascinated, and have never completely lost my love of electronic gear.

Music entered my life about this time. Once we went into Philadelphia to hear Leopold Stokowski conduct the Philadelphia Symphony Orchestra; we could hear its broadcasts on our tiny set; and we purchased a few phonograph records. The sound of those records is so fixed in my memory that I cannot now hear Tchaikovsky's Pathetique symphony, or the March Slav, without thinking the current performance wrong in tempo or dynamics or phrasing. (The Pathetique had been compressed to fit on a single 78 RPM record!)

The family's final move came in 1924, this time to a house my father had bought on Staten Island. He had been promoted to head the New York sales office, and he commuted each day by taking the Tottenville Local from Grasmere, where we lived, to the ferry in St. George (this took seven minutes), then the ferry to the Battery (the ferry then cost five cents). From the battery he walked up Broadway a few blocks to his office near the Woolworth Building. It was a pleasant trip, more than half of it on the water.

Our new house was tall and narrow, designed, like the houses on each side,

to fit on a 50-foot-wide lot (with room to one side for a driveway; in those days garages were always behind the house). When we moved in there was no electricity in the house; it was lit by gas fixtures which remained in place and operable for many years after we had electricity installed. The heating was truly central: a coal-fired furnace poured all its therms directly into the space above it from whence it was hoped that it would seep through a variety of apertures into the rest of the house. Behind the house were empty lots occupied by two clay tennis courts; these were much used, and were kept in shape, by the members of the "club". There were no houses across the dirt road (unpaved when we moved there; eventually it was paved, and later still came sidewalks), for on the other side of Lakeview Terrace was Brady's Pond (officially called Grasmere Lake). This was really two lakes, one large and one small, which were connected by the "narrows" across which a foot-bridge was ultimately built. Our house faced the smaller lake, and during the years we lived there a swampy area across from us was filled in and houses built. Neighbors who wanted to made small contributions each year to keep up swimming facilities on the larger lake. I had learned to swim in the Philippines, and during warm weather I would swim every day. The lake was also used for canoeing, and in winter for ice-skating. There were almost no houses around the large lake, so there was lots of room for adventure and exploration. Our house was at the bottom of a small hill up which the road ran, and since there was little traffic, it was a great place to skin your knees trying to roller-skate down. In winter we competed to see who could sled farthest out onto the lake after coming down the hill.

For the first time I had a social life. By the time I was ten or eleven I discovered that I liked girls. I spent much of one sultry summer lying in a hammock on the front porch smooching with a girl a year or so older named Dolores Dewilder. Life went on around us, people came and stared, but we ignored them. I was the butt of much jejune banter (graffiti saying "D.D. loves D.D.", etc.) because it was de rigueur among my confreres to pretend one hated girls, but for some reason I decided early that I might as well openly brave the sort of rejection and obloquy that nonconformity invites. This did not sit well with my father, for he had tried all his life to avoid being classed as a sissy (though playing tennis in those days was often regarded as somewhat foppish). To help me stave off this danger, he undertook various projects. He bought boxing gloves and each Sunday morning we "fought". This grim exercise finally came to an end when, having slowly grown, I one day knocked my father to the floor.

My father also knew that every red-blooded American boy could play baseball, and he was determined that I should at least be competent at throwing and catching a ball. I have no idea whether he was any good at these basic skills. He told me he had distinguished himself in high school (in Jersey

City) as a runner. In college, after more ambitious goals eluded him, he settled for being the manager of the fencing team. During the time I knew him he played tennis fairly well, swam slowly but strongly, and skated with enthusiasm. His main interest in sports was as a spectator. He watched football with special dedication, and ruined each year's Thanksgiving Day feast by insisting on listening to, and later watching, whatever big game was on. To this day I cannot stand watching football games. While I was at Harvard the first game of the year was between Harvard and Cornell. My father insisted that we go (it was in Cambridge). To open the game, Harvard kicked off to Cornell, which immediately ran the ball for a touchdown. I doubt that Harvard ever scored. For once, my father and I were both happy: he was delighted Cornell had roundly beaten effeminate Harvard; I was pleased to be at an institution where nobody seemed to care.

Once the family settled on Staten Island there was nothing to stop me from going to school. I was entered in the first grade in Public School 34, though I was years too old for this grade. I liked tramping across the hills to school, carrying the orthodox metal lunch pail, and I liked the girl named Olga who sat in front of me. But for the rest, it was, of course, a terrible bore, since I was far ahead of my schoolmates in everything except penmanship (Palmer method).

I was rescued by Mrs. Wilcox, a stately widow with an enormous house in an old section of Staten Island. Her father (or grandfather?) was Sidney Howard Gay and her mother an Otis: famous abolitionists on both sides. Mrs. Wilcox remembered when her family ran a station in the underground railway. She and her friends and relatives were sold on "progressive education" as promoted by John Dewey and exemplified in New York by the Dalton School in upper Manhattan. They had built a school in St. George, at the north end of Staten Island, and she subsidized my attendance there. So I quitted P.S. 34 and was installed in the fourth grade at the Staten Island Academy. The year was 1926, and I was nine. I flourished, by my standards, which were not high. I liked my teachers and I found the schoolwork easy, so I had lots of time to do what I wanted. My relations with my classmates were less easy, especially with the boys, but I did as well as might have been expected given that this was my first real plunge into the jungle of childhood relationships.

As time went on I made a few male friends, though they seemed usually to be loners like me. One of them shared my interest in electronics. We would carefully disassemble all the discarded radios we found in trash barrels and build our own sets from the salvaged pieces. At first I used diagrams I found in *Popular Mechanics*, but I soon learned enough of the basic principles to be able to build a simple receiver, amplifier, or rectifier without guidance. I filled our basement with amateur shortwave equipment, learned the Morse code, and communicated with other amateurs around the country and occasionally

abroad. The school subsidized a kit, and my friend and I built a primitive TV set which could produce a picture about the size of a postage stamp when an experimental station came on the air for an hour every now and then. I can still sometimes diagnose the ills of electronic gear, but I understand only a little of today's sophisticated circuits.

Another lasting interest was born in this period: flight. I learned all I could about airplanes and gliders. When I was twelve or so my father bought us a brief flight in a barnstorming seaplane. The pilot did a few loops at my request, and even let me try my hand at the controls. I found I could more or less fly the plane because I had been putting myself to sleep for years by imagining that I was manipulating the joystick and rudder pedals. I built little balsa wood planes of my own design, and I constructed an elementary trainer in the basement out of a discarded electric fan and a suspended model the controls of which I could manipulate from the full sized "cockpit". In my early teens I was in modest demand as an after lunch speaker at local Kiwanis Clubs where I would confidently improvise talks on the future of aviation, ending up by flying my tiny planes over the heads of local businessmen. On one of these occasions I proudly shared the platform with Clarence Chamberlin, who had recently (1927) followed Lindberg by flying the Atlantic.

Shy as I was in ordinary social situations, I was shamelessly relaxed appearing in public. I usually was toastmaster at the annual fathers' and sons' banquet, and enjoyed gently roasting my teachers. The Academy had an asset that fascinated me and that called out for use: a fully equipped stage, with flies, a green room, and an elaborate electrical system with overheads, spots, and footlights. I organized many instant productions which were put on for the school's weekly assembly meetings after a few rehearsals. I discovered that I could manage a fairly big part without much memorizing by writing key lines in chalk on the floor of the stage, leaving books open around the set, and improvising. Perhaps this prepared me for teaching.

Sometime early in my high school career music became important to me. I had earlier taken piano lessons of the standard sort which demanded endless practicing, the memorization of a few silly pieces, and a once-a-year public performance to advertise the prowess of the teacher. I hated it, and quit just before the yearly demonstration. Then one day, as they say, I sat down at the family upright and started to play. Well not quite. What happened was that I became fascinated by the fact that music could be *read*, and in about two weeks of frenzied effort I taught myself to read piano music, though of course not well. I then sought out a good teacher, and I was lucky to find a young recent graduate of Julliard who accepted me on my terms. I told her: no practicing, no memorizing, lots of theory, and above all sight-reading. She was delighted, and explained that I would have to learn some harmony and counterpoint, not to mention something about composition. She set aside

Sunday mornings for me, and they were exhilarating. We played a lot of four-hand music, and she let me stumble through a lot of basic stuff that was far beyond my technique. She would tune the radio to Toscanini and the New York Philharmonic and set a metronome going to show me how Toscanini's rubatos never forgot the underlying tempo. Our music-making was pleasantly laced with the sexiness four-hand playing promotes.

My taste for learning to read music and my general curiosity about the devices that produce it led me to try any instrument I could put my hands on. The Academy had inherited a variety of instruments which anyone was free to use. I went through the available horns, teaching myself how to read music for each: starting with the tuba I went on to the E-flat alto horn (also called a mellophone—really a poor man's French horn) and the trumpet. My lip was too tight for the tuba and too flabby for the trumpet so I settled on the E-flat horn, which I played each Saturday during football season in the marching band of a neighboring high school. The only instrument I took at all seriously (besides the piano) was the clarinet. I took lessons for a year or so from the first clarinetist of a second-rate orchestra in Manhattan, but though I played in a few amateur groups I never became much good.

One night I was walking a friend home from a late party. There was a heavy snow falling. The only place to walk was in the ruts left by the few cars still on the road. A car came up silently from behind and swept my companion from my arm and into a snowbank. She was unconscious; I picked her up and carried her into her house, which happened to be at hand, shouting to the driver of the car to stay where he was. When, not long after, an ambulance came, accompanied by the police, the driver and the car were gone. My friend recovered with a few bruises, but a day or so later the police found the car that had struck my friend and arrested the driver for a hit-and-run offense. At the trial, the judge asked me if I had had a conversation with the driver. I said I had spoken to him, but he had not answered. "Just answer yes or no young man" ordered the judge. I replied that I didn't know whether my speaking to a mute respondent counted as a conversation. The judge would have none of my smart aleck nitpicking. I now see that I was working my way toward a valid philosophical point: when the application of a concept in a particular case depends on a number of underlying factors and no others, and those factors have been exhaustively specified, there is no point in asking whether, *in addition*, the original concept applies.

Another activity to which I was devoted from the time we moved to Staten Island was sailing small boats. We had moved to Staten Island partly because some friends of my father's, Henry Wilcox and his wife, Anita, lived there. Henry was a son of old Mrs. Wilcox. All the Wilcoxes were rich by our standards. Henry and Anita had built themselves a large and definitely original house on a wooded hill ("the highest point on the coast from Maine to

Florida"—about 400 feet high). It had a swimming pool with an imitation totem pole which provided various platforms from which one could dive: the wings, the nose, the top. There were four Wilcox children (and one more later who was adopted). Roger, the oldest, was only a year or so younger than I was; then came Warner, Sally, and Ann. My sister and I played with these children while our parents did their slightly more adult things. There was sailing in the Lower Bay almost every weekend during the summer, in boats owned by the Wilcoxes. They all were skilled sailors, much into racing. As he grew into his teens, Roger emulated his father by building his own boats, at first to his own design (an early catamaran), and then various one-design boats for serious racing. Roger sailed a Star he had built, sometimes with me as crew, in the Nationals, but I forget the highest level at which he won. Henry also won many local races, but it was Warner who in the end distinguished himself racing in ocean-going yachts. In this atmosphere I picked up the rudiments of sailing. One summer friends who were away let me use their boat, and I decided to race it. I won the local yacht club competition in my class, and went on to win in some East Coast inter-club weekend regatta. I still have a yellowed clipping from the local Staten Island paper showing me sailing over the finish line with my crew, Lola Borgemeister, a classmate.

The Wilcox family seemed to me far better in almost every way than my own: they were more laid back, had more fun, did more exciting things, accomplished more. We were pedestrian and middle class by comparison. I particularly admired Henry, who was, or so I thought, part American Indian, and had a hole in his nasal septum where he had once worn a ring. He was physically strong, and very daring. He taught us how to take a canoe out through the surf, empty it while in deep water, and return (the hard part). He knew endless poetry by heart, and was a talented story teller. My mother and Henry had something going in those days, but I figured this out only much later. My father and Anita were less romantic, more cerebral and argumentative, than Henry and my mother. They carried on one of those slightly forced office-style flirtations the pleasures of which escaped me then as they do now.

My best friend through high school and undergraduate days was Hume Dow. Although an Australian, he and his family were living in this country because his father was the Australian consul to New York. Hume was a bit older than I and a class ahead of me at the Academy. He opened up worlds of interest to me. He showed me how you could borrow five or ten books at one time from the public library (get your friends to get cards, then use your friends' cards), and he infected me with some of his enthusiasm for literary criticism, nineteenth-century and more recent French and Russian literature, history, and philosophy. We were encouraged by our wonderful English teacher, Mrs. Hoover, who was as much a friend as a teacher. Hume also turned my interests to politics; our views were socialist, strongly pro-labor,

more than a little tinged with Trotskyite sympathies. On most of the issues of the day we were dupes of the Communist Party line, and we aligned ourselves with The United Front Against War and Fascism. Almost every weekend we took the ferry to Manhattan to march in some demonstration, attend a concert, or go to a museum. We loved the Museum of Modern Art, then ensconced, I seem to remember, in a brownstone on Fourth Street. We haunted second-hand bookstores. Hume left the Academy a year before me to go to Harvard, and this had much to do with my subsequent decision to do the same. Hume was one of the two people his senior year at Harvard to graduate Summa cum Laude (he was an English major), and immediately after graduating he disappeared to Australia. This was in 1938. With the confusion of war, I lost touch with him, and later was told he had lost his life while serving as a war correspondent. Thirty years later, on my first trip to Australia, I discovered that he was very much alive, and teaching in the English Department at the University of Melbourne. We got together, and I met his wife Gwen, a distinguished professor in the education department. Since then we have met a few times in various parts of the world, and I look forward to our next encounter. (Alas, since writing this, I have heard that both Hume and his wife have died.)

During the summer of 1934 my father arranged a job for me working as a messboy on a general cargo ship owned by the Bethlehem Steel Company. I had no idea what I was getting into. I shipped aboard in Philadelphia, where I displaced an elderly ventriloquist that the crew loved; a very bad start, since it was known I had the job through pull. I was immediately put to work carrying hundred-pound sacks of potatoes from the dock to the bins where they were stored. We sailed without stop through the Panama Canal to San Pedro, the port of Los Angeles. My duties were to serve the petty officers' mess and to insure that there was hot coffee available at all hours of the day and night. All complaints about the food and the coffee were directed at me, and I was not good at handling the rough humor, if that is what it was, of which I was the butt.

When we landed in San Pedro there was high drama. The docks were guarded by police; there was an air of tension. We soon found out why. Harry Bridges, the Australian who headed the longshoreman's union, had called a strike, and word went around that anyone who failed to join the union and the strike would be in a lot of trouble. The lesson was reinforced on my ship when a non-union crew member "accidentally" fell into a hold and was killed. I joined the union. For some reason, our ship was allowed to continue to San Francisco, where things were worse. In San Francisco, while we were at sea, the shipping companies brought in strike-breakers, and policemen charged a picket line of several thousand strikers. Two men were killed and many wounded; this was on July 5, "Bloody Thursday". A general strike was called

which brought things to a halt in the city. It was at this moment that we docked at one of the wharfs in San Francisco; by then there were militiamen with machine guns along the docks. Presently most of the demands of Bridges and his union were met and the strike called off. "The first general strike that was ever won", Bridges said afterwards. I had been sympathetic with the strikers from the first on principle. The consequences of the strike brought me to appreciate what a good union could accomplish: the food on the ship became better, working hours were shortened, pay improved, and (most important) union hiring halls replaced the shapeup. While things settled down, I took off to visit one of my aunts, who taught in a school in Berkeley. I fell in love with the Bay Area with its waters filled with ferry boats and its trolleys that seemed to go everywhere. To me there was something excitingly raw about San Francisco itself; utterly unlike New York, you had the feeling that there was earth, not macadam, under the city. Our ship moved to Alameda where a huge crane unloaded a 55-ton cross-brace for the south tower of the Golden Gate Bridge, then under construction. Presently we moved a short way up the Sacramento River to Crockett to pick up sugar. It was a longer trip up the Columbia to Portland. We then sailed back to New York through a Pacific storm that had most of the crew seasick. During this trip I was scared, lonely, and anxious. It whetted a taste for travel that never left me.

Two of my teachers in high school influenced me. One was Roswell Cole, who taught history and government. His views were openly socialist, and he had a philosophical turn of mind that stirred me to try reading Plato and Kant. I didn't make much of them; Nietzsche and Schopenhauer were more to my adolescent taste. The other teacher who mattered to me was our English teacher, "Maggie" Hoover, whom I mentioned before. She frequently had Hume and me to dinner at her cozy flat across the street from the school, and she and her husband, who taught at Barnard College, influenced our reading through their own enthusiasm, especially for Shakespeare and the eighteenth-century English novel. Each year some senior was chosen to be editor of our school magazine, the *Quill*. I had often written for it, and in my junior year had a monthly column called "Hic et Ubique", so I became editor.

I took the matter of choosing a college seriously. During my senior year I visited the colleges I was considering: Swarthmore, Yale, Harvard, and Dartmouth. Hume Dow was already at Harvard, so I spent a few days with him, meeting his friends and going to classes. At the other places I wrote the Dean of Admissions saying I was considering going there and asking them to arrange for me to stay in a dormitory, and to suggest classes I might attend. When I applied for financial aid, Swarthmore offered me a tempting four-year scholarship, but Harvard offered me more, though only for the first year. The Harvard offer came not from Harvard itself, but from the Harvard Club of New York. I submitted my application at the last minute and so was

interviewed last of some forty other hopefuls. The interview was in the office of Harrison Tweed, the lawyer. I remember thinking the room looked like a movie set for a large corporation board meeting: lots of stuffed furniture and shirts. As part of the material I had submitted I had included a list of books I had taken out of the library for the last year: there were more than a hundred titles. Had I really read all those books, I was asked? No, I said, but I looked at them. This one, some stock broker said, the *Critique of Pure Reason* by Kant; did you understand it? No, I said, but I tried. So did I, he said. At the end, Tweed looked slowly around the room and then rose and shook my hand. You've got it, he said. There's a lot to be said for sheer gall I thought to myself. Shortly after midterm exams at Harvard, Tweed asked me to come to see him, and I did. He had my grades in front of him. I had three A's in various subjects, and a C in Greek. He asked in a kindly way if I were wise to continue with the Greek. I don't know how I answered, but I did go on with Greek, though probably not wisely. For all his kindly manner, Tweed had reminded me of my father.

Two things particularly strike me now about Harvard in those days. One was the fact that students were allowed to take almost any courses they pleased. My advisor was James B. Munn, chairman of the English Department. I don't think he ever tried to dissuade me from anything, though he did give me lots of helpful information. He went out of his way to be friendly, inviting me to tea a number of times and introducing me to his family. That is the other thing that now seems amazing: the extent to which my teachers made themselves available, and in many cases became friends. Early in my freshman year I got to know John Goheen, who taught the once-a-week section of the introductory philosophy course I was taking. He had recently returned from France with his wife Nancy, having completed his Harvard Ph.D. with a dissertation on Thomas Aquinas. His interests in philosophy were mainly historical, and soon mine were too; by this I mean (in my own case) that I was fascinated by the views of historical figures without much caring whether or not they were true.

I knew that my sophomore year was the last year Whitehead would be teaching, so I took his course the first semester and his graduate seminar the next. The course was "historical", based on *Adventures of Ideas*. I was so impressed by being present at Whitehead's final classroom performances that I attempted to write down every word he uttered. Although I didn't know shorthand, this wasn't as difficult as it sounds, since he spoke very slowly, and repeated himself a good deal. I found that by inventing a symbol for his favorite phrase, "as a matter of fact", I could just about keep up. The seminar was for graduate students, but Whitehead cheerfully admitted me. The contents of the seminar were what you find in *Process and Reality*, a book most people now find unreadable. They probably found it unreadable then too, but

nevertheless everyone was awed by the great mind, and assumed that the book was so deep that the true content escaped them. I actually read it and could soon spout sentences in its lingo. How I could find it "easy" for an untrained mind and at the same time deep I don't know. My term paper was unusual—at least in the course of fifty years of teaching I have never, I'm happy to say, received a paper like it. Along with the magic vocabulary of "eternal objects", "ingression", "actual occasions", etc., I included a couple of poems and two pictures illustrating such events as two occasions prehending one another. Whitehead appreciated all this: he gave me an A+; none of the graduate students did as well (no doubt because, like Socrates, they knew they didn't understand). Whitehead started inviting me to his famous Sunday afternoon teas. He and his formidable wife held forth in different rooms; midway in the session, they changed places. I have often thought my encounter with Whitehead set me back philosophically for years; he confirmed my inclination to think that doing philosophy was like writing poetry: anything, as long as it sounded important and mysterious, was as good as anything else (this is unfair to poetry). Truth, or even serious argument, was irrelevant. You didn't even have to be a good poet: a little flair and you were at the top, with an A+.

It was only towards the end of my undergraduate career that I learned much about philosophy, and that was because I had to take the four comprehensive exams in ethics, history of philosophy, logic, and metaphysics (this last included epistemology). I avoided taking the courses in these basic topics; I felt that if I had to take the exams I would learn the material on my own. Instead I took a smattering of courses and seminars on such subjects as St. Augustine, Plato, and the Pre-Socratics, the last two in the classics department. My interest was mainly in the history of philosophy and the history of ideas more generally.

For my first two years in college I had been an English major, and at the end of that time I took and passed the Bible and Shakespeare exams and the Ancient and Modern Authors exams; I think I chose Homer and Goethe for the latter. These exams actually came at the beginning of the junior year, so one had the summer to bone up. About half of the Bible and Shakespeare exams required the identification of dozens of short excerpts (who said it; which play and scene, or book, does it come from; etc.), so one needed a comprehensive, if superficial, knowledge of these works. I greatly enjoyed preparing for these exams, but having done most of what was required for a degree in English after two years I shifted to comparative literature with its emphasis on tracing ideas from the Greeks through the Romans, the Middle Ages, and the Renaissance to modern times. I had a series of marvelous tutors. There was John Finley, expert on Thucydides and subsequent master of Eliot House. He infected me with his admiration for Thucydides, an enthusiasm that I still have, though I wouldn't now attempt the Greek. Theodore Spencer, in seminar

and tutorial, took me through the parts of the Renaissance that particularly interested him, along with the Greek sources in the *De Anima*, the *Poetics*, and Homer. We went through Chaucer's *Troilus and Criseyde* in Chaucer's English as well as Shakespeare's *Troilus and Cressida*. Harry Levin was writing his ground-breaking book on Joyce, and introduced me not only to Joyce but also to Proust and a number of modern authors I had not read. F.O. Matthiessen tried to get me interested in American literature without, I'm sorry to say, much success: like everyone else, I read Hemingway, Dos Passos, James, Fitzgerald, and *Moby Dick*, but I never got the background I should have had in Emerson and Thoreau.

My only tutor in philosophy, so far as I remember, was David Prall. His views in aesthetics were influenced by I.A. Richards but were more extreme: for example, he thought the only legitimate aesthetic interest in poetry was in the sounds. He made me read Locke. He also gave me a shock by asking me to write a paper on free will and determinism. It now seems astonishing, but this was the first time anyone had suggested that I try to make up my own mind, however tentatively, on a philosophical issue. I remember the sweat I was in for a week or so grappling in my unaccustomed and naive way with the problem. Prall wanted to know what I thought and why, so I couldn't fall back on St. Augustine or Thomas. I came down on the side of determinism, thinking I was abandoning all thoughts of free will for the rest of my life. The decision was, however, very much in line with the main tendency of my thinking. I never had the child's faith in miracles; I was always certain—probably too certain—that everything has a perfectly good explanation. Einstein described the development of "our world of thought" as "a flight away from the miraculous". What amazes me is not what seems contrary to science, but the fact that very intricate devices, the details of whose operations are well understood, work as well as they do. Computers are an example. No mysteries there, but it is astonishing that anyone succeeded in making them. I shall never get over my surprise that we managed to put people on the surface of the moon, and return them safely to earth.

During my freshman year I attended a few performances of the Ballet Russe de Monte Carlo, and became an instant balletomane. I cursed my parents for not having started me as a dancer when I was seven or ten, and dreamed of a successful late start. Fortunately I did nothing about this fantasy except go to every performance (in standing room, of course) each year the ballet came to town. By luck an acquaintance, the painter Alfonso Ossorio (already foreshadowing his future fame as a painter) knew people in the ballet and introduced me backstage. There I met Lichine and Massine, who was then choreographing vast, symphony-long, works. Massine's contribution to the evolution of the dance was, I now am told, to compose ballets that didn't exactly tell a story. I also met two of the delicious "baby ballerinas", Tatiana

Riabouchinska and Tamara Toumanova, and had the nerve to invite the latter to lunch at Eliot House. She came, almost as ill at ease as I was. She spoke no English, so I staggered along in my embarrassed French, wishing I were actually earning the envious stares of my fellow students.

My social life in college was very different from my social life in high school. I was used to having women around; at Harvard there were none. The few attractive Radcliffe girls were reserved for the athletes, the socialites, and the millionaires, and I was none of these. During my senior year things picked up, but that was after a long time in the desert. Summers were a relief: for three of them I was lifeguard at the beach on Grasmere Lake. The summer of 1937 I went to Europe for the first time. My father generously gave me $300. Almost two-thirds of that went for boat fare. I spent $15 to have a bicycle built in Paris, and the remaining $100 kept me going for three months. I debarked at Cherbourg but got off the boat train to Paris at Caen: I was determined to see as many Romanesque churches as I could, and the two transitional churches in Caen were high on my list. I'm glad I saw them then, for both were very badly damaged by the Allies during the war (they have been reconstructed since). Then on to Paris, where I was met by John Goheen. He took me on a little tour by taxi on the way to an apartment a friend had let him and his wife, Nancy, use. There was room for me also, and I stayed on after they left for Freiburg. I was thrilled by everything, the crowds in the street, the great boulevards, the new things to eat, and discovering that I could make my way in a foreign language. The apartment on the rue Jacob was in the house occupied by Wagner while he was writing *Der Fliegende Holländer*. Inspired by the romance of it all I went down to the quays by the Seine and bought some second-hand music which I played on an old upright in the apartment. I put my bicycle and myself on a train to Bonn for a rendezvous with a high school flame, the Lola Borgemeister with whom I had sailed in high school, and we made a mini-tour of the Ahr river valley. The affair turned out to be dead, however, for she had fallen in love with a handsome young Nazi. Very much by myself I cycled to Weimar, then south to Munich, where I stayed for a few weeks. The Goheens were there, having become disenchanted with Freiburg. I met a group of students of various nationalities, and we spent our evenings drinking beer and trying to enter into the uneasy Gemütlichkeit of pre-war Munich. Like the Bavarians we muttered "drei Liter" when the situation called for a "Heil Hitler". I saw the original Entartete Kunst exhibit and was depressed by the open anti-semitism of the press, but I am now astonished by the extent to which my friends and I took these ugly portents as little more than a bad joke.

I finished my grand tour by cutting first east by the Königsee, down into Austria and then west along the Inn. I skirted Lake Constance on the south, made my way to Zürich, and reentered Germany for a tour of the Black Forest.

This led to Freiburg, where I suppose Heidegger was holding forth. I crossed the Rhine to Colmar, and zigzagged across Burgundy, far more delighted with Vézelay and Autun than with any Gothic or Romanesque I had seen in Germany (more recently I have developed a taste for the vast double-ended Romanesque churches of Germany). I had little time left for the rest of France, but luckily Auxerre, Sens, and Chartres lay on my path back to Cherbourg. Altogether I figured I had biked about three thousand miles. I sold my bicycle for $10, so most of my transportation for the summer cost $5.

Harvard tradition required that once every four years the Classics Club mount a Greek or Roman comedy, and in my senior year it was time for Aristophanes. For some reason I had just read all the extant plays, so I easily persuaded the Club to go along with my choice: *The Birds*. I was told that since I had picked the play I should act the part of the protagonist, Peisthetairos. I soon discovered that, choruses aside, the main character in a play by Aristophanes has about half the lines. It was too late to back out. But the burden of memorizing those hundreds of lines of Greek put a serious crimp in my study time and permanently added to my (already not inconsiderable) distaste for the dirty work of mastering a foreign language. We did the play in what we thought was the right spirit, wearing masks, adding contemporary touches, and singing the parts that were probably sung in Aristophanes' day. The music, however, was neither Greek nor ancient: we persuaded Leonard Bernstein, also a senior in 1938–39, to write the music and to conduct. We wrote out the Greek scansion for him and he did the rest. As I remember it, his score was for string quartet, wind quartet, and percussion; some of this music subsequently turned up in the music for the ballet *Fancy Free*. *Life* magazine published a full page photograph of me, looking small and impish, posing with three magnificent gods.

One result of this comedy was that I got to know Bernstein. I introduced him to the later Beethoven string quartets (recorded), and in return he let me play secondo in four-hand arrangements of the Beethoven symphonies. We were so pleased with our performances in *The Birds* that a month or so later we put on Marc Blitzstein's *The Cradle Will Rock*. This comic opera, somewhat in the style of Kurt Weill's *Three Penny Opera*, had played a year or so before in New York. There had been a bit of drama at the opening. Just as it was about to open the musicians' union struck, so Blitzstein had an upright piano placed on the stage, and he played the orchestral score. The irony was that the piece glorified labor and unions, and featured a capitalist villain, Mr. Mr., and his lackeys. We followed Blitzstein's suit, with Bernstein at the piano (but with the difference that by the time he had played through it twice Bernstein had memorized the score). I was the hero, Larry Foreman. The first performance sold out, so we gave a second. The Boston critics, starved for excitement, came out to Cambridge, and gave us good reviews. Blitzstein

traveled down from New York, and we had a wonderful party. Blitzstein asked me if I would be interested in a part in his *Regina*, which was in preparation. Luckily I declined; the play was a flop.

The heroine of *The Cradle Will Rock* was a prostitute, played by Bernstein's sister Shirley, then a high school student. Of course I fell in love with her, but the flirtation shriveled when Lenny told me he would kill me if I "did anything" to his sister. Those were the days. Fortunately a more suitable object for my affection soon turned up in the person of a woman student from Wellesley who was attending a Plato seminar at Harvard.

As a freshman I had been assigned a roommate, Crosby Keller, a strong athletic type from the Midwest. After freshman year we were allowed to express a preference for a house and roommates, and I opted for Eliot House where two friends from the class ahead of mine had just lost the third occupant of their attic (and therefore cheap) quarters. To my delight I was able to join them. Bob Cumming was then, like me, at least partly in Classics, and Ben Bart was in French Literature. We were all studious, and we got along well. Ben and Bob were old friends, and had spent a summer together touring the French Romanesque churches. Both went on to become academics, Bob as a professor of Philosophy at Columbia University, and Ben as a professor of French, in his later years at Pittsburgh University. Bob was to write two fine books on English Liberalism in the seventeenth and eighteenth centuries, and Ben was to write a successful book on Flaubert. Though I have seen little of them in recent years, our paths have crossed over the decades, and I have always wished we had been better at keeping in touch.

Another friend in those undergraduate days was Wells Lewis, the son of Sinclair Lewis and Dorothy Thompson. Though his parents were still married, I never heard him mention his father. We shared a taste for art and literature, and we were often joined by Hume Dow. Wells impressed us all by publishing a novel in his senior year. Immediately on graduating (in 1938) he went to Spain to fight Franco and was killed.

One of my teachers was John Wild. He had written on Berkeley, but by the time I knew him his interest had turned to Plato. He was an intense man, and I learned a lot from him about how to read a text with attention. He converted to Anglo-Catholicism during my junior year, and helped persuade many of my friends to join him, including Bob Cumming. I had never taken religion seriously, but here was a heady mixture of ideas I had been reading about, of intellectual and social excitement, with the hint of a mysterious secret I had not shared. Father Smythe had been set up in a rather grand house in the midst of Cambridge with the aim of proselytizing and he was doing a tremendous business. Sunday mornings he held mass and then presided over a splendid breakfast, served at his elegant antique Italian table. I was almost sucked in. Father Smythe instructed me once a week in his study which displayed an

enormous polyglot bible on a stand. At last he hinted that it was time for me to take the plunge. I demurred, saying I still couldn't bring myself to believe in the essential points. He explained that belief would follow faith. That weekend I went off skiing and standing on a slope in New Hampshire alone and in the sun, I had my revelation: so far as I was concerned, religious beliefs could be a fascinating part of the history of ideas, but there was no way I could embrace them. This was my sole brush with religion.

Crosby Keller, my roommate from freshman days, had become an enthusiastic skier, and for some reason asked me to come along with a group that drove up to the mountains whenever they could. One trip, and I was hooked. Skiing in those days was pretty primitive. The boots were poorly made, skis were wooden and lacked the metal edges they were to acquire later, and bindings were made to yield only if one fell on one's face. There were a few simple rope tows set up by farmers in their pastures; otherwise one walked up whatever one skied down. Someone gave me a half-hour lesson in doing the snow-plow turn, and I was on my own. The second week, I bought a pamphlet on how to ski, went off into a pasture, and taught myself the basics. By Sunday I could negotiate a trail, falling down on every third turn. I was entranced with the physical thrill combined with the open scenery and the good company. I still love skiing, and have done it where I could, in Europe, Canada, the United States, New Zealand, and Scotland. The last, which I tried in 1974, reminded me of the weather, terrain, and facilities that existed in New England in 1938.

Upon graduating I had no plans for the future. My Wellesley friend had a car, so we set out for Hollywood where her father was the agent for a number of celebrities. I was urged to write radio scripts for "Big Town", a once-a-week private-eye program starring Edward G. Robinson. They paid a thousand dollars for an idea they could use and another thousand if they used your script. My scripts were hopelessly amateurish, but they did use one idea. We spent most of the summer having fun, going to the races, swimming, and riding my friend's father's horses in what was then the undeveloped landscape of the Hollywood hills. During the summer I got a call from Harvard asking me if I would accept a scholarship in classics and philosophy. A man named Teschemacher had left a generous sum to establish such a fellowship, and Harvard had been unable to think of another eligible candidate. It was the largest graduate scholarship available to philosophy graduate students at Harvard. I don't suppose I would have won any scholarship at all in general competition, but no one else was interested in classical philosophy. I accepted. It is a question what I would have done otherwise.

Now I had to get serious about philosophy, for there were the preliminary exams that had to be taken at the end of the second year. I took my first course in logic with Quine, a course which covered the ground of his about-to-be

published *Mathematical Logic*. I was thrilled with the simple pleasure of proving theorems; I remember that I spent most of the time that semester working on this one course, often staying up late night after night, alternately immeasurably frustrated and immeasurably pleased. For some reason I had never much liked mathematics in high school, so mathematical logic was my introduction to mathematics as well as to formal logic. I was amazed to find I could do it at all. But much as I loved it, I realized from the start that I would never be as good at it as many others were. From time to time over subsequent years I was to rediscover how much I enjoyed solving simple mathematical and logical problems, but I always knew my gifts in this direction were slight.

When I entered Harvard as an undergraduate I had a shock of a sort that must be common: in high school I had thought of myself as a leader, and one who easily excelled at whatever he tried. At Harvard I was surrounded by people who knew much more than I did, who learned languages more easily, made friends more easily, talked more brilliantly, and of course were better at sports. Most of them also had more money. If I had any advantage, it was that I was genuinely interested in almost everything I studied and did, so while things did not come effortlessly, I found the effort pleasant and rewarding. Perhaps it also helped that I was not particularly concerned to get good grades or impress my instructors.

As I have discovered often happens to others, my rather happy-go-lucky attitude toward academic success began to fade when I became a graduate student; real life began to loom. The jolt I got on discovering my rank in the world as an undergraduate was mild compared to the realization that as a graduate student in philosophy I was, it seemed apparent to me, far behind my peers in sophistication, ability, and knowledge; and I was at least two-thirds right. The two Rodericks, Chisholm and Furth, were already deeply into the problems of epistemology, and could argue knowledgeably about sense data. Arthur Smullyan was challenging Quine on quantified modal logic, and chatting with Bertrand Russell about the nature of propositions when Russell visited Harvard. (I was flattered to be invited to meet the great man in Smullyan's rooms. I was impressed by Russell's easy, friendly manner, but was barely able to bring out a word myself.) Henry Aiken was clearly being groomed to occupy a senior position on the Harvard faculty, something he had already done by the time I returned to Harvard after the war as a continuing graduate student. I knew a few graduate students in other disciplines. One was Arthur Schlesinger Jr., who lived across a hall from me. His knowledge of the movies impressed me, but did not move me to emulation. Peter Viereck was a friend from undergraduate days, already slated for success as a poet, essayist, and historian.

During my second and third years as a graduate student I sublet a room in the attic of a large house occupied by two young junior fellows, James Baker

and Robert Woodward. Baker was an astronomer. His main interest involved making spectrographic studies of certain stars, but he needed better equipment, so he designed a sophisticated improvement on the then new Schmidt lens system (this became known as the Schmidt-Baker lens system). In order to apply theory to practice, he needed to solve some large number of simultaneous equations. I remember that this took weeks, during which he filled whole notebooks with calculations (I assume this could be done on a modern computer in minutes). Then he went down in the cellar to grind the lenses. (More weeks, even months.) Finally it was time to carry the equipment out to the Blue Hills Observatory and fit it to the large refractor. Baker's life became ruled by what then struck me as the wonderfully romantic timetable of the observing astronomer: breakfast while others ate supper, a long night's work with maybe a sandwich and coffee, then supper while the rest of us ate breakfast. One cold night I went along to the observatory, and was soon put to work keeping the giant telescope pointed at the star being studied; this involved my balancing somehow on the telescope and keeping the star on the crosshairs of a finder scope. As the night wore on the earth turned, and the telescope with it. In the end, I found myself almost upside down, hanging on by my finger tips. I was thrilled.

Bob Woodward was a wizard at chemistry. He was born in the same year I was, but had obtained his Ph.D. two years before I graduated from Harvard. His work was determining the structure of, and synthesizing, organic substances. He took me to his laboratory and gave me a brief description of how it was done: take gallons of some likely chemical, and painstakingly transform it in many steps into half a drop of what you hope will be what you were after. This can take a year or more, and you may run short of stuff to transform before you reach your goal. Start over. Bob thought I was wasting my time with philosophy; no money in it, for one thing. There certainly was money in chemistry for him: during the war he synthesized atebrin, a quinine substitute, and subsequently a number of other commercially valuable products (cortisone, strychnine, lysergic acid, chlorophyll, tetracycline). In 1965 he won the Nobel Prize in chemistry.

In my ignorant way I was fascinated by talking to these hard working and talented scientists and observing them solving their problems. I have always been glad I had the chance to catch even this much of a glimpse of what the life of a serious hands-on scientist is like.

While I was living with Baker and Woodward a graduate student in art history rented the room next to mine. I was attracted to her, and took an interest in Spanish art in which she was taking a seminar. She found the term paper forbidding, so I dashed off an essay for her. I knew nothing about the subject, but I found it easy to point out details in the paintings which might escape notice, and this passed as serious criticism; in any case the paper got

an A. Rather unfairly, I concluded that art criticism was near the end of some scale that had astronomy and organic chemistry at the other end. Philosophy was in between, but nearer art criticism than serious science.

During this period someone entered my name as a candidate for a Junior Fellowship. Baker and Woodward, while they had no say in the decision, kept me posted on my progress. This was easy for them, since the folders of candidates who were in the running were kept on a table where any Fellow could see them. Each week the number of folders decreased. Finally there was only one more folder than the number of Fellows who could be elected, and mine was still there. One last folder had to go, and it was mine. Fortunately I was not downcast; I did not consider myself on the same level of ability or accomplishment as the Junior Fellows I knew.

Quine had been in the very first batch of Junior Fellows, along with B.F. Skinner; by the time I was a graduate student Quine was teaching at Harvard. By coincidence, I met Quine on the steps of the Fellows' quarters in Eliot House after being interviewed. He inquired in a friendly way how things had gone. I blurted out my fatuous views on the relativity of truth to a conceptual scheme. He asked me whether I thought that the sentence "Snow is white" is true if and only if snow is white. I saw the point, and subsided. Many years later this exchange took on in retrospect a faintly ironic quality, for it was Quine who became something of a relativist about truth and I who rejected conceptual relativism.

In later years I heard graduate students at Harvard complain about Quine's teaching: they found it clear and carefully worked out, but uninspired. Quine himself has written that he did not much enjoy teaching, especially when it came to topics outside of logic. But he certainly turned me on, and in the process turned me around. I remarked above on my discovery, under Quine's tutelage, of the magical satisfactions of contriving elementary formal proofs. More important to me in the long run were Quine's scrupulous attention to the distinctions between use and mention, the conditional and entailment, substitutional and ontic quantification. These implied a seriousness about the relations between semantics and logic which I absorbed without realizing at the time how few philosophers shared such concerns.

What really changed my attitude to philosophy was Quine's seminar on logical positivism, which I took as a first year graduate student. Quine had come back from Europe in 1933 fired up by his encounters with the Vienna Circle, Tarski, and especially Carnap. On his return to Harvard he gave three lectures on Carnap (now published in *Dear Van, Dear Carnap*) which seemed to espouse all of Carnap's central doctrines; in any case there was no criticism. By the time I took Quine's seminar he had worked out his objections to the analytic-synthetic distinction, and to the reduction of ordinary statements about the physical world to statements about sense data, or indeed

protokollsätze of any kind. This led to the rejection of Carnap's distinction between "framework" questions and substantive issues, and hence to the rejection of Carnap's policy of tolerance with respect to general ontological issues. What mattered to me was not so much Quine's conclusions (I assumed he was right) as the realization that it was possible to be serious about getting things right in philosophy—or at least not getting things wrong. By comparison with most of the ideas I had studied as part of the history of ideas the issues being debated by Quine and his opponents were clear enough to warrant an interest in their truth. The change in my attitude to philosophy began to seep into my thinking about ethics and the history of philosophy: I found in Broad's *Five Types of Ethical Theory* and Russell's book on Leibniz the concerns with clarity and truth I was beginning to prize. I didn't know enough to be bothered by the historical inaccuracies in those books; what I liked was the application of contemporary analytic methods and standards to material I had previously viewed as beyond or above being judged as true or false. C.I. Lewis's famous Kant course had somewhat the same effect on me.

The summer of 1941 my friend from the Hollywood summer two years earlier and I planned to drive to and around Mexico. We invited Quine to join us, and to our delight he did. We met Van somewhere in Ohio. As we drove, we three read a Spanish grammar to each other. By the time we reached the border, Van was well on his way to speaking Spanish while my companion and I were still struggling with the irregular verbs.

We were on a tight budget. We sought out the cheapest hotels and restaurants, and read our bills with the natural suspicion of professional auditors. This sometimes led to odd or even hilarious consequences. On one of our stops in Mexico City we found an especially cheap hotel. The walls of our bedrooms were high enough to prevent seeing into the next room, but failed to reach the ceiling. As the night went on the sounds made it clear that we were in a brothel. In the morning we discovered that an expensive camera had been stolen from our car, which we had innocently parked in front of the establishment. Quine was not disturbed by the noise; as usual, he had risen an hour or two before we did to add a few pages to an article or review. He found it made him uneasy to spend a day without doing some serious work.

We had planned on spending a night in Amecameca, a small town in the saddle between Popocatepetl and Ixtacihuatl. (You read about Amecameca in Malcolm Cowley's *Under the Volcano*.) We had made a deal with a hotel only to be told they would charge us something extra, say 18 cents, to park the car in the roomy enclosure. Too much, we said, and stalked out. We then discovered it was the only hotel in town. It was too late to go on. Remembering that Amecameca was where one hired a guide to climb Popo, we found the name of a guide in a book and tracked him down. Supper had to be what we could find in the streets, there being no restaurants open: what we found was

an old witch with a cauldron of frightening stew. For the climb we bought some chocolate and oranges. (The chocolate turned out to be what Mexicans use to make mole, delicious when mixed with a few dozen herbs and spices and served on chicken or turkey, but nearly inedible in its raw state.) We then set out in the car to drive as high as possible, and started the climb about two in the morning. We had nothing but our street clothes, though our guide had supplied crampons, since much of the climb was on snow or ice. We became rather desperately cold as the night wore on, and as the altitude increased we also suffered more and more seriously from lack of oxygen. Seventeen thousand feet is not that bad if you are in shape, have decent shoes, and are acclimatized; we satisfied none of these conditions. The dawn was welcome, with the promise of warmth and a spectacular view as far as Orizaba, Mexico's highest and grandest volcano, some 130 miles away.

A final story (I'm repeating this from my review of Quine's autobiography, *The Time of My Life* [Davidson 1988]): Quine discovered a discrepancy between the prices on the menu and on our bill in some provincial bistro. In response to our question, the proprietor said the prices had changed. "Ah", said Quine,"then let me help you", and he started to write in the "new" prices on all the menus. The outwitted restaurateur decided it would cost him less to reduce our bill than to obtain new menus. This episode illustrates Quine's thesis that there is more than one way of adjusting one's beliefs in the light of recalcitrant experience.

At some point during this period Werner Jaeger joined the faculty at Harvard. Used to the ways of German academia, he cast around for someone to become his follower and menial. Who was there who both knew Greek and was interested in philosophy? He settled on me, and started inviting me to dinner once a week at his house. I was naturally impressed; he was the man who had written the three volumes of *Paidea*, and revised the accepted chronology for the composition of the *Nichomachean Ethics*. At dinner there was always his hospitable, but silent, wife, and his pleasingly plump teenaged daughter. After the meal we went into his study and he recounted the history of German classical scholarship. Each week we advanced a generation or so; I learned what students each man had produced, where he had taught, and what he had contributed to the subject. Finally we came to the present time and place: there before me was the great teacher, and there was I, the intended putty. It dawned on me that the compliant daughter was to be part of the deal. I was reminded of Father Smythe, and reacted in the same way.

When the entry of the United States into the second World War loomed, I wanted no part in it. With my political views in the penumbra of the Party line, I saw the war as a struggle for markets. When Germany invaded its quondam ally, my attitude changed, and I volunteered for service in the Naval Reserve. I wanted to be a pilot, but my eyes wouldn't pass, despite gallons of

carrot juice and equally useless eye exercises. Instead, I was put into a crash program intended to prepare me to teach pilots how to discriminate between friendly and enemy planes and ships (during the invasion of North Africa our ships had shot down the only planes they saw, all our own). There was no time left before the invasion of Sicily and mainland Italy to train others, so I was assigned to destroyers in the Mediterranean and practiced what I had learned to preach at the invasions of Sicily, Anzio, and Salerno. I have never regretted serving, though of course the years spent in the Navy were a dead loss personally. I found the Navy unpleasantly dedicated to maintaining the values and prerogatives of its lifetime professional officers; they were stuffy, racially prejudiced, and on the whole not very bright. I would have been better off in the Army which, because it expanded much faster, was far more democratic and less in the grip of career warriors.

My serious philosophical career and education began when I took up my first teaching job as an instructor at Queens College, one of the City Colleges of New York. This was in 1947. I was thirty years old, fresh out of the Naval Reserve. I did not have my Ph.D., so when I was released from active duty, I had returned to Harvard for a few months, during which I assisted in Quine's (summer) elementary logic course, and frantically tried to write a thesis. I did the latter on C.I. Lewis's advice; he said I had fallen far behind my contemporaries and had best get a job as soon as possible. Those sleepless months attempting to write a thesis from scratch were wasted. The thesis was poor, and was quite rightly rejected by the department. I would have done better to do some reading to get back into the swing of the subject. As it was, by the time I returned to the thesis (in 1947, when I had a year off on a Ford Foundation Fellowship), my idea of how to do philosophy had changed, and I had to start over again. But C.I. Lewis was right about my contemporaries. When I reentered civilian life, most of the people who had been in graduate school with me before the war were tenured professors; while I was futilely struggling to complete my degree, a friend and contemporary returned to Harvard as a full professor.

I was fortunate to get the job at Queens. It was then the newest of the City Colleges, it had an enlightened administration, a relatively young and energetic faculty, and an alert and interested student body. In general, students were expected to attend the City College in their own borough, but an exception was made for graduates of New York's Music and Art high school. These students were particulary gifted, and were allowed to attend Queens College, which had strong music and art departments. From the founding of Queens, John Goheen, my friend and teacher from Harvard, had been chairman of the department. He had put together a wonderful group of people. One colleague was Arnold Isenberg, who had taught me as an assistant to David Prall when I took an aesthetics course at Harvard as an undergraduate. One of Prall's

assignments had been to choose a poem and analyze it according to his principles. As a lark, I wrote a poem, the author of which I did not reveal, and then pointed out the poem's merits. To my delight, Isenberg commented that I had not understood the poem. My smile faded when I turned over the page to read ". . . even if you wrote the poem yourself". Isenberg was a brilliant philosopher. His articles on aesthetics are both subtle and convincing—a rare combination, especially in that generally pale field. But his ideas were sweeping and ambitious, and it is one of the melancholy outcomes of our calling that he did not get to put more of them on paper. Herbert Bohnert, a tall and intense man with a frustrated yen to become a classical guitarist, was also in the department. He was working on his dissertation with Nelson Goodman; he had started with Carnap at the University of Chicago, and when Carnap left for Los Angeles, he had switched to the University of Pennsylvania. Bohnert's idea was to treat theoretical terms as having no more content than their place in a theory, which connected them in various ways to observational terms, bestowed on them. Appreciating the failure (noticed by Carnap, and emphasized by Quine) of the attempt to define theoretical concepts in terms of observational concepts, he hit on the idea of writing out the axioms of the theory, replacing the theoretical terms with variables, and second order quantifiers for these terms in front of the whole. He was well into his thesis when Carl Hempel remarked that Frank Ramsey might have had a similar idea, and of course he had exactly that idea. It may seem surprising today, but at that time few people knew Ramsey's work, aside from his famous review of *Principia Mathematica*. Bohnert was crushed at the news, though a few years later he realized his and Ramsey's idea was worth much further development, and he completed his thesis. Also at Queens was Hempel himself. Goheen had heard about him from Carnap (both Hempel and Carnap had been attached to the Vienna Circle), and he needed a job after escaping with his wife from Germany and then Belgium. Peter (everyone called Hempel "Peter") was one of the kindest and most generous people in the world, and he was helpful to me. Although both Peter and Bohnert were far better logicians than I, I had to teach some of the logic classes, and Peter came to some of my sessions to give me his advice. One of my logic students was Nicholas Rescher. Since classes were limited to thirty students, and there were no teaching assistants, most classes were taught by a number of faculty members. We worked hard: everyone taught five different groups three times a week. In addition, there were special tutorials for students who wanted to study topics not offered in scheduled courses. Aside from those in the hard sciences, we all were expected to teach one or another part of the Columbia Contemporary Civilization program. I didn't mind; I enjoyed learning at least a bit about the history of political theory, economics, and, of course, literature.

During my time at Queens College a small group met more or less

regularly at our apartment in Styvesant Town. Arnold Isenberg, Herbert Bohnert, Mary Mothersill, Sydney Morgenbesser, and A. J. Ayer, who was visiting at NYU, were usually there, and the discussion was lively. We normally had a topic to discuss, and often a member would read a paper on which he was working. I believe I gave a talk on the relation between free will and determinism. I had by then decided not only that they could be reconciled, but that a free will ruled out a failure of causality either in the process that couples our actions to our attitudes or in the impact of the world on those attitudes.

I had a grant from the Rockefeller Foundation for the academic year 1947–48. I spent it in southern California, where I finally finished my dissertation. I had invested too much in my earlier attempt to change the topic completely, so I wrote an entirely new piece, but still on Plato's *Philebus*. I was no longer happy with the sort of historical approach I had adopted earlier, so I decided, first, to write about Plato in as analytic and contemporary a mode as I could, and second, to treat the dialogue on its merits, without trying to warp it to fit a preconceived vision of Plato's philosophy. I discovered that none of the available English translations was satisfactory, so I translated a good part of the dialogue. The only commentary that seemed to me have any philosophical merit was Hans-Georg Gadamer's dissertation, written very much under the influence of Heidegger.[2] When my dissertation was published in 1990, I wrote a short preface:

> The *Philebus* is hard to reconcile with standard interpretations of Plato's philosophy. Instead of attempting a reading of the dialogue that would fit it into a conventional picture of the late Plato, I tried in the dissertation to take the *Philebus* at face value, and reassessed Plato's late philosophy in the light of the results. The central thesis that emerged was that when Plato had reworked the theory of ideas as a consequence of the explorations and criticisms of the *Parmenides, Sophist, Theaetetus,* and *Politicus,* he realized that the theory could no longer be deployed as the main support of an ethical position, as it had been in the *Republic* and elsewhere. This mandated a new approach to ethics.
>
> What I did not appreciate at the time I wrote was the extent to which the approach to ethics in the *Philebus,* despite the innovative metaphysics, represented a return to the methodology of the earlier dialogues.

As an introduction, I reprinted my relatively recent S. V. Keeling Memorial Lecture in Greek Philosophy, given at University College, London, in 1985 (Davidson 1985). In that lecture, I emphasized Plato's reversion to the Socratic elenchus, and connected it with the startling reappearance of Socrates as the leading voice.

While writing my dissertation in California, I took my mind off work by getting a pilot license. In those days flying a small plane was less shackled with regulations than it is now; the planes I flew seldom had a radio, and no

planes had the navigational devices that have since made keeping track of one's location so easy. Flying by instruments was possible, of course; I had learned to do it in the Navy. But it was a tedious and often uncertain business. Most of my flying was done by using visual cues and dead reckoning. I often flew north from Pomona over the mountains and into the desert, spending the night beside the plane in Death Valley, or at some other unfrequented dirt airstrip. When I updated my skills years later, most of the fun and adventure had been replaced by the need to file flight plans and keep to them, and I pretty much gave up flying power planes.

During the summer of 1950 my wife, Virginia, whom I had married just as I entered the Navy, and I bicycled around France. We managed a complete circular tour, visiting Romanesque churches whenever possible, in about two months of travel. On our southern and western loop from Paris to the Mediterranean we were lucky enough to see the newly opened Lascaux caves, soon to be closed to the public. Before starting our trek back through the Maritime Alps and Chamonix and Burgundy, we spent a month in Cagnes-sur-Mer, the setting for Cyril Connolly's *The Tide Pool*. Our medieval stone house, four stories high and sharing three walls with its neighbors, cost a dollar a day. From my study I could look down across a small valley to the house and garden where Renoir spent the last years of his life. Out of my window to the right was Nice and much of the Riviera, to the left the snow-clad Maritime Alps. We had welcome visitors with whom we biked to some of the neighboring hill towns: Quine and his wife, Marge. Van had the manuscript of "Two Dogmas of Empiricism" with him. I found it as exciting and original as subsequent generations of readers have found it, and its attack on the analytic/synthetic distinction and empiricist reductionism convinced me once again. What bothered me, though, and continued to bother me over the years, was how the "tribunal of experience" was to be explained. I feared an appeal to something like sense data, and what I was later to call the dualism of scheme and content. This is an area in which Quine and I have never quite seen eye to eye, though recently our differences have shrunk.

While we were in France, the United States had become involved in fighting in Korea, and had commandeered the planes of the charter company on which we were booked to return to Queens. We were stranded in Luxembourg with, as it turned out, a number of my students, most of us with our funds exhausted. We appealed to the American ambassador to Luxembourg, who gave us a grand garden party, doled out a little money, and gave a patriotic speech, which fell on skeptical ears. The ambassador was Pearl Mesta, the "hostess with the mostess".

When I discovered that my classes at Queens College were full of talented musicians I was inspired to pursue a desire I had assumed I could never realize, to play a string instrument. I bought a cheap viola, and with helpful

hints from various students, I learned to play it in my own awkward way. I had chosen the viola knowing that it gave me the best chance of playing in quartets: serious players are drawn to the outer voices, the violin and the cello, and second violins are fair-minded or disappointed first violins. A quartet formed, with Amnon Goldworth, who was hoping for a serious career in music, as first violin, various excellent players who came along as seconds, and Lewis Lockwood as cello. Lewis went on to a fine career as a musicologist, becoming one of the world's experts on the Beethoven notebooks, and moving from Princeton to head the music department at Harvard. Amnon told me later that he was in those days practicing many hours each day, and that if he were lucky he would end up with a job in the New York Philharmonic—a rather drab culmination of so much hard work. "Then", he said, "I looked at you, who made a living by saying the first thing that came into his head, and I decided to become a philosopher". He did. He got a fellowship to do graduate work at the University of Washington, and then followed me to Stanford a year later. He wrote an interesting dissertation on Bentham, and is now teaching medical ethics in the Stanford medical school. Each Sunday while I was at Queens a group of students would come to our apartment in Styvesant Town and we would play string quartets, trios, piano quartets and quintets, string quintets, even some of the Brandenburg Concertos. One frequent addition to our group was an accomplished pianist. One day she asked if her father could join us: he played the double bass in the New York Philharmonic, and wanted to play the Schubert's Trout Quintet. We would play into the night until the neighbors started hammering on the pipes.

Many of the students at Queens had strong left-wing leanings; some were no doubt members of the Communist Party. So were several of the most talented faculty members. These were the days of loyalty oaths and McCarthy. Though I had no inclination to join the CP, these people were my friends, and I often marched with them, joined in demonstrations, and showed other signs of sympathy. When some of the philosophy students wanted a course on dialectical materialism, I agreed to give it when no one else volunteered. It turned out to be a good teaching opportunity: the participants were deeply involved, and I soon discovered that the philosophy was instructively bad. By the start of the 1950 academic year, I was the official faculty sponsor of half a dozen leftist student organizations; the students chose me because faculty sponsors were held responsible for what the students did, and they did not want to expose the real Communists in the faculty. Meanwhile, the administration had changed, and had become hostage to the Catholic majority in the borough. One day the new president of the university, Theobald, called me into his office, threw his arm around my shoulders, and said in a jovial voice, "Don, I see you are sponsor of the Marxist Study Group, etc., etc. I have to ask you: Do you have tenure?" "John," I replied in as friendly a tone as I could

muster, "are you threatening me?" (I had never called him "John", if that was his name, but then, he had never before called me "Don".) By luck, I received an offer of an Assistant Professorship at Stanford in the next week, and left Queens in December.

I joined Stanford in January of 1951, and though I left Stanford for Princeton in September of 1967, I returned to The Center for Advanced Study in the Behavioral Sciences at Stanford for the academic year 1969–70; so I spent the better part of twenty years at Stanford. When I arrived there, the university was rapidly changing from a rather sleepy institution to a world center of research and learning. Philosophy was gathering a staff capable of accepting candidates for higher degrees (though it had occasionally given an M.A. in the past). John Goheen had gone there from Queens the year before as chairman. John Mothershead and John Reid were on board when he became chairman, and Patrick Suppes had arrived in September of 1950. In a remarkably short time, we were able to attract a number of excellent graduate students. Ernie Adams was among the first; he was much later to be a colleague at Berkeley. Amnon Goldworth I have already mentioned. A number of students became good friends, among them Irving Thalberg, Sue Larson, Daniel Bennett, Fred Siegler, Jane Burton, John Wallace, John Dolan, Suzanne Thalberg, Joe Sneed, Muriel Winet, Fred Newman, Bruce Vermazen, Gordon Brittan, Arnulf Zweig, Samuel Gorowitz, and Jack Vickers. Most of them went on to teach philosophy. Discussion flourished. Over the years shifting groups of faculty members, graduates, and undergraduates met with fair regularity at our house. Virginia and I could afford to serve wine, which in those days cost a dollar a gallon. When there were visitors in town, they often came along. I was charged with inviting and entertaining visiting lecturers, so from time to time we had the stimulating company of Gilbert Ryle, Peter Strawson, Michael Dummett, Elizabeth Anscombe, Peter Geach, David Wiggins, David Pears, Paul Grice, W.V. Quine, and many others. Dummett visited for a quarter several times, and I learned much from him about Frege, the concept of truth, and how to think about the philosophy of language. Two people who joined the department during my years there were Jaakko Hintikka and Dagfinn Føllesdal. Dagfinn, like me a student of Quine's, became a close friend. Long after I had left Stanford, I went twice to Oslo at his invitation to lecture and to try to master cross-country skiing.

I had not settled on any particular field in philosophy as one in which I wanted to specialize; I was interested in almost everything, and felt no urge to rule anything out. I still don't. The profession seems to me to have changed in this respect. Today it would be unusual to find someone who would teach logic through three levels, ethics at the elementary and advanced levels, Plato's later dialogues, ancient and modern philosophy, a seminar on St. Augustine, epistemology, philosophy of science, philosophy of language, a

be represented in the reals, and any such representation was unique up to an interval scale for preferences and a ratio scale for subjective probabilities. In the process I made a discovery that thrilled me. Shopping around in the literature on decision making, I noticed that some experimentalists were testing for what they thought were subjective probabilities by assuming that utilities were linear in money. Others were testing for utilities by assuming that probabilities were "objective". But if both probabilities and utilities were to be seen from a subject's point of view, then the outcome of these experiments was hopelessly ambiguous. What I had discovered was a little trick which allowed the experimenter to determine that some event had a subjective probability of one half, and to determine this without assuming anything about the scale of utilities. Alas, like Herbert Bohnert, I was victim of the Ramsey effect: Ramsey had published my discovery in 1926. My only excuse was that no one seemed to have noticed Ramsey's early axiomatization of Bayesian decision theory; even Braithwaite, who had edited the very essay I refer to, and had written his inaugural lecture at Cambridge on the relevance of decision theory to moral philosophy, had failed to take in what Ramsey had done. I was disappointed at being scooped, but not really downcast, since I hardly expected to make my mark in this area. Suppes and I did, however, realize we had at hand an interesting experimental design; we could do what no one else had done, determine a person's subjective probabilities and relative degrees of preference simultaneously, assuming neither in advance. Over the course of a year or so, we did a series of experiments on willing undergraduates, and we published our results in a small book (Davidson and Suppes 1957).

This diversion into psychology, along with some further theoretical and experimental work I did with the economist Jacob Marschak (Davidson and Marschak 1959), had a lasting effect on me. It gave me some sense of what it is like to have a formally precise theory, and then to test it. There were at least two lessons here. One was that by putting formal conditions on simple concepts and their relations to one another, a powerful structure could be defined. I see this insight as important to philosophy because it offers an alternative to the generally futile attempt to define or analyze important concepts. Even if we cannot hope to define concepts like truth, virtue, probability, belief, action, or intention in terms of more basic concepts, there is legitimate philosophical work to be done in relating these concepts to one another in as clear a way as we can. The second lesson was that a formal theory says nothing about the world. It defines an abstract structure. There remains the question whether that structure is realized in the world, or even in some abstract domain of numbers or sets. The structure defined by decision theory is wonderfully clear, and its axioms are apt to contain words like "prefers", but the theory says nothing about what preference is. The real problems of decision theory are problems of interpretation.

seminar on musical theory, and a course called "Ideas in Literature" (Homer, Aeschylus, Sophocles, Dante, Shakespeare, and Joyce in some years). But I did teach all these things at Stanford, and enjoyed doing it. My own views were slowly taking shape. Because I taught the introductory course in ethics year after year, I soon formed a rough picture of the subject. I was struck by the fact that philosophers with otherwise very different views seemed to agree on one thing: that what everyone in some sense desired really was desirable. Aristotle came right out with it, but Plato, Hume, Mill, Bentham, and so on argued for it. Mill made the argument very short. Although he held that the good, and derivatively the right, are definable in descriptive terms, he also famously maintained that "the only proof that anything is desirable is that it is desired." While trying to straighten out Hume's three theories of morality, I noticed that he argued (in effect) that since facts alone will never sway us, evaluative judgments are not factual. The missing premise is obvious: evaluative judgments do sway us. The missing premise seemed to me then, and seems to me still, to be obviously correct: it is the connection between moral attitudes and action that distinguishes moral (and other) evaluative attitudes from other beliefs. This explains why moral philosophers so often segue into sermonizing, and why they want to convince their readers that what they recommend is what their readers have always really wanted. One of the many things I did not recognize at the time is the importance of the assumption (false in my opinion) that evaluative judgments are *merely* motivational or emotive or projective, and that (therefore) judgments of value are not objectively true or false.

J.J.C. McKinsey moved to Stanford soon after I did, and he did me two great favors. He and Pat Suppes were more aware than I apparently was of the fact that it was important to publish. I had published only a short piece the undergraduates had asked me to contribute to their (very short-lived) journal. So McKinsey and Suppes generously suggested that the three of us write an article on the implications for ethical theory of decision theory. To improve my education, they also set me as an exercise the simple task of axiomatizing decision theory on the basis of a new primitive concept. I was to show my axioms to be adequate by proving a representation theorem and a uniqueness theorem. The exercise was very much in line with what Tarski was training his students to do, but it was totally unlike anything I was prepared for. The sort of logic Quine had taught me was entirely formal: proofs had to be mechanically checkable. I had the rudiments of set theory, and the logical foundations of mathematics, but no skill in operating in these disciplines even in an elementary way. Learning how to produce informal proofs was like learning a foreign language, a new way of thinking.

I managed to come up with a somewhat inelegant set of axioms which I was able to prove had the appropriate features: the pattern they defined could

The second kindness McKinsey showed me was to invite me to coauthor an article on Carnap's "method of extension and intension" for a forthcoming volume in the Library of Living Philosophers. He was a natural for the job: he had written the first of two volumes on modal logic for one of those expensive Dutch publishers, but it had not been published (it never was). I had read it in manuscript as best I could, and made a few suggestions. What I did know enough to notice was that he had fully worked out a semantics for quantified modal logic. I was struggling to teach myself semantics in the course of teaching philosophy of language, but my understanding of the subject was limited to what I found in Quine's *From a Logical Point of View* and a few related texts. Before we started on the essay, McKinsey died. I called Paul Arthur Schilpp and asked him what to do. He told me to write the piece by myself. If I had known more, I would have refused. Instead, I spent a year trying to understand Carnap's semantics and the literature surrounding it. The outcome was an over-long, lumbering article (Davidson 1963), and by the time it was published (years after I finished it), it contained little that was new. A few people have told me they found it helpful, among them Wilfrid Sellars, but these were not people who knew a great deal about semantics.

Nevertheless, it was an eye-opening experience for me. Teaching philosophy of language, I concentrated on two topics: one centered on the question, What is meaning? The other was semantics as treated by Frege, Russell, Quine, and Carnap. The attempts to answer the first question that I found in Ogden and Richards, Charles Morris, B. F. Skinner, and others all seemed to me to founder in fairly obvious ways, and I had no better ideas of my own. But working on Carnap's *Meaning and Necessity* (1947) forced me to think seriously about semantics. In his earlier book, *Introduction to Semantics* (1942), Carnap had followed Russell in assigning extensions to singular terms, but intensions to predicates. Alonzo Church, in a review in the *Journal of Symbolic Logic*, suggested that Carnap should emulate Frege in assigning extensions and intensions to both singular terms and predicates. Carnap followed this advice: hence the "method of extension and intension", the subject which was assigned to me for the piece in the Library of Living Philosophers. I depended heavily on Quine's criticism of modal logic, but I sensed something wrong, quite independent of Quine's misgivings, in the whole attempt to introduce (with Frege) contexts in which words had their usual intensions as extensions. It was as if phrases like "said that" or "believes that" included a function that mapped extensions onto intensions—something clearly impossible, since part of the point of intensions is that they are more numerous than extensions.

One unexpected bonus of writing about Carnap was that he invited me to visit him in Los Angeles. I had first heard about Carnap from Quine when I was a student at Harvard. Quine had not long before been to Prague where he

had been greatly impressed by Carnap, and this came through strongly in Quine's teaching when he returned to Harvard. Reading Carnap as a graduate student had helped to persuade me that traditional philosophical problems could be treated with clarity and insight using the formal resources of logic. In 1940 Carnap taught at Harvard. I attended his lectures, and even met him briefly. Bertrand Russell, Tarski, and, of course, Quine were all there that year. Quine and Tarski were politely, but openly, skeptical about the concept of analyticity which was so central to Carnap's work.

I had sent my work to Carnap so that he could prepare his reply, and I trembled at the prospect of hearing his reaction. I was at the time virtually unpublished, and I was completely uncertain of my ability to cope with Carnap's writings, much less the man himself. But of course I made my way to Los Angeles. He greeted me graciously and immediately put me at ease. Far from criticizing my essay, he showed a lively interest in it, and we were soon deep in a fascinating philosophical discussion. It turned out that he was familiar with the experimental and theoretical work I had done with Patrick Suppes on decision theory, and he asked penetrating questions about the concept of subjective probability that was involved. Although his own approach to the subject was very different from mine, he showed nothing but a totally detached desire to get the issues and the arguments clear. Such freedom from the claims of ego is rare indeed. It struck me then, and I have often reflected since, that Carnap embodied an ideal of what a philosopher should be. He was kind, generous, and wise, and he sought the truth with a Socratic honesty that excluded agonistic competition or pride.

I became obsessed with the problem of giving a satisfactory semantics for indirect discourse, belief sentences, and other sentences involving intensionality. It kept me awake at night. Frege's solution not only didn't work; it offended my intuition that words in so-called opaque contexts must mean exactly what they mean in ordinary contexts. During those years there was a spate of suggested solutions, and criticisms of those solutions, by Carnap, Benson Mates, Wilfrid Sellars, Nelson Goodman, Alonzo Church, and others, mostly in the pages of *Analysis*. It gradually dawned on me that it was unclear what characteristics a satisfactory solution should have. What were the rules of this particular game?

While struggling with this question, I was asked to give a talk on my work on Carnap in Berkeley. I was intimidated by the audience, which contained many people who knew much more about my topic than I did, among them Benson Mates and Tarski. Tarski, who was often critical of his own student's talks, made some encouraging remarks about my amateur efforts, and we became friends. He gave me a reprint of his informal paper on the concept of truth. I was dissatisfied with this, since it simply leaves out the most interesting part of his work on truth, the concept of satisfaction and its

application to quantification theory, so I went to the source, the *Wahrheitsbegriff.* I did not find it easy. But by teaching it, I gradually took it in, and it seemed to me that Tarski's truth definitions could be viewed as providing an answer to the question that plagued me: an analysis of the logical form of a sentence was satisfactory only if it could be incorporated into a truth definition. Of course this came to no more than asking whether the analysis could be couched in first order quantification theory, for this was the sort of language for which Tarski had shown how to define truth. But looking at such analyses in the light of Tarski's truth definitions nevertheless made the beauty of quantification theory evident in a new way for me. There were now straightforward answers to such questions as: how can a finite mind understand a potential infinity of sentences?; do we need entities to correspond to predicates or sentences in order to specify the truth conditions of sentences? (no). One could now say exactly what a word in a sentence was doing there, what it contributed to the truth conditions of the sentences in which it appeared. I was impressed by how the test of the correctness of a truth definition depended only on recognizing that T-sentences of the simple form "'Grass is green' is true iff grass is green" are true. Whatever machinery it had taken to produce such sentences as theorems, that machinery had done its work provided only that it resulted in such perspicuous truths. This fitted with, if it did not confirm, the primacy of the sentence, Frege's remark that only in the context of a sentence does a word have a meaning.

Now that I felt I had a criterion for the adequacy of a logical form, I returned to some of the questions that had puzzled me. One thing I was sure of was that if an analysis of some idiom implied an infinite basic vocabulary, it had to be wrong, for a language with an infinite basic vocabulary would be unlearnable. With this in mind, I noticed that a number of proposed theories failed to satisfy the criterion. My examples were: the idea that any quotation is an unstructured singular term; Israel Scheffler's suggestion that the apparent opacity of indirect discourse could be overcome by treating expressions with the form "that-snow-is-white" as unitary predicates of utterances; Quine's idea that "believes-that", when applied to a sentence, produces a 'composite absolute general term', and Church's language for a "logic of sense and denotation", in which adding a subscript to certain expressions causes them to refer to their prior sense. I wrote up this observation and delivered the results at the 1964 International Congress for Logic, Methodology, and Philosophy of Language in Jerusalem. It was printed in the proceedings the next year, and appears as the first piece in my *Inquiries into Truth and Interpretation.*

Two years later I was invited to give a paper at the annual meeting of the Eastern Division of the American Philosophical Association, and I presented "Truth and Meaning" in which I claimed that a Tarski-type theory of truth,

modified to fit a natural language, could be treated as a theory of meaning. The proposal was bold, and it left a number of rather fundamental issues unrecognized or untouched, some of which I tried to cope with subsequently. In any case, I argued that Tarski was too easily discouraged about the possibility of giving a formal semantics of this type for a natural language, and I optimistically proposed that philosophers undertake to extend theories of truth in Tarski's style to the many apparently recalcitrant idioms of natural languages. This proposal came to be called, not without skepticism, "Davidson's Program". It has had a number of successes, but it would take someone more sanguine than I am now to predict ultimate completion of the "program". On the other hand, there is little agreement on what a more satisfactory semantics would be like, and the satisfaction of solving one or another problem within the discipline of a serious semantic theory has led a number of linguists and philosophers to do excellent work.

I did not think of it at the time, but Sellars's proposal to treat phrases like "that-snow-is-white" as adverbs modifying verbs like "believes" or "said" would also obviously fail for the same reason. This did come to me when, a few years later, I began to think about adverbial modification. John Wallace had been a student at Stanford, and had written a fine dissertation on various problems that naturally arose in trying to apply Tarskian semantics to the idioms of natural language. Both of us were excited about the prospect of taming the problems of logical form for more of English (and, we hoped, other natural languages). In a burst of absurd confidence, we took some novel (*Pride and Prejudice*?) with the aim of going straight through it, putting every sentence into proper logical form. After failing miserably on the first sentence, we gave up. Subsequently, during a summer we spent on Corfu, we fell into the habit of taking a long afternoon walk (after a morning of reading and writing, a swim, a large lunch, and a siesta), and our talk turned to adverbs. They "modify verbs", we had been told, but since verbs did not name anything in our semantics, the character of this "modification" was completely obscure. It was clear that a verb accompanied by its attendant adverbs could not be treated as an unstructured primitive (the threat of an infinite primitive vocabulary again). Adverbs had to be interpreted as modifiers, but of what? It was slow to dawn on me that there was really only one device available for an indefinitely large number of "modifications", and that was the way in which adjectives modify noun phrases. The solution was to introduce a way of referring to particular events; adverbs could then be treated as adjectives. Over the next few years, the fallout from this idea was considerable; it suggested a new way to construe talk about causality, and it helped implement the argument for anomalous monism.

The immediate fallout, however, was in application to theory of action. I had become interested in action theory through the work of Daniel Bennett, a

wonderfully talented student. In principle he was writing a dissertation with me, but he went off to Oxford for a year, and was impressed with the discussion of action that was going on there. I joined him and his wife briefly in Oxford, and we went off for a jaunt to Paris, but the seed had been sown. I read Anscombe's *Intention* and Hampshire's *Thought and Action*; this led me back to Wittgenstein and to some of those in his thrall. Dan and I discussed this subject, new to both of us, and gave a seminar exploring it. My own thinking eventually emerged in "Actions, Reasons, and Causes", which I read at the American Philosophical Association meeting in December of 1963. Since I argued against the then received opinion that causality and phenomena which involved intention, like thought and action, did not mix, I expected to be strongly attacked. In fact my paper hardly raised a ripple at the time; it was only after several years that it began to be discussed, and by then my trepidation had faded. Nevertheless, this was in many ways my first real public performance. That paper has now been reprinted two dozen times that I know of, and in nine languages.

Anscombe had claimed that if a man poisons the water supply by pouring the contents of a bucket into a reservoir with the intention of killing the inhabitants of a town, then he performs just one action, though "under different descriptions" ("He poured the contents of the pail into a reservoir", "He poisoned the water", etc.). I thought this was right. But what was the entity described in different ways? An action, of course; but where were the definite descriptions which picked it out? It was only after I had seen how to introduce events into the logical form of sentences that I realized that sentences like "He poisoned the water" don't contain a definite description of an action. Events are in this particular case introduced through existential quantification. "He poisoned the water" doesn't imply singularity; the sentence is true whether he poisoned the water once or twenty times. But it is false if he never poisoned the water. Therefore what is wanted is something like "There exist two events, x and y, such that x is a pouring of the contents of the pail into the reservoir, y is a poisoning of the water supply, he is the agent of x, and x caused y" (I suppress the implication that both events are in the past, as well as some of the structure of the predicates). This analysis explicitly introduces an ontology of events, it shows how various characteristics of events can be enumerated, and how the transitive and intransitive uses of certain verbs are related (thus "x poisoned y" becomes "x did something that caused y to be poisoned").

There was a tradition of treating sentences like "Striking the match caused it to light" as intensional, on the grounds that "caused" was a sentential connective, but couldn't be extensional, since although the sentence would be true only if both the "sentences" it connected were true, reversing the sentences would turn it false. But if one thought in terms of events, the logical

form of this sentence would be "There were two events, a striking of the match and a lighting of the match, and the first caused the second". This analysis has the merit of being extensional—a property of such sentences suggested by the fact that their truth value is not in general affected by the substitution of co-referring singular terms (say "this wooden object" for "the match"). John Wallace pointed out that this analysis was parallel to the generally accepted analysis (proposed by Frege) of temporal statements like "The match lit after it was struck". Frege's analysis quantified over times, but events will do as well as times, at least in this context, and have the merit (unlike times) of being concrete particulars.

I was both surprised and pleased to find my two major interests at that period, theory of action and philosophy of language, interacting in interesting ways. Each prompted questions in the other area that needed to be answered, and in a number of cases, one suggested an answer to a difficulty in the other. The realization that we very often characterize events in terms of their causes or their effects threw light on a number of puzzles. Thus both "Pete broke the window" and "The ball broke the window" say that something Pete (or the ball) did caused a breaking of the window: two events related causally. But also "Pete intentionally broke the window" tells us that Pete's act was caused by his reasons, such as they were.

Theory of action helped me make sense of Austin's claim that in uttering a sentence one performs a number of actions (locutionary, perlocutionary, illocutionary); I now saw here one action under a number of descriptions. More important, in the end, was the realization that when one honestly says "I promise to pay for dinner next time", one may indeed be promising, but this doesn't, as Austin had maintained, show that the utterance doesn't have a truth value. Theory of action had, however, plenty of problems of its own. One of these sprang from the idea that what often sound like separate actions are in fact one. The problem was this. If a terrorist places an altitude-sensitive bomb in an airplane, and the bomb destroys the plane with all on board, the terrorist placed the bomb, destroyed the plane, and killed all on board. The explosion, the destruction, and the mayhem are not separate actions; they are consequences of the original action, something we mark by describing the original action as a bombing and a killing. The time of the action must be the time when the bomb was placed on the plane; if this is also the time of the killing, then the terrorist killed all those on board the plane long, perhaps many hours, before the victims were dead. This problem, which I communicated to a number of our visitors to Stanford, became the subject of much discussion. Some decided that this, and related problems, discredited the unifying theory. I argued at first that we should accept the conclusion that the victims were killed, and so dead, before the explosion, but later saw that a better line was to say that the original action *became* a killing after the action

was completed, just as a person can become a grandfather, perhaps after he is dead. Some descriptions of an event or an object depend on what follows, and these descriptions apply only in the sequel.

From 1953 through 1960 I continued to write and lecture about decision theory, at least as often to economists and psychologists as to philosophers, but I had come to have my doubts about the interpretation of the experimental results. One problem was that the results were sensitive to the precise words used to present choices to subjects. In later years I came to think the only philosophically interesting solution to the presentation problem was to drop the assumption that the experimenter knows how the subject interprets the relevant words. This makes the problem one of using the same experimental design to determine simultaneously three independent factors: what the subject takes the words to mean, and the probabilities and values the subject attributes to the relevant event. But it was years before I tried to cope with this situation. The other thing that puzzled me was that there was an inescapably dynamic element in a subject's behavior. I thought I had noticed that a subject's choices revealed some sort of learning over time, even when every attempt was made to control factors that would rationally alter behavior. When I designed a study intended to reveal change, there turned out to be a systematic tendency for the patterns of a subject's choices, even among bets with identical actuarial value, to become perfectly hierarchical. It turned out that mathematically minded sociologists had studied a formally analogous situation: over time chickens develop a strictly hierarchical pecking order. Alas, the sociologists had failed to think of a mathematical model to explain this phenomenon. I abandoned experimental work in decision theory, convinced that although that theory gives a convincing account of some practical reasoning, and states our implicit strategy for explaining much intentional behavior, the problem of interpreting experiments was far too difficult to reveal much about how people react, even in controlled situations.

During the 1953–54 academic year I had a Ford Faculty Fellowship, and my interests started turning more and more to philosophy of language. I read a paper at the Pacific Division meeting of the American Philosophical Association on "Use and Meaning", promoting a distinction that I saw as essential to clearing the way for any systematic study of semantics. While teaching my course on ideas in literature (I call it mine since no one else ever taught it, or wanted to) I read a good deal of literary criticism and theory, and this prompted a few excursions into aesthetics: a paper on fictional names, one on metaphor, and one on "Meaning and Music". The last was a bit of a joke. I thought musical *notation* threw light on language, but that music itself was meaningless. For some reason I was invited to address the Music Educators of America at their annual meeting in Los Angeles. This was the largest audience I have ever spoken to; its thousands filled the hall where our political

parties hold their presidential nominating meetings. I spoke on "The Tuned String", telling them what chord the planets sang as they spun around the sun, and quoting Shakespeare's Ulysses: "Untune that string, / And hark what discord follows!"

In 1955 I was sent to Japan as a member of the then annual American Studies Seminars program, funded by the Ford Foundation. Six or seven of us, representing various disciplines, each taught a month-long seminar to about fifteen professors from various universities in Japan. My cohorts included economist Hank Houtaaker, once a colleague at Stanford, sociologist Talcott Parsons, and Harry Levin. In theory, those attending the seminars understood English, but in fact after each brief pronouncement on my part a committee produced a translation. The committee consisting of one person who knew Japanese, one who knew English, and one who knew philosophy, or so it seemed. I soon learned to be economical: no jokes, no digressions, much use of blackboard. My wife and I had chosen to live in a Japanese style house. This turned out to be a tea house in the lovely garden of a man who had been in charge of the national bank of Japan during the war. He was a dignified and gentle person, living alone in a large house with polished cryptomeria floors—soothing to walk on in bare feet. Before we left for Japan someone had given us a book describing Japanese etiquette. It explained that there were three standard bows: the perfunctory (incline about 5 degrees), the serious (15 degrees or so), and the all-out bow (down on your knees, touch forehead to floor). A visitor from Japan laughed when we told him this, and also claimed that in modern Japan the place of women had changed. No longer should we expect a silent wife to wait on her husband and his guests. The first day in our tea house we were called on by a philosophy professor from the University of Tokyo, where I was to teach. He removed his shoes on our doorstep (of course), entered, went down on his knees, forehead to tatami. We did the same. Later, our informant (also a philosophy professor) returned to Japan, and invited us to dinner. His wife silently waited on her husband, and on us.

Teaching was my main tutor in philosophy. The reading and preparing were certainly instructive, but above all it was the friendly, critical questions of my students, and endless discussion with them, that gently introduced me to serious philosophical thinking. No course I taught failed to intrigue me, and every dissertation I directed enlisted my genuine participation. I enjoyed and profited from teaching from the start, and luckily neither the pleasure nor the stimulation has faded. My time at Stanford was also a time during which I started doing quite a lot of lecturing outside my university, and the traveling that went with it.

To my great pleasure, Quine came to the Center for Advanced Study in the Behavioral Sciences in 1958–59. By luck I had a year off with an American Council of Learned Societies fellowship, and so could accept Quine's

invitation to read the manuscript of *Word and Object* which he was putting into final shape. In spite of my earlier exposure to Quine's thinking, and my repeated reading of the essays in *From a Logical Point of View*, I found this new work difficult to take in. When I finally began to get the central idea, I was immensely impressed; it changed my life. What I had found so hard to take in was the idea that there could be no more to meaning than could be learned by being exposed to the linguistic behavior of speakers. This doesn't seem so startling to anyone who has read the Wittgenstein of the *Investigations*. But what struck me had not really struck me before: when we learn or discover what words mean, the process of learning is *bestowing* on words whatever meaning they have for the learner. It's not as though words have some wonderful thing called a meaning to which those words have somehow become attached, and the learning process is just putting us in touch with that meaning. What the teacher may well think of as a matter of bringing the learner into step with society is, from the learner's point of view, giving the word what meaning it has. The appreciation of this point, and of its consequences, constitutes the biggest forward step in our understanding of language since the onset of the "linguistic turn". Where I found I differed from Quine was in how to account for the content of those sentences most closely connected with perception. I balked at the idea that the locus of shared meaning (so far as the meaning of observation sentences was concerned) depended on the proximal stimulus, what Quine called the "stimulus meaning"; I thought it should be the distal stimulus, the object or event or situation in the world speaker and hearer naturally shared.

In 1962 I again visited Japan, this time to attend a symposium sponsored by the Asia Foundation. When I got back to Stanford, I was invited out to lunch by a friendly professor from Berkeley who asked me a number of pointed questions about the politics of other participants. Years later I found out that the Asia Foundation was a front for the CIA. I enjoyed the conference, mainly because I had several delightful conversations with Satyendra Nath Bose, the Indian physicist who had developed quantum statistics with Einstein.

I continued west after Japan, since I had an invitation to give a talk in England, and going on around the world seemed an attractive route. I made brief stops in Hong Kong and Vietnam, where American involvement was heating up, and thence to Cambodia, Thailand, Burma, India, Nepal, Afghanistan, Lebanon, Turkey, and Greece. I have always been grateful that I had the luck to see Angkor Wat before its partial destruction, and Burma, the Vale of Kashmir, and Afghanistan before they became difficult or impossible to visit. I had arranged to meet Bose on his home territory in Calcutta, and we spent a wonderful hot, humid afternoon in his favorite tearoom eating ice-cream. He was distressed that India was determined to teach mathematics and

physics in various Indian languages instead of taking advantage of India's one common language, English. In Burma while padding around the vast Schwe Dagon Pagoda I fell in with a tall saffron-garbed monk who said he had been the Buddhist archbishop of Latvia. When I looked baffled he told me there had been a small Buddhist congregation in Latvia before the Russians took over, and that of course he wasn't an archbishop; he was just trying to give me a sense of his erstwhile position in the hierarchy. A few minutes later I was approached by a Burmese who turned out to be the fire chief of Rangoon. He took me to an excellent restaurant, explaining that he had recently come back from Texas where he had been tutored in how to put down unruly crowds. The next day I visited the university and talking with the philosophers there learned that a week or so before the authorities had shot a number of students who were protesting the evils of the regime. Apparently the fire chief had learned his lesson.

From Calcutta I flew directly to Kathmandu, glimpsing Kanchenjunga off to the east. There was one hotel in Kathmandu, the Shankar Hotel, once an authentic palace. In the Yak and Yeti Bar I met the proprietor, who had helped the early Everest expeditions. He said, "Why waste your time in Kathmandu? Get out into the country." I had about five days; how was this possible? He offered to obtain the necessary "visa" to visit Pohkara, the only town of any size to the east, and the next day I had a page-long, handwritten visa from the secretary of state in my passport, and took off for Pohkara. The plane was a familiar DC3. It could not fly over the intervening mountains, being unpressurized, but it made its way through the valleys. When it approached the field, a grassy pasture, the locals heard it coming and ground out a siren to advise those who cared to clear the cows from the landing strip. A young Swiss in the employ of the Red Cross met the plane. He was in charge of a large camp of Tibetan refugees (escaping the Chinese) ten miles or so from the field, and he invited me to stay with him. I was put on a Tibetan pony, but when it turned out that the pony was closer to the ground than my legs allowed, I walked. The camp was on a ridge west of Pohkara. I knew there were great mountains near by, but was told that during monsoon (it was late September), they were never visible. From the tent I had been assigned, I opened the flap early the next morning to an astonishing sight: during that night the monsoon had lifted, and I was looking straight out at Machhapuchhare, one of the most magnificent mountains in the world. I was at about the altitude of Zermatt, and the same distance from Machhapuchhare as Zermatt is from the Matterhorn, but Machhapuchhare is almost twice the height of the Matterhorn. My Swiss hosts offered me a Sherpa who spoke English as a guide, and we walked as far as the first village above the great chasm which divides the Anapurna massive from Dhaulagiri. My visa went no further, so we had to turn back.

One of the first things I had done when I got to Stanford was to join its Alpine Club. As the only faculty member, I was made its "advisor", but I was a novice climber. Back in July of 1947, on our way west for my year off on leave, my wife and I had tried to climb Longs Peak by an easy route. We were near the summit early, and it was pretty much covered with ice. I had on old ski boots with a smooth leather sole. I slipped, and found myself uncontrollably sliding. I threw myself around so I could see where I was going, Virginia grabbed my parka, and I stopped on a two-inch wide rock ledge. "A distance of three feet in either direction would have meant a fall of 1,000 feet and certain death . . . [J]ust at the edge of a precipice, with a drop of 1,000 feet, Davidson hit a rock, the only one in the area," writes Paul Nesbit in *Longs Peak: Its Story and a Climbing Guide*. I had dislocated my shoulder, and couldn't move, but after a wait of about eight hours, I was lowered in a stretcher to the head of the trail where a horse, and then an ambulance, carried me to a hospital. All this embarrassed me greatly. Since I liked scrambling in mountains, I thought I'd better learn to do it safely: hence the Stanford Alpine Club. It was a splendid group of people, and after a few practice climbs I was accompanying them when I could on expeditions to Yosemite. Ultimately I was designated a leader, and I led a number of climbs in Yosemite, and one up the Grand Teton, none of them very hard. Two climbing friends went on to great things. One was Nick Clinch, who organized two of America's first ascents of 8,000 meter mountains in the Karakoram, and the first ascent of the Vinson Massif, the highest mountain in Antarctica. The other was David Harrah who on graduating joined a Harvard group planning to climb a beautiful but desperately difficult mountain in the Andes. It had been nicknamed "The Butcher" by an experienced German group which had twice failed to climb it, but Harrah and a companion succeeded when the rest of their party had given up. An accident stranded Harrah and his companion on the summit ridge; the night at that altitude cost Harrah all of his toes. Harrah became a professional philosopher, and pioneered in the study of erotetic logic. I gave up serious climbing after a few years, though I continued to enjoy walking up such mountains as Popocatepetl, Nevado de Toluca, Fuji, and Kilimanjaro.

I had a National Science Foundation Research Fellowship for the academic year 1964–65, and I spent it mostly in Greece with my wife and eight-year-old daughter, Elizabeth. John Wallace, by then teaching at Princeton, also had a year off, and he and his wife and daughter came along. We rented an actress's slightly rundown penthouse on the slopes of the Lycabettus for the winter, and migrated to Corfu, where we had found a large, simple house with a small beach for the spring and early summer. Wallace and I talked philosophy pretty continually during the year, and it was then that we arrived at the treatment of adverbs I mentioned earlier. Our long walks in Athens, and then ranging

through the olive groves of Corfu, stretched both our minds and our limbs. Quine visited briefly in Athens, and he, Wallace, and I walked up Mount Pentele from which the marble for the Parthenon had been quarried. Virginia, who wanted to learn how to carve marble, apprenticed herself to the workmen who were employed maintaining the Parthenon, Elizabeth was voraciously reading Greek drama and Homer, and I was spending a couple of hours each day trying to master modern Greek. In these pursuits I was the least success-ful, finding that my knowledge of ancient Greek was more a hindrance than a help. I did get to the point where I could read the newspaper and haltingly join a conversation. Toward the end of summer, Wallace and I abandoned our families and drove a TR4, which I had just bought in England, along the Dalmatian coast and on to Gründelwald, where we spent a final month writing and tramping up and down the Bernese Alps.

At summer's end I returned to Stanford and Wallace to his job at Princeton. In March of 1966 I was asked to read a paper at Princeton, and what I had on hand was "How is Weakness of the Will Possible?" This marked the beginning of an interest in irrationality. I had realized that the explanation of intentional action that I had promoted in "Actions, Reason and Causes" made akrasia difficult to explain; indeed, according to Socrates, akrasia was impossible if one thought, as he (and I) did, that believing that a course of action was best was necessarily motivational. Anscombe had pointed out that it was ridiculous to suppose that one would (or could) perform any action one thought would realize some perceived value, so the standard syllogistic form of reasoning could not apply to practical reasoning. Not all reasons *could* be causes. This consideration led me to think of practical reasoning on the pattern that Hempel had described for the probabilistic relation between inconclusive evidence and hypothesis in scientific reasoning.

Not long after my visit to Princeton I was invited to join the department there. It was a hard decision. Virginia was all for the move, but I loved where I lived in the hills above Stanford, and I liked the relaxed informality with which junior faculty, senior faculty, undergraduates, and graduates educated one another. There were also the year-round outdoor activities, which meant a lot to me: tennis, skiing, surfing, and just spending time on the then nearly deserted beaches between Half Moon Bay and Santa Cruz. We had many picnics on the beach, frequently with groups of students. One day, not having planned to eat and with no store within miles we picked some brussels sprouts in a nearby field and cooked them in sea water in an old coffee can. My daughter imagined a headline: "Ethics Prof Caught Stealing Sprouts". Some undergraduates took me body surfing early in my time at Stanford, and even in the desperately cold water (we didn't know about wet suits yet), I loved it. Pretty soon I graduated to board surfing, which I found exhilarating. From

where I lived it was only an hour to Santa Cruz, a beautiful drive through redwoods and hills, and then along the coast. For several summers Irving Thalberg and I drove down the coast to San Diego, picking up the surfing spots as we went, sometimes sleeping on the beach. One time Irving said apologetically that we had to stop and have dinner with his mother, Norma Shearer. She and her ski-instructor husband took us to a small, swank Hollywood restaurant. We were sitting at the sole window at the end of the long narrow room when I saw a young couple approaching our table. Ah, I said to myself, this is what it's like to dine with the famous; they probably want an autograph. The couple didn't recognize our hostess. The woman shook my hand, saying, "Professor Davidson, I just wanted to thank you for your ethics course."

Irving and his wife Suzanne, who had also been a student of mine, rented an apartment in Biarritz, and Irving and I surfed that coast, and, years later, the Atlantic coast of Portugal. Irving was an excellent skier and he and his friend Frank Low-Beer, who had been an undergraduate in philosophy at Stanford, often took me skiing in the Sierras. Later I skied from time to time with Irving and Suzanne in Aspen, where they had bought a house after they took jobs in Chicago. Once Irving, Frank, and I spent a thrilling week helicopter skiing in the Bugaboos.

But there was good reason to go to Princeton. It had one of the best, perhaps the best, philosophy departments in the country, and I knew I would profit from being in a place where there were more people interested in the sort of philosophy I did. Stanford had provided a wonderful environment in which to develop in my own way, and there was plenty of stimulation from students and visitors. But there was a dearth of colleagues interested in the areas where I was working: philosophy of action, psychology, epistemology, language, and ethics. I needed the sharper challenges I knew I would find at Princeton, so in September of 1967 we moved to Princeton.

It turned out to have been the right decision so far as my career was concerned. I was working hard trying to bring my various views on the explanation of action and language into line with each other, and to resolve the various problems I knew I had not settled to my own satisfaction, much less to the satisfaction of others. At Princeton I was surrounded by people who had their own firmly held positions, and they were more than willing to put me straight. I talked a great deal with Gil Harman, who was sympathetic but skeptical, and he was a great help to me then and later. His knowledge of what was going on in linguistics was far more advanced than mine, and he encouraged me to pay more attention to the aspects of natural language which I had neglected. Gregory Vlastos rekindled my interest in Plato. He was the first person I had met who was both a fine student of Plato and Socrates, and a highly competent analytic philosopher. He was readdressing familiar puzzles

in the interpretation of Plato in a style a contemporary philosopher equipped with the tools of modern logic and semantics could easily follow. I realized how far short of Vlastos's standards of clarity and perception my own work on Plato had fallen. Paul Benacerraf was politely critical of some of my claims about how Tarski's work could be applied to the semantics of natural languages, and his doubts prodded me to revise my position more than once. John Wallace was already at Princeton when I arrived, and of course we continued our discussions. Peter Hempel, having been at Yale before coming to Princeton, once more became a welcome colleague. Arthur Szathmary, with whom I had acted in *The Cradle Will Rock* at Harvard, was also there, as was Tom Nagel, whom I had come to admire when he was at Berkeley and I at Stanford. The place sparkled with serious conversation and active teaching. The students were dedicated and interested, though definitely less willing to open up in class or seminar than my students at Stanford had been. Part of the reason may have been that it was common for one or more faculty members to attend someone else's seminar, though this had often been the case at Stanford also. In any case, it made for exciting and challenging exchanges. Among the students whose interests overlapped with mine were Tyler Burge and Sam Wheeler.

A number of people played both squash and tennis, and I took up squash again for the first time since Harvard (when I was there, Stanford had no squash courts). Paul Benacerraf, Gil Harman, George Pitcher, Richard Grandy, Terry Penner, and John Wallace all played, so I was able to find a partner almost every day. Aside from Wallace and Pitcher none of us was very good, but enthusiasm and a bit of philosophy between shots kept our spirits high. Princeton had one of the few doubles squash courts in the country, and we sometimes played hilarious games, four of us running like mad to keep out of each other's way while the hard little ball flew madly around the vast court.

I liked the spirit of collegiality which reigned during department meetings. There were a number of people with strong, and divergent, opinions, but every discussion was polite, friendly, and impressively rational. Everyone showed genuine respect for the views of others, and people yielded with good humor when a decision went against them. It was a model, unique in my experience, of a group of intellectuals working together for a common end without serious friction, and without the frivolous, time-wasting posturing academics so often go in for. Stuart Hampshire presided over this efficient, congenial crew my first year at Princeton, and the next year I took his place. I gave a lot of thought and effort to trying to preserve something I knew it had taken time to create and that it might be easy to damage. In later years I was told that I had been too solicitous. In my attempt to keep everyone happy I invited full discussion of all important issues; Hampshire, I was reminded, had saved every-

one time by quietly deciding things on his own. My year as chairman was a busy one for me. Hampshire and Vlastos had persuaded Laurance Rockefeller, who had been a philosophy student and ultimately a trustee at Princeton, to give the department a yearly sum which nearly doubled its usual budget. No really successful method of dispensing this largess had been devised, and a large surplus had accumulated. I knew it was unwise to let this continue, on the principle that if we didn't use it we would lose it, so I persuaded the department, and then the administration, to allow us to greatly expand the department, which we did. One pleasant result was that teaching loads were significantly reduced. Another was that Princeton hired a valued ex-colleague from Stanford, Dana Scott. I also made an effort to bring faculty salaries into equitable balance, which had to be done, needless to say, while increasing everyone's salary.

The wave of student unrest which began in Berkeley and Columbia was a long time coming to Princeton, but it reached there about the same time I did. During my tenure as chairman the philosophy students decided it was demeaning to be graded, so they did not sign their exams, saying they would identify themselves only if the faculty agreed to make comments without grades. There was a crisis, since under the rules of the university a number of students would fail to graduate. Several members of the department were at first in favor of taking a stern line. Somewhat to my own surprise I argued that since no one knew what succeeded in education, the students would probably learn more by being allowed to take an active role in deciding educational policy than by being forced to submit to the traditional policies. The department went along, but there remained the problem of persuading the entire faculty to agree. Tim Scanlon undertook to write the necessary brief, and he did it brilliantly. The faculty was won over, the victorious students graduated, and no discernable damage was done. A few years later a new batch of students decided they needed grades in order to get into law and business and medical schools, and something like the status quo ante was restored. In one matter I failed. Princeton was undergoing another revolution: it was expanding to admit women. It was suddenly noticed that there very few women teaching there. I proposed that we hire Angela Davis. She was interviewed, but the department faculty was unimpressed, and she wasn't appointed. I have sometimes reflected that she might never have become entangled with serious criminals if she had had to teach Princeton students. Under the new dispensation, students could petition for a course on an un-taught subject, and our students asked for a seminar on the early, humanistic Marx. I agreed that they should have it, but no one in the department, several of whom could have done it competently, volunteered, so I did it myself, as I had at Queens College. I let the students do most of the preparing and talking,

and they imported various famous student firebrands from Columbia and elsewhere. It was an interesting experiment, but it would have been better if Angela Davis had been there to teach it.

During the year between the time I joined the Princeton faculty and the end of the next summer I gave thirty-two lectures elsewhere. One was a memorial lecture for my aesthetics teacher at Harvard, and onetime colleague at both Queens College and Stanford, Arnold Isenberg. Two were invited lectures at APA meetings, Eastern and Central, and two, at the Rockefeller University and Berkeley, foretold my future, though I had no idea of this at the time. I gave a couple of talks at the University of British Columbia, and one at Simon Fraser. Frank Low-Beer, student and skiing companion from Stanford days, was now a successful lawyer in Vancouver, so after my stint at UBC we drove up to Whistler, then a new ski area, and enjoyed the deep powder. This was my first experience of being dropped on the top of relatively inaccessible mountains by helicopter.

Most of those thirty-two talks, however, were given in Australia during the Australian winter. I had been invited by Jack Smart to give the Gavin David Young Lectures at the University of Adelaide. I looked at the map of air routes in the *Times Atlas*, and realized that the usual itinerary went through Hawaii, but I could save thousands of miles by flying to Tahiti by way of Acapulco. In those days once you bought a ticket around the world, you could squander a considerable number of miles above the standard number on side trips, so I saved miles where I could. The topic of my Adelaide lectures was "Agency and Causality". When I started for Australia, I had four of my lectures in hand, but had to write the other two. I stopped for a week at the only hotel on Moorea, the Aimeo, run by a genial Frenchman. The place was virtually deserted, so I had a thatched hut on the edge of Cook's bay. Each morning I stepped into the warm water for a swim, and spent the rest of the day writing. Now I had five lectures. My stops in Samoa and the Fiji Islands were brief, and soon I was in Sydney, where I gave a series of four seminars on events, and a public lecture on James Joyce. David Armstrong was a congenial host, and he tried, while plying me with delicious Australian wine, to persuade me that causality was not, as I held, a relation between particular events, but a relation between properties. Between lectures I managed a week of surfing at Noosa Heads north of Brisbane, and wrote my sixth lecture. My lectures in Adelaide were well attended, and I had the stimulating company of Jack Smart to keep me on my toes. We had largely compatible, though somewhat orthogonal, views of the mind/body problem.

By early August I was in Perth, where I gave a couple of talks, and from then on all was fun. I wound down from my philosophical stint in Mauritius, that ex-English colony with an African-Indian population and an official French language, and then went on to Kenya, Zanzibar, Tanzania, Uganda,

Ghana, Côte d'Ivoire, and Senegal. I saw enough of the game parks and the unparalleled scenery to give me a permanent taste for Africa, and I vowed to return.

Before I went to Princeton I had been invited to spend a year at the Center for Advanced Study in Stanford, and after my year as chairman, I returned with my family to our house in the Woodside hills. The other philosophers that year were Dick Brandt and Jack Rawls. I found the company pleasant, and there was much good interdisciplinary conversation. But I had a large backlog of work to do, and what I liked best was the quiet hum of work going on around me in a setting perfectly arranged to promote scholarly endeavor. I had agreed to give the John Locke Lectures at Oxford at the end of my stay at the Center, and they needed to be written. My topic was "The Structure of Truth". Bearing in mind my audience, I began by trying to sort out the tangle of intentions involved in every speech act, and the accompanying uses to which language was put. I argued that it was possible to isolate a ground level of meaning which was amenable to formal treatment, more or less in the style of Tarski's semantics. Here Grice had been an enormous help in devising convincing ways for telling when common usage merely took advantage of an underlying meaning and when it revealed that meaning more directly. Then I set out to show that the discipline of formal semantics could throw light on familiar puzzles and problems in philosophy of language, in ontology, and in metaphysics. I rehearsed my proposal for accommodating adverbial modification, with its implications for an ontology of events, the logical form of action sentences, and causality. Next came the idea that sentences that attribute attitudes could be treated paratactically. I dumped on the attempts to make sense of truth as correspondence to facts, here following Strawson's lead, but adding the argument credited variously to Frege, Church, Gödel, and Russell which has come to be called the "slingshot". In my final lecture I attacked conceptual relativism, arguing that it was tenable only if one accepted the dichotomy of conceptual scheme and unconceptualized content. The custom, it seemed, was for lecturers to say their piece and depart: no discussion or questions. I said I would enjoy a little take with the give, so after each lecture those who were interested trooped from the large lecture hall in Schools over to the philosopher's quarters on Walton Street. These events had for me a slightly eerie quality. At each meeting some eminent philosopher quizzed me for half or three-quarters of an hour before anyone else spoke. It was as if it had all been planned. It was a test of a kind I had never taken before, but I found I enjoyed it. One consequence of these lectures was that my ideas generated an interest among some of the graduate students. In a backhanded tribute, Freddie Ayer afterwards wrote, in a review of a book that had nothing to do with me, that "The younger philosophers, seduced by Donald Davidson, devote their energy, and in many cases their considerable ability, to the

Sisyphean task of teasing a theory of meaning out of Tarski's theory of truth."

Quine was to receive an honorary degree from Oxford that June, but I had to leave for Israel before Encaenia. Nor long afterwards, however, Quine and his family met me and my family in Asmara, which was then in Ethiopia. After a trip to torrid Massawa on the narrow gauge railroad the Italians had built, we planned to fly to Aksum. When it turned out that our flight had been canceled, we suggested they drive us there, but they protested it was dangerous: "Bandits", we were told. We persisted, they shrugged and produced a small van. Half way to Aksum the "bandits", who certainly were well armed, stopped us, inspected our passports, and wished us well. Eritrea was then still part of Ethiopia; the "bandits" were separatists, and their war was not with us. We spent a good part of the summer touring more of Ethiopia, and then Kenya, Tanzania, and Uganda, with an illegal sortie into what was then Zaire. We drove ourselves through and between the game parks. One evening after dinner my wife, daughter, and I had an encounter on foot with a noisy and irritated elephant, and on another occasion we were threatened by a spear-bearing Masai warrior who was offended because we tried to photograph him without paying the usual ransom; we had no serious trouble.

During my year as chairman at Princeton I had received an offer from the Rockefeller University in New York. The position seemed too good to be true: no teaching unless one elected to do it, in which case the university would purchase the graduate students you wanted, no departmental chores because there was no department (each full professor had his own "laboratory"), total freedom to travel or teach elsewhere. I quizzed two philosophers who had left this Eden, Sidney Shoemaker and Bob Nozick. What, I asked, made you want to leave? Sidney plausibly mentioned the difficulty of raising a child in Manhattan; Nozick had felt deprived of the company of other humanists and people in the social sciences. I knew that Ernest Nagel had returned to Columbia after a very short stay. I consulted my conscience, which told me it was unfair to leave Princeton after only three years (one of which was to be at the Center in Stanford), and my imagination, which told me that I could stand the strain of a position where the only demands were inner. The decision was eased by Princeton's generous response. The department and administration (and board of trustees) offered to create a new permanent position called "lecturer with the rank of professor", with the understanding that I would teach a course or seminar each year, and direct dissertations if asked. I gratefully accepted, and in September of 1970 I moved with my family to New York. The house we rented in the Village was owned by Leonard Boudin, the splendid constitutional lawyer. Elizabeth slept in the bedroom of Kathy Boudin who was at the time on the FBI's most-wanted list.

My new senior colleagues at Rockefeller University were Harry Frankfurt,

who had been there almost from the start, and had been the main agent in the formation of the philosophy group, Joel Feinberg, and Saul Kripke. There were several non-tenured people, including my ex-students John Dolan and John Wallace. It was good company, and I enjoyed the freedom to pursue what I pleased at my own pace. The small amount of tutoring at Rockefeller, the teaching at Princeton, and a fair amount of travel to lecture satisfied my need to stay in touch with students and to exchange views with other philosophers. A group at Rockefeller which included people from physics, logic, biology, mathematics, and other disciplines met regularly, and as in my graduate student days, I enjoyed the contact with serious science. I had a few talks with Saul Kripke. His was the quickest philosophical mind I have ever encountered. I don't now remember what problem I presented to him one day, but I do remember it was something I had been puzzling over for more than a year. In about fifteen minutes Saul thought of just about every promising solution I had entertained and almost as quickly saw the objections to each. I wasn't too discouraged. I have never thought one had to be particularly brilliant to do good philosophy (not that it hurts). Michael Bratman, Scott Weinstein, Norton Batkin, Jonathan Lear, and Howard Burdick were among the students with whom I worked.

In January of 1971 I was invited to give two lectures at University College, London, and I lectured on the topic I had touched on in my final John Locke Lecture: the notion of conceptual relativism. I had been persuaded by Wilfrid Sellars of the absurdity of an unconceptualized "given", and by Quine of the impossibility of cleanly separating the aspect of our thinking that constitutes the conceptual framework from its empirical content. Quine had made the point by attacking Carnap's distinction between a framework or language which we can choose on pragmatic grounds, and the science that then fills the framework with empirical matter. Another example of the dualism of scheme and content could be found in C.I. Lewis's neo-Kantian *Mind and the World Order.* These variously described dualisms had a common origin in Kant, who clearly had the distinction though he thought there could be only one conceptual scheme. What I argued against was not just the idea of an unconceptualized given which might serve as the foundation of empirical knowledge. If one agreed with Kant that "Thoughts without content are empty, intuitions without concepts are blind", one could not conceive of intuitions as occurring separately and so serving as a basis for empirical knowledge. But in saying this, one would still be assuming that it is possible to distinguish between the conceptual element and the experiential element in thought, and it is the distinction itself I questioned. Without the distinction, conceptual relativism is a position that can't be formulated, and the idea of thought as "representing" reality becomes a misleading metaphor.

When I was at the Center for Advanced Study in Stanford, I had, along

with Gil Harman, organized a small conference on the semantics of natural language. About half the participants were linguists and half were philosophers, some of whom were also logicians: Dana Scott, Richard Montague, Jaakko Hintikka, Pat Suppes, and Quine. A book containing many of the papers read at the conference resulted (Davidson and Harman 1971). It also contained some new material by Paul Ziff, John R. Ross, Jim McCawley, and Saul Kripke's "Naming and Necessity". In the introduction Harman and I pointed out that the convergence of linguists and philosophers on the application of formal methods to the semantics of natural language which I had predicted in "Truth and Meaning" was actually coming to pass. "The purpose of the volume", we wrote, "is the same as that of the conference: to encourage the active exchange of ideas among logicians, philosophers, and linguists who are working on semantics for natural languages. We trust it will be agreed that there is more to this than the usual business of rubbing two or more disciplines together in the expectation of heat and the hope of light."

I had been one of the original group of philosophers who, at the instigation of Stuart Hampshire and Gregory Vlastos, had formed the Council for Philosophical Studies. The idea was primarily to provide a body that could encourage foundations and government agencies to support research and other enterprises in philosophy. One good thing the Council did was supply funds to enable the American Philosophical Association to set up a national office for the first time. The Council also attracted funds to support summer institutes for philosophers who were already teaching and doing research in a particular area. I was asked to organize such an institute, and I in turn once more asked Gil Harman to join me. The topic was again philosophy of language, and though most of the participants were philosophers, a number of linguists, most of whom had been at the conference two years before, gave courses of lectures. Many philosophers who have since become well known participated. It was an exciting six weeks at the new campus of the University of California at Irvine.

Earlier that same summer (1971), there had been a conference at Berkeley in honor of Tarski. I felt out of place among logicians. I guess I was invited because I had been promoting Tarski's treatment of truth as a powerful tool for philosophers. I gave a talk on "Coherence, Correspondence, and Convention T". It was a busy summer. After Berkeley I went to the Fourth International Congress for Logic, Methodology, and Philosophy of Science in Bucharest, my first peek behind the Iron Curtain. I had flown to Vienna with the intention of taking a Soviet ship down the Danube. I tried to buy a ticket before I left the United States, but was told to try London. In London I was told to try Vienna; in Vienna I was informed that all the spaces had been sold. This gave me an unexpected four or five days in Vienna. Remembering that

Schubert had written glorious music sitting in an open-air cafe, I decided to see if inspiration would strike me under the same circumstances. I had planned to talk without a paper at the Congress, but with time on my hands I settled at a table, ordered a coffee, and started writing. I had never before written in public, but I discovered that being observable provided a strong incentive to keep busy. Just as the books say, the waiters left me unmolested for hours, and in three days I had produced "The Material Mind". It is probably the only paper I ever wrote without footnotes. I then took the Orient Express—by now a slow, dilapidated train—to Bucharest. The sole other passenger in my compartment turned out to be reading a paper of mine. The passenger was Vincent Hope, a philosopher from Edinburgh. After Bucharest I dashed to Canterbury to a philosophy of psychology conference, and then to a week-long Balliol reading party in a chalet on a shoulder of Mt. Blanc. The party had been arranged by Tony Kenny, and after we had finished our work we had planned to climb to the top. Alas, it was not to be; bad weather. Years later, at a meeting in Rome, he told me he had subsequently reached the summit.

I spent the academic year 1973–74 as a visiting fellow at All Souls College, Oxford. It was a good year to be at Oxford: Quine was there for the whole year, and Dagfinn Føllesdal was there for much of the year. I had the opportunity to reestablish relations with people I had first met when I gave the John Locke Lectures, or when lecturing in London: John McDowell, Colin McGinn, Derek Parfit, Chris Peacocke, and Gareth Evans. I saw a good deal of Gareth, and came to admire the serious and original philosophy that emerged from his tempestuous personality. Gareth and John McDowell were determined to prove to the "Americans" that they had learned how to apply formal methods to the study of natural language, and they put together a fine volume, *Truth and Meaning*. This volume contained, along with much else of value, the long second part of Michael Dummett's "What is a Theory of Meaning?" This essay had been produced in the course of a seminar on truth that Michael and I gave during that year. The seminar was apparently viewed by the Oxford community as a sort of gladiatorial contest, and a large crowd turned out. At the first session I sketched the gist of my "Truth and Meaning". The burden of Dummett's two articles on what a theory of meaning should be were his response, and this took up most of the rest of the seminar. He contended that to specify what someone who knew a language knew by referring to a theory of truth in Tarski's style was to miss the real problem. It missed the real problem, according to Michael, because it assumed that the interpreter already had a language of his own in which he could state, if he wanted to, the truth conditions of the language he had mastered. Michael wanted an account that went much deeper: he wanted to specify in a non-circular way what behavior would count as showing that an agent commanded

the relevant concepts. Over the years that have followed, my position has developed in various ways, and we no longer are as far apart as we were then, or so it seems to me.

I had come to know Sam Guttenplan, who had helped organize a series of lectures during my year at All Souls: Føllesdal, Anscombe, Quine, Dummett, Geach, and I were the speakers. My paper was "Thought and Talk" in which I made the first of a number of attempts to provide a persuasive argument for a conclusion I was sure was true: that thought depends on language. This is a theme to which I have recurred a number of times. Sam and I played tennis on the grass courts in beautiful University Parks, and he took me to a nearby airfield where he belonged to a gliding club. Gliding was something I had always wanted to try, so I joined. I soon soloed, and spent many exhilarating hours playing with the cumulus clouds that drift over England during the summer. When I returned to the United States I added my new competence to my license for power flight. Over the years I have flown gliders in Switzerland, Australia, and various parts of the United States.

I was president of the Eastern Division of the American Philosophical Society, and this required me to return home several times, and to Atlanta in December to give the presidential address. This caused me to put into final form my criticism of conceptual relativism (Davidson 1974). Frequent trips back home suited me perfectly, for I had fallen in love with Nancy Hirshberg, who was a professor of psychology at the University of Illinois. Nancy had been an undergraduate at Stanford, and we had not lost touch during the years she was in graduate school at Stanford, and then taught, with her psychologist husband Jerry Wiggins, in Champaign. In the spring of 1972 Jerry suddenly decamped. Virginia and I had separated, to everyone's relief, shortly after I went to Rockefeller University, so Nancy and I became reacquainted. We spent a month or so in Portugal and Spain the summer of 1972, several times went skiing with my daughter Elizabeth in Aspen, and after my stint in Atlanta we spent a couple of weeks in Puerto Rico. There was a friendly divorce from Virginia, and Nancy and I were married in 1975. We were able to spend that year together, for Nancy had a visiting job at the Bell Laboratories in Murray Hill, but we needed to get permanent jobs in the same city. Serendipitously, the Rockefeller had decided to pay its philosophers to leave. I was offered a University Professorship at the University of Chicago, and Nancy moved from the University of Illinois campus in Champaign to its Chicago campus.

My new position was in many ways similar to the one I had just left. I was completely free for half of each year, and had no duties I did not choose to assume. I elected to become a voting member of the philosophy department, but from an administrative point of view I was independent of it. There was much to admire about the university and the city. The administration was committed to fostering scholarship; it is the only place I know of that would

offer people at any rank time off to write a book or do research. The ten university professorships were a grand idea. I'm sorry to have heard that I was the last one to be appointed. The special bequest that had made them possible had, I think, run out. My position made it natural to meet people from other disciplines, and Aian Donagan made this especially easy by inviting me to join a group from various departments who gave informal lectures to each other on their specialties. The group was similar to ones I had belonged to at Stanford, Princeton, and Rockefeller Universities, but for some reason it flourished as the others had not. The colleagues I talked with most were Bill Tait, who had been a colleague for a time at Stanford, David Malament, whom I had known as a student at Rockefeller University before he was sent to prison for refusing to be drafted, Raymond Geuss, and Alan Donagan. Alan and his wife Barbara became cherished friends. Alan and I met once a week for several years, plotting strategies to restore philosophy to the level the university deserved. We had no success. Alan ultimately decamped for the California Institute of Technology and I for Berkeley.

Chicago is the best city in the United States for architecture, having spawned the balloon frame house and the modern skyscraper, and welcomed the work of Louis Sullivan, Burnam & Root, George Elmslie, Frank Lloyd Wright, Saarinen, Mises van der Rohe, and Marcel Breuer. The lake and the skyline, with Henry Law Olmstead's continuous strip of park in between, comprise one of America's finest urban sights. Nancy and I bought and restored the top floor of an apartment building, built with the solid woods and workmanship of the first decades of Hyde Park construction.

We managed a good deal of travel. In 1977 we were both invited to spend a month or two at the Australian National University in Canberra. On the way there we seized the opportunity to spend a week visiting the Society Islands. We lectured in New Zealand, Sydney, Melbourne, and Perth, and, of course, in Canberra. Leaving Australia from Perth we went on to Mauritius, the Seychelles, and East Africa. Including the lecturing in Australia, I seem to have given thirty-seven lectures outside of Chicago that year. The following year we were both in London for the spring, Nancy at the London School of Economics and I at University College. I did the usual round of lecturing to philosophers, and (less usually) gave the annual Ernest Jones Lecture to the British Psycho-Analytical Society. This was "Paradoxes of Irrationality". The central paradox was the conflict between our grip on what determines the content of a thought, which partly depends on its logical relations to other thoughts, and the need to describe intelligibly the co-presence in the same mind of logically incompatible thoughts in cases of irrationality, such as akrasia, wishful thinking, and self-deception. Taking off from a rather wild example in an article by Ernest Jones, I mounted a limited defense of two Freudian theses which have often been criticized by philosophers: the resort

to comparing the workings of the mind to the purely causal operations of hydraulic or mechanical devices, and the idea that incompatible thoughts, desires, and emotions can be segregated in separate mental territories.

In May I gave several lectures on "Meaning, Metaphor and Malapropism" at University College. I emphasized that in metaphor words do not lose their ordinary meaning, or the force of metaphor will be lost. I also argued that what is interesting about a metaphor is not its paraphrasable cognitive content (if any), but its ability to make us see things in a new light. Max Black was intent on a general theory of the cognitive content of metaphors, something I thought was futile. Over the years, many philosophers have sided with Black. My views on malapropisms stirred up even more opposition. My central thesis was that we understand what others mean by being able to detect where their usage differs from some preferred, dictionary, or common usage, and that there is no point in maintaining that speakers ought to cleave to a common standard for any reason other than a desire to be understood. On this point, Grice, Dummett, Ian Hacking, and Tyler Burge have disagreed on various grounds, though without dissuading me from my original stand.

That summer Nancy, my daughter, and I took off for Frescal. Frescal was an old farmhouse in the Tarn in southern France which Gareth Evans, Arnold Cragg, and I had bought the year I spent as a Fellow of All Souls. This had come about when Gareth told me that he and Arnold had found a place they liked, but lacked the freely convertible currency to buy it. The cost was less than $10,000, so I offered to buy it, and the other two partners paid back their thirds over time. Ronnie Dworkin drew up an elaborate legal agreement for our amusement.

At Frescal, Nancy developed a slight cough, and by the time we were back in Chicago she was convinced it was lung cancer. Her doctor scoffed at the idea, and refused to x-ray her lungs, so she went to the hospital attached to Chicago Circle during a lunch period to have an x-ray made. She had been right. She continued teaching until mid-February, telling no one of her condition, but she died on February 21, 1979. I felt I might as well resign from life. Our marriage had been a source of wonder and delight to me. We had traveled, worked, and played together with an easy comradeship that was better than anything I had imagined possible. I backed out of teaching for the rest of the academic year, and spent the summer with John Goheen in Stanford, swimming and renewing my gliding skills. I got through that year and the next in a gloomy daze, though I managed to give the Carus Lectures in San Francisco in March of 1980.

My Carus Lectures were in outline something like C. I. Lewis's Carus Lectures: the first was on meaning, the second on epistemology, and the third on ethics. But there the similarity ended, for I shared Lewis's views neither on language nor on knowledge, since, following Quine, I had given up the

analytic/synthetic distinction and a foundationalism based on sense data. On ethics, my views did (and do) resemble Lewis's in one crucial respect, for I hold that values are objective. My reasons for believing this are, however, nothing like those Lewis gave.

That May I went to Uppsala to give the Hägerström Lectures at the invitation of Stig Kanger. I lectured on radical interpretation and various problems that arise in trying to give a formal theory of truth for a natural language. Stig and I discussed my attempts to extract a theory of meaning from a version of decision theory, something that I thought about and worked on over a period of years. Stig once came to a lecture of mine in Oslo in which I hazarded the view that since it was obvious that an agent should prefer (A exclusive-or B) to B if she preferred A to B, this fact would help to pick out the connective exclusive-or on the basis of preference alone. Stig said nothing during my lecture, but fifteen minutes after I finished he presented me with a proof that my "obvious" principle was inconsistent with the basic assumptions of decision theory. He was a bit surprised himself, and later published this proof. But it set back my thinking about the relations between meaning theory and decision theory by a couple of years. When I arrived at an entirely different approach, I showed it at once to Stig. He told me that I needed to add some important conditions, but agreed that I had solved my problem. The results are published as an appendix to my John Dewey Lectures (Davidson 1990c).

The University of Mexico had recently established a chair for visiting lecturers, and that August I gave the first Jose Gaos Lectures. I had the ambitious thought of giving the lectures in Spanish, but after attempting to put the first lecture into Spanish I fortunately abandoned the idea in favor of a brief summary in Spanish before each lecture, and then continuing in English. Olbeth Hansberg of the Philosophical Institute of the University gave me essential help both in composing the Spanish prologues and in coaching me in reading them. This was the start of a lasting relationship with philosophers in Mexico, for I was to return there in 1981, 1983, 1984, 1992, and, most recently, for a bracing conference on my work, organized by Olbeth, and celebrating my eightieth birthday (1997). Speakers at the conference included Akeel Bilgrami, John McDowell, Carol Rovane, Dick Rorty, Eduardo Rabbosi, Barry Stroud, Marcia Cavell, Ernie Lepore, Carlos Moya, and several members of the Institute.

Chicago had lost its attraction for me; Nancy was gone, Raymond Guess, the Donagans, and my favorite students, Carol Rovane and Akeel Bilgrami, had left. When the University of California invited me to join their philosophy department, I was glad to accept, and moved there in September of 1981. I had made several visits there after leaving Stanford, twice for week-long stays at the invitation of the graduate students, and had liked the atmosphere. Paul

Grice was a welcome presence (though I was his nominal replacement, since he had officially retired), as were Carl Aschenbrenner, whom I knew from Stanford days, and who had briefly been a fellow officer in the Navy's pre-flight school in Orinda, two ex-students, Ernest Adams and Bruce Vermazen, Barry Stroud, and John Searle, who had been in a joint Stanford-Berkeley discussion group with me in the sixties. It was a pleasure to be back in an active, well-run department. I also delighted once more in the Bay Area climate, near-by ocean and mountains, and generous public lands. Public institutions are more to my taste than private, though I have spent more time in the latter: I like the student mix better, and the sense of being embroiled, for better or worse, in the political scene. It is hard for me to imagine another university or location I would like as much.

The June before the move to Berkeley Dick Rorty organized a session of Germany's Hegel Society, meeting in Stuttgart. He invited me, Quine, and Putnam. My paper (the only one in English) was the badly mistitled "A Coherence Theory of Truth and Knowledge" (Davidson 1983). It was not a theory of truth, and it was a coherence theory only in that I argued that the only reason an agent could have for a belief was another belief. But I did not hold (as numerous critics who read only the first few pages supposed) that perception played no role in knowledge; my view then (and now) is that many beliefs are directly caused by events in, and aspects of, the world through the mediation of the senses. What I rejected was any attempt to interpose some sort of epistemic intermediary between the external object of a belief and the belief itself. Bolstering this idea was a form of externalism: I urged that the content of a perceptual belief was primarily determined by the nearest past causes shared by an agent and others with whom the agent was in communication. After Stuttgart, Rorty, Quine, Putnam, and I went on to Heidelberg to rehearse our positions at length. Dieter Henrich was there, and acted as a gracious host. For me the most interesting moment came when I argued for an externalist account of the contents of perceptual beliefs. Quine commented that it should make no difference whether we took the content to be deter-mined by patterns of sensory stimulation or by the external object, since they were simply at different points in a single causal chain. I claimed it did make a difference. I agreed that taking the proximal stimulus (Quine's "stimulus meaning") made error easier to explain, but it failed to anchor words and thoughts to the right objects. Quine (incredulous): "What someone believes is not [wholly] determined by the physical state which is, you agree, the belief?" Davidson: "That's right!" (I have a transcript of the exchange someone made from a tape recording.) The question whether the meaning of a perceptual sentence is fixed by the distal or the proximal stimulus was one on which we had long disagreed, but this was the first time the issue had been raised so clearly. Commenting on this exchange in his autobiography, Quine

pays me a compliment he deserves far more than I: "We pursue any initial differences with an eye on the problem and an interest in solving it, as scientists might, rather than with the dismal gamesmanship so common in philosophy" (Quine 1985, p. 454).

Six years later we were worrying the same bone, this time in a five-day closed session at Stanford, with Dagfinn Føllesdal and Burt Dreben to help us out. Quine records the failure of my attempt to persuade him: "I remain unswerved in locating stimulation at the neural input. . . .Unlike Davidson, I still locate the stimulations at the subject's surface, and private stimulus meanings with them" (Quine 1990b, pp. 41, 44). In April 1988, there was a conference on Quine's work at Washington University in St. Louis organized by Robert Barrett and Roger Gibson. I read a paper plumping for my point once more, though also emphasizing the many passages in Van's work that seemed to foreshadow my view (Davidson 1990a). Quine, in reply, and generous as always, "moved to an intermediate point between Don's distal and my old proximal position" (Quine 1990a). The new position abandoned stimulus meaning, but retained the priority of the neural stimulations. Only thus, Quine argued, could one keep track of the "flow of evidence from the triggering of the senses to the pronouncements of science" and give an account of how we arrive at the "reification of rabbits and the like". An emphasis on empathy emerged, to be further developed in Quine's reactions to the papers (among them one of mine [Davidson 1995b]) read at a conference in San Marino 1990. The idea was that we translate a native's observation sentence by imagining what we would say if we were placed as he is when he utters the sentence (Quine 1995, p. 348).

In recent years our positions have drawn even closer. Quine now emphasizes the fact that, as a result of evolutionary pressures, people (and many animals) have developed similar standards of perceptual similarity: their innate tendencies to group together seen or otherwise sensed objects and situations are much the same from person to person. The result is that "what two observers agree on is the shared distal subject matter and not the unshared proximal stimulations" (Quine 1996, p. 161). In recent years I have been stressing what I call "triangulation", which relates two people and an external situation, which is in some ways like Quine's present position (Davidson 1989; 1990a; 1991a; 1991b; 1992; 1993). I have also become increasingly impressed with the project, long one of Quine's, of accounting for the transition from mere perceptual intake to the individuation of objects and events. Differences of emphasis remain, particularly with respect to the epistemic importance of "neural intakes", and the closely related question of externalism.

I had met Ernie Lepore when he was a graduate student at the University of Minnesota. Three ex-students from Stanford taught there: John Dolan and

John Wallace had migrated to Minneapolis from Rockefeller University, and Marcia Eaton was also there. In 1975 I had given four John Dewey lectures in Minneapolis, and in 1977 I returned for a lecture, and then four lectures on events in Morris, Minnesota. Ernie came along in the four-passenger plane Morris had provided. Ernie and I had stayed in touch; when he graduated, he took a position at Notre Dame while I was in Chicago, and when he moved to Rutgers he organized a conference on my work. This was in April of 1984. His organizational skill was so potent that the modest meeting he had in mind mushroomed into a five-day affair. Since there were concurrent sessions, I couldn't attend every talk, so I decided my only course was to remain silent. As a consequence I found the five days distinctly unnerving, hearing about someone named "Davidson" who was certainly not I, since Davidson was said to be mostly wrong, and I didn't answer to that name.

Convention D, as wag Sydney Morgenbesser called it, brought me back in contact with many friends, colleagues, and students from times present and past. It was a sobering compliment to discover how many of them had knowledge of my work and were happy to explain to me how it could be improved. One participant I was particularly happy to see again was Marcia Cavell. She had been an undergraduate at Stanford in the early '50s, had gone on to a Ph.D. at Harvard, and was now teaching at Purchase, one of the colleges in the New York State University system. Our paths had crossed over the years, but now we became seriously reacquainted. In June we spent a week in Venice where I had been invited to a conference on Utility and Risk Theory; my talk was on "New Foundations for Decision Theory", an early version of my scheme for unifying decision theory and theory of meaning. On July 3 Marcia and I were married. Next month we were in Xalapa, Mexico, where both of us read papers at a conference on realism.

That September I moved to Oxford, where I had been appointed Eastman Professor. This chair, attached to Balliol College, came with a large house on the edge of the Balliol playing fields. In theory I had the duties of an Oxford professor. I was told these involved giving twenty-four "academic exercises" in the course of the year. The answer was a bit vague when I asked what an academic exercise was: a lecture or seminar counted, but I was told that an hour spent with a few students in a pub would also rate. In the event, I gave a course of lectures on action theory during Michaelmas Term, a joint seminar with Chris Peacocke in Hilary Term, and a seminar with John McDowell Trinity Term. Chris and I discussed my proposal that meaning, belief, and desire might suffice to explain human action; he contended that at least perception had to be added. I questioned this claim on the ground that perception presented a reason for action only insofar as it involved a belief. We had difficulty finding common ground on which to join the issue, but discussion with the participants was lively. John and I profitably discussed the question

of the objectivity of values, on which we were, I think, basically in agreement.

In October I gave the first Gareth Evans Memorial Lecture. Marcia was still teaching at Purchase, and so was unable to join me that fall, but one thing and another brought me to New York during the term, and after the Christmas holidays she returned to Oxford with me. It was a busy and enjoyable time. There were tennis courts in the back yard, which we used with enthusiasm when the weather agreed, there was the good company of Tony Kenny, now Master of Balliol, and much traveling and lecturing. We visited Belfast and Dublin, firsts for both of us. We were shown around Joyce's Dublin, and taught the pleasures of Guinness when it is tracked down to the source. Another trip took us to Copenhagen, Aarhus, and Turin, and still another to Scotland. In June, we volunteered to carry books and what cheer we could to the brave philosophers of Prague. This expedition, like similar forays, was organized by Kathy Wilkes and others in Oxford. Ours had its hilarious moments. Warned to evade police surveillance by having our taxi stop a few blocks short of our meeting with Hedonic's group of philosophers, we found an obvious spy at the door noting all who entered and left. Once there, it gradually emerged that word of our visit had failed to get through; the company had met to hear another visitor. His talk on religion was politely postponed while I gave out on some inappropriately abstract topic.

During my year as Eastman Professor I was vice-president of the Pacific Division of the APA. I tried to dodge this by arguing that I had already done my stint as president of the Eastern Division; that I would be away during my vice-presidential year; and that I had already served as vice-president of the Pacific Division. That had been back in 1961, before it was routine for the vice-president to become president the following year. My excuses were not accepted.

Marcia and I spent Christmas of 1985 in steaming Calcutta, my third visit there. I was on a Fulbright tour, lecturing in Calcutta, New Delhi, Bombay, Lucknow, and Jaipur, a total of nineteen lectures. We were longest in Calcutta, where analytic philosophy maintained a sturdy presence under the determined leadership of Pranab Sen. We delighted in the company of Pranab, his wife, and two daughters; the two latter were subsequently to win scholarships to do graduate work in philosophy in England.

Visiting threatened, badgered, or dispossessed philosophers has been my lot more than once. I had learned, when the entire philosophy department at Queens College was forced out by politically powerful Catholic forces, how philosophers could be seen as partisan ideologues, as well as easy targets. In '62 I had arrived in Burma just after a number of protesting university students had been shot by the army, and I talked with the shaken philosophers, who feared no good for themselves. In '80, and again in '81, I visited the beleaguered philosophers of SADAF in Buenos Aires. They had all been fired

from their positions in the university, and were holding informal courses of lectures for anyone who had the courage to come. We met in a house that had been donated by Genaro Carrió. As people drifted in, they put what they could afford into a box on the lecturer's desk. In better times, one might have been pleasantly reminded of the Middle Ages. When democracy was restored, these brave souls became department heads, Carrió became a justice of the Supreme Court, and Eduardo Rabossi was made a member of the politically important National Commission on the Disappeared. After my first trip to Argentina, in 1980, I flew the South Atlantic to Cape Town, where I lectured for a month. Before I had agreed to go, I asked Michael Dummett whether what support, intellectual and moral, I could bring to the anti-apartheid philosophers of the University of Cape Town would outweigh what might seem tacit acceptance of the regime. Michael thought about it for a day or two and then urged me to go. It was an educational but spooky experience. I arranged with black friends to visit Crossroads outside of Cape Town (it was bulldozed by the government subsequently), and Soweto. When I lectured at the University of Natal in Pietermarizburg, the Black settlement on the next hill still smoldered from a recent attack.

The day I left South Africa I lectured in Harare, the capital of newly independent Zimbabwe. I was amazed to find an audience of about fifty, about half of it Black. I was told there were several politicians, a number of government officials, and a handful of lawyers; the attendance was explained by the fact that there was no other entertainment available that evening. I put aside my prepared paper and improvised a talk on radical interpretation and my opposition to conceptual relativism. It was well received, and the discussion was animated. Next day I joined my host, philosopher Sandy Matthews, and two old friends from my childhood, Anne and Bob Seidman, and drove east to the Leopard Rock Hotel overlooking neighboring Mozambique. It was a relief to be out of South Africa and in a country where the original inhabitants could act and feel at home. More recently (1997) Marcia and I lectured in now booming Cape Town and Johannesburg. Things had changed for the better more smoothly than anyone had expected seventeen years before, though the outlook seemed uncertain. Those we had known before and during the transition, particularly hospitable Denise and Paul Taylor of the University of Cape Town, are cautiously optimistic. After South Africa we joined up with Anne Hollander, Tom Nagel, Barry Stroud and his friend Nancy Shaw in Victoria Falls for a two-week safari in Botswana.

When I went to Belgrade in March of 1995 at the invitation of a group of dissidents called the Belgrade Circle, I found that the philosophers in Serbia fell into two groups, those whose interests were exclusively historical, who mostly sided with the government, and the analytically inclined, who were mostly in opposition. The members of the Belgrade Circle, led by Obrad

Savič, included intellectuals of all sorts, but many were analytically-minded philosophers. They operated from a few rooms they had rented; George Soros subsidized them to a modest degree. But they expected Milosevič's government to find a way to cancel their lease, and Soros was banned from operating in Serbia not long after I was there. I gave a few talks, one in quarters provided by the US Information Service. During my visit a collection of my papers, translated into Serbian, came out, launched in a small bookstore–coffee shop. I was rewarded for my visit with a bottle of home-brewed slivovitz, the best I have ever tasted. I had lectured in what had been Yugoslavia in better days. In May of 1988, Marcia and I had both given talks in Ljubljana and Rijeka, and in November of the same year I returned for a conference on my philosophy which was held on the border between Austria and Slovenia. For several days the conferees shuttled back and forth between Bad Radkersburg and Gornja Radgona, each border-crossing calling for a new visa. Johannes Brandl and Wolfgang L. Gombocz, who organized this enjoyable get-together, edited the resulting book (Brandl and Gombocz 1989).

The philosophers of Israel cannot be considered threatened or beleaguered, or in need of moral support, though courageous souls, like Edna and Avishai Margalit, active in Peace Now, deserve all the support they can get. I have visited Israel seven times over a span of more than thirty years to participate in conferences and to lecture. In spite of its travails I have always found Israel's people and its land exhilarating. After one conference in 1974, Max Black, his wife, Nancy, and I were driven by an Israeli, accompanied by an armed guard, from the Gulf of Aqaba through a series of trackless wadis to the monastery of Santa Katarina. About four in the morning Nancy and I were let out the gates by a sleepy monk, and climbed Mt. Sinai. We had not expected to meet anyone except, perhaps, Moses, but at the top we found a happy cluster of American youths. Edward Said scolded me when he heard I was about to go to Israel in 1987, but extended grudging approval when I agreed to give a lecture at the Palestinian University of Bir Zeit. Beleaguered is the word for the faculty and student body of Bir Zeit; the university had been shut down by the Israelis for more than half the year. Lecturing there was a challenge; the audience was intent and asked sharp questions. They kept me long after the lecture for friendly, intelligent discussion. Afterwards, Avishai Margalit said he envied me the opportunity to talk on the West Bank; the philosophers at Bir Zeit, some of whom lived in Jerusalem, wished circumstances permitted them to attend lectures at the Hebrew University.

In 1993 I gave the yearly Spinoza Lecture in Jerusalem. I had always known that my view of the relation between the mental and the physical was Spinozistic in being ontologically monistic but conceptually dualistic, but on rereading Spinoza after many years, I discovered an interpretive puzzle and a convergence of my position with Spinoza's of which I had not been aware.

Spinoza was what is sometimes called a dual-aspect monist, and so was I. He also claimed that there were two causal chains, one connecting mental events, and a parallel one connecting physical events. The puzzle was that he denied that there are causal relations between the mental and the physical. This seems an outright contradiction: if mental event A causes mental event B, and B is identical with a physical event, how could one deny that a mental event has caused a physical event? I found no discussion of the problem, much less a solution, in the writings of the Spinozists I read: Stuart Hampshire, Alan Donagan, Edwin Curley, and others. The way to understand Spinoza, I decided, was to see him as not distinguishing between what I would call the (extensional) relation of causality and the (intensional) relation of causal explanation; what he was affirming was only that the second relation between the mental and the physical failed to hold. This would construe him as denying the possibility of definitional or nomological reduction of mental concepts to physical concepts.

It is doubly gratifying to "discover" that an esteemed philosopher of the past can be interpreted as having views that coincide with, or at least bear out, one's own attitudes, so it is not surprising when this happens. If I have not had as many such surprises as I should have, this shows how little I ever knew of the history of philosophy, and how little of what I once knew I have forgotten. Plato and Aristotle, Kant and Hume I have read and taught so many times that I am probably alert to the most obvious ways they have influenced me. When I was working on akrasia I restudied Plato and Aristotle (along with Augustine and Butler) with profit, and Gregory Vlastos rekindled my interest in the Socratic elenchus. At one point I decided to try to understand the second book of Hume's *Treatise*, which I had always found frustratingly obscure. In it I thought I found a subtle, and convincing, analysis of pride (Davidson 1976). Kant's influence has been the most pervasive, but it runs so deep that I have seldom acknowledged it in print. One exception is "Mental Events"; another is my treatment of the relation between laws and causality (Davidson 1995a). In Germany, where so much philosophical thought has its roots in Kant, my debt to Kant has apparently seemed obvious. In 1993 I gave the Kant Lectures at the University of Munich—my second set of Kant lectures, since I had already given lectures with that name at Stanford. I touch on these historical connections because students often ask me why they should bother to study the history of philosophy if their interests lie elsewhere. I have no firm advice to offer them, but in my own case I am sure that if I had known more about the history of philosophy I would have avoided some of the tempting errors to which I succumbed, I would have recognized problems sooner, and my thinking would have been deepened.

There was a time, not so long ago, when philosophy departments in this country were often bitterly divided between those who favored a historical

approach to philosophy and those who knew some logic, and favored clarity and good arguments. More recently this unnecessary split merged with, or transmogrified into, the equally noxious separation of philosophical styles into the "continental" and the analytic. To some, I seem perched on both of these ill-named stools. A recent review in the *Times Literary Supplement* counts me as a "hero" of the analytic group, while I find myself included in anthologies with titles like *After Philosophy* and *Post-Analytic Philosophy*. Articles explore similarities between my views and those of Derrida, and a few years ago there was a summer institute at Santa Cruz on Heidegger and Davidson. In 1991 I was honored to be the first English-speaking philosopher to receive the Hegel Prize from the City of Stuttgart. What this proves has little to do with me and lots to do with an increasingly less blinkered attitude on the part of many in the philosophical community, the ease of international travel, and the efforts of a few deliberate synthesizers like Dick Rorty, who cheerfully lumps me together with Dewey, the early Heidegger, and the late Wittgenstein.

In recent years my two most central interests have been in the concept of truth and the concept of objectivity. From the time of "Truth and Meaning" I have seen theories of truth as central to the study of language, but I was always aware that Tarski-style truth definitions or theories, though they illuminated the concept by demonstrating how it can be applied to particular languages or speakers, did not exhaust its content. In my Dewey Lectures at Columbia I argued that it was a mistake to try to define truth (Tarski had, after all, proven that under some natural assumptions it can't be done), or even to try to characterize it in a brief phrase or slogan. Correspondence theories, coherence theories, pragmatic theories, minimalist and deflationary theories of truth all seemed to me to fall short. What I proposed in their stead was inspired by what I had learned from Suppes and McKinsey. If one treats Tarski's constructions as axiomatized theories containing an undefined concept of truth, then in order to apply such a theory to an actual language, one needs a way of telling empirically when sentences containing the concept are true. Tarski's T-sentences are made for this job, since the totality of T-sentences for a given language exhaust the extension of a truth predicate. Thus the work of supplying an empirical content for the concept of truth is what radical interpretation is designed to deliver.

Interest in the concept of truth led to the question how we had acquired this concept. A case can be made for the view that this is as fundamental a concept as any we have, for without it we would have no concepts at all. The reasoning is simple: to have a concept is to judge that certain things fall under it, and others don't. To judge that something is, say, lavender, is to hold it to be true that that thing is lavender. To have any propositional attitude requires knowing what it would be for the proposition entertained to be true. Our conviction that there is a way things are however we may think they are

depends on our having the concept of truth, and this is the same as having the concept of an objective reality. I was an externalist of a sort from early days, certainly long before the word was current, for my insistence that it is the distal stimulus rather than the proximal stimulus that bestows content on perceptual sentences was a form of externalism. But an external stimulus can cause a thought only in a creature with concepts, and in particular, with the idea of the contrast between how things are and how they may be thought to be. What had to be explained was the origin of, or basis for, the concept of error. I pondered this problem for so long that I no longer know what made me think of what I now see as a partial solution. It is possible that it came from reading Kripke's little book on Wittgenstein; in any case it is now clear to me that the problem, or one aspect of the problem, is stated there. What Kripke saw was that a person cannot make a mistake without an external check, and the inanimate world cannot provide such a check. What Kripke thought was Wittgenstein's "skeptical" solution was that other people provide this check. I think this is right, though in my opinion this is not a skeptical idea, nor do I think it is as simple as Kripke made it out to be. The picture I formed is of a triangular relation between two people and a shared external stimulus, where each person can correlate what he or she senses with the other's reaction to that stimulus. This is not enough to explain error, but it makes room for it, for there will be cases where one person's reaction to a shared stimulus is not what the other person has come to correlate with that stimulus. My account of error builds on this foundation.

As my ideas have developed, I have tried them out on audiences here and there. I have been to wonderful conferences in Biel and Bern organized by Henri Lauener no less than seven times. The first of these, in the '70s, were held on the high continuous ridge of the Jurals, and looked across at the Bernese Alps. The last marked the retirement of good friend and sturdy champion of analytic philosophy, Henri himself. In 1993 I gave a series of lectures in Rome on truth and the concept of objectivity, and a small international conference on my work was organized. Those who read papers included Eva Picardi, who had made the excellent translations of my books into Italian, Paolo Leonardi, who had earlier arranged a month's lecturing in Venice, and is now a professor at the University of Bologna, and Rosario Egidi, who was responsible for my presence in Rome, and greatly contributed to the pleasure of being there. Akeel Bilgrami, Carol Rovane, Marcia Cavell, and Ernie Lepore also added to the festivities.

The first time I was asked to comment on a series of papers directed to aspects of my writings was in Alicante, Spain, in 1981. I had trouble following, for I was mostly hearing papers I had not read, and they were in Spanish, but I deciphered enough to manage what I hoped were relevant comments. In '87 a conference took me to Madrid where I met the doyen of

analytic philosophy in Spain, Manuel Garrido, who had kept the flame alight during the Franco days. He was now settled in Madrid, but earlier he had been in Valencia. I was to appreciate what he had accomplished the next year when Marcia and I spent a delightful five days in that attractive city with its hospitable and intelligent philosophers. In 1994 I had two weeks of lecturing and being quizzed in Girona, in Catalonia. Josep-Maria Terricabras, whom everyone calls Terri, had invited me to occupy the Josep Ferrater Mora Chair, which meant five lectures each week-day morning for two weeks, with the rest of each morning and afternoon taken up with discussion by the audience and invited guests. The chair generously arranges to pay the expenses not only of the lecturer, but also of several people suggested by him. In my case there were Barry Stroud, Akeel Bilgrami, Bruce Vermazen, and Quine. Burt Dreben also came along, and Ernie Lepore flew over from Italy where he was spending the year. In Quine's case it was turn about, for he had invited me when he gave the lectures in 1990. Quine's lectures became his book, *From Stimulus to Science*; mine were called "The Social Basis of Thought", and they emphasized my thesis that our grasp of the concepts of truth and objectivity, and hence our unique ability to entertain thoughts with a propositional content, depended on a social milieu. No small part of the pleasure of being in Girona was due to its Romanesque and Gothic treasures and its well preserved mediaeval ghetto. Terri and his wife Montserrat made the visit memorable, with side trips on weekends and a feast at their house near the coast.

Aside from Scandinavia, which has long belonged as much to the English speaking philosophical world as to the continental, Germany is the mainland European country which seems most alive to the analytic tradition. This is due, among other causes, to the influence of such powerful figures as Hans-Georg Gadamer, Dieter Henrich, and Jürgen Habermas. Open-minded about philosophical styles, they have helped create a generation of able scholars who are as familiar with, and competent at, analytic philosophy as any in the world. In Berlin, Heidelberg, Tübingen, Munich, Bielefeld, Saarbrücken, Frankfurt, Stuttgart, Erlangen, and Bamberg I have found responsive audiences who treated me to intelligent questions and good informal discussion.

In France, though the shadows of Derrida and Lyotard no longer darken the philosophic landscape, one feels that those who are associated with analytic philosophy constitute an uneasy minority. In spite of this, there are various centers of spirited activity. Excellent work is being done by Pierre Jacob, Pascal Engel, his wife Claudine Engel-Tiercelin, and others connected with CREA, and of course there is Jacques Bouveresse as teacher, writer, and inspiration. I am greatly indebted to Pascal for his excellent translations of many of my articles, and both of my books of essays. A most promising sign is the recently inaugurated Jean Nicod Lectures. Mine, given in 1995, were my

final try at putting my views on the concept of objectivity into shape, and will be (belatedly) published. Between two of my lectures, Marcia and I dashed to Oxford where I finally received a permanent, if only honorary, degree (I had twice had *temporary* degrees from Oxford, essential to being fed while in residence). We returned to Paris via the chunnel. After the lectures, and a brief tour of Normandy, I had an improvised exchange with Tom Nagel and Bob Morris at the Pompidou where Morris was having a retrospective show. Our subject was his *Blind Time Drawings with Davidson*.

It may seem that I have spent all my time traveling, but of course I have mainly been teaching. One of the rewards of teaching is discovering that the silent lad who has said nary a word in seminar has written a brilliant paper, or the giddy blond in the shades and a mini-skirt is by far the most talented student in a large class. These surprises remind us how easily we may underestimate our students, and even of how some people don't have to be taught how to do philosophy—what we had to work for came naturally to them. In somewhat the same way that students have surprised me, philosophers in faraway places have more than once pleasantly upset my expectations. Among such places, Russia, Armenia, Uruguay, Peru, Colombia, Greece, Portugal, Malta, and Portugal come to mind. There was a lot going on that I didn't know about. And, of course, there always will be. I want to know how philosophers in other cultures, economies, climates, and degrees of constraint manage their lives and do their work. I want to argue with them, depend on them for criticism and insight, and do what I can in return.

Not all travel has been work. I have often taken advantage of the luck that took me to a place that attracted me to poke around as a tourist, there or on the way. And in a few cases in recent years Marcia and I have recognized there were locales where we would never be invited but that we had always wanted to see. This thought took us to Ushuaia and neighboring parts of Argentina and Chile with Anne Hollander and Tom Nagel, and later to the western desert of Egypt, presently to the Okavango Delta, this time with Tom and Anne and Barry Stroud. Barry was also with us when we went to Morocco and Petra, this last a place we had dreamed about for years.

NOTES

1. I owe much of this information, as well as many corrections, to my sister, Jean Baldwin. I had much additional help on later years from Marcia Cavell and Ernie Lepore.

2. Gadamer's book, *Platos dialektische Ethik*, was first published in 1931; the English translation came out in 1991. By coincidence, my thesis, *Plato's **Philebus*** (Davidson 1990b), had been published the previous year. I have discussed the relation between the two works in "Gadamer and Plato's *Philebus*" (Davidson 1997).

REFERENCES

Brandl, J., and W. L. Gombocz, eds. 1989. *The Mind of Donald Davidson.* Amsterdam: Rodopi.

Davidson, Donald. 1963. "The Method of Extension and Intension." In *The Philosophy of Rudolf Carnap*, edited by P. A. Schilpp. La Salle, Ill.: Open Court.

———. 1974. "On the Very Idea of a Conceptual Scheme." In *Proceedings and Addresses of the American Philosophical Association.*

———. 1976. "Hume's Cognitive Theory of Pride." *Journal of Philosophy* 73:744–57.

———. 1983. "A Coherence Theory of Truth and Knowledge." In *Kant oder Hegel*, edited by D. Henrich. Stuttgart: Klett-Cotta.

———. 1985. "Plato's Philosopher." *The London Review of Books* 7 (14):15–17.

———. 1988. Review of Quine's *The Time of My Life: An Autobiography*, in *Journal of Symbolic Logic* 53:293–95.

———. 1989. "The Conditions of Thought." In *The Mind of Donald Davidson*, edited by J. Brandl and W. Gombocz. Amsterdam: Rodopi.

———. 1990a. "Meaning, Truth and Evidence." In *Perspectives on Quine*, edited by R. B. Barrett and R. F. Gibson. Oxford: Blackwell.

———. 1990b. *Plato's Philebus.* Edited by R. Nozick, *Harvard Dissertations in Philosophy.* New York: Garland Publishing.

———. 1990c. "The Structure and Content of Truth." *Journal of Philosophy* 87:279–328.

———. 1991a. "Epistemology Externalized." *Dialectica* 45:191–202.

———. 1991b. "Three Varieties of Knowledge." In *A. J. Ayer Memorial Essays: Royal Institute of Philosophy Supplement 30*, edited by A. P. Griffiths. Cambridge: Cambridge University Press.

———. 1992. "The Second Person." In *The Wittgenstein Legacy*, edited by P. French, T. E. Uehling, and H. Wettstein. Notre Dame, Ill.: University of Notre Dame Press.

———. 1993. "Locating Literary Language." In *Literary Theory after Davidson*, edited by R. W. Dasenbrock. University Park, Pa.: Pennsylvania University Press.

———. 1995a. "Laws and Cause." *Dialectica* 49:263–79.

———. 1995b. "Pursuit of the Concept of Truth." In *On Quine*, edited by P. Leonardi and M. Santambrogio. Cambridge, U. K.: Cambridge University Press.

———. 1997. "Gadamer and Plato's Philebus." In *The Philosophy of Hans-Georg Gadamer*, edited by L. E. Hahn. Peru, Ill.: Open Court.

Davidson, Donald, and Gilbert Harman, eds. 1971. *Semantics of Natural Languages.* Dordrecht: D. Reidel.

Davidson, Donald, and Jacob Marschak. 1959. "Experimental Tests of a Stochastic Decision Theory." In *Measurement: Definitions and Theories*, edited by C. W. Churchman and P. Ratoosh. New York: John Wiley & Sons.

Davidson, Donald, and Patrick Suppes. 1957. *Decision-Making: An Experimental Approach.* Translated by *Decision-Making: An Experimental Approach.* Stanford University Press, 1957. (With Patrick Suppes.) Reprinted, University of Chicago Press, Midway Reprint Series, 1977. Parts reprinted. Stanford, Calif.: Stanford University Press.

Quine, W. V. 1985. *The Time of My Life: An Autobiography.* Cambridge, Mass.: MIT Press.

————. 1990a. "Comment on Davidson." In *Perspectives on Quine*, edited by R. Barrett and R. Gibson. Oxford: Blackwell.

————. 1990b. *Pursuit of Truth.* Cambridge, Mass.: Harvard University Press.

————. 1995. "Reactions." In *On Quine: New Essays*, edited by P. Leonardi and M. Santambrogio. Cambridge: Cambridge University Press.

————. 1996. "Progress on Two Fronts." *The Journal of Philosophy* 93 (April 1996):159–63.

ACKNOWLEDGMENT

I am grateful to Marcia Cavell for correcting my grammar, improving my style, proofreading most of my Replies, and keeping my spirits up.

PART TWO

DESCRIPTIVE AND CRITICAL ESSAYS WITH REPLIES

1

W. V. Quine

WHERE DO WE DISAGREE?

Readers of Davidson and me are bound to be struck by how deeply we agree, and hence puzzled the more by occasional points of apparent disagreement. I shall try to assess these differences.

We are in long-standing agreement regarding the indeterminacy of reference, which seems undebatable, and even the more speculative indeterminacy of translation of sentences as wholes. Regarding the former, Davidson has expressed misgivings over my phrase 'ontological relativity'. My first presentation of the thesis under that title, in 1968, seemed to relativize the ontology of any one language to the firmer ontology of some other, inviting an infinite regress. However, what I see as the appropriate relativity stands forth in my later writings. Indeterminacy of reference pertains only to the translation relation between languages, and ontological relativity is relativity to manuals of translation. 'Lapin' denotes rabbits relative to my favorite French-English dictionary. All languages are equal here, none more basic than another.

Further detail is in order, not for Davidson but for many readers. A manual of translation from one language to another, say to English, may be conceived mathematically as defining inductively a many-many relation of sentences of the alien language to English sentences. The relation is holophrastic; no particular correspondence of words or structure is called for. A manual of translation is good insofar as it conduces to smooth dialogue and successful negotiation. My thesis or conjecture of indeterminacy of translation, taken holophrastically, is that smooth dialogue and successful negotiation can be fostered as well as you please by each of two incompatible manuals of translation. Their incompatibility could be revealed by using the two manuals alternately, sentence by sentence, and coming out with an incoherent translation of some text that proves coherent when translated by either manual alone.

Such is the indeterminacy of holophrastic translation. Indeterminacy of reference, on the other hand, concerns the translation specifically of predicates and singular terms. It applies only to languages in which, thanks perhaps to previous holophrastic translation, we can recognize predicates and singular terms. What it says is that an arbitrary one-to-one reassignment of denotata to the terms and predicates preserves all truth values. The proof is trivial. If x was an F, then its proxy is one of the proxies of the Fs; and only then, since the reassignment was one to one.

In all this we agree. But a second point where Davidson sees us diverging is between what he calls his distal and my proximal theory of meaning. It concerns the causal chain from a thing or event in the external world to the act of utterance by which the subject reports it. He finds the meaning of the utterance at the distal end of the chain, at the thing or event reported, and he has me locating it proximally, at the subject's surface in the activated receptors.

My misleading term 'stimulus meaning' was no doubt at the root of the trouble, and should be neutrally paraphrased in terms of the triggering of nerve endings, as is now my way. The triggering is proximal and the external object or situation is distal. *Meaning* is as may be, and may best go without saying.

My observation sentences are and were about the distal external world. Like Davidson, I have always represented the translator as coordinating his speech with the native's by consideration of presumed distal reference and with no thought of nerve endings. My concern with the proximal was epistemological rather than semantical. It concerned not what the translator does or should do, but why it works.

Let us consider the first step in acquiring a language. The translator learns a word from the native, or the child from the mother, on the occasion of their jointly observing a distal object or event. There are two causal chains from the distal subject matter, one to each observer. The chains are alike at their distal ends, except for a slight difference in angle of view. The translator learns the appropriate word from the native, or the child from the mother, and comes up with it on similar occasions to the satisfaction of all concerned. Apparently those chains, so similar at their distal origins, found termini in the two observers that were similar enough to each other to make similar use of the input. Hence my conjectural ascription, in *Word and Object* (1960), of an at least approximate intersubjective homology of neuroceptors.

I have been putting the matter in terms of translation and language learning, but it applies equally to the use of observation sentences in the checking of scientific theories: the experimenters have to agree on the observations they are reporting.

By 1965 I felt that such homology of receptors should not matter.[1] At best

it would explain little, if we reflect with Darwin[2] on the diversity of internal neural networks from individual to individual. But I had nothing in mind to take its place in my reasoning. My conference with Davidson, Dreben, and Føllesdal at Stanford in 1986 left me single-mindedly rejecting the homology, though still with nothing to take its place.

The explanation of this harmony at the proximal pole struck me only years later:[3] it is an intersubjective harmony of our subjective standards of perceptual similarity of neural intakes. Each of us is born with his standards of perceptual similarity, which then change somewhat with experience. Though private, they are testable for each individual by reinforcement and extinction of responses. We make no sense of perceptual similarity between one subject's intakes and another's; what does prevail is this distal parallelism between one subject's standards of perceptual similarity and another's. If Paul and Maud jointly witness two events, and Paul's intakes are perceptually similar for him, Maud's will probably be similar for her.

This harmony is caused by neither interaction nor anatomical homologies. It is preestablished by natural selection, which has favorably slanted the inductive expectations of our forebears down the ages by molding their innate standards of perceptual similarity to mesh with environmental trends. Thus it is that translators and experimenters can blithely ply their distal trades and no questions asked.

A third divergence between Davidson and me appears in his term 'radical interpretation', as over against my 'radical translation'. The difference is not just terminological. Interpretation is broader than translation. There are scientific sentences in today's English that cannot be translated even into the English of 1900, let alone classical Arabic or Swahili; but still they can be adequately interpreted in all those languages. Any non-trivial context of the word 'neutrino' is an example. New terms like that one are not introduced by definition; we are not told how to translate a sentence containing the term into a sentence of our prior language, and in general it cannot be done. We are just told enough about neutrinos to be able to bandy the term effectively where needed. Such is interpretation in the absence of translation.

I characterized a manual of translation as an inductive definition of a relation between sentences. I think of no comparably crisp characterization of a manual of interpretation, but any actual inter-linguistic dictionary is in fact just that: a manual of interpretation. Similarly indeed for any domestic dictionary.

Though interpretation is broader than translation, the techniques called for do not diverge much. The data for either enterprise are observable behavior in observable circumstances, and the criteria of success in either are smoothness of dialogue and success in negotiation.

Davidson is right in tackling interpretation in general rather than

translation in particular, concerned as he is with semantics, or the theory of linguistic communication. My own thought experiment of radical translation had a narrower purpose: I was challenging the notion of propositions as meanings of sentences. Indeterminacy of translation meant failure of sentence synonymy to qualify as an equivalence relation, hence failure of individuation of propositions; and there is no entity without individuation, without identity.

In Davidson's actual methodology, even so, there is one point on which I have misgivings: his maxim of maximizing truth on the part of the native informant's utterances. I would maximize the psychological plausibility of my attributions of belief to the native, rather than the truth of the beliefs attributed. In the light of some of the natives' outlandish rites and taboos, glaring falsity of some of their utterances is apt to be a psychologically more plausible interpretation than truth. In the absence of such exotic behavior, however, and apart from domains where the natives are presumably unin-formed, the practical working assumption is indeed that they think as we do and hence that most of their utterances should be interpreted as true by our lights.

Truth is central to Davidson's theory of interpretation also in another way: his focus on Tarski's T-sentences as the very vehicles of interpretation. I applauded this move on Davidson's part from its very inception in 1966.[4] It is a neat inversion of Tarski's procedure. Tarski took the interpretation of the sentences for granted, as a basis for defining truth; Davidson takes truth for granted, as a basis for interpreting the sentences.

I do not know whether this strategy can press interpretation beyond the limits of translation, nor how it might accommodate pairs like 'Hesperus' and 'Phosphorus', whose difference is not reflected in reference. At any rate there is also another cardinal idea in Davidson's treatment of interpretation: the complementarity of belief and desire. What is directly observable in behavior is the seamless resultant of the two; but if we contrive to factor out the two components, their interpretation is forthcoming.

I return in conclusion to Tarski and the truth predicate, where some obscure issues await sorting out. Because of their dimness, I shall not try to pinpoint my differences from Davidson here; we surely agree on the tangibles. I shall just set forth my own views.

The keynote of truth is disquotation: 'Snow is white' is true if and only if snow is white. Denotation, or reference, is likewise disquotational: 'rabbit' denotes x if and only if x is a rabbit. The insight is Tarski's, but the word 'disquotation' is of my own making, so far as I know, and I have not meant it disparagingly. The last section of *Word and Object* is devoted to the indispensability of the truth predicate as an instrument of semantic ascent. Far from being trivial, indeed, truth in its disquotationality is like class member-ship in bursting the bonds of naive theory; for it engenders much the same

paradoxes. I have always deplored Ramsey's imperceptive dismissal of the disquotational account as "the disappearance theory of truth". It was a crowning outrage of my primordial bugaboo: the confusion of use and mention. My attitude here is closer to Davidson's than he seems to have thought.[5]

Does disquotation give the essence of truth? I am not sure how to deal with that. Disquotation gives the extension of truth within the home language. Translation is then needed to extend it to other languages.

Truth and denotation are sisters in disquotation, as we saw, and Tarski's truth definition is a definition of the one in terms of the other. Denotation is the relation of a one-place predicate to each thing of which it holds. More generally, it is the relation of an n-place predicate to each ordered n-tuple of which it holds. Generalizing further, we may think of a sentence with n free variables as an n-place predicate; and then that sentence may be said to denote each n-tuple that satisfies it as values of the variables. Tarski's construction, then, defines denotation in this full generality by recursion from *atomic* denotation, that is, denotation by one-word predicates. Truth then falls out as the degenerate case of denotation by 0-place predicates, that is, closed sentences.

And why did Tarski want to define truth on the basis of atomic denotation, rather than, say, vice versa? Simply because, in any specific language, the one-word predicates are finite in number, so that atomic denotation can be defined by exhaustion of specific disquotations.

The disquotational account renders truth vividly transcendent. For, through the liar paradox it shows that the truth predicate for a language cannot be fully expressed in the language. The paradox comes when truth is predicated of sentences which themselves contain the truth predicate or kindred predicates.[6] A second-order truth predicate may still be defined within the language to cover these cases, but it breaks down when applied to sentences containing that predicate. We can proceed thus up a hierarchy of ever better approximations to the disquotationally perfect truth predicate, which itself transcends the hierarchy. The aggressive naturalist just might cite the liar paradox as supporting this naturalism: it shows that the transcendent, in this instance anyway, leads to contradiction.

There is also another consideration, equally familiar, that incontestably gives truth a transcendent status in any likely sense of that redoubtable term. Namely, usage dictates that when in the course of scientific progress some former tenet comes to be superseded and denied, we do not say that it used to be true but became false. The usage is rather that we thought it was true but it never was. Truth is not the product of science, but its goal. It is an ideal of pure reason, in Kant's apt phrase.

Putting names to these two ways of transcendence, we might say that truth

is *semantically* and *doctrinally* transcendent.[7] Semantic transcendence followed inescapably from disquotation itself. Doctrinal transcendence follows from disquotation by less compelling considerations, but compelling enough—notably the law of excluded middle. Thus let '*p*' stand for a sentence to the effect that there were an even number of blades of grass in Boston Common at the inception of 1901. By excluded middle, *p* or not *p*; so, by disquotation, '*p*' is true or 'Not *p*' is true. Yet science in even the broadest sense—informed belief—takes no stand on either '*p*' nor 'Not *p*', and never will.

In a naturalistic spirit, C.S. Peirce tried to warp the doctrinally transcendent concept of truth over into immanence by identifying truth with the limit that scientific progress approaches. This rests on optimistic assumptions, and worse. Neither the '*p*' nor the 'Not *p*' of the example would be approached by scientific progress at the most glorious imaginable extreme. And Peirce was never, to my knowledge, one to question the law of excluded middle.

John Dewey proposed, in the interest of naturalism, simply to avoid the truth predicate and limp along with warranted belief. Otto Neurath in his last years took a similar line. But surely neither Dewey nor Neurath could have denied that the truth predicate is rendered crystal clear by disquotation, and presumably both philosophers subscribed to '*p* or not *p*'. So they did not circumvent the problem; they just did not sense it.

Anyway it is odd that we naturalists should bridle at truth's doctrinal transcendence, for it consists precisely in consigning truth to *nature* rather than to man's faltering approximations. The reason for bridling was that naturalism countenances no higher source of knowledge than enlightened scientific method. Very well, but truth is not knowledge. The concept of truth belongs to the conceptual apparatus of science on a par with the concepts of existence, matter, body, gravitation, number, neutrino, and chipmunk. Like Davidson, I make my peace with truth in its doctrinal transcendence. An ideal of pure reason, yes, and hallowed be its name.*

W. V. QUINE

DEPARTMENT OF PHILOSOPHY
HARVARD UNIVERSITY
JUNE 1993

*This paper is much the richer for comments on earlier drafts by Burton Dreben and Michael Shepanski.

NOTES

1. In "Propositional Objects," a lecture that appeared a year later in my *Ontological Relativity and Other Essays*.

2. *Origin of Species* (London, 1959), pp. 45–46.

3. See my *From Stimulus to Science* (Cambridge: Harvard University Press, 1995), pp. 20–21.

4. Davidson, "Truth and Meaning" (abstract), *Journal of Philosophy* 63, pp. 586–87.

5. Cf. Davidson, "The Structure and Content of Truth," *Journal of Philosophy* 87 (1990), p. 283.

6. Cf. my *Pursuit of Truth* (Cambridge: Harvard University Press, 1990, 1992), § 34.

7. In *Philosophy of Logic* I used 'transcendent' in yet a third and more mundane sense, having to do with syntax. It is irrelevant to issues of naturalism.

REPLY TO W. V. QUINE

Readers of Quine and me are bound to be struck by how deeply we agree, and I hope I have never left those readers in doubt as to the reason: Quine is, and has been since I took my first logic course with him some sixty years ago, my teacher and inspiration. Perhaps the most important thing he taught me was that there can be no more to the communicative content of words than is conveyed by verbal behavior. This seems obvious to many people: "meaning is use", quoth Wittgenstein. The idea *is* obvious, but its full force is still mostly unappreciated or misappropriated. Misappropriated by those who would convert any typical purpose served by uttering a sentence into a kind of meaning. Unappreciated by those who treat Wittgenstein's slogan as gesturing at a way of discovering a meaning already embedded in an expression. What wants emphasizing is not that use points the way to preexisting meanings, but that it creates, and so constitutes, meaning. This helps explain Quine's (and my) concentration on the tableau containing two people (teacher and pupil, jungle linguist and informant, speaker and hearer) in a shared environment, for in this situation it is irrelevant what powers may be lodged in the speaker's utterances in other contexts.

I say this not to denigrate the importance of the wider social applicability of the linguistic feats of accomplished speakers, but to stress the fact that social practice provides no clues to meaning different in kind from those directly given in the simplest cases. Talk of clues is apposite when applied to the jungle linguist worming his way into what he hopes is a going concern. But the radical interpreter, quizzing a sole informant, can count at best on coming to understand just that one speaker. What the learner or linguist or interpreter hears invests those utterances with whatever meaning they can have for him. Nothing else matters until further intercourse corrects or reinforces expectations.

If one holds this clearly in mind, there is every reason to accept, and no reason to reject, Quine's indeterminacy of translation. Since all there is for the translator or interpreter to get right, even given all possible evidence, is what

supervenes on causal interactions among speakers and the events and objects of their world, it is not surprising that there are many ways to capture this complex structure in the home language. So I accept the indeterminacy of *Word and Object*, which particularly affects sentences, and the subsequent extension to names and predicates. The former undermines the notion of invariant meanings, the latter the notion of invariant reference. Neither form of indeterminacy threatens communication.

The extent of indeterminacy is determined by the number of ways a speaker can be interpreted consistent with the available evidence. Conversely, what a speaker means is what is invariant in all correct ways of interpreting him. Here I have always thought it useful to make use of an analogy with measurement. In assigning numbers to keep track of the lengths or weights of objects, we take for granted that there are infinitely many sets of numbers that will do the job. What we want to know is what is invariant (the "facts of the matter"). In the case of weight or length, a uniqueness theorem tells us that if one set of numbers serves to represent the relevant magnitudes, so does any other set obtained by multiplying the numbers in the first set by any positive constant: the numbers are unique up to a linear transformation. The indeterminacy of reference can be specified equally clearly, but other forms of indeterminacy cannot.

I differ with Quine on the extent of indeterminism in two minor ways. The first has to do with logical constants. Quine depends on observed patterns of inference to spot the pure sentential connectives: thus whatever reverses assent and dissent is the mark of negation; whatever connective joins two sentences to produce a sentence held true if and only if each sentence is held true is the mark of conjunction, and so on. For various reasons, this won't work perfectly, but it is good enough for a start, deviations to be sorted out later. Quine holds that quantificational structure is not similarly determined by observable patterns of inference, but it is not clear why. Though the pattern is more complex, as far as I can see there can be the same sort of evidence for reading quantificational structure into an alien language as for reading in sentential logic. Is it possible, as Quine has suggested, to imagine a language built on an entirely different model? I'm not sure how to think about this. Quine says we might see that members of some group, from outer space, perhaps, are fluently conversing, though we could find no way to map our entities onto parts of their sentences. But how would we identify what we were witnessing as conversation? If apparent exchanges led to observable manipulation of objects and events we can identify, we would presumably be able to map those entities onto aspects of the alien's gestures or speech. Failing this, what evidence could count as showing there was communication? It is only quantificational structure, as far as we know, that entails an ontology, so if we cannot read such a structure into the spacepeople's

language, we quite literally do not know what they are talking about, if anything. (See Hopkins's essay in this volume.)

Indeterminacy can also be greatly reduced by replacing simple assent and dissent with degrees of belief. This can be done, roughly, to be sure, but well enough to matter, by appeal to some version of Bayesian decision theory, which extracts subjective probabilities and values from preferential behavior. Subjective probabilities are a help in interpreting observation sentences, where one can anticipate less than certainty when an observer is badly placed, the light is bad, or sense organs are impaired. But it is in interpreting sentences fairly remote from direct observability, those that contain theoretical terms, that degrees of belief will make the most difference. The key to interpreting such sentences, and the words in them, depends on relations of evidential support as evinced by an informant's degree of willingness to accept or volunteer one sentence given his degree of willingness to accept or volunteer another.

Quine has misgivings, he says, about my idea of maximizing truth in interpretation. So do I, and I said as much in the introduction to *Inquiries into Truth and Interpretation*. "Maximizing agreement," I remarked, "is a confused ideal. The aim of interpretation is not agreement but understanding" (Davidson 1984, p. xvii).

Quine is right that an issue that has separated us, or seemed to, is whether to tie a theory of meaning to proximal or distal stimuli. Quine suggests that I was misled by the term 'stimulus meaning' into thinking this located the subject matter of observation sentences at the skin, and perhaps that I longed to restore meanings to my theory. But no, though it is terminology that makes trouble with my phrase 'theory of meaning'; what I have in mind postulates no meanings. I count Quine's account of translation a theory of meaning and as Quine notes, I have argued that a formal theory of truth in the style of Tarski is an alternative. Nor did I think Quine confused patterns of stimulation (or anything else) with the contents of observation sentences; my objection was that homology of patterns of stimulation among observers could lead to wrong translation, and in any case was irrelevant to it. In my view, what makes communication possible is the fact that many of the same objects, events, and aspects of the world are salient for all humankind, frequently eliciting observably similar responses. As Quine now puts it, evolution has geared us to the same external features of the world, though our internal wiring may differ widely. On this point our views have converged.[1]

There is a related matter, however, where there may remain a difference. For many years I have wondered whether Quine's empiricism creates a significant gap between us, or merely marks a matter of emphasis.[2] Quine has characterized empiricism as based on two "cardinal tenets . . . One is that whatever evidence there *is* for science *is* sensory evidence. The other . . . is

that all inculcation of meanings of words must rest ultimately on sensory evidence" (Quine 1969, p. 75). I agree with Quine, and, indeed, learned from him, that the inculcation of meaning depends on the same considerations that knowledge does. The difficulty is in the phrase "sensory evidence". Quine's writings are replete with this phrase and variants: "surface irritations . . . exhaust our clues to an external world" (Quine 1960, p. 22); "The stimulation of his sensory receptors is all the evidence anybody has had to go on, ulti-mately, in arriving at his picture of the world" (Quine 1969, p. 75); " . . . our only source of information about the external world is through the impact of light rays and molecules upon our sensory surfaces" (Quine 1975, p. 68). Clearly, the stimulation of sensory receptors cannot in any literal sense constitute evidence for anything, since it does not have a cognitive content. Quine agrees: " . . . in my theory of evidence the term 'evidence' gets no explication and plays no role" (Quine 1990a, p. 80). How, then, are we to understand his remark, within the same covers: " . . . I remain unswerved in locating stimulation at the neural input, for my interest is epistemological, however naturalized. I am interested in the flow of evidence from the triggering of the senses to the pronouncements of science . . . " (Quine 1990b, p. 3). The location of the stimulus is not, of course, the issue: psychologists define it variously. The issue is what role the proximal stimulus plays in epistemology or in determining the content of observation sentences.

I grant, of course, that perception is essential to empirical knowledge, and that the sense organs play an uneliminable role in perception. What I question is whether this fact is of any more epistemological significance than the role of, say, the light or sound waves that assail the senses, or the neurons whose firings connect eye and ear to brain. What transpires at the skin is part of a causal chain from objects and events perceived to beliefs, but to promote that link in the chain to epistemic significance requires an argument. What is Quine's argument? Here we do well to look at Quine's recent book, *From Stimulus to Science* (Quine 1995). The title makes clear that Quine accepts what I call the dichotomy of scheme and content: the stimuli provide the content, the ultimate "evidence", and science is the scheme. Quine declares that he wants his naturalized epistemology to " . . . address the question how we . . . can have projected our scientific theory . . . from mere impacts of rays and particles on our surfaces" (Quine 1995, p. 16). The question is ap-proached by introducing a notion of *perceptual similarity,* which is intended to serve as the "physical correlate of . . . sensory experience." In other words, this is a recognizable version of empiricism in the tradition of C. I. Lewis and the Carnap of the *Logische Aufbau,* minus, of course, the two dogmas, and it is also a version of the scheme-content dichotomy against which I argued in "On the Very Idea of a Conceptual Scheme" (Davidson 1974).

Perceptual similarity is the foundation of the edifice which, starting from

sensory stimulations, is to become our science, our picture of the world. But how does perceptual similarity relate to the triggering of the senses? Although Quine speaks of "expecting" the firing of neurons (Quine 1995, p. 19), and of "inferring" science from them (Quine 1974), it is clear that one can no more make inferences from them than treat them as evidence. Putting aside, then, any literal use of epistemic words like "evidence", "clues", and "infer", there remains the possibility that what happens at our peripheries is a particularly significant part of the explanation of how we arrive at our theory of the world. It surely is, but mainly, I think, at a stage of science now pretty remote from philosophy. In spite of a heroic effort on Quine's part, there seems to me no interesting way to construct, from patterns of neural firings and behavioral responses, anything like the propositional contents of observation sentences. There is a way, of course, if we follow John Stuart Mill's general idea: physical objects are permanent patterns of sensation. Which patterns? Those that are routinely caused by physical objects.

But can any project of this sort, which starts from elements which are as tied to the individual as sensations, appearances, or sense data, ever yield the contents of observation sentences, or the beliefs such sentences express? Consider the situation that is fundamental in the acquisition of a first language: ostensive learning (which may be intentional on the part of a teacher or parent, or simply a matter of the initiate picking things up from the linguistic environment). In this situation, nothing can be conveyed that is not provided in the context of the triangle consisting of learner, relevant environment, and teacher. But all that teacher and learner *share* is the external world, the "distal" stimuli. The content the learner will pick up, with luck, is that an utterance of "Gavagai" means that a rabbit is in sight. The content is anchored to the shared object, event, or aspect of the world from the start. But if so, the content has an element that is not just accidentally related to the environment. It follows that there is no way an account of content which at no point depends on such a connection with the public world can succeed. Quine's account of the content of observation sentences does depend on such a connection, and that content thereby has an external control; his account of the content of beliefs expressed by such sentences lacks the connection and the control.

By cutting and pasting, I have represented Quine as looking back to what is basically an empiricist epistemology, but looking forward to what amounts to a form of what is now called externalism. Quine does not, I think, regard these views as opposed tendencies, but as features of different projects. I do not see how to reconcile them. Have I fairly described the situation? Quite possibly not, for Quine's views are subtle and original, and I have often in the past missed a vital point.

A final remark about the concept of truth. I have the impression from

Quine's remarks that I should no longer harbor the doubts I have had in the past. Tarski's "disquotational" account of truth works for the "home language", but only by using a concept not expressible in that language. As we know, one can go on raising the ante forever without arriving at a general definition. If there is a concept of truth that transcends one's own language, disquotation doesn't comprehend it. And quite apart from the paradoxes, it is easy to see that disquotation does not exhaust all that we need in order to apply the concept of truth to "our language" as this phrase is ordinarily meant. Disquotation works without a hitch when I apply it to my own sentences, but it is always an empirical question whether I am justified in applying it to someone else in the same straightforward way. My utterance of "Snow is white" is true if and only if snow is white, but does your utterance of the same sentence have the same truth conditions? This is, as Quine says, just the problem of translation or interpretation. Whatever goes into it is directly relevant to the application of the truth predicate in every case where we do not speak for ourselves, but are bent on understanding someone else. If truth has an essence, disquotation certainly does not exhaust it.

Quine judges our differences to be minor. If I seem to make much of them, this is just the sort of contrast in perception one expects between master and acolyte; I define my position by the differences. Seen from any reasonable distance, the gap is small, and I am glad it is.

 D. D.

NOTES

1. In 1988 I wrote (in a paper delivered at a Quine conference in St. Louis, subsequently published [Davidson 1990]):

> What makes communication possible is the sharing, inherited and acquired, of similarity responses. The interpreter's verbal responses class together or identify the same objects and events that the speaker's verbal responses class together. If the interpreter also classes together the verbal responses of the speaker, he can correlate items from two of his own classes: verbal responses of the speaker he finds similar and distal objects and events that he find similar (p. 77).

The notion of similarity responses came from *The Roots of Reference*, and I was urging Quine to exploit the distal orientation which I thought it suggested.

2. The following remarks, and the quotations from Quine, are recapitulated from (Davidson 1990).

REFERENCES

Davidson, Donald. 1974. "On the Very Idea of a Conceptual Scheme." In *Proceedings and Addresses of the American Philosophical Association*.
———. 1984. *Inquiries into Truth and Interpretation*. Oxford: Oxford University Press.
———. 1990. "Meaning, Truth and Evidence." In *Perspectives on Quine*, edited by R. B. Barrett and R. F. Gibson. Oxford: Blackwell.
Quine, W. V. 1960. *Word and Object*. Cambridge, Mass.: M. I. T. Press.
———. 1969. *Ontological Relativity and Other Essays*. New York: Columbia University Press.
———. 1974. *The Roots of Reference*. La Salle, Illinois: Open Court.
———. 1975. "The Nature of Natural Knowledge." In *Mind and Language*, edited by S. Guttenplan. Oxford: Oxford University Press.
———. 1990a. "Comment on Davidson." In *Perspectives on Quine*, edited by R. Barrett and R. Gibson. Oxford: Blackwell.
———. 1990b. "Three Indeterminacies." In *Perspectives on Quine*, edited by R. Barrett and R. Gibson. Oxford: Oxford University Press.
———. 1995. *From Stimulus to Science*. Cambridge, Mass.: Harvard University Press.

2

John McDowell

SCHEME-CONTENT DUALISM AND EMPIRICISM

I

Donald Davidson has credited scheme-content dualism with an important role in setting the agenda of modern philosophy: "To a large extent this picture of mind and its place in nature has defined the problems modern philosophy has thought it had to solve."[1] That means that to deconstruct the dualism, as Davidson has undertaken to do in a number of writings, is potentially to transform philosophy's conception of itself. If we can rid ourselves of the dualism, we shall no longer think we have those problems—which is not the same as taking ourselves to have solved them.

I think Davidson is profoundly right in attaching this kind of significance to scheme-content dualism. But in what follows I want to suggest, with help from his own writings, that his diagnosis of the dualism's hold on modern thinking does not quite go to the roots; and hence that his recipe for a transformation of philosophy is not quite the one we need.

II

What is the dualism of scheme and content? I take it that the parties to the dualism are supposed to determine the significance of, say, bodies of belief or theories. The picture can be encapsulated in the familiar Kantian tag: "Thoughts without content are empty, intuitions without concepts are blind."[2] So "scheme" is, more fully, "conceptual scheme", and "content" is, more explicitly, "intuitions" or sensory intake. The idea is that beliefs or theories are significant, non-empty, because of an interaction between the conceptual

and the sensory. (Perhaps we should say "empirical beliefs or theories"; but it is a central Kantian thesis that this would not be to add anything.)

Now "dualism", as a term of philosophical criticism, implies more than just duality. In a *dualism* of scheme and content, the two putative determinants of significance are initially separated so far from each other that it becomes a problem how they can come together in the interaction that is supposed to yield significance.

Thus, on the scheme side of the dualism concepts are supposed to come into view in abstraction from any connection with the deliverances of the senses. So considered, employments of concepts would indeed be empty, just as the Kantian tag says. If we conceive a subject's employments of "concepts" (so called) in this way, we do not yet have in view anything we could recognize as the embracing of beliefs or theories, the adoption of determinate stands or commitments as to how things are in the world. (We could say "the empirical world", but with the same doubt about whether that would be to add anything.)

Similarly on the content side of the dualism sensory intake is supposed to come into view in abstraction from ("without") concepts. And so considered, sensory intake would indeed be blind, just as the Kantian tag says.

If abstracting it from content leaves a scheme empty, what can be the point of identifying this side of the dualism as *the conceptual*? It is not a routine idea that concepts and their exercises, considered in themselves, are empty, and it is not obvious why it should seem that we can abstract them away from what makes the embracing of beliefs or theories non-empty, but still have concepts and their exercises—what they essentially are—in view.

In the dualism, the relation between scheme and content is evidently a case of the relation between form and matter. So we can put the question like this: why should it seem right to equate the formal with the conceptual, given that we are using the idea of form in such a way that form without matter is empty? We can find an answer to this question in two thoughts. First, that the linkages between concepts that constitute the shape, so to speak, of a conceptual scheme are linkages that pertain to what is a reason for what. Second, that if matter, in this application of the form-matter contrast, is supplied by the deliverances of the senses, then the structure of reason must lie on the other side of the matter-form contrast, and hence must be formal; reason is set over against the senses. No doubt exercises of concepts, as we ordinarily conceive them, are not empty, since they already incorporate content as well as scheme. But if we can see how those two thoughts might be attractive, we can see how it might seem that the conceptual comes into view in a pure form only if we strip content away.

I think the first of those two thoughts, which connects the idea of a

conceptual scheme with the idea of reason, need be no more than a determination of the relevant idea of the conceptual. (By itself, without the second thought, this is innocent of the dualism.) The second thought, in which reason is kept pure of contamination by the mere matter yielded by the deliverances of the senses, is more problematic, and I shall return to it. Meanwhile, perhaps that rephrasing can begin to make it intelligible how the thought could be attractive, and so how one might be induced to take in one's stride the surprising idea that the conceptual, considered in itself, is devoid of empirical content.[3]

<div align="center">III</div>

Why is this dualism of scheme and content a suitable case for deconstruction? There are no doubt several things one could say in response to this question, but I shall focus on one glaring problem.

Considered by themselves, employments of elements of a scheme—exercises of a conceptual repertoire—are empty; they are not yet recognizable as cases of adopting commitments concerning how things are in the world. If we take in only this one side of the dualism, we have not yet entitled ourselves to the idea that employments of concepts are determinately answerable to how things are. We do not yet have the resources to see moves within a scheme as open to favourable assessment if things are a certain way and unfavourable assessment otherwise.

Now the other side of the duality is supposed to supply this missing requirement: to entitle us to the idea that a move within a scheme is determinately answerable to the world, and so intelligible as the adoption of a stand about the world. A move within a scheme is answerable to the deliverances of the senses ("the tribunal of experience", in W. V. Quine's phrase)[4]; that is supposed to supply the missing requirement, because being answerable to the tribunal of experience is being answerable to the facts that impress themselves on the senses.

But the dualism reflects the idea that the linkages recognized by reason are the linkages that constitute the organization of schemes, and it places the deliverances of the senses outside schemes. And that makes it *incoherent* to suppose that sensory intake, on this conception, can mediate answerability to the world. If rational relations hold exclusively between elements of schemes, it cannot be the case that what it is for something within a scheme to be rationally in good shape, and so worthy of credence, is its being related in a certain way to something outside the scheme. "Intuitions without concepts are blind," Kant said. But for present purposes, a more suggestive metaphor for

the point would be that intuitions without concepts are mute. They cannot intelligibly constitute a tribunal, something capable of passing favourable verdicts on some exercises of concepts and unfavourable verdicts on others.

IV

Davidson has identified the dualism of scheme and content as "the third dogma of empiricism," and accordingly he has suggested that when we abandon the dualism, as we must, we are thereby discarding the last vestige of empiricism.[5] By "empiricism" here, he means the thesis that the deliverances of the senses are epistemologically significant: they stand in relations of justification or warrant to world views or theories. He writes:

> Empiricism, like other isms, we can define pretty much as we please, but I take it to involve not only the pallid claim that all knowledge of the world comes through the agency of the senses, but also the conviction that this fact is of prime epistemological significance. The pallid idea merely recognizes the obvious causal role of the senses in mediating between objects and events in the world and our thoughts and talk about them; empiricism locates the ultimate evidence for those thoughts at this intermediate step.[6]

This crediting of epistemological significance to sensory intake is exactly what I have represented the dualism as wanting but, by the way it places intuitions outside the domain of rational linkages, making unavailable.

Suppose we want to give the deliverances of the senses an ultimate evidential role. Are we thereby committed to the dualism, with its conception of the deliverances of the senses as "intuitions without concepts"? If that is so, then empiricism in the non-pallid sense Davidson distinguishes is self-defeating, since the dualism is, and Davidson is right to declare empiricism defunct. I shall come back to this.

V

My sketch of the dualism and my account of why it must be rejected have diverged from what Davidson says about it on a couple of points that I shall mention.

First, where I have identified a scheme as one of two putative determinants of, say, a world view, Davidson (at least sometimes) equates world view and scheme. Quine wrote:[7]

> We can investigate the world, and man as a part of it, and thus find out what cues he could have of what goes on around him. Subtracting his cues from his world

view, we get man's net contribution as the difference. This difference marks the extent of man's conceptual sovereignty—the domain within which he can revise theory while saving the data.

Davidson quotes this, and remarks: "World view and cues, theory and data: these are the scheme and content of which I have been speaking."[8] But on the account of the dualism that I have given, world view or theory would not itself be one side of the dualism, as this remark of Davidson's makes it. World view or theory would be the result of the supposed interaction between the two sides of the dualism. A scheme would be, not a world view, but what is left when content is subtracted from a world view—what Quine speaks of as "man's net contribution" (we might say "reason's net contribution").

By itself this may not seem much of a divergence. All three items that are present in one version—world view, reason's contribution, the contribution of the senses—are equally present in the other. Perhaps it is just a question of taste which pair one picks to figure in what one attacks as a dualism. I find it neater to let the parties to the dualism be the two contributions, rather than one of the contributions on the one side and the supposed result of the two contributions on the other.

If this is indeed a neater fit to the idea of a scheme-content dualism, that may account for some cross-purposes between Davidson and Quine. Davidson first cast Quine as an adherent of scheme-content dualism in "On the Very Idea of a Conceptual Scheme." In a later paper Davidson writes: "What I had in mind as the scheme was language, with its built-in ontology and theory of the world, the content being supplied by the patterned firing of neurons."[9] In a footnote about Quine's "On the Very Idea of a Third Dogma,"[10] he says: "In this reply, Quine mistakenly took my picture of his dualism of scheme and content to involve a separation of conceptual scheme and language."[11] But perhaps Quine was simply understanding the accusation of dualism in the natural way. According to the dualism, as it is most naturally understood, we have something with a "built-in ontology and theory of the world" only *after* content has made its contribution. If conceptual scheme is the other contributor, and language does indeed have a "built-in ontology and theory of the world," then conceptual scheme must be distinguishable from language, as "man's net contribution" is distinguishable from the world view to which it is a contribution.

The second divergence is more immediately striking. The trouble with the dualism as I have depicted it is that it is *incoherent*. The world's impacts on the senses are given the task of making it intelligible that moves within a conceptual scheme, taken to be such that considered in themselves they are empty, can nevertheless be adoptions of stands as to how things are. But there can be so much as an appearance that this works only if we can see the

world's impacts on the senses as a tribunal, something capable of passing verdicts on moves within a scheme. Only so can we conceive an answerability to the world's impacts on the senses as a mediated answerability to the world itself. But when we distance content from scheme, in a way that reflects the idea that rational interrelatedness is confined to elements in schemes, we ensure that we cannot see experience as a tribunal. "Intuitions without concepts" are mute; they can pass no verdicts.

Contrast the problem Davidson most prominently urges about the dualism. When he finds the dualism in Quine, his complaint is not that Quine lapses into incoherence, but rather that Quine makes himself vulnerable to a familiar sort of scepticism. Here is a succinct formulation of the thought:[12]

> Quine's naturalized epistemology, because it is based on the empiricist premise that what we mean and what we think is conceptually (and not merely causally) founded on the testimony of the senses, is open to standard sceptical attack.

This remark blames empiricism for the vulnerability to scepticism that Davidson finds in Quine, but given Davidson's identification of scheme-content dualism as "the third dogma of empiricism," that comes to the same as blaming the dualism for it.

On the reading of the dualism that I have offered, this is a curiously muted objection. (I do not mean to be suggesting that vulnerability to standard scepticism is a comfortable condition.) This objection would fit if an epistemology organized in the terms of the dualism made it intelligible that the senses tell us *something*—with the trouble being that it represents them as not telling us *enough* to warrant our world view. But on my reading, the trouble with the dualism is rather this: the very idea that the senses provide testimony becomes unintelligible. "Intuitions without concepts" are mute. If one nevertheless cannot see how anything but answerability to intuitions could ensure that thoughts are not empty, one's predicament is more unnerving than any standard scepticism. Standard scepticism takes for granted that we have a world view, and merely questions whether we are entitled to it. The dualism, on my reading, generates a much more radical anxiety about whether we are in touch with reality. Within the dualism, it becomes unintelligible that we have a world view at all.

My claim that the dualism is incoherent depends on the thought that the domain of rational interrelatedness is coextensive with the domain of the conceptual. Suppose one wants to conceive the impacts of the world on us as "intuitions without concepts," but nevertheless wants those impacts to constitute a tribunal that world views must face. One will then be under pressure to avoid the threat of incoherence by denying that the domain of rational interrelatedness is coextensive with the domain of the conceptual.[13] But the thesis of coextensiveness is a way of putting a fundamental conviction

of Davidson's. (He is giving expression to it when he claims that "nothing can be a reason for holding a belief except another belief".)[14] The materials for the claim of incoherence come directly from Davidson himself.

VI

If Davidson is right, as I believe, in claiming that the dualism has set much of the agenda for modern philosophy, something deep must account for its attraction. What might that be?

Davidson answers this question in a way that belongs with the curiously muted objection. Summarizing a survey of the dualism, he writes: "What matters, then, is . . . that there should be an ultimate source of evidence whose character can be wholly specified without reference to what it is evidence for." He goes on:

> It is easy to remember what prompts this view: it is thought necessary to insulate the ultimate sources of evidence from the outside world in order to guarantee the authority of evidence for the subject. Since we cannot be certain what the world outside the mind is like, the subjective can keep its virtue—its chastity, its certainty for us—only by being protected from contamination by the world. The familiar trouble is, of course, that the disconnection creates a gap no reasoning or construction can possibly bridge.[15]

Now I would not dream of disputing that Davidson here captures a motivation that is familiar in modern philosophy, and reminds us of how the motivation defeats itself. But do these remarks adequately account for the grip of scheme-content dualism?

This question becomes especially pressing when we note that the survey of scheme-content dualism to which these remarks are appended culminates in Davidson's citing Quine as an adherent. This is not the first time I have mentioned this Davidsonian reading of Quine. I do not want to question it; on the contrary, I think it is very perceptive. But surely Quine does not belong in the context of the temptation that these diagnostic remarks of Davidson's appeal to: the admittedly familiar temptation to "interiorize", or "subjectivize", the ultimate evidence for world views, so that whatever the fate of the world views, at least the ultimate evidence is (supposedly) proof against sceptical challenge. A page further on, Davidson writes, summarizing the thought about trying to guarantee the authority of ultimate evidence:

> Instead of saying it is the scheme-content dichotomy that has dominated and defined the problems of modern philosophy, then, one could as well say it is how the dualism of the objective and the subjective has been conceived. For these dualisms have a common origin: a concept of the mind with its private states and objects.

Surely this concern with privacy or subjectivity does not fit Quine. When Quine espouses his version of scheme-content dualism, his concern is to stress the freedom of play that our "cues" leave us when we build or remodel a world view. What Quine wants to bring out is "the extent of man's conceptual sovereignty". There is nothing in Quine's thinking that would lead him to hanker after a peculiarly solid authority for beliefs corresponding to the "cues", an authority supposedly achievable by insulating the subject matter of those beliefs from the external world. On the contrary, Quine is unmoved by the familiar epistemological anxiety to which that move is an intelligible, though, as Davidson rightly points out, unsuccessful response.

Davidson's suggested source for scheme-content dualism is bound to be unsatisfying if one focuses on the fact that the dualism is incoherent, in the way it tries to conceive experience as a tribunal while distancing it from the domain of rational interrelatedness. If we follow Davidson's suggestion that the dualism responds to an anxiety about our *entitlement* to our world view, the sort of worry that might seem to be met by securing a solid authority for some supposedly basic evidence on which the world view is founded, then it becomes mysterious why that should have as its outcome a way of thinking in which the putative ultimate warrants for world views are pushed out of the domain of rational interrelatedness altogether—a move that in fact makes them incapable of intelligibly constituting warrants at all. This would be a much more radical case of a motivation's defeating itself than the one Davidson considers. In the case Davidson considers, the case of ordinary empiricism, we trade informational strength for immunity to sceptical challenge, and so secure the authority of the evidence only at the price of a vividly obvious gap between it and what it was supposed to be evidence for. The dualism is worse; it undermines the capacity of the supposed evidence to be seen as evidence at all, weak or strong.

Of course if the dualism of scheme and content is incoherent, it will fail to satisfy any motivation that is operative in embracing it. I am not suggesting we should look for a motivation that the dualism would satisfy, as it does not satisfy the one that Davidson offers. The point is that a quest for epistemic security cannot explain why one might be led beyond the mere failure of ordinary empiricistic epistemologies—in which the senses yield items of the right kind to be evidence, and the problem is just that the evidence falls short of warranting an ordinary world view ordinarily understood—into the incoherence of scheme-content dualism, in which the deliverances of the senses are simultaneously required to constitute a tribunal and rendered mute. To explain how this incoherence could stay hidden, and how the incoherent way of thinking could seem compulsory, we need something deeper than the motivation that Davidson considers.

VII

In order to understand scheme-content dualism, I think we need to forget, for a while at least, that familiar anxiety about whether we are sufficiently entitled to our world view. If we allow ourselves to feel that anxiety, we simply presuppose that we have a world view. But part of what underlies the dualism is something that lets that presupposition come into question. The felt need to conceive experience as a tribunal derives, not from what Davidson focuses on, a concern to give our possession of a world view—which we simply assume—a secure warrant, but from an interest in the conditions of its being intelligible that we have a world view (or theories, or beliefs) at all. How is it that some moves we can make, moves we should like to think of as exploitings of concepts, are takings of stands as to how things are in the world? This is intelligible only if we can see the moves as answerable, for their rational acceptability, ultimately to the facts themselves. And part of what underlies the dualism is the thought that this required answerability to the world can be realized only as an answerability to the way the world puts its mark on us; that is, an answerability to the deliverances of our senses.

Once the question "How is it possible that there are world views at all?" is in view, this thought is not easy to dismiss. Consider the thesis that responsiveness to reason is part of the content of the idea of exploiting conceptual capacities. I suggested that we can take that thesis simply to define a useful notion of conceptual capacities. Now it is a Kantian idea that responsiveness to reason is a kind of freedom. (The note of freedom sounds in Quine's talk of "the extent of man's conceptual sovereignty.") We cannot gloss this freedom in terms of an unlimited absence of constraint; exactly not, since it consists in undertaking one's moves in allegiance to—if you like—restrictions, constituted by what is a reason for what. But if these restrictions are conceived as wholly formal, in that responsiveness to reason does not extend as far as answerability to impacts the world makes on us, then it becomes a live question how, in exercising such a freedom, we could be adopting commitments as to how things are in the world. If "man's conceptual sovereignty" has no limits set by the facts themselves, it becomes unrecogniz-able as what it is meant to be, the power to make up our minds *about how things are*. And it is open to question whether we enable ourselves to see "man's conceptual sovereignty" as constrained in the right way if—like Davidson when he rejects empiricism—we say that impacts from the world exert a *causal* influence on how the sovereign power is exercised, but deny that they set *rational* constraints. If we say that, we preclude ourselves from pointing to rational answerability to the world's impacts on our senses as the way in which employments of concepts are ultimately rationally answerable

to the world itself, and then it becomes mysterious how these exploitations of freedom can be otherwise than empty, just as "thoughts without content" are in the Kantian tag.

It does not help to say that impacts from the world cause beliefs, which can then serve as a tribunal for world views to face. These beliefs would be just more elements of world views. The question we have allowed to arise is how there can be anything of that kind, if not because some things of that kind are answerable to a tribunal constituted by experience, and it is unresponsive to help ourselves to some things of that kind. The causal ancestry we cite for the ones we help ourselves to makes no difference to this.

That is to say that empiricism, even in Davidson's non-pallid sense, is not easy to dismiss. This is perfectly consistent with accepting his insistence that an ordinary empiricism, which "interiorizes" the supposed warrants for world views in order to make the warrants safe from sceptical challenge, yields a quite unsatisfying picture of our entitlement to our beliefs. Empiricism is separable from that "interiorizing" move, and the obsession with epistemic security that directly motivates it. We can concur with Davidson in rejecting that kind of epistemology, without threat to this thought: empiricism, in the non-pallid sense, captures a condition for it to be intelligible that thoughts are otherwise than empty.

Scheme-content dualism is incoherent, because it combines the conviction that world views are rationally answerable to experience—the core thesis of empiricism—with a conception of experience that makes it incapable of passing verdicts, because it removes the deliverances of the senses from the domain of the conceptual. According to the dualism, experience both must and cannot serve as a tribunal. Davidson's treatment of the dualism would resolve this contradiction by rejecting its first limb, its basic empiricism. But I am suggesting that this basic empiricism is not easy to dismiss. What holds it in place is not the concern with entitlement that Davidson discusses, but a concern with the very idea of content, which he seems not to consider as a motivation for it.

Here we can perhaps find a deeper significance in the first of the two divergences I noted between my reading of the dualism and Davidson's. The divergence was that in Davidson's reading what stands over against sensory intake in the dualism is already a world view; not, as in my reading, what Quine calls "man's net contribution." If the other party to the dualism is already a world view, before it comes into relation with sensory intake, then it cannot owe its being a world view (at all) to an interaction with sensory intake—not even according to the dualism, on this Davidsonian identification of its elements. The idea that the deliverances of the senses might matter for securing non-emptiness thus goes missing, in this reading of the dualism; they are left with no apparent role except the one Davidson considers, that of

putatively supplying warrants for world views, taken to be anyway and independently constituted as such. So perhaps the divergence is not just a matter of taste about how best to organize the triad of world view, reason's contribution, and sensory intake. Davidson's identification of scheme with world view belongs with the fact that his discussion of the dualism addresses only the epistemological unsatisfyingness of ordinary empiricisms (which of course I acknowledge), and never considers empiricism as a way of not being beset with a mystery over the fact that there are world views at all.[16]

I remarked that Quine is immune to the sort of anxiety that tends to issue in "interiorizing" the warrants for world views, so as to make them safe from sceptical challenge. It would be in the spirit of Davidson's remarks about that sort of epistemology to say that this immunity is desirable, since nothing but bad philosophy results from letting oneself feel the anxiety. What I am saying now is that Davidson is immune to any anxiety about how it is possible that there are world views at all. Is that not similarly a good way to be? Well, certainly I am not suggesting we should take ourselves to have the option of deciding that it is *not* possible that there are world views, any more than we should take ourselves to have the option of deciding that we know nothing about the external world. There is no real question whether world views are possible. But that leaves it open that entitlement to this absence of worry may depend on accepting the core thesis of empiricism. If that is so, then someone who rejects empiricism, like Davidson, thereby deprives himself of the right to his immunity to anxiety over the non-emptiness of thoughts. In this context, the immunity is not a philosophically desirable condition.

VIII

In Davidson's treatment, the diagnostic question that the dualism raises is this: why is it tempting to suppose that the deliverances of the senses would have to constitute a tribunal for our world views to face? Davidson suggests an answer in terms of the craving for epistemic security. I have been urging that that answer is unsatisfying, because it falls short of accounting for the temptation to fall into the dualism's incoherence, as opposed to the mere failure of ordinary empiricistic epistemologies. An empiricism with the different motivation I have pointed to cannot be dismissed on the grounds of vulnerability to standard scepticism. Perhaps there is nothing wrong with such an empiricism. In that case the diagnostic question that the dualism raises is rather this: why is it difficult to see how the deliverances of the senses could constitute a tribunal for our world views to face? Why is it tempting to suppose that the world's impacts on us would have to be "intuitions without concepts?"

With the intellectual development that we can sum up as the rise of modern science, there became available a newly sharp conception of the proper goal of the natural sciences, as we can (significantly) call them: namely, an understanding of phenomena as interrelated perhaps causally, but certainly (this becomes a tempting gloss on what it is to see phenomena as causally interrelated) within a framework of laws of nature. This supersedes a pre-modern outlook, which did not sharply differentiate a natural-scientific mode of understanding from one that places its objects in rational relations with one another, and so works with categories like meaning. In this pre-modern outlook, it was sensible to look for meaning in phenomena like the movement of the planets—phenomena that we are equipped, with modernity's conception of a special mode of understanding, the natural-scientific, to see as appropriately brought within its scope, and so as exactly not something to look for meaning in. In step with the emergence into clarity of this idea of a special mode of understanding, to be radically contrasted with finding meaning in things, it is only to be expected that there was an increasing sense of how special—by comparison with the framework of natural law—are the patterns or structures within which things are placed when they are understood in the contrasting way: how special are the linkages that constitute the domain of rational interrelatedness.

Now the idea of the world making its impact on a sentient being is the idea of a causal transaction, an instance of a kind of thing that takes place in nature. And that differentiation of modes of understanding can easily make it seem that once we conceive a happening in those terms, we are already thereby conceiving it in a way that is distanced from placement in the domain of rational interrelatedness. Succumbing to that appearance, we might say something on these lines: "The idea of the world's impacts on us is the idea of something natural. And we moderns now see clearly how the structure of rational linkages contrasts with the structure of the natural, the topic of natural-scientific understanding. Hence, given that the domain of the conceptual is the domain of rational interrelatedness, it must be that intuitions as such are without concepts."

That suggests how a familiar feature of modern thinking might explain the idea that the sensory stands opposed to the conceptual, as it does for Davidson as well as in the dualism of scheme and content. And it is not that this line of thought uncovers a mistake in the idea that I have suggested underlies the empiricism that figures, inconsistently with the conclusion of this line of thought, in the dualism: the idea that thought can be intelligibly non-empty only by virtue of answerability to experience. There are two independently tempting thoughts here: a thought about the conditions for it to be intelligible that we have world views, suggesting that experience must constitute a tribunal, and a thought about the naturalness of the idea of an impact on the

senses, suggesting that experience cannot constitute a tribunal. If we can see how these two influences might both shape reflection, we have an explanation of how one might be tempted into the incoherence of scheme-content dualism.

I have suggested that there is no obvious way to avoid the idea that empiricism captures a condition for thought not to be empty. (Davidson does not even consider that recommendation for empiricism.) Of course it cannot be obligatory to think incoherently. So if empiricism is compulsory, there must be a flaw in the line of thought I have just rehearsed, the one that makes it look as if intuitions as such are "without concepts".

It is indeed an achievement of modernity to have brought into clear focus the contrast between two modes of understanding: one that involves placing phenomena in the framework of natural law, and one that involves placing things in the domain of rational interconnectedness. But to give proper credit to that achievement, we do not need to accept that when we see something as a happening in nature—as the world's making its mark on a sentient creature would indeed be—we are *eo ipso* placing it in the sort of frame that is characteristic of the natural sciences. If that were so, then, given the contrast, the fact that something is a happening in nature would be a ground for supposing that—at least in itself, viewed as the happening in nature it is—it is "without concepts". But it is not so. We need not accept what might seem to be implied by the label "natural sciences", that phenomena are conceived in terms of their place in nature only when they are conceived in terms of their place in the framework of natural law. If we reject that, we make room for supposing that the world's impacts on us, even considered in themselves as just that, the world's impacts on us, are not "without concepts". That would allow the tension within scheme-content dualism to be resolved in the opposite direction to the one Davidson suggests: in the direction of a coherent empiricism.[17]

IX

What Davidson considers under the head of scheme-content dualism is an attempt to achieve security against sceptical challenge for evidence on which world views are putatively founded. This leads to a shrinkage in the informational content of the putative evidence. I have contrasted this with the more radical failure that, exploiting argumentative materials supplied by Davidson himself, I find in the dualism: namely that it disqualifies what it requires us to conceive as a tribunal from being a tribunal at all. Now I have acknowledged that the quest for epistemic security that Davidson focuses on is fundamental to modern epistemology. I have also said that I think Davidson is profoundly right in placing scheme-content dualism at the root of what is unsatisfactory

about modern philosophy. How can this hang together? How can what is in fact a disqualification of putative evidence from being evidence at all—with the upshot that, in the context of an empiricism that I suggested is hard to dismiss, our very possession of a world view becomes a mystery—be at the root of a philosophical tradition that is, as I acknowledge, driven by an obsession with the authority of our evidence for our world views, and takes it for granted that we have a world view and evidence for it?

No doubt the full story of why modern epistemology takes the course it does is complex, but I think this part of it can be told quite simply. The dualism is the outcome of a pair of independently intelligible temptations. It is intelligible that reflection should be shaped both by the genuine credentials of empiricism (which are not undermined by Davidson, since he considers empiricism only in the context of the quest for security, not in the context of the very idea of a world view), and by the conception of nature that I have depicted as underlying the idea that the world's impacts on us are "intuitions without concepts". Now consider someone who is susceptible to both those influences. Such a person is thereby *en route*, as it were, to a frame of mind in which it is a mystery how thought bears on the world at all. The outcome of the first influence sets a requirement for thought to bear on the world; the outcome of the second is that the requirement cannot be met. But it is not to be expected that the destination would be obvious at all stages in the journey; especially not if the reflection is undertaken early in the evolution of the conception of nature whose finished product, in this context, is the idea that experiences are "intuitions without concepts". (That the destination is not obvious is surely a condition of continuing to let oneself be subject to both influences.) At a primitive stage in such reflection, a sense of where it is headed need not take any clearer shape than something to this effect: thought's hold on the world is coming into question. And a disquiet that can be expressed like that is just what is responded to—ineptly given this account of its origin, but not at all surprisingly—by the sort of philosophy that is obsessed with the authority of our warrant for our world views; the sort of philosophy on which Davidson focuses, without this conception of what underlies it.

It is a familiar thought—I have concurred with Davidson in a form of it—that philosophy in this vein does not succeed in its own explicit aim, that of reassuring us as to our epistemic security in our world views. I am suggesting another respect in which this sort of philosophy is unsatisfying. It does not even correctly identify the drift of the submerged philosophical anxiety by which it is driven.

Scheme-content dualism figures in this picture as the conclusion to which a pair of influences that shape traditional epistemological reflection would take one if their tendencies achieved explicit formulation together. There is no

need to look for outright adherents of the dualism among proponents of the sort of traditional epistemology that Davidson rightly deplores.

We come perhaps as close as possible to an outright adherent of the dualism in Quine, and he is certainly not a proponent of traditional epistemology. He is not vulnerable to the disquiet about thought's hold on the world that I have suggested underlies the anxieties of traditional epistemology, and is ineptly responded to by its characteristic moves. (I exploited that fact when I pointed to a tension between Davidson's account of the source of scheme-content dualism and his reading of Quine as an adherent of it.) The pull of empiricism on Quine (in Davidson's interesting, non-pallid, sense of "empiricism") is almost vanishingly small. It is reflected only in his rhetoric about "the tribunal of experience", and that is out of line with the dominant feature of Quine's epistemological thinking: namely, a naturalism that cheerfully casts experience as "intuitions without concepts", and rejects questions about the warrant for world views altogether, in favour of questions about their causation. It is tempting to resolve this tension by discounting the empiricist rhetoric. In one way that would do Quine a favour, just by eliminating the tension; but if I am right about the credentials of empiricism, in another way it would not, since it would involve expunging the vestigial expression of a real philosophical insight.[18]

X

I suggested that with the modern achievement of clarity about a distinctive sort of understanding—now available to be cited as the defining aim of a distinctive intellectual endeavour, the natural sciences—there comes an appreciation of how special, by comparison, is the sort of understanding that involves placing things in rational relations to one another. The sense of specialness is expressed in a genre of philosophical questions that we can sum up, exploiting the connection between reason and freedom, like this: how is freedom related to the natural world? This wording points to familiar questions about action and responsibility as paradigms of the sort of thing I mean. But the problems posed by the tendency towards a dualism of scheme and content belong in this genre of philosophy too. Underlying the dualism of scheme and content is a dualism of freedom—the freedom of reason—and nature.

In "Mental Events"[19] and kindred writings, Davidson has undertaken to defuse philosophical anxieties of this genre, anxieties about integrating freedom into the natural world. He endorses the sense of specialness: he puts forward on his own behalf a quasi-Kantian picture of, as we might say, the realm of freedom, according to which it is organized by a "constitutive ideal

of rationality", wholly distinct from the organizing structure of the world as viewed by the natural sciences. But he aims to prevent this sense of specialness from generating metaphysical anxiety, by arguing that the distinction between freedom and nature reflects a duality of conceptual apparatuses and not a duality of ontological realms.[20]

Now I have cast the dualism of scheme and content as crystallizing a cognate philosophical anxiety: the question "How are world views possible?" is a form of the question "How is freedom possible?" But here Davidson's way with other forms of the anxiety does not help. Davidson's invocation of a duality that is conceptual, and not ontological, does not undermine the thought that the world's impacts on us are "intuitions without concepts". That is a thought that Davidson accepts. And it is a thought that, I have claimed, leaves the freedom of "conceptual sovereignty" a mystery.

Davidson misses this, because he misidentifies the incipient philosophical anxiety that is crystallized in scheme-content dualism; he takes it to be a concern about entitlement to world views, and he does not see that the familiar anxiety about freedom, applied in this context, takes shape fully only as a concern about how it is possible that exercises of "conceptual sovereignty" are world views at all. This concern rests in part on a recommendation for empiricism that does not come into view in Davidson's thinking at all. If we are to defuse the anxiety while respecting this quite different attraction for empiricism, something that Davidson does not give us reason not to want to do, we need to find a way to resist the idea that the impacts of the world on our senses are "intuitions without concepts". And for that we need a more radical counter to the underlying dualism of reason and nature than the one that Davidson supplies. On this view, the sources of what is unsatisfactory about modern philosophy include something that lies deeper than the interiorizing conception of subjectivity pointed to by Davidson. A more fundamental source is a misconception of the intellectual obligations of naturalism, to which Davidson himself—in his willingness to accept that the deliverances of the senses are "intuitions without concepts"—seems to be subject.

JOHN McDOWELL

DEPARTMENT OF PHILOSOPHY
UNIVERSITY OF PITTSBURGH
DECEMBER 1996

NOTES

1. "The Myth of the Subjective", in Michael Krausz, ed., *Relativism: Interpretation and Confrontation* (Notre Dame: Notre Dame University Press, 1989), pp. 159–72, at p. 161.

2. *Critique of Pure Reason*, translated by Norman Kemp Smith (London: Macmillan, 1929), A51/B75.

3. It would miss the point to protest that the connection of reason with form limits rational connections to those that would be exploited in inferences whose excellence is owed to their *logical* form. That is not the application of the concept of form that is in play here.

4. W. V. Quine, "Two Dogmas of Empiricism", in *From a Logical Point of View* (Cambridge, Mass.: Harvard University Press, 1961), pp. 20–46, at p. 41.

5. "On the Very Idea of a Conceptual Scheme", reprinted in *Inquiries into Truth and Interpretation* (Oxford: Clarendon Press, 1984), pp. 183–98. (The allusion is, of course, to Quine's "Two Dogmas".)

6. "Meaning, Truth and Evidence", in Robert B. Barrett and Roger F. Gibson, eds., *Perspectives on Quine* (Oxford: Basil Blackwell, 1990), pp. 68–79. (I quote from the beginning of the paper, and Davidson says "This characterization will undergo modification in what follows"; but the modification does not matter for my purposes.)

7. *Word and Object* (M.I.T. Press, 1960), p. 5.

8. "The Myth of the Subjective", p. 162.

9. "Meaning, Truth and Evidence", p. 69.

10. In Quine's *Theories and Things* (Cambridge, Mass.: Harvard University Press, 1981), pp. 38–42.

11. "Meaning, Truth and Evidence", p. 78.

12. From p. 136 of "Afterthoughts, 1987" (a postscript to "A Coherence Theory of Truth and Knowledge"), in Alan Malachowski, ed., *Reading Rorty* (Oxford: Basil Blackwell, 1990), pp. 134–37.

13. Note that one is not already committed to the thesis of coextensiveness if one accepts the stipulation about how to understand the idea of the conceptual that I considered above. That involved no more than that conceptual linkages are included in rational connections, and left open the possibility that the inclusion is proper.

14. "A Coherence Theory of Truth and Knowledge", in Ernest LePore, ed., *Truth and Interpretation: Perspectives on the Philosophy of Donald Davidson* (Oxford: Basil Blackwell, 1986), pp. 307–19, at p. 310.

15. "The Myth of the Subjective", p. 162.

16. This absence is quite strange, in view of the fact that "content," in Davidson's label for the dualism that he discusses, is plainly an echo of the Kantian tag. The Kantian tag surely gives content the role of securing the non-emptiness of thoughts; not that of supplying a warrant for accepting them.

17. I do not mean this lightning sketch to suggest that this resolution of the tension is easy. I discuss these issues slightly less breathlessly (to echo Davidson, "The Myth of the Subjective", p. 162) in *Mind and World* (Cambridge, Mass.: Harvard University Press, 1994).

18. In "Epistemology Externalized", *Dialectica* 45 (1991), pp. 191–202, Davidson claims that "Quine's naturalized epistemology, while it makes no serious attempt to answer the skeptic, is recognizably a fairly conventional form of empiricism" (pp. 192–93). But the vestigial empiricism in Quine is very far from conventional, just because its motivation has nothing to do with responding to ordinary sceptical challenges. And the empiricism is not an aspect of the naturalized epistemology; it is a trace of an insight that cannot genuinely find a home in the environment of Quine's naturalism, which removes experience from the category of warrant altogether.

19. Reprinted in *Essays on Actions and Events* (Oxford: Clarendon Press, 1980), pp. 207–25.

20. Just because it involves endorsing the sense of specialness, this is a much more promising programme for disarming the philosophical anxiety that the sense of specialness risks generating than that of Richard Rorty, at least in *Philosophy and the Mirror of Nature* (Princeton University Press, 1979). There Rorty pooh-poohed the sense of specialness, in debunking the idea of a philosophically significant contrast between the *Naturwissenschaften* and the *Geisteswissenschaften*.

REPLY TO JOHN MCDOWELL

I first attacked what I called the dualism of scheme and content in "On the Very Idea of a Conceptual Scheme" (1974). My target was the idea that on the one hand we have our world picture, consisting of the totality of our beliefs, and on the other hand we have an unconceptualized empirical input which provides the evidence for and content of our empirical beliefs. I urged that this dualism of scheme and content, "of organizing system and something waiting to be organized, cannot be made intelligible and defensible." I thought that if this dogma were abandoned, there would be nothing worth calling empiricism left. I included Quine in my strictures, quoting "Two Dogmas of Empiricism": "The totality of our so-called knowledge or beliefs . . . is a man-made fabric which impinges on experience only along the edges." Later, I tried to show that the epistemology of *Word and Object*, though it eschewed a subjective reading of "experience", still treated the unconceptualized input as the ultimate source of evidence (Davidson 1990). I was clear from the start that unconceptualized "experience", sense data, sensations, Hume's impressions and ideas, could not coherently serve as evidence for beliefs: only something with propositional content could do this. I stressed the point in "A Coherence Theory of Truth and Knowledge" (Davidson 1983). I also thought then, and think now, that empiricism as I understood it leads inevitably to skepticism.

I had, then, two objections to trying to base empirical knowledge on non-propositional "experience": first, that it couldn't be done, though many attempts had been made, and second, that if knowledge depended on something intermediate between its supposed object in the world and belief, skepticism was inevitable. This was ironic, of course, since one motive in turning to such "evidence" as sense data was the fact that, not being propositional in character, no doubts about them could be raised.

My view is that particular empirical beliefs are supported by other beliefs, some of them perceptual and some not. Perceptual beliefs are caused by features of the environment, but nothing in their causality (except in special,

derivative cases) provides a reason for such beliefs. Nevertheless, many basic perceptual beliefs are true, and the explanation of this fact shows why we are justified in believing them. We know many things where our only reasons for believing them are further beliefs.

John McDowell thinks this thesis leaves our beliefs without rational support or content. He is half right: I claim our perceptual beliefs require no more in the way of rational support than coherence with their fellows. But only half right, since I think I do have an account of how many of our perceptual beliefs come to have the contents they do, and I think this account also explains why we are justified in accepting them. Where does he think I go wrong? McDowell suggests that perhaps I am seduced by the fact that our sensations and experiences are caused by the environment into thinking that therefore we must treat this happening as outside "the domain of rational interrelatedness", since causality belongs to a way of thinking that deals with nature as dominated by laws, and treats phenomena as mindless. Nothing could be further from my views. I have from almost my first published essay ("Actions, Reason and Causes") emphasized the essential and uneliminable way causality is built into mental concepts and explanations. Perception, memory, and intentional action are all cases where events described in mental terms and events described in physical terms interact, and any account of reasoning must depend on the fact that some beliefs cause others.

Nor is McDowell right in thinking I do not want, as he does, to "give the deliverances of the senses an ultimate evidential role." What the senses "deliver" (i.e., cause) in perception is perceptual beliefs, and these do have an ultimate evidential role. If this is what it takes to be an empiricist, I'm an empiricist. An empiricist, however, in the "pallid" sense, since I postulate no epistemic intermediaries between reality and perceptual beliefs about reality.

McDowell also worries that if, as I claim, our perceptual beliefs are just caused by what they are about, then we lose the "freedom" to make up our minds about how things are. But no, the beliefs that are delivered by the senses are always open to revision, in the light of further perceptual experience, in the light of what we remember, in the light of our general knowledge of how the world works. There must be "friction" between the world and our thoughts if our thoughts are to have any content at all, and I find this friction right here, in the external causes of our perceptual beliefs. (I take the word "friction", used in this sense, from McDowell's splendid *Mind and World* (McDowell 1994).)

Where McDowell and I differ is not, as far as I can tell, in any difference in the importance we put on the incoherence of attempts to discover reasons or evidence in nonpropositional states, or how the general relations between our mental and physical vocabularies should be conceived, or the need to give an account of the content of our empirical concepts. The difference concerns

how this account should go. My account depends on a fairly detailed story of how the relevant cause, the cause that determines the content of a perceptual belief, is determined. This is done in interactions among two (or more) people and a shared environment. No amount of such interaction could generate propositional attitudes without the simultaneous development of communication, and the emergence of general ideas about what objects and their properties and changes are like. Central to my account of empirical content is the process of triangulation, which narrows down the relevant distal causes of perceptual beliefs, and makes possible grasp of the concept of objectivity. The type of cause repeatedly singled out as the cause of assent to a given perceptual sentence then constitutes the content of that sentence and of the belief that sentence can be used to express. Ostensive learning is a prime example of this process.

How does McDowell's account differ? It is not altogether clear what the answer is. I assume, perhaps wrongly, that he does not believe that intensional properties are realized in the world except in thinking creatures. If so, it does not make sense to characterize aspects of inanimate nature as harboring thoughts: what takes place in thinking creatures must, with the exception of the speech of others, be caused by events not intelligibly described as realized propositional entities. McDowell talks of our "taking in" facts, but it is entirely mysterious what this means unless it means that the way the world is causes us to entertain thoughts. This is the point at which our disagreement, at least as I understand it, emerges. McDowell holds that what is caused is not a belief, but a propositional attitude for which we have no word. We then decide whether or not to transform this neutral attitude into a belief.

If this is a fair way of describing the difference between my account of perceptual beliefs and McDowell's, then the difference is not as striking as he makes it seem. But it is hard to evaluate the difference, since he gives no explanation of why features of the world cause the particular propositional attitude they do, nor of why an attitude which has no subjective probability whatever can provide a reason for a positive belief. He also seems committed to epistemic intermediaries, the propositional contents we "take in", between the world and our opinions about the world.

D. D.

REFERENCES

Davidson, Donald. 1983. "A Coherence Theory of Truth and Knowledge." In *Kant oder Hegel*, edited by D. Henrich. Stuttgart: Klett-Cotta.

————. 1990. "Meaning, Truth and Evidence." In *Perspectives on Quine*, edited by R. B. Barrett and R. F. Gibson. Oxford: Blackwell.
McDowell, John. 1994. *Mind and World*. Cambridge, Mass.: Harvard University Press.

3

J. J. C. Smart

CORRESPONDENCE, COHERENCE, AND REALISM

In his recent paper "The Structure and Content of Truth"[1] Donald Davidson says that the only content that he can now find in talk of "realism" is rejection of the idea that truth is in some way epistemic, as in Dummett's anti-realism.[2] I agree with Davidson in the rejection of such anti-realisms and his desire to keep the theory of truth separate from the theory of knowledge.[3] Davidson talks in a footnote of "giving up" on realism, and praises Arthur Fine's "Natural Ontological Attitude."[4] Actually the issue here is orthogonal to that of the anti-realism of Dummett and of metaphysical realism as criticized by Putnam.[5] For example Putnam is an (internal) realist about the "theoretical entities" of physics, despite his rather Kantian metaphysics about truth, while someone who defends realism in the theory of truth might consistently be an instrumentalist about scientific theories. (I want to be a realist in both of these orthogonal directions.) Fine's natural ontological attitude is just to accept as real whatever entities scientists say (pro tem.) exist. I find this a fence-sitting attitude, in unstable equilibrium. An extreme Kuhnian (perhaps not Kuhn himself) who thinks that all our theoretical beliefs will one day be overturned will fall off the fence in one direction, espousing instrumentalist or other anti-realist accounts of science. If, like me, one is of the opinion that most of our scientific beliefs will never be overturned (though they may need qualifying as "approximate" or as restricted in scope) then one will fall off the fence in a realist direction. If Davidson were to follow me along this axis it would not affect the question of whether he rejects realism along the other axis.

I agree with Davidson's rejection of "correspondence" if this notion means that there are things (facts) to which beliefs or sentences correspond. However this by itself does not mean that there are not correspondences of a sort between the world and language. Following Davidson's much earlier paper

"True to the Facts"[6] we can find this in the relation of satisfaction (or conversely of reference). I can agree with Davidson's contention (following Frege) that if sentences corresponded to facts, there would be only one fact. I also agree with Davidson in rejecting causal and similar theories of reference, which define reference prior to a truth theory for the language. Reference is a theoretical predicate of the truth theory, a postulated primitive predicate. The evidence for the truth theory comes from the sentences that in interpretation we conjecture the speaker to hold true, not from any observable or near-observable relation of reference. However this, so it seems to me, does not prevent reference from being an objective relation between parts of language and parts (or sequences of parts) of the world. This appears to be Davidson's position at the time of this early paper, in which he indeed uses the term 'correspondence' in a rather extended sense in connection with his theory. I imagine that Davidson's uneasiness about such a position as I am taking here would arise from his view that the theory of interpretation is not part of objective science. Certainly it is not part of physics. As Davidson points out, it uses expressions such as 'rational' that do not occur in physics. Still, the theory of the human kidney is not part of physics, since many of its words (such as 'kidney') do not occur in physics. This does not prevent a kidney from being a purely physical entity and the theory of the kidney from being part of total science.[7] Nor are words used in electronics, such as 'triode valve', strictly part of physics, but the objects they represent are strictly physical. (Roughly, parts of biology are physics and chemistry plus natural history, and electronics is physics plus wiring diagrams.) So Davidson's objection cannot just be that the words such as 'rational' that occur in the theory of interpretation of a speaker's language are not words that occur in physics. It is that they are normative.[8] It may seem then that we are imposing our own human values on the language being interpreted and hence indirectly on the world. This looks like idealism. In defending realism about truth, or as Putnam has called it, "metaphysical realism,"[9] therefore, I must try to exhibit interpretation as value free and as part of total positive science.

Certainly Davidson's early papers on philosophy of language were particularly congenial to me in that they seemed to go with such a realism. So also were his early papers on the philosophy of mind and of psychology since they allowed for at least a token-token identification of the mental and the physical. His paper "Theories of Meaning and Learnable Languages"[10] alerted me to the importance of recursiveness in semantics. Part of this importance was due to the emphasis on learnability, which seemed to point to a possible connection between semantics and psycholinguistics. His subsequent papers initiated what seemed to me to be a brilliant research program of using surface rules to bend our colloquial language into a deep structure of standard first order logic, for which Tarski had provided a recursive semantics.[11] All this

seemed to hint at a partial explanation of how the brain might work so as to compute from a finite set of primitive truth conditions the truth conditions of arbitrarily long sentences. Cases of apparent intensionality were shown to be cases of extensionality after all, and all this without talk of possible worlds. (Thus Davidson was opposed to Montague grammars.) Also the notion of a recursive semantics is surely essential to Davidson's account of interpretation as getting at the T-sentences of an axiomatizable truth theory.[12]

This seemed to me to be a beautiful research program, very congenial to hard-headed philosophers. I am not linguist enough to comment on its prospects or its influence on the science of linguistics. It is certainly a program which I would *like* to see succeed. Moreover these early papers seemed to be compatible with a robust realism in metaphysics. Most congenial to the realist in me was Davidson's "True to the Facts."[13] Though he rejected a traditional correspondence theory, according to which sentences or beliefs correspond to facts, he argued for something that he then still called "correspondence," which was given by the satisfaction relation, which linked names and predicates to sequences or classes of sequences of n-tuples of objects. Thus though picturing of supposed facts was not what hooked language on to the world (Davidson rejected an ontology of facts) something else, satisfaction (or its converse reference), did the job.

Let us now turn once more to Davidson's much more recent paper "The Structure and Content of Truth." As I remarked earlier, Davidson now does not want to define truth in any way at all. He says: "We should not say that truth is correspondence, coherence, warranted assertability, ideally justified assertability, what is accepted in the conversation of the right people, what science will end up maintaining, what explains the convergence on single theories in science, or the success of our ordinary beliefs."[14] I do not see why a metaphysical realist, such as myself, need deny this. What a metaphysical realist wants is some correspondence between language and the world, and the natural place to find this is in the concept of reference or satisfaction. This is *not* to say that reference can be defined independently of the truth theory for a language as is done, for example, in causal theories of reference. Sentences and beliefs do not correspond to anything important, since what they would correspond to would be facts, and Davidson has argued that we cannot have an ontology of facts. A metaphysical realist can agree with Davidson in rejecting notions of fact and correspondence to facts. He or she can agree that the evidence for our truth theory must lie in T-sentences, which themselves mention complete sentences. But as a metaphysical realist I want some sort of correspondence between language and the world. In Davidson's approach 'refers to' (or its approximate converse 'satisfies') becomes a primitive (postulated) predicate of the truth theory. This in itself should not worry the metaphysical realist. The predicate defines a relation, and the fact that such a

relation is a theoretical or postulated primitive is no cause for worry. I shall consider other reasons why Davidson may think that the metaphysical realist should be disturbed.

A metaphysical realist must believe that even an ideal theory in the Peircean limit might be false in certain respects. This is not to say that a metaphysical realist should believe that *all* our scientific beliefs might be false. Quite independently of Davidson's considerations of charity in interpretation it seems to me that a realist would have to be mad to say that all our scientific beliefs might be false. For how would one elucidate the 'might'? Not being a believer in possible worlds other than the actual world I elucidate modal notions contextually. I follow Quine and others in elucidating 'possibly *p*' as asserting that *p* is consistent (in the sense of first order predicate logic) with contextually agreed background assumptions.[15] (If the reader thinks that there are analytic propositions that are relevant to consistency let him or her simply add these propositions to the background assumptions.) If the set of background assumptions is the null class of course the assertion that all our scientific beliefs might be false is trivially true. If the background assumptions are not null they are (or ought to be) core assertions of science (and perhaps common sense) that we have good reasons for believing will never be overturned. All that a metaphysical realist should say is that *some* of our best warranted beliefs might be false, and indeed that some parts of an ideal Peircean theory might be false. He or she should say that the universe might trick us even in the limit of a Peircean ideal theory though not always or centrally. As a metaphysical realist one of my main concerns is to reject any elucidation of truth in terms of warranted assertability, even in the limit of a Peircean ideal theory. Here I am at one with Davidson. Epistemology must be kept out of truth theory.

On the other hand we get to a truth theory for a speaker's language by interpreting the speaker's utterances. Epistemology comes into the methodology of interpretation. Does this sully the purity of the fruit of interpretation, namely a truth theory, and push us on to the slippery slope that leads to something like idealism? According to Davidson's use of the principle of charity we impose our standards of rationality and our values on to the speaker who we are interpreting, and this may be supposed to give interpretation a normative character. It may be thought that this normative character must inevitably seep through into the scientific or metaphysical language of the speaker. If this is so we cannot derive a robust scientific realism from our reading of science. This would indeed be a blow to me, since I regard plausibility in the light of science as giving the best touchstone of metaphysical truth. I am not sure that normativeness of the theory of interpretation would have this idealistic tendency, but in any case I want to suggest that the

theory of interpretation is not normative and that it can be regarded as part of a total positive science.

It is true that notions of belief, desire, and meaning (in the very abstract and holistic sense in which Davidson uses this last term) do occur in the theory (or methodology) of interpretation. In this sense a coherence theory of interpretation seems to be right. Thus, I used to think that Davidson's paper "A Coherence Theory of Truth and Knowledge"[16] would have been better titled "A Correspondence Theory of Truth and a Coherence Theory of Interpretation" (using 'Correspondence' in the rather non-standard way, already mentioned, in Davidson's paper "True to the Facts"). Here I would be taking the theory of interpretation (but not of truth) as a branch of epistemology. Coherence seems to me to be a good theory of warranted assertability even though it is a bad theory of truth. It is much the same as Quine's "Web of Belief."[17] In his "Structure and Content of Truth" Davidson backs off from coherence, even as an epistemological notion. This is because he describes coherence as mere logical consistency. Obviously a consistent set of sentences could contain falsehoods. However, I think that more than mere consistency should be imported into the notion of coherence. We also need possibly unformalizable notions of simplicity, mutual probabilification, and plausibility. Moreover, a theory needs to be not only consistent but comprehensive, and once we have some science going coherence leads naturally towards comprehensiveness. We want our theories to be true, not just coherent, and we know enough about the world (and the success of science) to know that we are more likely to get nearer to truth by testing our theories and trying to make them cohere with other well tested theories. So it coheres with this knowledge—and with our desire to attain truth—that we consider total evidence and indeed expand our evidential basis. So when I advocate coherence as an epistemological notion I have a richer notion of coherence than mere internal logical consistency. (This richer notion of coherence was characteristic of the Oxford idealists of the turn of the century, who were on the right track in epistemology, even if badly wrong about truth.)[18]

The question, then, is whether interpretation of a speaker's utterances can be regarded as belonging to natural science, much as the investigation of an alcoholic's liver is—in a broad sense—part of science. We need not worry on account of the mere fact that words such as 'rational' do not occur in physics. Nor does 'liver'. Explanations of a liver's functioning or of its non-functioning can be done with the aid of physics (or at least chemistry) together with some "natural history"—anatomy mainly. The worry must be that 'rational' is a normative expression. I shall postpone discussion of this worry and consider, neglecting it, whether our so called "folk psychology," which depends on words such as 'belief', 'desire,' and their cognates, can be part of

science in the sense in which the pathology of the liver can be scientific.

In his paper "Psychology as Philosophy"[19] Davidson describes F. P. Ramsey's method of measuring the strength of a subject's beliefs and desires, that is of separating the subject's values from his or her subjective probabilities. The method depended on certain assumptions which were experimentally refuted by some experiments that Davidson and Merrill Carlsmith did. I am not sure whether in his more recent "Structure and Content of Truth" he still thought that the experiments were decisive against Ramsey's method: at any rate in his "Structure and Content of Truth" he seems happy with a clever modification of Ramsey's method due to Richard Jeffrey,[20] which he describes in an appendix.

In any case, bad though it might be for decision theory and for ethics if Ramsey's method does not quite work, I am not sure that our ordinary talk of beliefs and desires requires that they be precisely measurable. We can, I think, use the principle of charity well enough to get to a theory of a person's strong beliefs and fairly strong desires and with further evidence of the relevant T-sentences be able to extend the theory to cover beliefs and desires of varying strengths without any hypotheses that depend on an ability to assign precise strengths.

To get something more like folk psychology as envisaged by many philosophers we should supplement this account of beliefs, desires, etc., as being got from the interpretative theories, by various platitudes such as those relating to the partially causal powers of their hypothesized entities. We might extend this folk psychology by various hypotheses concerning the relation of these entities to modelings in the nervous system. These modelings may be rather abstract entities, patterns of neural interconnections or even classes of such patterns. We may not want to go so far as, I gather, some connectionists do, namely as supposing that pretty well all the interconnections in our cortex are altered every time we alter some minor belief or desire. Nevertheless we may allow a fair degree of such holism. We must not suppose that a belief is like something rather concrete and fixed, such as a picture postcard.

F. P. Ramsey aphoristically compared beliefs to maps by which we steer.[21] The analogy with maps does have some misleading features. A map is a picture of a countryside, and might be thought to correspond to a fact, and I have agreed with Davidson in rejecting an ontology of facts. Ordinarily a model corresponds to a thing, and yet beliefs are in a way sentential. The *way* they are sentential is best seen from Quine's way of putting it: A believes-true S, where A is a person and S is a sentence. (Davidson's 'A believes *that*' with the S in the offing somewhere is not too different.) So we can think of believing-true as a relation between a person and a sentence (a sentence of which the believer is normally unaware). It is the sentence by which we indicate the belief, and here, it is important to note, we *mention* and do not *use*

the sentence. We can think of believing-true S as a state of the person, or more accurately of the person's brain.

Believing-true S is a holistic state in that it can, for all we know, distribute itself as a pattern of connections throughout the brain states, such as believing-true T. If one belief changes others will change automatically. For example, believing-true S may increase or diminish the strength of believing-true T. If U is a logical consequence of S then believing-true S together with the state which corresponds to knowing logic may contain the state of believing-true U.

David Lewis has pointed out that there is a sense in which even a map is holistic.[22] Take one square millimeter of a 1:25,000 map, say. Cut out this one square millimeter. It will tell you nothing. What the map will tell you is the spatial relations of things, horizontally by direct analogy, vertically more subtly by contour lines. The square millimeter by itself cannot do this.

Folk psychology of course eschews neurophysiological speculations, even of the abstract sort given above. For in folk psychology beliefs and desires are functional states, which can be defined if we think of the platitudes of folk psychology Ramseyfied.[23] When I identify neural states with the functional states, I am making only a token-token identification. I leave open the question of whether at a higher level of abstraction some sort of type-type identification is possible. It should also be noted that folk psychology is known to us only *implicitly*. This point has been made by Frank Jackson and Philip Pettit in an excellent article in which they defend folk psychology against eliminationists such as the Churchlands.[24] We know *how* to operate a folk psychological theory without being able to *state* much of it. We know how to predict one another's behavior to a remarkable extent. Were it otherwise daily life would be impossible.

What about indeterminacy? We individuate beliefs and desires by mentioning or alluding to *sentences*. Admittedly someone may say 'I desire a unicorn'. This is misleading because the desire cannot be a relation between the speaker and a unicorn, because there is no unicorn to be on the other end of the relation. I cannot kick a football without there existing a football to be kicked. Moreover, if I desire a football, there may be no particular football that I desire. That is why I see it as better to say with Quine "Smith desires-true 'Smith possesses a football'" or better still like Davidson, say simply "Smith desires-true that" with the 'Smith possesses a football' just somewhere in the offing and alluded to by the 'that'. However, the sentences must be thought of as interpreted sentences. Indeterminacy of translation will imply indeterminacy of belief and desire. Even in quantum mechanics we do not get *this* sort of indeterminacy.

Hence if I am going to naturalize folk psychology and with it the theory of interpretation I must exhibit this indeterminacy as harmless. A large part of

the indeterminacy of translation in Davidson comes simply from the inscrutability of reference. I think, and I believe that Davidson thinks, that inscrutability of reference has no effect on ontology. In which case I think that it *is* harmless to one who wants to naturalize the theory of interpretation. Could we also hold to an indeterminacy of belief and desire even while assuming that reference is constant? Thus if a man drinks from a tumbler this may apparently be explained by his belief that it contains wine and his liking for wine. However, it could be explained by his belief that it contains poison and his desire to end his life. It seems to me that it would not be plausible that such transformations could be carried through smoothly through all the person's beliefs and desires so as to give anything like a plausible explanation of total behavior. Therefore, I shall concern myself only with the inscrutability of reference.

Davidson in his paper "The Inscrutability of Reference" and drawing on a paper by John Wallace,[25] considers the possibility of a permutation of the objects in the universe so as to give a new scheme of reference. If a name refers to an object x then on the new scheme it refers to an object ϕx and if a predicate F refers to a class of ordered n-tuples $(x_1, x_2, \ldots x_n)$ etc., then on the new scheme it refers to $(\phi x_1, \phi x_2, \ldots \phi x_n)$, etc. Both theories imply exactly the same evidential basis for interpretation. The distinction between the different schemes of reference, as distinguished by the various permutations ϕ (which of course includes the identity permutation), can be stated only in a metalanguage. We need to distinguish in the metalanguage between our original theoretical predicate 'refers' and a new predicate 'ϕ refers'. Consider a ϕ that maps instantaneous temporal stages of David Lewis's cats Magpie and Possum on to instantaneous temporal stages of the Taj Mahal and Alpha Centauri (or even on to the numbers 5 and 7). It will also map a predicate 'is near to' (say) on to some symmetrical predicate true or false of the Taj Mahal and Alpha Centauri (or even of 5 and 7). It will be seen that such a mapped predicate 'ϕ near', for example, will in general be a rather gerrymandered one. Still, whatever the scheme of reference induced by ϕ, it is the case that the T-sentences will retain their truth values. Indeed the Wallace transformation leaves untouched the truth values of all the sentences of the language. Let us abbreviate to 'ϕF' the name of the predicate that refers to $\phi x_1, \phi x_2, \ldots \phi x_n$, etc. when 'F' refers to $x_1, x_2, \ldots x_n$. Since the transformation ϕ is a matter of interpretation 'F' and 'ϕF' will really be typographically indistinguishable.

Since the difference between reference and ϕ reference is just a matter of permutation of things in the universe, it follows, as Davidson says, that the inscrutability of reference does not have any ontological implications. The things that we say are in the world are the same and so are the relations that we say hold between them.

It might be thought odd that when we observe an interpretee speaking in

a certain way when and only when cats are in the offing that he or she might be referring to numbers. Quite so, but there is no problem about the fact that he or she might be φ referring to numbers. So there seems to be no fact of the matter as to whether a person is referring to cats or whether he or she is φ referring to numbers, and hence as to whether there is any fact of the matter as to whether what is going on is referring or whether it is φ referring. In this sense reference is inscrutable. Truth values of sentences are unaffected.

I do not think that such inscrutability of reference is a threat to a sensible metaphysical realist. The metaphysical realist need not be concerned with whether there is in the world only one relation of reference. The permutation of things in the world effected by φ clearly does not affect ontology. The things in the world are what they are independently of us, and so is the set of permutations of them. Davidson in this connection once described to me his notion of indeterminacy of translation as (unlike Quine's) trivial, no more significant than a translation of axes in mechanics.

One reason why Davidson's notion of indeterminacy is unworrying as compared with Quine's is due to Davidson's assumption that the deep structure of language is amenable to a Tarski type truth theory based on standard predicate logic. Quine's example of 'Gavagai'[26] can be dealt with because Davidson does not allow reinterpretation of the identity predicate. (A rabbit is identical with itself but parts of the rabbit are not identical with one another.) Similarly Davidson does not allow us to reinterpret the quantifiers and truth functional operators.

Trivial though the indeterminacy of reference may be, the metaphysical realist might worry that though there are correspondences between terms of language and the world, there are *too many* of them. We may be reminded here of Hilary Putnam's objections to metaphysical realism.[27] The metaphysical realist says that even a Peircean ideal theory could be false in important respects. Presumably the ideal theory is consistent, and has a model in the world (assuming a suitable cardinality for items in the world). So there must be a correspondence between the items in the model and the items in the world. Hence, by transitivity there is a correspondence between the ideal theory and the world. Therefore, Putnam says, the ideal theory cannot be false or else truth is not correspondence.

It should be noted that Putnam's transformations of reference are more complicated than Davidson's and Wallace's.[28] Within his *reductio ad absurdum* argument against the metaphysical realist Putnam wants to correlate a consistent set of sentences of the ideal theory, which the metaphysical realist thinks might obey the constraints and yet might conceivably contain some false sentences, with a set entirely of truths, even though Putnam's transformations preserve truth values. Of course Putnam's arguments (and a strengthened argument due to Barry Taylor)[29] do need answering. Putnam's

arguments are indeed hard to answer because of his "just more theory" move where he transforms not only the ideal theory but the operational and theoretical constraints on the theory. In this paper I am concerned with Davidson. To try to answer Putnam would need much more thought and a whole new paper, and so let me say that I here *assume* that Putnam can be answered, and argue that *even if* Wallace's and Davidson's inscrutability of reference is allowed, this is no threat to at least my sort of metaphysical realist.[30]

As a metaphysical realist I want to say that reference (but not truth) is indeed correspondence. No untoward implications arise from the fact that there can be infinitely many equally good correspondences under Wallace's type of transformations. (This does not imply that the ideal theory must be true.) Transformations of the reference relation must be truth value preserving, as in Davidson's theory. The metaphysical realist can agree with Davidson that causal and like-minded theories which define reference for individual words, in abstraction from a holistic truth theory for the sentences in which these words occur, just will not do. For me the reference relations are a theoretical posit of the truth theory as a whole.

If I were to stop here I would be rightly accused of naiveté. (Perhaps I will be anyway—I am rather a naive person!) I have tried to naturalize interpretation much as (so I claim) we can reconcile physicalism with clinical medicine and electronics, though neither of these are physics in the strict sense. Davidson would say, I suppose, that this comparison breaks down because we impose our own standards of rationality and value when we interpret a speaker's discourse. There is also another difference. We individuate beliefs and desires by interpreting a language, and individual beliefs and desires are referred to by naming a sentence, as in the Quinean formulation 'believes-true S' and 'desires-true S'. S has to be taken as 'in language L' and this is fuzzy. Davidson has even doubted whether there is such a thing as a language, if by this is meant something diachronic and interpersonal. The semantic style of individuation of beliefs, desires, and the like separates folk psychology off from even medicine, electronics, and neurophysiological psychology. Certainly this may introduce fuzziness into the meta-language of physics and metaphysics, but not, I think, any subjectivism or idea that "the mind and the world jointly make up the mind and the world"[31] to use Putnam's metaphor. Perhaps fuzziness in the meta-theory can even go along with precision in the theory.

If the notion of interpretation can be naturalized, as I have been suggesting, and interpretation is just a particular application of scientific method, is it not fallible? In this, of course, it is no different from physics and the other special sciences. Does this matter? The fallibility of science has often been exaggerated, as by Popper and his followers. Even when there are scientific revolutions, much truth or approximate truth usually remains in the old

theories. Perhaps the fallibility of interpretation seeps through to, in a way, increase the fallibility of the interpreted theories. For those who are not too intimidated by the philosophical problem of induction this need not, I think, be a serious worry.

What about the worry that we impose our own standards of rationality and value when we radically interpret a speaker's discourse? I do not think that this at all implies that "the real is the rational" (or "the good") as nineteenth-century idealists were wont to put it. In interpretation we impose rationality and values on to our theory only in the sense that we assume that most of the beliefs that we hold, at least in down to earth practical contexts, are true and that our desires and needs are similar to those of the person whose words we are interpreting. It is most unlikely that the interpretee desires poison or believes that a fox in the offing is a teapot. (Sometimes we must indeed be cautious when applying the principle of charity. We may miss out by thinking that words should provisionally be translated by 'that is a saddle between mountains' when in fact they would best be translated by 'that is a weir of a giant fish pond scooped out by a totemic ancestor'.) Charity in interpretation should initially be applied to rather basic beliefs and desires that we think would be almost universal among humans or, at any rate, are free of either theory or mythology.

When we apply the principle of charity we impose our values and norms of rationality only in the sense that we assume commonality between theirs and ours. In a way we are using ourselves as analogue computers. Of course, we are not good analogue computers. We all differ from one another. Nevertheless there is surely sufficient similarity nearly all the time when we are concerned with situations that involve very basic beliefs, and desires, relating to food, hunger, sleep, primitive social relations, local geography that is common to us, and so on. When the analogue computer fails to help us predict the behavior of the person whose language we are interpreting we make appropriate modifications of our interpretative theory. For example, we might explain behavior deviant from ours by such things as attributing to the other unusual beliefs and desires, or propensities to commit the gambler's fallacy or affirming the consequent or whatever. The situation in which, as I suggest, we are naturalistically talking *about* the other person's norms still can parallel that in which, according to Davidson, we are expressing norms of our own.

Except in our capacity as an analogue computer we are not making value judgements but only talking about value judgements. When we attribute to another person beliefs and desires similar to our own we are not ourselves expressing these desires and beliefs. Similarly the word 'rational' need not occur in our interpretative discourse, though it might occur in heuristic discourse *about* our interpretative discourse. Even here 'rational' need not be

value laden—it could mean 'similar to what I do'. For example we use *modus ponens* and assume that the interpretee does too. So also with inductive norms. Here we do not concern ourselves with validation or vindication of induction or deduction but merely assume that it is plausible to suppose that others adhere to these norms. Davidson would of course say more here, namely that since we could not devise a truth theory without attributing adherence to these norms, these norms are constitutive of the concept of truth. I am a bit suspicious of the use of the word 'constitutive' in such contexts. Let me explain why.

It might be said that the existence of rigid (or approximately rigid) bodies is constitutive of the concept of length or distance, since if one were Fred Hoyle's super-intelligent "Black Cloud"[32] and the rest of the universe were dust or gas or plasma one could not have defined addition of length by putting rigid rods end to end or equality of length by matching rigid rods. This use of rigid rods gives us the most primitive concept of length.[33] Later on with triangulation, parallax, etc. we can extend this concept of length and distance, and still further we can get to theoretical concepts of length. But it is hard to see how our concept of length could have got going without rigid bodies. Suppose that the universe were just a plasma (perhaps many of Brandon Carter's postulated "many universes" are such a plasma.)[34] Still there *would* be distances between particles or plasma clouds. So if it were said that operations on rigid bodies were constitutive of distance this would cut no ontological ice. Similarly if rationality and goodness are constitutive of our concept of truth or reality this no more implies idealism about truth or reality than does the consideration about length and distance imply rigid-body-ism about an all plasma universe.[35]

<div align="right">J. J. C. SMART</div>

AUSTRALIAN NATIONAL UNIVERSITY
MAY 1993

NOTES

1. *Journal of Philosophy* 87 (1990), pp. 279–328.

2. Ibid., pp. 308–9.

3. Contrast the idealist philosopher H. H. Joachim's horrible phrase 'knowledge-or-truth' which occurs frequently in Joachim's *Logical Studies* (Oxford: Clarendon Press, 1948).

4. Davidson, op. cit., p. 305. See Arthur Fine, *The Shaky Game: Einstein, Realism and the Quantum Theory* (Chicago University Press, 1986).

5. See Hilary Putnam, *Meaning and the Moral Sciences* (London: Routledge and Kegan Paul, 1978), Part 4.

6. In Davidson, *Inquiries into Truth and Interpretation* (Oxford: Clarendon Press, 1984).

7. As I am sure that Davidson would agree. See his remarks on geology on p. 46 of his 'Problems in the Explanation of Action', in Philip Pettit, Richard Sylvan and Jean Norman (eds.), *Metaphysics and Morality* (Oxford: Blackwell, 1987).

8. See, for example, "Problems in the Explanation of Action," op. cit., pp. 46–47.

9. See Putnam, loc. cit.

10. In *Inquiries into Truth and Interpretation*.

11. It is true, of course, that other logics can have a recursive semantics. In particular Tarski's recursive clauses go through when interpreted intuitionistically. Bivalence cannot be proved without bivalence in the meta-language but the rest of Tarski's theory goes through. Nevertheless, standard first order logic seemed a good bet. (Moreover any realist will want bivalence.)

12. In his "Semantics of Natural Languages," Davidson deals with indexicals by relativizing to persons and times, and also "in context C." Context can be either environmental or linguistic. I do not know how much this reference to context gets in the way of recursive semantics. For doubts on this score see L. Jonathan Cohen, "A Problem about Ambiguity in Truth-theoretical Semantics," *Analysis* 45 (1985), pp. 129–35, and "How is Conceptual Innovation Possible?" *Erkenntnis* 25 (1986), pp. 221–38. In attempting to answer such arguments it should be remembered that for Davidson a language is synchronic, not diachronic, and that one is doing radical interpretation all the time. See Davidson's "A Nice Derangement of Epitaphs" in Ernest LePore (ed.), *Truth and Interpretation* (Oxford: Blackwell, 1986). More surely needs to be said, but it is beyond the scope of the present paper for me to attempt to do so.

13. In *Inquiries into Truth and Interpretation*, op. cit.

14. "The Structure and Content of Truth," op. cit., p. 309.

15. See W. V. Quine, "Necessary Truth," in his *The Ways of Paradox and Other Essays* (New York: Random House, 1966).

16. In Ernest LePore (ed.), *Truth and Interpretation: Perspectives on the Philosophy of Donald Davidson* (Oxford: Blackwell, 1986).

17. See W. V. Quine and J. S. Ullian, *The Web of Belief*, revised edition (New York: Random House, 1978).

18. See, for example, Bernard Bosanquet, *Implication and Linear Inference* (London: Macmillan, 1920).

19. In Donald Davidson, *Essays on Actions and Events* (Oxford: Clarendon Press, 1980).

20. Richard Jeffrey, *The Logic of Decision*, 2nd ed. (Chicago: University of Chicago Press, 1983).

21. F. P. Ramsey, *The Foundations of Mathematics and Other Logical Essays* (London: Kegan Paul, 1931), p. 258.

22. See David Lewis, "Reduction of Mind," in Samuel Guttenplan (ed.), *A Companion to the Philosophy of Mind* (Oxford: Blackwell, 1994).

23. See David Lewis, "Psychological and Theoretical Identifications," *Australasian*

Journal of Philosophy, 50 (1972), pp. 249–58.

24. Frank Jackson and Philip Pettit, "In Defence of Folk Psychology," *Philosophical Studies* 59 (1990), 31–54.

25. John Wallace, "Only in the Context of a Sentence do Words have any Meaning," in Peter A. French, Theodore E. Uehling, Jr. and Howard K. Wettstein, *Contemporary Perspectives in the Philosophy of Language* (Minneapolis: University of Minnesota Press, 1977).

26. W. V. Quine, *Word and Object* (Cambridge Mass.: M.I.T. Press, 1960). See pp. 52ff and 73ff. It should be stressed, however, that the 'Gavagai' example is not crucial for Quine's discussion of indeterminacy of translation.

27. Hilary Putnam, *Meaning and the Moral Sciences*, loc. cit.

28. Hilary Putnam, *Reason, Truth and History* (Cambridge: Cambridge University Press, 1981), pp. 32–35 and Appendix pp. 217–18.

29. Barry Taylor, "Just More Theory: A Manoeuvre in Putnam's Model-Theoretic Argument for Anti-Realism," *Australasian Journal of Philosophy* 69 (1991), pp. 152–66.

30. I am grateful to Karen Green and Drew Khlentzos for some stimulating correspondence which I hope has helped me to clarify my mind about this matter.

31. Hilary Putnam, *Reason, Truth and History* (Cambridge: Cambridge University Press), p. xi.

32. Fred Hoyle, *The Black Cloud* (London: Heinemann, 1957).

33. See N. R. Campbell, *Foundations of Science* (formerly titled *Physics The Elements*), (Dover: New York, 1957), Chapter 10.

34. Brandon Carter, "Large Number Coincidences and the Anthropic Principle in Cosmology," in M. S. Longair (ed.), *Confrontation of Cosmological Theories with Observational Data* (International Astronomical Union, 1974), pp. 291–98.

35. I must say that 'constitutive' is a word of which *nearly always* I have an uneasy suspicion, though perhaps this suspicion may be due to intellectually puritanical fears of something like Aristotelian essentialism or perhaps of Kantian a priori.

REPLY TO J. J. C. SMART

There is little if anything of substance with which I disagree in this forthright essay. There are, however, some misunderstandings, most of them probably my fault. I certainly don't reject realism, at least not until I know what it is I am rejecting. I decided not to call myself a realist because I found that for a large number of philosophers being a realist meant accepting a correspondence theory of truth which held that one could *explain* the concept of truth as correspondence to facts. I have always been clear that I was not an anti-realist about any theoretical entities over which a theory I held true quantified. Quantification (in Quine's ontic sense) is the key to the significant connections between language and belief and the world, since there is no way to give an account of the truth of sentences in a language with general quantification except by relating parts of sentences to entities. Tarski's device of satisfaction expresses such a relation: it is, of course, a fancy form of reference. As Smart reminds me (and I have from time to time mentioned in print [Davidson 1983; 1990]), I once suggested that because satisfaction was a relation required for the explication of truth, we could (as Tarski himself did) think of his truth definitions as supporting the idea of correspondence. There is a point: semantics requires that we relate language to what it is about.

Smart worries that because I think psychological concepts, at least those that invoke the propositional attitudes, are not conceptually or nomologically reducible to the concepts of the natural sciences, that I do not believe they are suitable for scientific treatment. Here realism is not, at least for me, at issue. People have beliefs and desires and the rest, and attributions of these attitudes have objective truth values just as attributions of distance, weight, and electric charge do. As scientists we can study the relations among the attitudes as well as the relations between various physical magnitudes and psychological reactions. The laws governing these relations are not, in my opinion, ever going to have the precision and scope we hope for in the best of physics, but then, as Smart says, neither do the facts of biology or chemistry necessarily come out as deductions from what we know of relativity theory or quantum

mechanics. There are, or so I argue, important differences between these cases because of the normative considerations that necessarily enter into our psychological attributions. In some sense we think that though the concepts of biology may not be definable in the concepts of physics, the phenomena of which biology treats can be understood as belonging to the same conceptual domain as that of an inclusive physics. But what we count as psychological explanations, those that call on what everybody now calls folk psychology, are genuinely different in kind, because rationality and norms cannot be eliminated from such explanations without leaving behind what we are interested in. None of this removes what we describe and explain when we explain what people think and do from the scope of genuine, objective science. It just isn't physics. The reason is obvious: thinking, and what it explains, involve propositional contents, and propositions have logical relations which matter to psychological explanations. When we do physics, or biology, or chemistry we do not treat objects as having thoughts.

Smart is right that the indeterminacy of interpretation, which includes the inscrutability of reference, is no threat to the objectivity of interpretation or to whatever claims interpretation can make to scientific respectability. Indeterminacy just reflects the fact that the empirical and logical constraints on interpretation can be met in more than one way. What we are interested in is what these constraints leave invariant, as in any science. Quine emphasized indeterminacy in order to wean us away from the myth of meanings. Having been weaned, we can now turn to the legitimate question of what is invariant, the "facts of the matter".

I agree with Smart that folk psychology constitutes an empirical theory, which is why I have invested as much as I have in trying to spell out its logic, its application to intention, action, practical reasoning, and even various forms of irrationality. Like him, I do not think it can be replaced by something radically different. Our grasp of reality demands two different, though interlocking, modes of description, explanation, and prediction. Here I am a Spinozist: a single ontology, but two modes of apprehending it.

It is true that I abandoned experimental work in decision theory, but not, as Smart suspects, because I thought it was empirically worthless. On the contrary, I think of decision theory, in one or another form, as basic to our understanding of rational creatures, on a par with logic and formal semantics. I think of these abstract structures as organizing in a formal way what folk psychology takes for granted: thinking creatures tend to accept the logical consequences of their beliefs, to treat conjunctions as entailing each conjunct, and to pursue the ends they value most against odds they would not accept for what they value less. Needless to say, a lot more is involved in our ordinary ways of figuring out what people are up to, but if these idealized and simplified models had no application there would be no point in attributing

propositional attitudes. I became discouraged with attempts to test the empirical validity of decision theory because I could not think of a well-grounded way of separating the empirical and a priori demands of rationality. Too many apparent deviations from what rationality required were explicable as in accord with theory when reinterpreted. Socrates was exploring the same puzzle when he argued (on purely a priori grounds) that there could be no such thing as akrasia.

There remains a subject on which Smart and I may differ, the question whether we can "exhibit interpretation as value free and as part of total positive science." Much that he says here seems to me right: in reporting the attitudes of others we do not, for the most part, need to say anything about rationality, nor are we remarking on our own values and norms. Interpretation is, as he nicely says, "just a particular application of scientific method" (see my [Davidson 1991; Davidson 1995]). Rationality and goodness are not, in my opinion as in his, constitutive of our concepts of truth and reality, nor does the role of interpretation in our mental life have any tendency to make for idealism. But there remains a clear sense in which such concepts as belief, desire, and intention differ from the concepts of the natural sciences: when we apply them, we cannot avoid employing our own standards of rationality. This is not because we are using our own logic, for we do this if we reason about anything. It is because in trying to understand others we are looking for the best way of matching up our own sentences with the attitudes of others in order to render those attitudes intelligible. In the natural sciences, we can operate with standards we have agreed on with others. There are no such standards to which we can turn in interpretation, for agreeing with others *is* interpretation. Our norms play an uneliminable role in interpretation that they do not, and could not, play in the natural sciences.

D. D.

REFERENCES

Davidson, Donald. 1983. "A Coherence Theory of Truth and Knowledge." In *Kant oder Hegel*, edited by D. Henrich. Stuttgart: Klett-Cotta.
———. 1990. "Afterthoughts," 1987. In *Reading Rorty*, edited by A. Malachowski. Oxford: Blackwell.
———. 1991. "Three Varieties of Knowledge." In *A. J. Ayer Memorial Essays: Royal Institute of Philosophy Supplement* 30, edited by A. P. Griffiths. Cambridge: Cambridge University Press.
———. 1995. "Could There Be a Science of Rationality?" *International Journal of Philosophical Studies* 3:1–16.

4

Robert Morris

THE ART OF DONALD DAVIDSON

Only man has the privilege of absurdity.

—Thomas Hobbes

If, as Donald Davidson holds, truth is at the core of language, and (according to his "principle of charity") what most people believe—that mass of mundane propositional attitudes about the world—is true, and if language provides the social interaction that delivers an objective world (Davidson's famous "triangulation" between a subject, an object, and an other) where *truth*, though primitive, is central to a theory of meaning that allows us to understand speech and speakers, and if in making sense of the other it is necessary to consider his/her desires and beliefs as not foreign to our own, then given these inseparable elements and conditions, all of which hang together in a more or less coherent and holistic way, it becomes clear that what has been delivered is a *system*. It is a system that would reject both relativism and skepticism. It is a system organized around an interpretation of the nature of language and an interpretation of interpretation as, finally, more fundamental than language itself as a given system. Davidson's "radical interpretation" is a particular sort of unfinished and unfinishable system, one—as opposed to a systematic "conceptual scheme" through which the world is seen—that conceptualizes meaning as a condensate of social behavior. What is systematic is how meaning, truth, belief, desire, intention, action, the other, and the world are inseparably interlocked. It is a system that emerges strategically from a second-person perspective and would keep itself in the clear light of the public space and out of the shadows of a subjective Cartesian one. It is a system that builds on Wittgenstein (but is systematic), and builds on Quine, but is sensitive to the unsystematizable multitude of ways language is used.

Davidson's system hinges on a defense of both truth and a broad, if far from absolute, rationality that follows from it. What is implied is that it is not

only possible to behave rationally, but the use of language being a form of behavior, we actually do so much of the time. At least we do much of the time when we listen to the words of the other, which like our own, do not always express the truth. We constantly negotiate the interpretation of lies, jokes, insults, sarcasm, and the like. The truth is focused here in our belief that, whatever the language game being played, we more often than not correctly interpret it. Davidson's notion of truth appears to be two-tiered. There is the structural-linguistic level, which employs recursive characterizations in the style of Tarski: "Snow is white" is true if and only if snow is white. The literal truth of such sentences depends on "what the words as spoken mean, and how the world is arranged."[1] But interpretation often requires a second step. As Davidson remarks, "speech requires at least two levels of interpretation, there being both the question of what the speaker's words mean, and the question of what the speaker means in speaking them."[2] If we are lied to and yet not deceived we negotiate this double interpretation by trading the literal meaning of the statement for its opposite; if deceived, we have gone only halfway by taking it as true in its first or literal sense only. For it is the same sentence in both cases. But claims for rationality flowing through language are sustained by Davidson on deeper and more holistic levels connecting language to action. The liar's sentence certainly does not open a space through which rationality falls. But the more convincing claims for the rational are best sought outside strictly linguistic considerations of structure and interpretation that revolve around truth. The stronger case is to be made on the basis of the agent's *intentional* actions, which go beyond the linguistic.

But if the rational, also the irrational. Considerations of the latter throw considerable light on the former. In bracketing the rational with the irrational Davidson notes (in his "Paradoxes of Irrationality")[3] the explanation of Socrates, who argued that only "ignorance can explain foolish or evil acts." This is contrasted to the *Medea Principle*, which assigns the irrational to the actions of an agent overwhelmed by the alien force of passion. These cases are also compared to Aristotle's assertion that "weakness of the will is due to a kind of forgetting." But these examples do not deal with fully intentional actions. The *paradox* of irrationality lies in those actions the agent takes in full knowledge that, all things considered, it would be better to do A, while nonetheless doing B. Here the agent violates his principle. Or as Davidson puts it: "For though his motive for ignoring his principle was a reason for ignoring the principle, it was not a reason against the principle itself, and so when it entered in this second way, it was irrelevant as a reason, to the principle and to the action. The irrationality depends on the distinction between a reason for having, or acting on, a principle, and a reason for the principle."[4] In irrational actions the causal relation remains but the logical one is distorted or missing. Marcia Cavell put it well when she said that "Irrationality is a failure, not an absence, of rationality."[5] While mental causes

must be assigned to irrational acts, these causes do not count as reasons. Davidson goes on to account for the possibility of such irrationality by theorizing a "partitioning of the mind." Here both sides are characterized by a consistency and holism even though they are opposed to each another.

Davidson does not explore either the etiology of the divided mind that admits of the irrational or the relative command exercised over the subject by the one or the other. But he indicates a sympathy for Freud's "most important theses,"[6] one of which would be that the agent's irrational beliefs develop out of early thought processes (called by Freud the "primary process") dominated by fantasy, fears, and wishful thinking. Another of Freud's important theses would revolve around the concepts of the unconscious and repression.

Davidson says little directly about what constitutes the "better" in those "principles" of the agent that form his reference points for intentional actions or how the rational connects to and justifies these principles—although he rejects the notion of rational principles grounded in general or hierarchical moral platitudes, such as "it is wrong to lie." Furthermore, no indelible line can be drawn between either the so-called partitioned territories of the mind or the rational and irrational in intentional actions, since "all intentional actions, whether or not they are in some further sense irrational, have a rational element at the core."[7] What is common to all principles formed of desire and belief is the causal assumption—such as believing that stealing money will result in (be the cause of) the agent having money, whether it is rational or not to steal in the given circumstances. And there may be cases where the agent considers stealing the rational thing to do, the better thing to do, all things considered. Values are bound up in the desires and beliefs that form the agent's principles. How these principles of the "better" action are to be assessed as rational can only be determined, it would seem, in relation to a given situation judged in light of the action's nexus with other beliefs and values. The "better" here is normative in the logical rather than the moral sense—that is, it fits with other beliefs and desires of the agent. Whatever the particular principle in question, it presumably hangs together in ways consistent with those other beliefs and desires. It is this holistic aspect that confers a rationality defined in terms of consistency and appropriateness on any particular belief or principle.

"Every action has causes that rationalize it, that is, in terms of which it is rational. Of course those causes (beliefs and desires) may not be rational in the light of other beliefs and desires of the agent."[8] In Davidson's system, laws do not link the separate descriptions of mental and physical. The mental is supervenient on physical states, to be sure. But while physical events are subject to lawful description, mental events, according to Davidson's notion of "anomalous monism," are not. Mental "reasons," being irreducible to mechanisms of the physical, are sufficient to stand as causes, though never both necessary and sufficient ones.

Davidson has attacked relativism in a number of places. His principle of charity forms a general bulwark against it. But perhaps the most explicit assault is in the essay "On the Very Idea of a Conceptual Scheme." This is a two-pronged attack: against relativism on the one hand, and a kind of *coup de grâce* to moribund Empiricism on the other. Davidson's arguments always seem interlocking and strategic.

> In giving up dependence on the concept of an interpreted reality, something outside all schemes and science, we do not relinquish the notion of objective truth—quite the contrary. Given the dogma of a dualism of scheme and reality, we get conceptual relativity, and truth relative to a scheme. Without the dogma, this kind of relativity goes by the board. Of course truth of sentences remains relative to language, but that is as objective as can be. In giving up the dualism of scheme and world, we do not give up the world, but re-establish unmediated touch with the familiar objects whose antics make our sentences and opinions true or false.[9]

In another context, Davidson has found Roland Barthes's celebrated pronouncement of the death of the author (claims for a rampant relativism that leaves texts potentially open to all interpretation) premature. He does not mention Barthes by name, but in "Locating Literary Language" he concludes:

> It is true that every person, every age, every culture will make what it can of a text; and persons, periods and cultures differ. But how can a significant relativism follow from a truism? If you and I try to compare notes on our interpretation of a text we can do so only to the extent that we have or can establish a broad basis of agreement. If what we share provides a common standard of truth and objectivity, difference of opinion makes sense. But relativism about standards requires what there cannot be, a position beyond all standards.[10]

If Davidson's system, defending as it does against relativism and skepticism, stakes out a position opposed to postmodernist assumptions, his confrontation with the issues of the irrational contrasted to the rational leave much open ground to be explored. For the rational and the irrational mark the distantly opposed sites of a vast terrain that lies between: the nonrational. Davidson has had original and controversial things to say on those infrequent occasions when he has stepped out of the harsher light of a strict philosophical discourse on truth. Art and literature inhabit this broad space of the nonrational, where not truth but metaphor reigns and casts ambiguous shadows.[11] The essays collected in *Literary Theory After Davidson* testify to the breadth of implications inherent in Davidson's work for one of these zones of the nonrational. In a relatively late essay, "James Joyce and Humpty Dumpty," Davidson brings his notions of interpretation to bear on literary intentions. Here he cites Joyce to illuminate how art, at its best and most challenging, both makes possible and demands a creative effort of interpretation that

nevertheless stops short of hysterical claims for the "death of the author."[12]

It has generally been assumed (and perhaps still is by those not converted to postmodernism) that the line between truth and metaphor marks a boundary: Philosophy, illuminated by the former, stands on one side, while art stands on the other in more tangled landscapes. With Davidson's work I want to suspend such distinctions, without advocating a postmodernist collapse of truth and philosophy into literature. I think this suspension warranted because after giving all due consideration to his system as philosophy, there is a remainder. After threading through the issues of truth and belief and desire and interpretation and the other and the world, one emerges from this interlocking system and looks back to see an edifice standing. It is one that shows signs that more than a powerful analytic mind has been at work. This is an edifice that reverberates with a further interlocking element: the aesthetic. The aesthetic in Davidson's system is, I would argue, not separable from the philosophical content. It presides over the whole in the very will for a holistic, organic structure. But is it art? Paraphrasing Davidson, I would reply that it is not art if art is anything like what art historians and critics have supposed. I would not want to appropriate Davidson's system as a form of "conceptual art." Rather, I want here to appreciate that "remainder" in Davidson's system that is *art-like*.

Such an appreciation is not to suggest that truth might be blurred by art, but rather that in Davidson's writing truth is delivered with art. And more important, the ideas are somehow art-like. I think this art-like aspect has partly to do with the originality of some of the concepts themselves (the principle of charity, anomalous monism, the rejection of conceptual schemes, the rejection of language as an a priori abstraction), and partly with the uncanny way the concepts are locked together and how they resurface at unexpected times to reinforce one another. At a certain point this interlocking density seems to change state, and the system unfurls with a lightness and effortless wholeness as the systematic picture comes into focus. The magician's deck of separate cards becomes the seamless silk scarf; the parts of the sculpture resonate against one another and coalesce into an inseparable whole. Art-like as well is the daring move and unexpected shift that can erupt in Davidson's writing—not to mention the occasionally outrageous assertion. "A Nice Derangement of Epitaphs" is an essay that has sent philosophers into defensive fits—a situation more typical of the artist and his critics than that of the philosopher and his respondents. Here Davidson makes his infamous statement that "there is no such thing as a language, not if language is what many philosophers and linguists have supposed."[13] Two radical and related claims are being made in this text: (1) Language is not a finished, a priori abstraction, and (2) successful interpretation, the very lynchpin of Davidson's system, can only be negotiated by "wit, luck and wisdom from a private

vocabulary and grammar." Both of these assertions reduce the static and the systematic in his system. The first claim has much in common with Western art's protean and unfinished character, the second with the act of art making. A certain creative element becomes a necessity not only for interpretation but for the existence of language itself.

Davidson has constructed a large model that feels like an ambitious work of art. Yet this model, which deploys certain aspects of "folk psychology," is articulated by sets of logical relations that create no "schemes" or entities through which the world is captured. His edifice is both minimal and complex, legislative and transparent: a "thing" that is at the same time not a thing, a system that at its roots is mobile and anti-systematic. We understand Davidson as a philosopher, but he feels like an artist.

It is to point out the obvious to say that Davidson created his philosophy through a highly literary prose that moves with pace and often within a landscape of startling examples. It is writing that is as ambitious for style as for content. In its compression and leanness, its unforeseen leaps and strategic arguments, and its wide cultural references, it stands unparalleled as the best philosophical writing since Wittgenstein's *Philosophical Investigations*.

The numerous examples Davidson cites in *Essays on Actions and Events*[14] are colorful and frequently violent. Policemen are knocked downstairs, the battleship *Bismarck* is sunk, men are shot or run over by stampeding herds of wild pigs, roped climbers are in danger of being dropped by their partners, burns are suffered and houses are set afire. The anonymous Mr. Smith is murdered more than once. Leopards are presented to wives, and future tyrants risk assassination. This is not to mention the numerous examples from literature cited in the essays. Hamlet does in Polonius, Medea goes wild, and Oedipus does his thing. Dante's sinners squirm, Brutus stabs Caesar, and the queen pours poison in the king's ear. All of these examples illustrate aspects of a discourse devoted to issues of truth and rationality. Calm and reasonable action may be difficult to find in a wild and threatening world rife with murderous irrationality, but our capacity to make reasonable sense of such intentions, events, and actions endures. I do not know if a certain irony rises to the surface here. Perhaps it is rather a kind of cold but heroic comfort that Davidson's texts offer. We may live at the end of the bloodiest century in history—Elizabeth Bishop called it the "worst so far"—but we are capable of discerning the truth behind the most numbing and brutal actions and events. Going a step beyond Hobbes, we can interpret man's endless array of absurdities with a resolute precision. That such a saturnine use has never been made of Davidson's radical interpretation does not mean that it might not be called upon to function in such a light.

"Metaphors," Davidson says, are both "the dreamwork of language" and yet "mean what the words, in their most literal interpretation, mean, and

nothing more."[15] Metaphors lead us to see one thing as another; they open up the world and reveal astonishing landscapes across the terrain of the nonrational. Can Davidson's work—for all of its defense of truth, its clarity, its breadth and reach and boldness—be taken as a metaphor? Does his system, his model that seems so art-like, throw up a metaphorical image? It would be against his intentions for us to focus on his model in any art-like or iconic way. Yet I cannot help wondering how this polished, many-faceted system, firmly anchored to truth and the rational, also forms a picture—a picture of consistency, toughness, and strength, firmly planted and impervious to the violent waves of the twentieth century (the image of Parmenides holding his ground in a torrent unleashed by Heraclitus comes to mind). And here we pass from Hobbesian metaphors into utopian ones. For if the rationality that saturates Davidson's system has not informed many of those actions recorded as historically significant, it remains potentially available.

We take Davidson's system for what its words mean, to be sure—but this is also how Davidson says we must take a metaphor. But beyond this, can we use it as one thing to see another? James Joyce saw history as a nightmare from which he was trying to awake, while the insomniac poet Delmore Schwartz amended this to history as a nightmare in which he was trying to get a good night's sleep. Either way we have the metaphor of nightmare as history. And the future, with its chilling demographic and ecological portents, its economic, technological, social, political, and moral crises darkening the horizon, promises to continue the nightmare unabated. Could Davidson's system be taken as a light that glows in the midst of this gloom? A light to be thrown on the nightmare of history: one metaphor to illuminate another.

It is too easy to see this glow as Hobbesian, as illuminating the play of the rational and irrational forces behind behavior that has resulted in the wreckage and smoldering death of our time. But perhaps it is too hard to take this light as utopian, as a potential force of resistance to be brought to bear in facing the darkness of the future. Such a hope appears dim.

In the 1955 film *Mr. Arkadian*, Orson Welles tells the story of a scorpion coming to a river and asking a frog to carry him across on his back (I paraphrase): "I don't think so," says the frog, "you would sting me and we would both drown." "Would that be logical, if I want to get to the other side?" asks the scorpion. "All right," agrees the frog, and they start across. In the middle of the river the frog feels a paralyzing sting. As they are going down the frog asks, "Was that logical?" "No," replies the scorpion, "but it is my nature—what could I do?" Clearly the story of the scorpion stands as both an example of a severely partitioned mind and a familiar historical parable.

In the end, Freud did not express a great deal of hope for rational actions predominating in our behavior. It is not necessary to posit an anthropology about human nature so much as to look at history to be in sympathy with

Freud. We hang suspended over the abyss of the future, hoping and waiting for rational solutions to appear, although none seem forthcoming. Freud did, however, offer some small personal hope that we could gain a degree of insight and rein in some of our irrational "acting out" behavior.

There is no implication in Davidson's broad view—across that holistic interlocking operation of desire and action and belief and truth—for a kind of therapeutic rationality. The rational is normative in Davidson's system only as a set of logical relations. The dynamics of the agent's development and how the irrational comes to be formed or to what degree it encroaches on his more intentional behaviors lie outside of Davidson's system. As Marcia Cavell has said, "Just how these older structures [the agent's early repressed fears and fantasies] impinge on behavior, and the extent to which, when they do, they modify the agent's responsibility for his activity, are complicated questions"[16]

Philosophy, as Marx complained, sets out to understand the world and not to change it. In this sense Davidson's model remains outside history, casting a faint glow on its dark flank. But to take this reflected light as either ironic or utopian is to misread the hard-headed stance of this system—a system that does not budge from resisting both relativism and skepticism, one that places the concept of truth at the core of our comprehension of one another. As we wade into the dark and turbulent future we would do well to hold on to these notions, which, delivered as philosophical insights with aesthetic polish, are also, beneath their logic, moral assumptions.

ROBERT MORRIS

GARDINER, NEW YORK
APRIL 1996

NOTES

1. Donald Davidson, personal communication.

2. Donald Davidson, personal communication.

3. Donald Davidson, "Paradoxes of Irrationality," *Philosophical Essays on Freud*. Ed. R. Wollheim and J. Hopkins. New York and Cambridge: Cambridge University Press, 1982.

4. Ibid.

5. Marcia Cavell, *The Psychoanalytic Mind* (Cambridge, Mass., and London: Harvard University Press, 1993).

6. Davidson, "Paradoxes of Irrationality."

7. Davidson, "Paradoxes of Irrationality."

8. Donald Davidson, correspondence with the author.

9. Donald Davidson, "On the Very Idea of a Conceptual Scheme," *Truth and Interpretation* (Oxford: Clarendon Press. 1984).

10. Donald Davidson, "Locating Literary Language" (University Park, Pa: Pennsylvania State University Press, 1993).

11. Boundaries here are not hard and fast. Undoubtedly art and literature infiltrate the borders of both the rational and the irrational. Freud considered the territory of irrationality and primary process the base for creativity and art making. But clearly there is much in the construction process and the strategies of art that demands rational procedures that lie beyond whatever wellspring of the irrational can be claimed for the origins of art.

12. Donald Davidson, "James Joyce and Humpty Dumpty," *Midwest Studies in Philosophy* 16 (1990): 1–12.

13. Donald Davidson, "A Nice Derangement of Epitaphs," *Truth and Interpretation,* ed. Ernest LePore (Oxford: Basil Blackwood, Ltd., 1986).

14. Donald Davidson, *Essays on Actions and Events* (Oxford and New York: Oxford University Press, 1980).

15. Donald Davidson, "What Metaphors Mean," *Inquiries into Truth and Interpretation* (Oxford: Clarendon Press, 1978).

16. Cavell, *The Psychoanalytic Mind.*

One of Robert Morris's "Blind Time Drawings with Davidson" is reproduced on the following page, courtesy of the artist. The original picture is 41 x 53 inches. The text under the picture reads:

While working blindfolded a scrap of paper is dropped on the page and the fingers search it out. When found the scrap is rubbed with a blackened towel and its position fixed. This process is repeated for a certain estimated time.

Time estimation error: -23'

"The mode of inference carries over directly to causal statements. If it was a drying she gave herself with a coarse towel on the beach at noon that caused those awful splotches to appear on Flora's skin, then it was a drying she gave herself that did it; we may also conclude that it was something that happened on the beach, something that took place at noon, and something done with a towel, that caused the tragedy. These little pieces of reasoning seem all to be endorsed by intuition, and it speaks well for the analysis of causal statements in terms of events that on that analysis the arguments are transparently valid."
—Donald Davidson

REPLY TO ROBERT MORRIS

I am caught off-guard by Robert Morris when he takes my "system", or any-way the structure of related ideas and theses that has emerged in my writings, as an artistic construction, much as I took what I thought of as "philosophies" when I was younger. Unlike my adolescent self, however, Morris understands the problems I have been trying to solve, for he is a philosopher as well as an artist. It lifts my heart that he sees little difference between making art and doing philosophy. Like Leonardo da Vinci, he could say, "Painting is philosophy which is seen and not heard, and philosophy is painting which is heard but not seen." Of course, some art is heard, and some philosophy is not heard. The point remains: the philosophic and the aesthetic are two ways of approaching many of the same objects and activities, and there is often no point in trying to disentangle the two ways. Ben Jonson had it wrong when he said, "Of the two, the Pen is more noble, then the Pencill. For the one can speak to the Understanding; the other, but to the Sense."

Morris has made more than two score large drawings on which he has subscribed a paragraph or so from my essays. The drawings are all black on white, and he made them with his eyes closed, blind. Even without the philosophical quotations, these drawings would count as conceptual art, for Morris has also appended a description of the explicit task he set himself. Calvin Tomkins says the conceptual approach defines art "as a mental act rather than a visual one." Morris gives us a choice. We can read his task and then look if we want to see how the performance came out. What more explicit demonstration could there be of the idea of falling (or failing to fall) under a description, or of an action fulfilling (or partly fulfilling), an intention?

All art is conceptual. We are conceptualizing creatures: no matter what we see, we see it as one thing or another. As a duck or as a rabbit. It isn't art un-less we see it as art. So any viewing of art is a mental act as well as a visual act. Duchamps's urinal, which Tomkins was talking about, invites us to see as art something we would not usually see in those terms. The effect of Morris's "Blind Time Drawings with Davidson" is more complex. He invites

us to see as art something which he couldn't see when he made it, and in this case it really is art, made by the artist, and strikingly beautiful. He also invites us to look at philosophy as an aesthetic object, an idea he has spelled out for us in this essay. The philosophy in turn asks us to view the drawing in the light of the ideas it expresses. I have tried to explore one way in which it does this in "The Third Man" (Davidson 1992).

What interests me most about Morris's work as a whole is how it turns the spectator into a collaborator, not just by forcing or tempting or seducing him into inventing a way of seeing or thinking, but by engaging him in an exchange, a dialogue, with the artist. This was something I found in Joyce's writing: if the reader wanted to understand the text, he had actively to join Joyce in inventing a new language. Because we know Morris made his drawings with his eyes closed, and we know what he was attempting, we look at the result just as he must have: we share his surprise and pleasure, having taken part in the creation. I am reminded of the triangulation which, by collating the responses of two or more people to the same objects, makes it possible to regard the objects objectively, as existing independently of our interest in them. Writers and artists have the problem that they tend to disappear behind their works leaving the reader or viewer alone with an object, thus putting the work into a kind of limbo, its location and aetiology unknown or obscure. Plato, a master of the dialogue which by its nature tries to gather the reader into the discussion, complained that nothing written could answer the reader back. Wittgenstein's writings often succeed in putting the reader's questions and doubts into words. When this works, the reader feels he has engaged directly with Wittgenstein's own thoughts and doubts. Morris, by closing his eyes, prompts us to join him in trying to follow his written instructions. It should not surprise us that Morris has done a series of drawings each of which includes a quotation from Wittgenstein. Perhaps it is a coincidence, but both the drawings with my texts, and the Wittgenstein drawings are black and white. Joseph Brodsky wrote that "One is grateful for a black-on-white photograph, for it unleashes one's fantasy, one's intuition, so that viewing becomes an act of complicity: like reading" (Brodsky 1995, p. 275).

D. D.

REFERENCES

Brodsky, Joseph. 1995. *On Grief and Reason*. New York: Farrar Straus Giroux.
Davidson, Donald. 1992. "The Third Man." In *Robert Morris: Blind Time Drawings with Davidson (catalogue)*. Allentown, Pa.: The Frank Martin Gallery, Mühlenberg College.

5

Barry Stroud

RADICAL INTERPRETATION AND PHILOSOPHICAL SCEPTICISM

I

There is a very general philosophical question which asks how, on the basis of what human beings get through the senses, they can ever have good reason to accept the beliefs, hypotheses, and theories they hold about the world. What is in question are the credentials or the degree of well-foundedness of what is taken to be a fully-formed conception of the world and our place in it, as embodied in everything we believe. To show how (or which of) those beliefs amount to knowledge, or to beliefs we have good reason to hold, would be to explain, philosophically, how knowledge of the world is possible. If there are no such reasons, or our best reasons are inadequate, scepticism is the right answer; we do not know what we think we know.

Donald Davidson regards this philosophical question as misguided. He thinks that if we understood better how we could even be in a position to ask it, we would see that it can present no threat of general scepticism. In this respect, his approach is akin to that of Kant. Kant thought an understanding of the possibility of thought and experience in general was essential to, perhaps sufficient for, an understanding of the possibility of knowledge. This idea too is present in Davidson.

Kant found that what had been seen as potential obstacles to our knowledge of the world were demonstrably illusory and so posed no real threat. They rested on the assumption that each person can know what

experiences, thoughts, and beliefs he has while leaving open the question whether he has reason to believe anything about the world around him. But experience and knowledge of things in the independent world was for Kant a condition of making sense of oneself as having any experiences, thoughts, and beliefs at all. Davidson too argues against the alleged priority of knowledge of one's experiences or the contents of one's own mind over knowledge of the "external" world. By reflection on what we must know in order even to understand the question from which traditional "empiricist" epistemology appears to begin, he concludes that there can be no genuine barriers to knowledge of the world.

This seems to me by far the most fruitful and most promising general strategy for getting to the bottom of the appeal and frustration of philosophical scepticism. The distinctive Kantian concern with the sources of the very idea of an objective world promised real progress. But Kant's own treatment of objectivity ended up with something that looks like a typically philosophical theory of knowledge after all. Not content with securing the invulnerability of our knowledge against sceptical attack, he argued positively that our having a conception of a world and of ourselves as potential knowers of it is enough in itself to guarantee that the world must be in general just as we believe it to be. This too is a line of argument Davidson appears to pursue. Kant thought it was something he could prove, and the proofs were to proceed a priori, independently of all experience. He then felt the understandable need to explain how such a priori knowledge of the world is possible. It turned out that the only explanation was "transcendental idealism"; we can have a priori knowledge of the world only because the world we know in that way is in some sense "constituted" by the possibility of our knowing it. "Idealism" had to be true if there was to be a satisfactory explanation of how human knowledge of the world is possible.

Davidson's exposure of the ineffectiveness of philosophical scepticism is in a very broad sense Kantian. The outcome, if correctly reached, would be philosophically reassuring. I want to ask how far he goes, or how far must he go, in a Kantian direction for his anti-sceptical strategy to succeed. What exactly can be established along Davidson's lines about the invulnerability of our knowledge of the world? And is there an idealist price to be paid for whatever invulnerability can be secured in that way?

II

I am primarily concerned with the status of Davidson's conclusion, and with its implications, so I will accept more or less without question the reasons he gives for it. His starting-point, like Kant's, is distinctive in bringing to the

center of philosophical attention the conditions of our having the very beliefs that constitute the subject-matter of the traditional epistemological assessment. Anyone who asks or wonders whether he has any reason to think that his beliefs are true must have some idea of what beliefs are. To have the concept of belief is to possess a certain capacity, including the capacity to ascribe beliefs to people under the appropriate conditions—to know when to assert things which in English can be rendered in sentences of the form 'a believes that p'. That involves ascribing a belief with some determinate content; to believe is to believe *that* something or other is so. A sentence in the declarative or indicative mood which is intelligible to the ascriber must appear in the place of 'p' in his sentences of the form 'a believes that p'.

Davidson explores what is involved in ascribing beliefs with determinate contents, and what a person has to do, think, or know in order to have the concept of belief. From the conditions he identifies he derives the conclusion that "belief is in its nature veridical".[1] That is what is meant to block any threat of general scepticism and to erase any potentially troubling epistemological challenge. Whether that conclusion sustains those reassuring results depends on exactly what "belief is in its nature veridical" means and how it is supported. "Belief can be seen to be veridical", Davidson holds, "by considering what determines the existence and contents of a belief".[2] And that in turn can be seen by understanding the conditions of correct attribution of beliefs and other propositional attitudes. It is a matter of the successful "interpretation" of one person by another.

Interpretation requires that the person to be interpreted do or produce something that can be treated as an utterance—something to be interpreted. The interpreter must recognize that the speaker takes a certain attitude to what he produces; he holds something to be true, for instance, or he prefers something to be true rather than something else. If some such attitude is discoverable, the interpreter's easiest road into the thoughts of others is to start from those things which a speaker assents to, or holds true, or prefers true, on particular types of occasion but not always. Because what is so can be seen to change from occasion to occasion, and assent and dissent can be seen to change with it, the interpreter can ascertain the conditions under which sentences of that kind are assented to or held true, and the conditions under which they are not. He can then hazard hypotheses as to what causes the speaker to assent to or to dissent from the sentence in those circumstances. And that provides him with the meaning of that sentence.

Identifying the cause of a speaker's utterance or assent for the purposes of interpretation involves more than simply finding some cause or other. There will be many different causes in each case, all of which initiate causal chains leading up to the utterance. Some of those chains begin at different points inside the speaker's body; other longer chains start earlier and so contain those

shorter chains as parts. Some even longer chains begin in prehistoric times; others begin later but still many years before the utterance. The interpreter must pick out one cause, and he does so by responding himself to something in the environment and so converging on a common cause both of his own response and of the utterance or assent of the speaker. By correlating the two he gives content to the speaker's utterance. He makes sense of what he recognizes as instances of the same kind of utterance on the part of the speaker by connecting them with what he recognizes as instances of the same kind of object or event in the world which he and the speaker are both interacting with. And his recognition of that recurrent aspect of the world is marked by an actual or potential utterance of his own. Davidson sums up the situation this way:

> Without this sharing of reactions to common stimuli, thought and speech would have no particular content—that is, no content at all. It takes two points of view to give a location to the cause of a thought, and thus to define its content. We may think of it as a form of triangulation: each of two people is reacting differentially to sensory stimuli streaming in from a certain direction. If we project the incoming lines outward, their intersection is the common cause. If the two people now note each other's reactions . . . each can correlate these observed reactions with his or her stimuli from the world. The common cause can now determine the contents of an utterance and a thought. The triangle which gives content to thought and speech is complete. But it takes two to triangulate. Two, or, of course, more.[3]

With the sentences directly correlated with certain kinds of stimuli handled in this way, those sentences that a speaker will continue to assent to through obvious changes in local circumstances can be understood through their connections with these basic "occasion" sentences. One sentence is connected with others through their shared parts and their grammatical and logical relations. Beliefs and meanings of utterances with internal structure are ascribed to speakers only holistically, as part of a large body of beliefs or meanings.

III

One immediate consequence of these conditions of interpretation is that an interpreter cannot find speakers to have beliefs without himself having an opinion as to their general truth or falsity. In order to interpret, he must be able to notice that speakers hold certain sentences true, and, at least with respect to sentences directly correlated with current stimuli, he must be able to notice the occasions on which speakers do and those on which they do not have that attitude to those sentences. For that he himself needs beliefs about

what is so on those occasions. He needs both beliefs about the world and beliefs about the beliefs of others. His having views about what beliefs speakers hold therefore could not leave open for him any serious question as to the truth-values of most of the beliefs he thinks they hold. Their holding the beliefs they do could not be in that sense "epistemically prior" for him to the truth or falsity of those beliefs. But no one could have thoughts or beliefs of his own unless he were subject to interpretation by others with whom he is or could be in communication.[4] So even to have beliefs is to be capable of attributing beliefs to others, and so to have beliefs about what others believe as well as about what is so. The three kinds of belief are interdependent. Without any one of them, one could not match others' beliefs with conditions in the world and so with beliefs of one's own, so one could not attribute to anyone beliefs with determinate content.

The "triangulation" that Davidson sees as essential to thought therefore stands in the way of any line of thinking that would accord "epistemic priority" to one's own thoughts or beliefs over truths about the world, or to truths about the observable world over truths about the contents of the minds of others. There can be "no 'barriers', logical or epistemic, between the three varieties of knowledge".[5] But with no barriers or relations of priority between sets of beliefs of those different kinds no serious argument for epistemological scepticism in its traditional forms could get off the ground. That is why Davidson holds that "if I am right that each of the three varieties of empirical knowledge is indispensable, scepticism of the senses and scepticism about other minds must be dismissed".[6]

That negative result, if secured, would seem enough in itself to remove the threat of epistemological scepticism. But Davidson finds behind the persistent idea of levels of epistemic priority an unquestioned assumption which remains a standing invitation to the traditional epistemological question and so to its inevitably sceptical outcome. It is the assumption that "the truth concerning what a person believes about the world is logically independent of the truth of those beliefs".[7] If that were so, it would always seem to make sense to ask, of a given set of beliefs, whether any of them are true, and to entertain the possibility that all of them are false even though they are all held to be true. Davidson wants to show that the assumption is not correct; its acceptance is the source of the fatal epistemological step. He thinks that, given what beliefs are and how their contents are determined, the truth of everything we believe is not in general "logically independent" of our having those very beliefs. It is in that sense that "belief is in its nature veridical". Of course, any particular belief may be false even though it is held to be true. But it does not follow that *all* our beliefs might be false. Not only does Davidson reject that inference as fallacious, he holds in addition that its conclusion is not true. "Nor could it

happen", he says, "that all our beliefs about the world might be false".[8]

The idea of the essential "veridicality" of belief, or of the "logical" dependence of beliefs upon their truth, is expressed at different times in different ways. They are probably not all equivalent. Nor are they all fully satisfactory as they stand. To say that *most* of interpreted speakers' beliefs must be true would seem to require some way of counting beliefs, which is not an encouraging prospect. To say that falsity is attributable only "against a background" or "in a setting" of largely shared or true belief remains largely metaphor, if it is not explained in terms of numbers of beliefs. To say that successful interpretation shows that there is "a general presumption of truth for the body of belief as a whole",[10] or that "there is a legitimate presumption that any one of [a person's beliefs], if it coheres with most of the rest, is true",[11] seems in a way too weak. It could be said that anything that is believed has some presumption in its favor, simply by being believed by someone. But presumptions can be overturned, and to say that in interpretation *not all* of them could be overturned, or that even after revision *most* of them must be left standing, seems once again to revert to counting.

The differences among these formulations of the point do not matter much for my purposes here. Nor does the precise scope of possible falsity. We can still concentrate on the central idea that the way the contents of beliefs are determined puts certain limits on the extent of falsity that can be found in a coherent set of beliefs. Even with the limits left vague we can still ask about the status of this conclusion, and about the extent of its anti-sceptical consequences.

IV

The first step towards determining what those consequences are is to see that what is deduced from the conditions of interpretation so far is a conclusion about what a successful interpreter will or must find.

> What should be clear is that if the account I have given of how belief and meaning are related and understood by an interpreter [is correct], then most of the sentences a speaker holds to be true . . . are true, at least in the opinion of the interpreter.[12]

> Nor, from the interpreter's point of view, is there any way he can discover the speaker to be largely wrong about the world.[13]

> It is an artifact of the interpreter's correct interpretation of a person's speech and attitudes that there is a large degree of truth and consistency in the thought and speech of an agent. But this is truth and consistency by the interpreter's standards.[14]

> From the interpreter's point of view, methodology enforces a general presumption of truth for the body of beliefs as a whole.[15]

To speak of "the interpreter's point of view" or "standards" or "opinion" is presumably to speak of what the interpreter finds or believes. The method of interpretation "enforces" on any successful interpreter the conclusion that his speakers' beliefs are largely true.

The point is worth stressing because Davidson sometimes seems to endorse what looks like a stronger conclusion. He holds that "a correct understanding of the . . . propositional attitudes of a person leads to the conclusion that most of a person's beliefs must be true". That is perhaps ambiguous as between a weaker and a stronger reading. But he also says that it simply could not happen "that all our beliefs about the world might be false";[16] any view of the world shared by communicating speakers and interpreters "must, in its large features, be true";[17] and "it is impossible for all our beliefs to be false together".[18] This appears to say more than something about what successful interpreters will or must find, or what those who recognize others as having beliefs about the world must inevitably believe. It seems to imply not only that those who understand one another must be in agreement as to what the world is like, but that the world must be in general the way any agreeing believers believe it to be. "Belief is in its nature veridical" would then mean that *any* coherent and comprehensive set of beliefs must be largely true; their being largely true is implied by their being the beliefs that people hold. What is so could not possibly diverge in general from what is widely believed to be so.

That reading of "belief is in its nature veridical" is most strongly suggested by what Davidson says when he applies his theory of interpretation directly to the threat of scepticism. It is perhaps most explicit in the conclusion he draws from the "triangulation" that gives content to thought and speech.

> It should now be clear what ensures that our view of the world is, in its plainest features, largely correct. The reason is that the stimuli that cause our most basic verbal responses also determine what those verbal responses mean, and the content of the beliefs that accompany them. The nature of correct interpretation guarantees both that a large number of our simplest beliefs are true, and that the nature of those beliefs is known to others. Of course many beliefs are given content by their relations to further beliefs, or are caused by misleading sensations; any particular belief or set of beliefs about the world around us may be false. What cannot be the case is that our general picture of the world and our place in it is mistaken, for it is this picture which informs the rest of our beliefs, whether they be true or false, and makes them intelligible.[19]

There is a way of taking what Davidson says here in which it does not really endorse what I am calling the stronger reading. The important fact about

belief to which he draws attention is something that "we can be led to recognize by taking up . . . the interpreter's point of view".[20] And it could well be that in drawing the conclusion he does he is simply announcing what he finds (and anyone would find) on taking up an interpreter's point of view with respect to his fellow human beings. If he is right about the conditions of interpretation, no interpreter will be in a position to find all or most of the beliefs he ascribes to people false. So Donald Davidson in particular will find himself in that position as an interpreter, and can announce his results accordingly. That could be what he is doing when he says "our view" or "our general picture of the world" cannot be false. After carrying out or imagining an interpretation of a group of speakers it would be perfectly understandable to report one's discovery by saying "most of their beliefs are true", or even "most of their beliefs must be true" or "it is impossible for most of their beliefs to be false". Given that one has ascribed a set of beliefs to those speakers, that would be a way of expressing the fact that one's finding most or all of those attributed beliefs to be false is inconsistent with one's having found the people in question to have those very beliefs.

That inconsistency is a consequence of the conditions of interpretation as described so far. It implies that "belief is in its nature veridical" in the sense that belief-attribution is in its nature (largely) truth-ascribing: an interpreter must find the beliefs he ascribes to be largely true. But that is not what I am calling the stronger reading of that thesis. The admitted necessity of finding largely true beliefs among the beliefs one attributes does not imply that the beliefs one attributes are in fact largely true. What a successful interpreter concludes ("Most of their beliefs are true") is a conclusion anyone must draw about his fellow human beings after having taken up the interpreter's point of view towards them. But it does not follow that "Most of their beliefs are true" states a necessary condition of successful interpretation or of human beings' having any beliefs at all.

When he seems to be asserting the stronger claim Davidson does not always appear to be drawing a conclusion from his having interpreted his fellow human beings as they actually are. He says that the truth of a large number of our beliefs is "guaranteed" by "the nature of correct inter-pretation".[21] That is true if "correct interpretation" is interpretation carried out by interpreters whose beliefs about the world are all or mostly true. The truth of the beliefs they attribute is "guaranteed" by the conjunction of the weaker thesis that belief-attribution is in its nature (largely) truth-ascribing and the assumption that the beliefs of the interpreters are largely true. If an interpreta-tion is "correct" in that sense, the attributed beliefs must be largely true. But the stronger reading is the consequent of that conditional proposition, taken on its own. It says that any large and comprehensive set of beliefs must be largely true—that every interpretation of such a set of beliefs must be a

"correct" interpretation in the sense specified. That stronger thesis does not follow from the conditions of interpretation accepted so far. It would be true if being a "correct" interpretation in the sense specified were itself a condition of being an interpretation. That is in effect what the stronger reading says. But that is not supported by what has been said so far about the nature or conditions of interpretation.

What we have so far seen to be "guaranteed" or "methodologically enforced" by the nature or conditions of interpretation is that if a successful interpreter believes that speakers believe that p, that speakers believe that q, that speakers believe that r, and so on, then in general or in large part that interpreter will also believe that it is true that p, true that q, true that r, and so on. He and the speakers he interprets will be largely in agreement. But that what he and those speakers all agree about *is* in fact in general true is a further step beyond the fulfillment of that admitted condition. Of course, the interpreter will *regard* everything they all agree about as true, just as the other speakers will. But that is not something that the nature of interpretation is needed to guarantee. Any believer regards as true whatever he fully believes. But from that it does not follow that what many believers agree about is all or mostly true.

The truth of most or all of what believers believe does of course follow from *what* a successful interpreter of those believers believes. In interpreting them, he comes to believe that they believe that p, that they believe that q, that they believe that r, and so on, and (in the case of complete agreement) he himself also believes that p, that q, that r, and so on. So from everything he believes it follows that those speakers' beliefs are true. But again the nature of interpretation is not needed to secure that conclusion. It is guaranteed by the fact that any statement of what a person believes, together with the statement that he believes it, implies that the person's belief is true. An interpreter believes:

(1) They believe that p, they believe that q, they believe that r.
(2) p and q and r.

It follows from (1) and (2) that those speakers have true beliefs. But that implication neither supports nor relies on the idea that "belief is in its nature veridical" in the stronger sense. It holds whether or not the beliefs in question are in fact true.

V

Perhaps the clearest indication that Davidson endorses the stronger reading is that he explicitly takes up the issue of why it could not happen that speaker

and interpreter understand one another on the basis of "shared but erroneous beliefs". He argues that that "cannot be the rule";[22] "massive error about the world is simply unintelligible";[23] the beliefs in question must be largely true beliefs. The argument invokes the idea of an interpreter who is "omniscient about the world, and about what does and would cause a speaker to assent to any sentence in his (potentially unlimited) repertoire".[24] It is clear that such an interpreter, like any interpreter, would find the speakers he interprets to be largely correct. Since by hypothesis what that interpreter believes about the world is true, those speakers would in fact be correct in most of their beliefs. If the "omniscient" interpreter turned his attention to an ordinary, fallible interpreter at work among those speakers, he would find that interpreter also to be largely correct about the world. And by hypothesis he would be correct. But then that "fallible" interpreter could not possibly be sharing with those he interprets a body of erroneous beliefs. His beliefs would not be largely erroneous; and those are the very beliefs he must share with those he interprets.

I do not see that this thought-experiment as described adds anything to what has already been accepted as a condition of interpretation: that belief-attribution is in its nature (largely) truth-ascribing. It is true that an interpreter who was right in everything he believed about the world would attribute to the speakers he interprets beliefs that are in fact true. But in imagining such an interpreter we are simply adding to the already accepted requirement that the interpreter himself must have beliefs about the world the further thought that in this case those beliefs are all true. And that is how each of us regards all our own beliefs, even without thinking of ourselves as omniscient. We each say of ourselves, as we can say of the imagined interpreter, that *if* our beliefs are all true, as we think they are, then anyone we interpret and understand will also have largely true beliefs.

If the "omniscience" of the imagined interpreter meant that he simply *could not* get things wrong about the world, then of course we would be thinking of him in a way we do not think of ourselves. But omniscience in that sense seems to play no role in Davidson's story. He draws only on the fact that the "omniscient" interpreter's beliefs about the world are all true. Of course, Davidson does not claim that there actually is such an interpreter; he holds only that if there were, all those he interpreted would also be right about the world. But that same conditional thought is a thought we have about ourselves, or about anyone, with no mention of omniscience. *If* a person's beliefs about the world are true, then given that belief-attribution is largely truth-ascribing, anyone he interpreted would also have true beliefs about the world. Imagining an "omniscient" interpreter adds nothing to that point.

Davidson once even seemed to suggest that the mere fact that "there is nothing absurd in the idea of an omniscient interpreter" was enough to show

that "massive error about the world is simply unintelligible":

> for to suppose it intelligible is to suppose there could be an interpreter (the omniscient one) who correctly interpreted someone else as being massively mistaken, and this we have shown to be impossible.[25]

I do not think the invocation of an omniscient interpreter establishes the conclusion here either. It is admittedly impossible for an interpreter to interpret speakers as massively mistaken. But to suppose it intelligible or possible for speakers to be massively mistaken is to suppose only that it is intelligible or possible in general for there to be speakers who have beliefs about the world around them that are all or largely false. To suppose that that is possible is not necessarily to suppose that one has carried out an interpretation on some speakers and found their beliefs to be largely false. If Davidson is right about the conditions of interpretation, that cannot be done. So in acknowledging the mere possibility of massive falsity of some speakers' beliefs one need not be in a position to say what any of those speakers' beliefs are. But that alone does not rule out the abstract possibility. Nor is granting that there *could* be an interpreter who is omniscient about the world incompatible with there being speakers with largely false beliefs. What is ruled out is an omniscient interpreter's having interpreted those speakers and identified their beliefs as all or mostly false. But that is ruled out by the supposition that one has interpreted those speakers oneself, or that anyone has. No one could have done so while finding those identified beliefs to be mostly false, if Davidson is right. But that does not show that the thought of there being a set of beliefs that are all or mostly false is itself an impossibility or a contradiction.

One conclusion Davidson draws from his speculation about an "omniscient" interpreter does seem to me warranted, taken strictly as he expresses it.

> Once we agree to the general method of interpretation I have sketched, it becomes impossible correctly to hold that anyone could be mostly wrong about how things are.[26]

If belief-attribution is in its nature (largely) truth-ascribing, then no one who carries out an interpretation could correctly hold both that the speakers he has interpreted have such-and-such beliefs, and that those beliefs are all or mostly wrong. The conditions of interpretation, if Davidson is right about them, rule that out. That is to say, the verdict "Those speakers believe that p, believe that q, believe that r, and so on, and all or most of those beliefs are false" is not something that a successful interpreter could consistently believe about a set of attributed beliefs. Ascribing beliefs to people is not consistent with ascribing falsehood to all or most of them. But that is not to say that that

impossible-to-reach verdict states something which could not possibly be true. That is what is implied by "belief is in its nature veridical" on the stronger reading: no body of beliefs could be all or mostly false. I do not think that stronger conclusion is implied by anything Davidson says about an omniscient interpreter. And the weaker conclusion about belief-attribution is validly drawn from the conditions of ordinary or "fallible" interpretation, with no reliance on omniscience at all.

VI

If the stronger thesis is to be guaranteed by "the nature of correct interpretation" alone, then, it must be drawn from some conditions of interpretation beyond those described so far. We have seen so far that an interpreter must have beliefs about the world, and that those beliefs will in large part agree with the beliefs he attributes to those he interprets. That is because of the importance of causality. Davidson says we cannot:

> in general fix what someone means independently of what he believes and independently of what caused the belief. . . . we can't in general first identify beliefs and meanings and then ask what caused them. The causality plays an indispensable role in determining the content of what we say and believe.[27]

He sometimes describes that role by saying that, at least for simple occasion sentences, "the stimuli that cause our most basic verbal responses also determine what those responses mean, and the contents of the beliefs that accompany them".[28] This in turn is meant to carry the implication that whatever any group of speakers' beliefs happen to be, they simply have to be largely true:

> as long as we adhere to the basic intuition that in the simplest cases words and thoughts refer to what causes them, it is clear that it cannot happen that most of our plainest beliefs about what exists in the world are false.[29]

The beliefs in question cannot be false because, if they were, they would not have been held; what in fact caused those beliefs would not have been so. And if it had not been so, it could not have caused them.

> If anything is systematically causing certain experiences (or verbal responses), that is what the thoughts and utterances are about. This rules out systematic error.[30]

This description of the role of causality seems to say that it is not the responses of an interpreter that determine the meaning of a speaker's utterance and so the content of his belief, but that, at least for a sentence directly correlated with current stimuli, it means whatever in fact causes it. This must be understood in the light of Davidson's insistence that communication and

mutual understanding among speakers are necessary for meaning and thought. What an utterance means cannot be identified simply as *the* cause of the utterance. For one thing, there are too many available causes, all along an indefinitely extended causal chain. Since there must be convergence on a common cause between two or more speakers, an utterance's meaning what it does involves both speakers' and interpreter's responses. For the indispensability of causality directly to support the stronger reading of the impossibility of massive falsity, then, there would have to be no possible difference between what in fact cause verbal responses and what an interpreter takes their causes to be. This is perhaps what Davidson is getting at in the sentence I have italicized here:

> What stands in the way of global skepticism of the senses is, in my view, the fact that we must, in the plainest and methodologically most basic cases, take the objects of a belief to be the causes of that belief. *And what we, as interpreters, must take them to be is what they in fact are.* Communication begins where causes converge: your utterance means what mine does if belief in its truth is systematically caused by the same events and objects.[31]

It is not easy to find good reasons for holding that what an interpreter takes the cause and so the meaning of an utterance to be *must* be what is in fact the cause of that utterance. Davidson at one point appeals to the conditions of interpretation. If utterances mean what causes them, he says:

> it is clear that it cannot happen that most of our plainest beliefs about what exists in the world are false. The reason is that we do not first form concepts and then discover what they apply to; rather, in the basic cases the application determines the content of the concept. An interpreter who starts from scratch—who does not already understand the language of a speaker— cannot independently discover what an agent's beliefs are about, and then ask whether they are true. This is because the situations which normally cause a belief determine the conditions under which it is true.[32]

This appears to be an explanation of why utterances mean what causes them and so why "it cannot happen that most of our plainest beliefs . . . are false". It appeals to the fact that an interpreter cannot discover what an agent's beliefs are without also believing that they are largely true. But that admitted impossibility does not itself imply that most or any of the attributed beliefs are true. Nor is the truth of most of an agent's beliefs needed to explain why interpreters "cannot independently discover what an agent's beliefs are about, and then ask whether they are true". That is explained by the fact that interpreters attribute beliefs only by correlating the utterances they interpret with conditions which they believe to hold in the world they share with their speakers; they cannot discover what those speakers' beliefs are without also believing certain things to be the causes of those utterances. That interpreters

must take the utterances to mean whatever in fact causes them, or that "the situations which normally cause a belief determine the conditions under which it is true", does not follow from, nor is it needed to account for, that condition of interpretation.

This is not to deny the importance of causality in interpretation. Interpretation always takes place in some setting or other, and there must be utterances or something similar to be interpreted. Those utterances, like everything else that happens, will all be caused to happen, and they can be interpreted only by an interpreter's connecting them with the world they are responses to—with what causes them. But on Davidson's view it takes more than an utterance's simply being caused for it to mean something, and more than that for it to mean what caused it. Everything that happens is caused, but not everything that happens means something, or means what caused it. Meaning and thought for Davidson require communication, and the "triangulation" he sees as essential to communication shows that the identification of meanings and thoughts "rests . . . on a social basis".[33]

This means that there is meaning and the expression of belief only where there is communication, not simply wherever there is causation of utterance. And there is communication only where there is expression of thought and belief, not mere utterance. If A hears B utter the sound 'Gavagai' in all and only those situations in which A would be caused to utter 'Rabbit', that alone does not give A an interpretation of B's 'Gavagai'. Even if what causes B's utterance is that there is a rabbit in the vicinity, and that too is what causes A to utter 'Rabbit', that still does not give A an interpretation of B's utterance. As described so far, it could just be parallel behavior, like two people caused to sneeze by all and only the same things. To reach an interpretation, A must believe on the appropriate occasions that there is a rabbit in the vicinity, and he must know that he himself is or would be expressing that belief in intentionally uttering 'Rabbit'. Noticing what is so when B intentionally utters 'Gavagai', he could then see that B makes that utterance because there is a rabbit in the vicinity, and so he could conclude that that is what B means by it. That is what it takes for B to be expressing the belief that there is a rabbit in the vicinity in making that utterance on that occasion.

What then does it take for A to have that belief, or to be expressing that belief in uttering his 'Rabbit', on that occasion? That is the same kind of question about A that A had about B. The answer is the same. A's simply being caused by the presence of a rabbit to utter 'Rabbit' does not imply that he means by it that there is a rabbit in the vicinity, or that he or it means anything at all. The question cannot be settled by considering only the single speaker A. "It takes two points of view to give location to the cause of a thought, and thus to define its content".[34] But "points of view" in the sense required here are not to be understood merely as spatial and causal positions

in the world. Two sneezers occupy different "points of view" on the common cause of their sneezing in that sense. "Points of view" relevant to meaning involve having perceptions and thoughts and beliefs. On Davidson's view thoughts with propositional content are present only if there is communication or reciprocal interpretation. At work in all such interpretation are beliefs on the part of an interpreter about the utterances of others, beliefs about their causes, and beliefs about his own beliefs. And since an interpreter has beliefs at all only because he communicates with others and is interpreted by them in turn, those others must have beliefs as well. It is what they all take to be the causes of their utterances that determines the interpretations they put upon those utterances and so what they mean. Causality is indispensable, but the notion of cause plays its role in interpretation within the scope of the psychological verbs expressing the propositional attitudes of interpreters and speakers. A interprets B by having beliefs about what causes B's utterances, and B does the same for A.

If A believes that an utterance by B is caused by the presence of a rabbit, and B believes that an utterance by A is caused by the presence of a rabbit, they could each attribute meaning to the other's utterance, and so ascribe to each other the belief that there is a rabbit in the vicinity. They could communicate with each other on that basis. That their utterances are in fact caused by the presence of a rabbit is not required in order for that communication to take place. That is to say, it does not follow from 'A believes that B's utterance is caused by the presence of a rabbit' and 'B believes that A's utterance is caused by the presence of a rabbit' that their utterances are caused by the presence of a rabbit. It does not follow from those two sentences that there is a common cause of A's and B's utterances at all, or even that each of their utterances singly is caused by something. Of course, we know that their utterances were in fact caused by something, given that everything that happens is caused by something. And in the example as described, we know that they had a common cause, the presence of a rabbit. But that alone is not sufficient to determine that their utterances mean that there is a rabbit in the vicinity. Another common cause of their utterances is the birth of that rabbit and its subsequent meanderings through space until it appeared before them. But that is not what their utterances mean. Their *taking* the common cause to be the presence of a rabbit is required for their each meaning that there is a rabbit. And it is possible for them to take that to be so without its being so. The presence of a rabbit does not follow from their both believing that the presence of a rabbit is the common cause of their utterances. That is what I mean by saying that it is at least possible for what interpreter and speaker take to be the cause of an utterance not to be the actual cause of that utterance. I do not mean to suggest that that often or even ever happens, especially where a large number of utterances and beliefs are concerned. The point is only that

the conditions of interpretation as Davidson describes them do not alone guarantee that what interpreters take the causes of utterances to be is what they in fact are.

If that were required for interpretation, it looks as if the stronger reading of "belief is in its nature veridical" would then be a consequence of the nature of interpretation; beliefs attributed on the basis of interpreted utterances would have to be largely true. But if it is not a necessary condition of interpretation that the actual causes of utterances are what interpreters and speakers take their causes to be, as I think it is not, the guaranteed truth of attributed belief is not supported by the conditions of radical interpretation as described so far.

<center>VII</center>

Rather than explore further conditions or further possible support for what I am calling the stronger reading of "belief is in its nature veridical", I want to conclude by explaining why I think Davidson need not, and I hope does not, accept that reading. I have said why I cannot see that it follows from his account of radical interpretation; nor is it needed to explain why the conditions of interpretation are what he says they are. What is more, I do not think it is needed to block the threat of philosophical scepticism in the highly promising way he has in mind; the weaker reading alone, and the conditions of interpretation as described so far, suffice. The stronger reading appears to involve the adoption of a standpoint on our knowledge of the world which many philosophers, including Kant, have certainly aspired to. One of the greatest merits of Davidson's position as I understand it is to show why there is no such standpoint.

Even the stronger reading according to which any reasonably comprehensive set of beliefs must be largely true would not refute philosophical scepticism in the sense of implying that what it says is false. Scepticism says that no one knows or has good reason to believe anything about the world, and "belief is in its nature veridical" does not imply the negation of that. It does not imply that those who hold largely true beliefs thereby *know* those beliefs to be true or have good reason to hold them. Not all true beliefs constitute knowledge. Davidson himself makes this point.[35] The strategy he envisages would therefore "serve to rescue us from a standard form of scepticism", but not by establishing its falsity.

A sceptical threat is generated in epistemology by a line of thinking which begins, innocently enough, with the uncontroversial thought that something's being so does not follow from its being believed to be so. The truth of something does not follow from everyone in the world's believing it, even

fully reasonably believing it, or their being completely unable to avoid believing it. When all our knowledge, or all knowledge of a certain general kind, is then brought under scrutiny, there is a move to the more general thought that everything we believe, or everything of the kind in question, could be false consistently with our believing it.[36] This thought alone does not amount to scepticism. It is at most the logical point that there is a failure of implication from beliefs to truth, and so in that sense a possibility that the beliefs we hold are all or mostly false. The epistemological challenge that is eventually raised is to explain how we know that that possibility is not actual: how we know that our beliefs are in fact true. Various sceptical considerations are introduced at that point to show, in one way or another depending on the case, why the question cannot be given a satisfactory answer.

The stronger reading of "belief is in its nature veridical" would block this line of thinking right at the beginning. On that reading it is *not* possible for all or most of a reasonably comprehensive set of beliefs to be false. So the thought from which the epistemological question is meant to arise would be a contradiction; what it says is possible would not really be a possibility at all. That would leave nothing intelligible that we could be pressed to show is not actual; we could never get as far as having to answer a question that sceptical considerations might show cannot be given a satisfactory answer. That really would eliminate any threat of philosophical scepticism from that quarter, but not by giving a reassuringly positive answer to the epistemological question. No such question would have been intelligibly raised.

I think this way with scepticism is too quick, and if it rests on the strong thesis that a set of all or mostly false beliefs is impossible, I think it is unsound. I think we must grant the abstract possibility of a set of beliefs' being all or mostly false in the minimal sense that the truth of all or most or even any of them does not follow simply from their being held.[37] To insist otherwise seems to me to threaten the objectivity of what we believe to be so. It would be to deny that, considered all together, the truth or falsity of the things we believe is independent of their being believed to be so. I think there are other good reasons for not accepting that stronger reading. But at the very least, if that thesis does not follow from Davidson's conditions of interpretation, as I have argued it does not, then this quick and decisive elimination of scepticism cannot be derived from the theory of interpretation alone.

What can be derived from the conditions of interpretation, if Davidson is right about them, is that belief-attribution is in its nature largely truth-ascribing. Anyone who believes people to have a specific set of determinate beliefs will take those beliefs to be largely true. An interpreter's verdict "Those people believe that p, believe that q, believe that r, . . . and all or most of those beliefs are false" is not something that anyone could consistently believe about a specified set of attributed beliefs. That is weaker than saying

that no comprehensive set of beliefs could possibly be all or mostly false, but I think it can still serve to block the potentially sceptical line of thinking right at the beginning.

An epistemological investigation of human knowledge is meant to examine the beliefs that human beings have actually got. The possibility from which the potentially threatening line of thinking begins is the possibility of our having all the beliefs we now have while they are all false. I think we must grant, as against the stronger reading, that there is a sense in which that is a possibility: the (for the most part) truth of our beliefs does not follow from our having them. But the possibility we grant has two parts. If we believe the first part—that we do have all the beliefs we now take ourselves to have—then we cannot consistently find the second part to be true—that those beliefs are all or mostly false. The conditions of belief-attribution require that the beliefs we find people to have are beliefs which we hold to be mostly true. If we found them all to be false, and so found the second half of the possibility to be true, we could not then consistently find the first part of that possibility to be true. We could no longer ascribe all those beliefs that we had originally ascribed. The possibility from which the sceptical line of thinking begins is therefore not one which anyone could consistently find to be actual. It involves the presence of certain specific beliefs, but attribution of those beliefs requires our finding them to be largely true. Believing a certain set of propositions to be all or mostly false precludes our assigning them as contents of the beliefs of any people we find to have beliefs.

An inquirer's relation to the apparently innocent possibility from which a sceptical threat is thought eventually to arise is therefore parallel to a speaker's relation to the possibility expressed in the paradoxical sentence 'I believe that it is raining, and it is not raining'. That is not something one could consistently believe or assert. But not because it is something that could not possibly be true. It is possible for a person to believe that it is raining when it is not raining. The first conjunct does not imply that the second is false; what the whole sentence says is in that sense a genuine possibility. But no one could consistently believe that that possibility is actual, that both conjuncts are true. If she believed the second conjunct—that it is not raining—she could not consistently believe that it is raining. If that first conjunct were true, and she did believe that it is raining, she could not then consistently believe that the second conjunct is true. There is a difference between something's being simply inconsistent or impossible (which someone's believing that it's raining, and its not raining, is not) and something's being impossible for anyone consistently to believe or discover.

If the apparently innocent possibility from which the epistemological reasoning would begin is not a possibility anyone could consistently believe to be actual, it can be eliminated from serious consideration right at the

beginning. There would be no need to insist on the stronger view that it is simply impossible for human beings to have a comprehensive set of beliefs that are all or mostly false. Even if the falsity of most or all of a set of beliefs is in general consistent with their being believed, the conditions of belief-attribution as Davidson describes them imply that there can be no potentially unanswerable epistemological challenge. For any specific set of beliefs we take ourselves to possess, the question "Given that the truth of those things we believe does not follow simply from our believing them, how do we know that they are not all or for the most part false?" presents no serious general threat. Not because we could not possibly fail to be right in whatever set of beliefs we happened to have. And not because we could determine, in some way other than by acquiring beliefs, that our beliefs are for the most part true. There can be no general threat because our considering the specific attributed beliefs we are asking about guarantees that we find those beliefs to be for the most part true. Our having them and their being all or mostly false is not a possibility we could consistently believe to be actual, so it is not a possibility we could be pressed to explain how we know is not actual.

That is not to say that we therefore *know* that all or most of the things we believe are true. That would be the negation of scepticism, and it does not follow from this anti-sceptical strategy. The goal is only to block a familiar route to scepticism, not to show that scepticism is false. A certain possibility is to be removed from consideration as the source of a potentially unanswerable threat. That would leave us just where we were, or just where we are now, with respect to knowing the things we think we know about the world.

Scepticism is a negative verdict on a body of putative knowledge made in that sense from a position outside it; none of the very beliefs in question can be appealed to in making the assessment. The denial or negation of scepticism would accordingly be a positive verdict on that body of knowledge made from that same position outside it. It would share with the scepticism it opposes a common question and so a common standpoint from which the question is asked; they would differ only in the answers they give to that shared philosophical question. But that philosophical question does not seem to be what we answer when we straightforwardly conclude after careful consideration that most of the things we now believe are true, or even that we know that they are. That mundane answer is given from within whatever knowledge we take ourselves to have at the time.

The great importance of concentrating as Davidson does on the conditions of thought and so of belief-attribution is that it promises to reveal how and why we could never intelligibly get ourselves into the kind of disengaged position from which the general epistemological question can be raised with its special significance and force. If that is so, we could never get as far as facing the philosophical challenge, let alone trying to construct a non-sceptical

answer to it. We can face a general challenge to our beliefs only if we take ourselves to have many beliefs. But we understand ourselves to have the beliefs we do only by for the most part endorsing them and so finding ourselves in a world in which they are largely true.

Kant's way of showing that no general epistemological challenge could arise resembled the stronger reading of "belief is in its nature veridical" in claiming that any world we could even so much as think of must possess certain very general structural features. He thought he could identify those features; in those fundamental respects, the world must be just as we believe it to be. That is why no coherent line of thinking could possibly bring those central parts of our conception of the world into question. The success of that strategy depended on there being necessary connections between the world's being thought of in those ways and the world's being those ways; the truth or falsity of those general structural beliefs could not be "logically independent" of their being held. And that was to be proved, as for Kant all necessities could be proved, only a priori.

One danger of all such proofs is their proving what turns out to be too much. It has turned out that some of the general features Kant thought he had proved to be present in any world that anyone can conceive of are not even present in this world. An opposite danger is not being able to reach the conclusions that the proofs purport to establish. From our thinking in certain ways it was to be deduced, by necessary steps, that things are that way. At the very least, some explanation is then needed of how such audacious conclusions could be reached. Kant had his explanation: a priori knowledge of the world is possible only because the world's being in general the way it is is dependent on the forms of human sensibility and thought. We can know a priori only that which is in some sense dependent on or "in us". That is a form of idealism, but since it is meant only to explain how any a priori knowledge is possible, it is "transcendental" idealism. It is a thesis assertable only from a position in which we comprehend the world as a whole, and all of human thought and belief about it, and see why the two must in general correspond. Kant's way of showing that we can never achieve a disengaged position from which a sceptical verdict on our knowledge of the world might be reached was to show that human knowledge of the world is possible only because we can achieve a disengaged position from which we can see that idealism is true.

If "belief is in its nature veridical" were true in its stronger reading, some comparable explanation would surely be needed of how and why such a remarkable thing must be true. If it followed from the conditions of belief-attribution alone, no further explanation would perhaps be needed, but I have argued that it does not follow. Any richer explanation would seem then to be answering a question which we could never get ourselves into a position to ask, if the conditions of belief-attribution are as Davidson describes them.

That is why I think his strategy against philosophical scepticism precludes acceptance of the stronger thesis linking every comprehensive set of beliefs with the world's being in general as those beliefs say it is.

Davidson appears to repudiate the disengaged question to which the stronger thesis would be an answer when he writes:

> Communication, and the knowledge of other minds that it presupposes, is the basis of our concept of objectivity, our recognition of a distinction between false and true belief. There is no going outside this standard to check whether we have things right, any more than we can check whether the platinum-iridium standard kept at the International Bureau of Weights and Standards in Sevres, France, weighs a kilogram. We can, of course, turn to a third party and a fourth to broaden and secure the interpersonal standard of the real, but this leads not to something intrinsically different, just to more of the same, though the augmentation may be welcome.[38]

If "there is no going outside this standard to check whether we have things right", there is presumably no "going outside" it even to assert that we have got things right, that our beliefs are for the most part true. We can of course assert the things we believe, and say something to the effect that all or most of our beliefs are true. And if we have to we can even check to see whether they are. But what we say at the end of all that is a straightforward verdict on how our beliefs have measured up to what we now find to be the way things are. It involves or leads to nothing intrinsically different from what we had before, but just to more of, and perhaps to a welcome improvement of, what we already believed.

For Davidson the key to understanding ourselves as having thoughts and beliefs is to understand ourselves as part of a community of persons with thoughts and beliefs.

> A community of minds is the basis of knowledge; it provides the measure of all things. It makes no sense to question the adequacy of this measure, or to seek a more ultimate standard.[39]

This seems to reject the possibility of what I have called a disengaged question about the truth or adequacy of our beliefs as a whole. If his account of the conditions of belief-attribution shows that it "makes no sense" to question the general "adequacy" of the "measure" provided by our necessarily largely shared conception of what is so, it should equally "make no sense" even to *assert* the "adequacy" of that "measure". That is what the stronger reading of "belief is in its nature veridical" would seem to do. It would be an attempt to assure us, quite independently of what our actual beliefs happen to be and how well they stand up to scrutiny, that we *must* be getting things for the most part right about the world. I think the conditions of radical interpretation support only the weaker but still powerful anti-sceptical conclusion that the question

of whether our beliefs are all or for the most part true cannot be consistently asked with the possibility of reaching a negative answer. In that way it "makes no sense" to ask the question. But we should not conclude that the answer to the question is therefore "Yes". The stronger reading sounds like a positive answer to that question. But it is a question that I think Davidson's theory of interpretation has the great promise of showing we could never be faced with.

BARRY STROUD

DEPARTMENT OF PHILOSOPHY
UNIVERSITY OF CALIFORNIA, BERKELEY
MARCH 1997

NOTES

1. "A Coherence Theory of Truth and Knowledge," D. Henrich, ed., *Kant Oder Hegel?* (Stuttgart: Kett-Cotta, 1983), p. 432.
2. Ibid.
3. "Three Varieties of Knowledge," A. Phillips Griffiths, ed., *A. J. Ayer: Memorial Essays* (Cambridge: Cambridge University Press, 1991), pp. 159–60.
4. See, e.g., "Thought and Talk," *Inquiries into Truth and Interpretation* (Oxford: Clarendon Press, 1984) p. 157; "Three Varieties of Knowledge," p. 160.
5. "Three Varieties of Knowledge," p. 161.
6. Ibid., p. 156.
7. Ibid., p. 154.
8. "Epistemology Externalized," *Dialectica* (1991): 193.
9. See, e.g., "The Method of Truth in Metaphysics," in *Inquiries into Truth and Interpretation*, p. 200.
10. "A Coherence Theory of Truth and Knowledge," p. 437.
11. Ibid., p. 431.
12. Ibid., p. 434.
13. Ibid.
14. Ibid., p. 435.
15. Ibid., p. 437.
16. "Epistemology Externalized," p. 193.
17. "The Method of Truth in Metaphysics," p. 199.
18. "A Coherence Theory of Truth and Knowledge," p. 438.
19. "Three Varieties of Knowledge," p. 160.
20. "A Coherence Theory of Truth and Knowledge," p. 435.
21. "Three Varieties of Knowledge," p. 160.
22. "A Coherence Theory of Truth and Knowledge," p. 435.
23. "The Method of Truth in Metaphysics," p. 201.
24. "A Coherence Theory of Truth and Knowledge," p. 435.
25. "The Method of Truth in Metaphysics," p. 201.

26. "A Coherence Theory of Truth and Knowledge," p. 435.

27. Ibid.

28. "Three Varieties of Knowledge," p. 160.

29. "Epistemology Externalized," p. 195.

30. Ibid., p. 199.

31. "A Coherence Theory of Truth and Knowledge," p. 436.

32. "Epistemology Externalized," p. 195.

33. Ibid., p. 201.

34. "Three Varieties of Knowledge," p. 159.

35. "A Coherence Theory of Truth and Knowledge," p. 438.

36. There are exceptions to this when what is believed is itself something about believings or believers. For example, since 'There are beliefs' or 'Somebody believes something' must be true if anybody believes anything, they could not be believed (or disbelieved) without being true. Similarly for everything that follows from such propositions.

37. I exclude exceptions of the kind mentioned in note 36.

38. "Three Varieties of Knowledge," p. 164.

39. Ibid.

REPLY TO BARRY STROUD

B arry Stroud emphasizes the difference between the claim that a correct understanding of the propositional attitudes of another person leads to the conclusion that most of that person's beliefs are true, and the claim that most of anyone's beliefs are in fact true, or, as I have put it, "belief is in its nature veridical". Stroud thinks the first claim may well be correct, but that we have no reason to think the second is. He holds that the second claim, which amounts to denying the most important form of scepticism, was a mistake of Kant's, and he hopes that I have not fallen into the same error. However, by quoting me he shows that I have, in this respect, followed Kant.

What is Stroud's own view? He thinks *anyone* who tries to show that scepticism is wrong must be making a mistake. If we have no reason to believe the world is as we think it is, then whether or not what we believe is true, we do not know that the world is pretty much as we think it is. And if we do not know this, it seems pointless to hold that we know anything at all about the world around us. It seems to me that any position that assumes, or leads to, this conclusion must be demanding more of knowledge than is justified.

That Stroud may be asking too much of knowledge is suggested by a number of his remarks. One is his repeated insistence that it is logically possible that all, or a preponderance, of one's beliefs are false. Of course this is right; it cannot be a logical truth that I or anyone else knows anything, since (among other things) it cannot be a logical truth that I or anyone else exists. If we have knowledge, any explanation of this fact must start with the fact that we exist, that we have thoughts, and that we are creatures with certain abilities and limitations. "It is not easy" Stroud writes, "to find good reasons for holding that what an interpreter takes to be the cause and so the meaning of an utterance to be *must* be what is in fact the cause of that utterance." (Italics in original.) No, logic alone can't provide such reasons. But change "must be" to "is", and I think there are good reasons. A little later Stroud repeats the point; my position doesn't "guarantee" that what interpreters take the causes of utterances to be is what in fact they are. What may be the basic point that separates us emerges best when he characterizes the "epistemological challenge" of scepticism (p. 155). Pointing out again the "logical possibility" that

all our beliefs are false, the challenge is to explain "how we know that that possibility is not actual". My thesis is that from what we know about how perceptual beliefs come to have the contents they do, we can see (though certainly not by a series of "necessary steps") not only why such beliefs cannot be generally mistaken, but also why we are justified in holding them. We are justified in holding them not because they rest on something more secure or fundamental, but because they are the kind of beliefs they are and because they are supported by many other beliefs. This explains why we have knowledge of the world. But it does not take the additional step Stroud seems to require, that we explain how we know that we know these things. To say we do not really know something unless we know that we know sounds like a request for a "guarantee" that we are right, something we cannot reasonably expect to find.

I have vacillated over the years on how to describe my attitude toward scepticism. Do I think that if I am right about the nature of thought scepticism is false, or that scepticism simply can't get off the ground? Passages Stroud quotes suggest the former. At the same time, I have been happy to go along with Rorty in telling the sceptic to get lost.[1] The two poses can be reconciled by pointing out that though I think scepticism as Stroud formulates it is false, I did not set out to show this. Reflecting on the nature of thought and interpretation led me to a position which, if correct, entails that we have a basically sound view of the world around us. If so, there is no point in attempting, *in addition*, to show the sceptic wrong.

In his first two paragraphs, Stroud tries to distinguish my position from that of a philosopher who wants to "explain, philosophically, how knowledge of the world is possible". He thinks I regard this question as misguided. But I do not. It is only after the question has been answered that it is wrong to keep asking, but how do I know *that*? Perhaps Stroud thinks we can give a perfectly good explanation of how we know things (though I presumably have not), but scepticism is not thereby shown to be false. If the point is that we cannot prove it false in particular cases, I agree. If the point is we can't prove it is *logically* impossible that "most" of our beliefs are false, again I agree. These two claims are trivial. What is not trivial is to show that we know enough about the world to be able to say that it is pretty much as we think it is. On my understanding of scepticism, this is to show that it is false.

Am I condemned by my claim that our general picture of the world and its furnishings is right in attempting the impossible? Stroud thinks I am, since I am making a claim from "outside" my frame of reference, as if I could find a "disengaged" point of view. He quotes me as saying that it makes no sense to look for a more ultimate standard of judgment than that provided by a community of minds, and he admonishes me to accept this self-acknowledged limitation. I do. But is Stroud right when he says that if it makes no sense to

question the adequacy of this standard, it also makes no sense to assert its adequacy? I think not. To take up my analogy: when the standard for the kilogram was a weight kept in Sèvres, there was no point in checking whether that weight weighed a kilogram. It does not follow that that weight was not the standard. It is true that I think interpersonal communication and understanding is the basis of our concept of objective truth, but I think that recognizing this is an essential element in appreciating how, from our provincial standpoints, we can attain knowledge of the world, and analyze what makes this possible.

I have never thought we cannot be very wrong about what is going on around us at one time or another; it does not take brains in vats or mad scientists to demonstrate this. But we can be massively wrong only about a world we have already experienced, the main and more or less lasting features of which we have right. We can also hold plenty of foolish, ignorant, or mistaken opinions, either along with our cohorts or on our own, again on the basis of the ordinary things on which we have a grip. We think someone is a witch, in part because we know she is a woman and a gossip. We look for the fountain of youth, which we could not do if we did not know what a fountain is, and youth. We look at a shimmering desert and think we see a lake, but our mistake depends for its content on our routinely being right when we think we see a lake. These remarks are meant to defuse criticisms aimed at my loose use of expressions like "most of our beliefs".

Stroud grants, at least for the sake of argument, that a radical interpreter will necessarily interpret others as being right (according to his own lights) about the general character of the world. Two people, he imagines, might communicate with each other about a non-existent rabbit, each believing (falsely) the other to have been caused to think both he and his companion were viewing a rabbit (see the second paragraph from the end of section VI). Since it is things like people and rabbits inhabiting a common space and time that I think we know about, let me start here. Of course it could happen as Stroud imagines. But how did the discussants come to have the concept of a rabbit? Or, if they learned this concept indirectly, by being told what a rabbit is, or seeing a picture, then how did they acquire the concepts on which these learning procedures depend? At some point they learned enough concepts through ostensive occasions to anchor their sentences to the world, otherwise there would be no way to account for the contents of their perceptual beliefs and the sentences that express them. This is best seen by thinking of the radical interpreter who has an articulate grammar, a considerable supply of concepts tied to the world, and of course the idea that any thought may be true or false. This interpreter does not know what her informant means by the one-word sentence "Woozle", but notices that when the informant uses this word there is a pencil in plain sight or in her hand and not otherwise. Perhaps, the interpreter thinks, she means a pencil is in view by "Woozle". This hypothesis

remains to be confirmed by further connections. But the interpreter, like the informant, already has the idea of a small visible object with the usual causal properties, and the translation of "Woozle" by "Here's a pencil", since it carries with it a lot of baggage, can be confirmed or discarded. Among the required features is the fact that error is possible, and when it is, can be explained in obvious ways: bad light, failing eyesight, holograms, etc. Inferences on the part of the interpreter may or may not include explicit thoughts about what is causing the informant to be inclined to say "Woozle". What is essential to the ostensive process is that when the interpreter is caused to think there is a pencil, the informant is caused to say "Woozle". Thoughts *about* causality are not essential, though they may be likely for a sophisticated interpreter.

How does the sceptic view this situation? Can both interpreter and informant be mistaken regularly? From the start? No; as Wittgenstein points out, the interpreter (learner) is not in a position to doubt the ostensions he observes. For him, the new sentence is being given a content. For him, *whatever* is seen or thought to be ostended is the only content he has to work with, though further contexts can reinforce or modify this content. There is no crack here where the sceptic can drive a wedge between belief and reality. It does not matter if the informant is not using words as the rest of his community does; for the nonce he has an audience of one. It is only after belief has a content that it can be doubted. Only in the context of a system tied to the world can a doubt be formulated.

This story can easily be attacked at several points. Much rests on the claim that propositional thought depends on communication. Perception yields beliefs about a world conceived as objective only in a mind that has a network of concepts originally developed in interpersonal exchanges; so I have argued, and Stroud is apparently willing to go along. Having accepted so much, what is still open to doubt? One possibility hinges on the fact that communication depends, among other things, on the shared propensities of people to react in observably similar ways to their environment. Logic does not assure us of this: it's an empirical fact about people, and if it were not, we would not know what we do, at least in the way we now do.

What I propose is a modest form of externalism. If our past—the causal processes that gave our words and thoughts the content they have—had been different, those contents would have been different, even if our present state happens to be what it would have been had that past been different. I am not sure whether Stroud accepts this form of externalism, but my case against scepticism depends on it.

D. D.

NOTE

1. "Afterthoughts, 1987," *Reading Rorty*, edited by A. Malachowski (Oxford: Blackwell, 1990), 134–137.

6

A. C. Genova

THE VERY IDEA OF MASSIVE TRUTH

What has become generally known as Donald Davidson's 'omniscient interpreter argument' (OIA) has not been generally well received for two reasons: It remains a puzzle as to exactly what the argument is; and Davidson's own sketchy formulations have cast doubt on its validity.[1] The argument is offered as a conclusive proof of the unintelligibility of epistemological skepticism. He explicitly invokes it in two places in his work.[2] The designation of the argument as 'transcendental'—Jonathan Bennet calls it a 'bold transcendental argument'—does little to make it less cryptic or more persuasive.

With a view to making the strongest possible case for the validity of Davidson's argument, in what follows I offer an informal reconstruction—one which dispenses with his unnecessary and controversial notion of an omniscient interpreter (OI) and provides a missing premise (one which, I assume, Davidson takes for granted). I show that the OIA's validity does not require the invocation of an OI (an omniscient interpreter who necessarily has knowledge of all relevant data), but only the weaker notion of a fallible interpreter whose beliefs regarding the data happen to be true—what Davidson calls a 'fully informed interpreter', a non-omniscient one who just has true beliefs about all the relevant data required for interpretation. Let us label this the 'veridical interpreter' (VI). As for the missing premise, as we shall see, it is simply the central conclusion of one of his major papers—a conclusion which is repeated or assumed throughout most of his work, but not explicitly stated in the two instances of the OIA argument.

Armed with this well-advertised additional premise and a secularized reconstruction, in section II, I provide a new account of the structure of Davidson's argument and I would contend that it is strong enough to fend off most recent objections to its validity. Finally, in Section III, I provide a brief account of why Davidson's argument can indeed be labeled a 'transcendental

argument'—a designation he apparently acknowledges but leaves unexplained. However, in the end, I argue that this argument has force only for a certain (relatively uninteresting) sort of skeptic, while from the point of view of the unqualified sort of epistemological skeptic whom Davidson apparently envisages, it is not effective. But first, what exactly is the philosophical context in which Davidson's argument occurs, and if the argument is as unclear as I suggested above, why is it worth our philosophical concern?

I

What I think *is* clear is that the OIA fills a crucial link in his theory of epistemic justification. As is well known, Davidson espouses both a realist theory of meaning and truth. The former construes *meaning* in terms of truth conditions and formulates an empirical theory of meaning for a language in terms of a Tarski-style theory of truth for the language, having the form of a finitely axiomatized theory recursively yielding biconditional theorems in the familiar disquotational form. The latter construes *truth* (assuming that linguistic vagueness can be disambiguated in our language and the theory of meaning has the aforementioned Tarski-style form) as an epistemically unconstrained feature of sentences subject to bivalence, such that the truth value of a sentence is independent of whether we can verify its truth conditions. So to be a realist about meaning, in Davidson's sense, is to reject antirealist theories which explicate meaning in terms of verification, justification, coherence, or warranted assertibility conditions. And to be a realist about truth, in his sense, is to countenance a 'recognition-transcendent' or 'verification-transcendent' notion of truth—a notion of truth that is independent of warrant.[3]

Davidson's brand of realism—what Dummett calls 'semantic realism' —must be sharply distinguished from metaphysical realism (what Hilary Putnam calls 'external realism'), viz., the ontological doctrine, developed independently of semantic considerations, that posits a world consisting of a fixed totality of mind and language-independent entities admitting of only one true and complete description.[4] The difficulties associated with this metaphysical doctrine are formidable: the need to accommodate or refute the inscrutability of reference thesis, problems connected with the relation between mental and physical states, the opening of the door to 'brains in vat' skepticism, and perhaps above all, the task of specifying the criteria for epistemic justification. Metaphysical realism implies the intelligibility of global skepticism—the view that a universally endorsed, maximally coherent, theory or set of beliefs can nevertheless be false. But semantic realism—a thesis about meaning and truth—does not imply what metaphysical realism implies. The recent semantic

debates between realists and antirealists primarily concern the question of what is to be the core semantic notion in terms of which semantic content in a language is to be expressed. Should the core concept be the concept of truth such that meaning is to be expressed in terms of truth conditions? Or must a theory of meaning only specify meaning conditions that are compatible with our actual recognitional capacities and manifestable in actual usage, i.e., verificationist or warranted assertibility conditions?

I submit that the major problem confronting Davidson's semantic realism is that of developing an adequate semantics for natural language while avoiding two extremes: on the one hand, it must maintain its *semantic* (in contrast to metaphysical) orientation without relativizing its concept of truth and thereby compromising its realist commitment to the objectivity of truth; on the other hand, it must preserve its *realist* (in contrast to antirealist) commitment without degenerating into a version of metaphysical realism and thereby compromising its semantic status.[5]

Davidson avoids the first extreme—any relativization that would reduce truth to verification or justification—by rejecting any atomistic or decompositional approach to the theory of meaning.[6] If the semantic realist determined truth conditions of sentences directly and exclusively in terms of a prior specification of the reference of sentence components, then truth would indeed become as relativized, indeterminate, and conventional as reference—assuming, as with Davidson, that he acknowledges the inscrutability of reference. For Davidson (like Quine), it is impossible in principle to determine independently (of a background language and a chosen theory of translation or interpretation) the unique reference of individual terms or to analyze reference via unique non-linguistic entities. As Davidson says, reference 'drops out' because it plays no essential role in explaining the relation between language and reality.[7] The relevant connection is instead facilitated by his holistic methodology of interpretation. The interpretation of sentences in a language is dependent upon the empirical confirmation of a theory of meaning which interrelates literal meanings and propositional attitudes in the context of the ongoing construction of the complete web of sentences which constitute the language. If so, then abstracted, individualized reference becomes irrelevant to the holistic context of language behavior which provides the relevant basis for identifying the truth conditions of sentences.

Now this empirical constraint is entirely compatible with the additional formal constraint that governs the shape or logical form of an adequate theory. The theory must exhibit a general recursive form based on (1) a finite set of axioms which designate the truth-relevant semantic features of the linguistic elements (words), and (2) a set of rules stipulating the semantic import of the syntactical modes of combination of the elements, such that the Davidsonian T-sentences are entailed. The point is that the derived biconditionals are to be

holistically confirmed in the empirical context of interpretation, not logically guaranteed on the basis of formal derivations from prior and independent, one-by-one, determinations of individualized denotations of the elements at the atomic basis of the satisfaction recursion. A theory of truth, in the Tarski style, does not (as with the correspondence relation tied to metaphysical realism) explain truth by finding theory-independent entities or facts for sentences to correspond to.[8] Although its notion of correspondence does require a relation between linguistic terms and objects as characterized by the satisfaction relation, notions such as satisfaction and reference function like theoretical constructs which help explain the fact that sentences have the truth conditions which they as a matter of fact have. To suppose then, that the semantic conception of realist truth must inherit the subjectivity or relativity associated with referential indeterminacy, is to conflate the theoretic requirement of *explaining* the truth conditions of sentences on the basis of the semantic features of sentence components within a formal theory, with the empirical requirement of providing *evidence* for the truth of the theory.[9]

Davidson avoids the second aforementioned extreme—the slide to metaphysical realism—by adopting a non-foundationalist theory of epistemic justification in the context of his semantic holism.[10] He abjures any foundationalist theory of justification that attempts to justify beliefs in terms of something other than beliefs. He rejects foundationalist or confrontational models for belief, knowledge, meaning, or truth. The problem is that if the foundationalist model presumes direct confrontation with independent objects, then the correspondence relation cannot be satisfied because there is no independent stance or perspective, apart from our present belief system and language, from which we can verify the correspondence between beliefs and unconceptualized objects. While if the foundationalist model invokes intermediaries (experience, sense-data, sensory stimuli, etc.) through which such correspondence is confirmed indirectly, then these intermediaries are either causal (and therefore irrelevant to justification) or somehow purport to be information (and therefore of only contingent reliability). Quine, for example, by equating evidence with his naturalistic surrogates and insisting that our only source of information about the world is via nerve hits on our sensory surfaces, thereby invokes intermediaries in a foundationalist theory of justification. But Davidson's point is that there can be no *epistemic* intermediaries, only causal ones—otherwise we open the door to epistemological skepticism. Thus, Davidson banishes any notion of epistemic intermediaries and embraces a coherence theory of justification because nothing can count as a *reason* for holding a belief except another belief (CT, 426). There is no non-doxastic form of evidence.

As I understand him, Davidson construes coherence as the *test* of truth and truth itself is correspondence with the way things are as spelled out via

Tarskian satisfaction conditions which fix the application and extension of the truth predicate in a holistically confirmed empirical theory of meaning. If coherence is the test for truth, then the specification of truth conditions in the semantic theory is not implemented by one-on-one confrontation between what we believe and 'reality', but rather, coherence becomes the test for judging that objective truth conditions are satisfied. This yields 'correspondence without confrontation':

> My slogan is: correspondence without confrontation. Given a correct epistemology, we can be realists in all departments. We can accept objective truth conditions as the key to meaning, a realist view of truth, and we can insist that knowledge is of an objective world independent of our thought and language. (CT, 423)

The implication is that although any particular belief, regardless of its degree of coherence with other beliefs, may in fact be false, yet, due to Davidson's epistemological correlation between coherence and correspondence, it is not entailed that all (or even most) of our cohering beliefs may be false (CT, 426). On the contrary, for Davidson, the prospect of global falsity or massive error—always a possibility for the metaphysical realist—is unintelligible. Consequently, if the intelligibility of massive error is entailed by metaphysical realism, while this possibility is unintelligible for Davidson's realism, then there is no danger of any slippage—no way that semantic realism can be reduced to metaphysical realism. In sum, if Davidson's epistemology is sound, he has successfully differentiated his *semantic* realism from metaphysical realism without compromising the objectivity of truth, while also contrasting his semantic *realism* from semantic antirealism without opening the door to epistemological skepticism.

Now the above analysis may seem outdated in light of Davidson's recent Dewey lectures, 'The Structure and Content of Truth',[11] but this is not the case. At the urgings of Richard Rorty (SCT, 302, n. 40), he dispenses with such 'terminological infelicities' as 'realism', 'correspondence', and 'coherence'. But despite Davidson's disclaimers, a careful reading (SCT, 298–99, 301–9) will show that there is little or no philosophically significant change in his position. These terms are now seen as 'ill chosen' only because their previous use to characterize his semantic theory has been generally misunderstood. The reason is that 'realism' and 'correspondence' are closely associated with metaphysical realism and its radically non-epistemic, evidence-transcendent notion of truth; while 'coherence' is equally tied to standard coherence and pragmatic theories and their radically epistemic notions of truth. But Davidson's semantic realism and coherence theory are neither radically epistemic nor radically non-epistemic (SCT, 309). Davidson wants to reject antirealism in the sense of a radically epistemic theory which either does not

construe meaning in terms of truth conditions or interprets truth as directly dependent upon our epistemic powers (Dummett, Crispin Wright, and probably Putnam, Goodman, and Quine)—and it was in the service of contrasting his view with this semantic *antirealism* that he called his view 'realism'. Conversely, he also rejects any realism or correspondence theory that posits non-linguistic entities to which fine grained sentences or beliefs are said to correspond or represent—and in contrast to this *metaphysical* realism he invokes the notion of 'coherence' as employed in the context of his holistic semantics and methodology of interpretation (SCT, 304; 305, n. 47). Thus, Davidson's concept of truth is neither radically epistemic nor radically non-epistemic, but is best described as modestly non-epistemic. This is just to say that semantic realism (as previously discussed) thereby becomes an option to both semantic antirealism and metaphysical realism. Accordingly, in what follows, I shall retain Davidson's original terminology.

But why exactly is global falsity unintelligible? Why should a maximally coherent system of beliefs about the world be incompatible with massive error? Indeed, Davidson insists not merely that massive error is unintelligible, but that massive *truth* is a necessary presupposition of interpretation and communication. He must show his hypothetical skeptic that someone with a coherent system of contingent beliefs has sufficient reason to believe that this belief system is basically true. This means, as Peter Klein shows, that Davidson's skeptic is both non-Pyrrhonian and non-Cartesian—non-Pyrrhonian because the skeptic acknowledges the efficacy of argument, non-Cartesian because the skeptic does not insist on absolute certainty as a standard for knowledge.[12] The skeptic is simply insisting that there is no good reason to reject the thesis that all our beliefs about the external world, regardless of their mutual coherence, can be false. But if all our beliefs can be false, regardless of the degree or kind of coherence, then knowledge—construed as justified true belief where justification is some mode of coherence—is a problematic notion because truth is independent of justification. The dilemma facing Davidson is as follows: he needs a notion of coherence that 'yields correspondence', i.e., a view of coherence that guarantees objectivity, or if you prefer, a view of correspondence that is immune to epistemological skepticism—these, operationally, amount to the same thing. But if he construes knowledge simply as coherence, truth becomes divorced from the world; while if he construes truth as something beyond coherence or agreement, then coherence is insufficient to guarantee truth.

So Davidson must provide a sound argument, none of whose premises express knowledge of the world nor depends on knowledge of the world for its evidential support, and whose conclusion is that it is not possible that all our cohering beliefs about the world could be false, i.e., that this form of global skepticism is false or unintelligible. Moreover, the good reason invoked

to reject the skeptical thesis must itself be a reason *not* based on evidence (CT, 431). Why not? Because additional evidential support via other beliefs about the world would simply extend the sphere of justification, just enlarge the totality of cohering beliefs about the external world. Davidson needs an a priori argument that turns on some sort of conceptual connection.

II

Davidson sometimes talks as if the possibility of global falsity is sufficiently refuted *without* the need to invoke the OIA. This occurs when he speaks as if his methodology of interpretation itself guarantees that most of the sentences a speaker *holds* true *are* in fact true.[13] His Principle of Charity, which guides the methodology of radical interpretation, requires (among other things) that in the most basic cases, we must construe the content (object) of beliefs in terms of the causes of beliefs, i.e., the causal conditions under which beliefs are held true are construed as the truth conditions of those beliefs. Moreover, he says:

> What stands in the way of global skepticism of the senses is, in my view, the fact that we must, in the plainest and methodologically most basic cases, take the object of a belief to be the cause of the belief. And what we, as interpreters, must take them to be is what they in fact are. (CT, 436)

In this context, Davidson is saying that the 'good reason' we need to defuse the skeptical challenge—the reason which is not itself a form of evidence—is precisely the dependence of belief-content on the causes of belief. Given this premise, Davidson stresses the inherent, veridical nature of belief, the fact that our very understanding of the nature of belief and belief formation guarantees massive truth in any cohering system of beliefs:

> But there is no need to fear that these beliefs might just be a fairy tale. For the sentences that express the beliefs, and the beliefs themselves, are correctly understood to be about the public things and events that cause them, and so must be mainly veridical. Each individual knows this, since he knows the nature of speech and belief. (EC, 322)

Now the trouble with this way of putting it is that it invites two sorts of objection: The first, presented by philosophers like Peter Klein, is that the argument appears either circular or invalid.[14] Davidson is either merely assuming that the interpreter already knows that there are events external to our bodies which are causally correlated with belief states (circular, because this presupposes the falsity of global skepticism); or he is attempting to prove that our belief states are massively true merely because the methodology of interpretation requires massive agreement between interpreter and interpretee

(invalid, because the premises are insufficient for the desired conclusion). The second objection is the sort given by Colin McGinn: the argument, with its notion of the inherent veridicality of belief, suggests that Davidson is relying on an a priori (unsupported) claim that there is a purely conceptual, self-evident connection between the concepts of belief and truth.[15] This makes the argument too true to be good. As McGinn says, 'If Davidson is right about the inherently charitable nature of interpretation, then we could dismiss certain kinds of traditional skepticism; but it is absurd to suppose that skepticism could be dismissed in this oblique and roundabout way' (McGinn, 358). Indeed, McGinn says that if it were not for the fact that Davidson considers the anti-skeptical consequence a *virtue* of his account, he (McGinn) would have used this consequence as a *reductio* against Davidson (McGinn, 359, n. 6).

To be sure, if the above context is taken as sufficient on its face value as Davidson's anti-skeptical argument, then the argument is not sufficient for his desired conclusion. If it is a necessary presupposition of the methodology of interpretation that an interpreter must understand the sentences and beliefs of a speaker on the basis of the interpreter's estimated correlation between the events/things which prompt assent by speakers to queried sentences and the content of these sentences held true (beliefs), then what follows (so far) is not that most of the time the simplest sentences held true *are* true. Rather, what follows is that the interpreter must, for the most part, construe the speaker's beliefs and meanings to be *in agreement* with his or her own. What follows is not that the speaker's beliefs are mainly veridical but rather that we must correlate sentences held true with sentences held true. If we want to understand others, we must count them as right in most matters. But this is just Davidson's weaker 'basic claim'—what can be called his *agreement thesis* (MTM, 200). This would, as he says, assure an intersubjective agreement among the beliefs of speakers in a linguistic community—a guarantee that the interpreter's '. . . overall picture of the world around him is like the picture other people have'. The *other* thesis—what can be called his *objectivity thesis* —is his stronger 'extended claim', viz., that objective error can occur only in a setting of largely true belief (MTM, 200). In the above context, Davidson indeed asserts this stronger thesis, that the shared belief system must in fact be *true*, that one's overall picture of the world is largely *correct*, etc. If this stronger claim is already implied or presupposed by the premise-set, then the argument begins to look like a *petitio*; if, as seems obvious from the context, Davidson's extended claim is instead intended as a consequence that in turn entails the anti-skeptical conclusion, then the argument appears invalid. And it would hardly help matters to appeal to a self-evident tie between belief and truth.

Now I do not believe that Davidson's argument for the unintelligibility of epistemological skepticism is circular, invalid, or relies on self-evidency. The

problem is that philosophers such as Klein and McGinn have not focused on the full context of Davidson's argument. The context we reviewed above is merely a derivative context, a context that presupposes additional background premises. One step in the right direction here is to recognize that Davidson's formulation of the 'good reason' that blocks skepticism in the context so far considered (the fact that the content of belief depends on the cause of belief) itself needs support from one of the major conclusions of his 'On the Very Idea of a Conceptual Scheme' paper, viz., that scheme-content dualism is an unwarranted dogma of empiricism.[16] The point is that if we espouse scheme-content dualism, the content (object) of belief could be determined quite independently of its causal environment, thereby allowing a brains-in-vats type skeptic to drive a wedge between belief-content and the world, between belief and cause of belief. But as we know, for Davidson there are no epistemological intermediaries between belief and the world, no such thing as a 'given' (experience) that constrains or determines content independently of causal links, and no such thing as an abstract 'mind' that imposes conceptual structure or content. If a vat brain had a thought expressible by the sentence 'I have blue eyes' a Davidsonian interpreter must interpret the brain's implied belief as causally linked to the brain's environment, and the sentence 'I have blue eyes' would be a sentence in Vatese, not English.[17] I contend that when the context of radical interpretation so far considered is flushed out of its philosophical thicket, we see that Davidson's externalism is buttressed by a background assumption—the rejection of scheme-content dualism—and this is sufficient to defuse the brains-in-vats type skeptic unless the latter is prepared to countenance the dubious thesis of scheme-content dualism. Given this background assumption, Davidson's talk about the inherent, veridical character of belief is not a controversial premise, but rather one of the consequences of the argument so far considered.

But there remains something unresolved here, and that is why we need to take one more major step in the analysis and reconstruction of Davidson's anti-skeptical argument. What I find unresolved is this: Even if one concedes the untenability of scheme-content dualism, accepts Davidson's methodological tie between belief-content and causation, eschews brains-in-vats skepticism as untenable, and acknowledges Davidson's agreement thesis—all of this—it still may seem that the skeptical challenge can re-emerge *within* the context of radical interpretation itself. This can be called *internalized semantic skepticism.* I mean even if it is the case that belief-content must be paradigmatically tied to what we construe to be the causal conditions of belief, why is it unintelligible to suppose that these construals and the resultant specifications of belief-content could possibly be false or mostly false? Granted, as Davidson says, that the interpreter must tie belief-content to causation and find the speaker largely consistent and correct 'by his own

standards, of course' (CT, 433), why should the interpreter's standards be immune to massive falsity? This skeptic is proposing that Davidson's semantic realism is compatible with the intelligibility of a massively false, well-ordered belief system. It is interesting to note that this sort of internalized skepticism is analogous to the skeptical question that Kant posed immediately after his so-called 'metaphysical deduction' of his categories of understanding in the *Critique* (A85/B117–A91/B123, A94/B127, B160, and especially B167–168). Even if these categories are necessarily constitutive of our thought about objects, why should the objects themselves be necessarily constituted in accordance with these categories? What justifies our right to posit their objective validity? For Kant, what was still required was his transcendental deduction; for Davidson, it will be the OIA.

What Davidson's argument still needs is an a priori link between his basic claim (agreement thesis) and his extended claim (objectivity thesis), between sentences held-true and the truth of those sentences, between coherence and correspondence—it needs, once more, a good reason (perhaps we should say a *better* reason than so far given which neither is nor is based on evidence) for concluding that most of our sentences held-true cannot be false, or stronger, that these beliefs, in the main, are true. It is precisely at this point that Davidson introduces his transcendental argument based on the idea of an omniscient interpreter—an argument designed to show that the possibility of identifying cases of objective error in a speaker presupposes a shared, substantial background of objectively true belief between the speaker and interpreter (MTM, 201; CT, 435). If so, then the very intelligibility of the skeptic's ascription of possible objective falsity in our belief system will presuppose a massive, shared background of objectively true belief, thereby making the prospect of global falsity itself unintelligible. The thesis is that although agreement on coherence does not, as such, guarantee truth, much or most of what is agreed upon must be true if some of it is to be false. The OIA, unlike our earlier derivative context, will not depend merely on the method-ological thesis that belief content cannot be specified independently of the causes of belief, or on the supportive premise that scheme-content dualism is untenable. As we shall see shortly, the validity of the OIA depends upon a still more fundamental background assumption, viz., Davidson's primary conclusion in his 'On the Very Idea of a Conceptual Scheme': translatability is a criterion of languagehood. It is this principle that ultimately grounds his rejection of scheme-content dualism and warrants his view that the notion of a nontranslatable conceptual scheme is unintelligible.

At any rate, the two places where Davidson explicitly invokes the OIA are as follows:

> For imagine for a moment an interpreter who is omniscient about the world, and about what does and would cause a speaker to assent to any sentence in his

(potentially unlimited) repertoire. The omniscient interpreter, using the same method as the fallible interpreter, finds the fallible speaker largely consistent and correct. By his own standards of course, but since these are objectively correct, the fallible speaker is seen to be largely correct and consistent by objective standards. (CT, 433)

And the other instance of the OIA:

We do not need to be omniscient to interpret, but there is nothing absurd in the idea of an omniscient interpreter; he attributes beliefs to others and interprets their speech on the basis of his own beliefs just as the rest of us do. Since he does this as the rest of us do, he perforce finds as much agreement as is needed to make sense of his attributions and interpretations; and in this case, of course, what is agreed is by hypothesis true. But now it is plain why massive error about the world is simply unintelligible, for to suppose it intelligible is to suppose there could be an interpreter (the omniscient one) who correctly interpreted someone else as being massively mistaken, and this we have shown to be impossible. (MTM, 201)

The argument of these passages can be informally paraphrased as follows:[18]

It is conceivable (epistemically possible) that an omniscient being exists who knows everything there is to know that is relevant to interpretation, but does not know the meaning of my sentences or the content of my beliefs. For the determination of the latter, this being is subject to the same methodology and constraints on interpretation as the rest of us are, e.g., the various constraints of the Principle of Charity, etc. Thus, as required by the agreement thesis, the OI must maximize agreement be-tween his and my beliefs if I am to be interpreted. Suppose the OI arrives at an interpretation of my sentences and a corresponding specification of my belief contents as expressed by the sentences I hold true. Since the OI's beliefs are all true and the beliefs attributed to me must agree with the OI's beliefs, then my beliefs must be true or mostly true. Thus, I cannot be massively mistaken.

Now this sort of formulation of the argument—a rather standard and noncontroversial rendering of the above passages as far as I can tell—has been subject to a variety of objections. The primary ones can be classified under three heads: *First*—what might be called the *anti-theist objections*—turn on Davidson's appeal to an omniscient being. For example, Richard Foley and Richard Fumerton argue that the validity of the OIA depends on the existence of an omniscient being. If so, the conclusion of the OIA is not that we cannot be massively mistaken, but only that in any possible world containing us and an OI, we cannot be massively mistaken with respect to our beliefs about that world.[19] *Second*—what can be labeled the limitations to interpretation objections—turn on Davidson's apparent assumption that the OI *can* interpret any belief system, that the OI's attempt at interpreting us will always lead to success. Thus, S.A. Rasmussen argues that Davidson can not provide independent support for his 'spectacular' extended claim.[20] After all,

if we *were* massively wrong about our world, then the assumption of an OI in conjunction with Davidson's agreement constraint would seem to *negate* the possibility of successful interpretation by an OI. In other words, could not the OI have in hand all the relevant data for interpretation and yet be unable to construct a truth theory for a speaker precisely because the OI could not share enough background beliefs with the massively mistaken speaker so as to make sense of the speaker? As one of my colleagues said, 'It takes one to know one. God could not make a Pinto'.[21] In that case, another massively mistaken (non-omniscient) interpreter could interpret the massively mistaken speaker. As Jonathan Bennett says, '. . . a mostly false corpus of beliefs might be understood, on the basis of a complete agreement, by an interpreter whose own beliefs are mostly false'.[22] *Finally*, there are the *belief-content skepticism objections*, e.g., those set forth by Anthony Brueckner and Edward Craig, that contend that even if Davidson's conclusion *does* follow (we cannot be massively mistaken), another level of epistemological skepticism emerges: Even though we may know that our well-ordered system of beliefs cannot be massively mistaken, there is still the skeptical possibility that we could be wrong about *which* beliefs are truly ascribed to us by an OI—we might be systematically wrong about the *contents* of our beliefs.[23] This is not to be confused with the brains-in-vats skepticism discussed above. The latter concedes that we may know what beliefs we brains in vats have, but contends that these beliefs may be false because belief-content may be determined independently of the causes of belief; while the former concedes that we may know that the beliefs we have are true, but contends that we may be wrong about which beliefs we have.

Now if we take the above cited passages or my proffered paraphrase as sufficient for Davidson's OIA, then the rehearsed objections will have significant force. But I contend that (1) Davidson's appeal to an omniscient interpreter is misleading and superfluous: he only needs a 'fully informed' (veridical) interpreter (VI); (2) the above citations and paraphrase are actually only glosses on the full argument: they need to be reinforced by a few interrelated premises that are justified by the context of the argument and identified by just a bit of unpacking of what is implied in Davidson's methodology of interpretation and the central conclusion of his 'On the Very Idea of a Conceptual Scheme' (VIC) paper—background assumptions that (I contend) Davidson presumes and his hypothetical skeptic is taken to accept; and (3) given these adjustments, we can present a reconstruction—now relabeled as the 'veridical interpreter argument' (VIA) that defuses the rehearsed objections.

The reconstruction will be facilitated by a brief account of Davidson's stage setting for the argument. First, we need to take note of three very important characteristics of Davidson's hypothetical skeptic: *First*, the skeptic

does not claim that our system of coherent beliefs *is* false—only that the feature of coherence is compatible with our beliefs being true *or* false, and consequently, they can all (or mostly all) be false while cohering. So it is equally possible that our belief system is massively true. *Second*, this skeptic is presumably the same skeptic who would also challenge foundationalist attempts at justification, and hence (since foundationalist and non-foundationalist attempts are exhaustive), the skeptic is denying the possibility of justified true belief (knowledge). Consequently, it would be unfortunate for Davidson to introduce an OI if his argument turns on the *knowledge* the OI necessarily has, because that would be a *petitio*. But there will be no *petitio* if the argument merely turns on the fact that the interpreter's beliefs are all, in fact, true because *that* is an epistemic possibility the skeptic concedes.[24] Accordingly, in any reconstruction of the argument, I need only rely on that aspect of the OI which is coextensive with a fully informed or veridical interpreter (VI) and thereby avoid a potential red herring. Besides, Davidson's notion of an 'omniscient' interpreter involves *limited* omniscience i.e., the feature of omniscience is limited to knowledge about the relevant data for interpretation, not inclusive of knowledge of what a speaker's beliefs are—otherwise his argument couldn't get off the ground.[25] The OI must *attribute* beliefs to others via the method of interpretation— 'just as the rest of us do' (MTM, 201). So a VI is enough. And *third*, Davidson's hypothetical skeptic is a very accommodating skeptic, viz., one who is presumed to accept Davidson's methodology of interpretation—thereby also its presuppositions and implications—and still wants to deny Davidson's extended claim that we cannot be massively mistaken. The skeptic is asking: 'Why should we be obliged to think that your methodology of interpretation guarantees that massive falsity is unintelligible? What reason is there to believe that your notion of coherence or agreement entails massive truth'? That is why Davidson thinks that the task at hand is to provide such a reason—a reason that itself is not a form of evidence.

As for the methodology of interpretation, we need to complete the stage setting with the following reminders: Davidson needs to show that the very idea of a coherent system of objectively false (or mostly false) beliefs is unintelligible. Alternatively: that a presupposition for the intelligibility of a speaker (for understanding a speaker) is a shared system of true (or mostly true) beliefs between an interpreter and a speaker. These two ways of stating the problem are not equivalent in content (the latter is stronger than the former), but they equivalently entail his anti-skeptical conclusion. The key to Davidson's argument is not an unsupported view that beliefs are inherently true for the most part (McGinn), or that we must take the objects of beliefs as causes of beliefs (Klein), but rather, the central conclusion of his 'On the Very Idea of a Conceptual Scheme': translatability is a criterion of languagehood.[26]

Whatever could count as evidence of non-translatability (non-interpretability) is evidence for non-linguistic behavior. The idea of a system of beliefs or sentences which is not translatable or not interpretable is unintelligible. Consequently, if the idea of a coherent system of massively false beliefs is intelligible, it must be interpretable. This is the additional premise (taken for granted in the context) that does not explicitly occur in the two explicit instances of the OIA cited above. Interpretability, of course, is defined in terms of Davidson's methodology of interpretation; an interpreter constructs an empirical theory of truth for the speaker (as well as a theory of the speaker's beliefs, etc.) that conforms to the formal and empirical constraints on such a theory, and proceeds only on the basis of the relevant data for interpretation as grounded on the principle of charity—taking what one construes as the causes of beliefs as their truth conditions. The only possibility for understanding the speaker (making the speaker intelligible) rests on this 'unimpeachable method' (CT, 434). Moreover, all that is possible or needed for interpretation rests in this method and the relevant data for interpretation, and this holds for all interpreters (CT, 433). So a fully informed interpreter (VI) is merely an interpreter who has true beliefs about all the relevant data for interpretation. Since what a VI can learn about a speaker's beliefs and meanings is all there is to learn, it would be absurd to claim that a VI could not interpret what a not fully informed interpreter can interpret—they both must employ the same method and depend on the same data (CT, 433, 435).

Finally, we need the reminder that Davidson's notions of 'belief' or 'belief system' do *not* concern the abstract notions of a proposition or a system of beliefs independent of anyone's coming to hold them. He basically has a naturalized conception of cognitive attitudes. This is why he does not claim that *any* abstractly posited, coherent belief system is true or mostly true (CT, 424). His coherence theory concerns beliefs or sentences held-true by real flesh-and-blood agents who understand them—states of people with intentions, desires, and sense organs, states which are caused by and cause events both inside and outside the bodies of the belief-holders (CT, 424). Similarly, by 'possible' or 'intelligible', Davidson does not mean simply logically possible; he means 'what is possible to believe' by human beings (epistemic possibility) in the context of understanding, interpretation, and communication (CT, 424). Accordingly, for him, intelligibility, translatability, and interpretability are epistemologically equivalent.

So the bone of contention concerns Davidson's 'extended claim': that objective error can only occur in a setting of largely true belief (MTM, 200); alternatively, the interpreter cannot share massive error with the interpretee (CT, 435). This does *not* mean that coherence equals truth (truth is correspondence with reality, coherence just the test of truth). It does *not* mean that agreement guarantees truth—on the contrary (MTM, 200). It *does* mean

that much of what is agreed upon must be true if some of it is to be false (MTM, 200)—that just as attributing too much error (violation of agreement constraint) deprives the speaker of a subject matter, too much actual error (violation of objectivity constraint) deprives the speaker of anything to be wrong about (MTM, 200). How then, does Davidson make the connection between massive agreement and massive truth?

After taking stock of the epistemological context and philosophical importance of the OIA, and with the benefit of the stage-setting of the last several paragraphs, I can, at long last, offer the following reconstruction. We see that the argument can be construed as two overlapping arguments, both of which support the primary conclusion (a coherent system of massively false beliefs is unintelligible)—the first leading directly to the primary conclusion, the second leading to the primary conclusion via its secondary, stronger conclusion (all intelligible, coherent belief systems are massively true). I call the latter 'secondary' because it is sufficient, but not necessary for the defeat of Davidson's skeptic. Strictly speaking, the mere falsity of the skeptic's thesis is compatible with the falsity of Davidson's stronger thesis because it could presumably be the case that an intelligible, comprehensive, coherent belief system is neither massively false nor massively true. But we need both the primary and secondary conclusions because Davidson claims that he can provide the skeptic with a good reason to accept both. In the following reconstruction, for simplicity, I assume equivalence respectively between 'mostly true', 'massively true', etc., on the one hand and 'mostly false', 'massively false', etc., respectively, on the other hand.[27]

THE VERIDICAL INTERPRETER ARGUMENT (VIA)

H: Suppose a comprehensive, coherent system of massively false beliefs (MF) is intelligible (epistemically possible).

P1. A VI is epistemically possible, i.e., an interpreter who has all true beliefs with respect to the relevant data for the Davidsonian methodology of interpretation.

P2. If an interpreter has all true beliefs with respect to the relevant data for the Davidsonian methodology of interpretation, then that interpreter is capable of interpreting any interpretable belief system.

P3. (Therefore) If a belief system is interpretable, then it is interpretable by a VI. (P1, P2)

P4. A belief system is intelligible iff it is interpretable. (VICS, 186)

P5. If a belief system is interpretable, then it must be interpretable via a massive agreement between the belief system of the interpreter and the belief system interpreted. (Agreement Constraint)

P6. If an MF were interpretable by a VI, then the VI must interpret the MF (a)
 as an MF (as a nonveridical belief system massively differing from the VI's
 belief system), or (b) not as an MF (as a belief system in massive agreement
 with the belief system of the VI).

P7. (Therefore) since option (a) in P6 is impossible (P5) and option (b) is
 impossible (P1), an MF is not interpretable by a VI (P6).

C: Therefore, an MF, i.e., H, is unintelligible. (P3, P4, P7)

P6* (Therefore) all intelligible, comprehensive, coherent belief systems are
 interpretable by a VI and any belief system which is not interpretable by a
 VI is unintelligible. (P3, P4)

P7* (Therefore) if a belief system is interpretable by a VI, then the belief system
 is massively true. (P1, P5)

C* Therefore all intelligible comprehensive, coherent belief systems are
 massively true. (P6*, P7*)

C. Therefore an MF, i.e., H, is unintelligible. (C*)

What then, is Davidson's 'good reason' for believing that our coherent beliefs
cannot be massively false, or alternatively, must be massively true? Davidson
sometimes formulates this reason as follows: Given his methodology of
interpretation, the identification (and therefore intelligibility) of explicable,
objective error in a speaker presupposes a shared background of massively
true belief. This is a corollary—a direct result—of the above argument: Given
his reciprocal connection between interpretability and intelligibility, given his
constraints on interpretation and the conceded possibility of a VI, the very
intelligibility of explicable objective falsity presupposes a shared background
of massive truth. The a priori link between coherence and correspondence,
between agreement and truth, is provided by the freestanding premises of the
argument—especially P1 and P4—all of which Davidson's hypothetical
skeptic agrees with (this is a very friendly skeptic). These premises do not
constitute additional *data* for interpretation, not knowledge about causal
relations between observable things and speakers' beliefs—not, in short,
reasons based on adequate evidence. Moreover, Davidson's extended claim
(the objectivity thesis) is a conclusion entailed by premises which do not
include any claim about the inherent veridical character of belief. This, or
something like it, would be a *consequence* of Davidson's argument, not its
foundation. Given the VIA, Davidson can *now* say things like 'An agent has
only to reflect on what a belief is to appreciate that most of his basic beliefs
are true. . . . The question, How do I know my beliefs are generally true? thus
answers itself, simply because beliefs are by nature generally true' (CT, 437).
If we agree with his methodology of interpretation and the VIA, then '. . . it
becomes impossible correctly to hold that anyone could be mostly wrong
about how things are' (CT, 433). The point is that given the VIA, we now

have good reason to believe that since any coherent system of beliefs must be basically true, then any fallible interpreter's coherent belief system must be basically true; and hence, since the interpreter ascribes the content of beliefs on the basis of his perception of facts in the world which prompt speakers' beliefs, belief must, in general, be veridical.

Let us briefly consider the general consequences for the three kinds of objections previously cited. With respect to *anti-theist* objections (Foley and Fumerton), although my substitution of a fully informed, fallible interpreter for an omniscient one undercuts the claim that '. . . Davidson like Descartes before him needs the help of God to defeat the skeptic' (Foley and Fumerton, 84), cannot the objection be reformulated for the VI? Reformulated, the problem is this: Why should we think that a proposition P is true because it is true that a VI *would* believe P? (Foley and Fumerton, 85). If we construe the subjunctives in terms of a 'closest possible world' approach, then the claim that a VI would believe P, is the claim that the closest possible world containing a VI is a world in which the VI believes P (which is therefore true). But why should the truth value of P in that world be the same as in *our* world? If there is no VI in our world, then the closest possible world containing the VI who believes P may be so distant from ours that the truth value of P in our world is different. Accordingly, Davidson can only conclude that if there is a VI, then P is true—not that P is true (Foley and Fumerton, 85–86). But I contend that Davidson's argument (as reconstructed) turns only upon epistemic possibility equals intelligibility equals interpretability for its primary conclusion (the unintelligibility of the MF). Nothing turns on an *existing* OI or VI but only turns on what the skeptic concedes as conjointly possible in this world. The skeptic is shown to be asserting an inconsistent triad consisting of (1) the intelligibility of an MF, (2) a Davidsonian methodology of interpretation, and (3) the intelligibility of a VI. This conjunction is not an epistemic possibility. It is not possible for these to co-exist in *any* possible world; hence, not in this actual world. Davidson does not warrant his extended claim on the basis that a VI would believe this in the closest possible world containing a VI or OI. It is rather that the truth of the extended claim is warranted on the basis that in any possible world, an interpretable speaker's comprehensive, coherent belief system is intelligible and the intelligibility (epistemic possibility) of such a system presupposes that what the speaker (who possesses such a system) believes is mostly true. Therefore, in this world the extended claim is true. If this is correct, then the objection conflates the truth of P in relation to what a VI would believe with the truth of P in relation to the conditions for the intelligibility of P. Thus, for Davidson, we can '. . . justify saying not only that all actual coherent belief systems are largely correct, but that all possible ones are also' (CT, 424).

As for *limitations to interpretation* objections (Rasmussen, Bennett), the question is whether a VI could have in hand all the relevant data for interpretation and yet be unable to construct a truth theory for a speaker precisely because the VI could not share enough background beliefs with the massively mistaken speaker so as to make sense of the assertion conditions? The objection, in effect, challenges premise P3 (any interpretable belief system is interpretable by a VI). If so, then P7 (A VI could not interpret an MF) is compatible with saying that although an MF would thereby be unintelligible for a VI, not so for a fallible interpreter who also has a massively false belief system. But that rabbit won't run. The fallible interpreter cannot interpret via option (a) in P6 for the very same reason the VI cannot, viz., it would violate the agreement constraint (P5). But what about option (b)? Well, this situation *can* obtain (CT, 435), but only with respect to a limited context or subset of one's comprehensive belief system. With respect to a shared subset dominated by false belief, two speakers may well be able to engage in limited communication primarily on the basis of their shared error. But the fallible interpreter could not *in general* achieve understanding via shared error because this fallible interpreter and the VI share the very same methodology of interpretation and the fallible interpreter, if he has an intelligible belief system, must himself be interpretable by the VI who has 'all that is necessary and all that is possible' for interpretation (CT, 433–34; MTM, 201).

Finally, there are the *belief-content skepticism* objections (Brueckner, Craig) that concede massive truth but claim we could still be systematically wrong about the content of our true beliefs. I have responded in detail to these objections elsewhere,[28] but consider this: This sort of skeptic cannot both grant Davidson's OIA (or VIA) and also coherently maintain that it is possible to be systematically wrong about what beliefs we have. Otherwise, we would be systematically wrong about all our *second*-order beliefs (all our beliefs *that* we believe such-and-such) and all our still higher-order beliefs *ad indefinitum*—a situation that would obviously introduce massive error into our belief system, contrary to the OIA or VIA argument. Besides, we know what the contents of our well-ordered beliefs are, for Davidson, in virtue of knowing which sentences we hold true—a constraint of the principle of charity which already is a crucial normative constituent of the methodology of interpretation which is part of the premise-set of the VIA argument in the first place, so it makes no sense to talk of the content of a belief apart from what is interpreted in a language as its content.

The key to the VIA rests in the idea that there is no more to meaning, belief or desire—no more to the ascription of any cognitive attitude—than an adequately equipped interpreter can posit on the basis of relevant observation and theoretical constraints. To think otherwise is to assume that there is some

objective, independent truth about a speaker's mental states which is independent of translation or translational indeterminacy. Mental content is not determined independently of interpretation; content is a theoretical notion that only exists in the context of interpretation. In this sense, for Davidson, a truth theory for a speaker is *constructed*, not discovered. There is no fact of the matter applicable to semantics over and above the semantic content warranted in the context of the methodology of interpretation. This is not an option, but a necessary condition for the possibility of understanding or interpreting behavior. Accordingly, there is nothing more or less involved in the specification of linguistic meaning or belief-content than is interpreted to be the case by a rational interpreter using Davidson's 'unimpeachable' method. We do not possess any general concepts of truth, meaning, or belief content that transcend the truth, meaning, or content of all possible sentences in any language we can understand or translate into a language we could understand. Davidson's OIA argument, reconstructed as the VIA in the context of his semantic realism, shows not only that we cannot interpret an MF *as* an MF, and that we cannot interpret an MF in virtue of a sharing of massively false beliefs, but also that there cannot even *be* an MF—a fact of the matter independent of the conditions for interpretation.

III

I think that the upshot of Davidson's argument is threefold. First, it shows than an MF is just another purported instance of a radically different conceptual scheme—not interpretable or intelligible—and therefore not an epistemically possible case of linguistic expression (VICS, 185–86, 194). Except that here, rather than having a purported case of truth independent of translatability, we have a purported case of falsity independent of translatability. Neither can be permitted to make sense to a semantic realist who construes meaning in terms of truth conditions in a theory constructed along Tarskian lines. Second, in the context of Davidson's theory of epistemic justification, the OIA provides a shorthand, direct refutation of the epistemological skeptic. It provides a non-evidential reason why the very idea of massive error is unintelligible, and thereby forges the link between *his* senses of coherence and correspondence. But third, there is a more profound and programmatic upshot: the VIA provides a rationale for Davidson's contention that our picture of the world expressed in language conforms, for the most part, to the way the world is. At stake is his thesis that metaphysical conclusions must be read off from the construction of a theory of truth (meaning) for our language (MTM, 199, 201, 205ff). More broadly, at stake

is the legitimacy of the so-called 'linguistic turn'.

Why can Davidson's VIA be called a transcendental argument (TA)? Besides diverse examples from Kant (who is typically seen as the inventor of the TA), the transcendental style of inference has been attributed to Strawson's arguments for a public world of spatial-temporal material objects, Wittgenstein's so-called private language argument, Shoemaker's arguments about pain, Malcolm's arguments for the inconceivability of mechanism, Hampshire's isolation of the presuppositions of language, just to mention a few. Many philosophers have doubts as to whether there is some logically unique form of argument that can be certified as a TA, and even if there is, whether there are any valid TA's.[29] TA's have their greatest plausibility in the context of attempts to refute epistemological skepticism construed as systematic doubt or denial with respect to the possibility of justifying belief in or achieving knowledge of an external world (material bodies or other minds). In this context, the typical, general format for a TA is as follows: The TA is designed to show that with respect to the objective validity of certain primitive concepts or the truth of certain core propositions, skeptical claims are self-defeating or disingenuous because they entail the rejection of some of the necessary conditions of the conceptual scheme or epistemological context within which alone such skeptical claims make sense. If so, then the truth of what the skeptic doubts or denies is or entails a necessary condition (presupposition) of the skeptic's making sense; and so if the skeptic's claim makes sense, it must be false and its contradictory true.

Davidson's argument can be construed as a TA against his hypothetical skeptic in this sense: the argument attempts to show that the skeptical claim, in conjunction with the acknowledgment of the intelligibility of a VI (or OI) and the normative precepts of Davidsonian interpretation, entails the rejection or denial of a necessary condition (presupposition) for the intelligibility of the claim. That is to say, the argument entails that an MF is not interpretable, which is the negation of the condition for the intelligibility of what the skeptic claims, viz., the possibility of a comprehensive, coherent, system of objectively false beliefs. In the final analysis, does Davidson's argument refute the epistemological skeptic?

Probably not in the unqualified fashion that he apparently thinks it does. It refutes what I would call (analogous to Davidson's semantic realism) the *semantic* epistemological skeptic, but not (analogous to metaphysical realism) the traditional, *non-semantic* one. But Davidson does not distinguish these two kinds of skeptic, and that is why his extended thesis seems so arbitrary and remarkable to many of his detractors.

The *semantic* epistemological skeptic is one who identifies with Davidson's semantic context and agrees with his methodology of interpretation, but is not persuaded by his claim that coherence yields correspondence,

that we have a good reason to believe that a comprehensive, coherent, belief system is massively true. This is a misguided skeptic who has made the linguistic turn but cannot see why it is not intelligible to say that there could be a globally false system of ideally cohering beliefs. But *this* skeptic is wrong. The transcendental VIA defeats him. But if it is only this semantic skeptic whom Davidson refutes, the proof loses considerable interest. After all, this is our friendly but confused skeptic who accepts the premises of the VIA.

The *non-semantic* epistemological skeptic is one who rejoins as follows: what Davidson's TA shows, at most, is not that our coherent belief systems are mostly true, not than an MF is unqualifiedly unintelligible; but rather that if we accept his premises, then it is *necessary for us to think or believe* that coherent belief systems are massively true, that an MF is unintelligible. But this doesn't demonstrate the truth of those claims, just the subjective necessity to think that they are true. What Davidson still needs is *another* argument to show that what we must think is the case *is* the case. He has merely offered us 'a good reason' as to why we must *believe* that a coherent, comprehensive belief system is true, but has not shown that such a system is in fact true. For Davidson, the objects of knowledge are language-dependent, not in the sense of being arbitrary or conventional linguistic posits, but in that these objects cannot be confronted apart from our present beliefs and linguistic framework (CT, 426). In Davidson's hands, this apparently means that our ontological commitments are epistemically constrained—not in the radically epistemic sense that reduces truth to justification or warrant and thereby relativizes it to an internalized conceptual scheme (Putnam)—but in the modestly epistemic sense that harmlessly relativizes the truth of sentences to the language that contains them. Nevertheless, as Bennett says, Davidson's transcendental argument '. . . is employed in "The Method of Truth in Metaphysics" to throw a firm, broad bridge between linguistic premises and metaphysical conclusions' (Bennett, 610). Davidson's VIA guarantees that there is no independent status to the notion of content apart from the methodology of interpretation. And it is just here where our non-semantic skeptic objects. After all, a Davidsonian interpreter *could* not interpret a speaker's belief system as overwhelmingly non-veridical. The very idea of an MF thereby becomes simply unintelligible *relative to an interpreter*. We have then, as it were, a methodologically closed circle. Consequently if Davidson thinks that he has established his objectivity thesis—his 'extended claim'—then the argument is invalid; while if he contends that subjective necessity is enough—that he only wanted to prove what I say is, at best, proven—then the argument is valid but does not refute traditional epistemological skepticism, only its semantic ersatz.

The non-semantic skeptic is one whose skepticism is a progeny of

metaphysical realism which, as Davidson agrees, '. . . implies that all our best researched and established thoughts and theories may be false' (CT, 426). Davidson seems to think that it is this skeptic whom the OIA refutes—'skepticism in one of its traditional garbs' (CT, 426). But *this* skeptic has not made the linguistic turn (nor perhaps the Copernican one for that matter). He does not buy into throwing '. . . a firm, broad bridge between linguistic premises and metaphysical conclusions'. Among other things, he would not, of course, agree with the 'intelligibility iff interpretability' principle which is so integral to Davidson's theory of radical interpretation. The rejection of this principle would open up the logical or metaphysical possibility that what is non-interpretable via a semantic theory of truth for a language may nevertheless be intelligible; and even if it were not intelligible for rational animals like us, it could still be the case. Thus, from this point of view, it is perfectly intelligible that there could be an uninterpretable MF. This unfriendly skeptic—the non-semantic one—has not been refuted by my reconstruction of Davidson's argument. Moreover, this pre-Fregean, metaphysical interpolator cannot be refuted by any transcendental argument originating in the context of semantic realism. It would take a different *kind* of argument to refute his anachronistic challenge, viz., one that somehow would persuade him to convert to approaching metaphysical issues from a semantic point of view. I am not sure what such an argument, without begging the question, could look like.

Non-semantic skepticism, along with metaphysical realism, is purchased at the cost of the so-called linguistic turn, and in most of its guises, probably comes with scheme-content dualism as well. But lest we think that there are no present-day takers at such an exorbitant price, consider a philosopher like Michael Devitt who attempts to drive a quasi-Aristotelian wedge between a theory of meaning, a theory of mind, and a theory of utterly distinct objects in the context of his critique of Dummett's antirealism,[30] or perhaps Crawford Elder, who invokes theory-transcendent, noumena-like impingements from the world in his attempt to refute the sort of 'irrealism' that supposedly follows from Quine's indeterminacy semantics.[31] And there is no dearth of supporters for this revisitation to classical realism. For myself, I believe that these born again realists are making a philosophical mistake, but that topic is beyond our present scope.

CONCLUSION

I have argued that Davidson's OIA argument admits of a reconstruction which, in my judgment, is warranted on the basis of a full account of its

context and a reasonable exercise of charity with respect to its premises, explicitly stated or otherwise. I have also maintained that the reconstruction has sufficient strength to meet the recent objections to its validity examined in this paper. Finally, I have argued that if Davidson's transcendental argument only succeeds in refuting what I call the semantic epistemological skeptic, then Davidson may well be charged (by the traditional skeptic) with setting up a straw skeptic. If his argument is directed to the traditional skeptic (as it arguably is)—the uneasy bedfellow of the metaphysical realist—then the argument is either valid but proves too little, or is invalid because it proves too much. In that case, it is not a good transcendental argument, i.e., one which validly establishes its objectivity thesis without presuming a verificationist premise or relying merely on subjective necessity.[32] For this skeptic—the one who has been around, in various garbs for over two thousand years—the notion of massive truth, although intelligible like massive error, is not something that can be established as a presupposition for intelligibility. If one argues otherwise, then the very idea of massive truth is nothing but an unwarranted dogma of post-Fregean semantic realism.

A. C. GENOVA

DEPARTMENT OF PHILOSOPHY
UNIVERSITY OF KANSAS
OCTOBER 1992

NOTES

1. The text incorporates the indicated abbreviations for citations to the following papers by Davidson: 'The Method of Truth in Metaphysics' (MTM); 'On the Very Idea of a Conceptual Scheme' (VICS)—both in *Inquiries into Truth and Interpretation* (Oxford: Clarendon Press, 1984); 'A Coherence Theory of Truth and Knowledge' (CT), in *Kant oder Hegel?* ed. Dieter Henrich (Stuttgart: Klett-Cotta, 1983), 423–38; 'Empirical Content' (EC), *Grazer Philosophische Studien* 16/17 (1982), 471–89; and 'The Structure and Content of Truth' (SCT), *Journal of Philosophy* 87, no. 6 (1990), 279–328. Also the author gives special thanks to Robert Feleppa for his careful reading, queries, and suggestions.

2. In MTM, 201 and CT, 433.

3. A. H. Goldman, 'Fanciful Arguments for Realism', *Mind* 93 (1984), 19–27.

4. Hilary Putnam, *Reason, Truth and History* (Cambridge: Cambridge University Press, 1981), 49 and *Meaning and the Moral Sciences* (Boston: Routledge and Kegan Paul, 1981), 124–25.

5. I develop this issue in more detail in 'Fantastic Realism and Global Skepticism', *Philosophical Quarterly* 38, no. 15 (1988), 205–13.

6. Donald Davidson, 'Reality Without Reference', 215–25; and 'The Inscrutability of Reference', 227–41—both in *Inquiries into Truth and Interpretation*, op. cit. For an excellent discussion of the general sense in which Davidson, Quine, and Tarski, in their treatment of truth, all avoid the sort of relativity and indeterminacy associated with reference, see George Romanos, *Quine and Analytic Philosophy* (Cambridge: The MIT Press, 1983), chapter 5.

7. 'Reality Without Reference', op. cit., 225.

8. Donald Davidson, 'True to the Facts', *Inquiries into Truth and Interpretation*, op. cit., 37–54.

9. 'Reality Without Reference', op. cit., 221–22.

10. 'A Coherence Theory of Truth and Knowledge', op. cit., 369–86.

11. 'The Structure and Content of Truth', op. cit., 279–328. Also, the issues here are embedded in the recent Davidson/Quine debate about the nature of evidence and a theory of epistemic justification. For a clear summary of what divides Quine and Davidson, see Quine's 'Three Indeterminacies' (1–16) and Davidson's 'Meaning, Truth and Evidence' (68–80), both in *Perspectives on Quine*, ed. R. B. Barrett and R. F. Gibson. (Cambridge: Basil Blackwell Inc., 1990).

12. Peter Klein, 'Radical Interpretation and Global Skepticism', in *Truth and Interpretation*, ed. Ernest LePore (Basil Blackwell Ltd., 1986).

13. See Simon Evnine, *Donald Davidson* (Stanford: Stanford University Press, 1991), 141.

14. Klein, op . cit., 381.

15. Colin McGinn, 'Radical Interpretation and Epistemology', in *Truth and Interpretation,* op. cit., 357–68.

16. *Inquiries into Truth and Interpretation*, op. cit., 183–98. Also see Evnine, op. cit., 142–45, for a clear discussion of this point, although he believes there is a tension (inconsistency?) between Davidson's belief-content link with causation and his 'rationalist idealism'.

17. Evnine, op. cit., recognizes this as well, but if I understand him, he does not believe (as I do) that the OIA, in the final analysis, is fully consistent with Davidson's treatment of first-person authority.

18. This informal summary closely follows that of Anthony L. Brueckner, 'The Omniscient Interpreter Rides Again', *Analysis* 51, no. 4 (1991), 199–200. But my version (importantly, I think) emphasizes the limited knowledge of the OI and the OI's restriction to the same interpretative methodology as the rest of us.

19. Richard Foley and Richard Fumerton, 'Davidson's Theism?', *Philosophical Studies* 48 (1985), 84, 88.

20. Stig Alstrup Rasmussen, 'The Intelligibility of Abortive Omniscience', *Philosophical Quarterly* 37 (1987), 315–19.

21. The remark was offered by my colleague, Arthur Skidmore.

22. Jonathan Bennett, 'Critical Notice' (on Davidson's *Inquiries into Truth and Interpretation*), *Mind* 94 (1985), 610.

23. Anthony L. Brueckner, 'Charity and Skepticism', *Pacific Philosophical Quarterly* 67 (1986), 264–68; and Roger Craig, 'Davidson and the Sceptic: The Thumbnail Version', *Analysis* 50, no. 4 (1990), 213–14.

24. This shows that Klein, op. cit., 373, is wrong in faulting Davidson with construing the central point of disagreement with the skeptic as turning on whether there is good reason for thinking our coherent beliefs are true, rather than (as Klein would have it) showing that there is good reason for thinking that coherent beliefs arising from sense-experience constitute knowledge.

25. This point was previously emphasized by Bruce Vermazen, 'The Intelligibility of Massive Error', *Philosophical Quarterly* 33 (1983), p. 71.

26. Op. cit., 184, 186.

27. Vermazen (op. cit., 71, note) correctly points out that a caveat is required here: strictly, Davidson does not measure massiveness of error or truth in terms of a ratio between false and true beliefs; the goal of charity is strictly to *optimize*, not maximize, agreement. See Davidson, 'Thought and Talk', in *Inquiries into Truth and Interpretation*, op. cit., 155–70.

28. A. C. Genova, 'Craig on Davidson: A Thumbnail Refutation', *Analysis* 51, no. 4 (1991), 195–98.

29. I develop the criteria for a 'good' transcendental argument in 'Good Transcendental Arguments', *Kant-Studien* 75 (1984), 469–95. One of the criteria is that no good TA can have a verificationist premise. If so, then Davidson should resist Rasmussen's argument that Davidson can best reach his extended claim by invoking such a premise (Rasmussen, op. cit., 319). Also see Christopher Peacocke, 'Transcendental Arguments in the Theory of Content', Inaugural Lecture at University of Oxford (Oxford: Clarendon Press, 1989), 1–27.

30. Michael Devitt, 'Dummett's Anti-Realism', *Journal of Philosophy* 80 (1983), 73–79.

31. Crawford L. Elder, 'The Case Against Irrealism', *American Philosophical Quarterly* 20 (1983), 39–73. I critique the Devitt and Elder papers in 'Ambiguities About Realism and Utterly Distinct Objects', *Erkenntniss* 28 (1988), 87–95.

32. This is discussed in detail in 'Good Transcendental Arguments', op. cit.

REPLY TO A. C. GENOVA

Quine taught me to think of the contents of sentences as given by what could be picked up in the learning process, whether of a first or a later language. Tarski's work in semantics encouraged me to regard a theory of truth as a way of expressing in a systematic way a framework into which sentences could be fitted. Sellars persuaded me that no epistemology that was founded on any version of an unconceptualized given could succeed. Over the years these ideas have come together for me to varying degrees and in more than one guise. At a certain point, rather uncharacteristically reflecting on where my ruminations had led, it dawned on me that if something like the way I saw things was right, various familiar forms of skepticism could never get off the ground, particularly skepticism about other minds, and general skepticism about the world. People suggested that what I had hit on was a transcendental argument, and I didn't reject the idea. But was it?

This is the question A. C. Genova asks, and I think he gives the right answer. I certainly didn't prove, by unquestionable logical steps, that every possible way of stating universal skepticism depended on assumptions which undermined the skeptical position. As he makes clear, the plausibility of my position depends on several theses that are far from proven. Some of these theses I have tried to establish, though certainly not beyond all determined doubting. I am filled with admiration by Genova's attempt to put my anti-skepticism in the best light he can, and by the generous way he articulates what I left out in proclaiming my conclusions, but assumed on the basis of further considerations. I think Genova's main conclusion is correct: if one rejects what he calls my semantic realism, it is possible that our picture of the world is radically mistaken. How could this not be the case, given that rejecting semantic realism means supposing there is no necessary connection, or perhaps any connection at all, between what we think and how things are?

I also agree with him that the argument that summons up an Omniscient Interpreter does not advance my case. As with Swampman, I regret these sorties into science fiction and what a number of critics have taken to be theology. If the case can be made with an omniscient interpreter, it can be made without, and better. But how can it be made? Once more, Genova has

my number: what I think should "defuse the skeptical challenge" is the "dependence of belief-content on the causes of belief." The trouble with this idea, he says, is that it assumes the interpreter "already knows that there are events external to our bodies which are causally correlated with belief states." Well, of course the interpreter knows this if he knows he is interpreting another person in the light of that person's reactions to things to which the interpreter also reacts. But how does he know all this? Here Genova contrives a complicated defense for a restricted conclusion. The outcome is that you can't be both a semantic realist and a skeptic, which refutes only a "relatively uninteresting" sort of skeptic, a skeptic who accepts semantic realism.

Rather than try to patch up the inconclusive arguments for rejecting skepticism which Genova discusses, I will say how I now see things. I am still stuck with Genova's conclusion: I depend on the form of externalism that comes with what he calls semantic realism. But the description that fits this form of externalism has grown more complex, tightening the connection between thought and language, and putting the conditions for command of the concept of objectivity on a firmer basis. I would now put more emphasis on an idea that was adumbrated in a talk I gave at Oxford in 1974:

> Someone cannot have a belief unless he understands the possibility of being mistaken, and this requires grasping the contrast between truth and error — true belief and false belief. But this contrast . . . can emerge only in the context of interpretation, which alone forces us to the idea of an objective, public truth. (Davidson 1975, p. 22)

The thesis of that paper was that there is no thought without language. Thought, I came to believe, depends on social interaction. What was not clear to me in 1974 was why this should be so. The considerations I now think recommend this conclusion also put the rejection of skepticism in a new light.

I had long been convinced that a key element in Quine's approach to translation, and hence to interpretation, entailed a form of externalism. That element was what gave empirical content to observation sentences and the thoughts they conveyed. What it amounted to was ostensive learning, though Quine did not until recently unambiguously endorse tying the content of observation sentences directly to the distal objects and situations those sentences were about. With this identification, no question can arise about the general correctness of perceptual beliefs in those cases where the content was acquired through ostension or an equivalent. One can still wonder, however, how universal such correctness might be.

The passages in which I have claimed that we cannot be "radically" or "massively" or "mostly" wrong about the world are shorthand for a more nuanced position. All that the externalism implied by ostensive learning guarantees is the general correctness of a limited body of belief. But the beliefs in this category carry great weight, for they insure that there is a world

external to us that contains people and a considerable number of other macroscopic objects, and that these objects exist independent of us in a shared time and space. I assume that this is enough to make persuasive the familiar view that we learn to apply further empirical concepts on the basis of relations to the ostensively learned ones. We cannot, for reasons discussed elsewhere in these replies, be consistently wrong about the relations of ideas, since it is these relations which, in addition to the direct causal connections with the world, determine the contents of sentences and the thoughts they express.

It is with perceptual beliefs and the sentences that express them that the direct causal connections between world, thought, and language are made. Someone learns what such sentences as "This is a book (yellow, water, a cat, etc.)" ordinarily mean in English in situations in which books (yellow objects, water, cats) are salient for both teacher and learner. Of course it can always happen that the learner does not learn what the teacher has in mind, but as the number of instances increases, and interconnections with further sentences come into play, the chances of this rapidly diminish. But given the ultimate complexity of the pattern of connections thus established, and the extent to which people share inherited and learned discriminative powers, there is no chance that when communication succeeds there is not a shared external subject matter about which the communicators think and talk. If there were not, their thought and talk would have no content: there would be nothing for them to talk or think about.

The emphasis on communication is not accidental. Society provides two things on which both language and thought depend. The first is the element of objectivity, the awareness of the possibility of being wrong. The argument here is that not only is a first language necessarily social, but that thought in general depends on a social check. The second is the determination of the relevant public stimuli which constitute the subject matter of perceptual beliefs. (See replies to Stroud, Nagel, and McDowell.)

Is my argument for the "massive" (essential) truth of our perceptual beliefs transcendental? If you accept the steps that lead to my version of externalism, what Genova calls "semantic realism", then you cannot, I think, be a skeptic about the existence of an external world much like the one we all believe we share, nor about the existence of other people with minds like ours. But the considerations in favor of semantic realism seem to depend in part not on purely a priori considerations but rather on a view of the way people are.

<div align="right">D. D.</div>

REFERENCE

Davidson, Donald. 1975. "Thought and Talk." In *Mind and Language*, edited by S. Guttenplan. Oxford: Oxford University Press.

7

Thomas Nagel

DAVIDSON'S NEW *COGITO*

Skepticism depends on the claim that one could be in a subjectively indistinguishable state while the objective world outside one's mind was completely different from the way it appears: and not just temporarily, but permanently—past, present, and future. Call this the skeptical possibility.

There are two traditional methods of refuting skepticism. One is subjective reductionism—the reduction of the objective to the subjective, in one form or another—so that facts about the objective world are analyzed, in some more or less complicated way, in terms of how things appear to us. This includes various forms of phenomenalism, verificationism, pragmatism, transcendental idealism, and "internal" realism. Reductionism denies that the skeptical possibility is a real possibility.

The other response is to leave unchallenged the logical possibility of a gap between appearance and reality, but to argue that we are justified in believing that the world is in fact largely as we take it to be. This response includes arguments as various as Descartes's route to objective knowledge through God's benevolence and Quine's naturalized epistemology.

Davidson has produced a third response to skepticism. Like reductionism, it denies the skeptical possibility. But it does not reduce the objective to the subjective; and although in a sense it goes in the opposite direction, it does not proceed by reducing the subjective to something else that is objective, in the fashion of behaviorist philosophies of mind. It is not reductionist at all. Rather, Davidson insists on certain consequences of the fact that thought and subjective experience, the entire domain of appearances, must be regarded as elements of objective reality, and cannot be conceived apart from it. The subjective is in itself objective, and its connections with the objective world as a whole are such that the radical disjunction between appearance and reality that skepticism requires is not a genuine logical possibility.

The argument is that our thoughts depend for their content on their relations to things outside us, including other thinkers and speakers. And since

we can't doubt that we are thinking, we can't doubt that the world contains our thoughts and that it is of such a character as to be capable of containing those thoughts. Specifically, to have the content which they have, and which we cannot doubt that they have, our thoughts must be largely true of what they are about. Therefore our beliefs must be largely true, and the skeptical possibility is an illusion.

Though the argument from thought to the objective world is a little longer, and the conclusion much more comprehensive, the spirit is Cartesian: Not *je pense, donc je suis* but *je pense, donc je sais*. It is Cartesian in the sense of the *cogito* itself, because it depends on the impossibility of doubting that one is thinking the thoughts one thinks one is thinking.

This is my interpretation of Davidson's refutation of skepticism, which is most fully set out in "A Coherence theory of Truth and Knowledge,"[1] but whose elements appear in many of his writings.[2] He might not want to put it quite this way. In particular, he would certainly resist the dramatic structure which makes it an argument *from* thought *to* objective reality—on which the parallel with Descartes depends. Davidson's aim is anti-Cartesian: Instead of getting us out of the egocentric predicament, he is trying to show that we can't get into it.

> There are of course some beliefs that carry a very high degree of certitude, and in some cases their content creates a presumption in favor of their truth. These are beliefs about our own present propositional attitudes. But the relative certitude of these beliefs does not suit them to be the foundation of empirical knowledge. It springs, rather, from the nature of interpretation. As interpreters we have to treat self-ascriptions of belief, doubt, desire and the like as privileged; this is an essential step in interpreting the rest of what the person says and thinks. The foundations of interpretation are not the foundations of knowledge, though an appreciation of the nature of interpretation can lead to an appreciation of the essentially veridical nature of belief.[3]

On the other hand he also says, taking up the point of view of the subject: "The agent has only to reflect on what a belief is to appreciate that most of his basic beliefs are true."[4]

I find that when the argument for the "essentially veridical nature of belief," based on the nature of interpretation, is pressed against a seriously resisting skeptical doubt, it inevitably takes the form I have given it. At any rate, this is how I would express the deeply interesting refutation of skepticism contained in Davidson's views, and it is the argument I want to discuss. Sometimes Davidson talks as if the claim were almost mundane. In resisting this tendency, emphasizing its heroic character, and drawing a parallel with the *cogito*, I mean to express my sense of how remarkable it would be if it succeeded.

One does not beg the question against skepticism by claiming that it must

admit objective ideas from the start. Skepticism always depends on the possibility of forming an objective conception of the world in which one is placed, a conception which partitions the world between one's mind and the rest of it, in such a way as to admit the logical possibility of radically different alternatives on the other side of the divide while the contents of one's mind remain the same. The possibilities that one is dreaming or hallucinating stand in for these skeptical alternatives, but a mere temporary dream or hallucination is not the real skeptical possibility, and is not ruled out by Davidson's argument. Skepticism requires the possibility of systematic and general failure in the correspondence between appearance and reality, so that the world is not and never has been more or less as it appears to be. This would be satisfied by Descartes's evil demon story, or certain versions of the brain in the vat (those in which I have always been a brain in a vat, rather than having recently been envatted after an otherwise normal life).

The skeptic maintains that he can form the objective conception of a world containing someone who is subjectively just like himself, but whose perceptions and thoughts do not and never have corresponded to the way the world is. He concludes that he can have no grounds for ruling out the possibility that he himself is that person. Clearly, then, the skeptic is committed to at least one assumption about objective reality: namely a strong form of logical independence of the contents of minds from the general character of the world in which they are situated.

Davidson's challenge to this independence is posed initially in terms of the conditions of interpretation which govern the ascription of mental states to others. Someone who actually knew what was going on in the world—the evil demon himself, for example—could not, according to Davidson, ascribe beliefs to anyone else in it except as part of a systematic interpretation in which those beliefs were largely true, making it possible to understand errors against a background of truth. That is because interpretation must try to make sense of the other person's point of view, and the only way to do that is to ascribe to him representations of and beliefs about the world that you observe him reacting to. Even false beliefs must be formulated in terms of concepts whose content is established by their connections to the world in the context of other, true beliefs. So the evil demon couldn't systematically deceive me even if he were omnipotent: It is logically impossible.

This way of putting the argument may seem to leave open the possibility of doubt on the ground that these are merely conditions of *interpretation* and there is a gap between interpretation and reality, just as there is a gap between appearance and reality. Interpretations can be mistaken, even if they are supported by the evidence. And if it is logically possible that the appearances in a mind might diverge radically from reality, then it is equally possible that an interpretation of what is in that mind, supported by Davidson's charitable

principles of interpretation, should nevertheless diverge radically from the mind's actual contents. Davidson's principles might yield no coherent interpretation whatever, for example, even though the person was actually thinking about some completely nonexistent world. Therefore it may seem that this argument can't refute the skeptic without assuming in advance that his crucial premise, the skeptical possibility, is mistaken.

I believe, however, that this reply mistakes the character of Davidson's principles of interpretation.⑤ They are intended to belong not just to epistemology but to metaphysics, and to govern not only the ascription of mental states to others on the basis of observational evidence, but also, in a sense, the ascription of mental states to oneself. The objection to the skeptic is that he cannot really conceive of the strange objective world whose possibility he must suppose, because he cannot conceive of *himself* having the thoughts he now has, in that situation. And since he is entitled to the equivalent of Cartesian certainty about roughly what is going on in his own mind, he cannot intelligibly doubt that most of his beliefs are true. The argument against the skeptical possibility is that it violates the conditions for ascription of beliefs to anyone, including oneself. The would-be skeptic can conceive of a situation in which he would be incapable of having the thoughts he now has, just as he can conceive of his own nonexistence; but he can no more conceive that he is *now* incapable of having those thoughts than he can conceive that he may now not exist.

In discussing this argument, I shall not take up the difficult question of precisely how the "external" conditions for the possession of beliefs, perceptions, and so forth are best specified—how large a subset of beliefs, and of what kind, needs to be true to provide the leverage needed to interpret the false ones, what kinds of causal and other relations to the world and other people need to be present, or how large a space for error this leaves. The general idea of such a theory is sufficient for our purposes without a detailed interpretation, which in any case presumably cannot be given in the abstract, but would be revealed differently in relation to different areas of thought. I also won't consider independent reasons for and against the correctness of this theory of interpretation. My concern is with an argument based on it, so I will consider only the consequences for skepticism, and not the theory of interpretation itself. My aim is to understand better the face-off between Davidson's argument and the subjective certainty of the skeptic (or a provisional skeptic, like Descartes) that he is able to conceive of skeptical possibilities that Davidson claims are illusory. This investigation will inevitably have some implications for the theory of mental content, but that is not its main purpose.

Let's suppose the skeptic says that it is consistent with what he knows is going on in his mind that there are not, and never have been, any material

objects, including his own body. Davidson will reply that in saying this, he is making use of the concept of a material object, and that he could have that concept and use those words to express it only if he and his language were in a systematic objective relation, causal and referential, to actual material objects: For his thoughts to be thoughts about material objects, real or imaginary, it is not enough that some episode occur within the confines of his mind. For any such episode to be a thought about material objects, it must reach beyond itself, representing the world outside. And it cannot do that unless it has a role in a complex system of real interactions between the individual who has the thought, the kinds of things the thought is about, and other thinking individuals. This is a priori.

Now the skeptic will find it difficult to avoid the feeling that this argument must have something wrong with it, simply because the conclusion is too strong. Even if the conditions Davidson claims for possession of the concept of material object are correct, it would seem that there ought to be a way of formulating an alternative, weaker, disjunctive conclusion. But if the skeptic tries to express that conclusion, he will immediately get into trouble. Suppose he says: "Either there are material objects and I can talk and think about them; or else there aren't, in which case I don't have the concept and am thinking something else." This doesn't make sense. I don't have *what* concept? . . . or else there aren't *what*? The second disjunct seems inexpressible—and yet it also seems to be there, tantalizingly awaiting expression as part of a suitable weakening of the conclusion.

Suppose the skeptic tries this instead: "I am thinking about the possibility that there might not be any material objects only if there are material objects (and other people), and my thoughts are suitably related to them." But then what is the alternative? It will have to be, "Otherwise I am talking gibberish to myself, and these images I am having and symbols I am juggling fail to represent anything." But is that a thought I can have? The things going through my mind *seem* to me to be thoughts about material objects. Could I possibly be mistaken about this—and if I were mistaken, what mistake would I be making; that is, what would I be *thinking* my thoughts were about?

The skeptic might try another tack: to concede the conclusion of Davidson's argument but dismiss it as trivial, on the ground that the principle of charity in interpretation requires that the concept of material object be taken to refer to *whatever* it needs to refer to to make his beliefs largely true.[6] To know on this ground that his beliefs about material objects are largely true would be to know nothing about what the world is actually like: It would be analogous to the knowledge that I am *here*—wherever *that* is—which tells me nothing about my location.

This objection fails because in order to think, "There are material objects —whatever *they* are," the skeptic would have to employ the concept of a range

of possible referents for his concept of material object, none of which he can identify or form any true beliefs about—and that is something Davidson's view rules out. (Indeed, even in order to have the thought that I am *here*—wherever that is—I must have the concept of a range of possible locations to which "here" may refer, and that is possible only if I can make other correct judgments about spatial location.)

The skeptic always relies on the idea that however far he is pushed into his subjective corner by the elimination of objective knowledge, there will always be something for him to fall back on as a way of describing the contents of his own mind. But Davidson's argument seeks to prevent him from retreating into that corner, by showing that his conception of himself and his thoughts is necessarily objective, and with much broader objective implications than Descartes's *cogito* establishes. So there is no place in the mind for him to retreat *to* from the objective external world.

Now this seems like too strong a result to be possible. If ordinary claims about the contents of one's mind have strong objective implications, it must, one would think, be possible to doubt the implications and therefore by inference the subjective claims—and still find something even more subjective that remains, and that is logically detachable from the large, objective world picture that burdens ordinary psychological concepts. Can we really not describe the *inner surface* of our minds (the cognitive analogue of sense data), without all that? Surely we can fall back on the certainty that we at least *think* we are thinking about material objects—which might be enough to support a form of skepticism. Otherwise we seem to be faced with the dilemma of either maintaining very strong claims of certainty for which we lack adequate warrant, or being totally skeptical even about the contents of our own minds.

The acute problem of there being nowhere to retreat to is vividly expressed by Wittgenstein, in the course of his argument that without objective conditions, it would be impossible for a term to name a sensation.

> "Well, I *believe* that this is the sensation S again."—Perhaps you *believe* that you believe it![7]

> What reason have we for calling "S" the sign for a *sensation*? For "sensation" is a word of our common language, not of one intelligible to me alone. So the use of this word stands in need of a justification which everybody understands.—And it would not help either to say that it need not be a *sensation*; that when he writes "S", he has *something*—and that is all that can be said. "Has" and "something" also belong to our common language.—So in the end when one is doing philosophy one gets to the point where one would like just to emit an inarticulate sound.—But such a sound is an expression only as it occurs in a particular language-game, which should now be described.[8]

Wittgenstein is talking about the impossibility of retreat from the public language, rather than from causal relations to the external world, but it is the same point. Faced with Davidson's argument, the skeptic trying to say or to think what it is that he can be certain he *has*, in conceiving of material objects—which does not imply their existence or the existence of anything at all outside his mind—will likewise be reduced to emitting an inarticulate sound, because he cannot describe what he has as an idea of a material object, or even as an impression of an idea of a material object. What justifies him in calling it an impression of *that* idea? He will be reduced to trying to describe the conception without its content, which on the face of it looks impossible.

If this avenue of retreat is closed off, and he cannot find a core of subjective certainty which does not carry excessively strong objective implications, can the skeptic instead achieve a radical skepticism even about his own mind? It won't help to take as a model Lichtenberg's response to Descartes, namely a refusal even to admit *cogito* in the sense in which it implies *sum*. Something more radical than this would be needed to resist Davidson's conclusion: It would not be enough to say that all I can be sure of is that thoughts are going on, not that I am having them—for even that would require, for the thoughts to have content, that they be related to an objective world. Skepticism in the face of Davidson's argument would have to take the form of the hypothesis that the truth is inexpressible by me, and that I do not have real thoughts at all. But since this is something I cannot think, it can appear only as an unimaginable abyss which is the alternative to continuing to maintain that I have extensive knowledge of the world which may be inadequately grounded, but which I cannot abandon because I cannot think that I am not thinking.

Perhaps the closest it is possible to come to expressing this form of skepticism would be just to observe that we have no alternative to thinking that our system of beliefs is largely true. While we can (indeed must) think that some of our beliefs are probably false, we cannot on Davidson's view hold that all or most of them might be, so long as we think anything at all. And the aspiring skeptic might say that simply to recognize the unavoidability of this ought to undermine our confidence. Even if the alternative is literally unthinkable, the objective conception of the world that we are stuck with is tainted by its inescapability. Let me explain why this is so. An explanation is needed because not all inescapable beliefs are equally disturbing.

The nub of the problem is that Davidson has produced an a priori argument for a conclusion that is not a necessary truth, and is not claimed by the argument to be a necessary truth. It may be a necessary truth that *if* a being has beliefs, the bulk of them must be true. But that is just a premise of the argument against the skeptic. The conclusion is that a particular body of

beliefs, the ones I actually hold, consisting mostly of contingent propositions, is largely true. And that is not a necessary truth, but an enormous and remarkable natural fact, a fact about the world as a whole and not just about my own mind. The argument for it is a priori, however, because in addition to the necessary general principle which is one of the premises, the only other premise is that I have certain thoughts—which, while it is not a necessary truth, is still something that, for Cartesian reasons, I cannot doubt.

Such an a priori argument seems miraculous. More miraculous than the *cogito* itself, whose immediate conclusion, though contingent, seems relatively modest—and also more miraculous than a priori arguments, based on inconceivability of the alternatives, for the necessary truths of logic and mathematics. After all, the arguments for most necessary truths have to be a priori; but it is absolutely amazing that there should be an a priori argument which proves that *this* set of propositions, which I believe, covering vast tracts of history, natural science, and ordinary lore about the world, is largely true.

There are of course more particular grounds, of a familiar, empirical kind, for the particular contingent claims which compose the set of my beliefs about the world. But these establish only their likelihood relative to one another, since the grounds for my beliefs are always other beliefs. The claim that they are largely true, rather than just being a coherent set of propositions, is a further contingent claim. It is just this which Davidson's argument is designed to establish, by ruling out the possibility that, though coherent, they might be largely false. Because they are our actual beliefs, we cannot regard them simply as a coherent set of propositions, nor can we regard their truth as simply consisting in that coherence, which in itself is not sufficient for truth (since I can formulate coherent sets of propositions which I do not believe and which are not true).

Of course if Davidson is right, then the ordinary empirical grounds are the only grounds needed for true beliefs, and coherence among our beliefs yields truth. But if the skeptic questions this, proposing to suspend belief and consider the possibility that this is merely a coherent system of thoughts, Davidson's ground for refuting him is an a priori argument for the contingent truth that most of the things I in fact believe are true. Not just that *if* I have a body of beliefs, most of them must be true (this necessary truth is a premise of the argument) but that *these* beliefs, which I in fact have, are largely true.

The picture is that we have a rich objective conception of the world, which includes ourselves, complete with all the thoughts that go into that conception. The whole thing, including our own existence and the fact that we think all these things, is largely contingent. But it is not contingent that the parts have to hang together in a certain way, in particular that the existence of our thoughts requires that various things be true of our relation to the rest of the world, including the other people in it.[9] So if there is any part of the picture

which we cannot doubt, and it is attached with sufficient firmness and leverage to the rest, we get an a priori argument for the rough accuracy of the whole thing. This role is supplied by the contents of our own thoughts.

The a priori argument is needed because the empirical reasons for particular beliefs are not by themselves sufficient. It makes sense to think about each of a great many of my beliefs, taken one at a time, that it might be false, in spite of the evidence. Some reason must be given to show that these individual possibilities can't be combined into the possibility that most of them are false. That reason can't be just the sum of the particular reasons for each of them, since these are just further beliefs in the set, and the whole question is whether most of them might be false.[10] If they were, their apparent support of one another would be systematically misleading. So we cannot demonstrate empirically that this is not the case, as is proposed by naturalized epistemology; it must be *proved* to be impossible, if skepticism is to be ruled out. We need an a priori argument, and Davidson has given us one. It is an argument which does *not* rely on the reduction of truth to coherence.[11]

 (My feeling about it somewhat resembles the feeling one has about a major paradox, where you are faced with an argument leading to an unacceptable conclusion, but you can't figure out what has gone wrong. In this case the problem is not that the conclusion seems obviously false, but that it is too strong to have been established with the kind of certainty that this argument appears to provide. Skepticism seems to have been repressed and rendered mute, rather than really refuted; it is still there, trying to find an outlet.)

One way of resisting the argument would be to deny that the ascription of thoughts to ourselves carries objective implications about our relation to the rest of the world, but I am not inclined to take this way out. Even if these objective relations to our surroundings do not constitute the whole nature of thought (and how could they, given the normative character and infinite reach of intentionality?), still they seem to be among its necessary conditions. Even in thinking about my own sensations I use concepts which I believe to be part of a public language that I learned from others who could tell what I was feeling. And when it comes to thinking about tables and chairs, the objective story is even plainer. Such thoughts need some foothold in a relation to what is outside us. Yet once I have acquired these concepts, I cannot doubt that I am employing them if I seem to myself to be doing so—even though the attribution carries strong objective commitments.

At the same time, I can employ those concepts, given that the objective necessary conditions of my having them are met, to imagine a world in which those conditions do not obtain—either a world without any material objects, or at least one in which the external reality is totally different from the actual world. And if I then go on to imagine this world containing someone who, apart from external relations, is exactly like me, what is one to say about such

a creature? It doesn't seem right to describe him as believing that George Bush lost the 1992 election; but is there any mental condition at all that we can ascribe to him?

In order for him to have any beliefs at all, something going on in his mind must be such as to be rendered true or false by the way the world is. For example, in order for him to believe that there are material objects, or chairs, even though there aren't any, his thought would have to be of such a character as to be true if it occurred in the counterfactual situation in which there were some. His mental expression for material objects or chairs would have to apply correctly only to them, and his images would have to be images of them. But what could make this true, if there were none and neither the expression nor the images had ever had any occurrent relation to such a thing? What would make his mental word a word for chairs?

It is possible for someone to think about frescoes, for example, even though he has never seen a fresco, believes falsely that the murals by Chagall in the Metropolitan Opera House are frescoes, and also believes that Michelangelo's paintings on the Sistine ceiling are not frescoes. But this requires that he know something about the defining features of a fresco, so that with enough further information he would be able to recognize his error. To refer to frescoes, his thought has to be connected with other things, like wet plaster, which could in turn connect him with frescoes. What could it mean to say of someone who had no true beliefs about what was wet or dry, what had any colors or shapes, what was made of plaster, wool, or whipped cream, that he has the concept of a fresco? Even though it is possible to acquire some concepts by learning their definitions, this must lead eventually to ideas that are grasped in themselves and can be applied directly to their objects. It doesn't really mean anything to say of a disembodied mind in a world without matter that he could identify wet plaster if he encountered it, or that he believes that frescoes are applied onto wet plaster.

If this is right, then Descartes was mistaken in thinking that his ideas of space, and his idea of a piece of wax, were independent of the existence of space and material objects, and of his real relations to them. Even the evil demon, in an immaterial and nonspatial world, would not have those concepts, whatever else might be going on in its mind.

It seems to me there are only two alternatives to accepting Davidson's argument. One is Platonism, the view that we can grasp directly a system of necessarily existent universals by the pure operation of our minds, independently of any contingent facts about the world and our contingent relations to it. This means we can have a priori knowledge about the necessary structures of the world, but not a priori knowledge that our empirical beliefs are largely true, as Davidson contends—because my concept of a piece of wax does not require my ever having come in contact with wax, matter, space, or any actual

samples of anything that might come into the definition of wax. It is enough to apprehend the pure ideas of those things. This does still require that we have a critical core of true beliefs about the world to have any thoughts at all—beliefs about the universals and their relations—but the core has been shrunk and pulled inward, even though the beliefs are in a sense still about the external world. Given how mysterious thought is, it seems to me that Platonism must always be a candidate for the truth; but in a sense, it's not a real theory but just an expression of hope for a theory.

The alternative to Platonism as a way of escaping from Davidson's argument would be to admit a form of skepticism about whether one was really capable of significant thought, while at the same time admitting that it is inexpressible and strictly unthinkable, since it is equivalent to saying, "Perhaps the sentence I am uttering right now means nothing at all." This seems a distinctly unattractive alternative, but perhaps there is a way of redescribing it. It would be a genuinely new form of skepticism—based on the belief that it is impossible to conceive of the contents of any mind, including one's own, except as part of a conception of the whole world in which it is situated and to which it is related. Although the skeptic would not be able to describe a skeptical possibility in the traditional sense, he would be able to observe that the proposition that his actual empirical beliefs are largely true—a proposition he now realizes he cannot conceive to be false—involves a huge set of nonnecessary truths, which he can't possibly know a priori. By revealing the a priori character of our attachment to the set, Davidson's argument actually points us toward this inexpressible form of skepticism.

THOMAS NAGEL

DEPARTMENT OF PHILOSOPHY AND
SCHOOL OF LAW
NEW YORK UNIVERSITY
SEPTEMBER 1993

NOTES

1. In E. LePore, ed., *Truth and Interpretation* (Oxford: Blackwell, 1986).

2. See especially "On the Very Idea of a Conceptual Scheme," *Inquiries into Truth and Interpretation* (Oxford University Press, 1984).

3. "Empirical Content," in E. LePore, ed., *Truth and Interpretation* (Oxford: Blackwell, 1986), p. 332.

4. "A Coherence Theory of Truth and Knowledge," p. 319.

5. Cf. "A Coherence Theory of Truth and Knowledge," p. 315: "What a fully informed interpreter could learn about what a speaker means is all there is to learn; the same goes for what a speaker believes."

6. Cf. "Knowing One's Own Mind," *Proceedings of the American Philosophical Association*, 1987, p. 456: "The agent . . . is in no position to wonder whether she is generally using her own words to apply to the right objects and events, since whatever she regularly does apply them to gives her words the meaning they have and her thoughts the contents they have."

7. *Philosophical Investigations*, sec. 260.

8. Sec. 261.

9. How these things hang together is described in "Three varieties of Knowledge," in A. Phillips Griffiths, ed., *A.J. Ayer: Memorial Essays* (Cambridge University Press, 1991).

10. Cf. "A Coherence Theory of Truth and Knowledge," p. 309.

11. A coherent set of propositions could be largely false, on Davidson's principles, provided it were not believed.

REPLY TO THOMAS NAGEL

It is heartwarming indeed to read something that summarizes my views accurately, eloquently, and sympathetically. So many readers have misread my ill-titled "A Coherence Theory of Truth and Knowledge" that Thomas Nagel's perceptive grasp of what I was up to reassures me that difficult as it may be it is possible to get it right. I agree with Nagel that my starting point is the same as Descartes's *cogito*. Nagel wittily summarizes my argument, changing just one letter from how Descartes would have put it: *je pense, donc je sais*; much better than the way I have sometimes put it: *I think, therefore you are*. Do I, as Nagel thinks I certainly would, resist the idea that my argument runs *from* thought *to* objective reality? No: that is how the argument, in its most direct form, goes. I start from the empirical observation that thinking, propositional thinking, is going on, and ask two closely related questions: what explains the fact that thoughts are objective, that is, that their truth (generally) is independent of their being believed; and what accounts for the contents of these thoughts? The answers to these questions entail, or so I argue, that thoughts would not have objective truth conditions, or the contents they do have, unless they were in the minds of creatures with bodies interacting in a shared environment.

But I am probably missing the real point of his conjecture, for of course I reject the Cartesian assumption that thoughts, though "mine", might exist in a disembodied mind, and owe nothing to anything outside my mind except to a benevolent God. I don't reason from the existence of such thoughts because there could not be such thoughts. Nor do I think that clear and firmly held beliefs are, because of these characteristics, the foundations of knowledge. There are no foundations in either the Cartesian or the empiricist sense. Our perceptual beliefs (those caused by what we now sense or remember sensing), though none is indubitable, do constitute a foundation in the sense that they have first claim to empirical content, and confer content on further empirical beliefs. But here I simplify a complicated story, and invite misunderstanding by those for whom the word "foundation" is a red (or white) flag.

Nagel quotes "A Coherence Theory of Truth and Knowledge" as saying, "The agent has only to reflect on what a belief is to appreciate that most of his basic beliefs are true." I was concerned to show that each of us not only has a basis for his picture of the world in his perceptual beliefs, but that he also, on reflection, would see that there was a reason (my arguments) for thinking this. I was trying to fend off the criticism (which perhaps surfaces in Stroud's contribution to this volume) that I might have shown that we do have a large supply of true beliefs, but not have shown that these constitute knowledge. I now think this attempt at fending off criticism was a mistake, if for no other reason than that it would seem to credit only those whose philosophical thinking is correct with knowledge. The right thing to say is rather this: we are *justified* in taking our perceptual beliefs to be true, even when they are not, and so when they are true, they constitute knowledge (this is what I meant by saying our perceptual beliefs are "veridical"). But since our only reasons for holding them true are the support they get from further perceptual beliefs and general coherence with how we think things are, the underlying source of justification is not itself a reason. We do not *infer* our perceptual beliefs from something else more foundational. (There is more on this in my replies to Stroud and McDowell.)

When Wittgenstein talks of the impossibility of retreat from the public language, Nagel says this makes the same point I make when holding that we cannot retreat from causal relations to the external world. This is perceptive, for I see the two points, Wittgenstein's and mine, as closely related. The causal element in the determination of the content of perceptual beliefs is necessary, but by no means sufficient. Two things are missing. The first is an explanation of the normative character of judgment, the fact that in applying a concept to a case we can go wrong. Some of Wittgenstein's examples concern extending a sequence of numbers (these are the examples Kripke emphasizes), but other examples (as in the passages Nagel quotes) concern characterizing sensations, and still others simple ostensive learning. The problem in each case is to distinguish a mere disposition to carry on in one way or another from the norm inherent in judgment. Wittgenstein seems to hold that it takes a shared language to provide the norm, and this is certainly my view. In ostensive learning, the learner comes to apply a one word sentence in response to the pairing of the teacher's utterances with stimuli from the features of the environment to which the teacher is also responding. Here causality and language come together: between them they give substance to the norm that makes getting things right or wrong a meaningful distinction.

Language and causality also cooperate to help fix the causes which give perceptual judgments their content. A single observer responds in characteristic ways to aspects of the environment, but there is no point in trying to decide whether the relevant stimulus is distal or proximal or somewhere in between.

We, watching a creature adjust its behavior to its needs and opportunities, read into that behavior the beliefs and desires and intentions that naturally occur in animals with thoughts. But what, in such situations, gives us leave to ascribe thoughts to the creature, thoughts with specific contents? Part of the answer is that when a creature is responding to the correlation of another's responses with its own responses to the world, the relevant common stimulus must lie where the causes of those joint responses converge. If the joint responses include verbal responses, the triangle of two (or more) creatures and shared stimulus provide both the norm and the content that give language and thought their point.

Nagel is understandably astonished that a priori reasoning should show that our general picture of the world around us "covering vast tracts of history, natural science, and ordinary lore", is largely true. Of course, as he notes, there is an empirical premise, the *cogito*. There is not an a priori proof that there is a world more or less as I think of it. Nor is the empirical premise a small one. The conclusion that I know that the world, both in general and in many particular ways, is as I think it is, depends on the fact that I have just the beliefs I do.

D. D.

8

Akeel Bilgrami

WHY IS SELF-KNOWLEDGE DIFFERENT FROM OTHER KINDS OF KNOWLEDGE?

I

In his Presidential Address to the American Philosophical Association, "Knowing One's Own Mind", Donald Davidson says:

> I can be wrong about my own thoughts . . . but the possibility that one is mistaken about one's own thoughts cannot defeat the overriding presumption that a person knows what he or she believes; in general, the belief that one has the thought is enough to justify the belief. (p. 441)[1]

Davidson has an explanation of the phenomenon he describes in this passage. The explanation turns on the nature of interpretation of a speaker, and what goes into it. The heart of the explanation is that "there is a presumption—an unavoidable presumption built into the nature of interpretation—that the speaker usually knows what he means. So there is a presumption that if he knows that he holds a sentence true, he knows what he believes."[2] This explanation (or account) of the presumption is most convincing. The speaker, in order to be interpreted at all, must know what her sentences mean, and that implies that she must know in general what she believes. In this paper I will try and come at this point from a slightly different angle. I will try to explore what the phenomenon is that is to be explained and try and say in somewhat different terms than terms which appeal specifically to interpretation of speakers and their meanings, what explanation (or account) the phenomenon might get. The severe restrictions of space in this volume of papers will not make it possible for me to explore the links and the underlying integrity of the interpretative considerations in Davidson and the ones I pursue in this paper.

Like Davidson, I will restrict myself to self-knowledge of intentional states or 'thoughts', though I do think that the account, with some supplement, is extendible to include other sorts of mental states.

In describing the presumption, Davidson writes in the singular, but in fact in the passage quoted from the Presidential Address, he mentions two different phenomena. The very last words (the words after the semi-colon) describe the phenomenon of what is often called "first person authority". But in the words just before, he describes something else, the presumption that we know our beliefs.

(1) "Authority" is the idea that if one believes that one believes (or desires) something, then the presumption is that the second-order belief is true. (2) But the other phenomenon is not the same idea, it is rather the idea that if one believes (desires) something, then there is a presumption that one believes that one believes (desires) it. For want of a better word, let's call this, not the "authority" we have in our beliefs about our intentional states, but the "transparency" of our mental states to ourselves. *Both* these phenomena (both these presumptions) captured in these conditionals are, of course, very closely connected and once both these conditionals are properly understood, it will be clear how the phenomena they capture make for the special character of self-knowledge, which no other kind of knowledge possesses.

At the very beginning of the quoted passage, Davidson also points out that one can sometimes be mistaken about one's own thoughts. This is clearly true or else we would have to most implausibly deny that there is such a thing as self-deception. And self-deception is not the only way in which we may fail to know our own thoughts. Sometimes there may be nothing motivated about such failures, but rather we may be simply too deep for ourselves (where 'deep' is not intended as a bit of eulogy.) So there is an explicit denial on Davidson's part that the special character of self-knowledge can be erected into some sort of Cartesian doctrine. The challenge then is to understand and explain these two related phenomena that characterize self-knowledge while at the same time allowing that exceptions to self-knowledge (of which self-deception is an example) is perfectly possible. I will argue that these exceptions hold more of transparency than authority—but I am getting ahead of myself. The point for now is that despite these presumptions which make for the special character of self-knowledge, infallibility in the Cartesian sense is not part of what is special, and any account of the special character of self-knowledge must also say something to accommodate the fact that there are exceptions.

II

Transparency first.

Davidson often contrasts what is special about self-knowledge by saying that, unlike as with perceptual beliefs or judgments about the external world

which are causally dependent on our senses and which can therefore go wrong, judgments or beliefs about our own minds are not so dependent. This point is a very important one but put like that it seems to apply to 'authority' only and not 'transparency'.

The presumption of transparency is the presumption not that our beliefs about our intentional states are not usually wrong but rather that if there is an intentional state, then its possessor will believe that it is there. However, notice this too contrasts with perceptual knowledge of the external world since surely we are not even slightly tempted to say that if there is a fact or object in the external world, then there is a presumption that a perceiver will know that it is there. We are not tempted to say this perhaps because in perceptual knowledge of the external world, the agent has to do something or (more passively) be doing something—looking or seeing or at least she has to "check" if not look or see (as perhaps in knowledge of the position of her own limbs). Knowledge of the external world is paradigmatically a result of such *cognitive achievement*, which if the agent does not do or have happen to her, then she will not form the belief that there is some fact or object in the world. In the case of self-knowledge there is in the paradigmatic case, no such cognitive activity required to believe that one has some intentional state. (Again there are exceptions, and that is why I am stressing the paradigm cases.) The presumption of transparency, then, is a result of the fact that belief about our thoughts comes with the thoughts, as it were 'for free', without any cognition. (This, of course, does not stop them from being cognitive states in the sense that they are truth-value bearing. They are truth-value bearing or cognitive states which are not a result of cognition.)

But to have noticed that beliefs about our own intentional states are not a result of any analogue to looking, seeing, etc., does not yet give us the conclusion that self-knowledge is not akin in some basic way to perception. Here is how someone keen on pressing the perceptual analogy may insist that it is akin to perception. They may grant that there is no analogue to looking, seeing, etc., but there is nevertheless a crucial explanatory *causal connection* between what such beliefs amount to knowledge of (i.e., the first-order intentional states) and the beliefs themselves (i.e., the second-order beliefs). The idea would be that there is a causal mechanism whereby whenever there is a first-order intentional state, it causes its possessor to go into a second-order belief that she has the first-order state.[3] And it is this causal mechanism which explains the presumption of transparency. On this view, there is no need for a cognitive mechanism since there is no analogue to looking or seeing involved, but all the same there is a *minimal* common element shared with perception which is that there is a causal mechanism linking and explaining what is known with the knowing state, just as in perception. So when Davidson contrasts self-knowledge with perceptual knowledge of the external

world, he is contrasting self-knowledge with even this minimalist causal-perceptual account of self-knowledge. It is because one contrasts self-knowledge with even this minimal causal explanatory account, that the presumption of transparency amounts to something like a thesis about how self-knowledge of intentional states is *constitutive* of the very idea of intentional states.

We have to tread carefully here. We are not denying that there are or can be causal links between first-order intentional states and second-order beliefs about them. Perhaps (I'm not sure) we should not deny this if we are to allow that second-order belief or knowledge states are *different* states from the first-order intentional states they are knowledge of. But even if we don't deny this, what we are denying in denying such a minimal causal-perceptual account of self-knowledge is that if there are these causal links, they do any explaining of our self-knowledge and the phenomenon of presumption we are considering. I will return to this point later but let me just say for now that the point is that even if there are these causal relations they are not the ordinary sorts of causal relations found in perception of the external world, but rather they would have to be causal relations embedded in some form of *part-whole* relational system, which would echo in the causal characterization of the underlying physical realizations of states of first- and second-order, the constitutive nature that self-knowledge bears to first-order intentional states.[4]

Transparency is a very strong claim it seems, and it is bound to raise eyebrows and questions. How is it possible to say, given the manifest fact of self-deception and other such failures of knowledge of our intentional states, that we may presume that if we have an intentional state, then we believe that we have it? Don't these exceptions make clear that just as we may fail to know lots of things in our external environment, we may fail to know our own mental states? Why not then simply admit that there is a causal explanation linking our intentional states to our beliefs about them when we do have beliefs about them, rather than count these latter as constitutive of our intentional states. The claim of constitutiveness amounts to saying that there is a rule-like quality in the conditional, "If I believe (desire) that p then I believe that I believe (desire) that p". But surely there is no rule like quality here, only a very reliable causal mechanism responsible for the linkage.

Given these questions that are bound to arise, we must wonder: whence our intuition or philosophical conviction that there is a rule-like quality to this conditional? In the rest of this section I will make a tentative proposal by way of answer to this question. The proposal appeals to considerations which may seem somewhat distant from our theme of self-knowledge, but are only seemingly so. I will spell out the considerations first and then link them up with self-knowledge, in particular with the presumption of transparency.

To a considerable extent, our notions of intentional states, of beliefs and

desires, are bound up with the notion of agency and responsibility. This is not a cancelable nor perhaps even a controversial aspect of such states. And in turn (and just as important), our notion of responsible agency is not a purely metaphysical notion, but a fall-out of the fact that we think of our actions (and beliefs and desires) as being susceptible to criticism, including our own criticism. Though this may be familiar, it perhaps cannot go without some exposition.

In the standard dispute about whether or not freedom and responsible agency is possible, one traditional and familiar position used to be that it is possible only because causality did not hold universally, in particular human actions were not caused, but were a product of mental states which were, in the traditional phase, "contra-causal." The position which opposed this view in the standard dispute claimed that there were no exceptions to causality, at any rate none relevant to human action, and so human freedom of action was an illusion. Both these opposed positions on responsibility accepted a premise which was often called "incompatibilism". Responsibility and universal causality or determinism were not compatible, so if the former had any place in the universe, it was because the latter did not comprehensively occupy all the space. The two positions simply took different sides, given this assumption which they both shared.

It was Hume who first very explicitly repudiated the assumption itself and tried to make space for the compatibility of responsible agency and universal causality. He argued that it was not causality in itself which threatened responsible agency, it was rather the specially coercive nature of some causes which did so. This was intended to show that though some actions were indeed not free and responsible (those caused by some coercive element such as, say, holding a gun to a person's head), others were (such as, say, someone doing the very same action because that is what her beliefs and desires in-clined—caused—her to do.) The latter was paradigmatically non-coercive compared to those such as the former. Both however were a result of causes, so we could allow for responsible agency without denying the universal sway of causality. This Humean position, attractive though it is in its compatibilist conclusion, seems to be problematic or at any rate, incomplete. For a question arises: *what about* the coercive causes makes them coercive, makes them threatening of responsible agency, since they too are after all causes. Can we just stare at the causes and tell which ones are coercive and which not? What gives the clue in this scrutiny as to which was which?

It was perhaps Strawson who first argued that no purely descriptive property of the causes of human actions could possibly tell which ones were and were not threatening of freedom.[5] Freedom, thus, was not, as he came close to saying, a purely metaphysical notion but a "normative" one in the sense that what made the difference was which actions we found ourselves

responding to with "reactive attitudes" and which we did not. To put it simply, those to which we found ourselves praising and blaming or criticizing, resenting, and admiring, were free and not coercively caused, those to which we found ourselves not responding in any of these ways were those we counted as coerced. The point was that it was our evaluative responses which were the clues to responsible agency and not something intrinsic found in the causes of actions themselves. They need not always be evaluative responses attaching to actions in the realm of manners and morals, they could for instance be evaluative responses attaching to something like drawing some conclusion from some premises, but evaluative is what the responses would have to be. Also, the reactive attitudes need not always come from another, they could of course also come from the actor himself or herself. But in the end the basis of responsibility would still have to be these reactive attitudes and not some non-normative property of the action held responsible or its causes. Though this is a controversial claim and much contested by those who wish to see responsibility as a non-normative, *purely* metaphysical property, I believe that it is surely and firmly a step in the right direction.

In fact it seems to me that Strawson errs in not being more whole-heartedly normative. What he did not say, which needs saying is that these normative responses ("reactive attitudes", as he calls them) on our part need evaluative justification too. The right position is that if we could (in turn evaluatively) justify our normative reactions to some actions (or beliefs and desires) rather than others, those were the actions that counted as responsible and free. This modification or addition to Strawson is necessary since we do not want to allow the fact that we may sometimes resent (even kick) our televisions for not working or our cats for defecating on the sofa, to mean that these count as responsible. So the simple fact of having these normative responses is not enough, we must be able to justify them, too. If the actions of a cat or the limitations of a television lack the property of responsibility, it's not because we never have reactive attitudes towards them, it's because we cannot justify those reactive attitudes as appropriate. And the notion of 'inappropriateness' here is not some non-evaluative notion of how reactive attitudes simply do not (conceptually speaking) attach to such things, the notion of inappropriate is fully evaluative. If the general direction in which Strawson has pushed us is right, then these further justifications will also have to be *evaluative*. They, too, will have to come from somewhere internally among our own values. In fact, this normativist point holds not just in the figuring out of when our reactive attitudes are appropriate in specific cases but in the very right we have to the reactive attitudes at all. There is no getting outside of our values even to justify the fact that we have reactive and evaluative attitudes in the first place. So if the incompatibilist says, as many do (especially those influenced by psychiatry): "Well, perhaps we should not ever praise and blame

human beings just as we should not blame televisions and cats; we should in general try and get rid of these reactive attitudes once we recognize the universal sway of causality", the modified Strawsonian response I am urging would reply: "But we have *values*, very specific values perhaps, which tell us that we should continue to praise and blame even in the midst of acknowledging universal causality. The whole matter of agency is an evaluative matter and we are agents because we have the reactive evaluative attitudes *and because we want and value having them rather than giving them up.*" We justify being evaluative creatures (agents, if Strawson is right) not by going outside our values, but internally from among our values. There is no other place to go to justify them, and in this the situation mimics epistemology generally where there is no other place to go to justify belief than other beliefs. Thus, the notion of responsible agency is a thorough-going normative notion, more thorough-going even than Strawson noticed.

What does all this have to do with self-knowledge?

It is a conspicuous fact about responsibility, *so understood in evaluative terms*, that it takes for granted self-knowledge. Actions don't (justifiably in the evaluative sense mentioned above) get counted as responsible if the actor does not know that she has acted in a certain way. If this is right, if self-knowledge is a necessary condition for responsibility, then we can say that to the extent that intentional states are in the realm of responsibility, so long as they are tied to responsible action, then there must be self-knowledge of them. That is, transparency of intentional states is established so long as the intentional states are in the region of responsibility.

This will strike many as wrong. After all don't we praise and blame people and hold them culpable even if we know that they lack self-knowledge of what they have done? Dozens of examples come to mind of cases where that happens. But I submit that these cases (despite the common talk with which we praise and blame, talk that targets the actions themselves), are not cases of holding culpable the act of doing something done unknowingly but rather cases of being culpable for not knowing that one has done that thing. There is no justification for blaming an action under the description x but which the agent does not recognize as a description of her action, as she intended it and thinks of it. Of course, if the action was injurious or harmful, we moralists do talk as if that action was culpable. (Even the law sometimes talks that way.) But our blame is only justified if the blame is redescribed as targeting the agent's failing to know what she is doing, rather than blaming the doing, under the description x, which the agent does not even recognize. Thus, when we say "ignorance is no excuse", that ought not to be strictly interpreted as meaning "we will hold culpable the action you are ignorant of having committed", rather it is to be interpreted as what the law calls "culpable ignorance". It is the ignorance or lack of self-knowledge which is culpable, not the action under

that description. If this is right, then we may still maintain the claim that responsibility (which under the present conception is understood in evaluative terms of the reactive attitudes, of blame and praise, etc.) presupposes self-knowledge.

Another thing might strike the reader as needing to be argued. So far I have made my point about responsibility only of actions, but have gone on to make my point about self-knowledge about actions *as well as* intentional states. With what right did I make that extension? The extension is justified because of the familiar and obvious connection between intentional states and actions. Beliefs and desires which rationalize an action that is responsible in the sense we have been discussing, are also presumed to be self-known by the agent. They are after all what make it possible to describe the action being held responsible in the way we do describe it. Actions are dependent on their rational causes for the very descriptions they get, and under which they are evaluated, reacted to, and held responsible. And the claim is that if they are indeed responsible then they are self-known and so are the intentional states which are their rational causes. In fact one has justifiable reactive attitudes directly towards intentional states themselves, and that means that one takes it that their possessor has self-knowledge of them. One could not justifiably criticize, say, a belief or desire someone has (say, for being inconsistent or in other ways irrational) unless one assumed that she had self-knowledge of it. And this is of course *trivially true* in the case when she herself criticizes it. How could one be *self*-critical if one was not self-knowing of what one was criticizing? So in general one's actions and intentional states are transparent to their subjects, to the extent that responsibility is in place, to the extent that justifiable reactive attitudes are in place. The presumption of transparency simply lies in the fact that self-knowledge is a necessary condition of (responsible) agency.

In section I above we characterized transparency in terms of a conditional. We said that if a person believes (or desires) that p, then there is a presumption that she will believe that she believes (or desires) that p. What needed accounting for was the presumption. And it is my claim in this section that the first and major step in accounting for it was to be able to notice that self-knowledge is tied to responsibility. In other words, in this section what we have shown is that in the conditional above we can remove the words 'there is a presumption' and rewrite a new conditional: "To the extent that an intentional state is in the region of responsibility, i.e., to the extent that an intentional state is the rational cause of an action which is the object of justifiable reactive attitudes, or to the extent that an intentional state is itself the object of a justifiable reactive attitude, then that intentional state is known to its possessor." More abbreviatedly for convenience's sake, the rewritten conditional for transparency is (T): *"Given responsibility, if someone believes*

(or desires) that p, then she believes that she believes (or desires) that p."
This rewritten conditional I will claim explains the presumption specified in
the previous conditional.

There is of course more to be said about why we should find it interesting
for our question of the presumption of transparency, that transparency does
always hold under conditions of responsibility. That is to say, there is more to
be said about why it is that establishing that transparency holds under
conditions of responsibility is essential to showing why self-knowledge is
special and different among all knowledges. I will return to that in the
concluding section after dealing with *authority* in the next section.

 III

What then of authority? It too was characterized in the first section by a
conditional: "If one believes that one believes (or desires) that p, then there is
a presumption that one believes (or desires) that p."

Here again let me remove the words 'there is a presumption' from the
conditional and rewrite it. Without the words 'there is a presumption' there,
the conditional may look like much too strong a claim: *"If one believes that
one believes (or desires) that p, then one believes or (desires) that p."* How
can it possibly be true, someone may ask? Don't cases of self-deception
disprove it? In self-deception don't we often believe that we believe or desire
something, when we do not? And didn't I promise that I will allow for self-
deception in accounting for authority and in general accounting for the special
character of self-knowledge?

The answer to the question "Don't cases of self-deception show the
rewritten conditional above to be sometimes false?" is "No."

Here is why. When one believes that one believes (or desires) that p, and
one is self-deceived, it is not that one lacks the first-order belief (or desire)
that p, and therefore it is not that the second-order belief is false, it is rather
that one has another first-order belief (or desire) which is inconsistent with the
belief or (desire) that p, say, not-p. So let us take a standard sort of case of
self-deception. Suppose someone has the second-order belief that she believes
that her health is fine, but let us suppose that her behavior suggests to others
around her that she is full of anxiety about her health. Let us suppose that she
does not recognize her behavior as being anxious in these ways, but any
analyst or even friend can tell that it is so. One view to take of this sort of
familiar case is that her second-order belief is simply false. It is the simpler
view, and it is wrong. I think the right view is more complicated: her second-
order belief is true, which means she has the first-order belief that her health
is fine, but she also has another belief that she is not aware of, the belief that

she is sick. So authority is not unsettled by the phenomenon of self-deception, rather transparency is missing regarding one of the two inconsistent beliefs (i.e., it is missing of the belief that not-p). If this is right, then allowing for self-deception clearly does not undermine the rewritten conditional regarding *authority*.

Now, as I said at the end of the last section, it is all right for transparency to be missing sometimes since the rewritten conditional for *transparency* holds only when the proviso regarding responsibility holds. And if, as I pointed out, one cannot justifiably have reactive attitudes to actions caused by states which one lacks self-knowledge of, then responsibility does not hold for such actions. I claim then that in our example above we are not justified in having reactive attitudes to actions which are caused by the first-order belief that not-p, but only those which are caused by the first-order belief that p. If we blame the agent for any actions caused by not-p then that cannot be justified, and we should better see the person as blameable for not knowing what she is doing and thinking. It is the ignorance we find culpable, not the actions which the agent cannot even recognize as her own.

Why am I insisting that the second-order belief is not false even when there is self-deception and why am I giving this more complicated analysis of these cases? Because it seems there is no other way to understand what role second-order beliefs could have in our psychological economy, if they did not emerge in actions that indicated the existence of their embedded first-order beliefs or desires. Or if not in actions, then in a *preparedness* to act on the first-order beliefs (or desires) that are embedded. Of course, one could *say* that one believed (or desired) that p, and not even be prepared to act on it. That would be because one was insincere or because one was just sounding off, not "really saying", as it were. But the point here is one about *believing* that one had the belief or desire, and not just saying that one had it. So if one were genuinely to express this second-order belief in one's avowal, then the avowal, it would be assumed, would not be insincere or a mere sounding off. It would have to reflect, therefore, that, whether one actually did so or not, one at least was *prepared* to deploy the belief (or desire) that p in one's thinking, both in reaching other theoretical propositional conclusions on the basis of it, as well as coming to act on the basis of it (and other intentional states). In other words, an absence of the disposition to act on the belief (or desire) that p or come to any conclusions on the basis of it, may lead one to be skeptical as to whether to attribute to the agent the second-order belief, as to whether to attribute to his mouthing of an avowal any sincerity. But it would not lead one to attribute a false sincere avowal or a false second-order belief. If this is right, then what it shows is that if we did or did not have the disposition to act on the belief that p, that matter would by itself also be enough to decide on whether there was or was not the *second*-order belief as well, or whether or not the

avowal was sincere or not. They stand or fall together. So there is no reason to deny the point that one's second-order beliefs cannot fail to be true, even if there is self-deception. If we are correct in attributing a second-order belief or sincere avowal in the first place, then the belief avowed must also exist, thus making the avowal and second-order belief true.

I have argued that the rewritten conditional for authority at the beginning of this section is exceptionless. So is the rewritten conditional for transparency as we saw at the end of the last section. There is one difference, however, in the two conditionals. The one for authority I have said holds without any proviso regarding responsibility, the one for transparency does not. Transparency has exceptions; it's just that the exceptions don't unsettle the rewritten conditional for it since that conditional comes with a proviso regarding responsibility which, as I showed, accommodates the exceptions. But authority I am saying has no exceptions, and I have spent this entire section saying why.

All that is correct, but all it shows is that one does not need the proviso for the rewritten conditional for authority *in order to accommodate exceptions,* since there are no exceptions. Does it mean that one does not need the proviso for the conditional for authority at all, for *any* reason ? One does need it. One needs it because, even if the second-order belief is always true, and even if the first-order belief is always present whenever the second-order belief is present (that is after all what makes the second-order belief true), that still does not establish self-*knowledge*. For self-knowledge we demand and require more than that there be true second-order belief. This is so for just the standard sort of reason that we require and demand that in other kinds of knowledge there be more than true belief. In other sorts of knowledge (say perceptual knowledge of the external world) we require more than true belief because of standard problems such as that someone may believe that there is a table in front of him, and there is a table in front of him (thus, true belief), but he still does not have knowledge. We require some further element which elevates true belief to knowledge. We require it in order to rule out, as it were, true beliefs which are flukes, and which, therefore, do not amount to knowledge. So also, we need some further element to convert true self-belief to self-knowledge, to remove the element of fluke or mystery, and to give a full account of authoritative self-*knowledge*. That further element will of course not be at all like the further element for knowledge of the external world since we have been at pains to say that self-knowledge is special precisely because it is different from perceptual knowledge. It will be something entirely different, and I submit that that further element is precisely the normative element of responsibility we have identified. It is because the intentional states which are specified in the embedded clauses of second-order beliefs are necessarily the sorts of things that give rise to actions (or conclusions) to

which we have justifiable reactive attitudes, that if we believe we have them, and that belief is true, it is not true by fluke. Without seeing the links with agency, we would not be able to say what we said earlier, viz., that second-order beliefs must stand or fall with the first-order intentional states that are specified in the embedded clauses that specify those beliefs. They fall with them for instance because (as I said) we can see no role for second-order beliefs to play in the explanation of intentional action, we can see no role for them in our understanding of responsible agency, if the first-order intentional states they are about are not present. So the proviso regarding responsibility, is needed for the rewritten conditional for authority as well. Thus (A): *"Given responsibility, if someone believes that she believes (desires) that p, she believes (desires) that p."*

<div align="center">IV</div>

Conditionals (T) and (A) (or the biconditional that they form together) have replaced the conditionals I cited in section I which mentioned a presumption of transparency and authority. The earlier conditionals were the explananda, since it is the presumption, we wanted to explain. The rewritten conditionals (T) and (A) account for the presumptions, since they capture a rule-like quality that links first- and second-order beliefs that are involved in self-knowledge. This relation between second-order beliefs and first-order intentional states captures what it is we mean partly when we claim that self-knowledge is constitutive of intentional states. There cannot be exceptions to these conditionals, so rewritten, and in this rewritten form the proviso regarding responsibility fully explains why there is a conceptual truth captured in the bi-conditional, something which is, of course, denied in the causal-perceptualist accounts of self-knowledge. It is this contrast with perceptual accounts which we said earlier would reveal the special character of self-knowledge.

Let me then close by making explicit how this analysis establishes the special character of self-knowledge.

In a perceptual account of self-knowledge, even if there is no seeing and looking, minimally a causal mechanism is said to link first-order intentional states with second-order beliefs about them, and it is said that the causal mechanism is highly reliable. It is this reliability of a causal mechanism that underlies our intuitions about transparency and authority. In the account offered in this paper, these intuitions are instead captured by showing the essential connections between our notions of intentional states, self-knowledge, and responsible agency. Once these connections are properly understood and in place, we are able to formulate a bi-conditional (as we did over the last

two sections) which capture the intuitions of transparency and agency. In the perceptual account because it is a *causal* mechanism which is essential to the account, there could always be breakdowns in the mechanism, however reliable the mechanism is. The link between second-order beliefs and first-order intentional states could always thus break down, even if it mostly does not. In our quite different account, there is no question of any breakdown. And perhaps the best way to bring out the fact that the two accounts are very different is to say why the following thought trying to make them compatible is false.

The false thought is this: Despite my arguments against the perceptual view, I have admitted to the non-Cartesian claim that there are exceptions to self-knowledge—things like self-deception and other lapses. Now why can't one say that the breakdowns in the causal mechanism (a mechanism proffered by the perceptual account), when they occur, occur whenever these exceptions which even I allow in my account occur. If so, there is no incompatibility in the two accounts. I am right to point out the conceptual connections between notions of responsible agency and self-knowledge, but these conceptual connections do not threaten a perceptual account. The perceptual account may admit to these conceptual connections and still claim that in each case of self-knowledge the operation of such a causal mechanism accounts for it.

The thought is false because it quite fails to notice the principled *failure of fit* between the idea of breakdowns in ordinary sorts of causal mechanism and the idea of exceptions to self-knowledge in my picture of things. It is the entire point of this paper that the link between second-order beliefs and first-order intentional states in cases of self-knowledge are governed by a proviso that is *thoroughly normative*. That was the point of the entire excursus about Strawson's quite untraditional view of responsibility. Therefore, the biconditional mentions a proviso, which is thoroughly normative. So, though unlike Cartesians, of course, I admit to exceptions to self-knowledge, those exceptions (in my picture of things) are precisely signs of the inapplicability of the normative conditions specified in the proviso. Now, breakdowns in a causal mechanism cannot possibly match up with exceptions to self-knowledge in such a picture because causal mechanisms *do not operate and break down with an eye to whether normative conditions obtain or not*. No causal mechanism (think of the one in perception of the external world which is what the analogy is with) breaks down only when some normative condition fails to hold. Breakdowns in causal mechanism occur completely blind to such conditions. So the two accounts are quite incompatible. It is not that the account offered in this paper is insisting that there cannot be any causal mechanism there. But it is insisting that self-knowledge is not accounted for by it, as it is in cases of perception of the external world.

It is this contrast and incompatibility with perception which makes for the

special character of self-knowledge. The connection of self-knowledge with responsible agency is central to making that contrast, and the normative account of responsibility is central to the connection that makes that contrast. These central elements of the analysis I believe integrate in very specific and very interesting ways with the account of self-knowledge that Davidson gives in terms of his account of meaning and interpretation, and which I briefly mentioned in section I. I regret very much that the limitations of space in this volume will not allow me to spell that out here. But even without that, it should be obvious to the reader that what I have said in these pages, if right, shows that issues about intentionality are never far removed from those of responsibility and evaluation, a lesson that is taught constantly by Davidson who has, from his earliest writings to his most recent, integrated the study of meaning, thought, value, and action.[6]

AKEEL BILGRAMI

DEPARTMENT OF PHILOSOPHY
COLUMBIA UNIVERSITY OF NEW YORK
SEPTEMBER 1998

NOTES

1. *Proceedings of the American Philosophical Association*, 1987.

2. This quotation is from another paper by Davidson called "First Person Authority", *Dialectica* 38 (1984): 111.

3. David Armstrong in the chapter on "Introspection" in his *A Materialist Theory of Mind* (London: Routledge and Kegan Paul, 1968) takes this causal-perceptual view of self-knowledge.

4. I discuss this issue at some length in my *Self-Knowledge and Intentionality* (forthcoming, Harvard University Press).

5. For such an analysis of freedom and responsibility, see P. F. Strawson, "Freedom and Resentment" in *Freedom and Resentment and Other Essays* (London: Methuen, 1974).

6. Another regrettable thing is that I do not have the space in this paper to show that considerations of responsibility show in one stroke not only that self-knowledge is special (as I have tried to do in this paper) but also that other kinds of knowledge are precisely unlike self-knowledge in this way for the same reason. That is to say these considerations offer a *single* reason for why self-knowledge is a certain way *and* other kinds of knowledge are not *that* way. So it is not merely that these considerations show a difference, they show an *asymmetry*. Perhaps it will be obvious to the reader how they show it, but I have not had the space to make it explicit here how they do. In the last section of my "Self-Knowledge and Resentment" in *On Knowing One's Own Mind*, edited by Crispin Wright, Brian Smith, and Cynthia MacDonald (Oxford: Oxford University Press, 1998), I do make it explicit.

REPLY TO AKEEL BILGRAMI

The question how we know what other people think has long been a top attraction in the skeptic's introduction to philosophy. But there are other questions that can reasonably count as prior. If we are doubtful about the existence of an external world, there is little point in asking how we know what is in the minds of other people. On the other hand, if we accept the existence of a public world with people in it, there is a sense in which it is obvious how we achieve some idea of what those people want and believe: we observe their actions, and attend to what they say. As long as we have an epistemology that explains how perception yields empirical knowledge, either directly, or by theorizing, finding out what others think is in the same general line of business with finding out how hydrogen and oxygen combine to make water. In "First Person Authority" (Davidson 1984) I pointed out that there remains the question how we know what is in our own minds. It certainly is an empirical matter, but our normal ways of discovering facts about the world seem to fail us, for the blazingly plain reason that we can not directly observe our states of mind, nor do we normally infer them from what we do observe. We learn how to talk about other people's states of belief, desire, intention, hope, and doubt using the normal sort of observable evidence. How then do we know how to apply the same idiom to ourselves without appeal to observation?

It is no answer to point out that on rare occasions we learn something about our own attitudes from a psychoanalyst, even if she gained access to our minds by normal observational methods. This would not explain how we do it in the normal case, for the question would remain why we think what the analyst is talking about is the same sort of thing we know without observation. In other words, more basic than the problem of other minds is the question what explains the asymmetry between the way we normally know what is in our own minds, and the way we know what is in other minds. Since our techniques for determining the mental properties of others are pretty much the techniques we use for learning anything about the world, and these techniques

are not employed in our own case, the problem would seem not how we know the minds of others, but how we know our own minds.

I proposed an answer which appealed to the nature of interpretation and was intended to explain the asymmetry in a natural way without appeal to introspection or other eerie form of knowledge. I had the feeling, however, that there had to be more to the story, something that would throw more light on the nature of self-knowledge. Akeel Bilgrami has made a proposal which, if it is right, would provide the needed illumination and as a bonus, explain the apparent exceptional cases in which we are mistaken about our own attitudes. The argument is subtle and the outcome appealing. I do have some misgivings, both about Bilgrami's proposal and about the related proposal of Peter Strawson. As Bilgrami relates it, the thrust of Strawson's idea is that we count actions as free and treat them as responsible if they are actions toward which we respond with a "reactive attitude" such as resentment, praise, or blame. Thus the notion of a free act is not "purely descriptive"; it has an uneliminable evaluative or normative character. In a somewhat similar way, Bilgrami urges that if an action is a free and responsible action, then (without exception) the agent knows his reasons and if the agent believes he has certain reasons, he does. The connection between intentional actions and our reasons thus explains the normative character both of free and responsible action, and of self-knowledge.

Are Strawson (as reported by Bilgrami) and Bilgrami right? There is certainly a strong tendency to hold that it is free acts for which we hold people responsible, and hence appropriate targets of praise and blame, and we are more inclined to hold people responsible for their thoughts and motives if we think they knew what those thoughts and motives were. It is the reverse conditionals which seem dubious. Does an act count as free only if we resent it (or praise, blame, appraise it)? Well, I suppose the doctrine rather is that an act is free if it is *appropriate* to have a reactive attitude to it, even if no one in fact does. But granting this, does this make the freedom of an act a normative concept? Not in itself surely; we praise a knife because it is sharp, but its sharpness is not a normative property. I like to think that nothing is relevant to the question whether an act is free except the totality of causes that resulted in that act. It is always a matter of degree how free an act is, and judgments might reasonably differ even if all the facts were in (which they never are). On the basis of what we think the facts are, we decide whether the act deserves praise or blame or justifies our resentment. Our reasons for legitimate moral judgments are what we know or believe about the facts. This does not make the facts normative. I am inclined to say the same about self-knowledge. One important thing to consider in judging an action as good, bad, wrong, hateful or praiseworthy is the descriptions under which the agent knew or believed he was performing the action (and, therefore, whether he knew he

had the attitudes that caused him to act). This does not make our evaluative attitude something that determines whether or not he knew what his attitudes were.

On a somewhat peripheral point, I may disagree with Bilgrami about the necessity of *always* ruling out cases where by fluke we have true beliefs but not knowledge. The cases where we need to do this are cases where we have reasons for our belief. But some beliefs are justified in the absence of reasons, and these include perceptual beliefs and beliefs about our own attitudes (see reply to John McDowell).

D. D.

REFERENCES

1. Davidson, Donald. 1984. "First Person Authority." *Dialectica* 38: 101–111.

9

Tyler Burge

COMPREHENSION AND INTERPRETATION

I will explore some relations between my account of content preservation and the accounts of radical translation and interpretation developed by W.V. Quine and Donald Davidson.[1] I center on Davidson's account, and concentrate on epistemic issues.

Quine and Davidson claim that theorizing about understanding a foreigner's words from scratch is a good model for theorizing about understanding one's communal fellow's words, and indeed all linguistic understanding. Quine writes, "radical translation begins at home." Davidson writes, "All understanding of the speech of another involves radical interpretation."[2] Both can see differences in the two cases as well as anyone. Still, they maintain that similarities are what are important in principle, or for theoretical purposes. We need to get straight about the principles and purposes.

Quine and Davidson motivate using the radical situation as a model for understanding all speech by considering coming to understand a language. Quine writes,

> We have been beaten into an outward conformity to an outward standard; and thus it is that when I correlate your sentences with mine by the simple rule of phonetic correspondence, I find that the public circumstances of your affirmations and denials agree pretty well with those of my own. . . . The case of the linguist and his newly discovered heathen . . . differs simply in that the linguist has to grope for a general sentence-to-sentence correlation that will make the public circumstances of the heathen's affirmations and denials match up tolerably with the circumstances of the linguist's own.[3]

Davidson writes, "what evidence plausibly available to a potential interpreter would support the theory to a reasonable degree?" He continues, "To deal with the general case, the evidence must be of a sort that would be available to someone who does not already know how to interpret utterances the theory is designed to cover"[4].

I think that the line of reasoning is this. People understand what others say. Since they must start from a position of not knowing whatever language they learn, and since it is possible to understand a foreigner from scratch, this understanding must rest ultimately on nonlinguistic evidence—evidence that does not already involve a construal of words. One must use a person's relations to an environment and the person's behavior as evidence for what the person's words mean. So a general theory of linguistic understanding should explain how one could get from nonlinguistic evidence to linguistic understanding in any given case—even the hardest case. Communication among people who know one another, or who speak the same language, uses a mixture of contextual evidence and entrenched assumptions. But these assumptions go back to past, publicly available nonlinguistic evidence. So fundamentally, the domestic and radical situations are the same.

Since Quine (*in absentia*) and Davidson (*viva voce*) were my most influential teachers, this original and fruitful line was basic to my education in philosophy. It is clearly on to something. But it passes over important distinctions. Use of the term "evidence" to cover the innate background, the training, and the contextual bases for understanding is a case in point. I believe that one must distinguish, more sharply than the radical interpretation model does, differences between the psychology and epistemology of understanding. Quine blurs the distinction on principle. I am less certain how Davidson views it.

Davidson's aim in developing a theory of interpretation is different from my aim in investigating the epistemology of linguistic understanding. Davidson presents his account as a rational reconstruction, explaining neither the actual epistemology nor the actual psychology of communication. The account is meant to explain one way that someone *could* understand another.[5] It thus answers to the Kant-like question "how is linguistic understanding possible?" where the answer may give one of various possible ways. Although it is supposed to represent what an interpreter knows (presumably the truth conditions of sentences understood), it is not meant to explain how he knows it. Thus it is not assumed that an interpreter actually has, even tacitly, the truth theory that the model outlines.

Davidson's account of the relevance of his theory to actual psychology is sometimes elusive. He counts interpretation theory a "model of the interpreter's linguistic competence," adding that "claims about what would constitute a satisfactory theory are not . . . claims about the propositional knowledge of an interpreter, nor are they claims about the details of the inner

workings of some part of the brain."[6] There follows this difficult sequence of statements:

> They [claims about what would constitute a satisfactory theory] are rather claims about what must be said to give a satisfactory description of the competence of the interpreter. *We* cannot describe what an interpreter can do except by appeal to a recursive theory of a certain sort. It does not add anything to this thesis to say that if the theory does correctly describe the competence of an interpreter, some mechanism in the interpreter must correspond to the theory.

If the radical interpretation model is a claim about what *must* be said to give a satisfactory description of competence, it is not clear wherein the model concerns only *our* descriptions of interpreters' competences rather than the structure and content of the competences themselves. Perhaps Davidson is being non-realist about psychological descriptions generally. But if he is not (as I am certainly not), it seems to me that anything that must be said to give a satisfactory description of the competence of the interpreter is a true description of part of the competence of an interpreter.

I see no difficulty in principle in taking truth-theoretic interpretation systems to correspond to actual psychological structures. The competence described is certainly not explicit, conscious, knowledge. Whether the theory would describe a *basic* psychological system for understanding others seems open. It could describe a system superimposed on a basic system only when an individual develops concepts of truth and reference. I believe that communicators understand utterances from the beginning by associating them with truth conditions—with intentional content that sets conditions on what it would take to make them true. It is an open question whether the semantical concepts are ground-floor concepts (either innate, or present as soon as communication is), or whether they are later conceptualizations of non-conceptualized operations that assign truth conditions.[7]

As long as the best psychological accounts continue to treat the competence as a computational mechanism, Davidson's approach may well have a place in psychological theory. My epistemic picture will be broadly compatible with truth-theoretic interpretation systems taken as structures of a psychological competence, possible or actual.[8]

Even where Davidson considers epistemic warrant, his project is orthogonal to mine. He asks what evidence would suffice to make linguistic understanding possible. I ask what warrants underwrite actual understanding. For all its value for other purposes, the interpretation model is likely to mislead as regards this question.

Davidson's rational reconstruction emphasizes similarities between domestic and radical cases. I believe that the domestic and radical cases are epistemically very different. The differences can be usefully developed by first

considering differences between standing and contextual elements within *domestic* understanding.

There is a traditional and worthwhile distinction between elements of linguistic understanding that are "standing" or "constant" within an individual's repertoire and elements that depend on "context". Logical constants, common nouns, verbs, prepositions, adjectives are items in one's language or idiolect whose understanding does not depend in a linguistically systematic way on the context in which they are used. Indexicals, tense, demonstratives, proper names depend for a primary aspect of their construal on a context of use. There are constant elements in the context-dependent devices, and contextual elements in the constant ones. But at our level of description, these reminders will suffice.

Context can figure in another way in understanding, as Davidson has emphasized. One can use constant aspects of one's language to yield meaning in context that is at variance with or supplemental to one's ordinary understanding. Irony, humor, metaphor, conversational implicature, and speaker meaning are cases in point.

Whereas understanding contextual devices commonly depends essentially on background knowledge and generalized intelligence, standing linguistic understanding is commonly a specifically linguistic competence. Of course, in understanding even standing aspects of language, one relies on a background of belief about nonlinguistic matters. And in acquiring linguistic understanding, one must rely on attitudes about nonlinguistic matters. But I assume, with backing from empirical psycholinguistics, that linguistic understanding is in part a distinctive ability.

As a way of developing epistemic implications of this distinction between standing linguistic understanding and contextual understanding, I want to go over some familiar ground in the epistemology of perceptual belief. One *can* justify perceptual beliefs. One can justify one's perceptual belief that there is a brown lectern, by saying that one knows that one has a perceptual experience as of a brown lectern (or alternatively that one has stimulations commonly caused by brown lecterns), that one has checked one's perceptual apparatus and insured that no sources of illusion are in play, and that having such experiences under such conditions makes it reasonable to believe that there is a brown lectern in front of one. But this routine is not routine. The individual need not even be able to go through it to be warranted in perceptual beliefs in ordinary circumstances.

To be warranted in one's perceptual belief, one normally need not refer to—or be able to refer to—experiences, seemings, stimulations, ordinary conditions, possible sources of error, or the like. One need not be able to *justify* one's perceptual belief at all. One is normally warranted in one's perceptual belief straightway, without reason, evidence, or justification. In my

terminology, one is *entitled* to the belief without raising questions about it, unless specific contextual grounds for doubting it arise. Entitlement is an epistemic warrant that need not be fully available to the warranted individual. The individual need not even have the concepts to explain the warrant. Entitlement thus contrasts with justification, including unarticulated but operative justification, the kind of warrant that involves evidence or reason accessible to the individual on reflection. One can be warranted in one's perceptual beliefs, without being able to justify those beliefs, and even without having the concepts to do so. Such warrant requires having perceptual experience, but it requires no reference to it. Experience does not function as evidence which the individual need think about.

Ordinary understanding of constant aspects of words used by another person is, I think, in this way analogous to ordinary perception. In neither case is evidence or justification needed for warrant. The point is not that justification is unconscious. It is that justification need not even be conceptually available to the individual on reflection. The warrant for the understanding does not rest on an unconscious transition from a reason or evidence. Nor is the warrant a matter purely of coherence with other beliefs. The reliability of the competence (in perception or understanding) is the main source of the individual's warrant. One develops a competence to take in what other people say, when they use words one shares with them. Unless specific contextual grounds arise for doubting one's understanding, one is entitled to it.

Talk of evidence and theory is misleading here in the way that it is in talking about ordinary perception. Perceiving the words and behavior of the interlocutor need be no more *evidence* for understanding, in ordinary cases of smooth domestic communication, than stimulations or sense impressions and the background conditions for perception are, ordinarily, evidence for perceptual beliefs. In both cases, what would mistakenly be called evidence is part of the causal enabling conditions for having and exercising the competence. The sense-perceptual presentations or experiences contribute to the individual's warrant. But they do not do so by being reasons or evidence that the individual needs to have conceptualized as such, or needs to refer to. Sophisticates can think about experiences as reliable signs of the physical objects the perceptual beliefs are about. But such meta-inferences are supplementary justifications, at best. The fundamental perceptual warrant is an entitlement that does not go through such inferences.

Similarly, with understanding. We can reconstruct an inference from perceptual beliefs about words and behavior to our understanding. But such an inference would be supplementary. The basic warrant for distinctively linguistic understanding is an entitlement that rests on the content and reliability of our non-inferential understanding.

Of course, the psychology of understanding depends on perceiving words

and having some mechanism that assigns them meaning. The psychology of perception depends on having sense impressions and having some complex mechanism that assigns perceptual content to those impressions. In both cases, psychology may describe the mechanism in computational terms. But it is a mistake to take psychology as itself an account of our warrant for (entitlement to) perceptual belief or standing linguistic understanding. For the points about an individual's subsystems do not track the *individual's* reasons.

Wherein lie one's entitlements to perception and ordinary linguistic understanding? The general *pro tanto* entitlement to perceptual belief resides in one's status as a perceiver, and one's default entitlement to presume on that status. Being a perceiver *necessarily* involves certain reliabilities in perceiving normal perceptual objects in normal circumstances. The entitlement derives from reliabilities coded in the causal, transformational, and presentational conditions that are constitutive of being a perceiver, and in the workings of the perceptual system. The same point applies to linguistic understanding. Being an understander necessarily involves certain automatic reliabilities in understanding expressions. Warrant resides in the reliabilities encoded in this cognitive competence and in the exercise of the competence.

All the preceding pertains to *standing* linguistic abilities applied in normal domestic cases. To understand many *context-dependent* devices one must exercise different abilities. To understand the application of the demonstrative in "That is beautiful", one must normally find the physical referent and note the angle of perception on it. One's standing linguistic competence will not suffice for understanding the utterance. In this case, exercise of nonlinguistic perceptual abilities seems integral to the understanding.[9]

There is the second class of contextual elements to consider. Here also, understanding involves assignments of meaning that commonly go beyond standing linguistic competence. In understanding conversational implicature, for example, standing competence is supplemented with reasoning about the speaker's intentions.[10] This case is analogous to cases in which one has contextual reason to doubt one's perceptual presentation of an object, and one must invoke further evidence to be justified in forming a belief.

So I distinguish two sources of justificational force or warrant. First, there are entitlements deriving just from applying standing cognitive abilities. One is immediately though defeasibly entitled to a perceptual belief or to understanding aspects of an utterance. Then, second, there are warrants that derive partly from contextual, nonlinguistic supplementation of such entitlements.

How does Davidson's position on evidence relate to this picture of the epistemology of domestic communication? Since Davidson intends his remarks as an idealized account of psychological input and psychological

structure, my epistemic points might be seen as entirely compatible with this approach.

But even on this irenic construal, I think that the interpretation model underplays differences between radical and domestic cases. The radical case is a matter of theory development until the foreign language is learned. We use an already mastered language to interpret forms over which we have no competence, by thinking about words as objects to be theorized about. In domestic cases, we are competent with the same words our interlocutors use. The vast preponderance of the time, we presume on understanding the speaker's words as he or she does.

In the domestic case, we do not use evidence much to understand what another says, except to correct or supplement the standing mastery that we already have. Normally we need not scrutinize the behavior of a stranger who uses words familiar to us. When we talk on the phone, or when we read, we have no new world-word relations and little or no nonlinguistic behavior to rely upon. The standing mechanism yields an enormous amount of understanding. It is so reliable that the unsophisticated are slow to recognize verbal disputes. In treating the radical and domestic cases alike, interpretation theory passes over epistemic differences associated with the reliability of linguistic competence.

The interpretation model's portrayal of word-world, behavioral, and psychological facts that go into fixing content as *evidence* does have application to idiolect variations, tongue slips, irony, conversational implicature. Davidson fixes on malapropism in domestic communication because it maximizes analogies between the domestic and foreign cases.[11] But malapropism is not the norm. The norm in normal linguistic communities is taking one's homophonic understanding for granted. Things go wrong often, but not significantly so in comparison to their going right.

No one need disagree with this. But there is danger, even for an account of competence, in taking the abnormal as a paradigm of the normal. Since I am not centering on psychology, I will not ask how far assimilating ordinary communication to interpretation might distort psychological theory.

Let us pursue the epistemological issue. On a natural extrapolation of the interpretation model, domestic communication is like radical interpretation except that the evidence used in standing understanding is held over, unconsciously, from past cases. In past cases, one is justified because one rested understanding on behavioral and environmental evidence. What grounded past understanding grounds understanding of new interlocutors who sound similar, unless there are reasons to call this background evidence into question. So in communication that smoothly treads well-worn paths, one need not attend to contextual evidence about what standing elements in speech mean.

One doubt about this empirical-theorizing model derives from the unlikelihood that many have grounds that support the inferential justification that the theory postulates. Competent neophyte understanders have no inductive-explanatory reason to think that if a stranger makes sounds that they have previously understood, the stranger is likely to mean what others meant by those sounds. Yet competent, neophyte understanders seem warranted in relying on unreasoned understanding of strangers, until things go wrong. There is no doubt sociological evidence that underwrites such an inference. But many do not have it, and they do not seem to need it to be warranted in presuming on understanding.

One could avoid appeal to inductive-explanatory evidence and invoke the idea of justification through coherence with other things one believes. But we seem to be warranted in understanding single utterances by strangers out of the blue. Here, coherence carries little weight. In *most* cases, any of a wide range of interpretations is equally coherent with everything we know.

Some of one's standing understanding derives from training during a period in which one lacked a language or theory. Assimilation of this background to evidence used in the radical situation is especially problematic for epistemology. The point applies not merely to past behavioral and word-world evidence. It extends to perception of the words themselves. All our exposure to what the empirical-theory account treats as "evidence" goes into the formation or exercise of our competence. But not all of what goes into how we gained the competence enters into the justificational basis for our understanding of utterances. This was a lesson of the comparison of understanding with perception. The fact that sensations, or irritations of our nerve endings, play a necessary role in mediating our perception of objects should not lead one to conclude that they play the role of evidence for our perceptual beliefs. Much of what the empirical-theorizing model counts as "background" evidence in the interpretation of strangers is merely part of the formation conditions or enabling conditions for our linguistic competence.

I would like to distinguish two kinds of understanding.[12] Let us label them *"comprehension"* and *"interpretation"*. Comprehension is understanding that is epistemically immediate, unreasoned, and non-inferential. First-person comprehension is the minimal understanding presupposed in any thinking, in beings that understand their thoughts at all. (I believe that animals think but lack comprehension of what they think, since they lack a third-person perspective on thought content.) One thinks a given intentional content, and comprehends that content and its force in thinking it. What one comprehends is not ordinarily thought *about*. Of course, one can comprehend meta-thoughts that take thoughts or thought contents as their referential objects. But normally one comprehends thought contents that apply to other things.

I include words, in a derivative sense, as things one can comprehend in the

first-person way. One comprehends the words in one's idiolect as one uses them. The comprehended words are the *direct* expression of thoughts one comprehends. They express one's thoughts without mediation of further words or thoughts.

Comprehension in the third-person way is understanding that is epistemically immediate, unreasoned, and non-inferential and that carries no presumption that the comprehended material is one's own. It may *be* one's own. But it is comprehended without relying on taking it as one's own immediate or remembered product. I shall shortly discuss whether one can have third-person comprehension of others' thoughts and words.

Interpretation involves taking what is interpreted as the primary object of epistemic interest. Interpretation arises out of there being a question or issue about how to understand a candidate object of interpretation. Interpretation is always from the third-person point of view. I conjecture that it is always epistemically inferential. What one interprets may be a thought content, or it may be words. It may be directed toward one's own products as well as those of others. But in interpreting, one necessarily carries out the interpretation of the object of cognitive interest in terms of thoughts one presumes—and is entitled to presume—one comprehends.[13]

The distinction is a functional one. It concerns one's epistemic starting point. One must comprehend something to interpret something else. One cannot comprehend something that is interpreted until it no longer functions as object of interpretation. What one comprehends is a content one can take for granted.

In saying that the distinction is functional, I am allowing that it is relative. What one comprehends could become an object of interpretation if some question arises about the comprehension. But to pursue such a question, one must use other contents that one presumes to be comprehended. However fluid, the distinction is fundamental and inevitable. A critical reasoner *must* presume comprehension of some intentional content to engage in any thought, including any interpretation. Interpretation, by contrast, does not inform all critical thinking. So the understanding that I call comprehension is function-ally basic.

First-person comprehension can be criticized as more or less good. One can worry about whether one's understanding is flawed or incomplete. This is a constant theme in philosophy. But it occurs in the progress of science and in ordinary life. Learning more is not always sharply separable from enriching or even correcting one's comprehension. Our thought contents are fixed by a web of inferential and applicational connections. The inferentially associated thoughts which help fix the meaning or content of our thought contents make substantive and fallible commitments. Although no one capable of any comprehension at all can fail to comprehend their own thoughts—in the sense

that minimal, unreasoned understanding of the thoughts is necessary to think-
ing them—, the quality and depth of the comprehension can vary. Minimal
comprehension can be infected with erroneous commitments. Improvement of
comprehension can utilize self-interpretation. It can involve regarding the
comprehension as an object to be reasoned about from the point of view of an
outsider. Or it can utilize the sort of critical, elaborative reflection on
conceptual connections that stays within a comprehended point of view.

My primary claims do not depend on holding that first-person comprehen-
sion can be better or worse, though the argument I have just given shows that
it can be. What I want to insist on here is that even minimal first-person
comprehension falls within the broad domain of norms and warrant. This
point derives from two sources. One is the insight—variously developed by
Kant, Frege, Wittgenstein, Quine, and Davidson—that understanding is
essentially associated with inferential, applicational, explicational abilities.
These abilities involve propositional commitments that may be true or false.
The other source is Quine's insight, richly developed by Putnam, that even the
most fundamental propositional summaries of meaning or understanding are
about a subject matter, can be true or false, and are thus subject to epistemic
norms.

What is the nature of our warrant—our entitlement—to first-person
comprehension of our thoughts and words? The entitlement is non-sense-
perceptual—apriori. To be apriori a warrant's justificational force must be
independent from contributions to that force from sense-experience or sense-
perceptual belief. Apriority concerns the force of a warrant, not its vulnerabil-
ity to criticism. Some beliefs that are apriori warranted are subject to empirical
correction. As traditional rationalists noted, a warrant can be apriori or non-
sense-perceptual even if sense-experience is necessary for the acquisition of
the understanding involved in the warranted cognitive abilities. For a warrant
to be apriori it is enough that sense-experience and sense-perceptual belief not
contribute to its force.

I believe that we have an apriori *pro tanto* entitlement to our minimal
comprehension of our own thoughts and words—the sort of comprehension
necessary to think or use them at all. Unless some specific reason arises to
question comprehension, we are warranted in relying on it; the force of the
warrant does not derive from sense experience. Let me motivate and provide
an argument for this claim that the entitlement is non-sense-perceptual. The
issue of rational warrant that interests me arises for non-modular attitudes and
capacities of beings with minimal understanding. The relevant attitudes and
capacities require minimal understanding—comprehension. In the relevant
cases, such beings must presuppose comprehension of an intentional content
(and words directly expressing the content) in taking anything as an object of
cognitive interest. So all rational warrant for the relevant attitudes requires as

a necessary condition that such minimal understanding is in place. Such rational beings cannot be warranted, in relevant cases, in an attitude whose content they do not minimally understand (comprehend), at least for any warrants and attitudes that depend on understanding. Any interpretation or questioning of one's thoughts or words must presume a comprehension of content in terms of which those activities of questioning are carried out. Raising questions without ground is rationally capricious. So such beings have a rational entitlement to unquestioned reliance on comprehension of their thoughts and words, unless there is reason to question the nature or quality of that comprehension.

This account of our entitlement derives purely from conditions for thought of certain rational beings. Sense-perceptual experience is not epistemically relevant. The entitlement to the presumption of this comprehension is non-sense-perceptual. All this, notwithstanding the fact that comprehension depends on sense experience for its genesis, and may be subject to questioning, interpretation, and even revision.[14]

Traditionally, the view that apriori warrants derive from understanding was applied to understanding of thought contents. I will assume that comprehension of one's idiolect is subject to substantially the same points about entitlement that I have just made.

I conjecture that interpretation requires justification, not merely entitlement. The justification need not be conscious. But to be warranted, an interpretation must be backed by grounds or evidence available on reflection to the interpreter. The warrant for most interpretation is empirical. As I shall later note, some such warrant can be apriori.

I have argued that questions of warrant for attitudes of certain rational beings require presuming a starting point in comprehension. One is apriori *pro tanto* entitled to rely upon comprehension of one's own thoughts and language, unless reason for doubt arises.

I turn now to warrants for understanding others. I want to discuss three questions. First, in domestic communication that depends on constant linguistic understanding and that does not require contextual supplementation or correction, is the understanding of *another's* speech always interpretation? Or is it often comprehension? I will take the answer to hinge on a second, closely related question: Are we ever entitled to rely on our presumptive understanding of another person without evidence or justification? If the answer is affirmative, our understanding of others' speech is like our perceptual beliefs and our understanding of our own thoughts and speech, in that we have a prima facie entitlement that requires of us no justificatory inference or evidence, however unconscious. I have already signaled my answers to these two questions. But I wish to develop these answers more fully. Third, if understanding another is sometimes comprehension, is the entitlement always

empirical, as our entitlement to our perceptual beliefs is? Or is the entitlement sometimes apriori or non-sense-perceptual, as our entitlement to rely on first-person comprehension is? I do not hope to answer these questions decisively here. But I want to engage them. Let me begin with the second.

Can one ever reasonably presume, as a defeasible default position, that one comprehends what others say?[15] Is the warrant for such understanding ever an entitlement that requires no evidence or justification? I assume that there is always some unconscious psychological transformation from perception of words to understanding. I question whether, if the understanding is to be warranted, the perceptual basis for the transformation must provide evidence for that understanding. Similarly, I assume that in learning words, one's understanding is formed through associating behavior, words, and objects in the physical world. I question whether the understanding's being warranted requires that these associations justify the understanding through evidential relations, or inferences to the best explanation, or coherence with antecedent beliefs.

There seems little intuitive ground to think that evidence of these sorts is needed to support untrammeled domestic understanding. Not only are we not conscious of inferences. In most cases, explicating the justifications is well-nigh impossible—not only for ordinary speakers, but even for philosophers. Barring anomaly, understanding an interlocutor's speech, on ordinary topics, seems no less immediate than understanding one's own speech in thinking out loud.

These points are not decisive. One could postulate fast, unconscious inferences. There are psychologically relevant transformations. But these are mostly not person-level inferences. Moreover, the postulation would have to show some advantage in accounting for epistemic warrant. For it has no intuitive plausibility for ordinary understanding.

I am impressed with analogies to epistemically non-inferential epistemic abilities. As with perception, and comprehension of one's own speech, the processes underlying domestic understanding of others are fast, unconscious, difficult to articulate, nearly automatic, almost modular, and very reliable in ordinary contexts. Inferences relevant to epistemology are acts in the central cognitive system, though often unconscious ones. They are acts by the individual, not processes in subsystems. The transformations present in these three cases normally do not involve acts by individuals.

One reason why it is unreasonable to see ordinary perception as warranted by an inference from evidence about sensations or perceptual presentations to a conclusion about physical properties derives from the degree to which sensations are not an object of cognitive focus. The function of the central perceptual systems (especially vision, touch, and hearing) is to facilitate the individual's interaction with the physical world. For higher animals it is to

enable the individual to form reliable beliefs about physical objects and properties. Probably only critically rational beings conceptualize sensations or perceptual representations involved in perception of physical properties—conceptualize them as distinct from the physical properties they indicate. Such beings come to do so long after they have warranted perceptual beliefs about physical properties. Moreover, memory of the properties of sensations or perceptual representations, in ordinary perception of physical objects or properties, is less reliable and more ephemeral than memory of the physical items perceived. These points tell against taking the primary warrant for perceptual beliefs as an inference from properties of sensations. The sensations or perceptions are psychological stepping stones which once negotiated sink out of sight. They and beliefs about them are not ground-level evidential bases for perceptual beliefs.

I think that similar considerations tell against treating ordinary domestic understanding of others' speech as an inference starting with observations about words or behavior. Understanding depends on perceptual awareness and implicit memory of words in something like the way that perception depends on utilization of sensations or perceptual representations in forming perceptual beliefs. But forming beliefs about the properties of words is no more the aim of understanding than forming beliefs about sensations or perceptions is the aim of perception. Understanding of speech may well precede an ability to conceptualize and form beliefs about a distinction between words and the objects they indicate or the meanings they convey. It is well known that memory of the properties of words is less reliable and more ephemeral than memory of what one understands through the words. These considerations suggest that our warrant for understanding others' words in domestic cases does not rest on inferences involving beliefs about words as such.

A further ground for doubting the empirical theorizing model for domestic understanding rests on how we reason about justification in this domain. When communication runs smoothly, the question of justifying one's understanding does not seem to arise. It is no more in place to ask someone who is a perfectly competent language user to support his or her presumed understanding of someone who says "push-button telephones are more common than rotary ones" than it is to ask a normal perceiver how he or she justifies a perceptual belief that that is a brown lectern, when he or she is looking at one in a good light. These questions about warrant are philosophers' questions. Addressing them well requires giving weight to the fact that they do not arise in that form in ordinary life.

Normal perception and perceptual belief involves a default warrant (an entitlement) that requires no justification from the individual. Justification is required only when specific difficulties arise. If the light is bad, one may need to justify one's attribution of a color. If holograms are afoot, one may need to

justify a belief that it is a lectern rather than a hologram. But then specific alternatives are relevant and threatening.[16] In the absence of such alternatives, one's warrant resides in one's being a well-functioning perceiver and having the perceptual experiences. Being a perceiver involves having a perceptual system formed through reliable connection with entities categorized by the perceptual representations of the system. To be warranted in perceptual beliefs, one need not be able fully to conceptualize the warrant. One needs no justification or evidence in any space of reasons available to reflection (or even "unconsciously").

Similar points apply to domestic understanding. Linguistic training gives one a reliable understanding of what others say. Status as a competent understander and normal use of associated conceptual apparatus yields a defeasible warrant that obviates the need for evidence or justification. Justification is needed only when anomalies arise, or when one cannot rely on the transformations afforded by presumptive overlap with one's own idiolect. It is not a from-the-beginning open question what someone else says, if a reliable understander presumes on seeming immediate understanding. The understander is prima facie entitled to immediate presumptive understanding.[17]

Our usage does diverge from that of our fellows. People need not use words in the same way in order to communicate. But in normal communities, except where divergences appear to occur, there is no rational ground for departing from, or having to justify, the presumption of comprehension. A person's use of words could diverge from others' so completely as to leave no overlap. Then the person would be unable to comprehend others' speech and would have to rely on interpretation. But this no more shows that the epistemology of our actual situation centers on interpretation, as opposed to comprehension, than the fact that an individual could be placed in a world where perceptual inclinations could not be trusted, and had always to be double checked, shows that actual perception is epistemically dependent on inference and checking. Warrant for comprehension in the domestic case derives from contingent facts about reliability in a given social environment.

So my answer to the second question is that one's warrant for understanding others' speech and writing is commonly an entitlement, not based on evidence, inference, or coherence. My answer to the first question is that understanding others in domestic cases is often comprehension, not interpretation.

What of the third question? Is all such entitlement empirical, as our entitlement to perceptual beliefs is? Or is one sometimes entitled through some non-empirical warrant to understanding of another's speech, as one is entitled to rely on comprehension of one's own thoughts and words? I think that the basic entitlement is sometimes non-sense-perceptual, non-empirical.[18] The entitlement derives from one's status as a competent understander, and from the conceptual aspects of understanding. Sense-perception is necessary for this

understanding; but the warrant need not lean on it for justificational force.

I believe that we have a *general* apriori *pro tanto* entitlement to rely on understanding of others' words that are immediately prima facie intelligible to us. In certain circumstances, we can be apriori defeasibly entitled to comprehension of what others say *in particular cases* when what they say is immediately prima facie intelligible to us. The justificational force of the entitlement derives from the role of understanding in intellection. It rests on no *epistemic* underpinning from perception.

One reason for my view is that comprehending standing, conceptual aspects of one's own thought and idiolect is itself, as a matter of psychological and sociological fact, normally dependent on having comprehended thoughts (one's own) that were shaped and expressed through the words of others. Even innate nonlinguistic concepts are commonly associated with one's words only via understanding them as expressed by others' words. So homophonic comprehension of one's own words is normally interwoven with homophonic understanding of others'. So it cannot in general provide a prior framework for empirically grounded third-person understanding. This is a primary source of reliability in understanding others. Our reliability derives from the fact that understanding others to a large degree constitutes the nature of comprehension of our own idiolects, the entitlement to which is clearly apriori.

This is not a traditional private language argument. It does not depend on a claim that we metaphysically must begin with others' speech. The point is that that is how we do begin—and probably psychologically must begin. Epistemic norms arise out of actual situations of reliability and interdependence—rather as the norms for perceptual warrant center on facts about what is reliable in the environment that the perceiver is embedded in. There is no metaphysical necessity that the perceiver *be* in an environment that makes perception reliable (though one's perceptual system must have been formed in such an environment). Entitlements to comprehension rest on contingent, external reliabilities outside the control and perhaps even ken of the individual.

Here is not the place to explore differences between my and Davidson's views on the role of the social in linguistic understanding. It is, however, worth indicating where the chief difference lies. Davidson thinks that to have the concept of belief, and even to have beliefs at all, an individual must actually enter into a communication-interpretation relation with another language user. Actual social relations are necessary to thinking—not merely psychologically necessary but metaphysically necessary, or necessary in whatever way that goes with Davidson's apriori arguments for his view.[19] I do not accept these claims. I think that it is metaphysically possible for an individual to have beliefs without language (in fact, higher animals are actual examples), to have language without social relations, and to have the concept of belief without social relations.

I think it metaphysically necessary that certain attitudes, given certain facts about the individual, depend for their intentional content on relations that they bear to others' uses of language. The individual need not be in those relations to think. But to think thoughts he does think, given his actual intentions, relations to others, and limits on background knowledge, the individual (metaphysically) must have been in those relations. I locate the social dependence of mental states at a less global level than Davidson does. The necessities in my account depend on contingent parameters' being fixed.[20]

Suppose that we could not perceive words others speak. Suppose that the stimulus effects of the words nevertheless affected us by some natural causal process in such a way that we reliably understand their sense and their being used assertively, interrogatively, and so on, as received—rather than as initiated. Suppose that we could not directly know or even reliably guess anything about the words whose effects were thus injected. Suppose that the word sounds in the relevant contexts called up understanding of conceptual content and assertive force by bypassing the perceptual system, but triggering the same central mechanisms by which we understand our own speech. Thus I comprehend the interlocutor's conceptual content and assertive mode without perceiving words, as long as the communicator is using words in the ways I use them. The words might become perceptible when but only when something in the context provides grounds to doubt the standing comprehension of what the interlocutor is saying. Understanding, however, remains as good as ever.

In such a case, much of what we know in communication would, of course, be lost. But I think that the *basic* entitlement underlying understanding communication of intentional content and assertive mode, in ordinary domestic cases, would in its fundamentals be unchanged. Our starting point in domestic understanding is a non-sense-perceptual entitlement to rely on understanding of what one's system takes as immediately or non-inferentially intelligible. The warrant for relying on the apparent intelligibility can stand on its own. It need not lean on sense-experience of words or behavior, once a system of language-comprehension is developed.

In the injection case, we would lose access to empirical evidence for inference and interpretation. But such interpretation is not epistemically basic. Unreasoned putative comprehension of the interlocutor's thought content and force is basic. The role of words and intonation is to call up the conceptual mechanisms that make comprehension possible. In basic cases, they are not objects of cognition which serve as evidence, or even indispensable sources of warrant for comprehending the intentional content and basic illocutionary force of others' intentional acts.[21]

A presupposition of this argument is that non-inferential sense-perceptual

beliefs are warranted through a distinctively empirical, sense-perceptual entitlement. The entitlement derives its force not merely from the reliability of the beliefs' connection to their subject matters, but also from the beliefs' depending systematically for their content and application on the way perceptual objects are presented through sense perception. Some might deny this. They might maintain that all beliefs that depend at all for their warrant on reliable causal "tracking" connections to their subject matters have the same epistemic status. I believe that such a position would be seriously mistaken. It ignores what is distinctive about empirical warrant and runs together the very different contributions to the internal aspects of warrant made respectively by the systems of sense-perception and understanding. These are, however, topics for another occasion.

I have not discussed context-dependent aspects of linguistic understanding except as a foil to standing aspects. The warrant for understanding perceptually guided demonstratives would seem to be empirical. Indeed, most of the warrant for fully comprehending utterances about objects on display, in the here and now, will be empirical all the way down. But not all context-dependent elements in an intentional content require empirical elements in the understanding. Establishing certain tense parameters can normally rely on a rule working directly off the comprehension of the intentional act. The referent of the first-person pronoun, as used by someone else, is fixed as the author of the comprehended act. Similarly, certain context-dependent parameters surely have default readings that are fixed by comprehension of the language. The language is context-sensitive in being systematically open to having the default reading overturned by background knowledge. (The background knowledge could be nonlinguistic and empirical. But it could also be associated purely with comprehension of prior elements of the discourse.) Lacking special information, the contextually vulnerable default readings stand. I understand "red hair" normally to apply only to hair that in its natural state, in normal light, looks more like certain orange objects than most red objects. But empirical background knowledge in certain contexts could require that one understand that the phrase applies to hair that looks blood-red in normal light because it is painted, and not to hair normally counted "red". So although much contextual resolution of contextual-dependent elements in discourse is empirical, some depends on default settings associated with comprehension. Some depends on reasoning from comprehension of prior discourse.

Similar points apply to comprehending context-dependent elements of language whose understanding turns on the speaker's intended force. Understanding conversational implicature requires reasoning that goes beyond linguistic comprehension. The supplemental considerations will commonly be

empirical. Certain simple types of irony can, however, be comprehended using standing linguistic competence: a certain tone might mark irony, and the marker might be comprehended through a standing linguistic competence—very much like the way that normal cases of serious assertion can be comprehended. Then a simple, standing transformation on the standard meaning might yield understanding (even comprehension) of the irony. In other cases, understanding that irony is in play might require subtle empirical background knowledge; and the reinterpretation of the sentence might require ingenuity that goes well beyond automatic application of standing linguistic competences.

Although much *interpretation* is justified through perceptual beliefs, not all justificational force behind interpretation is sense-perceptual. Some interpretation rests on making a message as coherent as possible, or on prior comprehension. Insofar as such interpretation does not rely on empirical inference or on perceived elements in the context, its justification might be non-sense-perceptual.

Thus four combinations seem possible: apriori, non-sense-perceptual entitlement to comprehension; entitlement to comprehension that is partly sense-perceptual; apriori, non-sense-perceptual justification of interpretation; and justification of interpretation that is partly sense-perceptual. As noted, I am inclined to believe that interpretation must rest upon justification rather than entitlement.

I have claimed a fundamental symmetry in epistemic status between comprehension of standing aspects of our own thought contents and comprehension of similar aspects of our interlocutors'. Yet Davidson is clearly right in maintaining that there are significant asymmetries. What asymmetries do I acknowledge?

The question leads into fascinating issues about self-knowledge and knowledge of other minds. The issues are complex. But some simple points of agreement can be cited. First, whenever we use a word with a definite meaning, we can meaningfully but trivially disquote. We cannot misidentify the meaning of our words or the intentional content of our current thoughts. We can get them wrong only in the sense that our explications of them, or inferential associations with them, can be mistaken. But although we are apriori prima facie entitled to our seeming-homophonic comprehension of another person's words in the absence of reasonable doubt, we *can* in any given case question our homophonic comprehension of another's speech, without doubting that the speech has a definite meaning.

Second, we can utilize self-interpretation to doubt commitments associated with the comprehension of our words or thoughts; but we cannot treat all our words or thoughts and their associated commitments as objects of interpretation. By contrast, we can take all of another's words as objects of

interpretation. We can view another person as a foreigner, or even a black box. But we cannot view ourselves purely that way.

But the fact that we can, and sometimes have to, view others as foreigners to be interpreted does not indicate that we always must, or always do, or even rationally can, given our actual situations, view others that way all of the time. I think that fundamental to the social character of language is the fact that the norm within domestic communication is content preservation. We comprehend another's content without interpretation. We are entitled to take others as linguistic fellows rather than as objects of interpretation unless reasons arise for doubting our comprehension. For all their substantial philosophical virtues in other respects, radical interpretation and radical translation are misleading models for the epistemology of communication. Linguistic community provides epistemic norms in communication despite the wonderfully multifarious ways—including linguistic ways—in which we are individuals.

TYLER BURGE

DEPARTMENT OF PHILOSOPHY
UNIVERSITY OF CALIFORNIA AT LOS ANGELES
DECEMBER 1998

NOTES

I gave an earlier version of this paper at Rutgers University in 1993 on a week-long panel with W.V. Quine and Donald Davidson. I am grateful to both for comments that improved the paper, and to Davidson for pointing me to work of his that improved my understanding of his views. I have benefited from giving the paper at Brandeis, and at Harvard as the first of two Santayana Lectures, in the Fall of 1998. Bob Nozick, Hilary Putnam, and David Wong made comments on these two occasions that led to improvements.

1. Cf. my "Content Preservation," *Philosophical Review* 102 (1993): 457–88; W.V. Quine, *Word and Object* (Cambridge: MIT Press, 1960), chapter 2; Donald Davidson, *Inquiries into Truth and Interpretation* (Oxford: Clarendon Press, 1984), chapters 9–12.

2. W.V. Quine, *Ontological Relativity* (New York: Columbia University Press, 1969), p. 46; Donald Davidson, "Radical Interpretation" in *Inquiries*, op. cit., p. 125.

3. Quine, "Speaking of Objects," *Ontological Relativity*, op. cit., p. 5.

4. Davidson, "Radical Interpretation," *Inquiries*, op. cit., p. 125, 128.

5. Davidson, "Radical Interpretation," *Inquiries*, ibid., p. 125; "The Structure and Content of Truth," *Journal of Philosophy* 87 (1990): 324f, esp. note 67. Cf. also "Belief and the Basis of Meaning," *Inquiries*, op. cit., p. 141.

6. Donald Davidson, "A Nice Derangement of Epitaphs" in *Truth and Interpretation*, ed. E. Lepore (Basil Blackwell: New York, 1986), p. 438.

7. I do not accept Davidson's claim that to have beliefs one must *understand* (in the sense of conceptualize) the possibility of being mistaken, hence that to have a belief one must have the concepts of truth and falsity. Cf. "Thought and Talk" in *Inquiries*, op. cit., p. 170.

8. This point suggests that Quine's account of translation, which shares many basic features with Davidson's account of interpretation, may also be a contribution to psychology. The pleasant irony does not escape me.

9. The analog to such context-dependence in the perceptual case is not immediately salient. Here is a case. A certain type of visual perception might never in itself distinguish for the individual between two sorts of object, only one of which is what the individual's perceptual apparatus and reaction system has evolved to discern. The individual is then not entitled to rely on visual perception alone to yield a warranted justified perceptual belief. Perhaps vision must be supplemented by touch, or the word of an adult, to yield a warranted perceptual belief. Young monkeys cannot distinguish different types of eagles, as seen from below, only some of which are predators. They give predator calls for all of them. But their escaping action is often contextually dependent on the further predator call of an adult (which can make the distinctions). The adult in effect provides needed confirmation of the youth's perception of a given bird as a member of a predator species. The example is suggestive regardless of whether one thinks, as I do, that monkeys have warranted perceptual beliefs, with (roughly) the content of "there is a predator up there". Cf. D. Cheney and R. Seyarth, *How Monkeys See the World* (Chicago: University of Chicago Press, 1990), pp. 129ff.

10. Grice identified the key epistemic feature of conversational implicatures: one's understanding has to be "worked out" from contextual considerations, rather than inferred "intuitively" from meaning or constant understanding. Paul Grice, *Studies in the Way of Words* (Cambridge, Mass.: Harvard University Press, 1989), pp. 28–31.

11. "A Nice Derangement of Epitaphs," op. cit. I believe that Davidson underrates the role of shared linguistic framework in communication. He calls it "an enormous convenience" (p. 438) that many people speak in similar ways. He maintains that in principle communication "does not demand that any two people speak the same language." I think that this latter is true. But it does not follow that an account of the epistemology of communication can dispense with presumptions about overlapping linguistic frameworks and competences. Davidson points out that the linguistic elements that are shared are not sufficient to enable one to understand all that is said, and that one can expect variations in what is shared from one speaker to another (p. 444). He seems to infer from these points that shared linguistic frameworks do not characterize a communicator's linguistic competence. But no one ever thought that such frameworks did the whole job of characterizing linguistic competence, and variations are easy to allow on the presumption of substantial overlap.

12. Wittgenstein famously, though with characteristic obscurity, insisted on a related distinction in his dictum "There is a way of grasping a rule which is not an interpretation." Cf. *Investigations* 201. Michael Dummett, "Comments on Davidson and Hacking" in *Truth and Interpretation*, op. cit. cites Wittgenstein and criticizes

Davidson's treatment of communication as involving interpretation. Dummett does not note an important difference between Davidson's conception of interpretation and Wittgenstein's. Wittgenstein sees an interpretation as a substitution of one linguistic expression for another. Davidson's conception of interpretation is decidedly not one of relating words to words. My conception of interpretation makes no use of this point of Wittgenstein's. I do not assume that my conception of interpretation is Davidson's, but I think that it is strongly suggested by his interpretation model.

13. Interpreting something for someone else may involve conveying an interpretation that one could oneself simply comprehend. This is a different use of "interpret" than the one I focus upon.

14. I have discussed these matters further in "Content Preservation", op. cit. and "Interlocution, Perception, and Memory" *Philosophical Studies* 86 (1997): 21–47.

15. Davidson writes, "Speakers of the same language can go on the assumption that for them the same expressions are to be interpreted in the same way, but this does not indicate what justifies the assumption. All understanding of the speech of another involves radical interpretation," "Radical Interpretation," *Inquiries*, op. cit., p. 125. Davidson seems to suggest here that what justifies the assumption is the evidence for radical interpretation. On my view, the assumption is warranted by an entitlement that need not be supported by any evidence available to the individual. The "evidence" postulated by the theory of radical interpretation need not function as evidence in the individual's warrant for understanding standing aspects of another's speech.

16. For an introduction to the relevant possibilities idea in theory of perception, see Fred Dretske, "Epistemic Operators," *Journal of Philosophy* 67 (1970): 1007–23; "The Pragmatic Dimension of Knowledge," *Philosophical Studies* 40 (1981): 363–78; *Knowledge and the Flow of Information* (Cambridge: MIT Press, 1981).

17. These claims may be compatible with Davidson's theory, in view of its rational-reconstruction methodology. But I think that Davidson's emphasis on seeking evidence that enables us to deal with "the general case" (cf. the passage cited at notes 4 and 15) tends to ignore the restrictions on relevant possibilities and the obviation of the need for evidence that come with an individual's being contingently embedded in a relatively homogeneous speech community. Similarly, Davidson's emphasis on cases, such as malapropisms, in which standing understanding becomes problematic tends to suggest that because of the possibility of non-standard cases, evidence is always needed. Cf. "A Nice Derangement of Epitaphs" in *Truth and Interpretation*, op. cit., esp. pp. 442–43. But we need evidence only when such cases threaten the presumption, warranted for competent understanders, that we understand what we seem to understand.

18. I have argued for these claims in "Content Preservation," op. cit., and in "Interlocution, Perception, and Memory," *Philosophical Studies*, op. cit., pp. 21–47. In cases where we have a non-empirical entitlement to comprehension of others' speech, we may simultaneously have other entitlements or justifications that are empirical.

19. Davidson, "Thought and Talk" in *Inquiries*, op. cit., p. 170; "Three Varieties of Knowledge" in *A. J. Ayer Memorial Essays*, A. Phillips Griffiths ed. (Cambridge: Cambridge University Press, 1991); "Rational Animals," *Dialectica* 36 (1982):

317–27; "The Social Aspect of Language" in *The Philosophy of Michael Dummett*, ed. McGinness and Oliveri (Dordrecht: Kluwer Academic Publishers, 1994).

20. Burge, "Individualism and the Mental," *Midwest Studies* IV (1979): 73–121; "Intellectual Norms and Foundations of Mind," *Journal of Philosophy* 83 (1986): 697–720; "Wherein is Language Social?" in *Reflections on Chomsky*, ed. George (Oxford: Blackwell, 1989). Davidson criticizes some of my arguments in "Knowing One's Own Mind" in *Proceedings and Addresses of the American Philosophical Association* 60 (1987); and "Epistemology Externalized" *Dialectica* (1991): 191–202. He makes some important points, but I am not persuaded by the criticisms. I will not answer them here. Davidson is mistaken in attributing to me the view that "speaking in the socially accepted' way is essential to verbal communication." Cf. "The Social Basis of Meaning," op. cit. Moreover, I do not take social anti-individualism to explain the essence of communication.

21. Clearly the argument for the apriority of first-person comprehension is different from the argument for the apriority of third-person comprehension, as applied to the speech of others. The former is a transcendental argument. The non-empiricality of the warrant for first-person comprehension is a necessary condition for the possibility of any warranted comprehension, or comprehended thought, at all. The argument for the apriority of third-person comprehension yields only a prima facie warrant, allows for brute error, and adverts to contingent, reliable causal processes between the understanding and the event that is understood. Although they attribute different sub-species of apriority, the arguments agree in attributing a warrant whose justificational force is independent of the contributions of sense-experience or sense-perceptual beliefs. That is the sense in which both first- and third-person comprehension can be apriori warranted.

REPLY TO TYLER BURGE

L et me begin by making clear what I meant by the "difficult sequence of statements" Tyler Burge quotes from "A Nice Derangement of Epitaphs". It concerned what I hoped might constitute a satisfactory account of a basic aspect of the knowledge an interpreter has who understands a speaker. Such an interpreter, I thought (and think), knows, of each of the indefinitely large number of sentences the speaker might utter, what its truth conditions are. Thus someone who understands a speaker of German knows that if the speaker utters the sentence "Schnee ist weiss", he has uttered a sentence that is true if and only if snow is white. As someone who wants to characterize this knowledge of the interpreter, I am interested in explicitly specifying this potential infinity of pieces of knowledge. The only way I know how to do this is by invoking something like the apparatus Tarski used to define truth for specific languages, for his definitions (which I used, with logically significant changes, as theories in which the truth-predicate was not defined) in effect entailed a theorem of the form "The sentence 'Schnee ist weiss' is true in German iff snow is white". I explicitly noted (here and in many other places) that I had no illusions about the interpreter knowing the theory that entailed all these things I think an interpreter knows, though I did hint that perhaps some of the clauses in the characterization of the semantics of the truth functional connectives could probably be elicited from many people. Since people can understand (that is, know the truth conditions of) arbitrary sentences they have never heard, I did assume they somehow process them on the basis of their understanding of the semantic properties of the items in a finite vocabulary and rules for deriving the truth conditions of sentences from these properties and rules. Hence it adds nothing more than is already assumed to say that "some mechanism in the interpreter must correspond to the theory". I am a realist about psychological descriptions, but I didn't suppose that on the basis of largely a priori reasoning I (or anyone else) could arrive at a detailed knowledge of how our brains process sentences.

Burge seems not to disagree with most of this, and I think he is right both

in saying there is no reason to suppose such a theory describes the most basic psychological system for understanding others, and that the theory is applicable "only when an individual develops concepts of truth and reference". But unlike Burge, I think it is only as an individual develops these concepts that he or she has fully entered the domain of propositional thought. I can't tell whether we see eye to eye on the propositional knowledge I think an interpreter must have. I find no difficulty in the idea that interpreters know what the truth conditions of utterances they understand are; Burge says they "associate" such utterances with truth conditions. Is this a difference? I don't have a clear-cut opinion about where beliefs become so tacit or unconsidered as no longer to count as beliefs, nor am I convinced of the importance of doing so.

My concern with what I have (misleadingly, as Burge, following Dummett and others, emphasizes) called "interpretation" has been mainly with a question Burge does not discuss here, the question what, as philosophers, we want from an analysis of the concept of meaning. My idea was that many of the problems about meaning could be approached if we could say what it would suffice a listener to know about a speaker in order to understand that speaker, and could give a plausible account of how that listener might, in principle, learn what he had to know without a detailed prior understanding of the speaker's propositional attitudes. I think I have usually been careful to make clear that I did not think the theory which I argued was sufficient for understanding was actually known to comprehending listeners, nor that the method I outlined for discovering that theory was an account of how anyone, whether a jungle linguist or the learner of a first or second language, actually came to understand a speaker. Because the process I outlined came closest to a method that one could imagine being used by someone equipped with a language of her own trying to understand the lingo of an alien tribe without benefit of dictionary or bilingual speaker, I used the word "interpreter". When I spoke of processing the utterances of speakers of one's own language as interpretation, I was not supposing one had to go through the absurdly artificial maneuvers of radical interpretation, or that one had to search for evidence, consult a theory, or in general do any complicated thinking. My point was simply that it is always an empirical question, though one we normally do not raise, whether what we take for granted others mean is what they do in fact mean.

The implications of my approach to language for psychology are remote at best. One implication follows from the character and degree of holism I think obtains in the realms of thought and talk. I believe, and have argued at length, that to have any genuine thought (one with a propositional content), one must have many thoughts, and have been in linguistic communication with other people. This means that it is not possible to learn concepts one at a time,

or to master language a word or sentence at a time. Of course once we have the basic structure of thought and language, and a general idea of the nature of our environment, we can modify and add to our conceptual resources. I do not see such holism as making early learning paradoxical, since instead of learning the basics piecemeal or all of a sudden we can work our way by stages into the whole. We can partly learn the whole without having to learn the parts separately. But there is a problem: what makes it possible to work our way into something so complex? This is a problem I think my approach helps solve. In analogy with theories of fundamental measurement, it postulates, largely on a priori grounds, structures which embody norms of rationality to which actual patterns of thought and speech approximate, the norms of Bayesian decision theory, logic, and semantics. Like theories of measurement, to the extent that these patterns are realized in states, events, or objects in the world, very fine distinctions between and relations among those entities can be defined. Yet it is possible, by noting enough very simple properties of the entities, to confirm the existence of the complex pattern, and to apply the subtle distinctions to the elements. We do not ordinarily determine the weights of objects by using an equal-arm balance repeatedly; but we know that it is possible, within the limits of accuracy of our equipment, to determine the numerical relations in weight among objects to any degree of precision depending only on being able to detect the fact that one thing weighs at least as much as another. Similarly, given the structures of logic, decision theory, and formal semantics, we can see how it would be possible to figure out what a person believes, values, and means by what he or she says given only the ability to detect a simple qualitative relation: the person prefers one sentence true rather than another.

I have tried to make good on these claims elsewhere (Davidson 1983). The approach to understanding some of the basic psychological facts about an agent I have just sketched does not pretend to describe how we actually learn to understand people. But if it describes a feasible approach, it helps explain, if only in theory, how it is possible to do what we in fact do with surprising ease.

I accept the distinctions Burge draws between how we normally understand, without effort or conscious processing, the utterances of those around us, and the various situations in which we have to employ background knowledge of one sort or another in order to disambiguate a sentence, or when we must rack our brains to figure out the intended force of a pronouncement, get the point of a metaphor, grasp the underlying grammar of an interrupted sentence, or spot a malapropism. These cases are, as Burge insists, epistemically very different from one another. I agree, and regret it if readers have thought I was unaware of the importance of these distinctions while writing of hypothetical "theories" and "evidence".

What Burge says about perceptual beliefs in general is welcome, and pretty much what I have said myself, for example in (Davidson 1983) and (Davidson 1990). The essential point is that we are justified in accepting the beliefs we are caused to have by the workings of our senses, not because our senses provide us with reasons or evidence, but because of the nature of perception. This is what I argued for when I said perceptual beliefs are "veridical", meaning not that they are always true, but that we are justified in taking them to be true until shown wrong. Such beliefs can be supported in various ways when backing is called for, but the backing comes from further perceptual beliefs and background knowledge, not from something epistemically more basic (see my reply to McDowell). Like Burge, I think we understand most of what we commonly hear and read directly (Davidson 1997). But while Burge and I apparently have similar views about the epistemic nature of perceptual beliefs, I am not sure I understand his account of how such beliefs come to have the contents they do.

D. D.

REFERENCES

Davidson, Donald. 1983. "A Coherence Theory of Truth and Knowledge." In *Kant oder Hegel*, edited by D. Henrich. Stuttgart: Klett-Cotta.

———. 1990. "Meaning, Truth and Evidence." In *Perspectives on Quine*, edited by R. B. Barrett and R. F. Gibson. Oxford: Blackwell.

———. 1997. "Seeing Through Language." In *Thought and Language*, edited by J. M. Preston: Cambridge University Press.

10

Jim Hopkins

WITTGENSTEIN, DAVIDSON, AND RADICAL INTERPRETATION

In daily life we interpret one another—in the sense that we discern meaning and motive in one another's utterances and actions—spontaneously, continually, and with remarkable precision and accuracy. Since this kind of understanding encompasses both language and motive, it seems fundamental to our co-operative and cognitive lives.

Davidson has sought to cast light on this kind of understanding by considering the activity of an hypothetical radical interpreter, who seeks to frame an explicit theory which would suffice for interpretation. This imagined interpreter shares with us the basic grounds and conclusions of interpretation, and like us is set the task of passing in an empirically disciplined manner from observable behaviour to judgments about the meanings of sentences and the motives for actions. So insofar as we can give a non-question-begging account of the way the interpreter effects this transition, we attain a further perspective, articulated by an explicit theory, on the task we actually accomplish.

Davidson holds that we can see in outline how the requisite theory might be constructed, by combining a version of decision theory applicable to actions with a theory of truth applicable to sentences. This Unified Theory, he argues, could be systematically supported by data about an interpretee's preferences over uninterpreted sentences, and would yield specifications of the strength of the interpretee's desires, the degrees of the interpretee's beliefs, and the meanings of the sentences of his or her idiolect. We might imagine testing such a theory by using it to explain and predict an interpretee's actions. Still the point of the exercise, as Davidson stresses, is 'not to describe how we actually interpret, but to speculate on what it is about thought and language that makes them interpretable.'[1]

In this Davidson takes his lead from the project of radical translation set out by Quine. Quine can be seen as following Wittgenstein, who addressed the

question of the articulate interpretation of thought and language by consider-
ing the figure of an explorer-interpreter who enters 'an unknown country with
a language quite strange' (§206).[2] Wittgenstein, in turn, was inspired by
Augustine, who described how as an infant he worked out a detailed
understanding of the language and thoughts of those around him, thus treating
the infant, as Wittgenstein observed, as 'someone coming into a strange
country' (§32). So Davidson's work can also be seen as the culmination of a
tradition.

 In this essay I try to bring out two things. The first is that there are deep
similarities in Wittgenstein's and Davidson's uses of radical interpretation, so
that this notion provides a striking example of continuity, convergence, and
development in analytical philosophy. (As Davidson has written so as to be
readily understood I have mainly presupposed acquaintance with his views
and concentrated on spelling out Wittgenstein's.) The second is that a basic
and common aspect of their views can be brought to bear upon a further topic,
the fundamental role of interpretation in our thought.

 This can be approached via the link between thought and language. Since
so much of what we know is registered and expressed in language, the
capacity to understand language seems basic to our whole framework of
self-conscious thought and theory. If this is so, and if our grasp of language
is effected by interpretation, then we must understand commonsense
interpretation as capable of a precision and cogency correlative with our most
exacting theories. This, however, contrasts with the trend of many popular and
philosophical approaches to interpretation, which stress that interpretation is
invariably indeterminate, contestable, and the like. So we need to understand
not only what it is about thought and language which makes them interpret-
able, but what enables us to interpret them with the sureness which we
actually attain.

 We thus have, at the outset, two related questions: How deep a role does
interpretation play in our cognitive lives? And how does our commonsense
interpretive practice attain the precision and certainty which the role requires?
To relate these questions to the work of Wittgenstein and Davidson we can
start by considering how Wittgenstein defined a basic role for interpretation,
in his break with the epistemological tradition stemming from Descartes.

 I

A leading idea of the Cartesian tradition is that knowledge of the external
world and other persons is based on knowledge of one's own thoughts and
experiences. I may be wrong, as Descartes observes, in thinking (for example)
that I now see a tree, or another person: I may be suffering an illusion, or

dreaming, or some power may have brought it about that I have such thoughts even though there are in fact no such things as trees or other persons. But there is something I apparently cannot be wrong about, and so cannot doubt, and so can take as fundamental: namely that I *think* that I now see a tree, that it now *seems to me* that there is a person before me, and so on.

As Wittgenstein pointed out, however, this proposed foundation already presupposes a certain competence on my part. In holding that my experience is described by a word 'S', or is of kind S, I presume that I can apply the word or concept S to my experience *correctly*. The ascription of this competence, in turn, presupposes that there is some norm or standard of correctness, against which my use of S can be assessed; and Wittgenstein asked, as Descartes and his followers did not, how in one's own case such a norm could be constituted and acknowledged.

Wittgenstein attacked this question in a characteristic way, that is, by raising one of still greater scope and depth. What makes it the case that we can think, judge, or use words in accord with rules or norms at all? He raises this question via the notion of interpretation. He considers someone being taught the use of a simple arithmetic rule, such as that for adding two. This pupil is supposed, among other, things, to learn to continue the series 2, 4, 6, 8, . . . and so on indefinitely. The question then is, in what circumstances are we to interpret the pupil as having learned to follow the rule *correctly*?

Wittgenstein notes that a learner might continue the series correctly (as we would say) up to 1000, but then go on to write 1004, 1008. . . . We should regard this as incorrect, but it would not necessarily show lack of an understanding (some understanding) on the pupil's part. It might be that going on in this different way was natural to the pupil, and we might find an interpretation which explained this, and according to which it was indeed the correct thing for him to do.

§185. We say to him: "Look what you've done!"—He doesn't understand. We say: "you were meant to add two: look how you began the series!"—He answers "Yes, isn't it right? I thought that was how I was *meant* to do it." Or suppose he pointed at the series and said: "But I went on in the same way." It would now be no use to say: "But can't you see . . . ?"—and repeat the old examples and explanations.—In such a case we might say, perhaps: It comes naturally to this person to understand our order and our explanations as we should understand the order "Add 2 up to 1000, 4 up to 2000, 6 up to 3000 and so on."

Such a case would present similarities with one in which a person naturally reacted to the gesture of pointing with the hand by looking in the direction of the line from finger-tip to wrist, not from wrist to finger-tip.

This illustrates, as Wittgenstein says later, that "there are criteria for his 'thinking he understands', attaching some meaning to the word, but not the right one" (§269). So we are immediately faced with a deeper question. How

do we know that we are supposed to follow the rule for adding two in the particular way that we do—how do we know that our practice, as opposed to that of the person we treat as deviant, is the one which is actually *correct*? And this question, as Wittgenstein makes clear, can seem exceedingly difficult to answer. He has already noted that the infinite extension of a rule is in no sense 'present to the consciousness' of a person who follows it, and has considered various other ways in which follower and extension might be related, so as to render the latter the *correct* thing for the former to produce. Thus he has discussed the supposed event of grasping a Fregean sense (§138ff), together with a version of his own early picture theory of understanding (§139ff); and also the state of understanding more generally (§147ff), and the physiological mechanisms which might be supposed to underlie it (§158). It is clear from this discussion that the deeper question cannot be answered by citing any of these things, since the question concerns the presumed (and so far unexplained) *correctness* of such things.

We may be inclined to say that we know we are to do as we do because we are to write what *follows from* the rule, or the meaning we give it. But this again is no answer, because:

> §186 . . . that is just what is in question: what, at any stage, does follow from that sentence. Or again, what, at any stage, we are to call "being in accord" with that sentence (and with the *mean*-ing you then put into that sentence—whatever that may have consisted in). It would almost be more correct to say, not that a new intuition was needed at any stage, but that a new decision was needed at any stage.

So we seem faced with a deep and general problem, which Wittgenstein puts in terms of the notion of interpretation as follows:

> §198. "But how can a rule show me what I have to do at *this* point? Whatever I do is, on some interpretation, in accord with the rule?" That is not what we ought to say, but rather: any interpretation still hangs in the air with what it interprets, and cannot give it any support. Interpretations by themselves do not determine meaning. . . .

This question, as Wittgenstein makes clear, is not restricted to mathematics or logic, or to rules relating to the use of signs in general. For a question as to which action really accords with the mathematical rule expressed by the sentence 'Add 2' is also a question as to which action really accords with the intention or desire described by the same sentence, that is, the intention or desire to add 2; and Wittgenstein makes this an explicit part of his inquiry as well. Thus in discussing the following of a rule in §197 he turns abruptly to the same sort of question, but now about desire and intention:

> we say that there isn't any doubt that we understand the word, and on the other hand its meaning is in its use. There is no doubt that I now want to play chess, but chess is the game it is in virtue of its rules (and so on). Don't I know, then, which

game I want to play until I *have* played it? or are all the rules contained in my act of intending? Is it experience that tells me that this sort of game is the usual consequence of such an act of intending? so is it impossible for me to be certain what I am intending to do? And if that is nonsense—what kind of super-strong connexion exists between the act of intending and the thing intended?

The original problem thus seems quite general. It relates to items or states which have what we might call *sentential content*—content *that P*, which is assigned by the use of a sentence 'P'—and any of the actions or items in the world which are supposed (or meant) to *accord with* these bearers of content. Thus consider any sentence 'P' which can be used to specify something a person can do. ('P' might be 'Take the square root', 'Turn left', 'Find something *this* colour', 'Create a diversion' or whatever.) For each such 'P' we have the same questions: What makes it the case that it is correct to act in accord with 'P' in one way rather than another; and how do we know that this is so? And again we have corresponding questions about intention, belief, desire, and other states of mind. What makes it the case, and how do we know, that one action rather than another fulfils the desire or intention that P, or renders the belief that someone has done this true?

These questions relate to thought (propositional attitudes) and action as well as to language, and concern both the constitution of the norms we take to govern these phenomena, and our knowledge of these norms. So, in Wittgenstein's terms, they are also questions about 'the hardness of the logical must'—questions as to what constitutes this 'super-strong connection', and how we can know about it. So as he puts the question for propositional attitudes more generally.

§437. A wish seems already to know what will or would satisfy it; a proposition, a thought, what makes it true—even when that thing is not there at all. Whence this determining of what is not yet there? This despotic demand? ("The hardness of the logical must.")

Our understanding of how to go on in the case of adding two thus exemplifies a fundamental kind of relation, which we can regard as linking mind, language, and the world. We take thoughts and motives, words and sentences, and worldly things and situations to be related in a way which we describe in terms of *normative accord*, that is, accord which can be regarded in one way or another as correct or incorrect. As illustrated, we speak of such accord in many different ways: in terms of the *truth* of sentences or thoughts, the *fulfilment* of intentions, the *satisfaction* of desires or wishes, the *realization* of hopes and fears, the fact that a step *follows from* a premise, or *according to* a logical or mathematical rule, and so on. And as §197 and §437 make clear, since this includes the accord of states of mind and sentences with objects and situations in the world, it also encompasses *intentionality*, that is,

the capacity of the mind to be *about* or *engaged with* such objects and situations.

The question as to how these relations are constituted and known, in turn, is central to our sense of ourselves as agents who can knowingly think, speak, and act. Knowing the contents of our thoughts, intentions, or sentences is knowing the actions or states of affairs which are supposed to accord with them in this sort of way; and these are matters which we take ourselves not only to know about, but to know more about than others characteristically do or can know—matters in the sphere of our first-person authority about our own minds and meanings. Yet although such knowledge seems absolutely fundamental to us, we also seem quite unable to give any account of it, or to describe any justification for it. We acknowledge the normative requirements of thought and language spontaneously and without reflection, and we take them for granted in what we say, think, and do. But trying to answer Wittgenstein's explicit questions, we can seem quite unable to elucidate either the basis of these requirements or the knowledge of them which comes so readily to us. To suppose that we lack justification in these matters is therefore to be faced with a scepticism far more radical than any envisaged by Descartes. As Saul Kripke puts the point in his celebrated exposition, if we take Wittgenstein's remarks as sceptical 'It seems that the entire idea of meaning vanishes into thin air.' In this case scepticism would represent '*all* language, *all* concept formation, to be impossible, even unintelligible', so that 'assertions that anyone ever means anything are meaningless.' Such scepticism is thus 'insane and intolerable'.[3]

II

Now of course Wittgenstein was not proposing any form of scepticism, but rather indicating a problem about justification. We saw that he raised this problem by reference to interpretation—by citing the possibility of an interpretation which represents an intuitively mistaken way of following a rule as correct in some different or unexpected sense, and by stressing that interpretations alone do not determine meaning. Also I think he solves the problem by reference to interpretation; this emerges in the following remarks, which are, even for him, unusually difficult to understand.

> §206. Following a rule is analogous to obeying an order. We are trained to do so; we react to an order in a particular way. But what if one person reacts in one way and another in another to the order and the training. Which one is right?
>
> Suppose you came as an explorer into an unknown country with a language quite strange to you. In what circumstances would you say that the people there gave orders, understood them, obeyed them, rebelled against them, and so on?

The common behaviour of mankind is the system of reference by means of which we interpret an unknown language.

§207. Let us imagine that the people in that country carried on the usual human activities and in the course of them employed, apparently, an articulate language. If we watch their behaviour we find it intelligible, it seems 'logical'. But when we try to learn their language we find it impossible to do. For there is no regular connection between what they say, the sounds they make, and their actions; but still the sounds are not superfluous, for if we gag one of their people, it has the same consequences as with us; without the sounds their actions fall into confusion—as I feel like putting it.

Are we to say that these people have a language: orders, reports, and the rest?

There is not enough regularity for us to call it 'language'.

In these remarks—which we can readily relate to Davidson's claim that 'a form of activity that cannot be interpreted as speech behaviour in our language is not speech behaviour'[4]—Wittgenstein seems clearly to be putting forward his own speculations as to 'what it is about thought and language that makes them interpretable'; and we can see that like Quine and Davidson, he frames these speculations via the notion of a radical interpreter. He at first explicitly states the question of accord which he has been raising, using the examples of rules and orders, and people who respond to these in different ways ('Which one is right?'). He then replies to his own question indirectly, by describing a radical interpreter, who has the task of making sense of both the interpretees' utterances and actions, without prior knowledge of either. And here he makes a series of claims about the finding of empirical regularities ('regular connection') between sounds and actions which make interpretation possible.

What are we to make of these claims, and how do they constitute an answer to the general questions about correctness or normative accord which Wittgenstein has previously raised? Without going further into exegetical detail, I think we can take Wittgenstein here to be making a series of related points which we can partly bring out as follows. We are concerned with the interpretation of speech, and speech seems a kind of action which we understand particularly clearly. But as §207 suggests, speech is also a kind of behaviour which cannot be understood in isolation from the rest of the behavioural order of which it is a part. If people's productions of sounds or marks were not a co-ordinated part of a larger pattern of action, we could not interpret such sounds or marks, or regard them as language at all. By contrast, we can understand the order in much non-linguistic behaviour without relying on speech, at least up to a point. We can generally see the purposive patterns in people's behaviour in terms of their performance of commonplace intentional actions, and their being engaged in various everyday projects: 'the

usual human activities' which constitute 'the common behaviour of mankind'. But as Wittgenstein has previously stressed, unless we can link such actions with speech, we cannot, in many cases, know what people think; and in the absence of speech it would be doubtful how far we could ascribe precise thoughts or motives to people at all (Cf. §25, §32; and also §342).

So we have a general claim about interpretation and understanding. Words with no relation to deeds are unintelligible, and deeds with no relation to words are inarticulate. It follows that the kind of understanding of people which we actually attain, in which we take deeds to spring from motives with precise and determinate content, requires that we integrate our understanding of verbal and non-verbal action, and hence that we correlate and co-ordinate the two. In doing this we tie the complex structure of utterance to particular points in the framework of action and context, so as to interpret language; and this in turn enables us to interpret the rest of behaviour as informed by thought which, like that expressed in language, has fully articulate content.

Wittgenstein makes this conception of the relation of interpretation, utterance, and action clearer in further remarks. Thus in §243 he writes:

> A human being can encourage himself, give himself orders, obey, blame, and punish himself; he can ask himself a question, and answer it. We could even imagine human beings who spoke only in monologue; who accompanied their activities by talking to themselves.—An explorer who watched them and listened to their talk might succeed in translating their language into ours. (This would enable him to predict these people's actions correctly, for he also hears them making resolutions and decisions.)
>
> But could we also imagine a language . . . the individual words of [which] are to refer to what can only be known to the person speaking; to his immediate private sensations . . . [?]

This again involves the figure of the explorer/interpreter, in what is clearly a variation on the theme of §206–7. As before, according to Wittgenstein, we find meaning where we find a kind of correlation between utterance and action which a radical interpreter can specify. Here the idea is applied to 'resolutions and decisions', that is, to utterances which express the interpretee's intentions in the actions with which they can be correlated. Just as in §206–7 the radical interpreter is required to find regular connections between utterances of orders and actions which are obeyings of those orders, so in §243 the radical interpreter is required to find regular connections between expressions of intention and actions which are fulfillings of those intentions. In the earlier remarks Wittgenstein claimed that such correlations are necessary for interpretation, and here he adds that they also suffice for it. Given such correlations the explorer-interpreter can both 'predict these people's actions correctly' and 'succeed in translating their language into ours'.

This remark also makes more explicit how the specification of this kind of regularity bears upon mental states like intention and desire. In correlating sentences expressing 'resolutions and decisions' with actions in this way, an interpreter is relating specifications of intention to the actions which fulfil them. This is particularly obvious in the case of resolutions and decisions, but it also applies to the rules and orders which Wittgenstein considers in other remarks; for in general the linguistic expression of a rule or order can also be regarded as a specification of the intention with which the person who follows the rule or executes the order thereby acts.

To frame hypotheses about such correlations, as Wittgenstein observes, the interpreter/explorer must use his own language. So we can say that in specifying an interpretive regularity of the kind with which Wittgenstein is concerned, an interpreter seeks to map a single sentence of his or her own idiolect (i) to the interpretee's verbal behaviour, construed as an utterance of a sentence expressing a rule or order, or again a decision, resolution, or the like; and (ii) to the interpretee's non-verbal behaviour, construed as an action in accord with the rule, order, decision, etc.; and so (iii) to the interpretee's intention in acting, which is taken as expressed by the sentence in (i) and therefore fulfilled by the action in (ii). So an interpretive understanding of a single regular connection of this kind represents these three elements—the interpretee's utterance, intention, and action—as at once empirically correlated and in normative accord. (This also means, as we shall see below, that hypotheses about such regularities have a particular methodological feature, namely that they are framed and tested by successive applications of the same sentence.)

How do these considerations bear upon the problem of eliciting the foundations of normative accord? The key is evidently that in interpreting the basic and commonplace aspects of human behaviour, we find them, as Wittgenstein says, to be intelligible and 'logical'. (Davidson puts the same point by stressing the basic role of the notion of rationality in our understanding of human action.) In interpreting even the most basic aspects of behaviour, we construe this behaviour as in accord with norms of intelligibility and logic. Hence interpretation is both empirical and normative: it consists in the detection and understanding of a natural order in behaviour, which includes regular connections between utterances and other actions; but this is also a normative order, that is, one which we understand in terms of the adherence of both utterance and action to standards of reason.

The instances of 'regular connection' of which Wittgenstein speaks in §207 thus have a triple status: they obtain; we interpret them in normative terms; and they sustain interpretation of this kind. Hence we can see them not only as causal regularities, but as regularities which correctness demands, and which support the kind of interpretation in which correctness or the lack of it

is ascribed. This status explains the apparently 'superstrong connection' or the 'despotic demand for what is not yet there' which hold between the act of intending and the thing intended, or other elements of interpretive regularity generally. And it emerges clearly in the examples with which Wittgenstein both illustrates the questions and attempts to dissolve them.

> §198. "But how can a rule show me what I have to do at *this* point? Whatever I do is, on some interpretation, in accord with the rule"—That is not what we ought to say, but rather: any interpretation still hangs in the air with what it interprets, and cannot give it any support. Interpretations by themselves do not determine meaning.
>
> "Then can whatever I do be brought into accord with the rule?"—Let me ask this: what has the expression of a rule—say a sign-post—got to do with my actions? What sort of connection is there here?—Well, perhaps this one: I have been trained to react to this sign in a particular way, and now I do so react to it.
>
> But that is only to give a causal connection; to tell how it has come about that we now go by the sign-post; not what this going-by-the-sign really consists in. On the contrary: I have further indicated that a person goes by a sign-post only insofar as there exists a regular use of sign-posts, a custom.

The notion of 'regular use' or 'practice' here is simply that of interpretable regularity considered above.[5] Wittgenstein's example is the practice of going by a sign-post, in which there is a regular connection, brought about by training, between the sign and actions which accord with it. (The sign-post is of course not an utterance of an interpretee; but still it can be regarded as a concrete instance (token) of one of an interpretee's sentences, and so as involving the kind of sign/action regularity described above.) Thus an interpreter could use observation of behaviour connected with the sign-post to work out that the sign meant, say, 'turn left'; and also a person who used such a sign could point to the sign-post itself as part of specifying a rule or giving an order, or as specifying his or her desire or intention to act accordingly, that is, to turn left.

To interpret the sign this way is perforce to hold that a person trying to act in accord with it by turning right would not be acting in accord with it, and so in that sense would be behaving incorrectly. The sign-action regularity thus covers behaviour which both has a causal explanation, and can also be assessed for correctness. The regularity of which the sign is part is also essential to this potential for correctness, since, as §207 makes explicit, a degree of regularity in persons' behaviour in relation to sign-posts (use of the sign) is required for the cogent assignment of an interpretation to the sign, and hence also to the ascription of the desire or intention which agents link with the sign; and such an interpretation also specifies the norm against which correct use of the sign is assessed. So, in Wittgenstein's terms, we begin to understand 'what this going-by-the-sign really consists in' when we see the

matter both as one of causal connection and also in terms of the linked notions of practice, interpretation, and correctness.

Such understanding also yields answers to the questions Wittgenstein poses. Consider first the analogue of that in §206: What should we say if one person responds in one way and another in another to the sign-post and the training connected with it—which one is right? On the exegesis so far this is straightforward. If the best interpretive explanation we can give of the role of the sign in the lives of those who use it is that it means 'turn left', then someone who responds to the training and the sign by turning right is so far responding incorrectly. This, indeed, is comparable to the case with which the enquiry began, of the learner who responds to our training with '+2' by going on '1004, 1008'. . . . As in that case, misinterpreting the sign can be also compared with misinterpreting the gesture of pointing; and indeed if we take the kind of sign-post Wittgenstein actually describes in his argument [§85 'A rule stands there like a sign-post But where is it said which way I am to follow it; whether in the direction of its finger or (e.g.) in the opposite one?'] we see that the comparison is nearly exact.

The existence of a rule is thus constituted by the presence of such an interpretable 'regular connection', and discerned via interpretation in terms of one or another form of normative accord. As before, however, someone who is acting incorrectly may yet have what deserves to be called his own understanding of the training and the rule. As Wittgenstein holds, this should also show in regular behaviour on his part, which we should be able to interpret. If we succeed in formulating the way this person understands 'turn left', then there will also be the possibility that he will fail to act in accord with the rule as he understands it. Thus someone might regularly turn right at the sign, leading us to suppose that he understood it this way; then on occasion he might encounter the sign (or in another case hear the order 'turn left') and turn left, but then correct himself, and turn right. This too we could interpret, for as Wittgenstein emphasizes, self-correction—and other kinds of behaviour which show sensitivity to norms—are also observable aspects of our natural history, and hence material for radical interpretation.

§ 54. Let us recall the kinds of case where we say that a game is played according to a definite rule.

The rule may be an aid in teaching the game. The learner is told it and given practice in applying it.—Or it is an instrument of the game itself.—Or the rule is employed neither in the teaching nor in the game itself; nor is it set down in the list of rules. One learns the game by watching how others play. But we say that it is played according to such-and-such rules because an observer can read these rules off from the practice of the game—like a natural law governing the play.—But how does the observer distinguish in this case between players' mistakes and correct play?—There are characteristic signs of it in the players'

behaviour. Think of the behaviour characteristic of someone correcting a slip of the tongue. It would be possible to recognise that someone was doing so even without knowing his language.

Although this remark is an early one, it has a clear bearing on the themes we have been considering, which are made fully explicit only later in the book. In particular, since Wittgenstein compares games and language, his focus on a game learnt solely by observing the behaviour of others anticipates his remarks about the explorer/interpreter, who learns the language of the monologue people through observation in precisely this way. We may suppose, moreover, that such an interpreter would be aided in this work by attending to the 'characteristic signs', stressed here, of people's awareness of the relation of their own behaviour to their own norms, which can be recognised 'even without knowing [their] language.' We can thus see this early remark as ending with a reference to the idea of radical interpretation which Wittgenstein takes up more explicitly via the role of the explorer in §207 and §243. Also we can see that in this early remark too Wittgenstein is considering interpretive regularities, which in this case can be 'read off from the practice of the game—like a natural law governing the play.' Here again Wittgenstein indicates that these are at once natural regularities, and also regularities which have the further status of activity in accord with rules or norms; and that this is reflected in further observable behaviour relating to them. Wittgenstein sketches his views repeatedly.[6]

This suggests that the notion of radical interpretation figures in Wittgenstein's thinking from early in the *Investigations*; and indeed, as noted at the outset, we can see that it is already latent in the quotation from Augustine with which the book begins.

> When they (my elders) named some object, and accordingly moved towards something, I saw this and I grasped that the thing was called by the sound they uttered when they meant to point it out. Their intention was shown by their bodily movements, as it were the natural language of all peoples: the expression of the face, the play of the eyes, the movement of other parts of the body, and the tone of voice which expresses our state of mind in seeking, having, rejecting, or avoiding something. Thus, as I heard words repeatedly used in their proper places in various sentences, I gradually learned to understand what objects they signified; and after I had trained my mouth to form these signs, I used them to express my own desires.

We can now see that this passage already contains the elements of Wittgenstein's conception of radical interpretation. The infant in §1 is set the same task as the interpreter-explorer Wittgenstein introduces by comparison in §32: that of proceeding from observation of utterance and other expressive behaviour to the fully articulate understanding of language and action. Moreover the infant proceeds in the same way as the interpreter in §243, that is, by

finding 'regular connections' between utterance and action, as described in §206–7. The infant sees that utterances ('words repeatedly used in their proper place in various sentences') can be linked with intentional actions ('seeking, having, rejecting, or avoiding something'); and this correlation is mediated by a natural understanding of intention ('our state of mind in seeking, having, rejecting, or avoiding . . .') as this is shown in expressive behaviour. Thus Augustine's 'bodily movements' which are 'the natural language of all peoples' already play the universal and pivotal role which Wittgenstein generalizes in §206–7 as 'the common behavior of mankind' which provides 'the system of reference by which we interpret an unknown language.' (And these include 'the expression of the face, the play of the eyes, and the tone of voice' which Wittgenstein elsewhere takes as 'the primitive, the natural expressions. . .' [§244] of various states of mind.)

In this light Augustine's description of the infant appears particularly suited to the purpose for which Wittgenstein employs it, that is, as an introduction to his *Philosophical Investigations* as a whole. For Wittgenstein's reader can see Augustine's description as embodying not only errors from Wittgenstein's early work, but also insights from his mature philosophy; and the reader can see this by imposing on Augustine's description the same change in perspective—roughly, from a Cartesian view of psychological and semantic concepts to one which emphasizes their ascription via interpretable practice—as Wittgenstein seeks to effect in the course of the *Investigations* itself.

To effect this shift in perspective, however, we must replace Augustine's infant with the figure of an adult radical interpreter, as Wittgenstein does in §32. For Wittgenstein holds that Augustine errs in thinking that an infant's thoughts are rightly ascribed by, or rightly assigned the same contents as, the sentences of a natural language.[7] The infant's behaviour does not yet manifest the kind of order which gives this kind of ascription its explanatory focus, and will come to do so only as the infant learns language. So for Wittgenstein, as we can say, the learning of language both objectifies and socializes the mind, by rendering the child's thinking part of a behavioural order which is interpretable, and so subject to assessment for normative accord.

In this vision of our mental lives we are not, as in that of Descartes, isolated islands of potentially self-justifying intellect. Rather we are all intellectually bound together, in an interpretable 'form of life' (§242). To be in harmony with norms is potentially to be in co-ordination with an other, even in the absence of communication. For insofar as my uses of sentences and other actions lacked an order which would enable an other to make sense of them, I should have no right to regard them as correct myself. Thus while Descartes was right to think that he could be certain as to how things seemed to him, or how things were in his own mind, he was wrong to suppose that the

basis of this certainty lay entirely *within* his own mind, or could be found wholly in the perspective of his own case. The first-person perspective, in which we are most authoritative about the phenomena of mind and meaning, is not that in which an account of these phenomena can ultimately be grounded or justified. Rather, if Wittgenstein is right, our capacity to think and speak about ourselves, including our apprehension of the basic data of experience, is constituted as knowledge by a possible relation to others, which shows in our being such as to be interpretable by them. So it is in our natural co-ordination with one another—in which each speaks and acts in ways others can interpret, and therefore in accord with the norms which each imposes on others in making sense of their behaviour—that our practices of judgment, and the phenomenon of normative accord which they exhibit, are to be regarded as based. In this sense, it seems, the foundations of knowledge are to be regarded as both interpretive and social.

III

Despite some reservations to be discussed below, it seems that Davidson has a similar vision, according to which the interpretability and objectivity of our thought and language are rooted in the co-ordinated responses to the environment which constitute what he calls a shared 'way of life'.[8] We can bring the comparison into sharper focus by considering our understanding of language in our own case, and the way this relates to our psychological understanding of others.

As is familiar, each of us speaks and understands an idiolect, which we take to be that of a natural language; and in understanding the sentences of our idiolects we take ourselves to know the conditions in which they are true. So for example each speaker of an idiolect of English knows

> The sentence 'Freud worked in Vienna' is true (in my idiolect) just if Freud worked in Vienna.

> The sentence 'Wittgenstein lived in Vienna' is true (in my idiolect) just if Wittgenstein lived in Vienna.

> The sentence 'The moon is blue' is true (in my idiolect) just if the moon is blue.

and so on.

Each possessor of the concept of truth thus knows, or can readily come to know, an indefinitely large number of truths relating the sentences of his or her idiolect to objects and situations in the world. We can schematize this by

saying that each knows indefinitely many instances of the form:

$$\textbf{T}: \text{ 'P' is true (in my idiolect) just if P}$$

where occurrences of 'P' might be replaced by appropriate sentences of the idiolect.[9]

In commonsense psychological thinking we re-employ these sentences in a familiar and significant way. In understanding people we use a vocabulary of words like 'desires', 'believes', 'hopes', 'fears', etc., each of which admits of complementation by a further sentence. So we speak of the desire, belief, hope, fear, etc., *that P*, where 'P' can be replaced by a sentence suitable for specifying the object, event, or situation towards which the motive is directed.

This assignment of sentences to motives enables us to use a finite stock of psychological concepts as the basis for a potential infinity of ascriptions of mental states, and converts the truth-conditions of sentences to conditions of satisfaction, fulfilment, realization, etc., for motives themselves.[10] This establishing of a semantic relation between motive and world lends the motives so described the full relation to reality possessed by the articulating sentences, and enables us to represent causal relations between motive and motive, or between motive and world, by semantic relations which hold for the sentences in terms of which we describe them. This form of description thus simultaneously implements our conceptions of intentionality, normativity, and motivational causal role.[11] And it is central to the work of both Wittgenstein and Davidson, as can be seen from the way it allows the former to generalize his reflections about normative accord and the latter to represent belief and desire via preferences and probabilities about the truth of sentences.[12]

We can think of this practice as if it were built up in two stages. In the first we would learn to relate words and sentences to things and situations in the world, and so master the primary word-to-world mappings of our idiolects, as schematized in **T**. Then secondly we would learn to relate these sentences to our motives in commonsense psychological ascription, together with the situations now linked to them via the concept of truth. In this further mapping, therefore, we would pre-reflectively bond the representing mind/brain to the represented environment, by conceiving the inner causes of behaviour in terms of the sentially described situations in the environment which it is their function to produce or to reflect. This would enable us to think about these inner causes in semantic terms, and so to think articulately about motives in their connection with the world. (Individuals who could speak but lacked a 'theory of mind' would be capable of the first of these mappings but not the second.)

To review the working of this mode of description let us imagine that we watch someone reach out to get a drink, and assume (hypothesize) that she does this because she saw the drink, wanted it, and so reached for it. Then we

might spell this out, in an unnatural but useful way, as follows. Using 'A' to designate our agent, and abstracting away from details of pronouns, tense, etc., we have:

(1) **P** [There is a drink within A's reach.]
(2) A sees that **P** [that there is a drink within A's reach].
(3) A forms the belief that **P** [that there is a drink within A's reach].
(4) A forms the belief that if **Q** then **R** [that if she moves her hand in a certain way then she will get a drink]
(5) A desires that **R** [that she get a drink].
(6) A desires that **Q** [that she moves her hand in that way].
(7) **Q** [A moves her hand in that way.]
(8) **R** [A gets a drink.]

This brings out a number of patterns, which display the sentential repetition, and the combination of normative and causal linkage, described as characteristic of interpretable regularity above. Thus, speaking very roughly, we can take what we describe by (1) as a cause of what we describe by (2), what we describe by (2) as a cause of what we describe by (3); and something similar holds in later parts of the sequence. For, as we know, the transition between (1) and (2) marks the place at which light reflected by objects described in (1) strikes the eyes of the agent described in (2), and causes the changes in the retina, optic nerve, visual areas of the brain, etc., involved in seeing; and perception as described in (2) can be taken as a cause of belief, as described in (3); and so on. But also the use of the same sentence in (1) to (3) indicates that the perception and belief described there are correct, and correctly formed. In describing a perception that P as caused by a situation that P, we mark that the perception is veridical, that it accurately reflects the situation which it is a perception of; and in describing the resulting belief as a belief that P we mark that the belief is both true, as beliefs ought to be, and also caused by the situation which renders it true, and so well grounded.

We can write these patterns schematically as follows. (1) to (3) show:

(i) A pattern of perceptually well-founded belief
 P -[causes]-> A perceives that P -[causes]-> A bels that P

And this contains a sub-pattern which relates to well-founded empirical belief more generally.

B: P -[causes]-> A bels that P

Likewise (4) to (6) describe a formation of desire in light of belief which is both causal and rational. This gives

(ii) A pattern of practical reason (the rational formation of desire in light of belief)

PR: A des that P & A bels that if Q then P -[causes]-> A des that Q

Finally (5) to (8) describe intentional action which is successful, that is, action which is not only caused by desire, but in which desire is satisfied. This gives a familiar pattern of the satisfaction of desire:

A des that P -[causes]-> P

Although familiar, this pattern is notably incomplete; for we take it that desire not only prompts (causes) action, but also ceases to operate in response to the perception or belief that action has been successful. We assume, e.g., that someone who wants a particular drink will, after drinking, realize that she has had the drink she wanted, and so cease to want it. (She might now want *another* drink, or even to drink that drink *again*, but these are different matters.) Let us describe this by saying that we normally expect that when an agent satisfies a desire (that is, when A des that P -[causes]-> P), and in consequence believes that this is so (that is, when P -[causes]-> A bels that P), then this results in the pacification (ceasing of operation) of the agent's desire (that is, that A's des that P is pacified.) So, abbreviating as above, we have

 (iii) A pattern of the satisfaction and pacification of desire.
 D: A des that P -[causes]-> P -[causes]-> A bel that P -[causes]->
 A's des that P is pacified.

This pattern, which contains B, represents the life-cycle of a single desire in successful intentional action; and it shows clearly how we mark the working of desire by what we can regard as successive uses of the same sentence. Thus in thinking that a person, A, is (intentionally) going to get a drink, we in effect frame a predictive hypothesis, which could be put into words by using the sentence 'A gets a drink' in all four positions in an instance of D. We think, that is, that A desires that A get a drink, and we predict first that this will result in A moving her body in such a way that she gets a drink, secondly that she will come to believe that she has done so, and third that this will pacify her desire, so that she turns to something else. (Of course, again, we do not formulate such predictions, or anything like D, explicitly to ourselves. But that we do predict shows in the ways in which we would be surprised if the agent's action unfolded differently from our expectation.)[13]

As this example suggests, our tacit explanatory and predictive use of patterns like B, PR, and D is more frequent and complex than we are aware. Indeed we commonly see intentional actions as informed by very many more desires and beliefs than we can perspicuously represent by listing the desires and beliefs as above. We can, however, *begin* to show some of the complexity involved by a familiar kind of diagram. Thus for an explanation of a speech-act of saying that the day is warm, we might have:

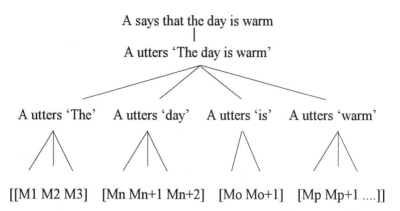

In this we display the hypothesized constituent structure of an agent's goals in action by a tree diagram, which grows from an aerial root down through a series of branching nodes. Such a tree will have an agent's overall goal in acting at the top (root), and will go down from this motive through the ordered series of other goals which the agent takes as requisite to securing the root. We can take each of these subordinate goals to give rise to a further tree of the same kind, until we reach goals which are simply the performing of various desired bodily movements in sequence, which we can label by M1, M2, etc. This lets us indicate the overall structure of actions or projects approaching everyday complexity, such as getting cash from a till.

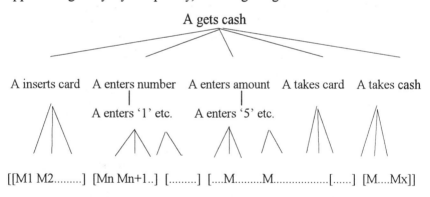

An agent's choices can be construed as indicating preferences among such ordered trees of sentences, and each such tree relates the sentence at its root to a sequence of hypothesised effects, which, if all goes correctly, should also ultimately be describable as a bringing about of the situation, and thence of the belief, and thence of the pacification of the desire, described by that same root sentence. The same holds for each subsidiary sentence likewise, and in the

order marked by the tree. The whole hypothesis thus fixes for each goal and for each intentional movement by which that goal is executed a place in a determinate order of satisfaction and pacification. This imposes a complex bracketing or phrasing on behaviour, which segments the flow of movement upon which the hypothesis is directed into the series of units and sequences, groups and subgroups, which we perceive as the unfolding rhythm of intention in action. The whole, moreover, can be seen as consisting of iterations of simpler parts which correspond to each aspect of this segmentation, that is, to instances of D governed by instances of PR. So we can see each goal-specifying sentence in a tree as applied repeatedly, now to articulate a motive as hypothesis, now to describe predicted (or cohering) effects of that motive as test, as in the simple case spelt out above. In such a tree, therefore, we find the basic normative and hypothetical structure of D both repeatedly and in the large.

<div align="center">IV</div>

This representation indicates in more detail how our norms for the sentences of our idiolects, as registered in T, reappear in our interpretive practice as norms for the proper working of perception, belief, and desire, as schematized in B, PR, and D. This in turn enables us to put Wittgenstein's discussion of rule-following in a form which relates more closely to Davidson. Our account of sentential mapping entails that our success in ascribing and assessing the working of motives like belief and desire depends upon our mastery of our own idiolects. For each of us, however, T schematizes a massive (potentially infinitary) claim to empirical knowledge about our own uses of sentences; and this is something about which it seems we could be wrong (and in respect of which persons with certain neural deficits perhaps actually are incompetent). So the question arises as to how we know that the claims in T are true. How does each of us know that the sentences in his or her idiolect—and hence the desires, beliefs, thoughts, and feelings which we articulate by means of these sentences—*really* relate to the world in the way we *think* they do?

This is another version of Wittgenstein's question. (Wittgenstein focuses on what he rightly takes to be the basic case, in which the question is that of *acting* in accord with a sentence of one's idiolect; but this is included in the broader formulation.) And this way of putting the matter is also close to Davidson's. For as Davidson writes:

> People are as publicly observable as anything else in nature, but the entities we use to construct a picture of someone else's thoughts must be our own sentences, as understood by us, or other entities with the same provenance and structure. The meanings of our sentences are indeed dependent on our relations to the world

which these sentences are about, and our linguistic interactions with others. But there is no escape from the fact that we cannot check up on the objective credentials of the measure we are using in the way we can check up on the numbers; we cannot check up on the objective correctness of our own norms by checking with others, since to do this would be to make basic use of our own norms once more.[14]

Here, as in Wittgenstein's account and that just above, the norms basic to our understanding of thought seem to be those borne by the sentences of our idiolects, as these are related to the world; and as Davidson also stresses, there is no escape from the fact that we cannot check up on their objective credentials without using them and so, as it seems, presupposing their correctness. This raises the question as to what does establish the objective correctness of these norms, and how we are to know of it; and as before, once we ask this question, it becomes clear that we cannot answer it without going outside the first-person perspective. If I am asked how I know that I hold the sentence 'Freud worked in Vienna' as true in my idiolect just if a certain person (Freud) performed a certain activity (worked) in a certain place (Vienna), there is nothing to the point which I can reply besides insisting that I do.[15] To suppose that I am mistaken about such things, or that I do not use my words coherently, is to suppose that I do not know what my thoughts are, and so cannot think reflectively at all.

In occupying the first-person perspective we use our idiolects, either overtly or in thought; and we cannot assess the correctness of these uses in the way an interpreter does. In this sense, as Davidson holds, first-person authority is ultimately validated from outside, and by interpretation. An account of radical interpretation should therefore cast light on what enables an interpreter to establish that an interpretee's uses of language and self-ascription of psychological states are objectively correct. As we saw, Wittgenstein held that the key lay in the interpreter's establishing correlations between verbal and non-verbal behaviour. Davidson's account is far more explicit and detailed, but I think we can see that it takes the same correlations as basic.

In setting out the 'official story' as to how the Unified Theory can be applied without assuming specific contents for an interpretee's beliefs and desires, Davidson stresses that the basic grounds available to an interpreter concern 'information about what episodes and situations cause [the interpretee] to prefer that one rather than another sentence be true.'[16] Roughly, the interpretee's preferences among sentences can be made to yield the subjective probabilities and desirabilities the interpretee attaches to their truth, so that the sentences can then be assigned semantic content via causal relations to the environment. Sentential preferences together with the decision-theoretic assumption that an individual will rate a tautology between

a sentence and its negation enable an interpreter to frame and support hypotheses as to which words are truth-functional connectives. Given these, Jeffrey's methods can be applied to fix the subjective probability as well as the desirability of the sentences which articulate beliefs and desires; and these, together with their causal relations to the environment, serve finally to interpret the sentences.

This indicates how Davidson represents the whole edifice of interpretation as resting upon the causes of sentential preference (desire). Hence, as he says 'it would not be wrong to say that the evaluative attitudes, and the actions that reveal them, form the foundation of our understanding of the speech and behaviour of others.'[17] He supports his reliance upon 'protocols that specify [the interpretee's] preference that one sentence rather than another be true' by asking us to 'observe that every utterance that can be treated as a sincere request or demand may be taken to express the utterer's preference that a certain sentence be true rather than its negation';[18] and the same, of course, applies to an utterance which expresses a desire or intention. But the basic role of preference-revealing utterances and actions clearly presupposes that verbal expressions of preference correlate with expressions in non-verbal action; and this entails that interpretees act, and know how to act, in accord with the utterances in which they make their preferences explicit. This, however, is precisely the 'regular connection' between utterance and action which Wittgenstein locates as basic for interpretation in §206–7; so it is fundamental to Davidson's approach as well.

Although Davidson's theoretical approach contrasts sharply with the later Wittgenstein's anti-theoretical one, this fundamental similarity seems to me to render the two approaches complementary and compatible (or at least more so than one might have thought). Davidson has sometimes distanced himself from a Wittgensteinian emphasis on conventions or rules, saying, e.g., that 'Most language learning is accomplished without learning or knowing any rules at all.'[19] But the requirement that agents know how to act in accord with their utterances imposes a relation of accord between sentences and actions to which correctness or the lack of it is applicable, and which is indistinguishable from that of a rule discussed in connection with Wittgenstein above. Such sentence-action links will, moreover, be customary or conventional for Davidson in the same sense as for Wittgenstein: they will require to be shown with a degree of regularity which renders interpretation in accord with them possible.[20]

Likewise Davidson's programme cannot be held liable to the criticism Wittgenstein levels at Augustine as well as his own *Tractatus*, that is, of failing to grasp that the notions of action and practice are more basic in the explanation of meaning than those of reference and truth. For Davidson's emphasis on action and his assumption that interpretees can act in accord with

their sentences mean that what Wittgenstein called practice enters his account at a basic level. There is thus a case for saying that the theoretically expanded and action-engaging role which Davidson assigns to truth serves ends which Wittgenstein himself might (or ought to) have regarded as desirable. For this can be seen as enabling Davidson to integrate the general reference- and truth-based approach to meaning of the *Tractatus* with the emphasis upon the basic and endlessly diverse role of interpretable practice characteristic of the *Investigations*; and also to represent general facts about language, including those which Wittgenstein took to be required for interpretation, in an explicit and systematic way.

<div align="center">V</div>

The argument so far has been that interpretation is epistemically basic in the sense that it is required to justify our first-person authority about what we think and mean, and hence our capacity to engage in self-conscious reflective thought. Let us now try to understand how we can regard our interpretive practice as capable of attaining the precision and certainty required for this role, and particularly that with which we take ourselves to understand language itself. I think we can begin to see the outlines of this by attending to the basic correlation between verbal and non-verbal action.

We said above—and this is the reason that the action-utterance correlation is basic—that words with no relation to deeds would be unintelligible, and deeds with no relation to words would be inarticulate. To interpret utterances and actions as we do we must integrate our understanding of them, so as to tie language to the environment and describe non-verbal behaviour as the product of precisely conceptualized thought. I think that we can see ourselves as doing this in a particular way. The mode of integration we use involves what we can regard as a process of interpretive triangulation. This turns on the fact that in interpreting speech we do not merely assign meanings to sounds; rather we characteristically take utterances as expressions of desire, belief, intention, and other motives. (Thus we regularly take assertions as expressing beliefs, questions as expressing desires to know something, requests or orders as expressing desires that something be done, and so forth.) This enables us to interpret the motives which we take to be expressed in this way with precision, and also to relate such interpretation to the speaker's ability to express such motives with first-person authority. Clearly, however, we could not take utterances as such expressions of motives with any degree of accuracy and certainty, unless we also had independent means of determining what the agent's operative desires, beliefs, or intentions really were. Evidently the means we use are the interpretation of further actions, including non-verbal ones.

In general, we are able to regard utterances as accurate or authoritative expressions of motives because doing so enables us to interpret other actions, and with cogency, as stemming from those same motives, or others related to them. In understanding persons in this way, therefore, we in effect correlate their utterances with their other actions, as effects of a set of common causes (motives). Schematically, insofar as we take an utterance of 'P' as an expression of a desire, intention, or belief that P, and then confirm this by independently interpreting further actions as flowing from that same motive, we thereby correlate utterance and action, as effects of that desire, intention, or belief. By this means we triangulate from episodes in speech and non-verbal action to focus upon their common causes, that is, motives which we specify by relation to both verbal and non-verbal behaviour.

In this we constantly and tacitly cross-check the motives we assign via speech against those we assign via non-verbal action; and this method attains particular power when the interpretee also has first-person authority. Roughly, the more an interpretee can put his or her goals and beliefs into words—the more the interpretee exhibits first-person authority—the better an interpreter is able to use those words to understand both the interpretee's speech and other actions. But the better an interpreter is able to understand the interpretee's speech and other actions, the more fully that interpreter can check the interpretee's first-person authority. So there is a benign circle; and in favourable circumstances an interpreter can cross-check his or her understanding of an interpretee's verbal action, non-verbal action, and first-person authority together, and in such a way as simultaneously to confirm all three.

To represent this more explicitly, let us imagine that we have an interpreter A and an interpretee B, and that the sentences of their idiolects are numbered, so that A's sentences include P1, P2 . . . Pn. . . . and B's include $\Sigma 1$, $\Sigma 2$, . . . Σn. . . . Then in trying to understand B's language A will be trying to devise a correlation in his own idiolect whose instances might be represented as:

'$\Sigma 1$' is true (in B's idiolect) just if P1
'$\Sigma 2$' is true (in B's idiolect) just if P2
'$\Sigma 3$' is true (in B's idiolect) just if P3
'$\Sigma 4$' is true (in B's idiolect) just if P4
and so on.

We can take it that A is trying to represent this correlation via a theory of truth for B's idiolect in his own, the output of which we can represent by:

T: 'Σ_i' is true (in B's idiolect) just if P_i

Suppose now that A has a hypothetical understanding of B's utterances

which includes these interpretations, and also that A is able to interpret some non-verbal action of B's, by a tree such as the following.

Since A also has a tentative understanding of B's idiolect, he can use this to translate this tree into B's sentences, that is, as

Now suppose also that B explains what B is doing, or otherwise expresses the desires and beliefs upon which B is acting, so that A can construct a further tree from B's own use of sentences, which might (or might not) be identical with that above. A now has two trees in B's idiolect, the first supplied via A's hypothetical interpretation of B's language and action, the second via B's own exercise of what may be first-person authority. So A can test his understanding of B's language and action together by comparing these trees. If (i) A has understood B's initial action correctly, and (ii) A's translation of A's hypothesized tree into B's idiolect is correct, and (iii) B has expressed the motives relating to his own action with first-person authority, then the translated tree, and that derived from B's utterances, should match sentence for sentence.

This is a very precise prediction, and one which, given the potential infinity of sentences in B's idiolect, is antecedently very improbable. The best explanation of its success should thus be that the hypotheses which prompted it—that is, (i), (ii), and (iii) above—are all true. So the match should raise A's confidence in his initial tree, towards whatever level he associates with B's first-person authority in the case, while also confirming B's possession of this authority, by showing a correlation between self-ascription and the results of interpretation by another. Again, the match indicates that A is mapping the sentences of B's idiolect to just the same actions and situations as B himself,

and so confirms A's theory of B's idiolect, with regard to all the sentences which figured in the trees.

Now although this pertains to confirmation of an imagined theory, we can see that it also holds in situations common in everyday interpretive understanding. Suppose that I frame hypotheses as to the motives upon which you are presently acting, and also about what the sounds in your idiolect mean. Then suppose that you also make sounds which, according to my understanding of your idiolect, constitute authoritative expressions of the motives upon which I take you to act, and that your further behaviour bears this out. Questions of sincerity aside, this tends to show, as in the example above, both that my hypotheses about both the meanings of your utterances and the motives for your present behaviour are correct, and that you have first-person authority about these things.

In such informal cross-checking of interpretive hyptheses everything is confirmed empirically, so that nothing is merely assumed or taken on trust. As I test my understanding of your non-verbal actions against my understanding of your expressions of motive my confidence in my interpretations is based upon their success in explaining and predicting what you do and say, and my confidence in your first-person authority is based upon its coinciding with my independent understanding of the actions and utterances in which it is expressed. The same, of course, also holds for your understanding of me. So given that each of us is both a competent interpreter and an authoritative interpretee, it seems that by this method we may attain mutual understanding which is highly precise and certain. Of course, an interpreter will not always interpret accurately, and there are circumstances in which an interpretee's first-person authority will fail. Still, an interpreter can correct faulty interpretations in light of evidence provided by an interpretee, can check how far the interpretee's first-person account is accurate, and can try to correct it where it is not. Interpreter and interpretee can thus together continually explore the assumptions and presuppositions of interpretation of this kind, in a process which admits of continual extension and refinement.

As noted, this applies particularly to language. For each of us can in principle take any of our countless interpretations of another's non-verbal actions, and seek to pair them with appropriate self-ascriptions from the other; and by this means each interpretation of non-verbal action, provided it is correct, can also be made to test and improve each's understanding of the other's use of language. This potentially infinite correlation between verbal and non-verbal action can thus be exploited indefinitely often, to drive confirmation of the hypothesis that each understands the language of the other steadily upwards, towards whatever limit is required. (And of course we also test utterances against one another in a comparable tree-comparing way.) So systematic triangulation between utterance and action can tend simultaneously to render interpretation cogent, first-person authority credible, and our

interpretive grip on the meanings of sentences as firm as any we possess.

VII

This account of our interpretive grasp complements those from Wittgenstein and Davidson above, according to which first-person authority is at the root of our articulate understanding of things, and yet also requires and receives justification from outside the first-person perspective. For such interpretive triangulation makes the greatest possible use of first-person authority, while at the same time providing it with continuous checking and ratification from the perspective of the other.

If correct these arguments give reason to hold that our capacity to interpret one another should be seen both as epistemically basic, and yet also as resting on, and so interdependent with, our possession of first-person authority. It is no coincidence that we should both have first-person authority and also be able to interpret one another so accurately, for these apparently distinct phenomena are interwoven. The potential accuracy of tree-comparing interpretive triangulation is set by the range and precision of the correlations which can be brought within its scope, and this is effectively a measure of first-person authority. In this light, moreover, first-person authority does not seem essentially self-directed. Rather it appears as a social complement to the ability to interpret: the ability to manifest the kind of correlation between utterance and action which makes precise and fully grounded interpretation possible, and thereby to make oneself understood.

This view of epistemology and first-person authority is clearly consistent with externalism, and may also admit of other support. The dovetailing of expressive and interpretive abilities we have been considering seems such as to have been shaped by natural selection, and may itself have contributed to the shaping of the mind.[21] Roughly, and other things being equal, we should expect that an increase in the ability to understand and anticipate the behaviour of others should increase the fitness of members of a species who possess it; and the same should hold for an increase in the ability to influence the way in which one is interpreted by others. We might therefore expect that there would be circumstances in which evolution could get its hands on behaviour which expresses motive to cull and save in favour of both these abilities. Thus it seems that we might also begin to sketch an evolutionary account of the process by which our capacities for expressing and describing motives have become welded to the relevant behaviour-governing states and events in our brains with the firmness and precision (and also the limitations) which we observe in our exercise of first-person authority.[22] Although this process would turn on the role of interpretation, it would also be essential to the development of our capacity to think about ourselves and our motives and

reasons. So evolution itself may underpin the picture sketched here, in which our framework of articulate thinking depends simultaneously upon interpretation and first-person authority, with the two coiled in a tight but benign circle at the basis of our cognitive lives.

VIII

Let us end with a comparison which touches both on the mind and on the nature of philosophy. In *Zettel* §608ff Wittgenstein compares structures in the brain which give rise to thought, speech, and writing to seeds which give rise to plants of various kinds. He clearly regards these structures as physical, and as causes of behaviour, as well as effects of learning and the like; so he here holds (i) that physical events (or structures) cause mental events, and vice-versa. Also he assumes (ii) that causality, even in the brain, has a nomological character. The seed-structures, he says, give rise to behaviour in accord with laws, in that 'a seed always produces a plant of the same kind as that from which it was produced . . .' (§608); and hence there might be 'a natural law connecting a starting point and a finishing state of a system' (§613). Finally, he also holds (iii) that there is a no set of lawlike psycho-physical connections, and again no form of linguistic encoding in the brain, which would make it possible 'to read thought-processes off from brain processes' (§608).

These remarks show Wittgenstein's adherence to the three apparently inconsistent principles—of interaction, nomologicality, and anomalism respectively—which Davidson discusses and reconciles in 'Mental Events'.[23] Wittgenstein himself, moreover, seems clearly to regard the principles as inconsistent. For he assumes that if he is to affirm his versions of (i) and (iii), then he must deny something ordinarily encompassed in (ii). He therefore seeks to hold that while the brain works in accord with laws it lacks what he calls *causal efficacy* (§613). This is a property possessed by a physical mechanism or structure just insofar as the effects produced by it can be explained by reference to its *intrinsic* physical features together with the laws in accord with which it operates.

Wittgenstein takes it that if mechanisms have causal efficacy then they will be subject to a further principle, which we may label (ii)*: that mechanisms which are intrinsically alike must operate in like ways in like circumstances. This is a version of the maxim that like causes have like effects, and a direct consequence of the notion that the mechanisms in question are alike in respect of the features by reference to which their output can be fully explained in accord with laws. Hence Wittgenstein seeks to deny that brain mechanisms have causal efficacy by denying that they are subject to principle (ii)*; and he

presents his seeds as providing an alternative model which is both metaphysically possible and empirically plausible. The seeds are supposed to be intrinsically alike, but to produce different effects, and in accord with laws; for the laws to which they are subject relate to their history rather than their physical structure. Hence, as he puts the point, 'nothing in the seed [neural mechanism] corresponds to the plant [thought and behaviour] which comes from it; so that it is impossible to infer the properties or structure of the plant [the properties or struture of thought and intentional behaviour] from those of the seed [the underlying neural mechanism] . . . this can only be done from the history of the seed [the history of the mechanism]' (§608).

By this means Wittgenstein manages to find a way out of the contradiction apparently engendered by the three principles, that is, an account which allows him to affirm anomalism without denying interaction or nomologicality. He holds that while the output of the brain, like that of the seeds, is subject to law, it is not fully explicable by reference to the physical structure of the brain, as opposed, say, to its history. Accordingly this output 'might come into being out of something quite amorphous, as it were causelessly'; and he urges that 'there is no reason why this should not really hold for our thoughts, and hence for our talking and writing.' (§608). (His 'as it were' marks the fact that the nomological-causal role of the physiological mechanisms has been so qualified by the imagined role of history as to render the contribution of the mechanisms ambiguous, and hence not necessary to the detail of the effects they produce.)

This line of thought combines insight with confusion. On the one hand, Wittgenstein seems right to insist on the anomalism of the mental, and also to hold that the mechanisms in the brain which give rise to the systematic production of symbols in speech or writing need not themselves be thought of as embodying some parallel symbolic form. On the other, he surely errs in suggesting that there is reason to expect that neural mechanisms which are intrinsically exactly similar may yet produce output in systematically different ways. Wittgenstein apparently had no reason to deny (ii)* besides his version of (iii) and his sense that this would otherwise be inconsistent with (i) and (ii). Hence his arguments on this point are forced, and the line he constructs is artificial and ad hoc.

Wittgenstein did not include these arguments in the *Investigations*, and it is hard to suppose that he would have felt impelled to frame them if he had seen Davidson's simpler way of affirming (i), (ii), and (iii) together. Davidson's argument, moreover, can be seen as embodying the idea that the apparent inconsistency results from a confusion between types and tokens. So Davidson's approach bears out Wittgenstein's claim that philosophical confusions can be resolved through understanding the working of language which gives rise to them. So Davidson's approach bears out Wittgenstein's

claim that philosophical confusions can be resolved through understanding the working of language which gives rise to them; and this time in the case of Wittgenstein himself.

JIM HOPKINS

DEPARTMENT OF PHILOSOPHY
KING'S COLLEGE, UNIVERSITY OF LONDON
JUNE 1998

NOTES

1. Davidson (1995), p. 10.
2. Wittgenstein (1954). Further references to this are by numbered remark in parentheses.
3. Kripke (1984); quotations from pages 22, 62, 77, and 50 respectively.
4. Davidson (1984), p. 185.
5. This remark also illustrates Wittgenstein's play on first-/third-person assymetries about interpretation. His 'any interpretation still hangs in the air . . .' of §198, like 'there is a way of grasping a rule which is *not* an *interpretation* . . .' of §201 relate to first-person uses of the concept of interpretation, whereas §206–7 and other remarks deal with third-person uses. (See also Wittgenstein 1978, pp. 352–53, and *Investigations*, pt. II, p. xi.) A fuller account of Wittgenstein on radical interpretation can be found in the early version of this paper posted at http://www.kcl.ac.uk/kis/schools/hums/philosophy/ staff/jimh.html.
6. Other early remarks clearly about interpretation include §31 and §82.
7. Cf. Davidson's 'Thought and Talk' in (1980)
8. See for example (1992), pp. 263–64, and (1982), p. 20.
9. This representation is oversimple in its use of both quotation and sentential repetition.
10. Thus we have, e.g.:
A belief described by 'P' (a belief that P) is true just if 'P' is true, that is, just if P.
An intention described by 'P' (an intention that P) is fulfilled just if 'P' is true, that is, just if P.
A desire described by 'P' (a desire that P) is satisfied just if 'P' is true, that is, just if P.
A fear described by 'P' (a fear that P) is realised just if 'P' is true, that is, just if P.
A hope described by 'P' (a hope that P) is fulfilled just if 'P' is true, that is, just if P
etc.
11. Thus Davidson's argument against strict psycho-physical laws could as well have been based on intentionality as normativity, as he has indicated. See for example (1995), pp. 4–5.
12. The importance for Wittgenstein's late work is summed up in §445: 'It is in language that an expectation and its fulfilment make contact.' See also (1922), 5.541–2 and (1969), p. 70.

13. Expectations which are predictive in accord with **D** are falsifiable in a number of ways. Thus for example (i) an agent may do something we do not expect (instead of drinking the water she pours it on the flowers) so that we conclude that we were wrong about her desire (we were wrong about the sentence 'P' in des P); (ii) an agent may try as expected but fail (des P was present but failed to cause P); (iii) an agent may not succeed but think she has (des P produces something besides P, which yet causes bel P); (iv) an agent may succeed but not notice that she has and keep trying (des P causes P, which fails to cause bels P); and other variations are possible. Given this we take them as confirmed when things go as expected.

14. (1995), p. 14. Wittgenstein compares interpretation with measurement in §142 and §242.

15. This is also a point which Davidson emphasizes. See (1984b), esp. p. 111.

16. (1990), 322ff, and (1995), 9ff.

17. (1982), p. 17–18.

18. (1995), p. 9; (1990), p. 325n.

19. (1992), p 257.

20. For an account of linguistic convention which accords with this see Millikan (1998).

21. For a recent discussion of the co-evolution of mind and language see Deacon (1998).

22. For evolutionary speculation about these limitations see Trivers (1985), chapt. 16.

23. (1980), p. 207ff.

REFERENCES

Davidson, D. (1980) *Essays on Actions and Events*. Oxford: Clarendon Press.

———. (1982) 'Expressing Evaluations'. *The Lindley Lecture*. The University of Kansas Libraries.

———. (1984a) *Inquiries into Truth and Interpretation*. Oxford: Clarendon Press.

———. (1984b) 'First Person Authority'. *Dialectica* 38.

———. (1990) 'The Structure and Content of Truth'. *Journal of Philosophy* 10.

———. (1992) 'The Second Person'. *Midwest Studies in Philosophy* 17.

———. (1995) 'Could There Be a Science of Rationality?' *International Journal of Philosophical Studies* 3.

Deacon, T. (1998) *The Symbolic Species*. London: Penguin.

Kripke, S. (1984) *Wittgenstein on Rules and Private Language*. Oxford: Blackwell Publishers.

Millikan, R. (1984) *Language, Thought, and Other Biological Categories*. Cambridge: MIT Press.

———. (1998) 'Language Conventions Made Simple'. *Journal of Philosophy* 4.

Tarski, A. (1956) 'The Concept of Truth in Formalized Languages'. Collected in *Logic, Semantics, Mathematics*. Oxford: Clarendon Press.

Trivers, R. (1985) *Social Evolution*. California: Benjamin/Cummings.

Wittgenstein, L. (1922) *Tractatus Logico-Philosophicus*. London: Routledge & Kegan Paul.

————. (1954) *Philosophical Investigations*. Oxford: Blackwell Publishers.

————. (1964) *Philosophical Remarks*. Oxford: Blackwell Publishers.

————. (1967) *Zettel*. Oxford: Blackwell Publishers.

————. (1978) *Remarks on the Foundations of Mathematics*. Oxford: Blackwell Publishers.

REPLY TO JIM HOPKINS

I have been scolded by friend and attacked by foe for not emulating Wittgenstein's progress from the semi-formalism of the *Tractatus* to the anti-theoretical stance of the later work. It is therefore wonderfully refreshing to be told not only that my attempt to systematize our understanding of language and action is a reasonable enterprise but that it can be seen as "complementary and compatible (at least more than one might have thought)" with Wittgenstein's approach. Maybe those long hours I spent years ago admiring and puzzling over the *Investigations* were not spent in vain. James Hopkins does much more than make a convincing case for the "convergence" he finds between Wittgenstein's and my views on the nature and role of interpretation; by spelling out in some detail how he sees things going together he constructs a coherent account more systematic than Wittgenstein's and closer to psychological reality than mine.

Particularly striking is the persuasive way he relates the starting point of my theory (the preference that one sentence be true rather than another) to everyday situations in which we discover the intentions and motivations of people while confirming the interpretations we put on their words. I have dropped hints here and there (which he generously acknowledges) trying to make this starting point seem less artificial, but Hopkins shows how natural it is. He accomplishes this by summoning up scenes in which my version of preference is just one of several ways in which language and action interact. This is certainly the right approach. Readers cannot do better than to compare Hopkins's account with my rather apologetic defense of my theory in my reply to Soles in this volume.

Hopkins appreciates the extent to which our capacity to interpret speech is "basic to our whole framework of self-conscious thought and theory." (Though here I would edit out the "self-conscious".) This emerges particularly in his treatment of objectivity and error. I am pleased that he attributes the idea that it is only in a social setting that we come to understand "following

a rule" to Wittgenstein. I have often said I thought I owed this view, and some of the arguments for it, to Wittgenstein, though I have been uncertain whether I really understood what I was reading. In any case, Hopkins is surely right that this point is more basic than any other we can raise concerning thought, language, or conceptualization, for without a conception of error and objectivity we are not even in a position to be skeptics. Incidentally, I have no objection to Hopkins's understanding of what Wittgenstein calls rules and conventions, for nothing more is involved than an awareness of the regularities of response to actions, objects, and events we share with others. I do object, though, to the way these words have come to be used, or misused, in much contemporary philosophy, as though merely invoking them solved hard problems.

Another issue on which I am glad to find Hopkins and Wittgenstein on my side has to do with the infant's early steps toward language. I have from the start rejected the building-block theory according to which the learner is viewed as acquiring the rudiments of language piece by piece, the pieces being suited without alteration for the finished product, and I knew that in this I was taking to heart Wittgenstein's poke at Augustine in the opening section of the *Investigations*. Hopkins places this rejection in a larger context when he writes of the subsequent stage of language mastery, "[F]or Wittgenstein . . . the learning of language both objectifies and socializes the mind, by rendering the child's thinking part of a behavioral order which is interpretable, and so subject to assessment for normative accord."

In section VII, Hopkins is very good on the central role of the first-person perspective and first-person authority in interpretation. He sees clearly that this does not, and cannot, make the contents of our thoughts about our own thoughts any more subjective than our thoughts about anything else. Here he is brought close to how I summarized my position on the relations among our knowledge of our own minds, of other minds, and of a public world in (Davidson 1991):

> If I am right, our propositional knowledge has its basis not in the impersonal but in the interpersonal. Thus when we look at the natural world we share with others we do not lose contact with ourselves, but rather acknowledge membership in a society of minds. If I did not know what others think I would have no thoughts of my own and so would not know what I think. If I did not know what I think, I would lack the ability to gauge the thought of others. Gauging the thoughts of others requires that I live in the same world with them, sharing many reactions to its major features, including its values. So there is no danger that in viewing the world objectively we will lose touch with ourselves. The three sorts of knowledge form a tripod: if any leg were lost, no part would stand.

D. D.

REFERENCE

Davidson, Donald. 1991. "Three Varieties of Knowledge." In *A.J. Ayer Memorial Essays: Royal Institute of Philosophy Supplement 30*, edited by A. P. Griffiths. Cambridge: Cambridge University Press.

11

Simon J. Evnine

ON THE WAY TO LANGUAGE

. . . for, as regards reason or sense, since it is the only thing that makes us men and distinguishes us from the beasts, I am inclined to believe that it exists whole and complete in each of us.

—Descartes, *Discourse on Method*

I

It seems indisputable that children learn words like "mother" and "hungry" (and so acquire the concepts *mother* and *hunger*) before words like "justice" and "digestion."[1] When it comes to the use of language and reason, children can do some, but not all, of the things adults can do. Progress comes with age.

These simple and meager data might suggest the following hypothesis about language and its acquisition. The ability to speak a language is a complex capacity, in the sense that it is made up of various component capacities. The structure and components of language—sentences, the logical relations between them, and the words of which the sentences are composed—are mirrored in the various sub-capacities that together constitute mastery of them. So, for example, the ability to speak a language would be partially constituted by the abilities to use its sentences, and those abilities, in turn, would involve the abilities to use various words. The process by which we come to acquire the complex ability matches the way in which the various sub-capacities make up the complex ability. We begin by learning simple words and logical relations and by gradually adding more difficult and complex elements we finally attain a grasp of the whole.

Such is, as Davidson caricatures it, the "building-block theory of language learning, echoing, chapter by dusty chapter, empiricist epistemology."[2] In fact,

as I described it, the theory is not especially empiricist. For even on an innatist view, the activation of some innate capacities could be held to depend partially on the activation of others. So the idea of being able to exercise a complex capacity through becoming able to exercise its various sub-capacities remains intact. Empiricism and innatism might disagree over whether the order in which the various abilities are accessed must match the evidential and analytical relations between the concepts and propositions those abilities reflect. But they can agree that we come to possess a complex capacity through the gradual accession (be it through learning or through activation of innate mechanisms) of various component capacities.

As attractive and uncontroversial as this highly general picture of language and its acquisition may seem, it appears to be inconsistent with Davidson's holism. It is a consequence of the view just sketched that at some point during its acquisition of language, a creature will possess some, but not all, of the capacities that constitute the ability to speak that language. According to Davidson's holism, however, the identity of sentences and words is at least partially constituted by their manifold relations to other sentences and words. If you change what surrounds a given item in the network, you change the identity of that item itself. Thus, Davidson writes:

> Because of the holistic character of the semantic aspect of language, it is wrong to suppose that a sentence (or word) belonging to a natural language would have the same meaning if its linguistic environment were radically impoverished. By the same token, there is no reason to suppose any element of pre-speech behavior, or of animal communication, has the same meaning as the utterance of a word or sentence in a developed language.[3]

On the view expressed here, we have no reason to think that the child's utterance of "mama" has the same meaning as does our (adult) utterance of the same word, or indeed, of any word. This in itself will seem implausible to many. But Davidson's troubles may be even more extreme. He goes on to say, shortly after the passage just quoted, that "until a language, or language-like structure, is found to have expressive powers very similar to the most highly developed languages, we are apparently at a loss to make clear sense of what its sentences, or utterances, mean, or are about."[4] Putting the matter in terms of our inability to make sense of, for instance, the 'language' of the young child, however, is deceptively concessive. For we know from other works that Davidson thinks that if we are at a loss to understand some behavior, that behavior cannot be linguistic behavior at all: "translatability into a familiar tongue [is] a criterion of languagehood."[5] Since translatability requires the shared acceptance of various norms, referred to collectively by Davidson as the Principle of Charity, and since the impoverished environment of the infant's utterance of "mama" does not allow the application of these norms,

the infant's noises are not translatable, and hence not part of a language at all.

So, Davidson's apparent problem is not just that the infant's 'words' do not mean the *same* as their homonyms in the adult language, but that they are actually meaningless. This conflicts both with (some of) our intuitions, and with the natural picture of the acquisition of language described at the beginning of this essay.

This problem is similar to the problem Davidson faces over the issue of animal thought and communication (as the long quotation above suggests), but there is one important difference. With animals, Davidson takes a hard line, denying them any thought or language. Many people object to this hard line as being counter-intuitive. But if Davidson takes the same hard line in the case of children, he not only faces the problem of counter-intuitiveness; he also fails to lay to rest the initial problem. For the untranslatable child grows into the translatable adult, and somewhere in the course of this change, we would either have to allow that the child had some, but not all, of the conceptual and linguistic resources of the adult, thus apparently giving up on holism after all; or we would have to say that the child makes the jump from not having a language to having one all in one go—a most implausible contention.[6]

Davidson himself, in recent work, can be caught saying things that seem to go against his earlier thorough-going holism and its consequences. For instance, he records that "my mother kept a record . . . of the language I spoke when I was two years old. It certainly was not the language spoken by others in the family. . . . But she claimed, rightly, that she understood me and I her."[7] Although Davidson's point here is that communication does not require sameness of language (a point on which he has long insisted), in making it he admits that as a two-year-old he spoke a language and was interpretable (and himself an interpreter), though I presume that the linguistic environment of his utterances was radically impoverished compared to that of his mother's. If this little vignette is to be taken as described, some revision of holism is required.[8]

In the sections that follow, I shall consider two approaches to resolving the problem of how Davidson should describe the acquisition of language, both of which can be gleaned from his writings. The first, discussed in section II, does not question holism as such. The second, dealt with in section III, derives from constraints placed on holism and so is associated with some potentially far-reaching modifications of Davidson's views.

II

In his early paper "Theories of Meaning and Learnable Languages," Davidson already recognized that the holism he was working towards would not allow

the simple building-block picture of language acquisition: "in so far as we take the 'organic' [i.e. holistic] character of language seriously, we cannot accurately describe the first steps towards its conquest as learning part of the language; rather it is a matter of partly learning."[9] We do not have to suppose that the conquest of language happens instantaneously in order to avoid the view, unacceptable to holism, that we learn it piece by piece. We may spend time learning, gradually better and better, the whole thing. "[T]here is no reason a child cannot master a complex system without it ever being accurate to say he has mastered part of it first."[10]

Thus stated, the suggestion is, as Davidson recognizes, insufficient, for it offers no positive way of characterizing the utterances of the pre-linguistic child.[11] Holism prevents us from saying that the child's utterance of "mama" has the same meaning as the adult's utterance of that word. It may even prevent us from saying that the child means anything, since meaning something requires that one is interpretable in accordance with the Principle of Charity. Yet we do not want to say that the child's utterance is totally meaningless. If it does not *mean* something, it does something else very like meaning. In other words, we want some form of proto-semantics for the child.

The image suggested by the idea of partly learning without learning a part is of a picture coming into sharper and sharper focus, becoming, as we might say, more and more determinate. So it is no surprise that Davidson has looked to the notion of indeterminacy of meaning to supply the kind of proto-semantics needed if this solution is to work. He writes:

> let us say small children and animals have beliefs and the rudiments of speech up to some system of transformations of ways of assigning propositions to their utterances or intentions. The fewer acceptable transformations, the more thought.[12]

Davidson's suggestion seems to be something like this. In interpreting children, we can allow ourselves greater freedom in redescribing their utterances as meaning something or other. Distinctions that can be made in the language of the interpreter become irrelevant for the purposes of assigning meanings to the utterances of young children. This is because the linguistic (and presumably behavioral) environment provided by children is not sufficiently complex to give those distinctions any empirical significance.

The following might provide a concrete example of what Davidson means. Quine, in discussing possible translations of the imaginary one-word sentence "Gavagai," suggests—along with "Rabbit"—"undetached rabbit parts," "Rabbiteth," and so on.[13] Gareth Evans has denied that some of Quine's alternatives are sustainable, given certain linguistic behavior that includes the use of compound sentences. For creatures, such as adult humans, with lin-guistic behavior of a certain degree of complexity, Quine has overstated the

range of acceptable transformations.[14] But where the creature being inter-preted has the linguistic behavior of an infant, and does not produce compound sentences in such a way as to rule out these alternatives, there may be genuine indeterminacy of a greater degree than that which affects the interpretation of adults. It may, for instance, be indeterminate whether the child is referring to its mother, as an object, or noting the current instantiation of a pleasurable property. That Davidson has *something* like this in mind is suggested by his following the statement of his suggestion with the claim that "it is only when the machinery of quantification is present that questions of ontology have a clear application."[15]

In effect, Davidson's suggestion amounts to a relativization of the concepts of meaning, belief, and so on, to a particular degree of indeterminacy. Just as there can be varying degrees of indeterminacy, so there can be varying degrees of meaning, belief, and all the other intentional concepts. There is 'meaning' relative to a promiscuous "system of transformations of ways of assigning propositions" (this is how the child means something), and 'meaning' relative to more restrictive systems of transformations. In all of these cases, "we will continue to talk as if [the objects of our interpretation] have propositional attitudes [and therefore mean and believe things *simplici-ter*]. We can do so with a good conscience if we keep track as best we can of the *level of significance* of such talk."[16]

It seems to me that this solution runs Davidson into difficulties in some related areas. In order to explain why, I must digress to give an account of Thomas Nagel's criticism of Davidson in *The View from Nowhere*. (This will also be important when we come to section III.) Nagel contrasts two views which he calls "realism" and "idealism." He defines "realism" as the view that "our grasp on the world is limited not only in respect of what we can know but also in respect of what we can conceive. In a very strong sense, the world extends beyond the reach of our minds." By contrast, "idealism" is the view that "what there is is what we can think about or conceive of."[17]

Nagel, rightly as it seems to me, describes Davidson as an idealist. This follows from the claim that translatability is a criterion of languagehood, together with the assumption that whatever there is can be conceived of by some rational creature or other.[18] Dropping this further assumption would yield a weaker form of idealism (which would still be in marked contrast to Nagel's realism), namely, that we can conceive of anything of which any other rational creature can conceive. Nothing hinges on the distinction between these two versions of idealism in what follows.

In arguing against idealism, Nagel exploits the possibility that translata-bility may sometimes be asymmetrical—that is, that one language may be translatable into another but not vice versa. This is a possibility that Davidson declined to discuss in "On the Very Idea of a Conceptual Scheme" (and has

not discussed anywhere else).[19] Let us say that, where there is a pair of languages subject to an asymmetrical translatability relation, the language into which translation is possible is inclusive and the other language is non-inclusive. In such a case, speakers of the inclusive language would be able to think and talk about everything that the speakers of the non-inclusive language could. But speakers of the non-inclusive language would not have cognitive access to everything about which speakers of the inclusive language could think and speak. The possibility of languages related in this way would show that the idealist claim that what there is and what we can think about are co-extensive could be at best accidentally true.

Furthermore, if it could be shown that we adult humans might be speakers of a language that was non-inclusive in relation to some other language, then the idealist claim would be false; there would actually be things that we could not think and talk about. That is, we would be shown to be cognitively cut off from part of our world.[20]

What remains for Nagel, in his defense of realism, is to establish that there might be some language with respect to which our adult language is non-inclusive. One way to do this, hinted at but not explicitly developed by Nagel, would be to invoke the case of children. The language of children is non-inclusive with respect to adult language. That is, adults can successfully translate children, yet there are many aspects of adult language that children cannot understand. Now children become adults by some process of development. Would it not be arbitrary to insist that this process could not go any further than to produce normal adult conceptual abilities? In theory, could not the process continue, leading to creatures who stood to typical adults as those adults stand to typical children? If so, our adult language would be non-inclusive with respect to the language of these super-adults.

Davidson might attempt to respond to this challenge by making a distinction between two different types of untranslatability. Suppose that, at present, my language does not include the term "quark" though it does include a number of other terms from physics. In conversation with a physicist, she explains to me what a quark is, and thus enlarges my language and conceptual repertoire. Assuming there are no other significant differences between our idiolects, before the conversation my language was non-inclusive with respect to the physicist's. Yet the fact that, with the means at our common disposal, she was able to introduce the term "quark" to me suggests that the initial untranslatability of her language into mine was of a benign sort. Such untranslatability does not pose a threat to Davidsonian idealism since it is (more or less) easily overcome by enlarging the resources of the non-inclusive language, or the conceptual abilities of the speaker of that language. This is to be distinguished from malign untranslatability, which cannot be remedied by any amount of education.

This distinction is necessary, for one thing, to allow for the idea of scientific progress. Aristotle could certainly not translate quantum theory straight into ancient Greek. But there is nothing mysterious here: he would simply have to learn quantum theory and introduce new terms into his language to express the concepts he had learnt. Of course, the greater the historical distance, the longer the learning process. Perhaps Aristotle would have to learn Newtonian physics before he got on to quantum theory and so on. And I suppose it is possible that progress could reach so far that a single human lifetime would not, as a matter of fact, be long enough to learn everything one would have to learn to update oneself. Nonetheless, in principle, all such difficulties can be overcome. Or, to put it another way, the existence of such difficulties depends on factors extraneous to our mental and linguistic abilities as such.

Now, since children do, usually, learn what adults know, and in so doing become fully able to understand adult language, it might be argued that the untranslatability they experience as children of some parts of adult language must be of the benign sort. In the same way, the beings whose intellectual capacities were formed by the further progress of whatever development makes children into adults (from a cognitive point of view) must only be benignly untranslatable by adults. If this were so, the example would not pose a serious threat to Davidson's idealism.

Yet I think that Nagel would hold, with reason, that the case of children is not one of benign untranslatability. True, children do learn adult language, and in that sense overcome the original impediment to translation, but it is surely only by undergoing a development in their cognitive capacities that they are able to do this. They require, that is, some kind of constitutional transformation.[21] Freeze their capacities at the point at which they are still unable to translate adult language, and no amount of instruction will be effective. We thus have a distinction, parallel to that between benign and malign untranslatability, of learning given a certain cognitive hardware or constitutional capacity (the sort that Aristotle would have to do to learn about quantum mechanics) and learning that requires the improvement or development of cognitive hardware (the sort that children have to do to learn about quantum mechanics).

That Nagel wants to present a problem for Davidson by pointing to cases in which untranslatability can only be overcome by the development of mental constitution is evident. He seeks to establish that we might be speakers of a non-inclusive language with respect to some other beings by describing a possible population of people who are blind from birth and have a permanent mental age of nine. These are people who "*constitutionally* lack the capacity to conceive of some of the things that others [i.e. sighted adults] know about."[22] Insofar as they have a mental age of nine they cannot understand

such things as the general theory of relativity or Gödel's theorem; insofar as they are blind from birth they are unable to 'understand'—Nagel's word —colors. Just as people in these groups cannot conceive of everything of which we can conceive, so, Nagel argues, it seems arbitrary to deny that there could be others to whom we stood as congenitally blind nine-year-olds stand to us.[23]

In response to this challenge, Davidson might try to keep his idealism unchanged and show that both the untranslatability of color concepts by the congenitally blind, and that of the concepts involved in Gödel's theorem by those with a mental age of nine, are actually cases of benign untranslatability. I think this is not a promising strategy. A better response would be to retrench the idealism, by retrenching the holism that leads to it, not giving up the central core, but allowing it to accommodate such cases as these. I shall discuss this in the next section, since I think Davidson has, in fact, suggested some of the necessary modifications to his original position in a way that relates directly to the original problem of the acquisition of language and reason.

I return now to the point at which this digression into Nagel started. We were, it will be remembered, faced with Davidson's suggestion that we interpret children by assigning sentences of our language to describe their proto-speech acts, but that interpretation is subject to a greater degree of indeterminacy than is the interpretation of adults. There is thus a spectrum of concepts of belief and meaning, each relative to some degree of indeterminacy. Now, the danger in this suggestion is that if we allow different degrees of indeterminacy, we must either argue that the interpretation of adult humans is subject to the least degree of indeterminacy, or allow that there might be others who stand to us as we do to children. The second possibility seems to be tantamount to a concession that Nagel's realism is after all correct. Just as we can distinguish between positing the presence of the mother as an object and noting the instantiation of some property, while the infant who cries "mama" cannot, so there may be similar distinctions of which we are totally oblivious which are nonetheless part and parcel of some more intelligent creatures' conceptual repertoire. Their language would be only partially translatable by us, just as ours is only partially translatable by children.

If Davidson is to resist this option, he must embrace the idea that we adult humans exhibit the limit of determinacy. While there may be creatures, such as children, who are subject to more indeterminacy than we are, there could be none subject to less. It seems difficult to see how this might be argued for. In fact, Davidson's whole attitude to the existence and nature of indeterminacy is rather perplexing, and this makes it even more difficult to evaluate the proposal under discussion and to see how to argue for the claim that we are at the limit of determinacy.

Davidson's favorite analogy for indeterminacy, one which occurs in the context of his suggestion that interpretations of children are subject to more systems of transformations of ways of assigning propositions, is the 'indeterminacy' involved in being able to measure temperature in Fahrenheit or centigrade. Yet if this is all indeterminacy means, it is trivial, for even a believer in total determinacy could allow the possibility of, say, describing in either French or English what a subject means, and it is this, surely, that is analogous to the temperature example.[24] In addition, Quine characterizes indeterminacy as allowing different incompatible translations of a speaker,[25] but nothing we could correctly say in 'centigrade' about the temperature of an object could be *incompatible* with anything we could correctly say about it in 'Fahrenheit'.

For these reasons, I am inclined to think that Davidson is much less a believer in indeterminacy than he represents himself as being.[26] And if this is so, it seems to call into question his suggestion that children are subject to more of it than we are. He might suggest that, rather than a quantitative difference, there is a qualitative gap between children and adults. We are not subject to indeterminacy, they are. But in that case, we are back with the old problem of how the transition is effected. Alternatively, perhaps Davidson could show that although adults are subject to serious indeterminacy (not of the centigrade-Fahrenheit sort), there is some reason why no creature could be more determinate than we are. We need more clarification from Davidson on indeterminacy before we can decide.

III

The attempt mooted in the previous section to describe creatures on the way to language did not challenge the basic premise of holism. Some recent developments in Davidson's philosophy, however, do seem to me to provide some retrenchment of his original holism, and hence to provide some answer to the question of how to describe the acquisition of language and reason. In order to approach this issue, though, we must take a few steps back.

In the classic, early version of his holism (as expressed, for example, in "Radical Interpretation," "Psychology as Philosophy," "Belief and the Basis of Meaning," "Thought and Talk," etc.), Davidson emphasized how the identity of concepts and beliefs was determined by their relations to other concepts and beliefs. Thus, he questioned:

> how clear are we that the ancients . . . believed that the earth was flat? *This* earth? Well, this earth of ours is part of the solar system, a system partly identified by the fact that it is a gaggle of large, cool, solid bodies circling around a very large, hot

star. If someone believes *none* of this about the earth, is it certain that it is the earth that he is thinking about?[27]

Although Davidson immediately adds that a definite answer is not called for, the thrust of his papers from around that time was that such holistic connections served to identify propositional content. The passage just quoted was criticized in a way that prefigured the development of Davidson's position.[28] For Davidson began to put more and more weight, in the middle 1980s, on causation as a factor in the determination of content. For instance, if the sentence "the earth is flat," held true by the ancients, were causally connected, in the right way, to the earth, we might be certain that the ancients were referring to this earth, even if they believed none, or very few, of the other beliefs Davidson suggests would be necessary to make their sentence be about this earth.

These two factors, causal origin and logical relations to other beliefs, when transmuted into constraints on interpretation, constitute the two main subdivisions of the Principle of Charity. Davidson has recently referred to them as the Principles of Coherence and Correspondence: "The Principle of Coherence prompts the interpreter to discover a degree of logical consistency in the thought of the speaker; the Principle of Correspondence prompts the interpreter to take the speaker to be responding to the same features of the world that he (the interpreter) would be responding to under similar circumstances."[29]

It is clear why Davidson should have turned to causation. The reason does not lie so much in the anti-skeptical arguments it made possible, as in the thought that, however complicated are the logical relations between beliefs, they could never generate, by themselves, intentional content. At some point, we must look for a relation between a belief and the world, if the belief is to be about that world. Davidson wanted to show that "coherence yields correspondence."[30] But mere coherence can never yield correspondence. Relations among beliefs can never help one of those beliefs to reach outside the circle of beliefs and be about something else. If there is to be any intentional content, we must appeal, at some point, to factors other than holistic relations among beliefs.

There is, however, a problem in combining the Principles of Coherence and Correspondence, for the Principle of Coherence is holistic (it governs the relations among all beliefs) while the Principle of Correspondence is not (it governs the relations between individual beliefs and the world).[31] Take those ancients again. As we have just seen, the causal origins of their beliefs might lead us to attribute certain contents to them, even at the cost of making them come out mistaken or inconsistent. Conversely, the drive for consistency might

lead us to ignore the causal origins of certain beliefs in determining what they were about. It may be that where these two principles come into conflict, interpretation must take the form of balancing their various requirements. Alternatively, we might try to show that the principles do not potentially conflict because they have distinct spheres of application. This is a line that Davidson seems to have pursued in some of his recent work.[32]

Davidson often writes now in terms of a two-strata picture of language. The picture, moreover, is intimately tied to the situation of learning a first language. On this picture, the infant first learns a number of words by having its babbling reinforced and encouraged in various ways by a teacher. What guides the teacher in these confirmations is his or her perception of similarities in the environment plus the perception of similarities in the infant's responses to the environment. Davidson likens the teacher and infant to two points of a triangle, the third point being the intersection of the causal chains reaching from the environment to their perceptual systems. He uses this image to argue against the possibility of a private language, on the grounds that any objective reference requires first, a communal determination, a point where people's causal links with the environment intersect, and secondly, communication between the people, in order for them to know that they are corners of such a triangle. Without the triangulation, nothing would serve to establish that one point as opposed to another on the causal chain that led from the world to the speech-act was the object of reference. Without the knowledge that one was part of such a triangle, one could not have the concept of an independent object of reference.

The cogency of this anti-private-language argument is not our concern.[33] What is important for our present purposes is that at this first stage of language-learning, the only interpretative principle at work is the Principle of Correspondence. Single bits of verbal behavior are associated with what the teacher takes as their salient causes. Holistically-applicable rationality constraints—the Principle of Coherence—play no part. Thus, the first stratum of language and the process of its acquisition are molecular, not holistic. Davidson holds that it is with this first stratum "that the ties between language and the world are established and that central constraints on meaning are fixed."[34] In Davidson's writing, the phrase "constraints on meaning" is most likely to conjure up the notion of rationality constraints, the need in interpreting others to find them consistent and coherent. But it is clear that in this case, the constraints are those based on our mutual perceptions of our causal contact with the world. Rationality constraints are not at issue here.

Only when language has been securely anchored to the world in this way can we go on to extend it, introducing discourse about the past, the future, the unobservable, the abstract, and so on. Here is where interpretation must be

guided by considerations of overall rationality. Here is the proper sphere of operations of the Principle of Coherence.

Any arguments Davidson has for the necessary inter-translatability of languages which are founded on the necessity of principles of rationality will need to be re-evaluated in the light of this new theory. For the first stage of language does not require shared norms, but rather a shared world. If a creature came from an environment sufficiently different from ours, or if its perceptual access to the world were too different from ours, we now would have no reason to suppose that any linguistic activity must be translatable or interpretable by us. For this early part of language, translatability should not be a criterion of languagehood.

It is in this light that Davidson should respond to Nagel's claim that congenitally blind people could not translate our color talk, or, as Nagel puts it, could not 'understand' colors. Whether Nagel is right to insist that the blind could not form concepts of colors is much debated. But let us suppose he is right about this and see what the consequences are for Davidson's position. Not sharing with us the perception of the world through visual experiences, a society of such people might be totally at a loss to interpret that part of our language with which we refer to colors. This would not be a benign sort of untranslatability for them. Nothing we could teach them would give them the same concepts of colors that we have. Lacking the right sense organs, no amount of learning would help. Yet there is absolutely no reason why they should not recognize that the sighted are nonetheless using language when they talk about colors. Similarly, there is no reason why we should not be prepared to admit that other creatures whose means of perceiving the world are just too different from ours, might use language in ways that are untranslatable by us to refer to perceptual features of their environment.

The important point about color concepts is that they can be isolated from the rest of the fabric of concepts without unraveling the whole cloth. The broad network of holistically interrelated concepts does not embrace them; they are precisely such that they can be lopped off from the system of concepts while leaving the remainder unaffected.[35] Likewise, the other concepts learned at the first stage of language acquisition seem to have attribution conditions which do not link their possession constitutively to the possession of other concepts. The first stratum of language, the stratum at which language is anchored to the world, is molecular, not holistic.[36]

I think that this response would give Nagel his due in the color-concept case, while allowing Davidson to preserve the heart of his holism and the associated idealism. Our recognition that there may be creatures which have ways of experiencing the world of which we could never conceive does not have the same isolating bleakness that goes with the thought that much of reality itself could be inaccessible to us. As a matter of fact, though, I don't

think this is Davidson's response. In one place he writes: "Too much difference in what can be perceived will put limits on the possibility of communication *and thought*."[37] It is clear that too great a difference in perceptual abilities should render communication difficult or impossible, but why should Davidson think that it also puts limits on what can be thought? What argument does he have, parallel to the argument that certain rational norms are built in to the very notion of thought, to show that too great a difference from us with respect to perceptual capacities is inconsistent with thought? It seems to me that Davidson has gone further here than he is entitled to go.

Given enough of a shared world for this basic stratum to be commensurable, shared both in terms of its objective features and our ways of apprehending them, the rest of language, if Davidson's holism is correct, must be translatable. Any failures of translatability at this stage must be of the benign sort, easily cured by a crash course in alien theory.

As for the problem with which we started, the difficulty in describing the acquisition of language and reason, we could now say that there is no bar to describing the beginnings as the serial acquisition (or activation, if we want to be innatist) of the various skills associated with such basic concepts as mama, red, person, etc. Here the child proceeds bit by bit, piling one capacity on another. When it comes to the second stage, however, holism will require that the child does indeed master everything in one go. Not, of course, in the sense that it gets to know every concept or word at one time. Rather, it reaches a point suddenly at which everything becomes learnable. From here on, asymmetrical failures of translatability can be easily rectified with a bit (or in some cases, a lot) of explanation.

The challenge to idealism, based on the fact that adults are malignly untranslatable by children, but that children develop into adults, is thus diffused. For the way in which children develop into adults is not through an indefinitely extendible process that could, in theory, continue on to result in some super-adults who would be malignly untranslatable to us. It rather involves the crossing of a threshold which, once overstepped, reveals on its further side the whole world waiting to be grasped and understood.

The only trouble with this picture of language acquisition is that it may sound a little too much like the old dualism of observation versus theory for Davidson to be comfortable with. It may be that it does not fall foul of the various objections to dualism. After all, there is no reason to think that it relies on "a concept of the mind with its private states and objects."[38] And it is this conception of mind that is supposed to make the various dualisms untenable. Furthermore, Davidson does not unequivocally call for their rejection. He says that these dualisms "are being questioned in new ways or are being radically reworked. There is a good chance they will be abandoned, *at least in their present form*."[39] Is Davidson offering us a reworked form of the old dualism

of theory and observation? Whatever the answer to this question, I believe that the picture I have sketched is strongly suggested both by what Davidson writes and by the exigencies of his philosophy.[40]

SIMON J. EVNINE

DEPARTMENT OF PHILOSOPHY
UNIVERSITY OF CALIFORNIA AT LOS ANGELES
MAY 1995

NOTES

1. Davidson holds that the ability to speak a language and the possession of reason necessarily imply each other, and I accept this here without argument. So the following pairs should be read as more or less inter-substitutable: (interpreted) sentence/proposition; (interpreted) word/concept; ability to speak a language/ rationality.

2. "Theories of Meaning and Learnable Languages" in *Inquiries into Truth and Interpretation* (Oxford: Clarendon Press, 1984), p. 4.

3. "Introduction" in S. Harnad, H. Steklis and J. Lancaster, eds., *Origins and Evolution of Language and Speech*, vol. 280 of *Annals of the New York Academy of Sciences* (New York: New York Academy of Sciences, 1976), p. 18.

4. Ibid., p. 19.

5. "On the Very Idea of a Conceptual Scheme" in *Inquiries,* p. 186.

6. This problem has been briefly urged by Patrick Suppes ("Davidson's Views on Psychology as a Science" in B. Vermazen and M. Hintikka, eds., *Essays on Davidson: Actions and Events* (Oxford: Clarendon Press, 1985), p. 189; and, in a different context, by Michael Dummett in "What is a Theory of Meaning?" in S. Guttenplan, ed., *Mind and Language* (Oxford: Clarendon Press, 1975).

7. "The Second Person" in P. French, T. E. Uehling, H. Wettstein, eds., *Midwest Studies in Philosophy* 17 (Notre Dame: University of Notre Dame Press, 1992): 266.

8. Davidson seems to realize that his holism opens up various new problems, which are the counterparts of old epistemological problems that his view does away with, and that some retrenchment of holism will be required to deal with the new problems. For instance, he notes that "error is hard to identify and explain if the holism that goes with a nonfoundational approach is not somehow checked" ("The Myth of the Subjective," in M. Krausz, ed., *Relativism: Interpretation and Confrontation* (Notre Dame: University of Notre Dame Press, 1989), pp. 166–67.

9. *Inquiries,* p. 7.

10. "Reply to Suppes" in *Essays on Davidson: Actions and Events,* p. 252.

11. "The trouble with this answer is that it leaves us not knowing how to describe the early stages, just as the general thesis that animals don't have beliefs leaves us without our usual useful way of explaining and describing their behaviour" (ibid.).

12. Ibid.

13. W. V. Quine, *Word and Object* (Cambridge, Mass.: MIT Press, 1960), ch. 2.

14. Gareth Evans, "Identity and Predication," *Journal of Philosophy* 72 (1975): 343–63.

15. Davidson, "Reply to Suppes," p. 252.

16. Ibid., (italics mine).

17. *The View from Nowhere* (New York: Oxford University Press, 1986), p. 90.

18. It might be wondered what reason Davidson has for holding this further assumption; *that* he holds it is clear. In his argument against skepticism he introduces the notion of an omniscient creature. See, for instance, "A Coherence Theory of Truth and Knowledge" in E. LePore, ed., *Truth and Interpretation: Perspectives on the Philosophy of Donald Davidson* (Oxford: Basil Blackwell, 1986). As long as such a creature is in some sense possible, this premise of Davidson's idealism seems acceptable. For some discussion of this device see my *Donald Davidson* (Stanford: Stanford University Press, 1991), pp. 141–42, 164–68.

19. "In what follows I consider . . . complete, and partial, failures of translatability . . . (I shall neglect possible asymmetries.)" ("On the Very Idea of a Conceptual Scheme," p. 185.)

20. This thought—the denial of which forms, I think, a large part of the unconscious fuel for Davidson's work—is actually eagerly embraced and argued for by a number of philosophers. See, in addition to the work of Nagel, Noam Chomsky, *Reflections on Language* (New York: Pantheon Books, 1975); Jerry Fodor, *The Modularity of Mind* (Cambridge, Mass.: MIT Press, 1983); Colin McGinn, *The Problem of Consciousness* (Oxford: Basil Blackwell, 1991).

21. I put the point so as to be neutral on questions of ontology. The constitution that must be transformed might be that of the neural hardware in the brain, or it might be that of some immaterial substance.

22. *The View from Nowhere*, p. 95; (italics mine).

23. In this context, one should also consult his paper "What is it like to be a Bat?" in *Mortal Questions* (Cambridge: Cambridge University Press, 1979).

24. This seems to be consistent with Davidson's own interpretation of the analogy: "It should not bother us that the Frenchman and I use different utterances to characterize the same state of Paul's mind: this is like measuring weight in carats or ounces" ("What is Present to the Mind?" in Enrique Villanueva, ed., *Consciousness* [Atascadero, CA: Ridgeview Publishing Company, 1991], p. 210). Yet following on from this passage, Davidson uses the same analogy to apply to differences in the way a *single* speaker might characterize someone's beliefs. Does Davidson think that the difference between the Frenchman and me when he uses French and I use English to describe someone's beliefs is of the same sort as the difference between interpreting someone as believing there is a rabbit there, and believing that there are undetached rabbit parts there? Or is his use of the analogy imprecise?

25. *Word and Object*, p. 27.

26. Ian Hacking argues that indeterminacy is actually incompatible with Davidson's semantics. See his *Why Does Language Matter to Philosophy?* (Cambridge: Cambridge University Press, 1975), pp. 150–56.

27. "Thought and Talk" in *Inquiries*, p. 168.

28. By Colin McGinn in "Charity, Interpretation, and Belief," *Journal of Philosophy* 74 (1977): 521–35.

29. "Three Varieties of Knowledge" in A. Phillips Griffiths, ed., *A. J. Ayer: Memorial Essays. Royal Institute of Philosophy Supplement* 30 (Cambridge: Cambridge University Press, 1991), p. 158.

30. "A Coherence Theory of Truth and Knowledge," p. 307.

31. Essentially the same tension surfaced in the conflict between the coherence and correspondence theories of truth in such papers as "A Coherence Theory of Truth and Knowledge" (see my *Donald Davidson*, pp. 134–43). Although Davidson has now renounced any claim to either theory of truth (see "The Structure and Content of Truth" in *Journal of Philosophy* 87 (1990): 279–328, the reappearance of the two words "coherence" and "correspondence" in the descriptions of the principles, after their banishment from descriptions of theories of truth, is evidence that Davidson's 'dissolution' of the problem of truth may not be completely satisfactory.

32. For example, "Three Varieties of Knowledge," "The Second Person" and "Epistemology Externalized" in *Dialectica* 45 (1991).

33. For a good discussion of this argument see William Child, *Causality, Interpretation and the Mind* (Oxford: Clarendon Press, 1994), pp. 19–23.

34. "Epistemology Externalized," p. 198. See also "The Myth of the Subjective" where he says: "Of course very many words and sentences are not learned [by conditioning in the presence of the things they are about], but it is those that are that anchor language to the world" (p. 164).

35. Cf. Davidson, "Introduction," p. 18.

36. It is possible, however, that there are local eddies of holism in these molecular waters. Perhaps one cannot learn a single color concept at a time, but must latch onto a whole color spectrum. But even if this is so, the holism that binds together the group of color concepts is merely local, and does not extend beyond these concepts, constitutively tying them to other concepts.

37. "Turing's Test," in K. A. Mohyeldin Said, W. H. Newton-Smith, R. Viale, K. V. Wilkes, eds., *Modeling the Mind* (Oxford: Clarendon Press, 1990), p. 8 (italics mine). Actually, Davidson follows this with the claim that "the ability to perceive things does not depend on the details of the sense organs (the blind can perceive the same things the sighted perceive)." This rather suggests that Davidson would like to undercut Nagel's case by denying, what I have allowed for the sake of argument, that the congenitally blind could not understand colors.

38. "The Myth of the Subjective," p. 163. Of course, my suggestion of how Davidson might deal with Nagel's color-concept case might rely on such a conception of mind (and I suspect that that is one of the reasons Davidson would not go along with it). But that should not affect the general idea that the example was meant to illustrate.

39. Ibid., (italics mine).

40. I would like to thank Tyler Burge and Michael Jacovides for reading several drafts of this paper and commenting on them extensively.

REPLY TO SIMON J. EVNINE

The untranslatable child grows into the translatable adult, says Simon Evnine, and he thinks this is a problem for me. For either the child must, at some intermediate point, have some, but not all, of "the conceptual and linguistic resources of the adult", in which case my claims about the holism of the mental are seriously wrong, or the child "makes the jump at one go", which is absurd. He is right that I think there is a serious problem in knowing how to describe the states of mind of a child who is partly into language and the kind of thought that goes with it, and that there is a problem how to understand the utterances of such a child. Evnine knows I have claimed we can get around this particular difficulty by distinguishing between saying the child learns the language part by part (which would offend my holistic leanings) and saying the child, at various stages, has partly learned the whole. Evnine's own suggestions for ways of describing language acquisition seem in accord with this idea. He thinks, along with many who study the matter, that the ability to speak a language is made up of various "component capacities" and "sub-capacities", and these capacities are sequentially activated. I have no reason to deny it. In itself, this tells us nothing about how to translate the sounds the child utters, or how to describe its thought processes. Since Evnine says very little more concerning how to think about the problem that puzzles me, let me turn to what he considers my strongly counterintuitive position.

We all attribute all sorts of sharply individuated propositional attitudes to animals and infants, and fond parents go to lengths to make sage sense of their children's cooing. If we all do it, how can we be misusing the concepts we are applying? I suppose we recognize some limits: we don't really imagine that a parrot means anything by the sounds it makes, even though it utters those sounds in situations in which it would be appropriate for a language speaker to mean them. Still, it is hard to explain a great many things even quite simple animals do without assigning thoughts and intentions to them. Something much like thinking is going on, and we often have no alternative explanation available of what they do.

Considerations such as these prompted me to put my point as follows. Different kinds of measurement are distinguished in part by the ways in which numbers can be assigned to keep track of the empirical facts. The Mohs hardness scale, or the Beaufort scale of wind velocities, are simple orderings: any set of numbers that reflects the ordering is as good as any other. But this rather negative way of putting the point can be put positively: any ascending set of numbers captures the empirical facts. The facts captured by the Centigrade and Fahrenheit scales are equally well represented by any linear transformation of those scales: what matters is only the relations among intervals. Put positively, the numbers are unique up to a linear transformation. The scales for length or weight are unique up to multiplication by any positive number, and so on. These scales differ in how many of the properties of numbers they make use of: the more of these properties they depend on, the more information they convey. In the same way, we can think of our sentences as capturing two sorts of relations: those between sentences and the world, and those between one sentence and another. In translation, we attempt to reflect those relations as they obtain in one language by mapping them onto the sentences of another language with the same (as nearly as possible) relations to one another and to the world. Given the richness of natural languages, it would be surprising if there were only one such mapping which mirrored all the significant relations of one language in another. The inscrutability of reference is the clearest example of such "indeterminacy". But what is indeterminate? In the cases of Centigrade and Fahrenheit, nothing depends on whether we use one set of numbers or another. Since nothing is lost when we switch from Fahrenheit to Centigrade, it would be more enlightened to speak of what is *invariant* as we switch from one set of numbers to another, namely the facts of temperature. In the case of language, recognizing that at each stage in the process of mastering the language (as well as at the final stage) there are multiple translation manuals available does not mean either that communication has no content, nor that those at an advanced stage can make no sense of those at a more elementary level.

My suggestion, with respect to the early stages of language acquisition, was that we should ask: in how many different ways can we represent the information conveyed by the child's utterances in our own language. The more ways we can represent what the child says, the less information the child's utterances convey. When the ways become as constrained as they are with accomplished speakers, the child is an accomplished speaker.

Evnine does not tell us what he finds wrong with this proposal, but one senses that he is bothered by the idea that we cannot, almost from the start, match the words of the neophyte word for word with our own words. He apparently wants to say the beginner has fully mastered part of the language. To my mind this suggests a devotion to the concept of fixed meanings, the

very concept Quine intended to undermine by invoking the indeterminacy of translation. Quine's point was that when we reflect on the empirical constraints on meaning (translation, interpretation), we discover nothing that could be called "the" meaning.

The same worry lies behind the fear that holism makes understanding others impossibly difficult. This is thought by Fodor, and apparently Evnine, to entail that the meaning of an expression is so tightly tied to the meaning of all the rest of one's words that two speakers can mean the same thing by a word only if they control exactly the same linguistic and conceptual resources. So let me do what I can to quiet this anxiety. My form of holism is mainly a logical constraint. Sentences have logical relations with other sentences, and interpretation must, as far as possible, preserve these relations. Relations of evidential support, that is, the degree to which we treat the truth of one sentence as supporting that of another, are important but flexible; such considerations matter, in some cases a lot and in others little, to interpretation and translation. Most of us think something can't be red all over and at the same time green, so if someone seems to be saying with conviction that something is red and green all over, we have to doubt that we have understood him. But just possibly, that *is* what he believes; only further evidence will help decide. The thing to bear in mind is that interpretation, translation, the understanding of others is a matter of finding a best fit. As interpreters, we have our sentences, and we assign them (in most cases automatically—see reply to Burge) to the sentences and attitudes of others, thereby giving those sentences and attitudes the content we deem best captures what they mean and think. We won't understand them unless we find a core of agreement, but agreement isn't the aim. The aim is understanding.

Among people who, as we say, speak the same language, time and custom insure that homophonic "translation" for the most part works well enough. But there is no reason to suppose the understanding of another's utterances is ever perfect, nor does it need to be. The myth of meanings summons up the dream of a perfect understanding which nothing in the actual process of conversation justifies.

People differ greatly in the scope of their vocabularies and in their conceptual resources. This does not prevent them from communicating in the area of overlap, nor does it stop them from increasing the overlap. I doubt, though, that I will ever understand quantum mechanics, and probably I couldn't if I tried. I will never command the ideas needed to understand the proof of Fermat's last theorem, and most of today's molecular biology is beyond me. It seems to me almost certain that there are things mortals will never understand. It is a mystery to me why Evnine, and apparently Nagel, suppose I think otherwise. The accusation apparently rests on a pretty shaky reading of my fable of an omniscient interpreter. It's not a fable of which I am

very fond (see reply to Genova), but in any case it was never intended as Evnine reads it. As most readers have divined, the omniscient interpreter would spoil my story if he were actually omniscient; he can't know what is in other people's minds. But there is also no point in supposing he knows anything more than the truth or falsity of the beliefs of some person he is interpreting. So Evnine cannot claim that it is clear I think anyone knows everything, and I certainly do not.

But it is the other "premise" of the argument designed to show I am some sort of idealist that reveals a more serious misunderstanding of my views. Evnine thinks I reject the possibility that languages may be asymmetrical, solely on the grounds that in a parenthesis I say I am not going to discuss the topic at that point. He adds that I have never discussed asymmetries. But in fact anyone who knows Tarski's work will have discussed the paradoxes which arise if a truth predicate which is defined for a language can be translated into that language, and I have. I have also repeatedly mentioned the fact that since many people lack concepts (and the words that express them) that others command, of course there are many cases of asymmetry where one language can, more or less completely, be translated into a second but not vice versa. Glancing through (Davidson 1984), I see that I discuss a case of asymmetry on page 63 in an essay published four years before the one Evnine concentrates on. On the page following the one with the parenthetical remark, I actually spend two paragraphs discussing asymmetries.

So what explains these serious misreadings? I think the explanation is that Evnine has misunderstood my claim that it is the test of whether something is a language that it is translatable into a familiar idiom, along with my statement that we cannot make clear sense of utterances unless they are part of a structure found to have "expressive powers very similar to the most highly developed languages". Read out of the context of the argument against conceptual schemes *radically* different from ours, this sounds like the all-or-nothing attitude Evnine thinks is mine. Here is the reading I had in mind: every natural language we know has expressive powers very similar to those of the most highly developed languages. These powers are: an underlying logical structure equivalent to the first-order predicate calculus with identity, an ontology of medium-sized objects with causal potentialities and a location in public space and time, ways of referring to the speaker and others, to places, to the past, to the present and future. Children get this far early. Once one has this core, one has a language, and it can be translated into any other. This explains why, given my project, I was not much concerned with "asymmetries". The elements in anyone's language or repertoire of concepts that lie outside the shared core I think of as suburbs of the core. Their addition may in some cases put a strain on how the words in the central core are understood

by those who lack the suburb, but generally not enough to hinder communication. It was not my idea that every new word or concept produced a new conceptual scheme. The scheme is the core we all share.

From the point of view of gradualism, the idea that there is a continuous process in the acquisition of language, with no real plateaus, putting any premium on the core scheme would seem out of place. But from a conceptual point of view, we can pick out particularly significant features, and although these cannot spring into existence suddenly, it is worth saying why they are significant. Some of them seem to me so important that until they are present we may not want to say there is language. But I realize this is a matter where intuitions differ. One feature on which there may be agreement, however, is the stage at which there is awareness of the possibility of error. I do not mean explicit control of the concept of truth, but the realization that what is believed may not be correct. I think it is possible for an animal to have considerable learned mastery of an environment, to employ implements, solve problems, and generally perform many tasks that require memory, learning, and calculation, without ever entertaining a propositional content. I would say such an animal does not have beliefs, it does not reason, it does not have concepts, and cannot have a language. Someone who disagrees with this is, I think, using some words with a different meaning than I give them. Other plateaus can be defined by considering the nature of the semantics that must be employed to account for what is going on at that level. (I say "must" because we can always use more powerful semantics than are necessary, that is, read more into what is going on than the evidence supports.) What may seem like a fairly powerful language, for example, can sometimes demand only a very simple semantics. Consider a language with a considerable, though finite, list of names, and a finite list of predicates with various numbers of places, plus signs for the truth functional connectives. Such a language has a potential infinity of sentences, names can replace other names within predicates, and so forth. Yet the semantics does not have to consider the structure of the basic sentences at all (since there are only a finite number of sentences that lack truth functional connectives); it can simply give the truth conditions of each of these basic sentences one by one. This means that such a language, if that is what it is, does not demand that its speakers have an ontology; they do not reveal, in their speech, that they have the concept of an object. It is only when they have what amount to pronouns and the concepts of generality and identity that they reveal thinking geared to language. This is why I say something counts as a language only when it has the expressive powers of the most highly developed languages.

Evnine suggests that in my recent writing I have, more or less inadvertently, shown a partial way out of the problems created by my holism: he spots

this accidental progress in my recent insistence on the role of causality in contributing to the contents of perceptual sentences. I have, of course, following Quine, always emphasized the role of stimulations in determining the contents of observation sentences. I differed from Quine, though, and always have, in locating the relevant stimulus out where the events and objects that constitute the subject matter of perceptual beliefs and the utterances that express them are located. My recent emphasis on the triangle that connects the radical interpreter, her interpretee, and the world is not a discovery of how this works, but a somewhat recent conviction not only that this triangle is essential to understanding others, but that it is also essential to the awareness of objectivity, the fact that error is possible, and that there is a distinction between what is believed and what is the case. If this is right, it is a powerful argument for the view that language and thought are interdependent, and that thought originates in a social setting.

But Evnine is surely right that the relation between the contents of perceptual beliefs and the features of the world that typically cause them helps explain why we often have no trouble understanding others with whom we disagree, and why we do not have to go along with Feyerabend's and Kuhn's view that every serious advance in science implies a radical change of subject matter. To accept this point is not, however, to suppose we can dispense with the constraints on meaning due to connections among sentences, even in the case of perceptual utterances and beliefs. You and I may not be in accord about whether a man we are viewing is wearing a wig, but only because we both know a lot about men and wigs, and both have mastered the scheme that makes sense of such objects.

D. D.

REFERENCE

Davidson, Donald. 1984. *Inquiries into Truth and Interpretation*. Oxford: Oxford University Press.

12

Deborah Hansen Soles

PREFERS TRUE: ARCHIMEDEAN POINT OR ACHILLES' HEEL?[1]

Donald Davidson has argued that *preferring one sentence true to another* is the primitive undefined attitude upon which a unified theory of radical interpretation is to be built (1980, 1982b, 1985, 1990b). Out of it, we can get attributions of desire, belief, and meaning.[2] As such, the attitude of prefers true functions as the Archimedean point upon which the edifice of radical interpretation balances. It is also the point of contact between the formal theories of truth and decision theory and our lives as communicators and doers, for it is through the evidence gleaned at this point of contact that substantive theories of radical interpretation for individuals can be constructed. The evidence gleaned at this point of contact is not just the linguistic evidence of which (uninterpreted) sentences an agent prefers true; it also includes the presence of events, objects, and situations in which these preferences are expressed. But out of this very sparse basis of the attitude of prefers true, together with observed events, objects, and situations and a policy of rational accommodation, radical interpretation can take place. Davidson repeatedly tells us that we must solve for all three attitudes more or less at the same time; the theoretical strategy is to hold some parts temporarily still while solving for others.

In this paper, I will raise some concerns about how, and whether, the radical interpreter can get access to the kind of data needed. There are some lingering questions, if not profound difficulties, about this enterprise, and they may threaten to topple the edifice. I will begin by recapitulating some of the salient features of Davidson's unified theory of radical interpretation, and then move to a discussion of the problematic nature of the evidence available to the radical interpreter.

Davidson has frequently reminded his readers that the theory of radical interpretation is not offered as a description of what interpreters actually do

when they engage in interpretation, either domestic or foreign. Rather, the theory is offered as a characterization of the explicit propositional knowledge which, if possessed by an idealized radical interpreter, would be sufficient to enable that interpreter to understand the behavior, actions, and speech of other people; in short, the theory should help us, as philosophers, to see "how the structural features of the propositional attitudes make the understanding of human action possible" (1982b, 14). While not intended as empirical description, the theory does carry with it certain empirical assumptions and ramifications. The ultimate usefulness of a theory of this sort is that it helps us in understanding the constellation of concepts we appeal to, and their intrinsic interrelations, in making sense of others.

The project of radical interpretation is constrained by several factors. First of all, it must work with the fact that what someone says is a function of what that person believes and what her words mean; what someone means or intends her words to mean is a function of her beliefs and desires; and what someone chooses to do is again a function of her beliefs and desires. None of these attitudes are observable, yet interpretation requires that we attribute beliefs, desires, and meanings to the speaker. Second, there is the need to take into account the intrinsically interpersonal and public nature of language use. This constraint cannot be ignored; disregarding the publicity of language produces a parcel of distasteful philosophical consequences, including the mystification of other minds, the forging of unproductive concepts of knowledge, and the rendering of meaning inaccessible, unlearnable, and incommunicable. Given these dangers, the philosophically unexceptional requirement not to assume any of the concepts to be illuminated takes on further significance, and great caution must be used in constructing a theory of radical interpretation and in characterizing the data available to the radical interpreter. In particular, we must guard against endowing the interpreter with any suspect information about the agent's meanings or beliefs or desires, or any knowledge of what Davidson calls the agent's *individuative* propositional attitudes — hence the interpreter is a *radical* interpreter.

Given that we, as ordinary interpreters and ordinary communicators, manage to interpret and communicate quite nicely most of the time, we must be basing our interpretive and communicative moves and strategies on observable behavior, objects, and events. The theory of radical interpretation as well needs to be built up from a similar empirical base. The radical interpreter will not be able to construct a substantive (not merely formal) theory of truth for a speaker or an agent without having access to at least some of the speaker's or agent's subjective probabilities or strengths of desires, since correct verbal interpretation requires knowing the extent to which the speaker counts the truth of one sentence as support for the truth of another. Knowing degrees of evidential support between sentences is needed in order

to determine the predicates the speaker uses and the range of their application, especially when the predicates and sentences containing them are at some remove from observation. But knowing the agent's subjective probabilities and strengths of desire is knowing the agent's beliefs and desires—that is, knowing something about the agent's propositional attitudes, which is part of what the radical interpreter is trying to discover. Thus, Davidson argues that the empirical data needed for a *unified* theory of radical interpretation are uninterpreted linguistic productions to which a speaker has some observationally discernible simple attitude. Although the attitude is a sort of intensional state, it is not an individuative intensional state with a "propositional object". Davidson summarizes:

> Such a theory must be based on some simple attitude that an interpreter can recognize in an agent before the interpreter has detailed knowledge of any of the agent's propositional attitudes. The following attitude will serve: the attitude an agent has toward two of his sentences when he prefers the truth of one to the truth of the other. The sentences must be endowed with meaning by the speaker, of course, but interpreting the sentences is part of the interpreter's task. What the interpreter has to go on, then, is information about what episodes and situations in the world cause an agent to prefer that one rather than another sentence be true. Clearly an interpreter can know this without knowing what the sentences mean, what states of affairs the agent values, or what he believes. But the preferring true of sentences by an agent is equally clearly a function of what the agent takes the sentences to mean, the value he sets on various possible or actual states of the world, and the probability he attaches to those states contingent on the truth of the relevant sentences. So it is not absurd to think that all three attitudes of the agent can be abstracted from the pattern of an agent's preferences among sentences. (1990b, 322)

The *formal* machinery for abstracting these attitudes is a combination of a modified Tarski-style theory of truth and Bayesian decision theory. The systematic interpretation of a speaker's utterances, the assigning of meaning to them, can be represented by means of the Tarski-style theory of truth;[3] decision theory provides a way of generating an assignment of subjective probabilities and relative strengths of desire. The strategies for obtaining these abstractions derive from a variation on Quine's (e.g. 1960) radical translation approach and a modification of Jeffrey's (1983) version of decision theory. Quine has shown how to separate out meaning and belief from utterances; Jeffrey shows how to get subjective probability (degrees of belief) and cardinal utilities (strengths of desire) from knowledge only about the agent's preferences between sentences, or better, between utterances. The key idea in both of these strategies is that observable behavior is explained in terms of attributions of the relevant attitudes to the agent; these attributions are intrinsically a matter of rationalizing the behavior, linguistic or otherwise, of

the agent. The attribution of meaning and belief to the agent explains the linguistic behavior of the agent, by showing that the agent says what she does because of the beliefs she has and the meanings she attaches to her words, on the assumption that the agent is (largely) rational and consistent and correct in her beliefs. Decision theory is of course rational decision theory: an agent's choices are explained by means of attributing subjective probabilities and relative desirabilities to the agent. These beliefs and desires are attributed on the assumption that the agent is a rational agent, whose choices reflect rational patterns.

Quine's radical translational strategy provides an entering wedge into the uninterpreted linguistic stream. The goal of the radical translator is to provide a translation manual. Based on the observable attitude of prompted assent, together with patterns of stimulation of the speaker, the radical translator is able to produce a series of hypotheses about the meanings of the speaker's words and the beliefs which the speaker has. By selectively querying the speaker, the radical translator is able to test translational hypotheses, using the speaker's assent and dissent to queries under various conditions as evidence for (or against) these hypotheses. Crucial to the Quinean endeavor is the notion of the observation sentence; it is the observation sentence upon which the radical translator bases his first hypotheses about meaning ("stimulus meaning"), it is the highly observational sentence which can be translated without invoking the principle of charity, it is the "Janus-faced" observation sentence which ties experience to theory (Quine, 1993). Viewed from one perspective, observation sentences function as "holophrastic signals", keyed as a whole to the stimulations of the speaker; viewed from another perspective, the content of observation sentences has roles to play in systems of belief and "tows the tug of theory". With his situation of radical translation, Quine shows just how a radical interpreter is able to *construct*, on the basis of observation and judicious use of the principle of charity, a translation manual; in effect, this can be seen as providing a "theory of both belief and meaning for the speaker" (Davidson, 1991b, 158). Putting the emphasis differently, Quine shows how a radical translator can *get started*, by gathering data of a certain sort; and so how it is possible for an ordinary language-learner or an ordinary language-user to "translate" another.

While endorsing Quine's general strategy of solving for meaning and belief, and accepting the indeterminacy of translation, Davidson rejects details of Quine's account, including the goal of producing a translation manual, and in particular Quine's use of the attitude of prompted assent caused by patterns of stimulation. Nor does he share Quine's devotion to observation sentences. As he puts it, he finds Quine's views on the nature of knowledge to be "essentially first person and Cartesian" (1991a, 193; see also 1974 and 1990a), as well as leaving room for skepticism. Davidson opts instead for

what he considers a more resolutely third-person approach: an externalized epistemology which maintains that in the simplest cases, at least, the cause of a belief is the content of a belief, that "in the simplest cases words and thoughts refer to what causes them", that "the situations which normally cause a belief determine the conditions in which it is true" (1991a, 195). It makes no sense to even talk of belief and related concepts unless there are at least two creatures who are sharing reactions to *common* stimuli, with one creature observing the other. And it is only when an observer consciously correlates the responses of another creature with objects and events in the observer's world that there is any basis for saying the creature is responding to those objects or events (rather than any other source of the creature's stimuli)" (1991b, 159). Without shared stimuli to provide content, speaking and thinking would have no (particular) content. This means that communication *assumes* an objective standard of truth, at least for the simplest sentences. Davidson's externalism aims to hold belief apart from truth to the requisite degree that keeps truth from collapsing into belief. This does not make particular errors on occasion impossible—a creature can have misleading sensations which cause (false) beliefs—but it does guarantee that our general picture of the world is correct. Radical interpretation requires both the assumption of rationality, in the form of reading our logic onto the subject, and the assumption that for many cases, the beliefs held by the agent are true of the world.

Jeffrey's version of decision theory provides a way of determining subjective probabilities for sentences and strengths of desire that they be true on the basis of preferences between sentences.[4] In order to apply the theory to discovered preference rankings, one must have identified truth-functional connectives, since the precise method for determining subjective probabilities and relative desirabilities depends on the truth-functional structure of sentences. So, as Davidson points out, the problem is one of determining truth-functional connectives on the basis of patterns of preference between (uninterpreted) sentences. Davidson has discovered one such pattern, which could be discerned on the basis of patterns of preference between sentences. It is the pattern for the Sheffer stroke, which captures the truth-functional properties of 'not both'.[5] The advantage of the Sheffer stroke is that it does not require a prior identification of the negation operator; in principle, a sufficiently rich pattern of preferences between sentences should reveal the operator. Once the operator is identified, then we can in principle identify a negation operator. And so on. Once we have truth-functional operators, we can isolate tautologies, and so can fill out and refine the preference rankings. Then, Jeffrey's desirability axiom can be applied to the preference rankings, and subjective probabilities and relative strengths of desire for uninterpreted sentences (including truth-functionally compounded uninterpreted sentences) can be calculated. Jeffrey's theory does not yield completely determinate

assignments, but this indeterminacy fits comfortably with the indeterminacy encountered in linguistic interpretation. Since sentences are used in constructing the preference rankings, it is fairly straightforward to assign degrees of belief and relative strengths of desire to sentences. The subjective probability of a sentence, or degree of belief in a sentence, is a function of the desirability of that sentence and its negation.

From this theoretical perspective of combined truth theory and decision theory, the primitive concept is that of a speaker preferring one sentence true to another. Out of this, one can tease the concept of holding true, which is the starting point for interpreting the uninterpreted sentences and the application of the truth-theoretic machinery.[6] Sentences held true are sentences with a subjective probability of 1 or something very close to 1. For at least some of these sentences—the very basic ones—truth conditions can be assigned in terms of the cause of the utterance of such sentences by a speaker, and the interpretation of a speaker is under way. Once the speaker's sentences have been interpreted, once, that is, meanings have been assigned to them by means of a Tarski-style truth theory, and "given degrees of belief and relative strengths of desire for the truth of interpreted sentences, we can give a propositional content to the beliefs and desires of an agent" (1990b, 328).

How can a radical interpreter find out that an agent prefers that one uninterpreted sentence rather than another be true? How can a radical interpreter find out what causes the agent to prefer one *uninterpreted* sentence rather than another be true? Given this picture of the formal and structural properties and relationships among our propositional attitudes, how exactly does the radical interpreter gather the requisite data to get the enterprise going?

I think that there is an interesting difficulty in answering these questions which illuminates some issues about the program of radical interpretation.

Davidson has suggested on more than one occasion that a radical interpreter can acquire data about an agent's preferences toward sentences, including uninterpreted sentences (1982b, 1985, 1990b, 1991b), but his suggestions about what we might call the "experimental design" for obtaining these data are highly schematic and ultimately not as helpful as one would wish. This is in contrast to his discussions of radical interpretation which focus on the relation between meaning and belief: in addition to what we can transfer from Quine's radical translation scenario,[7] Davidson has often limned what might be involved, since spelling this out has been central to the development of his externalism and to his rationality assumptions.[8] In the absence of something equally substantive for the decision-theoretic context, it is very hard to see how a radical interpreter, equipped with the right conceptual resources of truth theory and decision theory, could ever break into the seamless body of uninterpreted linguistic behavior to gather sufficient

information about the agent's preferences. And if the radical interpreter cannot do this, it is hard to see how the attitude of preferring one sentence true to another can perform its task of being a balance point.

Davidson has occasionally addressed the question of how to acquire the data. In (1985), for example, he suggests that discerning the agent's preferences between uninterpreted sentences is quite straightforward: the experimental situation is identical to that of standard experimental tests of theories of decision making under uncertainty, where subjects make a number of pairwise choices between options, and the responses to interpreted sentences are recorded; the only difference in his application is that what is recorded are responses to uninterpreted sentences (1985, 88). The suggestion is repeated in (1990b, 325, fn 67) with the dropped assumption characterized as the assumption that "subjects understand these descriptions [of alternatives] as the experimenters do." But as a way of discerning preferences between uninterpreted sentences in the context of radical interpretation, this simply won't do. At best, this is a case of assuming or pretending, for certain purposes, that the responses are responses to uninterpreted sentences. It is as if the radical interpreter were present and observing an experimental test being conducted by others on yet still others. In that sort of a case, the character of the options, as well as the content of the responses, would be inaccessible to the radical interpreter, and so it is very hard to see how there is anything in this situation which would provide the radical interpreter with "information about what episodes and situations in the world cause an agent to prefer that one rather than another sentence be true" (1990b, 322). But, if this is what Davidson has in mind—that the radical interpreter is in the position of a visitor to a series of experimental tests—I find it extraordinarily difficult to fit such a picture together with what Davidson has to say about the overall project of radical interpretation, his externalism, and even his defense of the use of attitudes towards sentences. Perhaps I am being too literal-minded in my reading of the suggestion, and in trying to adapt it to the circumstance of radical interpretation. I don't think so. Other suggestions, to which I will allude later, are almost as unhelpful. I also think that there is an underlying reason, which I shall discuss shortly, for Davidson's lack of interest in spelling this out.

From a purely formal standpoint, there is no problem. Davidson has shown how the parts of the theory fit together, and they do so in an extraordinarily neat and clever way. The problem has to do with the empirical applicability of the unified theory of radical interpretation.

In what follows I will consider some possible ways that a radical interpreter might acquire the relevant data. I will begin by reiterating the need for endowing the radical interpreter with some way of determining the agent's preferences between sentences, by pointing out that merely knowing which

sentences the agent holds true is insufficient to determine the agent's preferences between sentences. I will then consider how the radical interpreter might proceed, on three different assumptions: in the first scenario, the radical interpreter has access to some sentences the agent holds true, but does not engage in any linguistic interpretation while detecting the agent's attitudes of preferring one sentence true to some other; in the second, the radical interpreter discovers the agent's preferences between sentences without any access to any sentences held true or any interpretation of the agent's utterances; and in the third, the radical interpreter interprets (some) of the sentences held true by the agent as part of the enterprise of gathering data and forming hypotheses about the agent's preference patterns. Although these scenarios will deal only with the simplest sorts of case, success or failure should be illuminating.

Clearly, the radical interpreter knows what is going on in the vicinity of the agent, and knows, at least sometimes, when the agent is aware of what is going on. But the radical interpreter cannot get preference patterns out of just knowing that the agent holds certain sentences true, or even, in the most basic cases, knowing as well what the agent means and believes in uttering those sentences. If all a radical interpreter has to go on are sentences which are plausibly counted as ones the speaker holds true, there is no way to determine anything about the agent's preferences. All such sentences are equally preferred, and so equally preferred true. In such a case, there is no purchase for the application of decision theory. More is needed.

The radical interpreter has her own knowledge of on-going events in the vicinity, observations of the agent, and observations of the agent's observations. The radical interpreter also has available certain assumptions about human activities. Among these assumptions, which of course are the assumptions about the rationality of others which go jointly under the label of the principle of charity, are certain basic assumptions about the behavior and interests of human beings. Not only can radical interpretation of others proceed only on the assumption that they and the interpreter largely agree (on Davidson's reading of "largely agree") on what is true, interpretation of the behavior of others can proceed only on the assumption that they and the radical interpreter share certain basic patterns of preference. By this I mean that the interpreter, and the interpretees, will or would act in similar kinds of ways under certain similar kinds of circumstances. While doubtless there is great variety across agents with respect to preferences, it seems that there must also be some shared actions or reactions in certain kinds of circumstances and so some shared very basic preference patterns; otherwise the radical interpretive effort cannot get going. Davidson tells us that the

> key to the solution for simultaneously identifying the meanings, beliefs, and values
> of an agent is a policy of rational accommodation (this is what I have called in the

past the principle of charity) . . . we might do better to think of it [the policy of rational accommodation] as a way of expressing the fact that creatures with thoughts, values, and speech must be rational creatures, are necessarily inhabitants of the same objective world as ourselves, and necessarily share their leading values with us. (1982b, 18)

It looks as though a solution to detecting preferences between sentences must be found in these shared reactions and values. The assumption of shared values is a necessary condition for correct interpretation, just as is an assumption of a shared objective world. Davidson has been careful to deny that we should assume that we share with agents particular objects of desire or ultimate values. There is no reason to think that everyone values chocolate, or education, or reading Davidson, in the way in which I do. But there do seem to be some (relatively) universal human values which are intimately linked to what people do. As Davidson puts it, "there is a presumption (often overridden by other considerations) that similar causes beget similar evaluations in interpreter and interpreted" (1986, 208). I have in mind things like avoiding pain if possible, taking steps to protect the very weak and helpless from looming harm, ensuring that dependent young are fed, and so on. Furthermore, we may assume, as seems reasonable, that the radical interpreter can recognize some expressions of concern, encouragement, and warning.[9]

On the first assumption, that the radical interpreter has access to some sentences that the agent holds true but does not engage in any interpretive efforts in trying to discover patterns of preference, the picture might look like this. The radical interpreter finds some sentences to which the agent will unhesitatingly accede; such sentences are ones which the radical interpreter is confident that the agent holds true. On the principle that "old news is no news", any sentence representing a choice which the agent makes, or an agent's response to an uninterpreted sentence representing that option, will be preferred true to the "old news". This strategy assumes that the agent does produce utterances which do represent the action, but it assumes nothing whatsoever about the particular content of the utterances, and so assumes no individuative propositional attitudes.

However, this strategy will not get the radical interpreter very far. At best, it will only get some very crude scalings, the result being merely a set of sentences preferred to some other sentence. Preferences *amongst* the sentences preferred to old news are undiscovered. Something more direct is needed, with some pairs of (incompatible) choices, say between sitting still and running to retrieve a child in danger, on the one hand, and sitting still and rooting through the garbage on the other. This is not surprising, for the strategy sketched so far takes no notice of any assumed very basic preference patterns, values, or shared reactions; appealing to these may provide an entering wedge. While the interpreter does not know what the agent's sentences mean (nor the content of

the agent's beliefs), observed actions performed under certain conditions, but not performed under other conditions, may provide the interpreter with the rudiments of more complex preference scalings.

Here is a more concrete kind of case. Parents speak to toddlers, warning them, exhorting them, cajoling them, encouraging them, disciplining them. Even when a radical interpreter knows nothing about the interpretation of the sentences uttered, in this sort of situation, she can begin her investigation. The toddler gets very close to the fire (or the hot stove), the parent utters a sentence A and then moves between the stove and the child.

The toddler runs across the room and the parent, utters B and then goes after and picks up the child; the toddler carries a sharply pointed object toward a piece of furniture and the parent utters C and takes the object; the toddler runs across the room carrying a sharply pointed object, the parent utters $relCB$ and moves toward the child and takes the object. The parent then utters D, while holding an open hand out toward the child. Shortly thereafter, the parent utters E and then holds a banana out to the child. In all of these cases, the child's behavior is apparent to both the parent and to the interpreter; and a degree of risk of danger to the child associated with the parent's action or inaction is apparent to both the parent and to the interpreter. It is clear to the radical interpreter that, under certain circumstances, the parent prefers true A to B, prefers true C to B, prefers true $relCB$ to either B or to C. At this point, perhaps the interpreter cannot determine whether the parent prefers true A to $relCB$ or vice versa, or whether the parent prefers true D to E, or E to B, but the beginnings of a ranking, under certain circumstances, are emerging. These incipient rankings are rankings of weak preferences for truth, not of strengths of parental desires or degrees of belief.

What the radical interpreter is doing in these cases is "reading" her own choices on to the agent; that is, she is assuming, as she must, that events and objects in the environment are causing the agent to act (and utter) in these ways. Under normal circumstances, a child's safety is of major value, and so a child running across a room is preferred to a child carrying a sharp object running across a room; a child running across a room is preferred to a child being burned on a hot stove.

The strategy sketched is obviously analogous to the strategy that Davidson uses to begin to capture the content of belief and the content of utterances (1974, 1991a, 1991b). As I have developed it so far, the data do not seem sufficient to determine the *content* of the utterances, but the events, objects, dangers, and likely and perceived consequences of various courses of action are at least in the simplest cases available to the radical interpreter. There is no assumption that the interpreter has any kind of special access to the beliefs or desires of the agent; the interpreter is assuming only that the agent is behaving in *some* kind of rational way, given the circumstances. It is also

apparent that, as far as detecting preferences for sentences being true, uninterpreted sentences held true have little role to play. The fact that an agent prefers true a sentence to a known truth, or to some (non-tautologous) sentence held true, is insufficient to provide the needed rankings, as we saw. In essence, this scenario is one in which all the work is being done by efforts to detect the agent's preferences without regard to the sentences the agent holds true, and so the first scenario collapses into the second. Putting the point differently, it is clear that allowing the radical interpreter access to uninterpreted sentences *held* true adds little or nothing to her investigative repertoire. So we find ourselves in the second scenario, operating under the assumption that the radical interpreter is constructing preference rankings on the strength of one attitude of preference towards uninterpreted sentences.

As mentioned before, Davidson suggests that the radical interpreter can detect certain attitudes speakers have toward sentences, including the attitude of preferring one sentence true *to another*. Yet this is not an attitude that we are, in non-philosophical circumstances, remotely familiar with; in this respect it is very unlike the attitude of holding true, which is far more closely related to our ordinary notion of belief, and which is typically expressed by means of assertions. The relevant attitude we are far more familiar with is that of choosing or wanting, or even choosing some sentence true. In the scenario sketched above, the attitude toward sentences was taken to be one of choice, not one of a sentence being preferred true to another. The attitude of preferring one sentence true to another is, in the situation of radical interpretation, the result of an inference.[10] And it is an inference which needs to be checked.

In order to test whether the hypothesized preferences are the agent's preferences, it appears that the radical interpreter needs to be able to expose the agent to contrived choices between sentence-pairs or repeatedly observe the agent hesitating between incompatible choices (sentence-pairs). But the radical interpreter must do this without access to any of the agent's idioms for logical operators, and in particular, without access to any expression(s) having the logical properties of 'or' or of 'not'. Without at least *this* vital bit of information, it is very difficult to see how the radical interpreter can detect *incompatible* pairs of sentences without already knowing something about the content or interpretation of these sentences—at least enough to be fairly sure that they are incompatible. What we are looking for are cases where in making one choice, the agent is refraining from making another choice.

Perhaps there is a suggestion in Davidson's observation that "every utterance that can be treated as a sincere request or demand may be taken to express the utterer's preference that a certain sentence be true rather than its negation" (1990b, 325, fn 67). This is true, but when one drops the assumption that the interpreter already understands the utterer, it is very unclear which sentences the relation of prefers true is relating. The agent may prefer

true *S* to some other sentence, which in radical interpretese might come out as the hybrid *not S*. But the hybrid *not S* is not a sentence for the speaker, and it is not an uninterpreted sentence (nor yet an interpreted sentence) for the interpreter. And it is certainly not something upon which the interpretation of the agent's negation operator can be based. What the radical interpreter needs are pairs of sentences, *both* of which the agent understands. And at least, sometimes, these pairs need to represent more than complementarity.

So perhaps the third scenario may be the right one. The radical interpreter tests the hypothesized preference patterns of an agent with the help of sentences held true by that agent, and some hypotheses about their content. Seemingly, the radical interpreter has to do some interpreting after all, in order to determine preference patterns. Just how much interpretation is required is a question of some interest. Does the radical interpreter interpret some set of sentences in order to test her hypotheses about preferences? Does she (also) isolate the agent's idioms for some of the truth-functional operators?

It is clear that if the radical interpreter knows, at least in the simplest cases, that the agent holds some sentences true, she can detect the causes, and so the content, and so the truth conditions for those sentences; the interpreter can learn that an asserted 'Squit' means that the stove is hot. Similarly, it seems that if the radical interpreter knows that the agent chooses or desires some sentences true, she can detect what is causing that choice, and so can access the content for those sentences, either via previously established hypotheses about what the agent's meaning is, or from scratch. If an agent says, in an urgent tone of voice, something that sounds like 'Squit' when the toddler is heading for the stove, and again utters 'Squit' to an adult near the stove, a reasonable hypothesis is that 'Squit' means something like the stove will burn you, be careful. The hypothesis gains likelihood by cross-checking with what the interpreter has already gleaned about the agent's meanings based on sentences the agent holds true. But even in the absence of such hypotheses based on sentences held true, the radical interpreter may be in a position to ascribe some meaning to the agent's words. If the agent utters 'Plurg' to a running toddler, regardless of the location or what the child is carrying, but the agent does not utter 'Plurg' to a child who is still, it is reasonable for the interpreter to take 'Plurg' as meaning that the child should slow down. And given that rational people ordinarily prefer the avoidance of great harm to the avoidance of lesser harm or inconvenience, and that being burned is in general more harmful than falling down, the interpreter may hypothesize that the agent prefers 'Plurg' to 'Squit'.[11] And the interpreter can check this hypothesis, for there will surely be cases in which an agent can express only one choice and the available risks will be sufficiently apparent that a warning against a particular danger can be taken as confirmation of a preference between two sentences, e.g. when a toddler is running dead ahead at a hot stove.

In the abstract, this way of looking at things has its attractions. The radical interpreter moves back and forth between (low-level) interpretation of sentences recognized as held true (they are asserted by speakers) and the ranking of preferences. The sentences are interpreted by means of the radical interpreter's awareness of the environment and the knowledge that both the interpreter and the speaker share an awareness of salient features surrounding them. The interpretations are tentative, as are the preference rankings, but they are enough to get the project going, and the holism in radical interpretation is apparent. This seems to be a nice case of showing how the radical interpreter can get going without presupposing a division of labor which Davidson is at pains to deny can be performed: "There is no way simply to add one to the other since in order to get started each requires an element drawn from the other" (1990b, 322).

However, Davidson does not appear to think that radical interpretation occurs prior to the accumulation of the speaker's probabilities, even for a highly observational sentence which is taken to mean that it is raining (1982b, 16–17). This suggests that not even highly observational sentences can be radically interpreted without appeal to the "interanimation of sentences". Unless Davidson is willing to allow some "partial" or preliminary interpretation of sentences at this point, it seems that the only option is that all sentences must remain uninterpreted. But if utterances (or sentences) must remain uninterpreted, it seems that the radical interpreter needs to be able to at least isolate operators with the properties of truth-functional connectives. If the radical interpreter had *this* access, then she could determine at least sometimes when the agent was indeed making choices *between* options, instead of just choosing or desiring some sentence true.

Yet this option is also foreclosed. Why does Davidson think that discerning truth-functional operators from patterns of preference is the only strategy for capturing one (or more) truth-functional logical operator(s)? Why, for example, should the radical interpreter not (or not be able to) isolate the truth-functional connectives in terms of patterns of straightforward acceding to and denial of sentences? At the most observational level, when the radical interpreter has sufficient access to both utterance and events and objects in the vicinity of the speaker to establish some working hypotheses about the content of the utterance based on likely environmental causes, it seems that the radical interpreter could rely on such patterns with respect to observationally-keyed utterances in order to discern the truth-functional connectives.

Recall that Quine's picture is something like the following: The speaker assents to a queried *ogAB* when he assents to a queried *A* and a queried *B*; the speaker dissents from a queried *ogAB* when he dissents from a queried *A* and from a queried *B*, or when he dissents from a queried *A* and assents to a queried *B*, or when he assents to a queried *A* and dissents from a queried *B*.

Voila! og has the properties of the truth-functional 'and'. While Davidson distrusts the details of Quine's picture, a Davidsonian description of the situation would be similar; e.g. the agent is found to hold true $ogAB$ when and only when the agent holds true A and holds true B. The radical interpreter can easily discover when the agent holds true these sentences, and, assuming that these are some of the most basic and banal cases, we can discover what they mean, what their truth conditions are, via Davidson's externalist strategy. This is a picture Davidson might seemingly endorse, for he says that in interpreting, we have no choice but to read not only truth-functional connectives but also the inferential relations reflected in the apparatus of first-order logic onto the agent. This is part of the fundamentally rational pattern that must be assumed if any interpretation at all is to take place. "If we suppose, as the principle of charity says we unavoidably must, that the pattern of sentences to which a speaker assents reflects the semantics of the logical constants, it is possible to detect and interpret those constants" (1990b, 319), and that "we have no choice, then, but to project our own logic onto the language and beliefs of another" (1990b, 320).

I am considering only the possibility of identifying the truth-functional constants at this point, not the rest of first-order logic. It is very clear that *complete* radical interpretation of a speaker requires access to the speaker's degrees of belief, which in turn requires the availability of the entire decision-theoretic structure. But is this sufficient reason to require that truth-functional connectives be generated from preference patterns in the context of radical interpretation?

Perhaps Davidson finds that there is something inherently inadequate about the alternative strategy for isolating the truth-functional connectives. And indeed this seems to be the case. The underlying argument against the holds-true strategy for isolating the truth-functional connectives might go like this. Our evidence for attributing belief and meaning is what we know about what causes a speaker to hold sentences true. But speakers do not hold all sentences true to the same degree, not even all highly observational sentences. Sometimes, we will find very clear-cut cases at the observation level, where, to borrow Quine's terminology, a speaker will simply assent without hesitation to a queried utterance (observation sentence). Such cases are clear-cut cases of a speaker holding a sentence true. But under slightly different circumstances, even though much of the relevant causal data is relevantly similar, the speaker might react differently to a similar query. Recall Quine's efforts to handle the cases of peripheral glimpses of a rabbit hopping by, or of seeing rabbit ears sticking out of a bush. In these cases, a query of 'Gavagai' cannot satisfactorily be answered with simple assent or dissent; some kind of qualified response is more appropriate and more likely. To put the point more generally: Simple assent and dissent are not sufficient to handle

variations in the degree to which speakers hold sentences true. To the extent that speakers hold sentences true to varying degrees, the patterns of sentences in which those sentences occur become de facto ineligible as a source for finding the truth-functional connectives. The variations in extent to which speakers hold sentences true have to be taken into account when trying to isolate the truth-functional connectives, since the truth-functional connectives can only be isolated by means of their occurrences in patterns and combinations of sentences. Consequently, we will have to find some other way of isolating the truth-functional connectives.[12] Davidson's solution is in terms of a pattern of relationships between sentences preferred true.

What does all this mean for the radical interpreter's project? There is still empirical constraint on the theory, in the sense that a (unified) theory of radical interpretation must be something which would enable an interpreter to radically interpret another. More to the point, the radical interpreter must be able to discover enough about the preferences of the agent in order to apply Jeffrey's decision theory; otherwise, the whole point of appealing to a radical interpreter, and a theory of radical interpretation containing decision theory, as a way of showing that "the constraints laid down by the theory are adequate to yield something close to the concepts of belief, desire and meaning we normally use in understanding, describing and explaining human behavior" (1982b, 14) is undercut, in exactly the same way that a theory of meaning which makes meaning unlearnable undercuts itself.

Davidson has maintained that the logical order of progression is first, the isolation and so interpretation of the truth-functional connectives via the Sheffer stroke manoeuver, then the assignment of subjective probabilities (and strengths of desire), and *then* the interpretation of the rest of the speaker's language, remarking that "the sequence in which these steps are described is dictated by logical, not practical considerations" (1982b, 14). He disavows any concretely descriptive aims and has shown himself to be uninterested in giving a fuller account of the "radical experimental design" when it comes to discovering agent's preferences between uninterpreted sentences. As I have suggested, this seems to be because he thinks there is nothing particularly elaborate to characterize: do it like experimental decision theorists do it, but don't assume the interpreter and the agent understand each other. The interpreter just records preferences between uninterpreted sentences. But the deletion of this assumption of mutual understanding, while defensible in the context of articulating a theoretical perspective, introduces a kind of opacity into the theory of radical interpretation at a crucial point. To respond that the interest is not in experiment or in *that kind* of empirical description which is true of actual people, but rather is in an "idealized description of patterns of behavior that make it possible for people to fathom one another's thoughts and meanings" (1985, 89) misses the worry which prompts the question. A

lack of interest in actual experimental design should not vindicate automatically a lack of interest in *radical* experimental design, for this is where the description, or redescription, of the evidence is itself probed.

The worry stems from the fact that the whole project of unified radical interpretation is designed to show that, on the basis of empirical evidence generally available to interpreters, an idealized radical interpreter could come to know propositional attitudes and meanings attributable to an agent or a speaker. Much of Davidson's work has been to develop the formal or structural relationships between these concepts which show how interpretation is possible. But an idealized description which leaves it unclear how a radical interpreter can apply the formal machinery makes moot the whole point of radical interpretation. If we do not see how in principle the theory is to be applied, what is it telling us? Davidson's concept of prefers true, construed as a nonindividuative attitude a speaker has toward sentences, sentences which are uninterpreted from the radical interpreter's perspective, is introduced to provide a characterization of the empirical basis of the unified theory. But this attitude does *not* have an *obvious* linkage to what we ordinarily think of as empirical evidence generally available to interpreters. And so it requires more spelling out. This is not a request that Davidson establish that people actually do this.[13] It is a request for something like what Quine has given us for radical translation. If this request is misguided, then Davidson would seem to be far further apart from Quine, even in matters of strategy, than is generally recognized.

The character and actual role of the concept of preferring true one sentence to another in the context of the methodology of radical interpretation is not clear. The thought-experiment of radical interpretation assumes that prefers true is observationally available, relying for the plausibility of this assumption on an analogy with the use of this concept in decision-theoretic contexts. I have argued that in the context of radical interpretation the assumption of the observational availability of preferring one sentence true rather than another is highly questionable. I simply do not think that we have the kind of basic and essential grasp of the concept of preferring one sentence true to another that we have of the concept of truth.[14] We may have an almost as essential and basic grasp on the concept of action or choice[15] but not, I think, of the preference relation. In discussing the theory of verbal interpretation, Davidson remarks that a "general requirement on a theory of interpretation is that it can be supported or verified by evidence plausibly available to an interpreter" (1973, 128). My concern is that it is insufficiently clear that the evidence needed is plausibly available to the radical interpreter, given other constraints on the theory and the ways in which the theory of radical interpretation has been developed. And until we can see just how the radical interpreter is to proceed, it seems that the unified theory of radical interpretation is teetering

precariously, not balancing, on the attitude of preferring true one sentence rather than another.

DEBORAH HANSEN SOLES

DEPARTMENT OF PHILOSOPHY
WICHITA STATE UNIVERSITY
APRIL 1997

NOTES

1. I am indebted to Robert Feleppa for many helpful discussions of this work, and for his kindness in reading earlier versions. I also wish to thank Jeffrey Hershfield and Katherine Bradfield for their comments.

2. The triad of meaning, belief, and desire is intended by Davidson to serve as a kind of shorthand for all the propositional attitudes; these three are the most basic.

3. Tarski's theory is extensively modified to perform the tasks Davidson sets it; hence the idiom 'Tarski-style' theory of truth.

4. This is not quite correct. Jeffrey (1983) develops his theory for propositions; Davidson effects a revision so that the theory operates on sentences.

5. This strategy allows Davidson to maintain that the observable evidence is strong enough to engender connectives that obey bivalence, and so strengthens his hand against Dummett-type concerns.

6. Davidson sometimes speaks as if the empirical base of the unified theory is widened when sentences held true are added (e.g. 1985), and at other times as if sentences held true fall out of the empirical base of preferring one sentence true to another (e.g. 1990b). Since there is a way of generating sentences held true from sentences preferred true, I will take it that the latter is his more considered opinion. The bigger question, of whether holds true is adequate for generating sentence meaning, identified with truth conditions, I will leave unaddressed.

7. Davidson has frequently acknowledged his debt to Quine, and to Quine's radical translation argument (e.g. 1974a and in many subsequent works). I also think that familiarity with Quine's work on radical translation has added to the plausibility of Davidson's arguments.

8. This also includes the capacity to recognize assertions. Davidson does not have any *theory* of illocutionary force, and is skeptical about the possibility of such a theory (1982a, 1990b).

9. The idea here is to provide the radical interpreter with the capacity to recognize at least some choice-indicating devices, on the analogy of the radical interpreter's ability to recognize assertions; I choose this list merely because these items have some familiar connection with perceived risks.

10. There is clearly an inference from a preference between utterances to a preference between sentences. But if I am right, there is another inference from chooses true to prefers true. Davidson apparently changed his views about which

attitudes can be *directly* detected: (1982b) suggests that it is desires true, (1985, 1990b, 1991a) seem to claim this feature for the attitude of prefers true. Since the concept of desiring true has a role to play in *explaining* actions, I will use the less confusing (and less Davidsonian) idiom of choosing true to represent the attitude an agent has to a sentence which represents an action or choice.

11. This might be revised in light of later information of course.

12. The point is not a skeptical one. Rather, it is that the Quinean strategy for isolating the truth-functional connectives depends, in a central way, on the availability of only two responses, assent and dissent. I am pointing to the impossibility of trying to isolate the truth-functional operators on the basis of subjective probabilistic data. The result of Field's (1977) efforts in this regard do not yield standard truth-functional operators.

13. It appears that Davidson has taken it this way on at least one occasion (1993).

14. Prefers true has the role in decision theory that holds true has for truth theory; it is the empirically accessible evidence base. It is not part of the internal workings of the theory, in the way, say, that the concept of satisfaction is in the theory of truth. We don't *need* a story about satisfaction in order to use the theory of truth as Davidson wants to use it (1977, 1990b, 1996), but that is because in an important way we already have a grasp of the concept of truth. What I am arguing is that we do not have the same kind of grasp of something analogous to prefers true, and so we do need a story.

15. If it turned out that chooses true were treated as the empirical base instead of prefers true, then of course my concerns about testing hypotheses come back with a vengeance.

REFERENCES

Davidson, D. (1973) "Radical Interpretation", in Davidson (1984).
———. (1974a) "Belief and the Basis of Meaning", in Davidson (1984).
———. (1974b) "On the Very Idea of a Conceptual Scheme", in Davidson (1984).
———. (1976) "Hempel on Explaining Action", in Davidson (1980a).
———. (1977) "Reality without Reference", in Davidson (1984).
———. (1980a) *Essays on Actions and Events*. Oxford: Clarendon Press.
———. (1980b) "Toward a Unified Theory of Meaning and Action". *Graze Philosophische Studien* 11.
———. (1982a) "Communication and Convention", in Davidson (1984).
———. (1982b) "Expressing Evaluations", The Lindley Lecture, (monograph), University of Kansas.
———. (1984) *Inquiries into Truth and Interpretation*. Oxford: Clarendon Press.
———. (1985) "A New Basis for Decision Theory". *Theory and Decision* 18.
———. (1986) "Judging Interpersonal Interests". In *Foundations of Social Choice Theory*, edited by J. Elster and A. Hylland. Cambridge: Cambridge University Press.

———. (1990a) "Meaning, Truth and Evidence". In *Perspectives on Quine*, edited by R. Barrett and R. Gibson. Cambridge, Mass. and Oxford: Basil Blackwell.

———. (1990b) "The Structure and Content of Truth". *Journal of Philosophy* 87.

———. (1991a) "Epistemology Externalized". *Dialectica* 45.

———. (1991b) "Three Varieties of Knowledge". In *A. J. Ayer Memorial Essays*, edited by A. P. Griffiths, supp. to *Philosophy* 30.

———. (1993) "Reply to Lorenz Lorenz-Meyer". In *Reflecting Davidson: Donald Davidson Responding to an International Forum of Philosophers*, edited by R. Stoecker. Berlin and New York: W. de Gruyter.

———. (1996) "The Folly of Trying to Define Truth". *Journal of Philosophy* 93.

Field, H. (1977) "Logic, Meaning and Conceptual Role". *Journal of Philosophy* 74.

Jeffrey, R. (1983) *The Logic of Decision*, 2nd. ed. Chicago and London: University of Chicago Press.

Quine, W. V. (1960) *Word and Object*. Cambridge, Mass.: MIT Press.

———. (1993) "In Praise of Observation Sentences". *Journal of Philosophy* 90.

REPLY TO DEBORAH HANSEN SOLES

If I ever thought the way I have shown that one could in theory determine the beliefs, preferences, and meanings of an agent described how we actually do it, or how a clever experimenter might succeed in doing it, I would certainly have been wrong. But that was not my idea. Here is what I did think. We could not figure out beliefs one by one: each depends on many others to fix its content. We could not figure out a single belief unless we had some idea what motivates an agent. We could not start to guess what someone meant by his utterances unless we had a pretty good idea what he believed and wanted. And so forth. How can we master all this? No doubt nature provides us with a huge head start in these matters, by endowing us all with similar discriminatory devices, and with pre-wired abilities suited to the tasks of mutual understanding. But given the complexity of the systems we succeed in acquiring and penetrating, those systems must have a structure that helps explain how, even with all our advantages, we come to have such a system and to discern one in others. I would love to know, in detail, how we actually do it. But even if I did know, I would still be interested in the question what the formal properties of the system are that make it possible. My unified theory of belief, preference, and meaning is a crude attempt at saying how these basic propositional attitudes are related. If this much is more or less right, then it should be possible to demonstrate that someone with normal human capacities might, in theory, worm his way into the pattern of attitudes of another thinking creature.

The "logical order of progression" I outlined that an interpreter could follow in the attempt to discover the attitudes of an agent was meant to constitute, as I said, a sort of informal proof that the pattern I had postulated had the desired properties. My model here was Ramsey's treatment of subjective probability and degree of belief. Ramsey defined a pattern he

thought a rational agent's beliefs and preferences would reveal in the pattern of his or her choices. He then described a series of steps, that is, choices, which would prove that the patterns had the desired properties; in effect, he was proving an adequacy and a representation theorem. It was not his idea that anyone should use this story as an experimental design, though much later various people, including me, tried (with indifferent success) to test the theory experimentally. No one supposes that in our ordinary dealings with people we undertake this series of steps to determine their subjective probabilities and relative values.

Deborah Soles points out that the preferences of others cannot be directly perceived: all we can observe is choices. This is, of course, true. Ramsey took it for granted, and so do I. Similarly, we cannot directly see that someone holds a sentence true: what we can observe are assents and dissents. It is a tricky matter to decide what is theoretical and what observational, what inferred and what known without inference, especially in this area (see Tyler Burge's essay in this volume). It also is not easy to decide whether preferring one sentence true to another is more or less distant from observation than holding true. Assent is a subtle attitude (though we often detect it with ease) compared to giving an order because it is much less directly connected with action. A drill master who says, "Left, right, left, right" makes clear to someone who does not understand these abbreviated sentential utterances which one he prefers to have made true from moment to moment. (Someone who does not think imperatives have truth values will have no difficulty figuring out what the drill master wants made true.) Commands, demands, and requests are among the most pressing uses of language we are apt, as children and aliens, to be exposed to.

From the point of view of my concerns, however, it doesn't much matter how often or easily we do or could discover that someone preferred the truth of one sentence over another. My claim was that there is an idealized pattern of propositional attitudes which guides how we understand people's speech and other behavior, and that I could describe a route by which this pattern could be filled in by an outsider in a non-question-begging way. I was clear that this is not the only possible route, and certainly not one we follow. On one point, Soles seems to have misunderstood me. My unified theory does not *replace* the earlier theory based on assent and dissent, but includes it. The earlier theory is easier to explain, and I often revert to it. There is no reason to reject whatever evidence is available in support of the simpler theory when asking how the more comprehensive theory can be supported. The point of the

exercise I outlined in the appendix to (Davidson 1990) was to demonstrate how the various aspects of the structure of thought hang together.

In connection with this essay and reply, see the excellent essay by James Hopkins in this volume.

D. D.

REFERENCES

Davidson, Donald. 1990. "The Structure and Content of Truth." *The Journal of Philosophy* 87:279–328.

13

Andrew Cutrofello

ON THE TRANSCENDENTAL PRETENSIONS OF THE PRINCIPLE OF CHARITY

In his essay "Radical Interpretation," Donald Davidson offers a model of what we must do to interpret a speaker of an "alien" language: "Kurt utters the words 'Es regnet' and under the right conditions we know that he has said that it is raining."[1] The question is this: how is it possible that we can successfully interpret Kurt's utterance? In answer to this question, Davidson argues that what we need to interpret Kurt (or anyone else) is a truth theory for the language that he speaks. We can construct such a theory only by making certain assumptions when we interpret Kurt's speech. Specifically, we must try to "maximize" or "optimize" agreement between him and ourselves.[2] Put otherwise, we must invoke the so-called "principle of charity," according to which it is necessary for interpreters to assume that all rational creatures share mostly true beliefs about the world. For Davidson, it is a condition of our taking others to be rational that we interpret them in accordance with this principle.[3]

Critics of Davidson have maintained that the principle of charity implicitly sanctions a kind of ethnocentric prejudice. For to suggest that everyone shares most of the same beliefs seems prima facie to imply that it is all right for interpreters to expect everyone else to share their particular cultural biases. Two distinct versions of this objection have been put forth. The first depends on an assumption that the principle of charity is just one of many possible principles that interpreters could choose to follow.[4] Davidson, on this view, is criticized for favoring the principle of charity over others. The problem with this objection, as Bjørn Ramberg has shown, is that Davidson's defense of the principle of charity is intended to be something akin to a transcendental argument. The principle of charity is supposed to be a universally binding condition for the very possibility of interpreting anyone at all.[5] Because it

assumes otherwise, the first version of the charge of ethnocentrism misses the mark.

A second version of the objection fully acknowledges the transcendental pretensions of the principle of charity, and instead argues that Davidson's transcendental defense of the principle fails.[6] Steve Fuller, for example, tries to refute the doctrine by showing that a Davidsonian interpreter might produce "a systematically distorted understanding of a text" without realizing it.[7] Maintaining that we cannot always be sure whether or not we have interpreted others correctly, Fuller highlights problems that necessarily arise when the principle of charity is applied to interpret people from cultures very different from our own.[8] If, as the principle of charity bids, we are to maximize agreement between ourselves and the "alien," "How exactly does one count 'beliefs' so as to be able to tell that we and the alien agree on more than we disagree?"[9] For that matter, "how exactly does one characterize those common beliefs" which we think we can establish? Can they be characterized so that both the alien and we would assent to them?"[10] Fuller argues that to get an alien to agree with an interpreter's characterization of her beliefs does not suffice to show that the interpreter has adequately rendered the alien's beliefs in the interpreter's language.[11] Just because the alien can communicate with the interpreter, it need not follow that the alien's beliefs are commensurate with those of the interpreter.[12] A Davidsonian interpreter is liable to take commensurability for granted when in fact a fundamental incommensurability of belief systems persists.

In my view, the argument for the principle of charity that Davidson gives in "Radical Interpretation" does not suffice to address Fuller's criticisms. However, in later essays—most notably, in "On the Very Idea of a Conceptual Scheme"—Davidson offers a different argument in support of the claim that invoking the principle is necessary to interpret others. This second argument, if successful, would provide an adequate rejoinder to the kind of problem that concerns Fuller. I will call the first (the one put forth in "Radical Interpretation") Davidson's "methodological" argument, and the second (the one developed in "On the Very Idea") his "ontological" argument.

The methodological argument (the argument we have already examined) maintains that interpretation cannot take place unless interpreters try to maximize agreement between themselves and those they interpret. By itself, this argument cannot support Davidson's grandiloquent extrapolation that all rational beings must share the same beliefs. After all, the argument is strictly hypothetical—it says only that *if* we are to understand others, *then* we must interpret them in accordance with the principle of charity. Now Fuller's point, it seems, is that we have no reason to suppose that everyone's beliefs are *capable* of being understood by everyone else. Why should we expect to be able to understand others in the first place? Moreover, this problem persists

even if we grant Davidson (as Fuller does not) the claim that we can only interpret others by invoking the principle of charity. Thus the methodological argument cannot by itself establish the claim that all people share mostly the same beliefs about the world.

Since Davidson's argument is supposed to be a kind of transcendental argument, it is instructive to put the issue in Kantian terms. We can say that the methodological justification of the principle of charity lacks something like a transcendental deduction which alone would establish its legitimate employment in actual experience. For Kant, demonstrating that the understanding can only think in terms of its a priori categories does not suffice to show that these categories are legitimately applied to experience; the metaphysical deduction has to be supplemented with a transcendental deduction. Davidson's methodological argument is like the metaphysical deduction in that it shows only how we must interpret, not whether interpreting the way we do will lead us to make accurate judgments about the views of others. Thus the methodological justification of the principle of charity must be supplemented by something analogous to a transcendental deduction.

The burden of Davidson's "On the Very Idea" is to provide this missing argument. As with Kant's transcendental deduction, the task of this new argument is to establish the *quid juris* of the applicability of the principle to our actual experiences (in this case, our experiences interpreting others). Here, the analogy between Kant and Davidson becomes especially interesting, because (as we shall see) Davidson's "deduction"—what I am calling his "ontological argument"—is virtually identical to an argument which Kant presents in the "Transcendental Aesthetic" of the first *Critique*. Davidson's ontological argument tries to show that everyone must share most of the same beliefs about the world, *because there is only one world about which we have beliefs.* If there is only one world, then all world views are commensurable. And if this is so, then the *quid juris* of the principle of charity is established.

Arguments which purport to show the existence of incommensurable belief systems are often based on the idea that different people somehow "inhabit different worlds." Davidson contrasts two ways of theorizing about "different worlds." On the one hand, there is the sort of *possible-world* theorizing undertaken by P.F. Strawson and others; on the other, there is the sort of *multiple-world* theorizing of the likes of Whorf, Kuhn, and Feyerabend. Unlike multiple-world theorists, possible-world theorists need not be committed to the idea that there could actually be a set of radically incommensurable worlds. The possible-world theorist merely imagines what other worlds might be like.[13] As for multiple-world theorists, however, Davidson maintains that their alleged multiple-world theories are really multiple-perspectives-of-one-world theories. When Kuhn says of scientists working in

terms of different paradigms that they "inhabit different worlds," Davidson assumes this must be taken not literally but figuratively: "Kuhn . . . wants us to think of different observers *of the same world* who come to it with incommensurable systems of concepts Kuhn's one world is seen from different points of view."[14]

Davidson suggests that every multiple-world theory is merely a metaphor for a multiple-perspective theory—or put otherwise, that every multiple-world theory can be reduced to a commensurable-world theory. "Different points of view make sense, but only if there is a common co-ordinate system on which to plot them; yet the existence of a common system belies the claim of dramatic incomparability."[15] We could only judge there to be many worlds if these many worlds were commensurable in some way. There must exist a common "meta-world" which would somehow "contain" all the others. But in that case, there really must be only one world, and all the supposedly many "worlds" are just many *parts* of the same world.

Curiously, this is almost exactly the same argument as the one which Kant develops in the first *Critique* in order to establish the unity of space. Kant maintains that "we can represent to ourselves only one space; and if we speak of diverse spaces, we mean thereby only parts of one and the same unique space. . . . Space is essentially one."[16] Like Kant, Davidson claims to show the incoherence of the very idea of multiple worlds; multiple-world-view theories can all be reduced to multiple-perspectives-of-one-world theories.

Again, it is important to understand the hypothetical structure of Davidson's larger argument. He is trying to show that *if* there is a single world which is common to all, *then* the idea of different conceptual schemes makes no sense. But has Davidson done justice to the idea of multiple worlds or of multiple world views? What if we can intelligibly make sense of the idea of different people *literally* inhabiting different worlds? If we can, then the ontological argument in support of the principle of charity fails.

Davidson urges us to think that when we posit the existence of multiple world views, we necessarily assume the existence of a common world in which the supposedly incommensurable world views which we posit would exist. Obviously if we admit the necessity of thinking the existence of such a "common space," Davidson's argument makes sense. But why couldn't it turn out that we can conceive of a multiplicity—of world views or of anything else for that matter —without being able to think of a common space in which the multiplicity would exist? A common space will exist only in those cases where the multiplicity *can* co-exist. If, however, we posit the existence of incompatible sorts of things, then we imply precisely that they *cannot* co-exist. Davidson in effect takes it for granted that multiple world views must be compatible; but this only begs the question at hand.

The question, in its transcendental form, would be this: must it always be

possible to think of a "common space" for every posited multiplicity? Put differently, we could ask: do we have a coherent concept of a *heterotopia*? By "heterotopia," I mean a multiplicity for which there can be no common space. This word is used by Michel Foucault in order to refer to the impossible "space" of a multiplicity for which there can be no common space.

Foucault begins *The Order of Things* by recounting an impossible taxonomy which appears in a story by Jorge Luis Borges.[17] This fictional taxonomy, which purports to be from a Chinese encyclopedia, claims to classify all of the animals of the Empire. It is an impossible taxonomy in that the boundaries which purport to separate distinct classes of animals are not well-defined, for a variety of reasons. For example, the classification includes, under supposedly distinct headings, those animals that are "sucking pigs," "fabulous," "stray dogs," "included in the present classification," "frenzied," "*et cetera*," and "that from a long way off look like flies."[18] Of particular interest to Foucault is the manner in which Borges presents to the reader a "system of thought" that is, from our perspective, radically unthinkable. What makes this impossible taxonomy unthinkable, Foucault stresses, is our inability to imagine a *common space* for that range of objects which the taxonomy purports to lay out for us. That common space simply cannot exist.[19] It is important to see that a heterotopia cannot be reduced to an "ordinary" multiplicity, for which there might always be a possible common space. Foucault writes of "the disorder in which fragments of a large number of possible orders glitter separately in the dimension, . . . 'arranged' in sites so very different from one another that it is impossible to find a place of residence for them, to define a *common locus* beneath them all."[20]

Foucault dubs the impossible space of a radically incompatible multiplicity a "heterotopia"—at the same time acknowledging that the very idea of such a thing is an affront to thought.[21] But this does not lead him to reject the concept as incoherent. Rather, he wonders whether the thought of heterotopias might pose a legitimate—albeit an uncanny, disturbing, and *in some sense* unthinkable—alternative to our system of thought.

Because of the a priori impossibility of there being a common space for the animals listed in Borges's classification, the idea of such a "space"—i.e., the idea of a heterotopia—cannot be reduced to the idea of a common world with multiple sites. That is, Davidson's ontological argument fails if the concept of a heterotopia is coherent.

But is the concept coherent? Can we really conceive of a heterotopia? Foucault seems to be uncertain as to whether he wants to say that heterotopias are thinkable (though disturbing), or just plain unthinkable.[22] Perhaps this uncertainty should not be attributed to indecision on his part so much as to a fundamental problem of what to do with the thought of an impossible thought. To some extent, this is the old familiar problem of round squares; should we

say that the concept of a round square is coherent but (necessarily) without any (real or imagined) referents, or should we say that the concept itself is simply incoherent?

We need not rehearse the familiar arguments on both sides of this debate from Meinong to the present. But it should be made clear that for us the question cannot be about whether or not *we* can think of "entities" like round squares or heterotopias. The Davidsonian cannot merely establish the counterintuitiveness of the idea of a heterotopia *for us*, but also demonstrate its incoherence *for any rational being*. For the real question is whether something that we find unthinkable might nonetheless be thinkable by someone else.

The history of philosophy is replete with examples that show how easy it is to conflate unthinkability with incoherence. Just because a concept is unthinkable does not mean that it is incoherent. Once again, an analogy between Davidsonian and Kantian arguments is apposite. Since the advent of non-Euclidean geometries, the Kantian view of space has been criticized repeatedly on the grounds that the mere fact that we might not be able to intuit an idea does not suffice to prove the incoherence of the idea. It is wrong to conclude from something like the alleged "unthinkability" of non-Euclidean space that the very idea of non-Euclidean space is incoherent.

If the concept of a heterotopia is coherent, then Davidson's ontological argument in support of the principle of charity fails. Briefly, now, I want to raise some objections to the methodological argument as well. Specifically, I want to suggest that there might be belief systems which we can interpret only if we violate the principle of charity.

First, there are cases in which it makes sense to interpret others as holding incompatible beliefs. One way of explaining the Aristotelian problem of *akrasia*, for instance, would be to attribute incompatible beliefs to those who act contrary to what we think they know. Smith believes both that x is good and that x is not good. Of course, there are other ways of interpreting cases of *akrasia*. Instead of attributing contradictory beliefs to *akratic* people, we might simply say that they act contrary to their better judgment. We could say that Smith believes only that x is good, but acts *as if* he believed that x is not good. Now assuming that *we* think only that x is good, the "maximize agreement" principle would have us opt for the second interpretation of Smith's *akrasia*. But what if it should turn out that the first interpretation is the true one? Must we let the principle of charity decide a substantive philosophical issue about the nature of *akrasia*?

To take a different example, Freud maintains that the unconscious thinks in terms of what we might call "heterotopic logic." To illustrate the way in which the unconscious thinks in dreams, Freud recounts the story of a man who borrows a kettle, and then when he returns it to its owner, the kettle is

broken. To defend himself, the man offers a series of independently satisfactory but mutually incompatible explanations, claiming that he never borrowed a kettle, that it was broken when he borrowed it, and that when he returned the kettle it was in brand-new condition.

Now it is clear that this list of responses is comparable to Borges's list of animals in that the several classes are incompatible with one another. Like Foucault, Freud characterizes this incompatibility in terms of the impossibility of a common space upon which the several answers can co-exist; but such an impossible space is implied by the "and" which unites the incompatible alternatives: "We might also say: 'A. Has put an "and" where only an "either-or" is possible'."[23] Freud goes on to suggest that the thoughts expressed by the unconscious often exhibit this "kettle logic":

> In dreams, in which the modes of thought of the unconscious are actually manifest, there is accordingly no such thing as an 'either-or', only a simultaneous juxtaposition.[24]

The unconscious "thinks," Freud implies, in a way that our conscious minds find "unthinkable." Therefore, in the case of psychoanalytic interpretation it would be a mistake to try to "maximize agreement" between ourselves (we conscious thinkers) and the unconscious. Whatever we think of psychoanalysis, it is an example of a type of interpretation whose method *cannot* be based on the principle of charity. Indeed, we are more likely to interpret unconscious beliefs correctly if we violate the principle.[25]

These brief examples suggest reasons for rejecting the methodological argument in support of the principle of charity. We have also shown that the very idea of a heterotopia suffices to reject the ontological argument. In sum, the transcendental pretensions of the principle of charity should be recognized for what they are—mere pretensions.[26]

ANDREW CUTROFELLO

DEPARTMENT OF PHILOSOPHY
LOYOLA UNIVERSITY
APRIL 1992

NOTES

1. Donald Davidson, "Radical Interpretation," pp. 125–39 in *Inquiries into Truth and Interpretation* (New York: Oxford University Press, 1984), p. 125.

2. "We want a theory that satisfies the formal constraints on a theory of truth, and that maximizes agreement, in the sense of making Kurt (and others) right, as far as we can tell, as often as possible." (Ibid., p. 136.)

3. "The methodological advice to interpret in a way that optimizes agreement should not be conceived as resting on a charitable assumption about human intelligence that might turn out to be false. If we cannot find a way to interpret the utterances and other behavior of a creature as revealing a set of beliefs largely consistent and true by our own standards, we have no reason to count that creature as rational, as having beliefs, or as saying anything." (Ibid., p. 137.)

4. Bjørn Ramberg discusses arguments of this sort put forth by Steven Lukes, Ian Hacking, Bruce Vermazen, and John Wallace. (Bjørn T. Ramberg, *Donald Davidson's Philosophy of Language: An Introduction* [New York: Basil Blackwell, 1989], pp. 66–75.)

5. Ramberg thus warns against confusing the (transcendental) principles of radical interpretation with "principles of actual interpretation"; a conflation he calls "fatal." (Ramberg, op. cit., p. 74.)

6. Those who have put forth such arguments include: Christopher Norris, *The Contest of Faculties: Philosophy and Theory After Deconstruction* (New York: Methuen, 1985), pp. 206–17; and Steve Fuller, *Social Epistemology* (Bloomington: Indiana University Press, 1988), pp. 153–62.

7. Steve Fuller, *Social Epistemology*, op. cit., p. 159.

8. Of course, since radical interpretation "begins at home," to borrow a phrase from Quine, Fuller's point should be applicable to all cases of interpretation.

9. Ibid.

10. Ibid.

11. Ibid., p. 160.

12. Ibid., p. 161.

13. "Strawson's *The Bounds of Sense* begins with the remark that 'It is possible to imagine kinds of worlds very different from the world as we know it'. Since there is at most one world, these pluralities are metaphorical or merely imagined." (Donald Davidson, "On the Very Idea of a Conceptual Scheme," pp. 183–98 in *Inquiries into Truth and Interpretation*, op. cit., p. 187.)

14. Ibid.; my italics. Davidson concludes, "Kuhn's scientists may, like those who need Webster's dictionary, be only words apart." (p. 189.)

15. Ibid., p. 184.

16. Immanuel Kant, *Critique of Pure Reason*, trans. Norman Kemp Smith, (New York: St. Martin's Press, 1965), p. 69, (A25/B39). Of course, Kant can support this claim with an appeal to our pure intuition of space. Presumably Davidson is not committed to the doctrines put forth in Kant's transcendental aesthetic. In that case, does he really have an argument to support his claim that the world must be one?

17. Michel Foucault, *The Order of Things: An Archaeology of the Human Sciences*, trans. not listed, (New York: Vintage, 1973), p. xv.

18. Ibid.

19. "The *common ground* on which such meetings are possible has itself been destroyed. What is impossible is not the propinquity of the things listed, but *the very site* on which their propinquity would be possible." (Ibid., p. xvi.)

20. Ibid., pp. xvii–xviii.

21. If any common space is implied in the Borges taxonomy, Foucault observes, that space is simply the language in which it is expressed; for language is the common

medium of any and every so-called "universe of discourse." "Where else could they be juxtaposed except in the non-place of language? Yet, though language can spread them before us, it can do so only in an *unthinkable space*." (Ibid., p. xvi–xvii; my italics.) But heterotopias do violence even to language itself, Foucault suggests: "*Heterotopias* are disturbing, probably because they secretly undermine language, because they make it impossible to name this *and* that." (Ibid., p. xvii–xviii.)

22. On the one hand, Foucault affirms the impossibility of thinking the common ground that would unite the radically heterogenous. Yet on the other hand, he suggests that the thought of this very impossibility gives us the idea of a heterotopia. At any rate, Foucault seems to want to use the concept of a heterotopia as a kind of regulative ideal guiding his own "archaeological" analyses. To exhibit for us radically different "discursive formations" from our own is his goal.

23. Sigmund Freud, "Jokes and their Relation to the Unconscious," trans. James Strachley, (New York: W. W. Norton & Company, 1963), p. 62.

24. Ibid., p. 205.

25. Of course, the Davidsonian might respond by maintaining that the unconscious —if there be such a thing—is not a rational agent, and that therefore psychoanalytic interpretation is not the same as the interpretation of *beliefs*. But Davidson's transcendental argument is supposed to show that *all* interpretation requires that we invoke the principle of charity.

26. Note (1999): In her 1993 book *The Psychoanalytic Mind*, Marcia Cavell suggests how a Davidsonian critique of Freud's conception of primary process thinking could respond to the argument presented in my paper. The heart of Cavell's strategy is to appeal to Davidson's notion of a divided self. Here I would simply point out that, strictly speaking, the concept of a divided self as Davidson develops it *presupposes* the principle of charity. It would therefore beg the question for a Davidsonian to turn around and defend the principle of charity by appealing to the concept of a divided self.

REPLY TO ANDREW CUTROFELLO

I don't know if my arguments for the principle of charity are transcendental or not; Andrew Cutrofello does not quote me as saying so. In any case, the arguments he says are mine are not transcendental, good, or mine. He does quote me as saying "We want a theory that maximizes agreement" in the sense of making others right, "as far as we can tell, as often as possible". He fails to quote or note the following sentence which goes on, "The concept of maximization cannot be taken literally here, since sentences are infinite in number, and anyway once the theory begins to take shape it makes sense to accept intelligible error and to make allowance for the relative likelihood of various kinds of mistake", and here a footnote directs the reader to fuller discussions of what this caveat implies. More context would have helped in other ways. In the introduction to the book in which Cutrofello was reading, I remarked that "maximizing agreement" was how I sometimes expressed the idea of the principle of charity in my early essays, wanting, as I said, to stress the inevitability of the appeal to that principle. "But maximizing agreement", I went on, "is a confused ideal. The aim of interpretation is not agreement but understanding. My point has always been that understanding can be secured only by interpreting in a way that makes for the right sort of agreement."

Cutrofello suggests that there might be systems of belief which "violate the principle of charity", and he mentions *akrasia*. If *akrasia* really does violate the principle, it is astonishing that I missed it, since I had published an article on *akrasia* just three years before the article he discusses (Davidson 1969), and have subsequently published a series of articles on various other forms of irrationality. But charity does not demand that we find a person either always right (by our standards) or always consistent. What it does demand is that we find enough agreement to enable us to make sense of our disagreements.

Might there be other worlds in which rational creatures have thoughts we could not penetrate? Cutrofello does not say what he means by rational. But

there are plenty of thoughts my fellow creatures have that I cannot penetrate for one reason or another: I will never understand quantum mechanics, and it may be quite beyond my powers ever to do so. Almost everyone has knowledge of things others don't. The reach of charity is less wide, and deeper than this. Less wide in that it has only indirect application to such outskirts of common sense as the knowledge of experts or the acquaintance of immediate friends and territory, deeper in that it depends on the things we all know, such as that there is a public world of more or less lasting macroscopic objects, that these objects have obvious causal powers, and that there are other people with minds like our own. When we speculate about kinds of rationality or kinds of worlds we could not understand at all, we are playing with counterfactuals we are not equipped, by definition, to evaluate. (See my reply to Quine.)

Cutrofello does not discuss my arguments for the inevitability of the appeal to the principle of charity which is implicit in the articles he discusses, and explicit elsewhere within the same covers. Briefly, the argument has two parts. The first part has to do with coherence. Thoughts with a propositional content have logical properties; they entail and are entailed by other thoughts. Our actual reasonings or fixed attitudes don't always reflect these logical relations. But since it is the logical relations of a thought that partly identify it as the thought it is, thoughts can't be totally incoherent, for if they were, they would be robbed of any possibility of being identified as one thought rather than another. The principle of charity expresses this by saying: unless there is some coherence in a mind, there are no thoughts, and if an interpreter is to grasp the thoughts of someone else, the interpreter must discover a sufficient degree of coherence to identify those thoughts.

The second part of the argument has to do with the empirical content of perceptions, and of the observation sentences that express them. We learn how to apply our earliest observation sentences from others in the conspicuous (to us) presence of mutually sensed objects, events, and features of the world. It is this that anchors language and belief to the world, and guarantees that what we mean in using these sentences is usually true. As our grasp of a language increases, we connect observation terms with observation terms, and we not only become better at applying these terms, but also learn how errors can be explained. Terms less directly tied to perception take on content through logical and other connections with observation terms, but as these connections become complex and attenuated, the possibility of error increases. The principle of charity recognizes the way in which we must learn perceptual sentences and the consequence that such sentences, when uttered with conviction, cannot be routinely false. Someone may object that we could learn the sentence "There's a witch" through ostension, and so always be wrong when we used it. But the objection overlooks the fact that the concept of a

witch is one that cannot be correctly learned through simple ostension, since as with "There's a bachelor", mere pointing cannot teach us how to go on.

D. D.

REFERENCE

Davidson, Donald. 1969. "How is Weakness of the Will Possible?" In *Moral Concepts*, edited by J. Feinberg. Oxford: Oxford University Press.

14

Bill Martin

INTERPRETATION AND RESPONSIBILITY: EXCAVATING DAVIDSON'S ETHICAL THEORY

1. THE QUESTION OF THE ETHICAL IN PLATO, KANT, AND DAVIDSON

Donald Davidson has spoken, in recent years, to meta-ethical questions in general, developing the response to ethical relativism that is implied by his argument in "On the Very Idea of a Conceptual Scheme." In that essay, Davidson argues that, just as it would be impossible for two interpreters to have radically different conceptual frameworks while still being able to understand each other as interpreting beings, so would it also be impossible for such interpreters to have radically divergent sets of values. In a more recent essay, "Expressing Evaluations," Davidson argues that valuation is always already a fundamental dimension of interpretation or, to put the point more generally, language use. In my own earlier essay on this subject, "The moral atmosphere: language and value in Davidson," I argued that "Davidson's moral realism is more about *ethos* than ethics *per se*; Davidson's moral realism provides a ground for meaningful discussion of ethical questions, but *not* for the resolution of any given question in an 'objective' way" (p. 89). In other words, the fact that language users must in general share the same beliefs and values is the basis for meaningful discussions concerning the true and the good (Davidson has not said much about the beautiful, but I take it that the argument concerning aesthetic value would also fit within the purview of what is shown by the conceptual schemes argument).

The language of Plato is invoked for a purpose. Whether Davidson would

actually go all the way with Plato, to the point of asserting that the true and the good are two facets of the same crystal, is a question worthy of further investigation; however, it is clear that Davidson and Plato agree that truth, meaning, and value are so closely connected as to be inseparable. Davidson is perhaps even more closely allied with Kant in the former's emphasis on intersubjectivity. With Kant, as with Plato (and I emphatically mean the Plato who is not a Platonist, not a "pure" formalist—in this I am influenced by Sayre and League), there is an interwining of, on the one hand, a metaphysics of relationality, and, on the other hand, a focus on ethics, or, as I prefer to say, "the ethical," as the heart of philosophy and of human pursuits generally. This interconnection is the reason why, for both Plato and Kant, unethical behavior must be an expression of either ignorance or irrationality. I believe that Davidson would have to be committed to much of what has just been claimed for Plato and Kant. Furthermore, the fact that Davidson's conceptual schemes argument gives language users the basis for meaningful discussion regarding what is true and good, but does not give particular answers to specific questions of the true and the good, neither places him at odds with Plato or Kant, nor does it detract from the overall "objectivity" that is available, in Davidson's view, in discussions of what is true and what is good. That is, Davidson's moral realism is not a strict "moral calculus," nor does the moral realism of Plato or Kant provide such a calculus. True enough, with Kant, there is the availability of a well-formulated moral law, but Kant claims that to be able to show how the categorical imperative is a logical deduction is beyond the powers of human beings. Indeed, this must necessarily be the case for there to be, in the Kantian sense, ethics at all. If there could be a strict moral calculus, there would be no sense to the idea of responsibility, and thus no ethical project, and thus, in the final analysis, no human project. For Kant, to be human is not simply to *have* responsibility; more deeply, it is to *be* responsibility. Similarly, for Plato the pursuit of the good is at the limit of dialectic and even beyond; as he puts it, famously, in *Republic*, Book VI, the good is "beyond being." The impossibility of the ethical, and of the ethical calculus, is also its possibility. (Clearly my language here is indebted to Levinas and Derrida; e.g., see the closing passages in the latter's recent text, *L'autre cap*, concerning the "ethics of calculation.")

My question in this essay is whether Davidson, whom I take to be a contemporary Kantian who, like Derrida, has rewritten the language of subjectivity and consciousness in terms of the language of language, would follow Kant even unto the latter's placement of the ethical project at the heart of the human project (and therefore, of course, at the heart of intellectual pursuits, including philosophy). To put it another way, and to take the pressure off of the question whether Davidson himself will pursue this project,

the question might also be stated: is it also possible to rewrite Kant's ethical project in Davidsonian terms, showing at the same time that this ethical project is at the center of Davidson's philosophy?

I believe that such a rewriting is both possible and necessary. The necessity is actually threefold. First, foremost, and perhaps obviously, the necessity is that of the ethical generally, in a world dominated by calculation. (Remember, for Kant, the "ethic of calculation," i.e. utilitarianism, is no ethic at all.) Second, there is the necessity of better establishing the place and role of valuation in Davidson's holism. The answer to the question whether or not the ethical does in fact occupy the center of Davidson's philosophy will in itself tell us something very important. Third, beyond establishing the answer to the second question—and I believe we are already some distance toward that answer with the arguments that Davidson provides in the conceptual schemes and "Expressing Evaluations" essays—there is the necessity, if a Davidsonian ethical theory is going to have any "bite" to it, of going beyond, at least in principle, meta-ethics, toward specifying more concretely the meaning of responsibility.

As for the necessity of the ethical (or, as Derrida puts it, in a formulation that I am in broad sympathy with, the "ethical-political"—we shall see the sense of this conjunction in the final part of this essay), I will not provide an argument here. Indeed, I believe that this necessity, in keeping with the thinking of Plato and Kant, is just beyond the limit of argument. To ignore this necessity is to, as both Plato and Kant argue, also ignore, and therefore to oppose or give up on, the human possibility—but I also believe, with them, that to establish the necessity of this possibility is just beyond the limit of argument, and necessarily so. However, I take it that Davidson accepts not only the necessity of the ethical, but, further, the unavoidability of the possibility of the ethical. For Davidson, to participate in language is to depend on the possibility of the ethical, for it is to be engaged in and, indeed, to be formed by a never-complete unfolding (I'm recalling the ending to Davidson's "A Nice Derangement of Epitaphs," where it is made clear that language is never a finished object) of language and valuation. My purpose here will be to speak to the second and third necessities. Incidentally, I recognize that my subtitle is, of fortunate necessity, inappropriate. Davidson is also similar to Plato and Kant in that, in the final analysis, there can be no "ethical theory," or, for that matter, "philosophy of language," "metaphysics," or what-have-you, as fully distinct fields of inquiry. This fact marks Davidson's distance, as an analytic philosopher, from positivism. As with Plato and Kant, Davidson's "ethical theory" cannot be, in the final analysis, something essentially different from his metaphysics, epistemology, theory of language, etc. (I take this issue up in detail in my *Matrix and line*, third chapter.) My

subtitle, however, does attempt to speak to another necessity, which is to think the ethical as such in Davidson's philosophy. It is to this necessity that we will now turn.

2. THE CENTRALITY OF AUTONOMY IN DAVIDSON'S PHILOSOPHY

A few years ago I saw Patricia Churchland on a television show with Bill Moyers. Something she said about her philosophical program of "neuro-philosophy" made me aware, by negative example, of a very important point in Davidson's philosophy, a point that I think is not especially apparent to most analytic philosophers or readers of Davidson in general. "Neuro-philosophy" is the attempt to integrate analytic philosophy of mind with findings in neurophysiology. The goal is a fully worked-out science of the human mind/brain (as they put it in those circles) or, put in a slightly different form, a fully scientific psychology. Professor Churchland asserted that, with such a science at hand, doctors would be able to take people who are not normal (I won't put the word in scare-quotes, because it was clear that Churchland didn't) and fix (ditto) them. My first reaction upon hearing this was to want to get some additional locks for my doors. My first more philosophical reaction was to realize that Davidson's anomalous monism is not only a principle of psychology or philosophy of mind, it is, further, an ethical-political principle. In "Psychology as Philosophy," Davidson argues that there cannot be a fully scientific psychology. The point that needs to be stressed much more than Davidson generally does is that this is a very good thing, that human psychology is an anomaly in nature. Without this anomaly—the fact that "psychological phenomena do not constitute a closed system" (p. 239)—there is no human being.

(Incidentally, Davidson goes perhaps too far in assuming that physics is ultimately a closed system; however, rather than get into the Einstein/Bohr debate—although, who knows, perhaps there are quantum effects in the brain that do have something to do with what makes us the kind of creature that we are—the point is that "[w]hat lies behind our inability to discover determinis-tic psychophysical laws is" that, "[w]hen we attribute a belief, a desire, a goal, an intention or a meaning to an agent, we necessarily operate within a system of concepts in part determined by the structure of beliefs and desires of the agent himself;" "we cannot escape this feature of the psychological" [p. 230]. One final interruption: Davidson does give an explanation why there cannot be a fully scientific [i.e., predictive] decision theory, one that sounds very much like a basic principle of quantum physics, namely, "that the testing procedure disturbs the pattern we wish to examine" [p. 235].)

The point that I have tried to make regarding Churchland's program is that, there may be the possibility of a kind of closure of human psychology, achieved at the expense of destroying human being(s). I do not think that it is merely alarmist to point to the *Brave New World* implications of neurophilosophy. The difficult thing, of course, is to be able to walk the fine line between understanding the ethical implications of the attempt to create a neurophilosophy such as Churchland proposes, and, on the other hand, indicting basic research into neurophysiology. I have no desire to do the latter (as long as we remain aware, of course, that there is no "research" that is so "basic" or pure as to be ethically and/or politically neutral; and in fact I must admit to being skeptical of most research that goes under the name of psychology, especially because of the institutional affiliations of that research—I believe that Davidson's writings on rationality and irrationality could and should be forged into a powerful critique of these very powerful institutions). Positively, the point that I am driving toward can be expressed as follows: where programs such as Churchland's deny—in the first instance and in the final analysis—autonomy, Davidson's argument for anomalous monism is a powerful argument for autonomy.

A reader of "Mental Events" should be struck by the fact that the essay is all about autonomy in the epistemological sense of "independent thought." That is, thinking does not come under strict laws. But despite Davidson's appeal to Kant at the beginning and end of the essay, this point is lost, I think, to many readers (and I have especially in mind analytic philosophers who are still mired in positivism), who immediately set off into the technical field of token/type relations. On one level, this is not to be criticized, for the question why the brain, or the human organism as a whole, which is (a) material (being), should not submit to the same laws of cause and effect as all material objects (leaving aside quarks and such!) is both difficult and fascinating. It is significant that, although Davidson does get into the technical details of the question (in the entire "Philosophy of Psychology" section of *Essays on Actions and Events* and elsewhere), his answer can be put straightforwardly in general, humanistic terms. That is, the "human difference" is that, the actions and comportment (to speak Heideggerian for a moment) of human beings, unlike those/that of other physical objects and creatures on our planet, can be described in both physical and psychological terms. Terms such as "intention," "belief," "desire," "meaning," as well as terms denoting propositional attitudes such as "hope," "care," "fear," etc., appropriately describe states of the human mind.

It is worth noting that detractors of Davidson's argument to the effect that thinking is something that humans do and that other animals, to the best of our knowledge, do not do, leave out something fundamental from their arguments.

Davidson's argument, as set out in "Thought and Talk" and "Rational Animals" (essays the purpose of which is often misconstrued; Davidson's purpose is to understand what humans do when they engage in the activity called "thinking" more than it is to show that animals do not engage in this activity; the latter point is an implication of a careful consideration of the former question), is that there is a basic connection between thought and language use: thinkers are language users, and vice versa. This argument of course connects with the conceptual schemes essay in that, if we could not interpret the signs (utterances, markings, or what-have-you; there is no universal rule as to what can be a sign) of a creature, we could also not interpret that creature as a thinking being. We will return to this point in due course. Those who assert that Davidson is wrong because "of course my (your favorite animal here) can think!" should be asked the following question, which gets to the heart of the matter. To wit: "If dogs, cats, monkeys, egrets, or what-have-you, can think, then why not hold these animals responsible for their actions? For example, when a pit-bull on the loose mauls a child, why not put the dog on trial?" The same reason why it would not make sense to hold the dog responsible in other than a purely causal sense (that is, in the same sense that, e.g., Mount Vesuvius can be said to have been responsible for the destruction of Pompeii) speaks volumes to the issues at stake in the present discussion. That is, the intertwining of interpretation and valuation, both activities of thought and both underlying the possibility of responsibility, is an essential aspect of what it means to be human. Just as it does not make sense to make dogs, etc., morally responsible for their behavior, it also does not make sense to ask what thoughts, intentions, or preferences are behind that behavior.

Davidson recognizes that human minds are material (see, e.g., "The Material Mind"); there is no ethereal spirit-mind hovering over the human brain. His argument for anomalous monism depends not on the irreducibility of the mind to the brain in a metaphysical or ontological sense, but rather on the irreducibility of the psychological vocabulary to the physical (neuro-physiological) vocabulary; both vocabularies are appropriate and necessary for an accurate description of what occurs when humans think. As Davidson puts it in the conceptual schemes essay, it is not a matter of "tun[ing] our language to an improved science." Davidson continues: "[b]oth Quine and Smart, in somewhat different ways, regretfully admit that our present ways of talking make a serious science of behavior impossible. (Wittgenstein and Ryle have said similar things without regret)" (p. 188). The irreducibility of vocabularies lies in the fact that a fully worked-out science of the brain will not yield a science of intentions, beliefs, meanings, or preferences (this latter term encapsulates the intersection of beliefs and meanings with what is desired and what is valued).

To return to the earlier point, it seems to me that readers often lose sight of the fact that "Mental Events" (and, by implication, other essays in this same vein) is about autonomy in the epistemological sense because Davidson does not bring out the point that anomalous monism must also be about autonomy in the ethical sense; that is, in the Kantian sense that the ability to interpret, which is after all the possibility of response, is conceptually bound up with the possibility of responsibility. And yet this point is implied, I believe, by the arguments outlined just now. Davidson concludes "Mental Events" with a rather strong assertion: "The anomalism of the mental is thus a necessary condition for viewing action as autonomous" (p. 225). Agency is an anomaly; "agency" is an appropriate term for a being that forms intentions and has the capability (in general) of acting upon intentions; the formation of intentions cannot be separated from valuation; thus, valuation is an aspect of the anomaly. The mental activity of valuation, however, only contains the possibility of responsibility. It would be a violation of anomalous monism to say that there is a necessity of responsibility in some metaphysical sense. That is, even if it can be shown that responsibility is fundamentally implied by acts of interpretation, the metaphysical necessity of responsibility would cancel its ethical-epistemological possibility.

The point of these too-hasty formulations (which should be developed in more detail) is that (the) human (mode of) being is both defined by the ability to respond, and by the ability to *choose* to respond; these abilities, taken together, define autonomy. Davidson has given us some new ways to think about these abilities and the fact that they are defining features of human being. Two things remain to be shown, however. First, we need more than a meta-ethical answer to the question, What is our responsibility? Second, we need an argument for why we *should* choose our responsibility. Again, the question I want to answer in this discussion is whether or not good answers to these questions can be given in terms of Davidson's philosophy. As a guidepost, it will not hurt to return, for a brief moment, to Plato and Kant. Their answer to the second question is that one can only deny responsibility by at the same time denying one's humanity. Therefore, such denial is a possibility, but it is not a human possibility. I believe that a Davidsonian answer to this question will be strikingly similar. Indeed we are already some distance toward the Davidsonian answer when we see that valuation is not an "optional" activity of the thinking, intending, language-using, believing human being. A human being can choose not to respond responsibly to the other, but a human being cannot choose not to have the ability to respond, without at the same time choosing not to be a human being. But our aim now is to ask why, in the terms of Davidson's philosophy, a person ought to choose to respond, that is, why a human ought to choose to be a person.

3. Interpretation and Responsibility

The social conditions of interpretation, as well as thought, language use, and valuation, have only been hinted at thus far. In concluding the essay "Rational Animals," Davidson says, "Rationality is a social trait. Only communicators have it." Put with a slightly different spin, what Davidson is saying is that rationality, and therefore subjectivity, arise from an essentially intersubjective situation. Insomuch as the intersection of epistemology and metaphysics is concerned, this side of Davidson's work has been explicated and developed elsewhere (see, e.g., Davidson's more recent essays, "The Conditions of Thought" and "Epistemology Externalized"; a very good explication of the basic issues, drawing out the Kantian side of Davidson, is Carol Rovane, "The Metaphysics of Interpretation"; an excellent essay that shows how Davidson has "textualized" this Kantian problematic—and which therefore shows some similarities between Davidson and Derrida—is S. Pradhan, "Minimalist Semantics"; all of these issues are also treated in my *Matrix*, ch. 3). My interest here is more in the epistemological-ethical side.

In this respect it is important, therefore, to stress the dependence of subjects upon one another. In a sense, Davidson has simply ramified the priority of the social for individual life through the root concepts of psychology and epistemology. We might say (speaking Derridean) that he has "materialized" the psyche. In doing so he has shown the outlines of a materialism that is only naturalistic until the final instant, and this in itself is a subject that should be pursued for its metaphysical and ontological implications (I take this up in chapter 1 of *Matrix*; another way to put this point would be to say that Davidson's materialism is ultimately non-naturalistic). This material psyche is the product of materiality in general, but also a product of the recognition of other material psyches in the specific terms of human psychology: intentions, beliefs, meanings, values. (Anything that had the material basis for the development of a human psyche, but that did not receive such recognition, would not develop such a psyche.) The most basic form of such recognition is interaction; in this way the material basis for the individual psyche is brought into social, and therefore, psychological life. (An interesting question is that of the "first" recognition; therein lies a paradox: how could there be a first, unless there had already been a first? Freud encounters a similar problem with the first psychoanalysis.) Put in a formula, the point is: no cognition without recognition.

Therefore, *everything* human depends on recognition, the basic impulse of which, I would argue, ties together epistemology, metaphysics, theory of language, ethics, politics, and all of the other traditional categories of philosophy into an inseparable whole. To reiterate the earlier point about the (fortunate) impossibility, in the final analysis, of separating these subjects, the

concern here is to look at one facet of the crystal, the facet that we are calling "the ethical."

Now, let us look at one aspect of this recognition, relating that aspect to anomalous monism. The aspect that I have in mind is the ability to respond. Without this aspect there is no possibility of recognition. One way to conceive the argument for anomalous monism is to allow that the material of cognition is also the material of response; here we mean especially language, for creatures without language will also not have beliefs, intentions, meanings, and values. Every conscious brain state is also a "meaning state." Brain states are states of matter and are thus capable of physical (i.e., neurophysical) explanation. In other words, a physicalist vocabulary is fully appropriate for brain states. Particular meanings, or bits of meaning, however, are implicated in a web that is not localized to particular brains. Meanings depend on this web. Picking up the line of reasoning set out by Hilary Putnam in "The Meaning of 'Meaning'," where it is said, "Meanings ain't in the head," Davidson has argued that the semantic analysis of sentences that attribute attitudes must be relational, necessarily without appeal to intentional entities (this formulation is adapted from one by Piers Rawling). A slight spin on the terminology of anomalous monism would show, then, that the problem for (any purportedly scientific) psychology is that no strict determination can be made between brain states and meaning states. (The import of this fortunate failure of determination is enormous. For example, such a determination would be necessary for the direct interface of consciousness and computers imagined in novels such as William Gibson's *Necromancer*. That the exact scenario as regards mind/machine interface is thankfully not possible does not mean, however, that there is not a great deal to be learned from the novel about the attempt to achieve such an interface. Again, we are on the terrain of the human possibility, and the possibility of denying that possibility—the former is a necessary condition of the latter.) I take it that Davidson is hinting at this aspect of the problem when he mentions that a basic problem with decision theory (he is referring specifically to the decision theory of Frank Rams) is that it "has no predictive power at all unless it is assumed that beliefs and values do not change over time" ("Psychology as Philosophy," p. 235). But of course not only do beliefs and values, and therefore meanings (and vice versa) change over time, the very attempt to gauge beliefs, meanings, and values, even if conducted in a tightly-controlled experimental situation, is fundamentally no different from any other situation of social interaction. That is, to repeat, the interaction itself affects the beliefs, meanings, and values that we wish to examine (I'm simply restating Davidson's point from ibid., p. 235, in a slightly different form). This tells us once again that there is no pure self, no pure psyche, that can be the object of scientific investigation.

This is not the end of psychology, but it is certainly the end of biologist, behaviorism, physicalism, determinism, and, one can only hope, neuro-philosophy. And it is a reminder (which Harold Bloom, among others, has recently restated) that we should always count the great writers, from Aeschylus to Shakespeare to Joyce and Woolf, not to mention the writers of the great epics and religious texts of all societies, among our greatest psychologists.

The aim of restating anomalous monism this way is to bring Davidson's work on action theory and philosophy of mind into greater integration with his arguments concerning meaning and interpretation. I believe that the restate-ment has the further benefit of showing better how it is that a scientific psychology is impossible, because the upshot of characterizing states of mind as both brain states and meaning states is that the social work of interpreta-tion, in which particular brains play a part, problematizes any attempt to create a strictly physicalist theory of the human brain (or, how it is that the brain is conscious, that it thinks, intends, means, believes, etc.).

And yet the real aim of this analysis, apart from developing the anomalous monism argument's implications for metaphysics, epistemology, and philosophy of language, is to ground the sense that human consciousness, at root, is and must be responsive, that is, it is defined by the ability to respond.

However, we must now move toward the responsibility of response, to ask what grounds this responsibility. How do we move from the "is" of response-ability to the "ought" of responsibility?

The answer to this question is that, to engage in an activity that is not only fundamentally human but, further, fundamentally defines what it is to be human, namely *interpretation*, is already to be on the road to responsibility. And to *faithfully* engage in interpretation is to choose responsibility and the material and spiritual prerequisites and implications of responsibility.

The quotations from Kant with which Davidson begins and ends "Mental Events" come, appropriately, from the *Groundwork*. If one is going to argue for a universalism that is both ethical and epistemological (that is, interpreters share the same beliefs and values, at least for the overwhelming part), as both Kant and Davidson do, then it seems to me that an extension of the categorical imperative is implied.

The societies on this planet are rife with power relations. Many, perhaps most, of these relations are of an oppressively hierarchical nature. (With this formulation there is no need to assume that all power relations must nec-essarily be oppressive or hierarchical, nor must it be assumed that all hierarchical relations are oppressive.) Does this fact put an obstacle in the path of Davidson's radical interpreter? (This is the interpreter who must, from scratch, figure out what the other is attempting to communicate. In order to accomplish this interpretation, Davidson argues, she or he must extend the

"policy of rational accommodation"—a.k.a. the "principle of charity"—that is, the interpreter must attribute to the other a set of beliefs, meanings, intentions, and values that are, for the overwhelming part, those of the interpreter. This argument is developed in "Radical Interpretation," "Thought and Talk," "On the Very Idea of a Conceptual Scheme," and numerous other essays by Davidson.) Here it is absolutely essential to remember that Kant's aims are not only ethical but, crucially, *practical*. Ethics may, as Kant says, set an "infinite task," but it is a task that we are required, if we are to be ethical, if we are to be human, to get on with. Karl Marx, in *Critique of Hegel's Philosophy of Right*, gives a fourth formulation of the categorical imperative, "to overthrow all those conditions in which humanity is debased." This practical task, Marx argues, is the material prerequisite for the kingdom of ends, and therefore is demanded by the third formulation.

There are both abstract and concrete conditions of interpretation. It seems to me that the former must depend on the latter. Davidson has set out the former, the abstract conditions of interpretation. How might we materialize these conditions, just as Davidson has materialized the psyche? My sense, following both Kant and Marx, is that faithful interpretation requires practical action to bring about the material conditions that would make discourse meaningful. Anything less is a false and ideologically pernicious "universalism." (Recall Malcolm X's concentrated argument about purely formal civil rights: "I am not a diner unless I am able to dine.")

The radical interpreter has to get still more radical. This interpreter, in order to really interpret, must have more than an anthropological mission in mind. (Or, we might say, thinking about interpretation in this way forces us to reexamine the discipline of anthropology, and the power networks of which it is a part.) There is, at a more fundamental level than that of the mere encounter with the other, a responsibility in interpretation that is an imperative to respect the other and to address those social relations, institutions, and social inequalities that stand in the way of understanding the other. To fail to address these relations is also to fail to interpret, to understand, and, ultimately, to be human. The possibility of interpretation is the possibility of responsibility; to *faithfully* interpret, attempting to bridge the gap between what is materially driven in the nomological net and what is material but submits to no strict law, is to keep faith with humanity. Taking stock of Davidson's matrix of interpretation and valuation urges us in this direction.

BILL MARTIN

DEPARTMENT OF PHILOSOPHY
DEPAUL UNIVERSITY
APRIL 1994

WORKS CITED

Davidson, Donald. *Essays on Actions and Events*. Oxford: Oxford University Press, 1982. (Abbrev. AE).
————. *Inquiries into Truth and Interpretation*. Oxford: Oxford University Press, 1985. (Abbrev. TI).
————. "Expressing Evaluations." The Lindley Lecture. University of Kansas. 1982.
————. "The Material Mind." In AE, pp. 245–59.
————. "Mental Events." In AE, pp. 207–27.
————. "On the Very Idea of a Conceptual Scheme." In TI, pp. 183–98.
————. "Psychology as Philosophy." In AE, pp. 229–44.
————. "Radical Interpretation." In TI, pp. 125–39.
————. "Rational Animals." In Ernest LePore and Brian McLaughlin, eds., *Actions and Events: Perspectives on the Philosophy of Donald Davidson*. Oxford: Basil Blackwell, 1985; pp. 473–80.
————. "Thought and Talk." In TI, pp. 155–70.
Derrida, Jacques. *L'autre cap*. English translation: *The Other Heading: Reflections on Today's Europe*. Trans. Pascale-Anne Brault and Michael Naas. Bloomington: Indiana University Press, 1992.
League, Kathleen. "Plato is (not) the Metaphysician." Unpublished manuscript, 1991.
Martin, Bill. "The Moral Atmosphere: Language and Value in Davidson." *Southwest Philosophy Review* 6, no. 1 (January 1990); pp. 89–97.
————. *Matrix and line: Derrida and the possibilities of postmodern social theory*. Albany, NY: SUNY Press, 1992.
Putnam, Hilary. "The Meaning of 'Meaning'." In *Mind, Language, and Reality*. Cambridge: Cambridge University Press, 1975.
Sayre, Kenneth. *Plato's Late Ontology: A Riddle Resolved*. Princeton, NJ: Princeton University Press, 1983.

REPLY TO BILL MARTIN

Most of my published work is probably viewed as peripheral to the issues of ethics and moral philosophy, so I am glad Bill Martin raises the question just how peripheral my work is to such issues. I will try to summarize where I have thought I was touching on matters relevant to ethics. There are four areas: the nature of practical reasoning, the question of the objectivity of value judgments, the autonomy of the intentional, and the normative aspects of interpretation.

Shortly after I wrote "Actions, Reasons and Causes" I began to worry about the right way to describe the basic form of practical reasoning, the so-called practical syllogism. There was a clash between the existence of akrasia, which requires that an agent be torn between two evaluative principles, and the idea that evaluative principles serve as major premises in practical reasoning (Lying is wrong, Do not cause unnecessary pain). Akrasia, it is evident, is just a special case of a general difficulty: acceptable values may conflict. But then if values feature in practical reasoning as universal principles, acceptable premises will frequently lead to logical contradictions. Elizabeth Anscombe had not put the point quite this way in *Intending*, but she was clear about the difficulty. So either one has to give up the idea that valid principles can lead to contradictions, or give up the idea that moral principles are universally quantified conditionals. I was convinced that valid principles can conflict, and so had to give up the standard picture of the logical form of such principles and of practical reasoning. It did not seem to me adequate to call some values prima facie since the values under consideration may not lose their appeal in the course of reasoning. They may be *overridden* by other values without diminishing in cogency.

The solution I proposed in (Davidson 1969) drew on an analogy with Hempel's analysis of reasoning about a scientific hypothesis in the face of relevant, but inconclusive, evidence. This in turn naturally led to a view of practical reasoning which abandoned the normal syllogistic form, but also fitted well with Ramsey's formalization of decision making in the face of

uncertainty. This was hardly a major advance in our understanding of practical reasoning, but it persuaded me of two things: it was possible to incorporate the expression of evaluative attitudes into a general theory of language and action, and it would be more difficult than I had thought to make a case for the objectivity of evaluative judgments.

I have argued that evaluative judgments (including moral judgments) are objective, first in (Davidson 1984), and more recently in (Davidson 1995). There are several considerations that seem to me to support this view. The first is that unless we treat expressions of evaluation as having truth values, it is extremely difficult to provide a satisfactory semantics for many sentences. I have in mind sentences like "Susan burned John's manuscript and that was a very bad thing to do." The problem is that we treat a conjunction as true if and only if both conjuncts are true, and no other analysis comes readily to mind. In any case, it would be strongly counterintuitive to suppose that "and" is ambiguous. Since any attempt to resolve this problem by treating evaluative judgments as not having truth values will almost certainly result in a wildly baroque semantics, I reject this course.

There is a closely related consideration that also points to the objectivity of value judgments. Words like "good", "bad", "right", and "wrong" are classificatory. We think some things (actions, people) belong in one class and some in another. But if we believe that what Susan did was bad, we have classified her action just as definitely as we would if we judged that her act was a burning of John's manuscript. What sense does it make to say we do not think it is *true* that her act belongs in the class of bad actions, just as we think it belongs in the class of manuscript burnings?

Value judgments typically express our positive and negative sentiments, and are potentially motivational: they are reasons for and against acting when action is possible or appropriate. These features of value judgments have, at least since the time of Hume, often been thought to distinguish them from "factual" or "descriptive" judgments. Properly qualified, I think this is right. But it does not follow that value judgments are not true or false. The emotive and motivational attitudes that always, or typically, or often, go with a judgment do not tell us its semantics; they follow from the semantics. Given what value judgments mean, they naturally express the passions and attitudes they do. One is frequently told that evaluative properties are not in the objects and events to which we ascribe them (their source is in us). Of course, it is true that evaluative properties are not in the objects and events we ascribe them to, for being properties (if we like to talk this way), they are not anywhere. There are those who balk at the idea that value judgments are true or false on the grounds that they explain nothing, or that they add nothing to the world, or that they simply "sit on top of" descriptive properties. The point of these claims seems to be simply that evaluative properties are supervenient on

properties treated by the natural sciences. If this is enough to show they have no explanatory power, it shows this equally about secondary qualities or the propositional attitudes. In fact, of course, secondary qualities and propositional attitudes both feature in explanations. This candy is sweet, which is why I value it, and my valuing it explains why I eat it, which explains why it is no longer on the table.

It is not surprising that evaluative concepts, like the concepts of belief, desire, preference, and intention, are supervenient on concepts drawn from the natural sciences, and are not reducible to them, for the propositional attitudes are normative. They are normative in that they are subject to rational control and criticism (see James Hopkins's essay in this volume). This becomes apparent when we attribute propositional attitudes to others, for we cannot make sense of what an agent says or thinks without assuming a degree of rational coherence in his or her mental economy. Actions, including speech, are understood only as the result of the attitudes of the agent, and the explanation depends on how the contents of those attitudes meshed to make the action seem attractive to the agent. Our own norms enter here, not because we understand only what we ourselves think and or would do, but because we understand only what we can appreciate seemed reasonable to someone else. This feature of our intentional psychological concepts is what makes them so essential to our thoughtful lives. It also is what makes those concepts irreducible, either definitionally or nomologically, to the concepts of natural science.

The irreducibility of the mental removes it from the domain of physical law and explanation. It is this, at least in part, that accounts for the autonomy of the mental. Of course, the objects, states, and events that are the subject matter of psychology are also the subject matter of biology, neurology, and physics; the dualism is conceptual, not ontological, as Spinoza and Kant, in their different ways, recognized. There are laws of psychology also, some of them psychophysical, some more like laws of thought (logic and decision theory are roughly descriptive of how the mind works). But these laws are not, and cannot be made, precise: they hold only when the conditions are right, and we cannot specify in any detail when the conditions are right. When we are making up our minds what to do or what to think we cannot at the same time conceive of our reasoning as bound by the strict laws of physics. Reasoning, described in terms of beliefs, inference, and the weighing of evidence, is not part of the subject matter of the natural sciences.

If value judgments are objectively true or false, how do we discover such truths and falsehoods? In brief, in the same way we discover other truths and falsehoods. Think of learning to use the word "good". Others show us, intentionally or not, what things and actions are called good. So far, we have no reason to question the lesson. In the beginning no doubt we find, usually

sooner than later, that the things called good are pleasant, rewarding, fulfilling. The semantics are given by the properties of the things we learn to group under the heading of good, the pragmatics, somewhat less certain, give us the idea that utterances of the word are often used to praise, advise, and so forth. As sophistication grows, we are prepared to strike out on our own and judge things good that others do not. Communication nevertheless succeeds when there is enough basic agreement on what is good or desirable to make reasoned discussion possible. Here, as in disagreements on any topic, we try to convince others by depending on areas of agreement to serve as premises. But because there are many goods which compete in the formation of intentions for each individual, interpersonal disagreements are common. There is, needless to say, much more to the story. One part of that story concerns what is called the interpersonal comparison of utilities. On this subject, I differ with the consensus: I think there is an objective basis for comparing the worth of a good for one person with the worth of a good for another person (Davidson 1986). The rest of the story pretty much follows the pattern I have tried to trace elsewhere: the simplest sentences and concepts take on their content and are anchored to the world and through interactions among people in the context of their environment. This forms a basis of interpersonal agreement which, when elaborated, makes communication and debate possible. Against this background, judgments have objectively truth conditions.

Martin would be pleased if I could say that my approach implies that certain values are objectively valid. I'm afraid I cannot claim this. I do not think rationality in itself delivers moral imperatives; only our purposes and experience can do this. But if we cherish rationality, then we are bound to seek discourse with others, for we owe our ability to entertain thoughts and to reason to the society of others, and the better we understand others the better we understand the world and ourselves.

<div align="right">D. D.</div>

REFERENCES

Davidson, Donald. 1969. "How is Weakness of the Will Possible?" In *Moral Concepts*, edited by J. Feinberg. Oxford: Oxford University Press.

———. 1984. "Expressing Evaluations" (The Lindley Lecture). Lawrence: University of Kansas Press.

———. 1986. "Judging Interperson Interests." In *Foundations of Social Choice Theory*, edited by J. Elster and A. Hylland. Cambridge, England: Cambridge University Press.

———. 1995. "The Objectivity of Values." In *El Trabajo Filosófico de Hoy en el Continente*, edited by C. Gutiérrez. Bogatá: Editorial ABC.

15

Reed Way Dasenbrock

LOCATING DONALD DAVIDSON AND LITERARY LANGUAGE

Anyone looking, as I have been asked to do here, at the relation between the work of Donald Davidson and literary studies has a choice to make, either to look at the role of literature in Davidson's own work or to look at the effect that work has had on literary studies, pre-eminently on certain debates in literary theory. Both tasks involve the examination of absences as well as presences: why, given Davidson's early training in literary studies, does he turn to explicit discussion of literary texts so late in his work? Why have literary theorists, despite the degree to which Davidson has long been working on issues central to literary theory, been so slow to learn from his work? These questions interpenetrate, it seems to me, so what I am attempting to do here is to look at all of these questions, to whatever degree of detail is possible in an essay of this kind.

Anyone looking quickly at Davidson's work as collected in *Essays on Actions and Events* and *Inquiries into Truth and Interpretation* could with some justice take Davidson's work as that of one more "technical" analytic philosopher fundamentally uninterested in literature. Even when the themes of that work move closest to questions central to literary theory, examining interpretation for instance, the examples are taken from conversations, not from literature, or from the repertoire of examples of Quinean and Tarskian philosophy of language such as "the snow is white," "gavagai," and other odd phrases. Such a quick view would confirm the prejudice common among literary theorists that only Continental philosophy is engaged with literature and therefore is the only stream of contemporary philosophy of interest to literary theorists.

That such a view is *tout court* a misunderstanding of the analytic tradition is not something I will try to demonstrate here. But it's an easy enough task, especially when one moves beyond the two collections of essays to work done

early and late in Davidson's career, to see how badly this misrepresents Davidson's concerns. We can begin to complicate this way of presenting Davidson's *oeuvre* by noting that after his undergraduate education in comparative literature at Harvard, Davidson went on to write his doctoral dissertation (subsequently published only in 1990) on Plato's *Philebus*, intriguingly the same dialogue Hans-Georg Gadamer wrote his dissertation on a generation before. However, despite this early engagement with literature and historical questions in philosophical studies, Davidson's work over the next twenty-five years stayed away from issues explicitly involving literature and literary language.

What led Davidson back to questions involving literature was above all his interest in anomalous or unusual uses of language. Davidson has long been concerned with seeing how far a theory of truth can serve us in an understanding of interpretation, and his answer—to encapsulate a great deal of work—is that it will take us a very long way. However, this approach to interpretation needs to deal with the fact that there are very considerable differences in the way we use language, and not all of those differences can be explained by pointing to the differences in our general beliefs about the world. "On the Very Idea of a Conceptual Scheme" is a crucial essay here as for so many other aspects of Davidson's work, since it argued against the idea that people who held different beliefs about the world somehow spoke a different language or couldn't understand each other. Central to all of Davidson's work on interpretation is his ringing endorsement of the common-sense view that we do communicate with each other successfully, and the task of an analytic understanding of interpretation is to explain that success, not find it implausible. Yet if we are not divided into mutually exclusive groups speaking a language which only we can understand, nonetheless we are also not one big happy epistemic family. We use words remarkably differently, and it is precisely in those differences, in the investigation of the anomalous, that we find the pressure points in most of our existing theories of communication.

In a series of papers after "On the Very Idea of a Conceptual Scheme," most notably "What Metaphors Mean" (1978), "Communication and Convention" (1980), and finally "A Nice Derangement of Epitaphs" (1986), Davidson develops a critique of a set of reigning assumptions about meaning and interpretation which leads him steadily in the direction of an investigation of literary language. I will call the view he opposes "conventionalism," a term which may cause some confusion among philosophers familiar with David Lewis's very different approach to conventions, but which provides a useful umbrella term for a view with adherents in philosophy, linguistics, and literary studies. The most widespread form of conventionalism is speech-act theory as developed by J. L. Austin and John Searle, but Davidson finds strains of

conventionalism in the very different work of Michael Dummett and certain strains of French structuralism (which Davidson never discusses) are also heavily conventionalist. Conventionalist theories of meaning take their point of departure from exactly the same phenomenon Davidson is interested in exploring, which is the enormous variation between what we say and what we mean, between the literal meaning of the phrases we use and how those words are understood or, to use different terminology, between the sense and the force of an utterance. Davidson's work here begins with a look at metaphor in "What Metaphors Mean," and the reigning view of metaphor is conventionalist in that there is supposed to be something called "metaphorical meaning" as opposed to "literal meaning." How we know when someone is being metaphorical is supposed to be a matter of convention, in that there is an arbitrary collective agreement that certain phrases are metaphorical and others are not in the same way that there is an arbitrary collective agreement that forks go on the left and knives go on the right. This view—though acknowledging exceptions—posits something like an 'off-on' switch by which metaphorical language works one way and literal language works another. In contrast, Davidson is not willing to posit a category of linguistic expressions or of language use called the metaphorical which is somehow sealed off from the regular, standard ways of using language:

> I think metaphor belongs exclusively to the domain of use. It is something brought off by the imaginative employment of words and sentences and depends entirely on the ordinary meanings of those words and hence on the ordinary meanings of the sentences they comprise. (247)

Davidson sounds a note here which will last throughout all of his examinations of issues involving literary aspects of language, which is to refuse to divide language use into two discrete realms, one of which is marked as the normal or standard. To sound paradoxical for a moment, his instinct is always that the non-standard is just as standard as the standard, that if you try to prise off the non-literal uses of language from the literal, you won't have much left.

It is in the final essay in *Inquiries into Truth and Interpretation*, "Communication and Convention" (1982), that Davidson takes a more systematic look at conventionalism as a theory of meaning. Davidson begins his essay where analytic philosophy begins, with Frege's attempt to bracket assertion as a linguistic act distinguishable from others and his concept of the assertion sign. Davidson freely grants that an assertion sign would be a handy thing to have on occasion. Imagine, for example, that one were in a theater watching a play in which there had been a pretend fire. If at a later point in the play, a real fire broke out in the theater and the actors wanted to alert the audience that no pretense was involved, an assertion sign would indeed be

useful. But as Davidson dryly observes, "It would be obvious that the asser-
tion sign would have done no good, for the actor would have used it in the first
place, when he was only acting" (270). Davidson goes on to say that the
"plight of the actor is always with us" (270), but what he really means here,
I think, is that the plight of the audience is always with us. Lies may be
statements imitating "serious assertions" which are expected to be taken as
having assertoric force, but jokes, ironic statements, figurative uses of
language, fiction are uses of language which utilize the form of an assertion
without always entailing assertoric force. An utterance which has the form of
an assertion is not always to be taken as having the force of an assertion, but
there is no simple algorithm—no automatic sorting device—which allows us
to assign utterances with the form of assertions to the class of utterances with
the force of assertions.

There is, as Davidson goes on to say, no convention governing assertion,
no agreement in place about how utterances in the form of assertions are to be
connected to speakers apparently intending to assert something. Such a
convention—if it existed—would immediately be violated by every liar as well
as every actor:

> Convention cannot connect what may always be secret—the intention to say
> something true—with what must be public—making an assertion. There is no
> convention of sincerity. (270)

As the next part of "Communication and Convention" goes on to argue, the
failure of conventions to regulate the making of assertions is part of a more
general failure. For any explanation of meaning in terms of conventions to
work, the speaker needs to be brought into the picture: it is necessary for the
speaker to mean what he or she says, to be sincere, and that the speaker intend
the standard or conventional meaning. All is well as long as the speaker's
intention is to respect the convention or, to put this the other way around, as
long as the convention directly embodies the speaker's intention. However,
this flies apart the minute there is the slightest misalignment between the
received convention and the speaker's intention.

In other words, it is apparent enough from the field linguistics we all do
every day that many of the ways language is used in everyday life do not
involve a literal use of language. We go beyond the literal in a bewildering
variety of ways all the time. One way of thinking about the non-literal is to say
that a different set of conventions comes into play to regulate things like
metaphor, pretending, fiction, etc., but the problem with this view is that it
requires a specificity or univocity to the notion of convention which doesn't
obtain. If I break the regular rules of language use, I don't switch to an
alternative set of rules which we can describe; I simply break the rules. For
Davidson, there is nothing in words or sentences themselves which specify

their meaning or specify the force with which they are to be taken, since so many different kinds of meaning beyond the literal can be involved. However, there is also no available convention or set of conventions which regulate the force of an utterance, since there can be no convention in force regulating how conventions are handled. The literary (or in the case of this paper, the theatrical) comes to be Davidson's prime source of examples of non-literal and anti-conventional aspects of communication, but it is important to recognize that his interest here is not because they constitute a separate realm but because they display aspects of language also seen (if perhaps in more diluted form) in ordinary communication,

Another way of putting Davidson's position by the end of *Inquiries into Truth and Interpretation* is that he doesn't think a single theory of meaning is available. What we need instead is a theory of interpretation: we need to ask not what the words used by a speaker mean but rather what the speaker of those words means by them. "A Nice Derangement of Epitaphs" is the central paper developing Davidson's considered theory of interpretation, and it is a paper in which literary language is absolutely central. "A nice derangement of epitaphs" is a malaprop, a malaprop which comes from the horse's mouth as it were, since it is something Mrs. Malaprop says in Richard Sheridan's play, *The Rivals*. Mrs. Malaprop is presented to us in Sheridan's play, of course, as an ignorant speaker, malaproping because she doesn't quite know the right word. So she says 'a nice derangement of epitaphs' even though she means to say 'a nice arrangement of epithets.' But behind her is the playwright, who knows exactly what he is doing, whose ingenuity at coining new ways of speaking not only gives us this richly comic character but has also enriched the English language with these new words and phrases.

Thinking about the malaprop from the speaker's point of view reflects the emerging importance of the literary in Davidson's understanding of language. No agreement in advance about what a word means prevents someone else from using it differently: literal or standard or normal meaning—Davidson's term here is "first meaning"—does not determine what Davidson goes on to call "speaker's meaning," and it is speaker's meaning which is crucial. In emphasizing the mutability of meaning, how speakers can change the language they inherit in substantial as well as trivial ways, Davidson establishes innovation and creativity at the very heart of language use. It is not just that we need to keep in mind the fact that the speaker's and interpreter's "prior theories" about meaning may not match as we communicate in order to prevent miscommunication; it is also that we can take advantage of or even create this lack of match, by challenging a listener's or reader's prior theory, by confronting and overturning received conventions. Every speaker can and does—as Davidson says—"get away with it" by violating a convention or prior theory in such a way that the listener comes to understand what is meant.

This is the crucial part: even though Mrs. Malaprop doesn't use the English language as we expect it to be used, we come to understand her. When we know that a speaker is not using the word the way we would use it, we do not rest content with our prior understanding or theory about the meaning of the word but instead try to figure out what the speaker means by it. Thus, where the speaker's theory and the interpreter's theory conflict, if we wish to understand the speaker, we must assign priority to the speaker's theory and then attempt to understand what that theory is. Our prior theories have to give way in the face of the unconventional: where conventions are violated, intentions are decisive.

This does not mean, however, that the concept of speaker's meaning exists in some kind of isolation from other forms of meaning. Davidson turns to another literary text to get at some of the necessary connections between what any individual speaker might mean and the larger linguistic horizon in which any utterance is placed by discussing a conversation from Lewis Carroll which had already entered the philosophical literature. In *Through the Looking Glass*, Humpty Dumpty used the word 'glory' to mean 'a nice knock-down argument' and in response to Alice's common-sense objection that this isn't what the word glory means, Humpty Dumpty tells Alice, "When I use a word, it means just what I choose it to mean." Davidson does not take Humpty Dumpty's side:

> The absurdity of the position is clear. In speaking or writing we intend to be understood. We cannot intend what we know to be impossible; people can only understand words they are somehow prepared in advance to understand. ("James Joyce and Humpty Dumpty" 4)

But this does mean, as Davidson makes it clear in his discussion in "A Nice Derangement of Epitaphs," that "there's glory for you" can't ever mean what Humpty Dumpty wants it to mean. In the exchange which Davidson is working off of, Alfred MacKay had accused Keith Donellan of having Humpty Dumpty's theory of language. Donellan responded to this charge in the following way:

> If I were to end this reply to MacKay with the sentence 'There's glory for you' I would be guilty of arrogance and, no doubt, of estimating the strength of what I have said, but given the background I do not think I could be accused of saying something unintelligible. I would be understood, and would I not have meant by 'glory' 'a nice knockdown argument'? (qtd. by Davidson 439)

Davidson says, "I like this reply," but he goes on to clarify his position:

> Humpty Dumpty is out of it. He cannot mean what he says he means because he knows that 'There's glory for you' cannot be interpreted by Alice as meaning 'There's a nice knockdown argument for you.' We know he knows this because

Alice says, 'I don't know what you mean by "glory"', and Humpty Dumpty retorts, 'Of course you don't—til I tell you.' It is Mrs. Malaprop and Donellan who interest me; Mrs. Malaprop because she gets away with it without even trying or knowing, and Donellan because he gets away with it on purpose. (440)

A full exploration of the philosophical aspects of the theory of language Davidson develops here would take us well beyond the scope of this essay. He moves to some revolutionary and controversial positions. Most famous is his declaration at the end of "A Nice Derangement of Epitaphs" that "there is no such thing as a language, not if a language is anything like what many philosophers and linguists have supposed" (440). What he means by this ringing declaration has been the subject of a fair amount of discussion,[1] a discussion I expect has been continued in this book, but I take the qualifying clause as the important part, suggesting that most philosophers of language have gotten it all wrong as to what a language is. The problem is that they have taken the theories of meaning we all work with (in Davidson's terms, our prior theories which are about first meaning) as an adequate description of meaning. They wouldn't have done this, I suspect, if they had paid as much attention to literary language and to the interpretation of literature as Davidson has. The kind of linguistic innovation found in the writers Davidson is interested in—Sheridan, Carroll, and James Joyce—is not a marginal literary tradition of little interest to philosophy of language: these writers simply do more thoroughly and more self-consciously what every speaker of language does every day. A theory of meaning which will not work for these writers will also not work for more ordinary users of language.

Since "A Nice Derangement of Epitaphs" is one of Davidson's central papers (I would judge it, "The Structure and Content of Truth," and "The Myth of the Subjective" as the three central papers in the work Davidson has done after *Essays on Actions and Events* and *Inquiries into Truth and Interpretation*), that gives literary language a central place in Davidson's theory of language. However, Davidson has not really followed on from that into any full-scale exploration of literary or cultural matters in the manner of other philosophers such as Stanley Cavell, Richard Rorty, or Jacques Derrida; his disciplinary identity remains intact. Two subsequent papers do continue on from the exploration of literary language in "A Nice Derangement," "James Joyce and Humpty Dumpty" (1991) and "Locating Literary Language" (1993). "James Joyce and Humpty Dumpty" uses the work of James Joyce—particularly *Finnegans Wake*—to revisit the questions explored in "A Nice Derangement" involving Humpty Dumpty. Joyce would seem at first glance to be very much on the Humpty Dumpty side of the fence, someone whose exploration of language led him to the creation of new forms of language as unintelligible to the reader as Humpty Dumpty was to Alice. This isn't how Davidson reads Joyce's work, however, even *Finnegans Wake*.

Davidson looks at the famous passage in *A Portrait of the Artist as a Young Man* in which Stephen says that he wants to fly by the net of language, but for Joyce in Davidson's analysis, "Flying by the net of language could not, then, imply the unconstrained invention of meaning, Humpty Dumpty style."

> No one knew this better than Joyce. When he spent sixteen hundred hours writing the Anna Livia Plurabelle section of *Finnegans Wake*, he was searching for existing names of rivers, names he could use, distorted or masked, to tell the story. Joyce draws on every resource his readers command (or that he hopes they command, or thinks they should command), every linguistic resource, knowledge of history, geography, past writers and styles. (4)

Joyce interests Davidson, thus, as someone who stretches the language to its limits yet can nonetheless be understood. Joyce is the exemplar of someone who "gets away with it."[2]

"Locating Literary Language" is the final paper in what I have defined as a series of papers looking at questions involving literary language. It is primarily a response to a set of papers on Davidson's work, but the opening of the paper gives one of the clearest statements of the basis of Davidson's interest in literature:

> Literature poses a challenge for philosophy of language, for it directly challenges any theory of meaning that makes the assertorial or truth-seeking uses of language primary and pretends that other linguistic performances are in some sense "etiolated" or "parasitical." The sources of trouble are to be sure far more ubiquitous than the reference to literature suggests: jokes, skits, polite nothings, ironies, all break the mold of sincere, literal, would-be truth-telling. But literature can serve as the focus of the problem if only by dint of its kinship with and employment of such verbal tricks and turns. Literature and these comrade conceits are a prime test of the adequacy of any view of the nature of language, and it is a test I have argued that many theories fail. (295)

On this account, even if explicit discussion of literary texts surfaces only late in Davidson's work, nonetheless literature has played an essential role in the development of his work on philosophy of language.

However, it would be difficult to say that the relationship is reciprocal. Even though Davidson has worked for many years on concepts central to literary theory and has probably the most robust theory of interpretation developed within analytic philosophy, and even though literary theory as a whole is deeply indebted to philosophy, Davidson's celebrity in and importance to philosophy has not yet been paralleled in literary theory. At an earlier stage, this asymmetry would have been very easy to explain: as literary theory emerged as a field in the late 1960s and 1970s, it was essentially an application of the ideas of French post-structuralism to the domain of literary studies.

Even though some theorists criticized their fellow theorists for ignoring the philosophical contexts of the ideas they sought to use, nonetheless the 'right' philosophical context—Continental Philosophy descending from Hegel, Nietzsche, and Heidegger—was taken for granted. This affiliation was strengthened by the fact that literary theory was initially more at home in departments of comparative literature, French, and German than in departments of English. So the turn of literary studies towards philosophy a generation ago was in general not a turn towards the analytic tradition, which is to say towards the philosophy dominant in the philosophy departments on the same campuses where literary theory was flourishing.

This odd sociological formation has continued to influence the reception of analytic philosophy in departments of literary study. At the same time that several polemic encounters (above all, the Derrida-Searle exchange over the work of J. L. Austin) hardened the perception that analytic philosophy and Continental Philosophy as mediated by post-structuralism and deconstruction were polar opposites, selective philosophers of the analytic tradition were repositioned as somehow fundamentally in a state of affinity with deconstruction. The primary question brought to the work of a number of philosophers in the late 1970s and across the 1980s was exactly the same—what relation did their work have to the application of philosophy to literature which everyone needed to have a response to, deconstruction? The narrative of confrontation established by the Derrida-Searle exchange was gradually replaced by a narrative of convergence in which various philosophers (first Wittgenstein, then Austin, Kuhn, and others) were seen as much closer to deconstructive positions than first envisioned.[3] The fact that virtually everyone on the analytic side failed to understand why this question mattered meant that much of the 'dialogue' among analytic philosophy, deconstruction, and literary theory which then followed had few actual participants from the discipline of philosophy; the side of analytic philosophy was represented by literary theorists interested in analytic philosophy more than by philosophers themselves. The most conspicuous exception to this generalization is Richard Rorty, who in *Philosophy and the Mirror of Nature, Consequences of Pragmatism,* and other works presented an essentially Whiggish version of the history of philosophy in the twentieth century in which the latest versions of 'post-analytic' philosophy were on a convergence course with post-structuralist thinking and the best versions of American pragmatism as well, in one happy post-theoretical epistemic community. Rorty quickly became the authoritative historian of philosophy for most literary theorists, who were eager to find in Rorty's narrative of convergence the comforting implication that since all these philosophical traditions were at bottom coming to the same conclusion, they really didn't need to learn much about the analytic tradition, internally divided as it apparently was between a scientistic current now

superseded and the new wave of post-analytic, indeed post-philosophical thinking celebrated by Rorty.

The first key figure retroactively converted into a 'friend' of deconstruction was Wittgenstein, who after being presented by M. H. Abrams, Charles Altieri, and others as a possible antidote to deconstruction, was refigured by Rorty as close to Heidegger and then by Henry Staten and others as close to Derrida himself.[4] Virtually the same process was then undergone by J. L. Austin, as commentators on the Derrida-Searle debate including Stanley Fish, Shoshana Felman, and others saw Austin as a kind of proto-deconstructor not nearly as opposed to Derrida as Searle might have assumed.[5] Finally, Donald Davidson's entry into the arena of literary theory had exactly the same shape, if in somewhat more muted form. Charles Altieri's *Act and Quality* was the first work of literary theory to discuss Davidson's work at length: Altieri's discussion focused on Davidson's work in action theory, arguing that Wittgenstein's work might serve as an Aristotelian mean between Davidson and Derrida. But subsequent work—focusing more on Davidson's work in philosophy of language than philosophy of action—by Christopher Norris, Shekhar Pradhan, Samuel Wheeler, and others repositioned Davidson as comparable to Derrida in his anti-conventionalist theories of linguistic meaning.[6] Sustaining this increase of attention paid to Davidson and the particular angle of attention was the increasing prominence of Davidson in Rorty's work. Davidson is not a major presence in *Philosophy and the Mirror of Nature* or *Consequences of Pragmatism*, but he becomes a central point of reference in *Contingency, Irony and Solidarity*, in the papers collected in *Objectivity, Relativism and Truth* and in the writing which followed. Rorty's description of his own positions as 'Davidsonian' thus became many literary theorists' first point of contact with Davidson's work, and for the most part the subsequent apprehension of Davidson which has followed has been shaped by this (in my view, quite misleading) presentation of Davidson as a post-analytic philosopher whose perspectives are fundamentally compatible with Rorty's and with post-structuralist positions.[7]

There is therefore very little overlap between Davidson's interest in literature and the world of literary study's interest in him. The actual essays which touch on literary topics have received comparatively little attention (with the exception of "A Nice Derangement"), and Davidson's interest in figuration and literary language as a site of the anomalous has not been echoed by theorists who when they have discussed his work have focused above all on his critique of relativistic theories of truth. There certainly has been some work reacting against the Rortyean appropriation of Davidson: this was an important theme in several essays in the collection of essays I edited, *Literary Theory after Davidson*, which contains the most extensive discussion in print of Davidson's potential applicability to literary theory (as well as "Locating

Literary Language").[8] However, the dynamic already in place in which the primary question brought to any analytic philosopher was where he or she stood vis-à-vis Derrida in terms of a friend-enemy distinction has meant that such work—even though far more careful in its discussion than Rorty's sweeping treatments tend to be—has made little headway in its argument that Davidson's work demands careful, separate investigation. As the highcrest of literary theory has subsided in the 1990s and literary studies have moved into a 'post-theoretical' phase in which the post-structuralist positions once argued for are now essentially assumed without much question or disputation, the potential of Davidson's work to contribute substantially to central issues in literary studies has not been fully realized.

I can't show this in detail in anything like the space allotted me here, but I'd like to discuss one issue more fully which will also round off the discussion of Davidson's actual writing about literature. If there has been one unifying element among virtually all of the bewilderingly numerous positions in literary criticism and theory over the past half-century, it has been opposition to intentionalist models of interpretation. Wimsatt and Beardsley declared this the "intentional fallacy" back in 1947, and the waves of New Critical, structuralist, post-structuralist, New Historicist, Cultural Materialist, etc. movements which have followed have with only an occasional exception taken this anti-intentionalist stance almost for granted. One of the recurring attractions of various forms of conventionalism for literary studies is that conventionalist theories of meaning are clearly and unequivocally anti-intentionalist: if the meaning of something is given by a set of conventions in place, then there is little if anything an individual author can be said to have to do with it. However, conventionalism can hardly be said to have ruled the day. For instance, Jacques Derrida's theory of meaning is deeply anti-conventionalist, in a way which does have some points of contact with Davidson's work, since both criticize the conventionalism of speech-act theory along similar lines. However, Derrida's work is as anti-intentionalist as every other leading position in literary theory: they all unite in denying the author a privileged position in the specification of meaning and in denying that the purpose of interpretation is the recovery of what the author meant by his or her words.

Donald Davidson's work has an absolutely unique contribution to make to literary studies here. His analysis of meaning and interpretation shares with Derrida a deep-seated critique of conventionalism, but where he differs from Derrida and from virtually all the other major influences on literary theory is his belief that the only coherent theory of meaning available is an intentionalist one and the only coherent purpose of interpretation is the recovery of the intended meaning. This emphasis on intentions emerges only fairly late in Davidson's work, remaining latent even in "A Nice Derangement

of Epitaphs." However, the differentiation between prior and passing theories developed in that essay and his emphasis on the importance of finding the right passing theory to interpret the anomalous utterance successfully is clearly if implicitly intentionalist in nature. It is not irrelevant that "A Nice Derangement" was first published in a festscrift for the late Paul Grice, and Grice's work on the reflexive nature of meaning is relevant here. To cite the classic non-verbal example, a wink can be physically indistinguishable from an involuntary movement of one's eyelid: what makes a wink a wink is both the fact that it is recognized as a wink and the fact that it is intended to be recognized as a wink. The intent to wink is the intent to be perceived as intending to wink.

Remember that in Davidson's model we enter every interpretive situation with a prior theory about the meaning of the words the speaker uses. That prior theory never works perfectly because no one speaks exactly the same way as we do. When we encounter the anomalous as we inevitably do, we recognize that our prior theory must be modified. As speakers violate their audience's expectations or their prior theories, whether unintentionally as in the case of Mrs. Malaprop or intentionally as in the case of Sheridan, Carroll, and Joyce, the interpreters recognize that their prior theories or what they take to be the relevant conventions are not controlling meaning in this particular situation. What interpreters do when faced with anomalous utterances such as those of a Mrs. Malaprop is to develop a passing theory which is adequate to the situation. As we move from the prior to the passing theory, we must modify our prior theories in the direction of a match between the author's and the interpreter's. This requires us to move (or at least we aim to move) from first meaning to speaker's meaning because our aim is to understand the speaker as he or she wishes to be understood. In other words, our task is not to figure out what "a nice derangement of epitaphs" means in the abstract, it is to figure out what Mrs. Malaprop means by those words.

There is, of course, no guarantee that this will be successful, no convention in place about what to do when conventions are broken, but our lived experience as interpreters gives us confidence that this kind of renegotiation is possible and it is possible for it to be successful. We do learn new words, new ways of saying things, new idiolects and even whole new languages, often without any formal instruction in them. The learning this represents does sometimes involve learning about conventions, since some communication does follow conventional scripts, but a great deal of it is about waters uncharted by conventions: these are the waters Davidson associates with literature itself.

It is in his most recent papers on literary topics, "James Joyce and Humpty Dumpty" and "Locating Literary Language," that Davidson explicitly outlines the intentionalist nature of his understanding of interpretation. If Joyce is the

prime example of someone who breaks the rules and violates every convention of language, in Davidson's account, he is no Humpty Dumpty. Joyce intends to break the rules, but unlike Humpty Dumpty Joyce also intends to communicate just what he means to the reader willing to do the work necessary to understand him. Joyce is an anti-conventionalist who is also an intentionalist, and the theory of interpretation Davidson wants to develop from his consideration of writers such as Joyce is also an anti-conventionalist intentionalism. "Joyce draws on every resource the reader commands," as Davidson says: we aren't left with a sense of linguistic freeplay in which language escapes control; we are left with a strong sense of James Joyce in control. As Davidson says, "to emphasize the role of intention is to acknowledge the power of innovation and creativity in the use of language" ("James Joyce and Humpty Dumpty" 1), and for Davidson that innovation and creativity is perfectly embodied in a writer such as Joyce.

Finally, or at least most recently, Davidson opens and closes "Locating Literary Language" with some stimulating if enigmatic remarks about intentionality and interpretation:

> although the literary uses of language have long interested me, I have neglected to indicate, or even to think very hard about, how my account of the origins of intentionality and objectivity (which I see as emerging simultaneously and as mutually dependent) should be adapted to the case of literature. Indeed, it is clear to me now that any gesture in the direction of such adaptation will also reveal the need for a sharper focus on the role of intention in writing, and hence on the relation between writer and reader. (295)

What probably requires the most exploration in this passage is the link he makes between intentionality and objectivity, but to explore this more fully would require a look at a number of aspects of Davidson's philosophy we haven't examined and can't here. Suffice it to say that essays such as "The Myth of the Subjective" are relevant here and constitute a sharp challenge to the relativistic positions on truth taken for granted in literary theory today. But of equal importance is his suggestion that focusing on intention requires us to think about "the relation between writer and reader." He ends the paper by looking more directly at positions in literary theory than he does anywhere else in his work:

> Should we then agree with Hans-Georg Gadamer when he says that what the text means changes as the audience changes: "A text is understood only if it is understood in a different way every time"? I think not. . . . If you and I try to compare notes on our interpretation of a text we can do so only to the extent that we have or can establish a broad basis of agreement. If what we share provides a common standard of truth and objectivity, difference of opinion makes sense. But relativism about standards requires what there cannot be, a position beyond standards. (307)

Davidson leaves it up to us to fill out the implications of these extremely suggestive remarks for literary theory. What they suggest to me is that the unified theory of meaning and action developed in Davidson's work from "On the Very Idea of a Conceptual Scheme" gives us the basis of a theory of interpretation which would leave space for both objective truth and authorial intention, neither of which are concepts commonly found today in the vocabulary of most literary theorists. Thus, it is not just that Davidson celebrates the writer who violates convention and asks us to rethink our prior theories; he is—as far as the by now highly conventionalized world of literary theory is concerned—one of those writers himself. Listening to Davidson and attempting to come to an understanding of the meaning of his work on questions central to literary theory would require many of us to abandon cherished prior theories. It will be interesting to see in the years to come how many in literary theory will be willing to do the work required.

REED WAY DASENBROCK

NEW MEXICO STATE UNIVERSITY
NOVEMBER 1998

NOTES

1. See essays by Ian Hacking and Michael Dummett included in the collection edited by Ernest LePore, *Truth and Interpretation: Perspectives on the Philosophy of Donald Davidson* (Oxford: Basil Blackwell, 1986), "A Parody of Conversation" (pp. 447–58) and "'A Nice Derangement of Epitaphs': Some Comments on Davidson and Hacking" (pp. 459–76). Further commentary can be found in two essays in my collection, *Literary Theory after Davidson* (University Park: Penn State Press, 1993), Shekhar Pradhan's "The Dream of a Common Language" (pp. 180–200) and David Gorman's "Davidson and Dummett on Language and Interpretation" (pp. 201–31).

2. It's interesting to note that Jacques Derrida has also written about Joyce and is similarly fascinated by *Finnegans Wake*. Joyce is therefore one of the places where Davidson's work and Derrida's do find some common ground (see note 6 below), though as I argue in an unpublished paper, "Philosophy after Joyce: Derrida and Davidson," their arguments about Joyce finally diverge as significantly as their theories of interpretation.

3. A much fuller narrative of this process can be found in my Introduction to *Redrawing the Lines: Analytic Philosophy, Deconstruction, and Literary Theory* (Minneapolis: University of Minnesota Press, 1989), pp. 3–26.

4. Key texts here in addition to *Philosophy and the Mirror of Nature* include M. H. Abrams, "How to Do Things with Texts," *Partisan Review* 46, no. 4 (1979): 566–88, Charles Altieri, *Act and Quality: A Theory of Literary Meaning and Humanistic Understanding* (Amherst: University of Massachusetts, 1981), and Henry

Staten, *Wittgenstein and Derrida* (Lincoln: University of Nebraska Press, 1984).

5. The Derrida-Searle debate was printed in two issues of *Glyph* as follows: Jacques Derrida, "Signature Event Context," trans. Samuel Weber and Jeffrey Mehlman, *Glyph* 1 (1977): 172–97; John Searle, "Reiterating the Differences," *Glyph* 1 (1977): 198–208; and Jacques Derrida, "Limited Inc abc," trans. Samuel Weber, *Glyph* 2 (1999): 162–254. Stanley Fish's commentary is found in "With the Compliments of the Author: Reflections on Austin and Derrida," *Critical Inquiry* 8, no. 4 (Summer 1982): 693–721, an essay reprinted in *Doing What Comes Naturally: Change, Rhetoric, and the Practice of Theory in Literary and Legal Studies* (Durham: Duke University Press, 1989). See also Shoshana Felman, *The Literary Speech Act: Don Juan with J. L. Austin, or Seduction in Two Languages* (Ithaca: Cornell University Press, 1983).

6. My "Introduction: Davidson and Literary Theory" in *Literary Theory after Davidson* (pp. 1–17) gives a fuller account of this work than I can here and gives a complete bibliography of work on Davidson in literary theory up until 1993. Selected key texts in this regard include Christopher Norris, *The Contest of Faculties: Philosophy and Theory after Deconstruction* (London: Methuen, 1985), Shekhar Pradhan, "Minimalist Semantics: Davidson and Derrida on Meaning," *Diacritics* 16, no. 1 (Spring 1986): 66–77, and Samuel C. Wheeler III, "Indeterminacy of French Interpretation: Derrida and Davidson," in LePore, 477–94.

7. Two good discussions of this question in the secondary literature on Davidson are found in J. E. Malpas, *Donald Davidson and the Mirror of Meaning: Holism, Truth, Interpretation* (Cambridge: Cambridge University Press, 1992), esp. 252–59, and Frank B. Farrell, *Subjectivity, Realism, and Postmodernism—The Recovery of the World* (Cambridge: Cambridge University Press, 1994), esp. "Rorty and Antirealism" (pp. 117–47).

8. Relevant essays here include Steven E. Cole, "The Scrutable Subject: Davidson, Literary Theory, and the Claims of Knowledge" (pp. 59–91), Michael Morton, "Strict Constructionism: Davidsonian Realism and the World of Belief" (pp. 92–123), and Paisley Livingston, "Writing Action: Davidson, Rationality, and Literary Research" (pp. 257–285), which is virtually the only essay to apply Davidson's work on action theory to questions in literary theory.

BIBLIOGRAPHY

Abrams, M. H. "How to Do Things with Texts." *Partisan Review* 46, no. 4 (1979): 566–88.

Altieri, Charles. *Act and Quality: A Theory of Literary Meaning and Humanistic Understanding.* Amherst: University of Massachusetts Press, 1981.

Cole, Steven E. "The Scrutable Subject: Davidson, Literary Theory, and the Claims of Knowledge." In Dasenbrock, *Literary Theory after Davidson.* 59–91.

Dasenbrock, Reed Way, ed. *Literary Theory after Davidson.* University Park: Penn State Press, 1993.

———. "Philosophy after Joyce: Derrida and Davidson." Unpublished ms.

————, ed. *Redrawing the Lines: Analytic Philosophy, Deconstruction and Literary Theory*. Minneapolis: University of Minnesota Press, 1989.

Davidson, Donald. "Communication and Convention." 1982. In *Inquiries into Truth and Interpretation*. New York: Oxford University Press, 1984. 265–80.

————. "James Joyce and Humpty Dumpty." *Midwest Studies in Philosophy* 16 (1991): 1–12.

————. "Locating Literary Language." In Dasenbrock, *Literary Theory after Davidson*. 295–308.

————. "The Myth of the Subjective." In *Relativism: Interpretation and Confrontation*, edited by Michael Krausz. Notre Dame: University of Notre Dame Press, 1989. 159–72.

————. "A Nice Derangement of Epitaphs." In LePore. Oxford: Basil Blackwell, 1986. 433–46.

————. "On the Very Idea of a Conceptual Scheme." 1974. In *Inquiries into Truth and Interpretation*. Oxford: Clarendon Press, 1984. 183–98.

————. *Plato's Philebus*. New York: Garland, 1990.

————. "The Structure and Content of Truth." *Journal of Philosophy* 87, no. 6 (1990): 279–328.

————. "What Metaphors Mean." 1978. In *Inquiries into Truth and Interpretation*. New York: Oxford University Press, 1984. 245–64.

Derrida, Jacques. "Limited Inc abc." Trans. Samuel Weber. *Glyph* 2 (1977): 162–254.

————. "Signature Event Context." Trans. Samuel Weber & Jeffrey Mehlman. *Glyph* 1 (1977): 172–97.

Dummett, Michael. "'A Nice Derangement of Epitaphs': Some Comments on Davidson and Hacking." In LePore. 459–76.

Farrell, Frank B. *Subjectivity, Realism, and Postmodernism—The Recovery of the World*. Cambridge: Cambridge University Press, 1994.

Felman, Shoshana. *The Literary Speech Act: Don Juan with J. L. Austin, or Seduction in Two Languages*. Trans. Catharine Porter. Ithaca: Cornell University Press, 1983.

Fish, Stanley. "With the Compliments of the Author: Reflections on Austin and Derrida." *Critical Inquiry* 8, no. 4 (1982): 693–721. Reprinted in *Doing What Comes Naturally: Change, Rhetoric, and the Practice of Theory in Literary and Legal Studies*. Durham: Duke University Press, 1989.

Gorman, David. "Davidson and Dummett on Language and Interpretation." In Dasenbrock, *Literary Theory after Davidson*. 201–31.

Hacking, Ian. "A Parody of Conversation." In LePore. 447–58.

LePore, Ernest, ed. *Truth and Interpretation: Perspectives on the Philosophy of Donald Davidson*. Oxford: Basil Blackwell, 1986.

Livingston, Paisley. "Writing Action: Davidson, Rationality, and Literary Research." In Dasenbrock, *Literary Theory after Davidson*. 257–85.

Malpas, J. E. *Donald Davidson and the Mirror of Meaning: Holism, Truth, Interpretation*. Cambridge: Cambridge University Press, 1992.

Morton, Michael. "Strict Constructionism: Davidsonian Realism and the World of Belief." In Dasenbrock, *Literary Theory after Davidson*. 92–123.

Norris, Christopher. *The Contest of Faculties: Philosophy and Theory after Deconstruction*. London: Methuen, 1985.

Pradhan, Shekhar. "The Dream of a Common Language." In Dasenbrock, *Literary Theory after Davidson*. 180–200.

———. "Minimalist Semantics: Davidson and Derrida on Meaning, Use and Convention." *Diacritics* 16, no. 1 (Spring 1986): 66–77.

Rorty, Richard. *Consequences of Pragmatism: Essays 1972–1980*. Minneapolis: University of Minnesota Press, 1982.

———. *Contingency, Irony and Solidarity*. Cambridge: Cambridge University Press, 1989.

———. *Objectivity, Relativism, and Truth: Philosophical Papers, Volume 1*. New York: Cambridge University Press, 1991.

———. *Philosophy and the Mirror of Nature*. Princeton: Princeton University Press, 1979.

Searle, John. "Reiterating the Differences: A Reply to Derrida." *Glyph* 1 (1977): 198–208.

Staten, Henry. *Wittgenstein and Derrida*. Lincoln: University of Nebraska Press, 1984.

Wheeler, Samuel C., III. "Indeterminacy of French Interpretation: Derrida and Davidson." In LePore. 477–94.

Wimsatt, W. K. and Monroe Beardsley. "The Intentional Fallacy." Reprinted in *The Verbal Icon: Studies in the Meaning of Poetry*. Lexington: University Press of Kentucky, 1954. 3–18.

REPLY TO REED WAY DASENBROCK

I have no explanation for the fact that I wrote so little and so late about literature and its theory. My undergraduate career centered on literature, English literature and ancient Greek literature at first, developing into comparative literature and the history of ideas as time went by. In my junior and senior years I was increasingly influenced by Harry Levin, John Findley, F.O. Matthiessen, and Theodore Spencer. Philosophy was a thread that ran through the entire period, but it was mainly as part of the history of ideas that it interested me, an attitude which was encouraged by Whitehead. My fascination with literature, literary criticism, and literary theory didn't fade, though I did come to care for philosophy as more than an imaginative way of assembling ideas. During my years at Stanford I often gave a course called Ideas in Literature, which, while it certainly contained criticism and theory, mainly tried to trace the philosophical attitudes imbedded, usually less than overtly, in literature. The readings changed from year to year, partly because I wanted to reread and rethink various plays of Sophocles or Shakespeare or take a new look at Dante or Joyce. I occasionally read a paper at an aesthetics meeting, but was never persuaded these pieces were worth publishing. In subsequent years my standards declined or my confidence increased, and themes and even paragraphs from those early pieces emerged in places like "James Joyce and Humpty Dumpty", "What Metaphors Mean", and "Locating Literary Language". At an intermediate stage a spy reported my interest in Joyce to people in the English Department at the University of Sydney, and I gave a lecture there in the midst of my philosophical activities. What precipitated the printed paper, however, was that while in Norway I was elected to the Norwegian Academy of Science and Letters, and asked to give a paper suitable for a general, though very distinguished, audience. I knew there was an interest in Joyce in Norway (there were two experts in the Academy) in part because a Dublin paper had published an essay on Ibsen in 1900. Ibsen saw the essay, and a correspondence ensued. Joyce is said to have

learned Norwegian to keep up his end, but not one of his letters in Norwegian, unlike his original letter to Ibsen in English expressing his admiration ("I am a young Irishman, eighteen years old, and the words of Ibsen I shall keep in my heart all my life") has survived.

Odysseus is my hero and antihero. He helped hold my course on literature together. Second year Greek at Harvard was Homer—not much of a preparation for Plato or Aristotle, but a wonderful introduction to themes that were to run through much of Western thinking. From the start Odysseus was a stubborn naturalist caught in a god-infested world, kidding around with Athena on the beach in Ithaca. I had my students follow his progress through Dante, Shakespeare, and Joyce, unable at the end to resist the sea (Dante, Tennyson), or driven to walk so far from it that he is asked what he is carrying (an oar: Homer).

As Reed Way Dasenbrock notes, I have always kept in mind that any satisfactory theory of meaning must accommodate the use of language in literature. Despite this, I have never arrived at a view that satisfies me about the semantics of names that fail to refer. Like Frege, I am tempted to hold that sentences containing such names have no truth value, at the same time shying away from the disagreeable complications with which one is faced if one yields to the temptation.

Dasenbrock also mentions my intentionalism, though it is unclear whether he approves of it. In "Locating Literary Language" I was mainly concerned, as I have been elsewhere, with distinguishing the multitude of intentions that nest inside one another in every act, including speech acts. I think the anti-intentionalism of Wimsatt and Beardsley was a sensible reaction against the idea that one should measure the success of a work in terms of what the author had tried to accomplish. But this is to reject only one of the many intentions a writer has as she puts words on paper, and it is absurd to say that as critics we should be concerned with none of them. To take an obvious example, it matters what literal meaning a writer intends her readers to assign to her words; if, with good reason, she expects her readers to understand her words as they would normally be understood in her neighboring times and places, it would be silly to say we might as well interpret those words as meaning something quite different. Of course, there is room for imaginative readings that may or may not have been in the author's mind. But these are interesting only if the author's meaning is also in our minds.

My taste in criticism and theory is shamelessly catholic. I think insights from any angle whatever may enhance our legitimate appreciation and enjoyment of literature. I am not put off by the foolish or extravagant claims of critics whose theories I find vaporous or mad as long as they focus my mind on a work I would otherwise have neglected, or shine a new light on a passage

I had only partly taken in. I like reading biographies of writers I admire, providing they are well written, and I cannot accept the frosty advice that what I learn in this way is irrelevant to my grasp of what is in the writings those lives produced.

D. D.

16

Ariela Lazar

AKRASIA AND THE PRINCIPLE OF CONTINENCE OR WHAT THE TORTOISE WOULD SAY TO ACHILLES

At a party, you offer me a cigarette and I consider your offer. On the one hand, I reckon that smoking a cigarette now would be very enjoyable. On the other hand, I believe that smoking is detrimental to my health. Not only would smoking this cigarette be harmful in itself, I think, but it would also increase the probability of my picking up an abandoned habit of smoking. In short, accepting your offer for a cigarette decreases my chances of leading a long and healthy life. I consider this goal superior to that of enjoying the short-term pleasure to be gotten out of smoking. Given my own values and goals, as well as the extent to which, I believe, accepting your offer would interfere with or satisfy them, I judge that I ought to decline your offer. Next, I take the cigarette, muttering uncomfortably: "Just this once."

In accepting your offer for a cigarette, I act against my better judgment (or: akratically). The action contrasts with my own assessment of what is dictated by my desires, goals, and values. Moreover, I am aware of this contrast. What then is the explanation of my acting in this peculiar way? Or have I really acted against my better judgment?

In a deep and original series of articles, Donald Davidson has attempted to answer both these questions and has set the agenda for the discussion of practical irrationality for a long time to come. Davidson's work mainly addresses the first question—of the nature of the psychological process which leads to akrasia. But in doing so, he also intends to say something about the

second question of whether it is possible to act against one's better judg-
ment. Davidson's discussion of akrasia, as well as that of the more general
topic of irrationality, deviates from philosophical tradition in two ways. First,
Davidson's discussion of akrasia is executed within a comprehensive theory
of mind and action. Hence, his engagement with these questions is rooted in
rather general philosophical considerations and escapes the trap of presenting
obscure or ad hoc solutions (as is occasionally the case in discussions of this
topic). These considerations inform both Davidson's understanding of the
problem as well as his solution. Second, Davidson's discussion of akrasia
disregards altogether the moral aspects of this phenomenon. In so doing, he
focuses on akrasia as a tool for understanding practical reasoning and
choice. This is precisely why Davidson's discussion of akrasia has significance
beyond the strict scope of this problem.

This article will present Davidson's views on why akrasia is difficult to
explain (section II), on how the akratic action is generated (sections III and
IV), and on the role of the principles of rationality in explaining the phenome-
non of acting against one's better judgment (section V). I will claim that,
without intending to so do, Davidson offers two accounts of akrasia which are
incompatible with each other in content and in spirit. The earlier account is
right, I shall claim, whereas its later development should be foregone. I will
also suggest what work is left to do beyond Davidson's first account (section
VI). I start with a brief overview of Davidson's views on practical reasoning.

I. BACKGROUND: THE BASICS OF DAVIDSON'S THEORY OF ACTION

According to Davidson, an action is an event that is caused by the agent's
reasons for performing the action.[1] A reason for acting consists, minimally, of
a pro-attitude, value, or goal of the agent, and her belief that by acting in a
certain way she can promote that goal.[2] More complex reasons involve a
number of different pro-attitudes and a multiplicity of beliefs. Davidson
introduces the term 'desire' to cover the wide range of existing pro-
attitudes. Two relations between reasons and action are constitutive of the
latter being explainable by the former: a logical relation, and a causal
relation. The logical relation makes it the case that an action explanation
rationalizes the action, i.e., it shows why the action is desirable in the light of
the cited beliefs and desires.[3] Davidson's account of action portrays it as
having a rational element at its core: the action must be rationalizable by those
mental states of the agent that bring it about. An intentional action must be
seen by the agent as a means towards promoting (at least) one of her goals.[4]

Davidson's account of practical reasoning is roughly this: various beliefs

and desires are perceived by the agent as relevant to the action which performance he deliberates. Some of these belief-desire sets are taken by the agent to weigh towards the performance of a certain action; some are thought to weigh against the performance of that action.[5] The fact that he has both reasons for and against an action, does not involve the agent in a contradiction: the agent judges certain features of the action to count in favor of performing it and other features to count against his performing it. These small sets of beliefs and desires constitute, according to Davidson, prima facie reasons for and against the action the performance of which is being deliberated. Strictly speaking, 'prima facie' is to be understood in terms of a sentential connective, associating a sentence that specifies possible actions and a sentence that specifies a relevant consideration.[6] Davidson compares such judgments to probability judgments of the form $pr(m_1,p)$, in which 'm_1' represents an evidentially relevant consideration, 'p' represents a state of affairs (to which m_1 is claimed to be relevant), and 'pr' represents a sentential connective (to be read 'probabilizes'). The claim is that unrestricted detachment of p from an argument featuring (m_1,p) and m_1 as premises is unwarranted because there may be another consideration which probabilizes $\sim p$ (e.g., $pr(m_2,\sim p)$). A conjunction of two considerations which respectively enhance and diminish the prospects of an event's occurring does not constitute a contradiction. Similarly, says Davidson, "putting together" considerations, some of which weigh in favor of performing a certain action and some against does not involve one in a contradiction.

In practical reasoning, the agent weighs both reasons for and against a particular course of action. She then forms a practical judgment which is based on the reasons surveyed. Ideally, all of the agent's relevant reasons are considered in forming the judgment concerning the practical question at hand. This, the all-things-considered judgment (ATC) is the most comprehensive judgment to arise directly out of prima facie considerations. It is a conditional judgment—conditioned by the evidence incorporated in the agent's deliberation ("Given all relevant considerations, I should do x").

The all-things-considered judgment is followed by an additional judgment —an unconditional judgment of the form: "I ought to do x" or "x is desirable." The last judgment, an "all out," or outright, judgment is different in form than all of the previous judgments. It is not conditional whereas the others are. The outright judgment is a necessary component of practical reasoning, according to Davidson: it corresponds to a commitment on the part of the subject to pursue the specified course of action. It is, in other words, identical with the agent's intention.[7] The justification for postulating the "all out" judgment as part of the causal history of an action concerns the

possibility of deliberating—of forming a view as to what the best course of action would be (given one's reasons)—and, at the same time, failing to commit to pursuing it. Thus, a person may conclude, following a thorough deliberation, that quitting her job is best, under the circumstances. At the same time, she may have no intention of pursuing this course of action. It is this kind of independence of the intention from the relevant considerations which leads Davidson to claim that it consists of an unconditional judgment.[8]

Normally, the content of the outright judgment corresponds to that of the ATC judgment, that is, the agent forms an intention (and consequently acts) according to the outcome of her deliberation. She acts according to her better judgment. In akratic cases, however, the agent judges that the preponderance of reasons weighs against her performing the action which she eventually performs. The agent has better reasons, by her own reckoning, for opting for a course of action that is incompatible with the one that she opts for.

II. A CONCEPTUAL PUZZLE CONCERNING AKRASIA

Davidson identifies two sources of the paradoxicality of the notion of akrasia: the notion of an action that is done for a reason and the holism of the mental. Only the first source—the notion of an intentional action—is directly relevant to the discussion below.[9] Within the framework of common-sense psychology, practical reasons make the performance of an action intelligible by presenting the agent's point of view, says Davidson: they show why the action makes sense in light of the agent's wants and beliefs. But, in akrasia, claims Davidson, the agent's reasons do not make the action intelligible from the agent's point of view.

Davidson is right and his position should be unpacked in the following way. In deliberating, the agent reflects upon her reasons and forms a judgment as to what she ought to do in light of her reasons. In normal cases, the agent's action *reflects* the content of the judgment. In such cases, the practical judgment explains the action (the judgment itself is explained by the agent's reasons). But in cases of akrasia, the agent's action *conflicts* with her practical judgment. Take, for example, my smoking against my better judgment. A common-sense psychological explanation of this action appeals to a set of reasons (such as the desire to lead a long and healthy life, the desire to not support the tobacco companies, the desire to smoke) as well as my practical judgment which is based on these reasons. But even if we make this explanation as detailed as we like, we end up with something which explains my *abstaining* from smoking. If, contrary to our example, I were to act according to my best judgment and turn down your offer for a cigarette, this action would be explained by appeal to the very same explanation which was cited

in the context of my yielding to temptation and taking you up on your offer. But if this set of reasons would explain an instance of abstaining from smoking (rather than "going for it"), it cannot explain a case of yielding to temptation (rather than abstaining from smoking). It is impossible for one explanation to explain two events that constitute each other's contrast groups. The explanation thus fails to address the question of why I smoked rather than turned down your offer. It follows that, if the explanation of an action by appeal to reasons works when the action corresponds to the agent's better judgment, it inevitably fails when the action is akratic. We must therefore wonder how we can hope to understand the occurrence of akratic actions within the framework of common-sense psychology.

III. The Definition of Akrasia and the First Account

In the case of akrasia, says Davidson, an agent x's (for a reason r) while believing that there is another course of action, y, open to him, which is incompatible with x-ing, and for which he has a reason r "which includes r, and more, on the basis of which he judges [the] alternative y to be better than x."[10] The strongest case of akrasia is that in which the agent acts against a reason based on all of the relevant considerations (a genuine ATC judgment). In such a case, the agent judges that, according to all her relevant beliefs and desires, she should do y, and still intentionally x's, whereby x-ing is incompatible with y-ing. The idea of a genuine ATC judgment, however, ought to be understood as an ideal rather than as a descriptive notion. Most often, practical reasoning is based on a subset of the relevant considerations. Davidson's characterization of akrasia corresponds to this fact: it merely requires that the agent act against a more comprehensive judgment. He seems to identify a better judgment with a more comprehensive judgment, whereas a best judgment is identified with a genuine ATC judgment.[11]

In a widely discussed article, "How is Weakness of the Will Possible?" Davidson offers the following account of akrasia. The akratic agent makes the ATC judgment in favor of x-ing while he also forms the intention to y.[12] If intention and best judgment are understood in the way suggested by Davidson, the akratic agent, who makes both judgments, is not involved in a contradiction since the (conditional) ATC judgment (i.e., 'In light of all my evidence, I ought to do x') is not inconsistent with the unconditional, "all out" judgment in favor of performing y (i.e., 'I ought to do y' or 'y is desirable').[13] This outcome is due to Davidson's construal of a best (or better) judgment as a conditional ATC judgment, and by his identifying an intention with an unconditional practical judgment. In this article, Davidson emphasizes the thesis that akrasia does not involve the agent in a contradictory frame of

mind: "The *akrates* does not, as is now clear, hold logically contradictory beliefs."[14] Indeed, Davidson uses this point in order to undermine a central argument which supports skepticism with respect to akrasia. This analysis of akrasia turns upon a distinction between two different features of propositional attitudes: their justificatory feature and their causal feature. A belief or a desire may constitute a weak reason in the sense that there are other reasons which the agent takes to be better reasons. A weak reason will not be very influential in the formation of the ATC judgment. Rather, the reasons which are deemed weighty by the agent will mostly affect the content of this judgment. At the same time, a weak reason may be effective qua cause in determining the action; whereas a strong reason may not be too effective in determining the practical outcome.

IV. THE SECOND ACCOUNT OF AKRASIA

In more recent articles, particularly in "Paradoxes of Irrationality" (1982), Davidson adds a new element to his account of akrasia. This new element generates an account of akrasia which is incompatible and different in spirit than the account suggested previously in "How is Weakness of the Will Possible?" In the later articles, the agent is said to hold a second-order principle to the effect that she should act according to her ATC judgment.[15] This additional element—*the principle of continence* —is said to involve the incontinent agent in an inconsistency: "pure internal inconsistency enters if I also hold, as in fact I do, that I ought to act on my own best judgment, what I judge best or obligatory, everything considered."[16] The agent is inconsistent since in forming an outright judgment in favor of the akratic action, she goes against her own principle.

In an example offered by Davidson, a man judges that, everything considered, he should not go back to the park to restore to its original place, a branch which he has previously displaced. The agent has a reason for returning to the park, namely his wish to restore the branch and his belief that by returning to the park he will achieve this goal.[17] The internal irrationality of the man's returning to the park is described in the following way: in returning to the park the agent ignores his second-order principle. The desire to return to the park was a reason for returning to the park (a reason which was outweighed by other reasons), but, in addition to that, it also functioned as a reason to ignore the second-order principle: "he has a motive for ignoring the principle, namely that he wants, perhaps very strongly, to return the branch to its original position."[18] However, "though his motive for ignoring his principle was a reason for ignoring the principle, it was not a reason against the principle itself, and so when it entered in this second way, it was irrelevant as a reason, to the principle and to the action."[19]

Davidson uses 'reasons' here in two different senses that should be clearly distinguished. Reasons for an action—*practical reasons*—are, on this view, sets of beliefs and pro-attitudes which cause the action and show it to be instrumental towards satisfaction of desires. But non-practical reasons are different: they are pertinent vis-à-vis the empirical adequacy, truth value (or other features) of judgments and are not markers of instrumentality vis-à-vis the satisfaction of desires. At a certain point in his explanation, Davidson shifts the discussion from practical reasons to non-practical reasons. The following explanation is thus offered for the action depicted in the example: the action of returning to the park is caused by a practical reason (roughly, the desire to return the branch to its original position) that is not very strong qua practical reason (the agent considers the desire to return the branch to be outweighed by better reasons such as the desire to go home together with the belief that his replacing the branch in its original position will not make a great difference vis-à-vis safety, etc.). However, this desire (to return the branch to its original position) is so strong that it causes the agent to decide to disregard his second-order principle. This desire, as seen from the last quote, rationalizes the action of ignoring the principle: it serves as a practical reason for ignoring the principle, although it is not "a reason against the principle." Since the principle of continence is thus ignored, the agent is able to form an outright judgment to the effect that he should return to the park solely on the basis of the corresponding desire. It should be noted that a fuller description of the reasons which cause the agent to ignore the principle of continence must include a belief that the outcome of the act would facilitate the fulfillment of the desire of returning to the park (or some similar belief). Otherwise, the agent's desire to ignore the principle, attributed to him by Davidson, is unintelligible: the desire to return to the park cannot, in itself, explain the action of ignoring the principle of continence.

Davidson's account in "Paradoxes" has two problems. The first, more minor, concern is discussed presently; the other—misrepresenting the role of the principle of continence—is discussed in the following section. It seems as though Davidson introduces two actions where it might be thought there is only one. His contention that "though [the agent's] motive for ignoring his principle was a reason for ignoring the principle, it was not a reason against the principle itself," indicates that he treats ignoring the principle of continence as an *action*. The outcome of this action, in turn, is supposed to facilitate the performance of the akratic action of returning to the park. The auxiliary action (ignoring the principle of continence) is deemed irrational since it is not justified by the reasons that cause it. More precisely, it seems to be minimally justified qua action, although the reasons that cause it do not undermine the principle of continence itself. In fact, one cannot conceive of reasons which would undermine the status of this principle.

Davidson does not seem to be aware of introducing two actions in the

account offered of the park example. He seems to acknowledge a single action when he says that "in doing this [i.e., returning to the park], he ignores his principle of acting on what he thinks is best, all things considered." A sentence of this kind ("in doing A, the agent did B") implies that 'A' and 'B' are two different descriptions of one and the same event.[20] In a typical context in which such a sentence is used, the agent has an ATC judgment favoring action A and acts correspondingly. She has no such reason to do B, but as a matter of fact doing A just is doing B. Clearly, this is not the type of case that is described by Davidson here. The agent described in the example has a motive both for returning to the park and for ignoring the principle. In fact, the action of ignoring the principle is instrumental towards fulfilling the goal of returning to the park.[21]

Postulation of two different actions in each case of akrasia constitutes a considerable prima facie disadvantage for the offered account, even if the peculiar nature of the auxiliary action is disregarded. One would tend to think that only one action is involved when I eat a piece of cake against my ATC judgment, just as there is only one action involved when I eat the piece of cake in accordance with my better judgment. An argument is required to convince us that, unlike an individual continent action, what appears to be an individual akratic action is constituted by two separate actions.

V. The Principle of Continence

According to Davidson's more recent account, the attribution to the agent of the principle of continence makes it the case that his akratic action (as well as the corresponding intention) exemplifies internal irrationality. The agent's holding the principle of continence makes the action irrational from his point of view, it is claimed, since it shows him as acting "counter to his own conception of what is reasonable":

> Only when beliefs are inconsistent with other beliefs according to principles held by the agent himself—in other words, only when there is inconsistency—that there is a clear case of irrationality.[22]

If, says Davidson, the agent does not endorse the principle of continence, his akratic action need not be irrational from his point of view —at least not in a way that poses a problem for explanation; in this kind of case, "we need only say that his desire to do what he held to be best, all things considered, was not as strong as his desire to do something else."[23]

Let us examine this point in terms of the park example. Interpreted according to Davidson's first analysis of akrasia, the agent is said to form the following judgments: given my wish to go home, I should go home; given my

wish to lessen danger to walkers, I should return to the park; given the slight effect that my returning to the park will have on the safety of walkers, I should not return to the park; given all my beliefs and desires, I should not return to the park; I should return to the park. According to the second account of akrasia, in which the agent is said to hold the principle of continence, he also holds: I should act according to my ATC judgment; given my principle to act according to my ATC judgment, I should not return to the park. As can be easily detected, the set of beliefs and desires that is involved in the second account is inconsistent.[24]

Attributing the principles of rationality (as propositional attitudes which figure regularly in practical reasoning) to the irrational agent might be thought to have the following advantage from an explanatory point of view. Attribution of such principles (in the way specified) portrays the irrational agent as inconsistent (in the sense that her judgments imply a contradiction). In contrast, refraining from attributing the principles of rationality as propositional attitudes would not present the agent as inconsistent. It may seem, therefore, that we can ground the akratic agent's practical irrationality in logical inconsistency. In other words, it may be thought that akrasia is an instance of irrationality precisely because it involves the agent in an inconsistent frame of mind. Furthermore, it may be thought that grounding akrasia in strict logical inconsistency would account for the fact that the notion of akrasia is problematic (to the extent that some philosophers believe that it is incoherent). Attribution of such blatant inconsistency to agents who are not self-deceived would be puzzling indeed.

But postulation of the principle of continence as an additional propositional attitude is not required in order to demonstrate the irrationality of ignoring one's ATC judgment. On the contrary, this approach yields a failed attempt to explain what is inherently irrational in the agent's reasoning. This may be the reasoning behind Davidson's inclusion of the principle of continence: an agent may have an ATC judgment to the effect that she should do A, and still judge ("all out") that she should do B (where A and B are incompatible) without getting involved in internal irrationality, since she may deny that she should act according to her ATC judgment. However, if she holds the principle of continence, this response is not available to her.

It may well be claimed, against Davidson, that it is questionable whether an agent may argue in this way once we attribute to her an ability for practical reasoning. Even if we disregard this concern for the moment and grant that it is possible to reason in this way, we will not salvage this account. The reason is simple: a more sophisticated agent who admits to holding the principle of continence, may deny that she believes that she should act according to the principle of continence. In other words, she may reject a third-order principle according to which she should adhere to the second-order principle. Such a

strategy yields yet another version of Achilles' exasperated attempts to reason with the Tortoise.[25]

Lewis Carroll's Tortoise demonstrates that it is a misunderstanding of the notion of entailment to suppose that a premise which explicitly licenses the adoption of the conclusion in light of the other premises is always required if the adoption of the conclusion is to be rational. This is why a person's failure to grasp the relation of entailment cannot be remedied by appeal to additional, higher-order, premises which function in this way. Every such attempt must end in infinite regress. By analogy, we ought to learn from the Tortoise that the principle of continence is not a psychological state (belief or evaluative judgment) which is a required premise in practical reasoning. If we were to view the principle of continence in this way, we would not be able to explain the failure of rationality that is involved in akrasia. In viewing the principle of continence as a mere psychological state, we create the option of the agent's rejecting the principle (or some of its derivatives) in a seemingly rational fashion.

To clarify this point, we may distinguish between the principle of continence, on the one hand, and e.g., one's strongly held principle of avoiding disorderly conduct, on the other. The heart of the difference between these two principles lies in the ways in which they respectively function in action explanations. A principle such as 'I should avoid engaging in disorderly conduct', if it were to play an explanatory role vis-à-vis someone's behavior, will do so primarily by figuring in the agent's practical reasoning. A principle which functions in this way is an *action-guiding principle*. It is possible, in the case of a genuine action-guiding principle, that it always fail to guide the behavior of a given agent without thereby compromising her status as an agent. An agent may be entirely indifferent as to whether or not her behavior is disorderly and so fail to hold the principle which prohibits disorderly conduct. In this frame of mind, the agent in question is no less an agent than someone who is seriously concerned with avoiding disorderly conduct. Action that is never guided by this concern is action nonetheless.

The principle of continence is not a genuine action-guiding principle since it cannot explain behavior in the way suggested above. An agent who shows no concern for acting in accordance with her better judgment is not an agent: she does not act in the same sense that we do.[26] Such an agent does not share our concept of what it is to act for a reason. Acting for a reason implies the notion of practical reasoning, in particular, the notion of assessing and choosing among conflicting goals. Davidson agrees, of course, that the principle of continence is *constitutive* of agency. Still, he may claim that it is also a genuine action-guiding principle—that it explains behavior through figuring in practical reasoning. But this cannot be the case. One cannot reason whether or not one ought to ignore a principle of rationality since the

principles of rationality are constitutive of reasoning. Put differently, an agent may not choose to abide by a principle which is constitutive of agency. The very idea of choice presupposes that the person upholds the principle of continence as a standard. Once the idea of reasoning whether or not to abandon the principle of continence is ruled out, so is the idea that abandoning the principle is an action that is done for a reason. Indeed, this is Davidson's own view of the matter:

> For it is only by interpreting a creature as largely in accord with these principles that we can intelligibly attribute propositional attitudes to it, or that we can raise the question of whether it is in some respect irrational. We see then that my word 'subscribe' is misleading. Agents can't decide whether or not to accept the fundamental attributes of rationality: if they are in a position to decide anything, they have those attributes.[27]

Davidson's second account of akrasia is incompatible with his own view of agency: it requires that the agent *choose* (by way of practical reasoning) to ignore the principle of continence. However, if it is to be viewed as action guiding, the principle of continence may not be viewed as constitutive of agency.[28]

Clearly, the treatment of akrasia in "Paradoxes" is incompatible with the account presented in "How Is Weakness of the Will Possible?" A major project of "Weakness" consists in showing that the akratic agent need not make judgments which are inconsistent with each other. In contrast, Davidson insists in "Paradoxes" that the *akrates* is characterized by a contradictory frame of mind. These accounts also differ in identifying the locus of irrationality in akrasia and, again, the earlier account is superior.

According to "Paradoxes," the akratic agent *reasons poorly* due to the presence of a strong desire: she unjustifiably ignores the principle of continence because of a strong desire to attain some practical goal and, as a consequence, forms an outright judgment that is inappropriate in light of her ATC judgment. This portrays the akratic agent as resembling the self-deceived person whose belief is undermined by the evidence at her disposal. The self-deceived person reasons poorly due to the presence of a strong desire or emotion. Thus, desires and emotions affect the formation of the belief whereas epistemically relevant considerations are less effective in shaping it. In contrast, the earlier account portrays the akratic agent's failure as a failure to *act properly*. According to this account, akrasia does not imply flawed reasoning on the part of the agent. The *akrates* typically deliberates properly—her deliberation unbiased by the presence of strong desires—yet she does not adhere to her own reasonable judgment. The best practical reasons, in the agent's view, are inefficacious in bringing about the corresponding action.

It may be argued, against this intuitive position, and in accordance with Davidson's second account, that akrasia must involve a failure in reasoning since the akratic agent does not merely act, but also intends, against her better judgment. In support of this view, an argument may be devised along the following lines. The akratic agent *intends* poorly: she intends to do A while her better judgment indicates she ought to do B (A and B are believed to be incompatible courses of action). The formation of the intention is the final element in the sequence of practical reasoning, it may be added. If this final element is ill formed, as is the case in akrasia, we must conclude that the agent's reasoning is flawed.

But the argument is not sound. The formation of an intention is not part of practical reasoning in a strict sense. Practical reasoning is the rational procedure by which we determine which action to perform. Once it is determined which action is best justified by one's reasons, the formation of an intention follows in the sequence of events. Once the ATC judgment is made, there is no more room for practical reasoning. The formation of the intention is not deliberated beyond the question of which action one ought to perform. Rather, the formation of the intention merely follows the formation of the ATC judgment and *indicates* that practical reasoning has concluded. The akratic agent's failure is therefore a failure to *act* according to reason, but it is not a failure in reasoning.

VI. WHY IS THE BETTER JUDGMENT FOLLOWED BY THE WRONG INTENTION?

At the top of the paper, I distinguished between two different questions which arise with respect to akrasia. The first question pertains to the possibility of acting akratically and the second concerns the psychological process which produces akrasia. It is easy to see that these two questions are tightly linked. Philosophers have often tried to answer the second question with an eye to answering the first: attempting to identify the process which brings about akrasia with the intention of meeting the skeptical challenge. In identifying the process which leads to akrasia, it is hoped, the skeptical threat according to which it is impossible to act akratically would be overcome.

This seems to be Davidson's strategy in "How Is Weakness of the Will Possible?" The response to the skeptic, which gives the paper its title, essentially consists in describing the psychological process which produces akrasia. By identifying this process, and especially by pointing out that the akratic agent does not entertain a contradiction, Davidson aims to alleviate one of the skeptic's worries: namely, that it is impossible to act akratically since such an occasion would inevitably involve the agent in a blatant contradiction.

In the first account suggested by Davidson, practical reasoning concludes normally with an ATC judgment. In the next step, an intention that does not correspond to this judgment is formed. But now it may be asked why it is that, in contrast to standard cases of action, the ATC judgment which precedes akrasia is causally inefficacious in producing a corresponding intention and action. Why is it that, in cases of akrasia, the ATC judgment is followed by the "wrong" intention? Now, in the standard case, the formation of an intention is explained merely by appeal to the formation of the ATC judgment: a person forms the intention to go fishing this summer, because she judges that, all things considered, this is the best vacation for her. But the formation of the akratic intention is obviously not explainable in this way. How then is it to be explained?

Davidson's first account does not provide a solution to this puzzle—*the puzzle of the deviant intention*; nor is it intended to do so. The account rather lays out the basic sequence of events which lead to akrasia. The psychological process that leads to this type of action, as it is depicted in this account, is identical with the process that leads to a continent action all through the formation of the ATC judgment. At that point, nothing is provided by the first account beyond the statement that, in akrasia, the ensuing intention does not correspond to the ATC judgment. Clearly, this fact does not imply that Davidson's first account is wrong: it merely states in what direction it ought to be supplemented.

Before pointing in such a direction, it is worth noting that even though the second account may appear to provide a better answer to the puzzle of the deviant intention, it does not. The false promises of such a strategy have derailed more than one account of akrasia.[29] In this version, the second account introduces an additional step between the formation of the ATC judgment and the formation of the intention. According to both of Davidson's accounts, the "culprit" desire which causes akrasia is taken into account in the formation of the ATC judgment but is outweighed by other desires: the resulting ATC judgment is incompatible with the satisfaction of this desire. Whereas the first account concludes at this point, the second account goes further. It introduces a new problem which supposedly faces the agent. The problem is whether to adhere by the principle of continence (and act according to her better judgment), on the one hand, or abandon the principle of continence (and satisfy the "culprit" desire), on the other. In this second stage of deliberation, the "culprit" desire prevails.

The lure of such a solution lies in its seemingly addressing the problem of the deviant intention. It purports to explain why the ATC judgment is followed by a "mismatched" intention by introducing another decision problem (and another ATC judgment). Essentially, the agent *chooses* to forego the principle of continence and this results in the problematic mismatch between the initial

ATC judgment and the intention. Once again, we see that Davidson's second account attempts to "rationalize" akrasia by introducing a non-akratic choice which yields the phenomenon. But we also noted that the question of whether or not to abide by the principle of continence is not a genuine practical problem: it is impossible to address by practical reasoning.

In contrast, Davidson's first account does not present akrasia as a consequence of a decision to abandon a principle of rationality. The framework of this account together with Davidson's theory of action, allow, indeed invite, a solution to the puzzle of the deviant intention.[30] The "trick" lies, not in showing akrasia to be a consequence of some odd decision, but, as Davidson himself suggests early on, in realizing that a desire may vary its efficacy (become a stronger or weaker element in determining action) in ways which do not correspond to its role within practical reasoning. Intuitively, in akrasia, one desire (the "culprit" desire) is more effective in determining action than it ought to be. But how effective ought a desire to be? How dominant ought it be in affecting an agent's behavior? In a nutshell, the role of a desire within practical reasoning is assessable only within its *role in a larger network of desires (and beliefs)*. Roughly, the status of a desire qua reason depends on how it relates to other desires: e.g., which desires—if any—it is instrumental towards fulfilling, which desires would be incompatible with fulfilling it, which desires are likely to arise if it is satisfied, etc. If e.g., the desire in question is instrumental towards the fulfillment of central desires, surely its status qua reason is higher. If, on the contrary, it primarily conflicts with the fulfillment of other desires, or is instrumental towards the fulfillment of a few minor desires, it is likely to be a minor reason.[31]

The point is that the efficacy of a desire in determining action may change—increase or decrease—even if its role within the greater scheme of the agent's desires remains pretty constant. Thus, a person's desire for food or for fast cars may increase by being presented with alluring images of the appropriate objects. When presented with a lavish spread, one's desire for food will increase, even though one hasn't acquired new reasons for consuming food beyond one's simply "feeling like eating." Furthermore, this urge may be present and even increase when one has very good reasons for abstaining from the type of food presented (sweet foods in the case of a diabetic agent) or when one isn't hungry in the first place. Similarly, the desire for a red convertible Chevrolet may increase considerably as a consequence of being exposed to the relevant commercials without thereby attaining a higher level of integration between this desire and others. One need not have adopted the idea that life is all about fun, or that red cars make one seem attractive to others, or that they are instrumental towards achieving long sustained goals. Rather, one's desire to own such a car may increase significantly (to the

extent that one is willing to go into serious debt) without any significant change in outlook, related goals, etc. A prominent form of advertising exploits this psychological phenomenon. Without providing the consumer with a *reason* for choosing the targeted product, many advertising campaigns merely manipulate the potential consumers' desire for the product by presenting it in exotic locations, in the vicinity of attractive people, etc.[32] The consumption of the product is related to the appealing surroundings within which it is presented. But one has no reason to believe that one is more likely to visit exotic locations, meet with young models, or become as strong as the car driver on one's television screen. Rather, the desire to own this type of car intensifies without thereby changing its role qua reason merely by the establishment of a strong association between satisfying existing goals, on the one hand, and ownership of such a vehicle, on the other. Thus fast cars are associated with success, sex appeal, and great adventures without their being generally instrumental towards satisfying these goals.

Psychological causes and reasons may "part ways": factors such as physical proximity, imagination, association may affect the intensity of a desire without this being reflected in its status qua reason. Once this is recognized, the road is open for making akrasia an intelligible phenomenon from a psychological point of view. An intense desire which is a minor reason may determine action. This, in a nutshell, is Davidson's first account: it explains how weakness of the will is *possible*. It remains to take it a step further and show how weakness of the will is *plausible*.[33]

ARIELA LAZAR

DEPARTMENT OF PHILOSOPHY
NORTHWESTERN UNIVERSITY
JUNE 1998

NOTES

1. Davidson (1971, p. 46). The domain of actions discussed by Davidson is only that of actions that are done for a reason. For the purposes of the present discussion, such a restriction is suitable since all akratic actions are of this kind.

The essential articles in which Davidson's theory of action is presented are "Actions, Reasons and Causes" (1963), "How is Weakness of the Will Possible?" (1970), "Agency" (1971), and "Intending" (1978).

2. Davidson (1963). A number of action explanations do not involve an instrumental belief but rather involve a belief which merely identifies the action at hand with the goal. Thus, a typical golf player who plays because of his desire to play golf must believe that the activity in which he now engages constitutes playing golf. If the agent lacks this belief, the desire to play golf cannot explain the agent's playing.

3. This does not mean that every action that is done for a reason is rational. This view merely implies that, if an action is done for a reason, some of the agent's reasons must weigh in favor of performing it.

4. Davidson's characterization of intentional action is not intended to rule out the possibility of an agent's lacking awareness of the actual reasons for which an action is done. Even in such cases, it is claimed, the agent identifies a goal which she believes (perhaps subconsciously) may be promoted by the action in question.

5. This passage is based on Davidson (1970).

6. Prima facie judgments are comparative. In the simplest case, the comparison is made between performing a certain action and refraining from performing it.

7. The following passage is based primarily on Davidson (1978).

8. Davidson (1970, pp. 21–42). A number of objections have been raised against Davidson's identification of an "all out" judgment with an intention (e.g., Charles, 1983; Peacocke, 1985), but they are not relevant to the central concerns of my discussion. The points made here stand regardless of the status of Davidson's particular understanding of intention.

9. The second source of trouble identified by Davidson is due to his holistic view of the mental. The gist of the problem is as follows. According to Davidson, the identity of a belief or a desire is constituted by its relations to events and objects in the world, as well as its relations to other beliefs and desires. It is constitutive of the belief that it will rain, to use Davidson's example, that, together with the desire to stay dry, it causes the appropriate action (such as taking an umbrella when leaving the house). Rationality is constitutive of the mental under this view: it establishes the framework within which we understand behavior that is described in mental terms (i.e., in terms of beliefs, wants, actions, etc.). The identities of mental states, according to Davidson, are constituted by the ways in which they function in psychological explanations. The patterns of explanation in which these entities function are rational: we appeal to reasons in order to explain an action; we appeal to the evidence at the subject's disposal in order to explain the fact that she holds a particular belief.

If the behavior to be explained is viewed as deviant (e.g., when the agent does not act on the reasons which she views as superior), holism implies that there is some measure of evidence for saying that the initial attribution of mental states to this subject was incorrect: that the agent did not opt for satisfying the desire which she deemed rather minor after all. Rather, a practical judgment which corresponds to the action may be attributed to the agent. In short, holism creates a theoretical difficulty for acknowledging akrasia since, in akrasia, beliefs and desires do not function normally (i.e., rationally). And the function of beliefs and desires in psychological explanation is constitutive of their identity, according to holism. Hence the problem of explaining an action that is done for a reason and yet does not correspond to the *agent's own* values, beliefs, and judgments. In light of this theory, says Davidson, the task of explaining akratic actions consists in "finding the mechanism that can be accepted as appropriate to mental processes and yet does not rationalize what is to be explained" (Davidson, 1971, p. 46). In other words, this process must meet minimal requirements of rationality (so as to constitute a psychological process in the first place) and, at the same time, yield irrationality.

Davidson's acknowledgment of irrationality in spite of holism is discussed in Lazar (1998).

10. Davidson (1970, p. 40; cf. p. 22). Davidson's requirement that the two competing courses of action be incompatible ought to be replaced with the requirement that the agent *believes* that these courses of action are incompatible. The phenomenon that is investigated by Davidson is that of a discrepancy between one's intention and one's better judgment. This phenomenon may occur even if the agent is mistaken in believing that the two competing courses of action are incompatible. Thus, I may deliberate whether to dedicate my evening to increasing my friend's motivation towards preparing for an upcoming test, on the one hand, or whether to go to the movies, on the other. I may go to the movies, against my better judgment, not realizing that the best way in which my friend's motivation for studying may be boosted tonight is by his recognizing that no help from external sources is forthcoming. In the sense that is important to Davidson's investigation, it would be right to say that I acted akratically.

11. Davidson's notion of an all-things-considered judgment should not be taken to imply that every case of practical reasoning results in a judgment which reflects the agent's consideration of all of the relevant reasons. It cannot be doubted that in almost all cases of deliberation, the agent fails to consider all relevant reasons. Davidson does not state explicitly that most cases of practical reasoning are based on a subset of the relevant considerations, but this interpretation seems to be in keeping with his thinking. His characterization of akrasia lends support to this interpretation. In what follows, unless otherwise specified, I use the phrase 'all-things-considered judgment' ('ATC judgment') to pick out the most comprehensive conditional judgment which figures in a line of practical reasoning, even if that judgment is not based on *all* the relevant considerations. I take it that this is also the way in which Davidson understands this phrase when he distinguishes between better and best judgments: "Our 'best' judgments, I urged, could naturally be taken to be those conditioned on all the considerations deemed relevant by the agent" (Davidson, 1985b, p. 201). It is thus implied that 'better' judgments may be based on a subset of all relevant considerations.

12. According to Davidson, every instance of acting for a reason is preceded or accompanied by an intention. Hence, every akratic action involves an intention (Davidson, 1978). This view will not be assessed here.

13. Paul Grice and Judith Baker (1985) contend, contrary to Davidson, that the two judgments in question ('In light of all my evidence, I ought to do x' and 'I ought to do y' whereby x and y are incompatible courses of action) are inconsistent with each other. Grice and Baker support this claim by saying that an all-things-considered judgment, if it is genuinely based on all the relevant considerations, is conditional in name only. They claim that an ATC judgment entails the outright judgment. Grice and Baker's position is contested in Lazar (manuscript).

14. Davidson (1970, p. 41).

15. Davidson formulates the principle of continence as follows: "perform the action judged best on the basis of all available relevant reasons" (1970, p. 41).

16. Davidson (1982, p. 297). This article is the primary locus of exposition of the new theory of akrasia. Echoes of this account may be found in more recent articles such as Davidson (1985a; 1986).

17. Davidson (1982, pp. 292, 297). The example, as presented by Davidson, offers

a richer description of the person's state of mind. At first, the agent believes that the branch, resting in the path, may endanger inattentive walkers and wishes to reduce danger. After removing the branch from the path, the agent comes to believe that the branch still poses danger to walkers and therefore wishes to remove the obstacle yet again. These details are not relevant to the discussion below. Davidson's example is inspired by Freud's case study of the Rat Man ("Notes Upon a Case of Obsessional Neurosis," Standard Edition, X, pp. 155–249).

18. Davidson (1982, p. 297).

19. Davidson (1982, p. 297).

20. This accords with Davidson's view. Cf. Davidson (1971, p. 53–61).

21. The phrase 'in doing A, the agent did B' allows that the agent has two independent ATC judgments to perform two different types of action and that acting on these judgments happens to constitute one action token (i.e., one event). I may have an ATC judgment to attend the performance of *Aida* by the San Francisco Opera, for example, and have an additional independent ATC judgment to attend any one of the San Francisco Opera performances since I wish to see the building from within and this is the only way by which I may be admitted to the building. It may be added that, had this performance of *Aida* not taken place, I still would have attended an Opera performance in order to satisfy my desire to see the building. In addition, had I been able to view the building without attending any performance, I still would have chosen to attend *Aida* tonight. It is true to say of me, when I act on the corresponding intentions, that in attending *Aida*, I also visit the Opera House.

It may be claimed that this is the relation that obtains between the action of ignoring the principle of continence and that of returning to the park. The claim would be that although Davidson's analysis of akrasia introduces two types of action, they always constitute a single token action. Therefore, it might be claimed, Davidson's analysis should not be seen as introducing two separate actions and is not counterintuitive in this respect. Unfortunately, the respective sets of reasons that rationalize each action in the park example are not independent of each other in the way exemplified above. The motivation for ignoring the principle is the desire to return to the park which also constitutes the motivation for the action of returning to the park.

Against my view, it may be argued that an agent may acquire a reason for performing an action if she believes the action will be identical with an action for which performance she has an independent motive. Thus, say I have no interest in the architecture of the Opera House in San Francisco, but I do wish to attend the performance of *Aida* tonight. Knowing that the performance is to take place at the Opera House, I acquire a reason to visit the Opera House tonight, since I believe that this action will be identical with my attending the desired performance. The claim would be that the relation between ignoring the principle of continence and returning to the park is a relation of identity after all. Seen in this light, Davidson's account would not involve two separate actions such that the first facilitates the performance of the other. Applied to our example, this reading would suggest that the desire to return to the park serves as a motive for the agent's ignoring the principle of continence, in concert with the belief that ignoring the principle will be identical with returning to the park. Hence, Davidson's account of akrasia does not involve two separate actions in place of one.

There is a problem with this interpretation. The belief that ignoring the principle

of continence will, in this case, be identical with returning to the park is rather odd. With respect to the opera example, it is clear how one may believe that visiting the Opera House tonight will be identical with attending the desired show. It is not at all clear, however, what kind of evidence the agent may have in favor of the analogous belief in the park example. How would the agent come to hold such a belief? Note also that this interpretation renders the inclusion of the principle of continence in the agent's deliberation devoid of explanatory power. According to this interpretation, it is only through believing that ignoring the principle of continence would be identical with returning to the park, that the agent acquires the motivation to perform this action: had the agent lacked this belief, she would not have had the motivation to abandon the principle of continence and the unfolding of the akratic action would have proceeded smoothly. According to the offered interpretation, a similar belief must be involved in every case of akrasia. It is rather difficult to see what grounds may be offered to support such a strong claim. This last interpretation of Davidson's account appears to rid us of the need to postulate two different actions in every case of akrasia. Unfortunately, it only does so at the high cost of introducing an unexplainable belief on the part of the akratic agent in each case of akrasia.

We must conclude, I think, that Davidson's more recent account of akrasia involves two separate actions, the first of which is of an especially strange nature. Davidson's formulation suggests that the action of abandoning the principle of continence is explained by the presence of a further goal of the agent's. The detailed analysis of the park example, the only analysis of an example in "Paradoxes", introduces two types of action that do not constitute one token action. Rather, the outcome of one action is supposed to facilitate the performance of the other.

22. Davidson (1985a, p. 348; cf. p. 346, pp. 348–49 and 1982, p. 297).

23. Davidson (1982, p. 297).

24. It is worth noting that, in his writings, Davidson is committed to an even stronger view. In some places, he suggests that if a person violates a principle of rationality that he holds (by e.g., being self-deceived or acting akratically), then he must simultaneously hold a belief and its negation:

> If someone has inconsistent beliefs or attitudes, as I have claimed (objective) irrationality demands, then he must at times believe some proposition p and also believe its negation. (1985a, p. 353)

This contention is not justified even in light of Davidson's more recent account of akrasia. According to this account, the akratic agent need not hold two beliefs which are negations of one another, such as p and ~p. Rather, a set of the agent's beliefs is supposed to imply a contradiction. In what follows I disregard this last, stronger, claim concerning the agent's mental economy and deal with Davidson's contention that the akratic agent is inconsistent. It should be noted that Davidson no longer holds the stronger view (personal communication).

25. Carroll (1895).

26. This does not imply that an agent cannot, in her actions, violate the principle of continence. But an agent whose action violates this principle is always, in a deep sense, committed to it. The agent herself views such an action as defective and problematic precisely because it violates the principle of continence.

27. Davidson (1985a, p. 352).

28. It would be wrong to claim that just because an agent's behavior usually corresponds to the principle of continence, we are justified in taking it as guiding her actions: one's behavior may correspond to different principles without it being guided by them.

29. Examples include Watson (1977) and Mele (1987).

30. For a more comprehensive discussion of this topic, see Lazar (manuscript).

31. Two points ought to be emphasized. First, these comments are not intended to provide a comprehensive discussion of the elements which determine the status of a desire qua reason. They are merely aimed at illustrating the point that the status of a reason depends, to a significant degree, on its relations to other goals. The specification of these relations is explored elsewhere (Lazar, manuscript). Second, these remarks are also neutral on the question of whether there are other elements, outside of the relations of one desire to others, which determine its status qua reason. In other words, this discussion is silent on the status of "external" reasons.

32. The literature on this type of induction of attitude change is vast. Zajonc (1980) and Zimbardo and Leippe (1991) provide excellent overviews.

33. I received valuable comments on this article from Michael Della Rocca, Greg Ray, Bruce Vermazen, and Bernard Williams. Mostly, I benefitted from many conversations with Donald Davidson.

REFERENCES

Carroll, Lewis. (1895): "What the Tortoise Said to Achilles." *Mind* 4: 278–80.

Charles, David. (1983): "Rationality and Irrationality." *Proceedings of the Aristotelian Society* 83: 191–212.

Davidson, Donald. (1963): "Actions, Reasons and Causes," reprinted in Davidson, (1980), pp. 3–19.

———. (1970): "How is Weakness of the Will Possible?" reprinted in Davidson (1980), pp. 21–42.

———. (1971): "Agency," reprinted in Davidson (1980), pp. 43–61.

———. (1978): "Intending," reprinted in Davidson (1980), pp. 83–102.

———. (1980): *Essays on Actions and Events*. Oxford: Oxford University Press.

———. (1982): "Paradoxes of Irrationality," in Hopkins and Wollheim (1982), pp. 289–305.

———. (1985a): "Incoherence and Irrationality," *Dialectica* 64: 345–54.

———. (1985b): "Reply to Paul Grice and Judith Baker," in Vermazen and Hintikka (1985).

———. (1986): "Deception and Division," in Elster (1986), pp. 79–92.

Dupuy, Jean-Pierre (ed.). (1988): *Self-Deception and Paradoxes of Rationality*. Stanford, Calif.: CSLI Series, Stanford University.

Elster, Jon (ed.). (1986): *The Multiple Self*, Cambridge: Cambridge University Press.

Freud, Sigmund (1981): "Notes Upon a Case of Obsessional Neurosis." In *The Standard Edition of the Complete Psychological Works of Sigmund Freud*, translated and edited by James Strachey. London: Hogarth Press.

Grice, Paul, and Judith Baker. (1985): "Davidson on 'Weakness of the Will'." In Vermazen and Hintikka (1985), pp. 27–49.

Hopkins, James, and Richard Wollheim (eds.). (1982): *Philosophical Essays on Freud*. Cambridge: Cambridge University Press.

Lazar, Ariela. (1998): "Division and Deception: Davidson on Self-Deception," in Dupuy.

———. (1999): "Deceiving Oneself or Self-Deceived: On the Formation of Beliefs 'Under the Influence'." *Mind* 108: 265–90.

———. (manuscript): "'Just This Once': Acting Against One's Better Judgment."

Mele, Alfred. (1987): *Irrationality: An Essay on Akrasia, Self-Deception and Self-Control*. Oxford: Oxford University Press.

Peacocke, Christopher. (1985): "Intention and Akrasia." In Vermazen and Hintikka (1985), pp. 51–73.

Vermazen, Bruce, and Merrill Hintikka (eds.). (1985): *Essays on Davidson: Actions and Events*. Oxford: Clarendon Press.

Watson, Gary. (1977): "Skepticism About Weakness of the Will." *Philosophical Review* 83: 32–54.

Williams, Bernard. (1973): "Deciding to Believe." In *Problems of the Self*. New York: Cambridge University Press, pp. 67–94.

Zajonc, Robert B. (1980): "Feeling and Thinking: Preferences Need No Inferences." In *American Psychologist* 35: 151–75.

Zimbardo, Philip G. and Michael R. Leippe. (1991): *The Psychology of Attitude Change and Social Influence*. Philadelphia: Temple University Press.

REPLY TO ARIELA LAZAR

This is a well argued essay, with many valuable distinctions, and useful, measured criticism. Ariela Lazar seems to approve of my first attempt to characterize akrasia (Davidson 1969), but finds my subsequent stab at going further (Davidson 1982) confused and actually at odds with my first try. I think she is right in finding the second paper unclear where the first was straightforward. I also agree that the view she urges me to adopt is, for the most part, the one I should accept. Looking back at these papers now, I have no trouble seeing what bothers her in "Paradoxes of Irrationality." I also find that four years after writing that paper I had changed my tune again, and this time (Davidson 1986) I took pretty much the line Lazar urges on me.

"How is Weakness of the Will Possible?" was not, as Lazar suggests, an attempt to "explain" akrasia, much less to explore the "psychological process which leads to akrasia." Its aim was given by the title: assumptions that seemed intuitively plausible led to a contradiction. These assumptions prompted Plato's Socrates to deny that akrasia was possible, and made Aristotle and many other philosophers deny, in effect, that it was possible for an agent to act freely and intentionally contrary to his own best judgment while realizing that this was what he was doing. The contradiction followed if one believed, as I did, that this was possible. I solved the problem to my own satisfaction by making a major revision in the picture of practical reasoning that I (along with many others) had accepted in "Actions, Reasons and Causes" (Davidson 1963). Moral or evaluative principles could not, I decided, be viewed as universally quantified conditionals such as "Lying is wrong" but rather as weighting principles like "That an act is a lying weighs (morally) against it". The difference is that while the former validates detachment of "A is wrong" given the premise "A is a lying", the latter does not: it only validates the conclusion "That A is a lying weighs (morally) against it". Weighting principles, and the particular conclusions we can draw from them, we may call "conditional". Conditional judgments, even all-things-considered judgments like "The totality of considerations of which I know

(both for and against) favor doing A", do not logically imply "I should do A"; this is the additional step that goes with decision and action. It is this last step that the akrates fails to take; though he acts on some of his reasons, he fails to act on the basis of all the reasons he considers pertinent: he acts contrary to his own all-things-considered (his best) judgment. If this puzzles us, we can explain that in such a case the agent finds she is more powerfully moved by one of her reasons (in Lazar's case, the desire to accept a smoke) than by her all-things-considered judgment (where her reasons include the desire to smoke but also more weighty considerations). Lazar thinks I should have left matters there.

But I was not satisfied. Though I may not have been as clear about it as I became four years later, I felt that there was something wrong with the idea that someone could simply lack, or forget, the principle of continence. This is the principle that says: perform the action judged best on the basis of all available relevant reasons. I concluded that in cases of incontinence "the actor . . . recognizes in his own intentional behavior, something essentially surd." If he recognizes the irrationality in his action, it can only be because he is aware of the principle of continence, and if he is aware of it, he realizes that his all-things-considered judgment entails that he should do something that in his opinion rules out what he is doing. In other words, he has logically inconsistent attitudes. This is what was bugging me when I wrote "Paradoxes of Irrationality" (Davidson 1982), and it explains why I wrote that the akrates suffers from an inner inconsistency. This still seems to me right, though I was surely wrong in saying every form of irrationality involves an inner inconsistency (wishful thinking, which I discussed in the same essay, does not). It is difficult, though, to accept the idea that it is possible for a creature capable of propositional thought to entertain flatly contradictory views, as Lazar says. It is more plausible, I wrote, to suppose the interpretation wrong (Davidson 1982). It was in the attempt to resolve this puzzle that I suggested a Freudian solution. The winning desire, which touches off the incontinent action, constitutes a "motive" to ignore the principle of continence, which is thus rendered ineffective.

It is at this point that Lazar has misunderstood me, though I cannot blame her. The winning desire is a motive, but not a reason, for ignoring the principle (the desire is "irrelevant as a reason"). Ignoring the principle is not an action; the agent does not "choose" or "decide" to do it. Nowhere do I use the words "action", "choose", or "decide". In "Deception and Division" I was clear: "It is no part of the analysis of weakness of the will that the falling off from the agent's standards is motivated."

The main thrust of "Paradoxes of Irrationality," as emerges in subsequent pages, is that there can be mental causes that are not reasons for what they cause. In wishful thinking, a desire that something be true causes the belief

that it is true, but of course the desire is not a reason for believing the thing to be true. (Here it is worth keeping in mind the distinction, emphasized by Lazar, between practical and non-practical reasons.) Similarly, in akrasia, the strong desire to do something one holds to be unjustified by the sum of one's considerations causes one to ignore the principle of continence, though nothing can be a reason for doing this. Neither in wishful thinking nor in akrasia is the relation between the desire that causes and the caused belief or suppression of the promptings of the principle of continence a process of reasoning, conscious or unconscious. I went on to explain the vague and confusing notion of an attitude or principle being ignored or suppressed by again appealing to a Freudian idea, that of a partially partitioned mind. The idea, as I employed it, meant that attitudes in the same mind could be kept from actively interacting, so that the agent remained to some extent protected from the clash that would result from facing unwelcome thoughts or their consequences. I confess that I am by no means sure this solution is any less puzzling than the problem it was meant to solve, but it does not have the flaws Lazar attributes to it.

What Lazar says about the status of the principle of continence is much to my taste. It is not just another premise to be accepted or rejected. It is constitutive of the concept of a creature with propositional attitudes capable of practical reasoning, and so, as she nicely puts it, "An agent who shows no concern for acting in accordance with her better judgment is not an agent." To think of it this way is, I agree, to hold the principle to be like a rule of inference rather than a premise. There is no reason, though, to suppose that an agent cannot articulate a rule of inference, and consciously employ it in reasoning, just as she can, on occasion, fail to employ it.

Finally, I would temper these final remarks as I did in "Deception and Division" (Davidson, 1986, pp. 82, 83). In a logic book the distinction between premise and rule of inference is clear, but in actual reasoning it is not. In the same way, I would hesitate to insist on a sharp boundary between principles that are constitutive of rationality and the norms of a particular culture, society, or group.

D. D.

REFERENCES

Davidson, Donald. 1963: "Actions, Reasons and Causes". *Journal of Philosophy* 60: 685–700.
———. 1969: "How is Weakness of the Will Possible?" In *Moral Concepts*, edited by J. Feinberg. Oxford: Oxford University Press.

————.1982. "Paradoxes of Irrationality." In *Philosophical Essays on Freud*, edited by R. Wollheim and J. Hopkins. Cambridge, UK: Cambridge University Press.

————. 1986: "Deception and Division". In *The Multiple Self*, edited by J. Elster. Cambridge, UK: Cambridge University Press.

17

Marcia Cavell

REASON AND THE GARDENER

What interested me was not a philosophy of the free man . . . but a technique: I hoped to discover the hinge where our will meets and moves with destiny, and where discipline strengthens, instead of restraining, our nature.

—Marguerite Yourcenar, *Memoirs of Hadrian*

In his various essays on irrationality Davidson confronts a problem that seems to threaten his views about the mind at the most fundamental level. He has argued that the content of a mental state like a belief or a desire is constrained by its normative relations with other mental states in a holistic mental network. Rationality, it follows, is not an optional feature of the mind but among the very conditions of its existence. The problem is that such a view seems to fly in the face of the fact that often we are irrational, as when we deceive ourselves or incontinently act adversely to our own will. Davidson seems to have defined an obvious aspect of human nature out of existence. My thesis is that his solution, with a little help from Freud, both homes unreason and discovers hidden richness in its parent concept, rationality.

Davidson's solution, we recall, is based on the premise that while typically the mental causes that explain an action are also the agent's reasons for doing it, sometimes a gap opens between these two explanatory schemes. When it does, cause and reason fail to coincide in a way that admits irrationality. Davidson asks us to consider first a case in which the cause and the effect occur in different minds:

> wishing to have you enter my garden, I grow a beautiful flower there. You crave a look at my flower and enter my garden. My desire caused your craving and action, but my desire was not a reason for your craving, nor a reason on which you acted. (Perhaps you did not even know about my wish.)[1]

This is a straightforward instance of intentional behavior on the part of two persons, an instance whose interest lies in the fact that A provides B with a reason for acting in such a way that A's end is achieved, even though B does not do what she does with A's end in mind. B acts for a reason, but it is not A's reason, which moves B merely as a cause.

Though there is of course neither paradox nor necessarily any irrationality in the two-person case, nevertheless it makes clear, Davidson continues, that "mental phenomena may cause other mental phenomena without being reasons for them . . . and still keep their character as mental, provided cause and effect are adequately segregated"; and so the two-person case suggests a strategy for dealing with irrationality in the solitary mind. The strategy, which incidentally throws light on Freud's ideas both of mental mechanisms and of 'splits in the ego', is to posit mental causes that are reasons, but not in relation to the effects they cause. When such nonrational mental causation is at work, the single mind may to some extent resemble a duality of minds, or a mind that is, as we familiarly say, divided within itself. I return later to self-division. But first I want to look at some interesting implications of this strategy at which Davidson himself hints.

In the last two paragraphs of the article just quoted Davidson remarks that the presence of causes that are not reasons for what they cause is a necessary but not a sufficient condition for irrationality, since such causes play a role as well in a certain cherished form of rationality. There are of course trivial cases of nonrational mental causation, as when the thought of forks reminds me of spoons—a caveat which already opens the door to processes of various sorts that escape the paradigm of practical reason. But far more interesting, Davidson goes on:

> is a form of self-criticism and reform that we tend to hold in high esteem, and that has often been thought to be the very essence of rationality and the source of freedom. . . . What I have in mind is a special kind of second-order desire or value, and the actions it can touch off. This happens when a person forms a positive or negative judgment of some of his own desires, and he acts to change these desires. From the point of view of the changed desire, there is no reason for the change—the reason comes from an independent source, and is based on further, and partly contrary, considerations.[2]

I'll call this the problem of self-transcendence. The cases that pose it, or that deserve the account just given, resemble irrationality in bringing to light something approaching paradox in our concept of the self. It may be helpful then in understanding both irrationality and this special form of reason to get the latter right.

The mere having of incompatible desires is not the case we are considering. In such a dilemma the agent looks more closely at what each desire entails and decides, if possible, which desire is the more important to her. Conflict of

this sort can be difficult, even paralyzing, but it is not conceptually puzzling. Nor is it if, moved by a desire of which I know you disapprove, I find I value your approval more than the satisfaction of my desire and so, only to please you, act when you are around as you would like me to. If there is someone that I wish were different in this instance it is less likely to be myself than you. The puzzle cases are rather those in which I have decided, apparently, by which desire I want to be moved; yet this desire finds an obstacle in the way of another desire of my own, the so-called first-order desire. At the extreme, I am then like the woman in Purcell's song who wants to fly from love's sickness but finds that she is herself her own fever.

Where the incontinent person remains fevered, however, betraying her own values or desires and so herself, the reasonable person instead gathers her conflicting desires under a banner to which she can give her allegiance and acts accordingly. Yet how does she manage it? If the incontinent act is irrational, it also seems to be, once one is in the state from which the act issues, inevitable. For how can one who desires to have different wants find a point of leverage on her wanting self? She must act intentionally, yet contrary, it seems, to desires that are easily urgent enough to lead her down another path. Augustine thought the problem so difficult as to require the grace of God. Freud appeals to the analyst and his 'therapeutic alliance' with the patient's 'healthy ego'. Davidson invokes yet something else in his talk of a kind of intentional behavior in which causes that are not reasons are at work. Here is how I see the sort of actions that might call for this description.

Suppose that I want to stop smoking. Since smoking doesn't befall me, as fits of coughing may, but is an activity I intentionally, if habitually, perform, we are in the domain sketched above in which one wants to change one's own effective wants. Clearly there is little available in the mental network closest to the desire to smoke which allows me to put my countervailing desire straightway into effect. This is my problem. And berating myself every time I fail in my resolve is only apt to enflame the anxiety that causes me to smoke. Yet there are things I can do, and do intentionally. For example, if I have been wanting to go white-water canoeing, an enterprise which I incidentally know will reduce the chance and even perhaps the desire to smoke to a minimum, I might sign on for such a trip, hoping to use it as occasion to change my ways. I play the gardener to myself by appealing to a desire x, the enacting of which will set a causal chain in motion that may eventuate in the satisfaction of a desire y which I am not able to achieve directly. Or if I am tired of my tendency to procrastinate writing letters, I might thrust myself into a position which allows no time for delay. Or if I would like to stop getting into wrangles in trivial matters, I might try diverting my own attention or the conversation when I see a wrangle in the offing.

Though just which strategy will be effective will vary from case to case

and person to person, the strategies agree in that one does something intentionally in the hope of changing a pattern of behavior of which the targeted desire is a part. If I am successful I will have done something I wanted to do; and my wanting was not irrelevant to my success. But to say *tout court* that I stopped smoking because I wanted to, wouldn't do justice to the complexity of the causal story, which includes intermediate and devious goals, and things that more or less happened to me along the way.

Changing bad habits like the ones in these examples is hard enough. But it is child's play compared with the difficulty of changing a characterological trait like the tendency to envy another's good, or to spoil his pleasure in his beautiful flower because it isn't one's own, or to take one's own misfortunes more seriously than one thinks seemly, and so on. Here we are up against things which most truly reveal who we are and before which we feel all the more helpless.

Let's revert again to the gardener, who seeks to lead his neighbor voluntarily into his garden by giving her a goal which will coincidentally achieve his own. His hope is that once she is in the garden and has come to know the gardener, sometimes her reasons will be his reasons in that he and she will enter into ventures which require the sharing of many goals in common. Towards this end he may have taken the trouble to learn that it is gardens and not, for example, antique cars to which she is susceptible, daffodils and not roses. So like the gardener the envious person may need to become a good detective, noting in what circumstance the envious wish takes hold, what anxieties emerge if he doesn't act on it, what old conflicts the circumstance reminds him of, and so on—the sort of thing that may go on in a psychoanalysis. Old splits begin to heal, bringing slightly new ways of seeing and feeling; or armed with such growing knowledge about his wishes and fears, the envier may see how to interrupt the old habits.

We might summarize the difference between the irrationally incontinent and the rationally continent persons in this way: Emma, who falls into incontinence, and Isabel, who manages to avoid it, are at the same fork in the woods. Emma, however, takes a familiar path marked out by habits of various kinds, towards an end which will incidentally (or not so incidentally) yield a familiar self-dismay. Isabel, minding and remembering that dismay, so knitting it into the fabric of her self, finds incentives to lead her in a different direction, one which may begin to put new habits into play. Only if we construe habit as more mindless than it is, and intention as less a matter of habit and of practice, should Isabel's behavior puzzle us. Dewey remarks that we tend to think of bad habits and dispositions as forces outside ourselves. We tell ourselves, truly, that the habit was not deliberately formed. "And how can anything be deeply ourselves which developed accidentally, without set intention?" But all habits, Dewey continues, are "demands for certain kinds

of activity; and they constitute the self. In any intelligible sense of the word will, they *are* will. They form our effective desires and they furnish us with our working capacities."[3]

Viewing action as set in motion by desire, the paradigm of practical reasoning takes desire itself as a given. Often, however, desire grows slowly from the things one does, not necessarily out of desire at all, or in any case not for just those doings. Desire by definition is a state of want, yet for what may not be clear. Habits are the material of desire; desire rises to the surface on a sea of practice. The so-called first order desires are just those fully formed desires which, unopposed by older desires more deeply ingrained in our behavior, come with the means for acting on them attached.

Dewey goes on to say: "If we could form a correct idea without a new habit, then possibly we could carry it out irrespective of habit. But a wish gets a definite form only in connection with an idea, and an idea gets consistency and shape only when it has a habit in back of it" (p. 30). This passage contains yet another idea which helps clarify the puzzles inherent in self-transcendence, namely that how much content an idea has is a relative matter, depending on the extent to which an idea has been worked into the fabric of the mind or the self. As Socrates demonstrated to his interlocutors again and again, one may, for many reasons and in many ways, 'have' an idea one doesn't truly understand.[4] (Freud construes 'repressed' ideas as ones which though temporarily opaque to the agent, are intrinsically as full of content and intelligible as any other. Such thoughts there may be. But some of what emerges after resistance has been removed might be better explained as content acquired just in the process Freud calls 'working through'.)

So now we might ask: Does the person who wishes to be less envious know what he wishes? I suggest that the answer is, Not quite; because by hypothesis the wish stands outside that organization of behavior, desire, and belief which expresses itself in the person's most characteristic or unconflicted actions. The following is admittedly too simple, yet I think something like it is right: If the ashamed envier fully knew what he wished in wanting to be a less envious person, then he would know what it would be like *for him* to act, and to be disposed to act, like a less envious person; and if he knew that, then that is the person he would be.

In sum: Desires—the sort of thing which can be reasons—are enmeshed in an ever changing network which includes dispositions, habits of responding, perceiving, and behaving. The beliefs and desires we single out as emblematic mental states are abstractions from a mental field that includes habits built up over a long time, acts of attention that are not guided by but that help to mold intention, patterns of salience that constrain and predate our full emergence as thinking creatures, thought associations of a relatively mechanical character, and so on. This mental field includes mental states which are sometimes

causes but not reasons, yet causes which can shape the sorts of effective reasons one forms. There are continuums, then, between one's less than fully deliberate will and what is one's will in the fullest sense, between habit and intention, between thoughts that are thoroughly incorporated into the network we call the self and thoughts just entering it at the edge. Taking our future selves in hand may require attending to any of these strands in the constantly shifting web.

Now I would like to return to irrationality, and to push Davidson's account a little closer to Freud's, in ways compatible with the view of reason just suggested. Before amending Davidson's account, however, we need to fill in more of its detail. He has argued that making sense of someone requires us to attribute to her various maxims of rationality, including the maxim he calls the principle of continence, or doing that which, all things considered, one thinks it best to do. The irrational agent is not one who altogether lacks this principle—such an *agent* there cannot be—but one who manages to bracket it off to one side.

As an example of such a 'bracketing' Davidson gives a variant of an incident in Freud's case history of the Rat Man.[5] A man walking in a park stumbles on a branch. Thinking it may be dangerous to others he removes the stick and throws it in a hedge beside the path. On his way home, however, it occurs to him that the branch may be dangerously projecting from the hedge, so he returns to the park and replaces the branch in the road. Both actions are rational in and of themselves, for in each the man acts in light of a reason, a belief-desire complex which is necessary to explain the action. If he had not had these reasons he would not have done what he did; so the reason in each case is also a cause.

The irrationality consists not in doing either of these actions, nor even in doing both, but in the fact that in returning to the park to replace the stick the man intentionally ignores not only his own initial reasons for removing it but also the principle of continence. He has a motive for ignoring it, namely that he wants—perhaps for very strong unconscious reasons—to restore the branch to its original position. Presumably he believes he will be less anxious or somehow happier if he does. But this motive enters his reasoning twice over, first in overruling his own reasons for removing the stick, and second in overruling the principle of continence. In brief: the irrational agent wishes not to act on his judgment of what it would be best to do, all things considered, and this wish causes him to put the principle of continence to the side. An explanation of such irrationality draws a boundary, then, between two groups of largely overlapping mental states, only one group of which contains the principle of continence. Desire, the sort of thing that can be a reason, causes one to do something for which there can be no *good reason*, namely to act without considering the consequences of one's action, or without taking all the

consequences one has considered into account. There can be no good reason for putting the principle of continence to one side since it is a principle constitutive of reason itself. The postulated boundary is not to be thought of necessarily as a line between conscious and unconscious mental states but merely as a conceptual aid in giving a coherent description of certain genuine irrationalities.[6]

Freud also recognizes the need for something like the principle of continence in describing irrationality. It is because he does that he is moved in *The Ego and the Id* to revise his topography of the mind.[7] He had earlier envisioned internal or intra-psychic conflict as taking place between consciousness and the system Unconscious, one 'self' knowing but not wanting to know, the other genuinely ignorant, with 'the censor' located more-or-less on the side of consciousness. But he came to see that among the facts not pictured by this model is that 'the repressed' does not merely happen to be unconscious but is actively kept out of consciousness, and by a repressing agency which is itself unconscious of what it does. So partly for this reason Freud introduces the structures 'id', 'ego', and 'super-ego', to cut across the conscious/unconscious divide. Much of the ego ('das Ich') is repressed; but the ego is also that which acknowledges and attempts to reconcile conflicting beliefs and desires, and in doing so sometimes represses. Freud's 'ego' is that agent who—because he or she implicitly acknowledges such principles of rationality as we have posited—can be said to repress and to 'split'.

In the following passage from a late essay, "Splitting of the Ego in the Process of Defence" (1940[1938]), Freud writes:

> He [the child] replies to the conflict with two contrary reactions, both of which are valid and effective. On the one hand, with the help of certain mechanisms he rejects reality . . . on the other hand, in the same breath he recognizes the danger of reality, takes over the fear of that danger as a pathological symptom and tries subsequently to divest himself of the fear. . . . But everything has to be paid for in one way or another, and this success is achieved at the price of a rift in the ego which never heals but which increases as time goes on[8]

Freud tells us more about the 'mechanisms' he has in mind when he writes in "Writers and Day-Dreaming:"

> every child at play behaves like a creative writer, in that he creates a world of his own or, rather, re-arranges the things of his world in a way that pleases him. . . . In spite of all the emotion with which he cathects his world of play, the child distinguishes it quite well from reality; and he likes to link his imagined objects and situations to the tangible things of the real world. This linking is all that differentiates the child's play from 'phantasying'. . . .[9]

It is clear enough what Freud has in mind by 'the playing child': he pretends that the broom is a horse, the rock a lion, knowing all the while he is

dealing with rocks and lions. But how are we to understand the phantasizing adult who 'gives up the link with real objects'? Surely Freud does not mean merely that the adult pretends without the aid of any props, nor that her phantasy makes no reference to objects; for words do not lose their normal ties to things in the world when they are employed in the making of a fiction. Freud does mean that while the phantasizing adult also knows that rocks aren't lions, and so on, yet she brackets off a part of what she knows, does not heed such rational principles as 'Believe that proposition for which you have the best evidence', and so is able to hold apart incompatible recognitions and beliefs, some of which she would have to revise or give up were she to put them all together. Freud calls just this bracketing 'the splitting of the ego'.

So far, then, Davidson and Freud agree in saying, first, that interpretation requires us to think of the mind as largely rational; second, that the irrational agent is able to hold beliefs or wants that he knows to be incompatible apart; and third, that irrationality of this sort forces us to think of what we call the mind as less an indivisible unity than is our custom. Like Davidson, the Freud I am invoking (there is another Freud who insists on the primacy of instinct) endorses an idea of the divided mind according to which desire, appetite, and belief are strands in a mental fabric of a generally rational character. Freud and Davidson agree in a view of irrationality quite different from Plato's division of the soul into a rational rider and two horses of a different color.

The notion of phantasy in Freud's picture, however, makes some important additions to Davidson's. In phantasizing, as Freud conceives it, the agent wishfully envisions that x is the case, and comes more-or-less to believe that it is. One difference between Freudian phantasizing and the sort of wishful thinking Davidson investigates is that the latter sort has the structure of a full-fledged intentional act. I wish to believe that x because I think I will be happier if I do; and so I seek out evidence to foster that belief. An analysis of this mental act would include a means-end belief, even though not articulated by the agent, to the effect that it is *this* evidence which will foster the desired belief.

Surely such wishful thinking happens. But I believe Freud would hold, and would be right to hold, that to ascribe a fully intentional structure to the sort of wishful thinking he has in mind would be a bit of philosophical legislation untrue to the phenomena. In phantasizing, the causal connection goes straight from an anxious wish that such and such were the case, or more typically that it were *not* the case, to an envisioning of the world in accordance with the wish. Wish (typically anxious) or desire causes an imagining, and when it does, *it is as if*—as Wollheim says— *the desire were gratified*. Desire characteristically expresses itself in imaginative acts, Wollheim adds, which tend to leave the imaginer in a condition appropriate to what they represent. Angry and wishing to express one's anger in a violent form, one imagines

doing so and feels to some extent gratified in the process.[10]

If Wollheim and I are right in thinking that philosophical psychology needs a concept of phantasy so defined, then there is at least one kind of mental mechanism different from the one Davidson discusses. Furthermore, it is crucial to phantasizing that, as will become clear shortly, it typically takes place in childhood and tends to perpetuate itself in relatively sequestered substructures of the mind.

So now with the concept of phantasy in the background, together with our earlier discussion of habit, let's see how Freud tells the story of the man and the stick that we looked at earlier:

> One day, when he was out with her [his lady] in a boat and there was a stiff breeze blowing, he was obliged to make her put on his cap, because a command had been formulated in his mind that *nothing must happen to her*. This was a kind of *obsession for protecting*, and it bore other fruit besides this. . . . On the day of her departure he knocked his foot against a stone lying in the road, and was *obliged* to put it out of the way by the side of the road, because the idea struck him that her carriage would be driving along the same road in a few hours' time and might come to grief against this stone. But a few minutes later it occurred to him that this was absurd, and he was *obliged* to go back and replace the stone in its original position on the road.[11]

The man's narrative begins with a tale of dreadful punishment involving rats, a tale by which he is obsessed and which he vividly imagines happening to his father and his 'lady'. At first this obsession presents itself as 'just a thought'; but the fact that his feelings about this 'thought' are fascination and anxious guilt suggests that he is envisioning this punishment for his father and his lady, and that for him it is as if what he envisions were about to come true. Freud links this incident to the rat obsession, to others of the man's obsessively violent thoughts, and to his bizarre compulsion to work until late at night, followed by his masturbating in front of the mirror. This last compulsion Freud analyzes, in part, as the acting out of a phantasy that the father he knows is dead is alive, and properly horrified by the man's defiantly exhibitionistic behavior.

Recall that on Davidson's analysis the irrationality of the man's behavior with the stick/stone enters at the point at which he ignores his own best all-things-considered judgment. I would say instead that in this instance there is no such judgment at all. Davidson's account of irrationality may more or less fit something that happened at some time in the agent's past. But whereas Davidson construes the division merely as a logical necessity of our analysis, I construe it as a full-fledged psychological event, perhaps recurring repeatedly with the recurrence of the traumatic situation, and creating a kind of psychological fault that persisted over time, consolidating habits and processes that have rendered the agent incapable of genuine all-things-

considered judgments in certain situations now. (By a 'genuine' all-things-considered judgment I mean one which sees, is able appropriately to weigh, and attempts to take account of the relevant facts; it is not the mere uttering of the formula 'this is my all-things-considered judgment'.) On the fuller concept of division that I am urging, the split-off structure precedes the irrational act; it is not another description of it in philosophical language, but an empirical explanation of how it can occur.

In the typical cases of 'Freudian' irrationality the split-off mental structures are created by relatively early anxiety and around phantasy. For imagine that the anxiety situation which initiates a split-off structure is chronic—for example, a threatening ever-present father and a seductive mother—and that the phantasy which bails the child out is one on which he comes habitually to rely. Then habits of misperception may begin to settle; the exiled structure begins to crystallize and consolidate.

It is such a structure which Freud's interpretation reveals behind the Rat Man's act of putting the stone back in the road. The structure contains his early hatred toward his father, perceptions of him as very powerful, a 'projection' of his own anger onto his father, perhaps misperceived as angry towards him, self-deceptive feelings of his own innocence, certain early beliefs (for example, that his thoughts are visible to others and endowed with a kind of magical power), and the tendency to see other persons either as objects of his desire or impediments to it, a tendency which has presumably governed his relations with the world from early childhood. The structure is marked as a whole by confusions between past and present, between what is and what one wishes there were, even between what are genuinely pleasurable thoughts and what are thoughts that are 'pleasurable' only in that they help ward off anxiety.

Thus early on the 'split' takes on character, dividing fragmentary impressions, together with phantasies formed as a defense against them, on the one hand, from more occurrent perceptions in potential conflict with the phantasy structure, on the other. There is a split between the past, as now both embedded and rewritten in phantasy, and the present. What started out as a wishful belief acquires the force and structure of a habit, a way of acting, a way also of perceiving, that reinforces the initial avoidance. Old fears, old memories both veridical and false that might have a very different meaning now if one reflected on them, are preserved. Furthermore, given that the imagination works in the associative way it does, more and more situations may come to remind the phantasizer of what he doesn't want to confront: If I avoid reflecting on x because it makes me anxious and x reminds me of y, then I avoid thoughts of y as well. So in that sense new thoughts are drawn into the structure that is split off.

Freud saw a crucial link between early childhood anxiety and repression.

Such there may be, simply because in childhood one is so vulnerable, and not yet able to deal with dangers in the world by taking the appropriate actions. A kind of psychic flight, or looking away, together with what Freud sometimes calls hallucinatory wish-fulfillment, may be the only defense at the child's disposal. Furthermore, the child has not articulated many of his own thoughts, not because he is in the grip of a pre-rational yet symbolic process that is intrinsically different from the ones inflected in language but because he hasn't yet acquired the techniques of spelling them out.

Davidson's account of irrationality is meant to be highly abstract; he explicitly says that he is not giving the psychological detail which would be required in a given case. But as applied to the episode of the stone in the road, and others like it, Davidson's account doesn't do justice to the fact that the divisions of the self are neither of the same temporal order, nor the same order of agency: in the main structure, occurrent beliefs and desires open to evidence and subject to revision in the ordinary way, along with the capacity for all-things-considered judgments; in the sub-structure, beliefs and desires that are embalmed, increasingly alien to those of the present, and inappropriate in light of present experience. When this sub-structure is activated, judgment is temporarily clouded, or in abeyance. Freud's story reminds us that beliefs and desires are enmeshed in habits, often of long standing, so that time must frequently be taken into account in a picture of adult irrationality. One of Freud's favorite metaphors for the mind was Rome, a city in which new structures often do not replace the old but are simply erected on top of or within the ancient ruins.[12]

Let's go back now to those non-mental causes that move the agent to act in a continent, rational, self-transcending way, and ask whether, like the desire to put one's own all-things-considered judgment to the side, such causes also threaten holism. Davidson does not address the question directly, but he seems to imply an affirmative answer in writing that "from the point of view of the changed desire, there is no reason for the change—the reason comes from an independent source. . . ." It's an interesting remark, for it suggests, as I argued above, that the source of desire is relevant to the question of irrationality. In division, I maintain, the source is often a mental constellation that precedes the irrational act and that is relatively distant, in ways that I tried to account for and elucidate, from the beliefs and desires which the agent acknowledges.

This point is connected with another which Davidson's metaphor misleadingly obscures: it is of course never desires but only desirers who have reasons and points of view; and in the continent act, I certainly do have reasons for denying one of my own desires. My desire to stop smoking flows from and into a great many other desires of mine; it is because it does, and because *I* see that smoking is incompatible with other states of affairs which *I* value more highly, that my desire to stop may win out in the end, providing

both cause and reason for the first step in my new direction. Nothing here compares to the banishment of a constitutive maxim of rationality in incontinent action. On the contrary, the reformed smoker is the very image of the continent person, the reasonable person who is free in the sense that her wants are *hers*, that she finds on reflection that she more or less does what she wants to do and wants to do what she does.

The desires that issue in the continent or self-transcending action are then *not* non-rational causes, nor are they inimical to holism. The opposite of a divided self is not a Cartesian, unitary transcendent ego but a self that is integrated; and in the context of the idea of a self the concept of integration implies the possibility of conflict, process, degree, effort, and luck. The continent desire that, with all its attendant beliefs, desires, and memories, brings other structures into its orbit, is achieving greater integration. Non-rational mental causation enters the story of how this happens not with the desire to stop smoking per se, but only when we are pressed to say how this desire becomes efficacious.[13]

The passage quoted earlier from Freud's "Splitting of the Ego in the Process of Defence" concludes: "we take for granted the synthetic nature of the processes of the ego. But we are clearly at fault in this. The synthetic function of the ego, though it is of such extraordinary importance, is subject to particular conditions and is liable to a whole number of disturbances." The moral is that the self is a constructed 'thing'; that the process of construction is always ongoing; that it is fragile, subject to deconstructive vicissitudes. Which brings me to a final point of comparison between Freud and Davidson.

Some may be struck as forcibly by a certain salient affinity between them, beyond the ones just discussed, as by an apparently profound irreconcilability. But I think there is a way of looking at the matter that casts both Freud and Davidson in an interestingly different light. The affinity consists in the importance they give to interpersonal relations in the forming of the mind, in their holding that what we call the self, or mind, is partly constituted out of its relations with other selves.

Davidson argues that to have a belief one must have the concept of an objective world in relation to which one's beliefs can be said to be true or false. How does a creature acquire such a concept? A necessary condition, Davidson answers, is that the creature be in communication with another creature in the presence of objects available to them both. We are invited to think of these two creatures as child and an adult, and to imagine that over time certain similarities in the responses of each to a variety of common objects enable the child to mean 'I want an apple' when she says "apple," and to intend to communicate this meaning to the adult. So, concepts, necessarily a great many in concert, are slowly figured. Davidson calls this condition 'triangulation', and he specifies that its three apexes are my self, other selves,

and external material world, with language as the baseline.

Freud argues that what he calls Oedipal triangulation, consisting of child and two other persons with whom the child is in intimate and prolonged contact, is the indispensable condition for the formulation of guilt, moral ideals and conscience, also the capacity to see oneself from the imagined perspective of another, to comprehend the other as an other, and to form pictures of oneself as one would like ideally to be. 'Oedipal triangulation' is arguably, then, not a superimposition on an already existing self but partially constitutive of it.

Freud dates the Oedipal period somewhat later than the acquisition of language *per se*; and here enters the apparent incompatibility with Davidson, since for him language distinguishes the mental from the non-mental while it only divides the conscious from the unconscious mind for Freud. Freud and Freudians contend that before there is rational mentality there is a primary process a-rational mentality to which concepts like the true and the false are alien. Freud invokes this Ur-mentality in accounting for the ways in which certain of the Rat Man's phantasies are out of touch with time and the world. Primary process, Freud thinks, is the pre-historical foundation on which every city of the mind is founded.

But there is a way of resolving this difference to the advantage, I think, of both Davidson and Freud. As for the latter, I would argue that insofar as the concept of 'the unconscious' is psychological rather than neurological, as it often is in Freud's writings, then the unconscious mind is as much subject to the constraints of holism—which of course include certain norms of rationality—as is the conscious mind; and that when he is true to his own best insights Freud thinks something like this himself. Yet he is right to hold, I believe, that early experiences leave a mark on the mind to which philosophical psychology has been relatively insensitive; that childhood memories, phantasies, beliefs, and desires persist in the adult mind in hidden ways, surprising perhaps even to the agent himself; and that these mental contents are often organized somewhat differently—along the lines of phantasizing, for example—from the more or less rational structures of practical reasoning. In saying this I have gone some way towards honoring the data enshrined in Freud's concept of a primary, pre-rational mentality but without accepting the theory that he tags to it.

As for Davidson, I argued earlier that his picture of irrationality needs some of the detail that Freud provides. Furthermore, Freud's emphasis on the essentially temporal nature of the mind reminds us that Davidsonian 'triangulation' is more than the austerely logical condition which he presents. The obvious but typically unremarked fact is that the interpersonal situation between speaker and language-learning child—we might call it Davidson's version of the primal scene—has been in place, and must have been, for some

time before the child becomes a thinker/speaker. The form of life in which the child makes the leap into language has been preparing her for it in innumerable ways from the beginning, shaping habits of perception and response that eventually—given as well the kinds of conditions Davidson supplies—express themselves in belief, desire, and intention. But these are calm words for stormy affairs; for that intercourse with world and persons which yields the concept of objectivity and so provides, in Davidson's view, the condition for the mental, will inevitably contain disturbing events. It is shot through with feelings which as the child grows, deserve more and more to be called terror, love, the sense of vulnerability, bafflement at the contingency of things, loss, anger, guilt, and so on through the litany of human joys and laments.

I speculate, then, that our picture of the mind may need to include a third sort of non-rational mental causation that like the desire to change is neither irrational nor self-divisive. If the holistic claim that a creature cannot have one concept without having a great many is true, it is also true that, as Wittgenstein said, light dawns gradually over the whole. As it is dawning, the child may have experiences that set certain desires, motivational patterns, habits of avoidance and attention, in motion. I need the vague word 'experiences' since the matter in question may not sustain the distinction 'mind' or 'body'. These experiences are causes that are not reasons; but neither are they simply in the domain of the non-mental. Some of these causes could not at the time have been articulated; others might be experiences so profound that they reverberate though the mind, for that very reason escaping articulation. Experiences of both kinds may be among the things Freud referred to in speaking of the unconscious sources of creativity.

Some philosophers might say in the face of holism's apparent difficulty with irrationality that holism must be wrong; it must not be the case that the mental as such is subject to normative, rational constraints.[14] It seems to me on the contrary that the puzzle cases are themselves a good argument for holism as Davidson deploys it, and handmaids towards its clarification. The cases clarify in emphasizing that the 'things' which are holistically related in any one mind are not propositions but attitudes we attempt to chart by way of propositions, attitudes which are of necessity in constant flux, since the creature holding them is in some interactive relationship with her environment even in periods of her most radical retreat, and also in interactive relation with herself whenever she is thinking, considering, desiring, forming intentions, and so on. Both the clarity or repleteness of mental content and the rationality that obtains within the structure as a whole can then be only matters of degree.

The puzzle cases are a good argument for holism of Davidson's sort because, suggesting as it does a view of the self as a structure of more-or-less rationally related mental states, it easily allows us to describe a mind divided against itself, or in the process of change; it accommodates what I take to be

the fact that one's continuity over time as 'the same self' is an empirical question, to be settled by looking at the sorts of intricate relations that hold within the structure; and it implies—as seems on independent grounds to be the case—that the unity of the self cannot simply be assumed. What makes my attitudes *mine* are, among other things, just the peculiar ways in which they are constantly exerting normative pressure on each other, demanding qualification, elaboration, or revision, or, on the contrary, willfully preventing it.

MARCIA CAVELL

DEPARTMENT OF PHILOSOPHY
UNIVERSITY OF CALIFORNIA, BERKELEY
MARCH 1994

NOTES

1. "Paradoxes of Irrationality," *Philosophical Essays on Freud*, ed. R. Wollheim and J. Hopkins (New York & Cambridge, England: Cambridge University Press, 1982), p. 300.

2. Op. cit., p. 305.

3. *Human Nature and Conduct* (Henry Holt & Co., New York, 1945), pp. 24–25.

4. See Davidson's "Socrates' Concept of Truth," *The Philosophy of Socrates: Elenchus, Ethics and Truth*, ed. K. J. Boudouris (Athens: 1992).

5. The variant appears in Freud's case in a footnote ("Notes upon a Case of Obsessional Neurosis," *S. E.* 10.).

6. "Deception and Division," *The Multiple Self*, ed. J. Elster (New York and Cambridge: Cambridge University Press, 1985).

7. *S. E.* 19.

8. *S. E.* 23, pp. 275–76.

9. *S. E.* 9, pp. 144–45.

10. What takes the place of instrumental belief in iconic imagining, Wollheim says, is instinct.

11. "Notes upon a Case of Obsessional Neurosis," *S. E.* 10, pp. 189–90.

12. The ideas in the preceding paragraphs, as well as the comparison between Davidson and Freud on the subject of triangulation, are developed more fully in my *The Psychoanalytic Mind, from Freud to Philosophy* (Cambridge: Harvard University Press, 1993).

13. I am grateful to conversations with Robert Morris for whatever clarity I have on this point.

14. See Mark Johnston's "Self-Deception and the Nature of the Mind," *Perspectives on Self-Deception*, ed. A. Rorty (Berkeley: University of California Press, 1988). I discuss Johnston's criticisms of Davidson at some length in chapter 10 of *The Psychoanalytic Mind*.

REPLY TO MARCIA CAVELL

R eading essays like this one by Marcia Cavell, and that of Ariela Lazar, makes me wonder why I ever thought I could tackle problems of rationality and irrationality as if one could somehow separate the logical and analytic difficulties from those of substantive psychology. Perhaps I hoped I could control the pesky outcroppings of unreason by showing they have their own quasi-rational structure. This is in part what Freud did, of course, but he was under no illusion that the psychological and the logical could be kept distinct. It's not that I think the relatively formal constructions I have promoted over the years are useless. They do trace some major fault lines in our common-sense psychological theories, and offer ways of thinking about apparent clashes between natural intuitions. But they only touch a surface. First, because their schematic character turns what is complex and subtle in reality into something overly neat. Second, because at best they describe only a few of the myriad phenomena that we casually group under such labels as wishful thinking, self-deception, and weakness of the will. For both these reasons I welcome the enrichment and correction of my views that others provide.

Marcia Cavell takes up a passing remark in "Paradoxes of Irrationality," a remark not about irrationality but about a puzzling form of rationality. I had suggested that many cases of irrationality involve situations in which one mental state causes another but is not a reason for it; wishful thinking is a simple example. A more complicated example is self-deception, when a person acts in such a way as to provide himself with reasons for altering an unpleasant belief. The passing remark noted that a salutary form of rationality can display a similar pattern. This can happen if someone intentionally acts to subvert an unwanted desire or habit, or even to improve one's character. Aristotle reflected gloomily on the near impossibility of such self-improvement, but Cavell quotes Dewey's upbeat and sage advice on how it can, with luck and application, be accomplished.

But are such efforts to integrate one's desires, emotions, convictions, and habits, wholly rational? Here Cavell points out a real paradox, and one that strikes me as psychologically acute; it reflects a sense of how certain truly

difficult decisions are experienced. The paradox is this: nothing in the domain of what reason can attempt is more important than the times when we know a choice open to us will profoundly and irreversibly change our lives and ultimately affect the sort of person we are. Changing vocation, abandoning a cherished project, getting married, moving to a new country. To the extent that we decide on the basis of a reasoned consideration of the values involved, and of what will happen to our future selves, this over-viewing of ourselves and our place in the world is perhaps the highest exercise of rationality. But at the same time, Cavell observes, there is an aspect of such a process which cannot be fully rational. When we take a step we know will change us forever, we cannot be clear what we want; we don't now know how to act in accord with values we do not yet have. It is by no means obvious how to think about such matters. There is some of the ambiguity that attends what Nelson Goodman called counter-identicals. Whose life is it?

Cavell criticizes my account of wishful thinking because I maintain that it involves a "full-fledged intentional act" based on the belief that I will be happier if I act to present myself with evidence that supports the wanted belief. She thinks Freud would reject the claim that there is such a "fully intentional structure". I reject it also; in fact, I don't even posit such "reasoning" on an unconscious level. Wishful thinking is basically a case where a wish (non-rationally) causes a belief. I do allow that sometimes wishful thinking prompts us to act in such a way as to promote the belief; it then becomes self-deception. I do not doubt that phantasizing can abet the process of self-deception, or be itself a form of wishful thinking.

What I find interesting is the question how to draw the lines between "full-fledged intentional acts", situations where no conscious reasoning goes on but we have no difficulty in giving our reasons when asked, and so on to the cases where it is clear that a person had reasons for acting as she did, and those reasons no doubt caused the action, but she is unaware, even on reflection, of saying why she acted as she did. Cavell does not hesitate to use the idiom of intentionality for the latter examples: "She brackets off part of what she knows", "he puts the principle to one side", the agent "is able to hold beliefs and wants that he knows to be incompatible apart". Her quotations from Freud include: the child "tries . . . to divest himself of the fear", "every child at play behaves like a creative writer". I suppose that in fact there is not just a continuum of cases but a multi-dimensional array, just as there are degrees of awareness and consciousness.

Cavell's aligning of the Oedipal situation with my notion of triangulation is certainly intriguing. It raises this question: is the Oedipal triangle an example of my triangulation, or a complication of it involving a minimum of three people and a shared world?

D. D.

18

Jon Elster

DAVIDSON ON WEAKNESS OF WILL AND SELF-DECEPTION

I realize that if you ask people to account for 'facts', they usually spend more time finding reasons for them than finding out whether they are true. . . . They skip over the facts but carefully deduce inferences. They normally begin thus: 'How does this come about?' But does it do so? That is what they ought to be asking.

—Montaigne

In abstract, it need hardly be said that before one proceeds to explain or interpret a phenomenon, it is advisable to establish that the phenomenon actually exists, that it is enough of a regularity to require and to allow explanation. Yet, sometimes in science as often in everyday life, explanations are provided of matters that are not and never were.

—Merton

I. INTRODUCTION

In four densely argued articles Davidson (1970, 1982, 1985, 1986) tries to account for "paradoxes of irrationality", notably weakness of will and self-deception. Because Davidson never tells us whether he changed his mind at any time between 1970 and 1986, it is tempting to treat the four articles as expounding one and the same view. Because they seem to diverge on important points, it is also tempting to assume that his view has changed over time.

The latter assumption seems to be the more charitable one. In these writings, Davidson also discusses, albeit more briefly, three other forms of irrationality: wishful thinking, irrational emotions, and what he calls "weakness of the warrant". He also mentions, very briefly, that there can be "irrational intentions to act" (1982, p. 299). In this article I focus on self-deception and weakness of the will, with some comments on wishful thinking. I first draw attention to some features that are common to his analyses of weakness of the will and self-deception, and then discuss the two accounts separately.

Davidson's arguments are straightforwardly transcendental. He takes the existence of these paradoxical phenomena as a datum and asks how they are possible. Concerning weakness of the will, for instance, he writes: "Does it never happen that I have an unclouded, unwavering judgement that my action is not for the best, all things considered, and yet where the action I do perform has no hint of compulsion or of the compulsive? There is no proving such actions exist; but it seems to me absolutely certain that they do" (1970, p. 29). In addition to the title of the 1970 article—"How Is Weakness of the Will Possible?"—the following statements make it clear that he is indeed concerned with establishing conditions of possibility:

> I am solely concerned to defend the idea of mental compartmentalization, and to argue that it is necessary if we are to explain a common form of irrationality. (1982, p. 300 note)

> Only by partitioning the mind does it seem possible to explain how a thought or impulse can cause another to which it bears no rational relation. (1982, p. 303)

> The irrationality of the resulting state consists in the fact that it contains inconsistent beliefs; the irrational step is therefore the step that makes this possible, the drawing of the boundary that keeps the inconsistent beliefs apart. (1986, p. 92)

As the passages quoted from Montaigne and Merton indicate, anyone who proposes a transcendental argument had better persuade us that the phenomenon to be explained actually exists. Davidson does not think the persuasion can take the form of demonstration ("There is no proving such actions exist"). Instead, he relies on intuition and examples. I'm not saying his intuitions are wrong, but I don't think they are conclusive either. And even if we grant him the explanandum, his explanation may still be questioned.

The problems of self-deception and weakness of will have a long philosophical pedigree. In an attempt to achieve greater generality, Davidson departs from the tradition and, in effect, redefines or recharacterizes the two phenomena. Consider first weakness of will. According to the tradition, there are two main variations of this phenomenon. First, there is the struggle of

passion against reason; second, the struggle of short-term against long-term interest. Weakness of will obtains when an agent acts on the first motive within each pair although he himself holds that the second is more weighty. Davidson, however, wants to "divorce [the problem of weakness of will] entirely from the moralist's concern that our sense of the conventionally right may be lulled, dulled, or duped by a lively pleasure" (1970, p. 30). Hence, as we shall see, he allows for situations in which the weak-willed agent acts according to principle or duty even when he believes that, all things considered, he should give in to pleasure or convenience. His definition of weakness of will, cited below, is entirely neutral about the nature of the conflicting motivations.

Consider next self-deception. In this case, Davidson's implicit definition of the phenomenon differs from that of the tradition in allowing for the phenomenon to be fully conscious. He also departs from tradition, with regard to the causes and consequences of self-deception. On the one hand, he explains self-deception through the Reality Principle rather than the Pleasure Principle (this language is demetaphorized below). On the other hand, he deviates from the traditional view that self-deception serves to make a painful situation less painful. True, in his main discussion of this phenomenon he begins by aligning himself with tradition: "Self-deception . . . typically relieves a person of some of the burden of painful thoughts" (1986, p. 79). Later, however, "typically" is weakened to "very often" (1986, p. 87), with the additional claim that "The thought bred by self-deception may be painful". Whether his examples of painful self-deception are plausible, or whether there are *any* plausible examples, is a different matter.

From 1982 onwards, Davidson proposes a unified scheme of explanation for these irrational phenomena. They can occur, he argues, only if the mind is in some sense internally divided. Contra Freud (also representative of the tradition), Davidson argues that the division need not coincide with the boundary between the conscious and the unconscious. "The standard case of akrasia is one in which the agent knows what he is doing, and why, and knows that it is not for the best, and knows why. He acknowledges his own irrationality" (1982, p. 304). Discussing a case in which an agent, Carlos, deceives himself into believing that he will not fail his upcoming test for a driving license, Davidson similarly claims that "core cases of self-deception demand that Carlos remain aware that his evidence favors the belief that he will fail, for it is awareness of this fact that motivates his efforts to rid himself of the fear that he will fail" (1986, p. 90). In the case of weakness of will, Davidson acknowledges that some of the thoughts and desires involved may be unconscious, although they don't have to be (1982, p. 305). In the case of self-deception, however, he argues that in some cases full awareness is not only not

impossible, but necessary: "When reality (or memory) continues to threaten the self-induced belief of the self-deceived, continuing motivation is necessary to hold the happy thought in place. If this is right, then the self-deceiver cannot afford to forget the factor that above all prompted his self-deceiving behavior: the preponderance of evidence against the induced belief" (1986, p. 90).

Yet while Davidson rejects the conscious-unconscious divide as the condition that enables irrationality, he does not put anything else in its place. He does not, that is, suggest independent ways of characterizing the several parts of the mind, or a mechanism by which the partition might come about. His argument is strictly transcendental. (i) Irrationality is a fact. (ii) It involves mental entities (desires, beliefs, impulses to act) serving as causes without at the same time being reasons for the mental entities they cause. (iii) This can occur only if the mind is divided, so that the mental entity that is affected and the entity that affects it belong to different subsets of the mind. From his point of view, it is not necessary to ask how the partitioning comes about or what the different subsets are made up of.

There is a pervasive ambiguity in Davidson's writings on irrationality. They all appeal to various "principles" or "standards" of rationality. These include the "principle of continence", according to which one should "perform the action judged best on the basis of all available reasons" (1970, p. 41); the "requirement of total evidence" according to which we should "give credence to the hypothesis most highly supported by all available relevant evidence" (1986, p. 81–82); and the principles of decision-theory and logic (1985, p. 351). The role of these principles will concern us below. Here I simply want to note their ambiguous or unclear status. In fact, Davidson suggests three different ways of thinking about them. On one account, they are "second-order principles" (1982, p. 297)—a phrase that, to me at least, suggests that they have to be consciously or at least actively entertained. His characterization of the principles as "live psychic forces" (see below) supports this reading. On another account, they are "customs" or "habits", with the implication that "it makes sense to imagine that a person has the principle without being aware of it or able to articulate it" (1986, p. 83). On yet another account, they are mere regularities in behavior, a form of revealed or rather imputed consistency. Once again, "the inconsistency need not be recognized by the agent, though of course it may be, nor does the existence of inconsistency depend on the agent's being able to formulate the principles against which he offends" (1985, p. 352). In general, however, a behavioral regularity need not be supported by a custom or habit, any more than a custom or habit needs to be crystallized into a second-order principle.[1]

II. WEAKNESS OF WILL

The explanandum. As noted, Davidson's definition of weakness of will allows for any kind of motivational conflict: "In doing *x* an agent acts incontinently if and only if: (a) the agent does *x* intentionally; (b) the agent believes there is an alternative action *y* open to him; and (c) the agent judges that all things considered, it would be better to do *y* than to do *x*" (1970, p.22). The definition needs to be supplemented on one important point: all the verbs ("does", "believes" and "judges") refer to the same point in time. After citing various characterizations of incontinence he says "Any of them might be a case of incontinence, as I have defined it. But as they stand, they are not necessarily cases of incontinence because none of them entails that *at the time he acts* the agent holds that another course of action would, all things considered, be better" (1970, p.26; my italics). Thus preference reversals are not instances of incontinence. Davidson is concerned with synchronic inconsistency, not with diachronic inconsistency (1985, p.353).

By insisting on synchronic inconsistency, Davidson rules out several types of behavior that are standardly, if perhaps loosely, characterized as weakness of will. Consider two ways in which an agent might succumb, against his better judgment, to the temptation to have dessert at a restaurant. On the one hand, he might be subject to *hyperbolic discounting* (Ainslie 1992), as shown in figure 1:

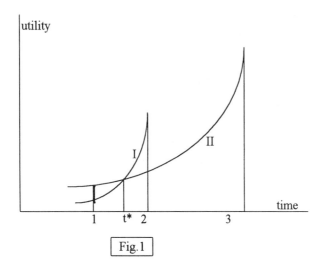

Fig.1

When the agent enters the restaurant at time 1, the discounted value of the early small reward (meal with dessert) is less than the discounted value of the greater, delayed reward (meal without dessert but with health benefits).[2] As the meal progresses, a preference reversal occurs at t* and when the waiter asks him, at time 2, whether he wants to order dessert he answers in the affirmative. Loosely speaking, he is acting against his better judgment. Before going to the restaurant and, let us assume, after leaving it, he wanted to keep away from dessert. He is not, however, acting against his better judgment *at the time of ordering dessert*. This is not Davidsonian weakness of will. An example of that phenomenon would be if the agent ordered dessert at time 1, against his better judgment at that time (Gjelsvik 1999).

On the other hand, the (loosely speaking) incontinent behavior might be triggered by *cue-dependence* (Laibson 1996). When the waiter comes around with the dessert trolley, the sight triggers a sudden, visceral craving that undermines the agent's earlier resolve (see also Loewenstein 1996). This example does not fit Davidson's paradigm case of weakness of will in which "the action I do perform has no hint of compulsion or of the compulsive". Nor, however, is it clear that Davidson's own examples fit his paradigm, as we shall see.

With the exception of the mechanism described by Gjelsvik (1999), Davidson cannot rely on examples involving the conflict between short-term and long-term interest. Nor can he rely on examples involving a conflict between reason and passion, since the latter in his opinion tends to bring about compulsive rather than fully intentional behavior.[3] Although being the main examples of weakness of will, as traditionally if loosely defined, they do not fit his model for the explanandum. In his opinion, the challenge is to explain why we sometimes "succumb to temptation with calm" (p. 29). Conversely, the examples that (he claims) do fit his model of the explanandum are very far from the traditional conception. Let me cite at some length three different examples from his writings:

> I have just relaxed in bed after a hard day when it occurs to me that I have not brushed my teeth. Concern for my health bids me rise and brush; sensual indulgence suggests I forget my teeth for once. I weight the alternatives in the light of the reasons; on the one hand my teeth are strong, and at my age decay is slow. It won't matter much if I don't brush them. On the other hand, if I get up, it will spoil my calm and may result in a bad night's sleep. Everything considered I judge that I would do better to stay in bed. Yet my feeling that I ought to brush my teeth is too strong for me: wearily I leave my bed and brush my teeth. My act is clearly intentional, although against my better judgment, and so is incontinent. (1970, p. 30)

A man walking in a park stumbles on a branch in the path. Thinking the branch may endanger others, he picks it up and throws it in a hedge beside the path. On his way home it occurs to him that the branch may be projecting from the hedge and so still be a threat to unwary walkers. He gets off the tram he is on, returns to the park, and restores the branch to its original position. . . . It is easy to imagine that the man who returned to the park to restore the branch to its original position in the path realizes that his action is not sensible. He has a motive for moving the stick, namely that it may endanger a passer-by. But he also has a motive for not returning, which is the time and trouble it costs. In his own judgment, the latter consideration outweighs the former; yet he acts on the former. In short, he goes against his own best judgment. (1982, pp. 292, 294)

I stay up late arguing with a friend about politics even though I know that I will not be able to change his mind (nor he mine) and I do not enjoy the clash of opinion. My action is an example of akrasia, since I am acting contrary to my own best judgment. No doubt there are reasons why I go on arguing: I am exasperated by my friend's false views and warped values (as I see them), and so I cannot resist the desire to set him straight, even though I know I will not succeed. I have my reasons for acting as I do, then, but these reasons are outweighed, in my own sober judgment, by the reasons I have against continuing the argument. (1985, p. 149)

I find none of these examples persuasive as instances of weakness of will. They do not provide the absolute certainty (1970, p. 29) that is required of a premise of a transcendental argument. The first example is more plausibly understood as illustrating George Ainslie's theory of "private rules" as a defense against the inconsistencies generated by hyperbolic discounting (Ainslie 1992). A naive hyperbolic discounter would simply procrastinate each night, telling himself "One abstention from tooth-brushing makes no difference; beginning tomorrow I will start brushing my teeth every night". Once the agent comes to understand that he is caught in this pattern, he may be able to break out of it by "bunching" his choices, telling himself that a single defection will set a precedent for all following nights. If not now, when? He may then come to realize that this policy is excessively strict, and that it makes sense for him to give himself a break on occasions when for some reason brushing his teeth would be too inconvenient. Yet he may then find that every night is "special" in some way, just as an alcoholic is always able to find a reason why *today* should not be the day to quit drinking. Out of fear of backsliding, then, he decides to make it an absolute rule to brush his teeth every night. On a given night he may think, as Davidson says, that "Everything considered I judge that I would do better to stay in bed"— everything, that is, except for the dangerous precedent-setting effect. Of course Davidson is free to answer that this is not the case he is describing. My rejoinder would

be that his case lacks psychological plausibility without some fleshing-out of details of this general kind.

The second example is also defective. Let me first cite the text by Freud (1909, p. 192–93) from which Davidson took this example:

> Another obsessional patient told me the following story. He was walking one day in the park at Schönbrunn when he kicked his foot against a branch that was lying on the ground. He picked it up and flung it into the hedge that bordered the path. On his way home he was suddenly seized with uneasiness that the branch in his new position might perhaps be projecting a little from the hedge and might cause an injury to someone passing by the same place after him. He was obliged to jump off his tram, hurry back to the park, find the place again, and put the branch back in its former position—*although anyone but the patient would have seen that, on the contrary, it was bound to be more dangerous to passers-by in the original position than where he had put it in the hedge.* The second and hostile act, which he carried out under compulsion, had clothed itself to his conscious view with the motives that really belonged to the first and philanthropic one.

In his retelling, Davidson omits the detail of the sentence I have italicized. This omission does not invalidate his claim that the man "has a motive for moving the stick, namely that it may endanger a passer-by", although the omitted facts make the case murkier by introducing an element of self-deception. If Davidson replies that he is free to adjust the example for his purposes, we should at least keep in mind that if the agent really was motivated by the dangers to a passer-by he should have stuck the branch firmly into the hedge rather than putting it back on the path. To this Davidson could answer, plausibly, that he just made a trivial mistake in not changing the example by letting the man put the branch firmly back in the hedge or disposing of it in some other way. Would this further change produce a compelling example? I do not think so. With Freud, I believe that the return, even in the amended example, could only be due to some kind of obsession or compulsion. The most plausible explanation of the action is that the agent needed to relieve himself of some kind of psychic tension or anxiety that would be produced by failure to act. To my mind, on any plausible interpretation of the actions in the first two examples they are more like compulsive behavior than like unconstrained intentional behavior. They have more than a "hint of compulsion or of the compulsive".

The third example is even more unconvincing. Davidson fails to produce *any* reason why he would go on arguing with his friend. The statement that he "cannot resist the desire to set him straight" does not provide a ceteris-paribus reason for arguing, but only restates the explanandum. But then the behavior cannot be akratic, for the incontinent man "has a reason for what he does" (1970, p. 32). No doubt the behavior he describes can be attributed to exasperation, but that does not provide a reason, even if we add that acting on

exasperation causes the exasperation to abate. I assume that Davidson would not argue, in this or in any of the other examples, that relief from anxiety or exasperation is the reason for acting. Under some circumstances, the desire to relieve oneself of a psychic tension may indeed serve as a reason for acting; that's why people take tranquilizers. It seems to me, however, that acts caused by exasperation (whether or not they also relieve it) typically are caused by a mental cause that is not a reason.

The failure of particular examples to establish the indubitable existence of the phenomenon does not prove, of course, that it doesn't exist. I certainly cannot show that it doesn't exist, and it may well do so. I believe, however, that in practice one can never be "absolutely certain", as Davidson claims to be, that a given case is an instance of synchronic inconsistency. We cannot differentiate between the hypothesis that the agent acted against what he judged best at the time of action, and that he acted against what he thought best at the time of action minus epsilon. In many cases, what we would pre-theoretically characterize as weakness of will is indubitably due to a preference reversal induced by hyperbolic discounting. If the switch occurs very shortly before action, the agent himself may, in retrospect, conflate the preferences before and after the reversal. Physical proximity (cue-dependence), no less than temporal proximity, may also induce sudden preference reversals. If the less preferred option suddenly becomes more preferred because of such temporary salience, there is no synchronic discounting.

The explanation. Because of my doubts concerning the existence of Davidson's explanandum, I shall say devote less space to his explanation of weakness of will. Let me first comment on a puzzling statement (1986, p. 85) to the effect that "it is no part of the analysis of weakness of the warrant or weakness of the will that the falling off from the agent's standard is motivated (though no doubt it often is)". I shall not discuss whether Davidson intends to say that weakness of the warrant is sometimes motivated and, if so, whether that claim is right, but only consider the claim that weakness of the will is sometimes unmotivated. I believe this claim goes flatly against a passage from the 1982 article:

> But someone who knowingly and intentionally acts contrary to his own principle; how can we explain that? The explanation must, it is evident, contain some features that go beyond the Plato Principle ["no intentional action can be internally irrational"]; otherwise the action is perfectly rational. On the other hand, the explanation must retain the core of the Plato principle; otherwise the action is not intentional. An account like this seems to satisfy both requirements: there is, we have agreed, a normal reason explanation for an akratic action. Thus the man who returns to the park to replace the branch has a reason: to remove a danger. But in doing this he ignores his principle of acting on what he thinks is best, all things considered. And there is no denying that he has a motive for ignoring his

principle, namely that he wants, very strongly, to return the branch to its original position. Let us say this motive does explain that he fails to act on his principle. (1982, p. 297)

As far as I can understand, this passage says that weakness of will is *always* motivated. Although the argument is driven by an example, everything suggests that it is intended to be perfectly general. Note that the "principle" must be actively entertained by the agent, since otherwise it does not make sense to say that he has a motive for ignoring it. Also, as I said, it seems that any "second-order principle" must be actively held (I use "actively" rather than "consciously" so as not to prejudge the question whether a principle could be held unconsciously).

In the 1985 and 1986 articles, as noted, Davidson no longer insists that active subscription to the principle of continence is a condition for weakness of will. Rather, the principle is "nothing more than . . . consistency in thought and action" (1985, p. 353). That may indeed be why he now also claims that weakness of will may be unmotivated. Yet even here there is some slippage, when he writes that "Synchronic inconsistency requires that all the beliefs, desires, intentions, and principles of the agent that create the inconsistency are present at once and are in some sense in operation—are live psychic forces" (ibid.). It would seem that for a principle to be a live psychic force, it must be actively held rather than be a mere regularity of behavior. But then it once again becomes hard to understand how violation of the principle could be unmotivated. I confess to a rather serious failure of understanding what Davidson is trying to say.

The 1982 treatment also deviates from the 1970 article. In the earlier pioneering study, there is no mention at all of the principle of continence, except at the very end. The principle "exhorts us to actions we can perform if we want; it leaves the motives to us. What is hard is to acquire the virtue of continence, to make the principle of continence our own" (1970, p. 41). The passage, read with the full paragraph in which it occurs, strongly suggests that weakness of the will is possible only in someone who has not made the principle of continence his own. The 1982 article, by contrast, explicitly says that it is possible only in someone who *has* made that principle his own: "If the agent does not have the principle that he ought to act on what he holds to be best, everything considered, then though his action may be irrational from *our* point of view, it need not be irrational from his point of view" (1982, p. 297).

What these two contradictory analyses have in common, is that they both assume that the principle of continence is something to which an agent may or may not subscribe. Perhaps the most important development in the later articles is the denial of this assumption: "I think everyone does subscribe [to the principles of decision theory], whether he knows it or not. . . . I would say

the same about the basic principles of logic, the principle of total evidence for inductive reasoning, or the analogous principle for continence" (1985, p. 351). At the same time, the principles are (mostly) reinterpreted as hermeneutic assumptions of consistency rather than as mental entities or forces in their own right. Although I think this argument is a clear gain in insight, it undermines some possible mechanisms for explaining weakness of will.

Yet although (if I am right) the 1985 and 1986 articles break with the 1982 argument that weakness of will occurs when and because the agent is motivated to ignore the principle of continence, they retain the idea (introduced in 1982) of a partitioning of the mind as the condition of possibility for weakness of will. Partitioning may be a sufficient condition, but I am not sure it is a necessary one, as would be required by the transcendental argument. For Davidson, "What is essential is that certain thoughts and feelings of the person be conceived as interacting to produce consequences on the principles of intentional action, these consequences then serving as causes, but not reasons, for further mental events" (1982, p. 304). I would amend the last clause to: "serving as causes, not only as reasons, for further mental events". Or more accurately (since reasons are also causes): "serving as causes both in the right way (qua reasons) and in the wrong way (not qua reasons)".

This dual function might in fact be essential to explain the behavior of the agent. Take the case of weakness of will, in which the agent chooses the action that is weakly supported by reason over the one that (in his own judgment) is better supported by reason. If the reasons for the weakly supported action are only *slightly* weaker qua reasons (according to the agent's judgment) than the reasons for the strongly supported conclusion, then there is more scope for the weaker reasons exercising a non-rational causal influence. In terms of figure 1, the shorter the heavily drawn vertical line segment at time 1, the more likely that the agent might succumb to Davidsonian weakness of will even before the point (t*) where he would give in to Ainsliean weakness of will. If this analysis is correct, the weaker reasons must exercise *some* influence qua reasons, contrary to what is assumed by the partitioning theory. This conclusion seems to undermine the transcendental argument for partitioning being a necessary condition for weakness of the will.

III. SELF-DECEPTION

The explanandum. Davidson does not offer a definition of (the state of) self-deception as explicit as the one he gives of weakness of will. Piecing together various statements, however, we can reconstruct an implicit definition. (i) An agent **A** believes p, which is supported by the total evidence available to him. (ii) At the same time the agent also believes that q, which is incompatible with

p.[4] (iii) The agent's belief that p enters among the causes of his believing that q. (iv) The agent's belief that q is also induced by a motive for believing that q or, more accurately, by a motive for making it the case that he believes that q.

Davidson (1986, p. 90) emphasizes that he wants to understand the *state* of self-deception rather than the *process* of deceiving oneself. Once again, he is concerned with *synchronic* inconsistency. Although it might seem as if (iii) and (iv) in the definition refer to the process by which the state of self-deception is brought about, Davidson argues that these causes may continue to operate in the present, to support the otherwise fragile conjunction of two incompatible beliefs. The idea that the process of self-deception always requires a "self-eraser" (Elster 1983, p. 57), for instance, is not compatible with this view. In a passage cited more fully above, Davidson writes that in some cases at least "The self-deceiver cannot afford to forget . . . the preponderance of evidence against the induced belief" (1986, p. 90), because if he did he would lose the motivation to keep that evidence at bay. This is hard to accept. To be sure, he would lose his motivation to ignore the evidence if he forgot it, but he would also lose any need to ignore it.

Davidson suggests that the need could be due to either "memory" or "reality". If Carlos manages to forget the evidence suggesting that he will fail the test, there is no threat from memory. Reality may of course hit him over the head when he takes it and fails, but until that happens reality does not (in this example) impinge on him. It is only if reality—for instance in the form of a nagging spouse—constantly reminds him of his likely failure that he needs to make a constant effort to ignore the evidence. Is this a plausible case? Can self-deception endure over time in the face of constant and active reality checks? Can one believe that one is losing weight, when the scales disconfirm the belief every morning? (Once again, we may suppose a nagging spouse who forces one to go on the scales; otherwise self-deception could well motivate one to abstain from this reality check.) I have no strong intuitions about such cases. They seem unlikely to me, but I might well be wrong.

Davidson's strong thesis is that (in some cases at least) self-deception *requires* that both beliefs be held in full awareness. I have argued against this view. One might imagine a weaker thesis, viz. that self-deception is *consistent* with (and at least sometimes accompanied by) full awareness. The weaker thesis would also constitute a departure from tradition, which holds that self-deception requires that one of the beliefs *not* be subject to awareness (see for instance Gur and Sackeim 1979, p. 149). If enduring self-deception in the face of constant reminders from reality actually occurs, the weak thesis would be supported and the traditional view would be undermined. Note that the traditional view could also be undermined from the opposite direction: one might deny that it is ever the case (or deny that it has been shown to be the

case) that a self-deceiving agent simultaneously entertains two incompatible beliefs. Alfred Mele (1997a,b) makes a sustained argument to this effect. On the spectrum of views, his thesis is at one extreme and Davidson's strong thesis at the other extreme.[5]

The explanation. Let me first cite Davidson's summary:

> An agent **A** is self-deceived with respect to the proposition *p* under the following conditions. **A** has evidence on the basis of which he believes that *p* is more apt to be true than its negation; the thought that *p*, or the thought that he ought rationally to believe *p*, motivates **A** to act in such a way as to cause himself to believe the negation of *p*. The action involved may be no more than an intentional directing of attention away from the evidence in favor of *p*; or it may involve the active search of evidence against *p*. *All that self-deception demands of the action is that the motive originates in a belief that p is true (or recognition that the evidence makes it more likely to be true than not), and that the action be done with the intention of producing a belief in the negation of p.* Finally, and it is especially this that makes self-deception a problem, the state that motivates self-deception and the state it produces coexist; in the strongest case, the belief that *p* not only causes a belief in the negation of *p*, but also sustains it. Self-deception is thus a form of self-induced weakness of the warrant [failing to obey the requirement of total evidence], where the motive for inducing a belief is a contradictory belief (or what is deemed to be sufficient evidence in favour of the contradictory belief). In some, but not all cases, the motive springs from the fact that the agent wishes that the proposition, a belief which he induces, were true or a fear that it might not be. So self-deception often involves wishful thinking as well.[6] (1986, p. 88–89)

As far as I can see, all the following cases fit the sentence that I have italicized. (i) If the truth pains me, I might be happier believing a falsehood. (ii) If the true belief about my abilities is unlikely to inspire me to great achievements, I might achieve more if I believed I can achieve more than I can in fact do. If I believe I can achieve 4, I will achieve 4; if I believe I can achieve 8, I will achieve 6. I add, for later reference, that if I believe I can achieve 20, I will achieve 0. (iii) If I believe that I will not be able to keep away from drugs if I have true beliefs about their effects, I may have a motive for believing that they are more dangerous than they in fact are (Winston 1980). (iv) If I believe it will be useful in strategic dealings with an adversary if I appear to believe *p* and if I also believe that the most efficient way of producing that appearance is to make myself believe *p*, I may have a motive for inducing that belief in myself. (v) If I believe, like Pascal, that there is a possibility that it might be rewarding to believe in God, I have a motive for making myself believe something I do not, now, believe.

The italicized statement is consistent with mental as well as extra-mental ways of inducing the relevant belief. Although the immediately preceding statement cites mental techniques only, I cannot see that there is anything in Davidson's general argument that precludes extra-mental techniques, such as

asking to be hypnotized into believing that drug use is more dangerous than it actually is, or going to mass in order to make oneself believe. Once one views belief formation as an intentional action, there seems to be no reason to privilege mental over extra-mental means. Moreover, there seems to be no reason to exclude long-term benefits from the reasons that motivate the agent to acquire the belief, nor to exclude indirect strategies of the kind "one step backwards, two steps forward". Adapting Max Weber's adage about historical materialism, the theory of intentional action is not like a taxi from which you can get out at will. If the mind is assumed to be capable of intentional belief formation, it must be assumed to be capable of doing a number of other things as well.

Yet if we look at Davidson's examples of self-deception, they include both less and more than the ones I have cited. Clearly, he believes there are cases like (i), although he goes against the tradition in denying that all cases are like that. By contrast, he does not mention cases (ii) through (v) or other cases of that general nature. Although he says that "Learning is probably more often encouraged than not by parents and teachers who overrate the intelligence of their wards" (1986, p. 86), he does not take the additional step of saying that a person could decide to overrate *his own* intelligence in order to achieve more. Not that I think he ought to have taken that step. In fact, I believe that cases (ii) through (v) and other cases of that general nature, involving long-term benefits and temporary sacrifices, are thoroughly implausible, especially when only mental techniques are used. That simply doesn't seem to be the way the mind works. The case is somewhat more plausible with non-mental techniques, although I continue to believe (with Pascal) that a self-eraser is needed.

Earlier, I alluded to the Pleasure Principle and the Reality Principle. Traditionally, self-deception and wishful thinking are associated with the former, whereas the requirement of total evidence is associated with the latter. To navigate the world successfully, one needs beliefs that are as good as they can be, given the available evidence.[7] Someone who believes that p merely because he wants p to be the case is more likely to see some of his long-term goals frustrated. On the intentional model of belief formation, this dichotomy would be too simple. In cases (ii) through (v), an agent might actually be able to navigate the world better if he had some false beliefs. Needless to say, the agent would need to have true beliefs (or beliefs warranted by the available evidence) that the causal mechanisms stipulated in (ii) through (v) actually obtain. In case (ii), for instance, he would need to hold true beliefs about the degree of overconfidence that is optimal for achievement. If he decides to use extra-mental techniques, he needs true beliefs about their reliability. Yet given those beliefs he can deceive himself in other respects and still remain guided by the Reality Principle—to form the beliefs that help one navigate the world successfully.

The implausibility of cases like (ii) through (v) suggests that a desire-belief model of belief-formation is untenable (Mele 1997 b, p. 132, arguing against Foss 1997). When a desire enters into the causation of a belief, it doesn't need another instrumental belief to identify the optimal means to the satisfaction of the desire. The plausible instances I can think of involve neither long term benefits nor short-term sacrifices, but only the instantaneous gratification of believing that what one wants to be the case is the case. The desire that p be the case causes the belief that p is the case. For Davidson (1986, p. 85), this is a definition of wishful thinking, not of self-deception. I shall return to his claim shortly.

First, however, I'd like to explain why Davidson's own examples of self-deception not only fall short of what his intentional model would predict, but also go beyond it. They do so when he claims that a self-deceptive belief might be painful, not just accidentally but (I assume) predictably, not just temporarily but (I assume) permanently. "A person driven by jealousy may find 'evidence' everywhere that confirms his worst suspicions; someone who seeks privacy may think he sees a spy behind every curtain. If a pessimist is someone who takes a darker view of matters than his evidence justifies, every pessimist is to some extent self-deceived into believing what he wishes were not the case" (1986, p. 87). But why would an agent deliberately take steps to acquire a false belief that he knows will cause him nothing but pain? This seems utterly strange to me. When making a similar argument with regard to fear and jealousy, David Pears asserts that the exaggerated beliefs involved are triggered by an emotional program set up (presumably) by natural selection, which is why "the formation of the intrinsically unpleasant belief is not felt to be the object of the wish" (1984, p. 43). Davidson, perhaps wisely, refrains from any such speculation. Yet he leaves it unexplained why the mind should play a trick on itself that involves the *production* rather than the reduction of cognitive dissonance. (I owe this characterization to discussions with Amos Tversky.)

Let me focus on Davidson's claim that "a pessimist is someone who takes a darker view of matters than his evidence justifies". Many individuals whom I would classify as pessimists do not form their beliefs in this way. Rather, failing to consider the evidence in an impartial manner, they form a dark view of *any* matter. Sometimes they are right—their belief is the very same that would have been warranted by the evidence, had they considered it impartially. What seems to happen in such cases is that the desire that p be the case causes the belief that p is not the case. We might refer to this phenomenon as *counterwishful thinking,* analogous to *counteradaptive preferences* ("the grass is always greener on the other side of the fence"). Both phenomena seem mysterious—they obey neither the Reality Principle nor the Pleasure Principle. Metaphorically, there seems to occur a "crossing of the wires in the pleasure machine" (Tversky's phrase) by which the desire for happiness directly

induces unhappiness. I do not know what a demetaphorized account would look like. Let me stress, however, my simple argument for believing that the phenomenon is a real one: the existence of congenital pessimists who, when things are bad enough, actually turn out to be right. They are like the broken clock which happens to show the right time once in any twelve-hour period, rather than (as on Davidson's account) a clock that is always one hour late. I firmly believe I know such people. True, I usually deal with them as if Davidson were right: whenever they say that something bad will happen, I assume that something less bad will happen. Yet if I adopt that rule, it is not because I believe its application will give the correct result in each and every case, any more than my reason for ignoring the hands on a broken clock is that it never shows the right time.

On my account, wishful thinking and self-deception have in common that a desire that p be the case directly causes the belief that p is the case. In wishful thinking this is a simple one-step process: the wish is the father of the thought. The evidence is not denied, but ignored. Self-deception involves four steps: first the evidence is considered; second, the appropriate belief is formed; third, this belief is rejected or suppressed because it is inconsistent with our desire; and lastly the desire causes another and more acceptable belief to be formed in its place. Needless to say, this is not a *theory* of self-deception. I do not understand the mechanism of belief-suppression. Unlike Mele (1997a,b), I do not think all apparent cases of self-deception can be explained as instances of wishful thinking. Yet as long as I cannot offer an account of belief-suppression, my opinion on this topic is not of any particular interest. The only positive contribution I feel I can make concerns the existence of counterwishful thinking, which points to an explanation of the most paradoxical aspects of the intrinsically paradoxical phenomenon of self-deception.

<div align="right">JON ELSTER</div>

COLUMBIA UNIVERSITY
MAY 1999

NOTES

I am grateful to Akeel Bilgrami, Michael Bratman, Dagfinn Føllesdal, Olav Gjelsvik, Ariela Lazar, and Gary Watson for their comments on an earlier draft of this article.

1. A further complication arises from Davidson's discussion of his predicament when he entered one of several row houses and wrongly thought it was his own, the

realization of the error being delayed by various belief adjustments (perhaps his wife had changed the furniture etc.). "Is there a point of view from which we can make out that my belief that I was in my own house was irrational? No doubt there is. I believe, like everyone else, that when I have to invent strange explanations of what I think I see or believe I should consider alternative hypotheses. If I had adhered to my own standards of hypothesis formation, of 'inference to the best explanation' as Harman calls it, I would have wondered much sooner than I did whether my assumption that I was in my own house was correct. . . . Suppose that, contrary to the facts, I had asked myself whether I was in my house or in my neighbor's house, and had acknowledged that the evidence, although not conclusive, favored the hypothesis that I was in my neighbor's house. Then I would again have been in a state of inner inconsistency *provided* I held to the general principle that one ought to adjust one's degree of belief to what one deems to be the extent to which it is supported by all one's available evidence" (1985, p. 348; the last "by" is added by me). I cannot make sense of the last sentence. Moreover, the idea that one and the same first-order belief (that he was in his neighbor's house) could be rational or irrational depending on which principles for belief-formation is adopted seems to conflict with the idea, expounded in the same article, that the principles that make first-order beliefs rational or irrational are "fundamental attributes of rationality" rather than variable across individuals or situations.

2. In actuality these benefits do not occur at one time, but are spread over the rest of the person's life. In figure 1, these many small benefits are represented by their discounted value at time 3.

3. But see Watson (1999) for a critical view of the idea that desires can be compulsive.

4. Davidson (1986) refers to the latter belief as the negation of *p* rather than as any proposition incompatible with *p*. I suspect, however, that most cases of self-deception involve the production of a belief that is *contrary* to and incompatible with the original one, rather than its logical negation. When there are more than two alternatives, as (say) in a gradation of skills, it seems more appropriate to reason in terms of contraries than in terms of contradictories.

5. This language may be too metaphorical. Some might find the stipulation of unconscious beliefs more radical than the stipulation of the simultaneous entertainment of contradictory beliefs. For them, the traditional view might be more paradoxical than Davidson's, not less.

6. There is some verbal confusion here. The motive for self-deception cannot be the original (un-selfdeceived) belief. Rather, the original belief together with some motive jointly cause the self-deceived belief. I assume this is just a minor slip of the pen.

7. Although Davidson usually refers to the "available evidence" as if it were given rather than a decision variable, he does mention in one place (Davidson 1986, p. 81 note 2) that rational belief formation might also include the search for new evidence (see also Elster 1985). I believe, in fact, that it is much easier to deceive oneself by not gathering information (e.g., by not going on the scales) than by forming beliefs that are not warranted by information one has already gathered. I should add, however, that motivated abstention from (costless) information-gathering may in some cases be quite rational (Carillo and Mariotti 1997).

REFERENCES

Ainslie, G. (1992). *Picoeconomics*. Cambridge: Cambridge University Press.

Carillo, J. and T. Mariotti, (1997). "Wishful Thinking and Strategic Ignorance". Unpublished manuscript, ECARE (Université Libre de Bruxelles) and GEMAQ (Université de Toulouse).

Davidson, D. (1970). "How Is Weakness of the Will Possible?" Cited after the reprint in *Essays on Actions and Events*. Oxford: Oxford University Press, 1980.

———. (1982). "Paradoxes of Irrationality". In R. Wollheim and J. Hopkins, eds., *Philosophical Essays on Freud*. Cambridge: Cambridge University Press, pp. 289–305.

———. (1985). "Incoherence and Irrationality". *Dialectica* 39 (1985): 345–54.

———. (1986). "Deception and Division". In J. Elster, ed., *The Multiple Self*. Cambridge: Cambridge University Press, 1986, pp. 79–92.

Elster, J. (1983). *Sour Grapes*. Cambridge: Cambridge University Press.

Elster, J. (1985). "The Nature and Scope of Rational-choice Explanation". In E. Lepore and B. Maclaughlin, eds., *Actions and Events: Perspectives on the Philosophy of Donald Davidson*. Oxford: Blackwell, pp. 60–72.

Foss, J. E. (1997). "How Many Beliefs Can Dance on the Head of the Self-deceived?" *Behavioral and Brain Sciences* 20:111–12.

Freud, S. (1909). "Notes upon a Case of Obsessional Neurosis". In *The Standard Edition of the Complete Psychological Works of Sigmund Freud*, vol. X. London: The Hogarth Press 1955. pp. 153–249.

Gjelsvik, O. (1999). "Addiction, Weakness of the Will, and Relapse". In J. Elster and O.-J. Skog, eds., *Getting Hooked*. Cambridge: Cambridge University Press, pp. 47–64.

Gur, R. C. and H. A. Sackeim, (1979). "Self-deception: a Concept in Search of a Phenomenon". *Journal of Personality and Social Psychology* 37:147–69.

Laibson (1996). "A Cue-theory of Consumption". Unpublished manuscript, Department of Economics, Harvard University.

Loewenstein, G. (1996). "Out of Control: Visceral Influences on Behavior". *Organizational Behavior and Human Decision Processes* 65:272–92

Mele, A. (1997a). "Real Self-deception". *Behavioral and Brain Sciences* 20:91–102.

———. (1997b). "Author's Response". *Behavioral and Brain Sciences* 20:127–34.

Merton, R. K. (1987). "Three Fragments from a Sociologist's Notebook". *Annual Review of Sociology* 13:1–28.

Montaigne, M. de (1991). *The Complete Essays*. Trans. M. A. Screech. Harmondsworth: Penguin.

Pears, D. (1985). *Motivated Irrationality*. Oxford: Oxford University Press.

Watson, G. (1999). "Disordered Appetites". In J. Elster, ed., *Addiction: Entries and Exits*. New York: Russell Sage.

Winston, G. (1980). "Addiction and Backsliding: A Theory of Compulsive Consumption". *Journal of Economic Behavior and Organization* 1:295–324.

REPLY TO JON ELSTER

Jon Elster seems at first to be setting out to persuade us that none of the forms of irrationality that I have tried to understand exist: wishful thinking, akrasia, self-deception, and failure to take into account all of the evidence of which one is aware. But in the end he doesn't do this. Rather he demonstrates that over a period of years I have changed my mind (without always saying so); that some of the things I have said were confusing or confused; that I did not discuss some of the mental states and actions commonly grouped with the phenomena I described; that there are alternative analyses available for some of my examples; that I borrowed some aspects of a famous case of Freud's but changed other aspects and then did not follow Freud's own treatment of the case in just the way Freud did. To all of these accusations I plead guilty.

Does Elster really think it never happens that we knowingly and intentionally do something which we believe at that very time to be unwise? He holds, and so do I, that some of my examples could be explained in other ways if the description I just gave does not fit them. But does he hold that cases like the one Ariela Lazar mentions in the first paragraph of her essay in this volume never occur? Many of my critics, like Elster, have shown that if you change the description of akrasia, other solutions are available. (Ainslie's suggestion for explaining certain situations in which a change of mind may seem an inconsistency is as old as Plato in the *Timaeus*. It is obvious that such cases do not necessarily involve any irrationality if future pleasures are discounted in view of uncertainty. However, they have nothing to do with the examples I was talking about.) As I said, I can't prove there are cases of the kind I found puzzling. My reaction is that Elster is a lucky man if he hasn't experienced them.

The cases of self-deception described as involving simultaneously held contrary beliefs where the existence of one helps explain the existence of the other are, I agree, more questionable. If one is in doubt about their existence (I am not), one should first explore, in a way I did not, the different senses in which one can be said to hold a belief. One should also explain much more

fully than I did exactly how the mechanism works which I claim keeps the opposed beliefs separate. My 1982 paper was an Earnest Jones lecture, read to the annual meeting of the British Psycho-Analytic Society, and I was, among other things, defending some basic views of Freud against the criticisms of a number of philosophers. In that context it did not seem necessary to say much about the mechanisms involved in keeping ideas and desires hostile to one another separate; my aim was to make such an idea (stated far more abstractly than Freud had) conceptually acceptable.

In neither this case nor others did I think of myself as doing depth psychology. I was, I thought I made reasonably clear, not out to compete with Freud and certainly not to correct his analysis of the Rat Man. As Elster puts it, my attempts were "transcendental" in the sense that descriptions of phenomena I thought existed seemed to conflict with other theses I thought true. Before I wrote "How is Weakness of the Will Possible?" I had accepted a view of the "practical syllogism" which ruled out the possibility of (one form of) akrasia. Reconciliation came about only when I altered my conception of practical reasoning. As I have recounted in my reply to Lazar, I then started worrying more generally about how to reconcile my insistence that understanding thought and action requires us to see them as rational from the agent's point of view with various forms of irrationality. As Lazar and Elster make evident, I stumbled around a good deal in my treatment of what I called the principle of continence, and this resulted in an accompanying vacillation in how I tried to account for actions and thoughts that were not in accord with the principle.

The trouble was that I was persuaded of two things. On the one hand, I was sure that people often hold views that are logically inconsistent (as Socrates repeatedly demonstrated); on the other hand I was convinced that no one could entertain obviously contrary beliefs. In general this raises no problem as long as the agent does not notice the conflict, just as it is quite easy (for me, anyway) to know I have an appointment at noon to see my dentist and to know I have agreed to see a student at noon without conjoining the two bits of knowledge until the last minute. The hard cases come when it would normally be impossible to resist confronting the conflict—cases where, for example, one is engaging in an activity one knows is not for the best, or where one is managing to hold off a disagreeable thought by encouraging its contrary. If there are such cases, and I am right that though one can hold conflicting views, one cannot hold the conjunction of those views, then it follows that the views must be kept separate. Elster thinks it is incumbent on me, if I think this, to go into much greater detail about such "partitioning" of the mind. I'm not against such a project, of course. Those who, like Freud and Elster, wish to speculate about the psychological mechanisms and aetiology of such divisions, have a different aim than mine. I was interested only in

trying to show that the project is appropriate.

This is the point at which the status of the principle of continence is hard to settle. If it is just one among other principles involved in practical reasoning, one can imagine it being overruled by other considerations. That I was thinking along these lines in "How is Weakness of the Will Possible?" is suggested by my talk of making the principle "our own", or of being motivated to ignore it in "Paradoxes of Irrationality". But even in these papers I seem to have sensed that this was wrong, and a different, better conception of the role of the principle emerged more or less clearly in "Deception and Division". This was, as I recount in my reply to Lazar, that the principle is partly constitutive of rationality; we therefore must in general find an agent reasoning and acting in accord with it in order to treat him as an agent. If so, it makes no sense to speak of someone consciously ignoring the principle, or of acting to set it aside. But one can have motives which are thwarted if one acts in accord with the principle, and such motives can cause us to act contrary to the principle. This is the thought that was so badly expressed in "Paradoxes of Irrationality".

When I called the principle "second-order" what I had in mind was its logical, not its psychological function. It serves logically to validate the inference from all-things-considered judgments to the unconditioned "This is what it is best to do" which accompanies action or intention. It is the counterpart of modus ponens in my version of the practical syllogism (which is technically no longer a syllogism), and the counterpart of Hempel and Carnap's rule of detachment for probabilistic reasoning.

A final remark on the existence of the sort of self-deception I discussed. It seems to me Cavell's discussion of attempts at self-improvement does much to support the existence of self-deception; the model is parallel in important respects (we consciously set about changing how we act and think). I have also attempted to make such cases plausible by an examination of Emma Bovary's behavior in a paper Elster does not discuss (Davidson 1997).

D. D.

REFERENCE

Davidson, Donald. 1997. "Who is Fooled?" In *Self-Deception and Paradoxes of Irrationality*, edited by J.-P. Dupuy. Stanford, CA: CSLI.

19

Pascal Engel

THE NORMS OF THE MENTAL

A central tenet of Davidson's philosophy is that there is an "irreducibly normative character" in the concepts that we use to describe and explain thought and meaning, in the sense that ascriptions of intentional contents are governed by a "constitutive ideal of rationality" which has no "echo" in the realm of natural and physical facts.[1] This view plays a prominent role in his argument for anomalous monism. It is also essential to his theory of the interpretation of speech and language.[2] But what does it mean to say that "norms enter in the study of mental phenomena", that there is a "normative element" or that there are "normative properties" in mental concepts?[3] I would like to examine here what seems to be a striking feature of Davidson's account of such norms: that they are, in a certain sense, elusive, and cannot be completely and precisely spelled out. I shall try here to say what these normative features consist in.

That there is a "normative character" to thought and meaning, or that norms "enter" our mental concepts is often misunderstood, and has been for this reason a source of puzzlement: for in what sense could thoughts and meaning imply any prescriptions about what we ought to think or do, or about what it is valuable to think or do, as the word "normative" seems to imply? But the "normativity" of meaning and thought does not mean that there are norms of mental in the sense in which one can say that there are rules of etiquette, social norms, or even linguistic rules. Davidson is quite clear on the fact that he rejects accounts of language and communication which rely upon such notions as those of rule, convention, or social norms in the sense that speakers would have, to make themselves understood or to understand others, to grasp such rules or to follow them. So "norm", in his sense, is not to be understood as involving the existence of *particular* rules attached either to words or to concepts which would determine the correct use of these words or concepts. Meaning and thought are not "normative" if this means that using

a word is to follow a certain prescription or rule.[4] Nor does it imply normativity in the sense of giving a particular *value* to rationality. The rational norms are there, whether we like them or not, and in this sense they are not good or bad. The normativity of meaning and thought pertains neither to particular rules nor to particular values, but to general principles of the interpretation of speech and thought. These are not, unlike particular rules, a matter of choice: they are compulsory because they are a priori requirements of the very task of making sense of others. Among these figure prominently the Principle of Charity—that one could not interpret someone else if one did not suppose that most of the beliefs that we hold true by our lights are true for him, and that one could not understand someone's beliefs and desires unless we could find in them an overall rational or coherent structure,[5] and in general the holistic requirements about thought and language.

Davidson sometimes talks as if these general norms of interpretative charity were codified in the normative *theories* that we currently use: logic, decision theory, or general principles or laws used by such theories: the law of noncontradiction, or the principle of maximizing expected utility. Sometimes he also alludes to specific epistemic principles, such as Carnap's requirement of "total evidence" for inductive reasoning ("give your credence to the hypothesis supported by all available evidence") or the counterpart principle for practical reasoning ("perform the action judged best on the basis of all available relevant reasons").[6] In such cases, these normative principles are indeed imperatives of a particular form, or something like rules for guiding beliefs or actions. But it is quite important here to see how general and unspecific such principles are and why they have to be so, for a number of critics have complained that they are too unspecific to serve as actual principles of interpretation: if *most* of someone's beliefs are to be true, it does not tell us which ones are true, and if an agent is to be by and large rational does not tell us how he is rational. But this is just as it should be:

> The issue is not whether we all agree on exactly what the norms of rationality are; the point is rather that we all have such norms, and that we cannot recognize as thought phenomena that are too far out of the line. Better say: what is too far out of line is not thought. It is only when we can see a creature (or 'object') as largely rational by our own lights that we can intelligibly ascribe thought to it at all, or explain its behaviour by reference to its ends and convictions. Anyone . . . when he ascribes thoughts to others, necessarily employs his own norms in making the ascriptions. There is no way he can check whether his norms are shared by someone else without first assuming that in large part they are; to the extent that he successfully interprets someone else, he will have discovered his own norms (nearly enough) in that person.[7]

In this sense, it is wrong to suppose that the general norms of interpreta- tion can be transcendent norms which have a universal validity, and which

could be applied like models or idealized principles in science. For to take them as such would be to mistake them for general laws or regularities *descriptive* of phenomena. For instance it is often said that the principles of rational choice-making involved in Bayesian decision theories are "normative" in the sense that they give us a picture of the perfectly rational agent, although they are not true of individual agents at the "descriptive" level, because they are oversimplified. As Davidson points out, this way of making the distinction between the normative and the descriptive is largely illusory: "Until a detailed empirical interpretation is given to a theory, it is impossible to tell whether or not an agent satisfies its norms; indeed without a clear interpretation, it is hard to say what content the theory, whether normative or descriptive, has."[8] If the rational norms governing our mental concepts had the form of specific, although in some sense idealized, principles such as, for instance, the Bayesian principle of maximization of expected utility, failures to apply these principles to human agents would imply clear failures of rationality on their part. But Davidson is quite clear that it is not easy to pin down empirically such failures, for rationality *in general* is a presupposition of any interpretation of human behaviour, and so cannot be tested at a purely descriptive level.

The point can be illustrated through many examples of empirical work on the psychology of decision, within the framework of research pioneered by Davidson and his associates at Stanford during the fifties.[9] Here is one example which, as far as I know, is not used by Davidson, but which he could have used. Allais's paradox seems to be a clear case where most agents violate the Bayesian norm of maximizing expected utilities (or, for that matter the "sure-thing principle"): where they are presented pairs of choices such that they should—if they respected the principle—choose choice *a* over choice *b*, and choice *c* over choice *d*, they reverse their preference in the second case (choosing *d* over *c*). Discussing this example, the statistician Leonard Savage does not conclude that agents are irrational. He tries to provide a point of view from which their mistake is understandable, reformulating the problem through a lottery with the choice between a corresponding number of tickets, and looking for a perspective which, in his own terms, "has a claim to universality", where in the end the reversal of preferences disappears. This, comments Savage, is just what happens when someone who buys a car for a large sum of money is tempted to order it with a radio installed, finding the difference trifling, but who, when he reflects that if he already had the car, he would not spend the amount on a radio for it.[10] Even if the agent violates the Bayesian norm, understanding him involves the interpreter finding another universal and objective norm to which the agent can be responsive. Here the interpreter does not presuppose any transcendent norm; he tries to construct one by agreement with the agent. This emphasis on the fact that the norms of

the mental are primarily those of the interpreter also explains why Davidson, after having formulated, in his first writings, the Principle of Charity as a principle of maximization of agreement, has finally preferred to talk of a maximization of understanding: the point is not to make those that we interpret as intelligent and as correct in their beliefs as possible, but to minimize unintelligible error.[11] This point is clearly emphasized in "A Nice Derangement of Epitaphs" about "passing theories", the theories that an interpreter formulates at a time for a given speaker:

> There are no rules for arriving at passing theories, no rules in any strict sense, as opposed to rough maxims and methodological generalities. A passing theory is like a theory at least in this, that it is derived by wit, luck, and wisdom from a private vocabulary and grammar, knowledge of the ways people get their points across, and rules of thumb for figuring out what deviations from the dictionary are most likely.[12]

If the norms of rationality which govern the interpretation of speech and action are so general and have such a high profile that they cannot consist in particular specific maxims, rules, or guides for actual interpretation, it seems to follow that the very notion of rationality cannot be, in McDowell's phrase, "codified" in any formulas or set of principles from which one could derive strict prediction about the behaviour or thought of agents.[13] If there were such principles or formulas, they could be applied, like strict laws, to any particular case, and they could tell us what to do or think in a particular situation. But even the best entrenched logical or decision-theoretic principles do not tell us *what* we ought to believe or do in a particular case, or whether it is rational or not to do something in a given situation.[14] There is always a slack between the formulas and their application, which can only be remedied by guesswork or by what Aristotle called *phronèsis*. The case can, once again, be illustrated with a decision-theoretic example. Bayesian Decision theorists claim that coherence in the probabilistic sense—non-violation of the axioms of the probability calculus—is a necessary condition of rationality; for otherwise a clever bookmaker could make a "Dutch book" against one such that the agent would systematically lose money on bets involving his beliefs. But it does not follow that an individual who is incoherent by this criterion—whose degree of belief violates the axioms of the probability calculus—is irrational. All that follows is that it is irrational to accept bets at odds that reflect one's degrees of beliefs when these degrees are incoherent. An agent might have good reasons not to accept such bets, just as he might have good reasons to accept them, without those reasons being epistemic ones.[15]

This "uncodifiability of rationality" can be evaluated also from other angles, which, according to Davidson, are intrinsically tied to the normative character of our mental concepts. One is the *causal* nature of these concepts,

which is "built into the concept of acting for a reason": a reason is "a rational cause", which can be spelled out as "a belief and a desire in the light of which the action is desirable."[16] But, as Davidson notoriously pointed out about examples of "deviant causal chains", where an agent performs an act in conformity with his intention, but not in the "right" way, there is no automatic specification of the conditions in which the beliefs and the desires are "appropriate" for making the action rational. "What I despair of spelling out," says Davidson, "is the way in which attitudes must cause actions if they are to rationalize the action."[17] And he actually seems to imply that there is no such way. The second angle from which the uncodifiable nature of the norms of rationality may be viewed is the *holistic* character of the rational patterns which must be presupposed to make an agent intelligible: the open-ended nature of the intentional contents which must be attributed is the mark of their rationality, but there is no clear limit to the extent of the pattern in question. Finally the normative character of mental concepts is closely tied to the *externalist* features of mental contents: because contents cannot be individuated internally, but by reference to a variety of causal factors which cannot be systematized under laws. As Davidson says:

> What I think is certain is that holism, externalism, and the normative feature of the mental stand or fall together. . . . There can be no serious science of the mental. I believe the normative, holistic, and externalist elements in psychological concepts cannot be eliminated without radically changing the subject.[18]

The distinctive character of our mental concepts is not simply that they are subject to norms. For there are also norms for our physical concepts, such as length or temperature, which Davidson once called "constitutive or synthetic a priori".[19] In physics too, there are norms of description and of explanation, for instance simplicity or explanatory power. What makes the normative element in the mental domain distinctive is that, unlike what happens in the physical case, where norms are employed about something which is essentially nonmental, in the mental case "norms are being employed as standards of norms."[20] We use norms to interpret patterns which are essentially normative. What does it mean? Here it seems to me that a comparison can be usefully made between Davidson's and Wittgenstein's views. For Wittgenstein there are rules of language, which record the use of words by speakers, and hence facts or regularities about these speakers—for instance that speakers of English usually mean cats by using the word "cat." But there are no *further* facts about what makes the rules *correct*. There is a correct application of the rules (Wittgenstein is not a "skeptic" about the existence of rules), but what makes it correct is not a special kind of fact (dispositional, psychological, or some Platonistic superfact). Davidson, as I pointed out above, feels no attraction in talk of rules and of specific norms of language. But his view

about the status of norms of rationality with respect to facts is quite similar to Wittgenstein's. For Davidson, there is a correct way (in spite of the unavoidable amount of indeterminacy) of interpreting a speaker and of making what he thinks or does intelligible, but there is no fact about what makes this interpretation correct, for there is no way of codifying the rational patterns that one has to attribute to a speaker in a particular circumstance. Wittgenstein and Davidson are, among the philosophers of this century, those who have most insisted on the existence of a particular kind of norms, distinct from the usual kinds of norms—practical, epistemic, or aesthetic—the *interpretative norms*. They both hold that such norms are distinctive, and that they cannot be reduced to facts.

If the foregoing account of Davidson's conception of the norms of rationality is correct, we should not expect any *definition*, nor any sort of specification of these norms. This is not, of course to deny that there are such standards, and that we can formulate them, for instance as principles of logic and of decision theory. The rules of logic are indeed those on which a theory of truth in Tarski's style must rely, and the standards of Bayesian theory are those on which Davidson's "unified theory" of meaning and action rests. But they offer no *definition* of rationality in general, just as a Tarskian theory of truth offers no general definition of the concept of truth. Just as we can think of truth as Ramsey thought about probability, by setting up a testable method of measurement of degrees of beliefs, and by defining the conditions under which a pattern of preferences can be "rational", we can think of the norms of rationality themselves as the undefined structures which a theory of interpretation must rely upon.[21] Thus, although we cannot say what the norms are, we can say what they do.

I subscribe to Davidson's view about the necessary normative character of mental concepts, and I agree with him that it is the feature which stands in the way of a complete science of the mental as well as in the way of attempts to reduce what Sellars calls the "space of reasons" to the space of natural laws and physical concepts. But the thesis that these norms cannot be codified nor defined is not unproblematic. I can see at least three kinds of difficulties (although they are related). First, if the standards of rationality used by an interpreter to make ascriptions of mental contents are not transcendent norms fixed in advance, but his "own norms" which he can only suppose are shared by others, don't we run the risk of a certain amount of *subjectivism* in the interpretation procedure? Davidson's account of interpretation certainly allows, and indeed requires, a large amount of convergence at the end of the process just as at the beginning, but how is this convergence acquired? Second, if we suppose that the interpreter is able, even by his own lights, to discern successfully rational from irrational patterns of thought or behaviour,

where does he get this ability from? This problem is similar to a problem which has often been raised about the knowledge of meaning that the Davidsonian interpreter must have in order to frame his ascriptions of held-true sentences to others. For a central feature of Davidson's conception of interpretation is that the interpreters-speakers must know what they mean by their words, without interpreting themselves, in order to interpret others and ascribe to them thoughts and meanings which are true by their own lights. But how do speakers know what they mean in the first place?[22] Why do they (rightly) think themselves authoritative about their own norms of rationality just as they (rightly) think themselves authoritative about the meanings of their own words? Even if the interpreter's ability for discerning rational patterns is not strictly codified, it must come from somewhere, and it must have a certain shape. It cannot have been acquired by magic.[23] The third difficulty has to do with the move taken by Davidson from a formulation of the Principle of Charity as a principle of maximization of truth and rationality to a formulation in terms of a principle or minimization of unintelligible error: if the rational and true beliefs ascribed by an interpreter must also be *intelligible* or *explainable* (in the interpreter's light) rational and true beliefs (so that it would be pointless to ascribe a vast majority of inexplicably correct beliefs), then it seems, if we do not want to say that there are no constraints at all upon such ascriptions, that there must be more particular constraints about what kind of contents are ascribable. When Davidson talks about the holistic character of interpretation, he always seems to have in mind very general (mostly logical) kinds of links within content, and does not mention the more particular or more local links that some contents might have; for instance, when a speaker can be interpreted as having thoughts about colours, or about shapes of objects, it may be presumed that he has some views about incompatibilities of colours, or about relationships between observational concepts of shape and colour. Making an agent intelligible must, at some point involve seeing the reasons why he holds a certain belief true, or his justification for holding true certain sentences. But Davidson's methodology of interpretation does not seem to give us more than a pattern of sentences held true, without any hint about what might justify a speaker to hold certain kinds of sentences true. This is in perfect agreement with his denial that truth could be equated with the grounds, or the warranted assertability of sentences: what matters are the truth-conditions of sentences, not their assertion conditions.[24] Now, even if we grant that point, we might try to find less global constraints than those that Davidson envisages.

Some writers, such as McDowell, have been tempted into reading into Davidson's position "the irreducible subjectivity of propositional attitudes" and the impossibility of "a distinction between what makes sense and what could come to make sense to us".[25] But Davidson's denial that rationality is

codifiable need not imply that it is not objective, and there cannot be a con-
vergence in the norms that speakers use to interpret each other. Indeed there
must, on his view, be such a convergence, since it is there from the start. The
way it is further reached is a matter of the extension of what he calls the basic
process of triangulation upon which objective thought rests.[26] It is enough that
the possibility of convergence is not ruled out a priori, and by definition it is
not. So it seems to me to be a very misleading way of interpreting his views
to read them in the way McDowell does.

It does not seem to me, however, that one can answer in the same way the
second and the third worry expressed above. The worry can be expressed
again thus: given that the rationality requirements on interpretation are so
general, and the interpreter has to rely upon his own sense of what is rational,
how can he read the rational patterns in a particular case? This is tied to the
problem of holism. There are two kinds of cases to distinguish: holistic
patterns within a particular attitude, say belief, and holistic patterns between
particular attitudes.[27] I shall say more about the second than the first. The first
kind of patterns are patterns such as those: in order for one to have beliefs
about rain, one must have beliefs about clouds, about the condensation of
drops in water-saturated air, about wetness, etc. If we set aside the problem
posed by the "etc.", which has been at the center of many discussions about
holism,[28] the holistic pattern within these beliefs is due to the way their
components are related, and these components are concepts. Davidson's
account of interpretation, as well as Quine's, tells us that in order to find basic
rational patterns among beliefs, we shall have to rely on basic logical
concepts, such as those of negation, conjunction, quantification, and the like,
but it tells us very little about other kinds of patterns within various types of
concepts, for instance observational concepts ("wet") vs. theoretical concepts
("condensation"), demonstrative concepts ("this rain") vs. general descriptive
concepts ("rain"). It is, however, legitimate to suppose that when an
interpreter ascribes a particular kind of belief, involving a particular kind of
concept, say an observational one, he takes it that there are certain *reasons*
which subjects typically have for having beliefs of such a kind, and that these
reasons enter into what makes the ascription intelligible to the interpreter. In
other words, what I want to suggest is that an interpreter, if he must use his
"own norms" for ascribing contents, must not simply find a pattern of
implications between sentences held true, but must have a certain conception
of the conditions of warrant or justification of such sentences, when they
contain particular concepts. In other terms, certain norms must be presup-
posed about what justifies a certain kind of content, what justifies its rejection,
or what inferences can be made about it. This line of thought might lead us to
try to give accounts of particular concepts along the line of various forms of

what is called "conceptual role semantics" or theories of "possession conditions" of concepts.[29] They might also help us to answer the objection voiced above, that the abilities of interpreters have to come from somewhere, for if mastery of a concept is a certain kind of ability or aptitude, the spelling out of the conditions under which the concepts are possessed should also tell us what kind of abilities they presuppose. Such accounts should be described much more precisely, but I suspect that Davidson would find them uncongenial for his own views, since they would have to assume much more individuation of content than he wants to assume in his theory of interpretation—the only kind of attitude assumed being that of holding certain sentences true. I think, nevertheless, that an account of the specific norms involved in the possession of an ascription of certain concepts can be extracted from his views.

For that we can consider the other kind of holism mentioned above, between attitudes. Beliefs cannot be ascribed without ascribing other attitudes, such as desires and intentions, and intentions themselves cannot be ascribed unless desires and beliefs are also ascribed. So an interpreter must not simply have an idea of the rational pattern within one kind of attitude, but must also have an idea of the relationships between attitudes themselves. If the preceding line of thought is correct, he must have some reasons to ascribe contents which are belief-like, and be able to distinguish them from those which are desire-like, regret-like, and so on. In his essays on animal thought, Davidson goes further: famously, he holds that the very having of a belief must presuppose the having of the *concept* of belief.[30] If we set aside the problem of animal thought, what does it mean to "have the concept of belief"? In one sense of that term, it means being able to have *beliefs about one's beliefs*, or to have reflexive beliefs. But in another, and as important, sense, it means being able to identify a particular kind of state as being a belief. Now, the concept of belief is the concept of a state which is *apt to be true or false*, or, to use a familiar phrase, which "aims at truth". Nothing, in this sense, can be a belief if it is not supposed to be true. According to this criterion, beliefs have a different "direction of fit" than desires: beliefs are states such that they should fit the world, whereas desires are such that the world should fit them. Now what I want to suggest is that this internal feature of the concept of belief, the fact that our beliefs "aim" at truth, is part of the "normative character" of this very concept. That beliefs are true or false according to whether their contents are true or false is part of why they are *correct or not*. The other part is that beliefs are justified according to whether the *reasons* for holding them are good or not. These are, indeed, platitudes, but they are integral to the concept of belief. The concept of belief is normative because it involves these basic norms of aiming at the truth and the justification of the contents of the corresponding state. Now, when Davidson

tells us that belief is "by its very nature veridical" or that "most of the point of the concept of belief is the potential gaps it introduces between what is held true and what is true,"[31] or that having the concept of belief is to have the contrast between subjective and objective, or to have the idea of an independent reality which is independent of my beliefs,[32] he seems to me to point just to this feature. This feature of beliefs is also integral to the basic choice of Davidson's interpretation procedure, to choose a particular attitude of taking certain sentences as true. If this is correct, then we have here an example of a particular kind of norm attached to a particular kind of concept. Indeed, this is not *any* sort of concept, for belief is central to most attitudes and concept formation. My suggestion is that we should try to give other similar normative conditions for various concepts.

We could also express the foregoing remarks thus: truth is the internal *goal* of belief. This, of course, does not mean that there is any sort of intention or teleological character in this, but that truth is the norm or the standard of appraisal of belief. This conclusion will be unwelcome to those who hold that the concept of truth is a concept which is necessarily extremely thin and "minimal" in its content, and Davidson is certainly a member of this family of theorists, although his views are specific. Davidson says that, although he does not agree with a "deflationist" reading of truth, according to which there is nothing more to truth than the schema " 'p' is true if and only if p", still it is a "folly" to try to define this concept. He claims that the concept can be shown to be explanatory by the use to which it can be put in a theory of interpretation.[33] But nothing that he says seems to me to be inconsistent with the following. Since aiming at truth is a norm of belief, the activities in which we are engaged when we try to assess our beliefs, the activities of inquiring, justifying, and giving reasons for these beliefs, are regulated by this norm. Interpretation would be impossible if it were not supposed that subjects do recognize this norm, which is thus part of the concept of truth. It does not follow that the norm is a convention of truthfulness, agreed to by the members of a community either tacitly or explicitly.[34] It is just that their attitudes could not be interpreted as attitudes of beliefs if they did not have this internal goal. If belief is thus central to our mental attitudes, then truth is indeed a norm of belief, and a norm—the basic norm—of the mental.

It is sometimes said that treating truth as a norm, as I suggest here, would imply some sort of appraisal, or some commandment to seek the truth.[35] It certainly implies no moral or ethical norm of the kind. Neither does it imply that truth is an essentially epistemic concept. It only implies that the norm of truth is among what I have called above interpretative norms. If to understand others is also to make intelligible their false or irrational beliefs, intelligibility requires grasp of the concept of truth. We can express it in the manner of John

Donne: "Though truth and falsehood bee neare twins, yet truth a little older is" (Satyre, II).

Pascal Engel

Université de Paris–Sorbonne
December 1998

NOTES

1. Davidson 1990, p. 25; Davidson 1970, p. 223.

2. See for instance Davidson 1990, p. 325: "What makes the task [of providing a unified theory of thought, desire, and speech] practicable at all is the structure the normative character of thought, desire, speech, and action imposes on correct attributions of attitudes to others, and hence to interpretations of attitudes to others, and hence on interpretations of speech and explanations of their actions." See also Davidson 1995, chapter 5: "The entire structure of the theory depends on the standards and norms of rationality."

3. Davidson 1990, p. 25; Davidson 1991, p. 162.

4. See in particular "Communication and Convention" in Davidson 1984, and Davidson 1986. A. Bilgrami (1992) is quite clear on the distinction between a "localist" and a "generalist" view of norms in their relevance to meaning and intentionality.

5. The first principle is sometimes called by Davidson the Principle of Correspondence and the second the Principle of Coherence (e.g. Davidson 1991, p. 158).

6. "How is Weakness of the Will Possible?" (1969) in Davidson 1980, p. 41.

7. Davidson 1990, p. 25.

8. Davidson 1985, p. 89.

9. See in particular his essays "Hempel on Explaining Action" and "Psychology as Philosophy" in Davidson 1980.

10. Leonard J. Savage 1954, pp. 103–4 (The relevance of this example for considerations on normativity in interpretation is pointed out by Skorupski 1990).

11. Davidson 1984, p. xvii. Some writers have held that this amounts to a redefinition of the Principle of Charity as a Principle of "Humanity", but I will not go into that.

12. Davidson 1986, p. 446.

13. McDowell 1979, p. 336 (reprinted in McDowell 1997, pp. 57–58). This view is well put by Child 1994, pp. 57–68 from whom I borrow the phrase "uncodifiability of rationality."

14. This could be said to be one of the numerous lessons of Lewis Carroll's tale of Achilles and the Tortoise: Achilles tries to force the Tortoise to recognize the

validity and applicability of a logical principle (the *modus ponens*) to a particular case, but the Tortoise always refuses to see it applied in *this* case.

15. See for instance, for further considerations on this point, Foley 1993, pp. 155–162.

16. "Psychology as Philosophy" (1974), in Davidson 1980, p. 233.

17. "Freedom to Act", in Davidson 1980, p. 79.

18. Nicod Lecture, Lecture 5, see also Davidson 1996.

19. "Mental Events" (1970), in Davidson 1980, p. 221.

20. Nicod Lectures, V.; see also Davidson 1996.

21. Davidson 1996, pp. 277–78.

22. The feature is emphasized by Davidson 1987, and the problem well put by Barry C. Smith 1998, p. 415.

23. This point is pressed by F. Jackson and D. Braddon-Mitchell 1996, pp. 155–56.

24. See, for instance, Davidson 1990, pp. 307–8.

25. McDowell 1986, p. 396.

26. See in particular Davidson 1991; 1995.

27. In his 1995 Nicod Lectures (Lecture 1), Davidson calls them respectively "intra-attitudinal" and "inter-attitudinal" aspects of holism; the example about rain below is his.

28. Davidson is obviously not committed to holding that the "etc." means that *all* the other beliefs of a person have to be related to a single one.

29. For an account of the first kind, see R. Brandom 1994; for an account of the second kind, see Peacocke 1992.

30. In particular "Thought and Talk" (1975) in Davidson 1984, and "Rational Animals" (1982), reprinted in Le Pore, 1985, pp. 473–80.

31. "A Coherence Theory of Truth and Knowledge" (1986), in Le Pore 1986, p. 308.

32. "Rational Animals", ibid. p. 480.

33. Davidson 1996.

34. David Lewis, in his theory of convention and of radical interpretation, has invoked such a convention. See his (1974). But there is no need here to think of it as a *convention*.

35. Richard Rorty (1995) suggests that taking truth as a norm implies this, and proposes his own deflationist version against Wright (1992) who advocated, in the same sense as here, such a view. He believes that such a view would imply what Davidson deplored, an attempt to "humanize" truth. My point is simply that we would lose the point of the notion of truth if we could not link it to the aims of our belief.

BIBLIOGRAPHY

Bilgrami, A. 1992. *Belief and Meaning*. Oxford: Blackwell.

Brandom, R. 1994. *Making it Explicit*. Harvard: Harvard University Press.

Child, W. *Causality, Interpretation and the Mind*. Oxford: Oxford University Press.

Davidson, D. 1980. *Essays on Actions and Events*. Oxford : Oxford University Press.

———. 1984. *Inquiries into Truth and Interpretation*. Oxford: Oxford University Press.

———. 1985. "A New Basis for Decision Theory". *Theory and Decision* 18: 87–98.

———. 1986. "A Nice Derangement of Epitaphs". In Le Pore 1986: 433–40.

———. 1990. "The Structure and Content of Truth". *Journal of Philosophy* 87, no. 6: 279–326.

———. 1990a. "Representation and Interpretation". In *Modelling the Mind*, edited by K. A. Mohyeldin Said, W. Newton-Smith, R. Viale and K. Wilkes,. Oxford: Oxford University Press, 13–26.

———. 1991. "Three Varieties of Knowledge". In *A. J. Ayer, Memorial Essays*, edited by A. Philipps Griffiths. Cambridge: Cambridge University Press, 153–66.

———. 1994. "The Measure of the Mental," ms, tr.fr. "La mesure du mental". In Engel 1994, 31–49.

———. 1995. *The Jean Nicod Lectures*. Paris, unpublished.

———. 1996. "The Folly of Trying to Define Truth". *Journal of Philosophy* 93 no. 6: 263–78.

Engel, P., ed. 1994. *Lire Davidson*. Combas: L'Eclat.

Foley, R. 1993. *Working Without a Net*. Oxford: Oxford University Press.

Jackson, F. and D. Braddon-Mitchell. 1996. *Philosophy of Mind and Cognition*. Oxford: Blackwell.

Le Pore, E., ed. 1985. *Actions and Events: Perspectives on the Philosophy of Donald Davidson*. Oxford: Blackwell.

———. 1986. *Truth and Interpretation: Perspectives on the Philosophy of Donald Davidson*. Oxford: Blackwell.

Lewis, D. 1974. "Radical Interpretation," *Synthese* 23: 331–44.

McDowell, J. 1979. "Virtue and Reason," *Monist* 62 (1979): 331–50. Reprinted in McDowell 1998.

———. 1986. "Functionalism and Anomalous Monism," in Le Pore 1985, 387–98. Reprinted in McDowell 1998.

———. 1998. *Mind, Value and Reality*. Harvard: Harvard University Press.

Peacocke, C. 1992. *A Study of Concepts*. Cambridge, Mass.: MIT Press.

Rorty, R. "Is Truth a Goal of Inquiry? Davidson vs Wright," *Philosophical Quarterly* 45, no. 180: 281–300.

Savage, L. J. 1954. *The Foundations of Statistics*. New York: Wiley (quoted after the 1972 edition, New York: Dover Books).

Skorupski, J. 1990. "Explanation and Understanding in the Social Sciences." In *Explanation*, edited by D. Knowles, Cambridge: Cambridge University Press, 119–34.

Smith, B. C. 1998. "On Knowing One's Own Language." In *Knowing Our Own Minds*, edited by C. Wright, B.C. Smith and C. McDonald, Oxford: Oxford University Press.

REPLY TO PASCAL ENGEL

A re our norms of rationality up to each of us, and so subjective? No; what is up to each of us is to apply his or her own norms, since we cannot check up on whether our norms are the same as other people's until we already have found a reasonable fit between their norms and ours. If no such fit is there to be found, we have no grounds on which to believe they have norms or thoughts. Once a fit is found, criticism and comparison are possible and intersubjectivity becomes the basis for objectivity.

Do we know what we mean by our words? Of course, we often do not know what others will take us to mean; what we are authoritative about is our intentions. We know, in the same way we know our own thoughts generally, how we intend others to understand us, and if we are reasonably consistent, others will be able to understand us. We don't need or usually have a "theory" about what we mean; only someone who wants to specify what an interpreter knows in order to understand a speaker needs a theory.

Pascal Engel says much that is accurate about my claim that the concepts we use to explain and describe thought, speech, and action are irreducibly normative. He surprises me, though, when he remarks that my methodology of interpretation does not give "any hint about what might justify a speaker [in holding] certain kinds of sentences true." It seems to me that the basic justification for holding empirical sentences true is given by the conditions under which we observe them to be held true. When we have succeeded in matching up a speaker's observation sentences with our own, we have discovered what justifies the speaker in holding them true. Of course, such matching is not to be trusted simply on the basis of a few successes; logically connected sentences must come out right, and so must explanations of error. The interpretation of any sentence depends on placing it in a network of other sentences. But the network must be tied to the world through the kind of triangulation that is fundamental to radical interpretation.

Engel thinks "conditions of warrant or justification" which take into account the reasons agents have for holding sentences true—reasons that go

beyond those that deductive logic provides—should be included in the methodology of interpretation. I agree, and I outlined how I thought this could be done (Davidson 1980), and subsequently made it explicit (Davidson 1990). The idea was that by combining decision theory with theory of meaning, one could derive not only flat-out beliefs and meanings but also degrees of belief and the usual way of comparing differences in degree of desire. Knowing degrees of belief in sentences (rather than the earlier flat-out belief) makes it possible to construct a measure of the extent to which a speaker considers one belief to support (justify) belief in another. Without this additional knowledge, it would be almost impossible to interpret theoretical sentences and terms, or to explain and predict action. It seems to me that neither conceptual role semantics nor possession condition accounts of concepts have given, or can be expected to give, as detailed or satisfactory a measure of the conditions under which it is justified to hold a sentence true.

There are times when we are certain that something is the case; we have excellent, even overwhelming, evidence, subsequent events bear us out, and everyone comes to agree with us. I have no doubt that very often what we believe in such cases is true. Induction should persuade us that there are other times when we are equally justified in a belief and it ultimately turns out to be false. There must be cases of fully justified beliefs where the fact that they are false will never come to be known. I cannot see that cases of the last kind are any more desirable than cases of the first kind. When we say we want our beliefs to be true we could as well say we want to be certain that they are, that the evidence for them is overwhelming, that all subsequent (observed) events will bear them out, that everyone will come to agree with us. It makes no sense to ask for more. Of course, if we have beliefs, we know under what conditions they are true. But I do not think it adds anything to say that truth is a goal, of science or anything else. We do not aim at truth but at honest justification. Truth is not, in my opinion, a norm.

D. D.

REFERENCES

Davidson, Donald. 1980. "Toward a Unified Theory of Meaning and Action". *Grazer Philosophische Studien* 11: 1–12.
———. 1990. "The Structure and Content of Truth". *Journal of Philosophy* 87: 279–328.

20

Carol Rovane

RATIONALITY AND IDENTITY

L ocke famously argued for a metaphysical distinction between personal and animal identity. I shall be arguing in this paper that Davidson's account of rationality and intentionality provides independent support for Locke's distinction or, I should say, for a version of it.

Locke's own grounds for affirming the distinction rested in large part on a thought experiment. He asked us to imagine that the respective consciousnesses of a prince and a cobbler are switched each into the other's body, and to consider which of the resulting persons would be the prince and which the cobbler. He thought it intuitively obvious that the identity of each of these persons would be grounded in the continuity—what he called the *sameness*—of its consciousness rather than in the life of any particular animal.

I will not be resting my argument in this paper on this particular Lockean intuition. Instead I will be appealing, as I have already said, to Davidson's account of rationality and intentionality. This approach will lead me to propose an analysis of personal identity which in its details is quite different from Locke's. Rather than analyze it as he did in phenomenological terms having to do with the unity and continuity of consciousness, I propose to analyze it instead in normative terms. According to the normative analysis, the condition of personal identity is the condition in which a certain normative commitment arises, a commitment to realizing what I call the *ideal of overall rational unity*. This normative analysis entails Locke's distinction between personal and animal identity because it entails the following two possibilities: group persons composed of many human beings and multiple persons within a single human being. These possibilities closely resemble the actual phenomena of joint agency and multiple personality disorder. Yet I am not lodging any empirical claims to the effect that these phenomena supply us with actual instances of group and multiple personhood. I wish only to insist on their possibility, not their reality.

Obviously, the twin possibilities of group and multiple persons are not what Locke aimed to establish with his thought experiment about the prince and the cobbler. That is why I said at the outset that Davidson's account of rationality and intentionality supports a *version* of Locke's distinction between personal and animal identity. You might even call it a *re-interpretation*.

It should not be assumed that Davidson himself is willing to endorse this re-interpretation of Locke's distinction—or, for that matter, *any* version of it. There is substantial evidence in his published writings that he is predisposed to embrace the animalist view that rejects the distinction altogether.[1] But nevertheless, if I am right then this predisposition stands in some tension with his interpretive perspective on rationality and intentionality.

In section I, I will urge that there are strong reasons for supposing that something is a person just in case it is an object of interpretation in Davidson's sense. It follows that the conditions a thing must satisfy in order to be interpretable are conditions of personhood. Among these conditions, the one that really matters to my argument is the normative condition that Davidson puts forward with his Principle of Charity. In section II I will explore this normative condition on interpretation in some detail. It will emerge that there is one person wherever there is one object of interpretation who by and large satisfies this normative condition and who is, moreover, committed to satisfying it. In section III I will argue that persons in this sense need not stand in one-to-one correspondence with human (or other) animals, because in certain cases groups and parts of human beings could be objects of interpretation and hence individual persons in their own rights, group and multiple persons, respectively. In section IV I will briefly consider one objection to this conclusion.[2]

I. INTERPRETATION AND PERSONHOOD

What recommends the view that something is a person just in case it is an object of interpretation in Davidson's sense? The quick answer is, whatever recommends the Enlightenment conception of the person as a self-conscious rational agent. For that is precisely how Davidson conceives the objects of interpretation.

Admittedly, the Enlightenment conception of the person is not above controversy. It is closely associated with several influential projects in ethics and politics, such as Kantian ethics, contractarian political theory and theories of rights, and all of these Enlightenment projects have been challenged from

a number of perspectives—communalist, feminist, anthropological, post-colonial, etc. However, I want to suggest that the Enlightenment conception has an ethical advantage which will remain even if we should abandon all of the controversial projects that have been so closely associated with it. It is this ethical advantage that recommends the conception, and along with it the idea that personhood goes along with interpretability.

Before describing this ethical advantage of the Enlightenment conception of the person, let me offer two good reasons why it makes sense, in any case, to assume it for the purposes of this paper.

First, it makes sense to assume the Enlightenment conception in *any* paper that aims to address the central philosophical dispute about personal identity that Locke inaugurated with his thought experiment about the prince and the cobbler, concerning whether personal identity is distinct from animal identity. Locke himself clearly subscribed to the conception. But moreover, so did his contemporary animalist opponents. When they argued against him that personal identity is not distinct from animal identity, they were not disagreeing with him about whether a person is a self-conscious rational agent. They were disagreeing with him about whether such agents are, necessarily, animals. The same is true in current discussions of personal identity. The current dispute (at least insofar as it is a metaphysical dispute rather than an ethical or political dispute) is not about whether we ought to conceive persons as self-conscious rational agents. The dispute is about whether persons so conceived are or are not identical with animals.

Secondly, and even more directly to the point of this paper, there is good evidence that Davidson himself subscribes to the Enlightenment conception of the person. Of course he rarely, if ever, uses the term "person" in his philosophical writings. His central preoccupations have been the nature of linguistic meaning, agency, rationality and intentionality, and how all of these traits emerge together in interpretation, and how none of them can exist apart from the activity of interpretation. This means that in his view, the *objects* of interpretation are also, necessarily, *interpreting agents*. And there really is no difference between his conception of an interpreting agent and the Enlightenment conception of a person. The only imputable difference between the two conceptions is this: unlike Davidson's conception, the Enlightenment conception does not make any specific mention of the ability to interpret. But it should be obvious that this social ability has always been implicit in the Enlightenment conception. For consider, who would deny Davidson's claim that a self-conscious rational agent is also a social agent who can communicate with other such agents? Only a skeptic who wants to insist on the possibility of rational reflection in a state of Cartesian doubt about the external world. And this skeptical possibility is quite irrelevant to the main

point and function of the Enlightenment conception, which is to provide a metaphysical starting point for ethical and political reflection. No ethical or political problems can arise for agents who are in the grip of Cartesian doubt; such problems arise only for agents who inhabit and know and interact in a social world. That is why I want to insist that sociality has always been implicit in the Enlightenment conception of the person. That is also why I take Davidson's conception of an interpreting agent to be equivalent to it.

This gives me all the justification I really need for taking the Enlightenment conception of the person for granted in this paper: the main parties to the central philosophical dispute about personal identity subscribe to it and so does Davidson himself, at least implicitly. But I cannot resist saying a bit more about what there is to recommend it independently of these facts. As I have said, it has a very important ethical advantage. And this advantage is especially easy to see once we make the connection between it and Davidson's conception of an interpreting agent.

When the Enlightenment conception of the person is equated with Davidson's conception of an interpreting agent, it provides for a clear and straightforward test of personhood: if something is a person then it must be something whom *we* find interpretable, and with whom *we* can therefore talk and reason.

Now, at first glance, and perhaps even at second glance, this way of conceiving persons might appear to be unduly exclusive. It clearly excludes certain human beings from the class of persons, namely, those who cannot engage in interpretation because they lack the requisite rational, reflective, or social capacities (such as very young human beings, and also those who are senile or brain-damaged or comatose or insane). It would also exclude any creatures who have the requisite capacities but whom we cannot interpret anyway, because they are either too sophisticated or too different from us. Davidson, of course, denies that there could be any such creatures. I mention them only because I want to bring out, for the sake of argument, all of the cases that someone might claim are excluded by the Enlightenment conception of the person.

Despite this appearance of exclusiveness in the Enlightenment conception of the person, the ethical advantage that I want to claim for it actually lies in its *inclusiveness*. *Any* agent who passes the test of interpretability counts as a person by its lights, and this is so no matter what race, gender, nation, or other group or metaphysical kind the agent might happen to belong to. Furthermore, once we persons adopt the Enlightenment conception of ourselves, we are thereby required to acknowledge and enforce this inclusiveness; that is, we are required to count all of the agents whom we can interpret as one of us. And note that there is very little scope for doubts and error in this matter concerning who is to be counted as one of us. Interpretability is *by*

definition the sort of thing that we persons, qua interpreting agents, can discover. Because this is so, it would (except in highly unusual circumstances) be an act of *hypocrisy* for us persons to deny one another's personhood.

I do not want to argue that there is any particular way in which we must or ought to treat other persons once we have acknowledged their personhood. But I do want to bring out that we stand in a distinctive ethical relation to other persons just by virtue of the fact that we can recognize them as such. To recognize other persons is *eo ipso* to recognize a whole range of practical possibilities for how we might treat them. First of all, there are all of the possibilities urged on us by the proponents of the Enlightenment conception of the person, such as respecting the rights of persons, taking them as partners in a social contract, or treating them as ends in themselves. But secondly, there are also much more mundane possibilities that have to do with treating persons specifically *as persons* in a less morally loaded sense. We treat persons as persons whenever we engage the rational, reflective, and social capacities that distinguish them from mere things—as we do whenever we talk to them, reason with them, criticize them, entreat them, lie to them, threaten them, bargain with them or cooperate with them. But of course, we can also treat persons as mere things, as if they did not even have the rational, reflective and social capacities that distinguish them as persons (I have in mind such things as pushing, binding, gagging, and drugging). Thus whenever we recognize other persons, we must also recognize that we face a choice concerning how to treat them, where this choice presupposes the whole range of practical possibilities I just described. *And merely to face this choice is already to stand in an ethical relation to other persons.* Why? Because the choice concerning how to treat other persons concerns an issue of ethical significance, and this remains true regardless of what we choose—for or against respecting rights, entering into social contracts, treating persons as ends in themselves, or even treating them as persons at all. In each and every case, we must acknowledge that the outcome of our choice will *matter* to the persons whom the choice concerns, and this suffices to confer ethical significance on our choice. (Or, if this does not suffice, then there simply are no issues of ethical significance at all.)

I am now finally in a position to give a proper statement of the ethical advantage of the Enlightenment conception of the person. The conception helps us to define and expose and, ultimately, to overcome a particular form of *prejudice* against persons which consists in a *hypocritical denial of their personhood.* I have already made clear that such denials are bound to be hypocritical, because interpretability constitutes a clear and straightforward test of personhood that leaves little room for doubts and error. But why do I say that such hypocrisy would constitute a form of *prejudice*? In general, prejudice involves an unjustifiable discrimination against, and perhaps even

hatred of, certain persons on the basis of the fact that they belong to a certain group. But when prejudice is *un*hypocritical, no attempt is made to cover over the differential treatment that is being meted out to different persons who belong to different groups. In contrast, the point of hypocritical prejudice is precisely to cover over such differential treatment of persons, by pretending that some of them are not really persons to begin with. In this way, we pretend that nothing of ethical significance has really happened. Thus, by hypocritically denying that certain persons are persons, we pretend that they do not present us with the unavoidable ethical choice that persons always present to us once we recognize them as such, concerning how to treat them.

It is arguable that much of the historical progress (such as it is) that has been made against prejudice along racial lines, especially in connection with racial prejudice against slaves of African descent, is best understood in terms of this point about hypocrisy. The prejudice has consisted, in large part, in denying that agents of a certain race are persons at all; the progress has come with the acknowledgment that the mere fact that such agents can be treated as persons is a sufficient condition for their actually being persons. And I would argue that this progress also involved acknowledging the hypocrisy of the earlier denial—which acknowledgment would presuppose, of course, the Enlightenment conception of the person.

However, it is also arguable that the failure to acknowledge the personhood of slaves did not really involve hypocrisy, so much as a different and more exclusionary conception of the person than the Enlightenment conception of a rational agent—such as a white property-owning male. If that were so, then the progress against prejudice would not have involved overcoming a hypocritical outlook; rather, it would have amounted to a kind of conceptual progress in which a more inclusive conception of the person was substituted for the earlier exclusionary one.

I am not convinced by this alternative account. The more inclusive conception of the person as a rational agent was available, and indeed widely subscribed to, well in advance of the political progress that has been made against the sort of prejudice I have in mind. After all, Hobbes, Locke, and Kant all clearly equated the term "person" with "rational agent." And there has never been any doubt about what counts as evidence of rational agency, namely, susceptibility to distinctively interpersonal forms of engagement in which persons treat one another specifically as persons in the ways I described above in the test. It is hard to credit the idea that white oppressors *sincerely* believed that there was no such evidence of the personhood of their African slaves. On the contrary, it would seem obvious that conversation, criticism, argument, etc. were all a central part of their intercourse. And this invites the conclusion that the prejudice against the members of this group, insofar as it involved a denial of their personhood, was indeed hypocritical.

This conclusion is further supported by the fact that at various times laws were passed to prohibit the education of slaves. Obviously, there would be no need for such laws if the slaves were not educable. But of course, they were educable. And this fact is of a piece with the fact that they could be treated specifically as persons. That is why I find it plausible to say that the denial of their personhood was indeed hypocritical. (Or perhaps, though I find this less plausible, the denial rested on self-deception rather than outright hypocrisy. But that would not put the deniers in a more comfortable or defensible moral position.)

I want to make clear the ethical advantage that I am claiming for the Enlightenment conception of the person does not hang on the correctness of my historical claims. It hangs rather on the way in which the conception helps to *define* this particular form that prejudice against persons *can* take, which consists in a hypocritical denial of their personhood—as opposed, say, to unhypocritical hatred of certain groups of persons. The second kind of prejudice is familiar and depressing. But there is a way in which hypocritical prejudice is more pernicious, because it involves the pretense that it is not prejudice at all.[3]

It is important to see that there is neither motive nor opportunity for such hypocritical prejudice with respect to the cases that the Enlightenment conception excludes as nonpersons. That is why the exclusions are not problematic. Take first the case of human beings whom we cannot treat as persons because they lack the requisite rational, reflective, or social capacities. These human beings raise many poignant ethical issues for us. But they do not occasion the same ethical choice that persons occasion, simply because they cannot be treated in the ways that persons can. And there is nothing hypocritical or prejudicial about acknowledging this difference in our ethical relations to these human beings and to the agents who satisfy the Enlightenment conception of the person. Take next the creatures whom we imagine to have the requisite rational, reflective, and social capacities for personhood, but who are nevertheless excluded by the conception because they defy our interpretive abilities. If such creatures were to exist, we could not recognize them as such, and in consequence, we would not stand in any ethical relation to them at all. In this point I am on somewhat easier ground than Davidson, who claims that such creatures are impossible. In claiming this, he is claiming that there can be no cases or forms of intentionality that we cannot understand. Inevitably, certain sorts of realists will complain that he has overstepped what we have a right to claim about the possible forms of mindedness which the world might contain. But whether or not this complaint against Davidson is justified, I want to emphasize that no similar complaint against me could ever be justified. My claim is not about intentionality in general; it is about personhood in particular. And it is really a *proposal*. I propose that we adopt

a particular conception of personhood, according to which something qualifies as a person just in case *we* can treat it specifically as a person. This does not require us to deny that there might be forms of intentionality that defy our understanding. It requires rather that we acknowledge the personhood of all of the self-conscious rational agents who do *not* defy our understanding, and with whom we therefore stand in the distinctive ethical relation in which persons alone can stand. To repeat, such a denial of their personhood would constitute an act of hypocritical prejudice. And the ethical advantage of the Enlightenment conception is that it keeps us more honest in our dealings with persons than that.

II. THE NORMATIVE IDEAL OF OVERALL RATIONAL UNITY

If a person is essentially (so to speak) the sort of thing that is interpretable, then the conditions that a thing must satisfy in order to be interpretable must be counted among the conditions of personhood.

The most important such condition—certainly it is the most discussed—is the normative condition that is articulated by the Principle of Charity. Davidson's early invocations of the principle were primarily motivated by, and directed towards, a proper understanding of the connection between interpretation and truth. In outline, the connection goes something like this: there can be no assignments of meanings to a speaker's words except in conjunction with attributions of belief; given the holistic character of belief, disagreement in belief is not intelligible except against a background of agreement; such background agreement always and necessarily outruns disagreement; this background of agreement constitutes a body of beliefs which must by and large be shared by *all* speakers and interpreters; since there is no possible interpretive point of view from which this body of beliefs could be regarded as largely mistaken, it must by and large be *true*.[4] This argument delivers an important result even if it fails to meet all skeptical challenges, or to undermine every version of relativism. For it also entails the slightly less ambitious claim that all communicators must have a shared conception of the truth, and that is a claim from which interesting philosophical work can begin.

In Davidson's work overall, these claims about the role of truth in interpretation are situated within a much broader vision. He has argued that the interdependence of meaning and belief is just one aspect of a complex network of interrelated psychological and normative concepts. This is because a theory of meaning for a speaker's language can be arrived at only in tandem with a larger psychological theory that makes sense of the speaker's intentional behavior overall, nonlinguistic as well as linguistic. In consequence, to interpret someone is nothing less than to arrive at a unified theory

of meaning, belief, and action for that person, a theory that ascribes motivational states and actions to the person as well as cognitive states and semantic intentions.

To go along with this expanded conception of interpretation, as aiming at a unified theory of meaning, belief, and action for a person, Davidson needed to expand the Principle of Charity that governs interpretation. That is, he needed to introduce further normative requirements on interpretation besides truth. These are the broader requirements of rationality that apply to other species of intentional episode besides belief, such as desire and action. Davidson has never specified these broader requirements of rationality very precisely. He has settled, and I will also settle, for a general sense of their role and purpose.

We can gain this general sense of the role and purpose of the normative requirements of rationality by taking a closer look at how they govern the interpretive process of arriving at a unified theory of meaning, belief and action for a person. Such a theory must portray all of a person's intentional actions—nonlinguistic as well as linguistic—as rational outcomes of the person's psychological attitudes. To so portray actions is to portray them as executions of all-things-considered judgments, judgments that specify what it would be best for the person to do in the light of all that the person wants and believes. Such judgments presuppose a variety of rational activities that together comprise a person's deliberations, such as the following: resolving contradictions among one's beliefs, working out the implications of one's beliefs and other attitudes, ranking one's preferences. No doubt deliberation involves many more rational activities than these. But it does not matter for my purposes what they happen to be. My argument depends on only the following four general claims. And these four claims will suffice to give us the sort of general sense that is wanted of the role and purpose of the various normative requirements of rationality. First, each component rational activity that deliberation involves counts as a *rational* activity because it aims to satisfy a specific normative requirement of rationality (in the cases I have mentioned, they are the requirements of consistency, closure, and transitivity of preferences). Second, whenever a person deliberates it engages in various rational activities with one overarching goal, which is to arrive at and act upon all-things-considered judgments which take all of its psychological attitudes into account. Third, insofar as a person does arrive at and act upon all-things-considered judgments, it thereby achieves a state of what I call *overall rational unity*. It should be obvious that achieving this state would involve meeting all of the more specific normative requirements that govern the component rational activities of deliberation such as resolving contradictions, accepting implications, and ranking one's preferences transitively. But also fourth, and finally, it should also be easy to see that whatever these specific

requirements might be, there is one very general normative requirement of rationality that applies in a comprehensive way to all of a person's intentional activities, which is just that a person is required to achieve a state of overall rational unity—is required, in other words, to arrive at and act upon all-things-considered judgments in a rationally optimal way.

As I see it, Davidson's expanded Principle of Charity should be understood as instructing interpreters to find by and large conformity to this very general normative requirement of overall rational unity. Like his original formulation of the principle, this formulation can be taken to articulate a *constitutive thesis*. Originally, Davidson's constitutive point was this: nothing counts as a belief unless it belongs to a body of beliefs that is largely true. In the expanded version, the constitutive thesis is that nothing counts as an intentional episode of any kind unless it belongs to the mental life of a person who by and large meets the normative requirement of overall rational unity.

It might seem that this latter constitutive thesis and corollary interpretive principle are far too stringent. The fact is that persons hardly ever do consider *all* things before they act. And this fact might seem to raise a difficulty for Davidson, concerning how much slippage we interpreters may legitimately tolerate between the actual intentional activities of persons and the normative requirements of rationality.[5] But I myself do not think that there is any grave difficulty here. Let me explain why.

We should not think of the normative requirement of overall rational unity as being like a moral requirement in Kant's sense, where *ought* implies *can*. It is clear that mere mortals cannot ever fully achieve overall rational unity. Such unity really constitutes an *ideal* of which we are bound to fall short. Accordingly, if there is a sense in which we *ought* to meet the normative requirement to achieve such unity, it must be a sense that does *not* imply *can*. What sense is that? The requirement tells us what we are required to do in order to be fully or ideally rational. This idealized understanding of the normative requirement of overall rational unity puts a different complexion on Davidson's constitutive thesis. The thesis can be taken as saying that something counts as an intentional episode only insofar as it belongs to the mental life of a person who in some significant degree approximates the normative ideal of overall rational unity. This clearly leaves plenty of room for rational failure.

It might seem that the idealized understanding of Davidson's expanded charity principle solves one difficulty only by introducing another. For it might seem that the very fact that the principle allows us to attribute significant rational failure to those we interpret also renders it less useful as a guide in interpretation. The point of charity, remember, is to constrain interpretations by ruling out those that fail to attribute enough conformity to the normative

requirement of overall rational unity. Clearly, then, the greater the scope for *non*conformity, the greater will be the number of alternative interpretations that we cannot rule out just on grounds of charity. And if it turned out that there were too many acceptable alternatives, that would indeed create a difficulty.

However, the idealized understanding of the normative requirement of overall rational unity does not really saddle us with such a difficulty. In order to see why, we must consider how the requirement actually figures in the lives of persons, as well as in the process of interpreting them. We persons must actually be *committed* to meeting this requirement. Why? Because qua beings who are reflective as well as rational, we are able to grasp the normative force of the requirement; and to grasp its normative force is just to recognize that we *ought* to meet it; and nothing more is required for being committed to meeting it than recognizing that we ought to meet it. Obviously, our commitment is to an ideal of which we are bound to fall short. But this does not prevent the ideal from serving as an effective normative guide in our lives. It provides a reference point by which we can evaluate our own thoughts and actions, and count them either as rational successes or as rational failures. It also provides a goal towards which we can strive even as we recognize our failures to achieve it. This is what makes us susceptible and responsive to criticism from others. Indeed, that is one very important way in which persons manifest their commitment to the normative ideal of overall rational unity, by responding to criticism. These two facts about persons—the fact that they are actually committed to meeting the normative requirement of overall rational unity and the fact that their commitment makes them responsive to criticism—serve to remove the difficulty I raised above. The difficulty was that leaving room for rational failure makes the expanded Principle of Charity less useful as a guide in ruling out alternative interpretations. But we have now discovered a guide for attributing rational failures: they must be failures that persons themselves are willing to acknowledge in the light of their own commitment to meeting the normative requirement of overall rational unity. So what charity really instructs us to do is to attribute nonconformity with this requirement only insofar as persons themselves accept and respond to criticism for such nonconformity.

It might, perhaps, still be doubted whether persons truly are committed to realizing the normative requirement of overall rational unity. I think these doubts are misplaced. After all, persons manifest this commitment whenever they respond to criticism. And in any case, there is another, much more ubiquitous sign of the commitment, namely, susceptibility to any kind of rational engagement at all. As a matter of definition all rational engagement aims at rational response. And if it is rational response at which rational

engagement aims, then it must appeal, however implicitly, to a person's commitment to arriving at and acting upon all-things-considered judgments. And that just is the person's commitment to realizing the normative ideal of overall rational unity. Think how many interpersonal interactions involve rational engagement in this sense that appeals to a person's commitment to overall rational unity. They include all of the interactions in which persons treat one another specifically as persons in the sense that I explained in section I. Even lies and threats appeal to this commitment. Their point is not to get a person to go in for rational failure; their point is rather to get a person to judge that it is best, all things considered, to believe the lie and comply with the threat. So it is in all of the interactions in which persons treat one another as persons in the sense of engaging their rational capacities; they must in all cases appeal, however implicitly, to the commitment that persons, qua self-conscious rational agents, must have to achieve the overall rational unity within themselves.

Let me close this section by quickly summarizing the main points of my argument so far. It is a necessary and sufficient condition of a thing's personhood that it be interpretable by us. Persons in this sense are agents who partially meet the normative requirement of overall rational unity in their actions. But even when persons fall short, they are nevertheless *committed* to satisfying this requirement, and this makes it possible for them to treat one another specifically as persons.

III. INTERPRETATION AND PERSONAL IDENTITY

There is a straightforward way in which all of the points that I brought out in the last section concerning the process of interpretation bear on the issue of personal identity.

The objects of interpretation are, obviously, individual persons. Accordingly, insofar as the aim of interpretation is a unified theory of meaning, belief, and action, it is a theory about the intentional activities of an individual person. Likewise, the normative requirement of overall rational unity which governs interpretation articulates an ideal of rationality that applies to individual persons. In fact, it *defines* what it is for an individual person to be fully or ideally rational. (This conceptual tie between the ideal of overall rational unity and the individual person is evident from the following fact: there is no failure of rationality when a group of persons fails to meet this ideal, but only when an individual fails to meet it. So for example, if I have inconsistent beliefs, I am guilty of rational failure; but my beliefs may be

inconsistent with yours without there being any rational failure on either of our parts.)

What should we infer about the condition of personal identity from all of this?

There is a natural assumption about the methodology of interpretation which would lead us to infer that Locke was mistaken to distinguish personal from animal identity. Although my ultimate aim in this section is to challenge this assumption, I want first to give a sympathetic account of it. The assumption is that the objects of interpretation—that is, persons—must be identified *prior* to the process of interpretation itself. Since all intentional facts about what a person believes, wants, or does can emerge only in the course of interpretation, this assumption requires that persons be identifiable on the basis of completely nonintentional criteria or, in other words, on the basis of their material rather than their psychological attributes. Since persons are first and foremost agents, the material attributes in terms of which we identify them prior to interpretation must be the material attributes of suitably active beings. Clearly, there are no other candidates in the field besides individual animals. And so we are led fairly directly from the natural methodological assumption about interpretation to the animalist view of personal identity.

I am willing to concede that the methodological assumption is very natural indeed. But I do not think that it reflects a very concrete or sophisticated understanding of the process of interpretation, so much as a pre-theoretical disposition to believe the animalist view of persons and personal identity. If we take a closer and harder look at the process of interpretation, we shall find support for the contrary view that distinguishes personal and animal identity.

Suppose that we begin interpretation as the assumption directs us to. We begin by identifying a certain animal—usually a human animal—that we believe to be interpretable. Then we observe its behavior with a view to discovering that it is intentional. This requires that we attribute thoughts in the light of which we can see the behavior as rational. And this requires in turn that we arrive at a unified theory of meaning, belief, and action for a person, which portrays the person as realizing in some significant degree the normative requirement of overall rational unity, and which also portrays the person as being committed to meeting this requirement. I now want to ask, why should this interpretive process preclude our finding that two (or more) human beings qualify together as a single object of interpretation, or finding more than one object of interpretation within a single human being—our finding, in other words group and multiple persons?

Take the group case. Imagine two human beings who have entered into a

certain ideal marital arrangement in which the aim is to achieve overall rational unity together, by always deliberating jointly about what it would be best for them to do as a pair in the light of all of their beliefs and desires. Imagine further that this pair is not only committed to achieving overall rational unity, but actually achieves it in some significant degree. To imagine all this is to imagine that the pair itself, as opposed to its members, is a fit object for interpretation. Now imagine trying to engage in interpretation on the basis of the natural methodological assumption, according to which each member of the pair is a separate object of interpretation. We might initially get somewhere by making this assumption. But ultimately, we would not be able to portray the actions of either member of the pair as rational unless we saw them as joint actions which were the rational outcomes of joint deliberations. To do that would be to arrive at one unified theory of meaning, belief, and action for the pair rather than separate theories for the members of the pair. And in this way, the pair itself would emerge as a single object of interpretation.

By the arguments of section I, such an object would, necessarily, be an individual—albeit dual-bodied—person. I am not claiming that there actually are any such group persons composed of more than one human being. I am only claiming that they are possible. But even if no such group persons yet exist, we already know what it would be like to treat them as individual persons in their own rights. We know this from our interactions with bureaucratic organizations that approximate in very diminished degree the rational unity that is characteristic of the individual person. Sometimes we try to engage the separate and, as we like to say, *humane* point of view of the individual human being behind the desk. But very often we fail, and find that the human being's responses only reflect the bureaucratic point of view. Something similar would happen in the case of a bona fide group person. Going back to the case of the ideal marital arrangement, we might try to engage each human constituent of the married pair separately as a person in its own right. But each time we tried to elicit a rational response from just one, we would find that the response was really a reflection of joint deliberations that the pair had carried out together, and indeed that the response itself was really a joint action of the pair. There would thus be no opportunity for treating the members of the pair as persons in their own rights. That would be possible only with respect to the pair itself.

Moving on to the case of multiple persons. My claim is that a single human being might be the site of several distinct objects of interpretation, each of whom we could treat separately as a person in its own right. Perhaps there are no such multiple persons in fact. But nevertheless, we know what it would

be like to discover their existence through interpretation and to interact with them. We know this from biographies and clinical descriptions of multiple personality disorder. Human beings with this disorder exhibit a striking form of rational disunity. However, this disunity is not such as to make rationalizing explanation, and hence interpretation, impossible. What emerge are separate pockets or centers of rational unity, each of which can be seen as providing a rational basis for some but not all of the human being's actions. In clinical jargon, what emerge are separate alter personalities. Each alter regards only some of the human host's thoughts and actions as its own, and assigns the rest to other companion alters within the same host. That is, each alter is committed to achieving overall rational unity within only a subset of the various intentional episodes that figure in the life of its human host. And when a human being is host to such alters, we typically find that the human being itself has no overarching commitment to achieving overall rational unity within itself. Because this is so, the host is not a fit object of interpretation, and cannot be treated as a person in its own right. Whenever we try to do so, we find that we are addressing one alter personality or another, whose responses reflect only its own thoughts and not the thoughts of the companion alters. And insofar as we truly can treat alter personalities in this way, as separate persons in their own rights, they can lay claim to the title "person."

Let me reiterate that I am not lodging any empirical claims about the actual existence of multiple persons, nor about the actual existence of group persons. All I am claiming is that such persons are possible.

IV. AN OBJECTION FROM COMMON SENSE

My conclusion flies in the face of much that we regard as common sense, especially those parts of common sense that concern the normative requirements of rationality. This is not because there is a challenge coming from common sense to my account in section II of what those requirements involve. I think common sense agrees with me that persons are subject to a broad normative requirement to achieve overall rational unity within themselves. But what common sense also affirms is that the individuals who are subject to this normative requirement are always *individual human beings* (or perhaps other suitably endowed animals). In many eyes, this is what justifies the therapeutic goal of "curing" multiple personality disorder: the existence of alter personalities is a transgression against the rational requirement of overall rational unity within the human being. And from the commonsense point of view, there is no similar transgression when a group of human beings fails to achieve overall rational unity; such groups simply are not, as far as common sense is

concerned, subject to a normative requirement to achieve such unity.

These aspects of the commonsense view of rationality obviously presuppose the animalist view of personal identity. I want to conclude by saying just a few words about why I do not think that they effectively undermine my defense of Locke's distinction in this paper via Davidson's interpretive perspective on rationality and intentionality.

The sense in which common sense holds that individual human beings are subject to the normative requirement of overall rational unity is completely indifferent to whether human beings themselves are *committed* to satisfying it. In fact, human beings who have multiple personality disorder are, notoriously, *not* committed to achieving such unity. This does not deter the therapeutic establishment from holding that these human beings are nevertheless subject to a requirement to do so. But my point is that being subject to the requirement in this merely *external* sense does not suffice for personhood in the Enlightenment sense. Human beings who lack an *internal commitment* to the normative ideal of overall rational unity simply are not fit objects for interpretation; they cannot be treated as persons in their own rights; and so they do not qualify as persons in the Enlightenment sense. But coming at it from the other side, anything that *does* have this internal commitment to achieving overall rational unity *does* qualify as a person in this sense, even if common sense does not see them as being subject to an external requirement to achieve such unity. So if a group of human beings should have this commitment, as in the case of the ideal marital arrangement, then it would count as an individual person. Likewise if distinct alter personalities within a single human being should have this commitment, they too would have to be counted as individual persons. For to have the commitment is to be the sort of thing who can be treated as a person, and by the lights of my argument in section I, it would be an act of hypocritical prejudice to deny that such a thing is a person—regardless of what common sense might pre-theoretically dictate about the case.

There are of course other objections from common sense that might be raised against my conclusion about the possibility of group and multiple persons. Common sense assumes, for example, that an individual person needs one animal body with which to act, and a unified consciousness with which to think. I do not have the space here to explain why I am prepared to give up these commonsense assumptions about personal agency. That is quite a long story. But I do want to emphasize that these assumptions do not gain any *extra* support—over and above the support they derive from common sense—from Davidson's interpretive perspective on rationality and intentionality. Interpretation requires us to find actions and thoughts that satisfy the normative conditions that the Principle of Charity enforces in

interpretation. This principle is silent, and I think rightly, about how these normative conditions may fall with respect to biological and phenomenological boundaries—that is, with respect to animal bodies and unified consciousnesses. That is why, once we equate persons with objects of interpretation, we should grant the possibilities of group and multiple persons.

CAROL ROVANE

DEPARTMENT OF PHILOSOPHY
YALE UNIVERSITY, MARCH 1998
COLUMBIA UNIVERSITY, JULY 1998

NOTES

1. Perhaps the most dramatic evidence is his title "Rational Animals" which refers to the very sorts of agents (namely, agents who are rational and self-conscious) who on Locke's account qualify as persons *as opposed to* animals.

2. For a more extended discussion of this objection, and indeed of all of the issues with which I am concerned in this paper, see my *The Bounds of Agency: An Essay in Revisionary Metaphysics* (Princeton: Princeton University Press, 1998).

3. In *The Bounds of Agency*, op. cit., I show in detail why this is both ethically important and yet ethically uncontroversial at the same time.

4. This set of claims is put forward in various ways, and in various states of completeness, in the articles collected in *Inquiries into Truth and Interpretation* (New York: Oxford University Press, 1984).

5. For his own account of some of these difficulties see his "Paradoxes of Irrationality," in *Philosophical Essays on Freud*, ed. R. Wollheim and J. Hopkins (New York: Cambridge University Press, 1982) and "Incoherence and Irrationality," *Dialectica* 39, no. 4 (1985).

REPLY TO CAROL ROVANE

Thought belongs to the domain of rationality. This is because thoughts—beliefs, hopes, expectations, plans, intentions, evaluative attitudes—have, as we say, propositional contents. They therefore have logical relations. We cannot entertain any arbitrary collection of thoughts; logic constrains us. This is not due to some failure of the seductive powers of irrationality. It is due to the fact that the contents of thoughts are in part determined by the company they keep, and enough of this company must be logically congenial to confer a particular content on a thought. This is the sense in which I have meant that rationality is constitutive of thought. At one time I emphasized this point as it applies to beliefs. The motive was to give sufficient structure to thought to make it possible to disentangle belief and meaning in the practice of radical interpretation.

As Carol Rovane says, I later came to regard interpretation as necessarily concerned with evaluative attitudes as well as with belief and meaning. As she nicely puts it, "nothing counts as an intentional episode of any kind unless it belongs to the mental life of a person who by and large meets the normative requirement of overall rational unity." Someone is interpretable by other rational creatures (at least ones like us, she adds) if and only if they meet this requirement of rational unity, and she proposes the requirement as a condition of personhood. It is an attractive idea. Rovane thinks it is consistent with things I have written and that I ought to embrace it. In the form in which I have just cast it, it seems to me a good way to shape our rather hazy concept of a person. It would revise our intuitions, but so, probably, would any relatively clear alternative.

Since people who (like most of us) fall well short of ideal rationality are nevertheless interpretable, Rovane allows "plenty of room for rational failure." This is certainly my view. We all have islands of rationality which shelve off into the swamps and seas of the irrational and non-rational, and it is the islands that allow us to treat ourselves and our fellows as capable of intentional action and the reasoning that goes with it. However, Rovane fears

successful interpretation would be a problem unless we were committed to the ideal of overall rational unity. Persons are so committed, she argues, while human beings who are not so committed are "simply not fit objects for interpretation" and so cannot be treated as persons. This seems a bit stern, though I may think so because I have not quite grasped what it means to be committed to the ideal of overall rational unity. If all it takes is to try, from time to time, to get things straight in one's head, or to worry that one has failed to take into consideration some important feature of a contemplated action, or to take a piece of advice or criticism seriously, then this is fine; this is what creatures with the power of reason do. But it would be an extra step to require that one bear in mind the concept of rational unity or the ideal of acting only on the basis of all that one knows and values.

Rovane says there is substantial evidence in my published writings that I am predisposed to embrace the animalist view that rejects the distinction between personal and animal identity. The evidence she mentions is the title of one of my papers: "Rational Animals". I confess I had not realized I was taking a stand on this topic, nor am I clear why my emphasis on interpretation is in tension with treating people (some of them) as rational animals. I distrust my intuitions concerning Locke's thought experiment, in part because I believe our mental vocabulary is entirely concerned with describing and explaining what animal bodies do and are, so that I don't see how the experiment is supposed to be carried out. (Are the *brains* transposed or rewired? Then the two bodies are no longer the same bodies they were.) But in any case, both the prince's consciousness and the cobbler's consciousness remain embodied, so both are "rational animals" before and after the switch. Rovane does not seem to believe in disembodied minds, which is a good thing, for they certainly wouldn't be interpretable by any methods I can think of. There remain questions of personal identity. This is something our ordinary idea of personal identity is ill suited to cope with; if problematic cases arise we will decide who keeps the old social security number and the driver's licence, who is married to whom, and who owns the palace.

<div align="right">D. D.</div>

21

Edna Ullmann-Margalit

"HE ASKED FOR WATER AND SHE GAVE HIM MILK": ON FULFILLMENT AND SATISFACTION OF INTENTIONS

In this paper I draw a distinction between fulfilling an intention and satisfying it. This distinction enables me to argue that, contrary to what is often assumed, intention is not a purely internal relation. I take this point, which goes against Wittgenstein, to be supportive—in an indirect but principled way—of Davidson's causal theory of reasons, or intentions. At the same time, however, the fulfillment/satisfaction distinction seems to allow for the possibility that an intention will be partially determined retroactively, by later events. If I am right that after-facts may indeed constitute, at least in part, the intention with which an action was performed, then this poses a problem for the causal theory of intentions, as well as for ordinary models of rational action. But my admiration for Donald Davidson, which led me to embark on this enquiry in the first place, leaves me in no doubt that, to the extent that the quandary I point to is real, he will show us the way out.

I

Consider: "If I have two friends with the same name and am writing one of them a letter, what does the fact that I am not writing it to the other consist in? In the content? But that might fit either. (I haven't yet written the address.) Well, the connection may be in the antecedents. But in that case it may also be in what *follows* the writing."[1]

This story of Wittgenstein's is somewhat bizarre. Here is an attempt to make it a little less implausible: you give your secretary a list of the names of

people you want to invite to a party, and a standard letter of invitation that is supposed to be sent to each. It turns out that one of the names on your list appears twice in your address book, i.e., you have two acquaintances with the same name, and the secretary asks you whom of the two you intend to invite. At this point, several things may happen. There may indeed be what Wittgenstein refers to as "antecedents". That is, you may have been actually thinking about one of these two acquaintances while you were writing her name on the list. You may have met her recently, or spoken to her, even told her about the party. In other words, you may have "had her in mind" when writing down her name. But then, you may not. It is possible that you had nothing and no one in mind at the time. When this is the case, the secretary's question may genuinely surprise you. You may find yourself deliberating the matter, and coming to a decision which of the two persons to invite (or both).

But Wittgenstein directs our attention at another possibility. It is the possibility that you had nothing and no one in mind at the time, and yet, upon the secretary's question, you give an immediate and resolute answer which of the two is the intended invitee. The difference between this case and the previous one, then, is that here there is supposed to be no process of deliberation which is ordinarily taken to be an intention-forming process.[2] Neither mental states nor mental processes are stipulated here but, rather, an unhesitating answer that seems to make the connection—between your act of writing down the name and the person who is the intended invitee—then and there, upon being asked. Or, to repeat Wittgenstein's formulation: "—it [the connection] may also be in what *follows* the writing."

In the Talmud, which is the canonical compilation of commentary and debate of Jewish legal norms edited in the fifth century, the case is discussed of a man whose two wives have the same name. He issues a writ of divorce in this name, without further specifying which of the two is the designated one. Since a writ of divorce in Jewish law can only be valid when at the time that it is issued it contains the proper name of the intended divorcee, the question here debated is whether or not this man's writ can be valid. The position of some of the sages is that it cannot. Interestingly, however, there is a dissenting position. This position is based on a Talmudic doctrine called *breira* (selection), which stipulates a legal fiction of retroactive intentions. On this view, once this man decides which of his two wives he wants to divorce—even if he does so only after he has issued the writ—it is as if she was selected in advance, i.e., as if she was the one he had intended to divorce at the time of writing the document, and therefore on this view the document is valid.[3]

Is it possible, as Wittgenstein seems to suggest, that an agent's intention will be constituted by no antecedents of his or her action, but rather by its consequents alone? This is too extreme. A weaker version of the question would be: is it possible that an agent's intention will be constituted not only

by the antecedents of the action, but by some of its consequents as well?

The strong intuitions we have with regard to intentions resemble the intuitions we have about causation. The very idea that an intention may be constituted (at least in part) by post-action facts resembles, in its counter-intuitiveness, the idea of backward causality, where the effect precedes the cause. Having noticed this affinity between intention and causation, however, we also recognize that, philosophically, intention and causation are supposed to be very far apart in that they are taken to exemplify the polar opposition between internal and external relations, respectively. A relation R between a and b is external when a's and b's identity conditions are independent of R; it is internal when a's and b's identity conditions are not independent of the relation R between them. Thus, since this pen fully retains its identity when described independently of the circumstance of my hand now holding it, the relation of holding between my hand and this pen is external; in contrast, the number 7 and the number 5 cannot retain their full identity independently of the former being greater than the latter—hence 'greater than' among numbers is an internal, conceptual, relation.[4]

Now, as was just mentioned, intention is often taken as a clear case of an internal relation—say between my intending to wave my hand and my waving of my hand, and causation, ever since Hume, is taken as a clear case of an external relation—say between the event of my eating rotten food and the event of my having a stomach ache. It is partly for this reason, surely, that it is seen by some as so very difficult, if not indeed as entirely implausible, to square an intentional account of an action with a causal account of it. "It was felt that Hume had shown that any two things which are causally related cannot have a logical relation to each other. Since it was also believed that reasons and the actions for which they are reasons do have some logical connection, the conclusion was drawn that they could not be causally related."[5] But this, of course, is precisely the import of Davidson's reasons-as-causes thesis. And in fact the idea that there must be a way to see the reasons for an action, or the intention with which the action is performed, as having caused that action has, *pace* the above, a strong intuitive, common-sensical, appeal. The conjunction of all of this presents a genuine philosophical tangle.

Let us remind ourselves of the three main approaches to intention which may be discerned in the philosophical literature. One approach, influenced by Wittgenstein, sees the role of intention as contributing to an interpretative redescription of events of certain kinds. The event, which may be a bodily movement or motion like the rising of the driver's arm, is redescribed as an action, say the driver's raising of her arm, and is interpreted as signaling, through the attribution to her of an intention to signal.[6] The interpretation has an explanatory role, albeit a non-causal explanatory role: the (physical) motion is connected, via the intention, to a network of beliefs, desires,

conventions, and norms, and is thereby explained *qua* (intentional) action. Another approach is the traditional one, which sees intention as an ingredient of Will. The will is taken to be an independent entity, a mental faculty responsible for acts of volition. And then there is Davidson's approach. Davidson has no use for the will as a separate entity, nor for intention as a special act of will. For him intention is ultimately reducible, through the notion of reasons, to beliefs and desires, whose role in explaining action is interpretative—but not only interpretative. The reasons for your action may do more than reinterpret your action: they may actually cause it. The bodily movement of my arm's rising can be interpreted as an intentional action of my raising my arm. Moreover, on Davidson's analysis the event of my arm's rising may have been caused (non-deviantly) by something which is a reason for it under the specific description of 'raising my arm'.[7]

Stripped to the bone, the problematic here focused on is how to reconcile the ideas that (1) causation is an external relation, (2) intention is an internal relation, and (3) intention may cause action. Wittgenstein and those who follow him deny (3). Davidson's tack, basically, is not to be overly impressed with the distinction between internal and external relations. He uses the pivotal idea that events can be described in a plurality (infinity) of ways to blur the distinction. Hume's view is that the relation of causality holds between events which are independent distinct particulars however described. For Davidson this view is entirely compatible with the observation that there can be descriptions of these events such that the existence of one may be inferred from that of the other. Consider: if it is true that the event a is the cause of the event b, then we may replace 'a' with 'the cause of b' and get 'the cause of b is the cause of b.' That is to say, a relation which under a particular description is external was shown to be trivially glossed, through another description, as an internal, conceptual, or logical relation. However, as far as I can see, even when the possibility of playing with descriptions is granted, the question still remains whether or not, given two items which stand in an internal relation to each other, there is *any* description of them under which they are shown to exist independently of each other (or that their existence is independent of the relation between them).

The view I shall offer here amounts to questioning (2). I shall not be challenging Davidson's account as to how reasons—and, by extension, intentions—may cause action, nor shall I be offering an alternative to it. What I am suggesting is that his project may seem less puzzling if we come to recognize that intention is not a purely internal relation. This suggestion takes into account the meaning-in-use of the notion of intention: when we take a closer look at it we realize that in order for us to say that our intention was met, more may be involved than the strict, technical, conceptual, internal relation referred to as fulfillment. The remainder of this article will flow from

the distinction which I shall now proceed to introduce, between two senses in which an intention may be met. The distinction is between fulfilling an intention and satisfying it.

II

Suppose the object of my intention is an item a. There is a straightforward sense in which a—and only a—fulfills my intention. This apple will fulfill my intention (desire, wish) to have this apple; any apple, and only an apple, will fulfill my intention to have an apple; a new car, any new car, and only a new car, will fulfill my intention to have a new car. How do we account, then, for the case when instead of an apple I get a pear, and feel happy with it? And how do we account for the case when I am presented with a surprise gift of a new jeep, and am disappointed with it? In other words, there seem to be cases where even though the intention is not strictly fulfilled, there is yet a not-irrelevant satisfaction, and also opposite cases, where even though the intention is fulfilled, there is yet a dissatisfaction.

Let us say that an intention is fulfilled if, and only if, it is met by a (specific) item which belongs to the extension class of the (possibly generic) object of the intention. This relation, as presented, is clearly internal. Now we may note that since intentions are, in one way or another, desire-based, then there is a first-approximation expectation that whenever an intention of mine is fulfilled, then, relative to this intention, I am satisfied. However, I shall want to show that this common-sensical, first-approximation expectation may fail. Furthermore, I shall want to be able to talk directly about my intention being satisfied, and I shall want this to be not merely a shortened notation for saying that, strictly speaking, it is I who am satisfied when my intention is fulfilled and that my intention is therefore only derivatively satisfied as well. Thus, my account will have to differ from Russell's, for whom the relation between an intention and that which satisfied it is an altogether external, causal relation.[8] Indeed, Russell's account is open to the sort of fun poked at him by Wittgenstein: "I believe Russell's theory amounts to the following. . . . If I wanted [intended] to eat an apple, and someone punched me in the stomach, taking away my appetite, then it was this punch that I originally wanted."[9] As we shall presently see, a fuller account of the satisfaction relation will require a more adequate semantics than the simple class-extension semantics used in connection with the fulfillment relation. A fuller account of the satisfaction relation will also reveal it as not purely an internal, or conceptual relation, like the fulfillment relation—yet at the same time as not purely an external relation either.

Before continuing, let us pause to consider the possibility, suggested by the

apple/pear and car/jeep cases sketched above, that all four fulfillment-satisfaction combinations may occur. That is, that an intention may be both fulfilled and satisfied, that it may be neither fulfilled nor satisfied, that it may—more interestingly—be fulfilled yet unsatisfied, or—perhaps even more interestingly—that it may be unfulfilled yet satisfied. These possibilities are summarized in the following 2-by-2 matrix:

	fulfilled	unfilled
satisfied	standard (+)	apple/pear
unsatisfied	car/jeep	standard (−)

The case where an intention is both fulfilled and satisfied we may regard as 'standard' with a positive marker, and the case where an intention is neither fulfilled nor satisfied—as 'standard' with a negative marker. Let us ignore these two standard cases, and focus, first, on the non-standard case where an intention is fulfilled yet unsatisfied. We are looking, then, at cases where strictly speaking one gets (achieves, does) what one intended to get (achieve, do), and yet one is unsatisfied. These are cases of disappointment. How are we to understand this sort of disappointment?

Disappointment relates to a wide range of phenomena. Central among them are cases of thwarted expectations, hopes, and aspirations. For present purposes, however, we want to attend to a particular sort of disappointment, which comes about when an intention remains unsatisfied even though it has been fulfilled. What can go wrong? My intention to get, or do, a presumably reflects, inter alia, my belief that the fulfillment of my intention will satisfy me. When I get, or do, a and yet remain unsatisfied, this belief turns out to have been mistaken: was I wrong about a, or was I perhaps wrong about myself?

Here is one possibility. Suppose that a is a generic term: that it is really A. Underlying my belief that a will satisfy me there might have been a belief, or possibly a default assumption, that *any* member of A will do equally well —and it is this underlying belief which may turn out to be wrong. Thus, if my intention was to get a new car, when I am presented with the new jeep it may hit me that "this is not what I had in mind". This may be so in spite of the facts (i) that a jeep is a car, and (ii) that when my intention was formed, or

expressed, I had no specific car in mind—nor, for that matter, was I excluding any cars in my mind. How can this be so?

In order to help the discussion onward we focus, then, on an intention to get some non-specific item *a*, where *a* is a member of A; *a* will be said to be the object of the intention. Such an intention is fulfilled if, and only if, it is met by a (specific) item which belongs to the extension class of the (generic) object of the intention. This intention-fulfillment relation assumes a semantics of homogenous extension. In order for an intention to be fulfilled, no differentiation need be made within the extension class of the object of the intention. The procedure whereby the extension class is determined is that of necessary-and-sufficient conditions, which goes back to Frege's venerable *Merkmale*, or defining-features, technique. The jeep example, however, suggests that the intention-satisfaction relation is based on a different semantics, which is one of non-homogenous extension. Here differentiation needs to be made within the extension class of the object of the intention, the differentiation relating to prototypical (central) versus atypical (peripheral) members of this class.[10] The procedure associated with this semantics has to do with the characteristic features, rather than with the defining-features, of the members of the class. For example, all members of the class of birds possess such defining features as being feathered, laying eggs, having two legs and two wings, being warm-blooded, and so on. But birds also possess features which are thought of as characteristic of birds, even though they are not properties of all birds. Thus, birds paradigmatically have short legs, are rather small, fly easily, sit in trees, have a musical call, etc. To be called a bird, an object need have the defining features of birds. But the more characteristic features a member of this class has, the more prototypical it is. (Robins, eagles, chickens, and penguins are thus viewed as progressively less typical of birds.)[11] In addition to the list of characteristic features, the procedure associated with this semantics requires some metrics of similarity which will make it possible to arrange the members of the class according to the measure of their closeness to or distance from the prototypical members of the class.

It is when the item obtained is judged to be a sufficiently prototypical, and not an atypical, member of the extension class of the object of the intention that the intention is commonly satisfied. A cozy Chevrolet sedan may be the prototypical member of the class of cars, while all other types of cars are arranged in the relevant semantic space according to some metrics of similarity which reflects one's judgment as to their closeness to or distance from the prototypical core. A jeep may indeed be judged as relatively distant from the prototypical Chevrolet, hence the disappointment. Note, however, that this disappointment, attendant upon a fulfilled-yet-unsatisfied intention, is different from the sort of disappointment that may come about when the

expectations which generate a particular intention are not met, in spite of the fact that the intention itself is both fulfilled and satisfied. Thus, even though I may get my Chevrolet, I may nevertheless eventually be disappointed with its performance; or, even though my intention to go to the movies tonight is both fulfilled and satisfied by my being taken to watch *The English Patient*, I may nevertheless be disappointed with the movie. The latter two cases belong to the broad category of cases where it is the intending person who is unsatisfied. The jeep case, on the other hand, exemplifies what we are after, namely, the category of cases where it is the intention itself which, while fulfilled, is unsatisfied. The point to be emphasized here is this: whether or not the intending person is satisfied is a psychological question, the answer to which depends on a set of conditions of an extremely wide-open, unconstrained, nature. Whether or not this person's intention is satisfied is, in contrast, a question the answer to which, in light of the above discussion, is subject to semantic considerations and constraints of a fairly structured nature.

Again, consider Wittgenstein's example: "Someone says to me 'shew the children a game.' I teach them gaming with dice, and the other says: 'I didn't mean that sort of game.' Must the exclusion of the game with dice have come before his mind when he gave me the order?"[12] Here, too, there is disappointment (or disapproval) even though gaming with dice *is* a game, and in spite of the fact that the exclusion of this game did *not* have "to come before the mind" of the person concerned at the time when his intention, or order, was expressed. While gaming with dice is an atypical game (especially with regard to children), any game from among those commonly taken as prototypical[13] would, presumably, have satisfied this person's intention.

Fulfillment of an intention, then, does not guarantee that the intention is satisfied as well. In order for there to be satisfaction, the extension class of the object of the intention can no longer be treated as undifferentiated; it has to be organized, structured, stratified. And it is here that the internal nature of the relation no longer remains pure. The satisfaction relation is internal by default as far as the core, prototypical, members of the extension class are concerned: my intention to get (have, do) *a* is not only fulfilled but it may also—in normal, non-devious circumstances—be assumed to be satisfied by "ideal-type" *a*'s; however, while it is fulfilled it may or may not be satisfied by peripheral, atypical *a*'s. And it is important to note here that what counts as central/peripheral, or the nature of the similarity/dissimilarity metrics that introduces the relevant differentiation within the extension class of *a*—these are subject to considerations which go beyond the purely conceptual. Whether or not the baby-sitter's playing dice with his wards will satisfy their parent's intention that he should play a game with them will depend, among other things, on the social background of the family, as well as on various expectations based on norms and conventions. In other words, the satisfaction

relation, while retaining a quasi-internal nature, introduces non-conceptual, external elements into the notion of intention—and this, I believe, is as it should be.

The non-standard case where an intention is unfulfilled yet satisfied (upper-right cell in the above matrix) will further drive the point home. The example used to introduce this case was my getting a pear, which does not fulfill my intention to get an apple, yet may satisfy it nevertheless. For Russell, if a pear satisfied me, then what I had wished for (desired, intended to get) was really a pear. This points to the possibility that we may sometimes be confused, or mistaken, or otherwise less than clear about our intentions (desires, etc.) This is an interesting phenomenon, and it certainly happens, but the present analysis suggests that it does not need to happen in the case in hand. A pear may well satisfy an intention to have an apple insofar as it counts as an adequate—possibly even as a superior—replacement for an apple, when 'apple' is taken *qua* member of the category of fruit.[14] Would a plum do? A fig? A coconut? All of these are fruit, but they are not prototypical of the category, whereas both apple and pear are.[15]

Consider: "He asked for water, and she gave him milk" (Judges 5, 26) The phrase refers to the Biblical Yael who invited Sisera, the Canaanite enemy general, into her tent. "And he said unto her, Give me, I pray thee, a little water to drink; for I am thirsty. And she opened a bottle of milk, and gave him drink" (Ibid. 4, 19). From the narrative of the story it is clear that Sisera's unfulfilled intention (wish, expectation) to get water is amply satisfied when Yael gives him milk instead. Indeed, both this and the apple/pear example suggest that while the non-standard cases of fulfilled-yet-unsatisfied intention discussed above commonly involve disappointment, the non-standard cases of unfulfilled-yet-satisfied intentions highlight the phenomenon of more-than-satisfaction.

Why does Yael give her guest milk rather than water? Surely not because she has no water to give. Clearly, she wants to please him; she treats him for more than he asked for. In the given context, milk is taken both by hostess and by guest to be superior to water; moreover, it is known to both that for each of them milk is indeed superior. When Sisera asks for "a little water to drink, for I am thirsty," his explicit intention is to get water, i.e. a specific item (unlike the case of the generic item 'car' discussed above). However, Yael correctly interprets this specific item as 'water-*qua*-(thirst-quenching)-drink', that is, as falling under the class, or category, of thirst-quenching drinks. While only a specific item can fulfill an express intention for that specific item, other members of the same category may satisfy it—provided they count as central and prototypical enough members of that category, and also provided that the category under which the item falls is taken in the circumstances to be correctly identified or interpreted. Now the question which

members of the category will and which will not do as a replacement for water—indeed, as a superior replacement for water—is not strictly conceptual. Milk did handsomely for Sisera; it may not do quite as well in an equivalent contemporary context. Would soda do? Coffee? Beer?—Well, it depends. It depends on the time of day, on the age of the guest, on social conventions. Moreover, in certain circumstances some non-liquid may conceivably do as a replacement, even as a superior replacement, for water: ice-cream, say, or watermelon. In such a case the category under which the item 'water' falls is liberally reinterpreted as 'refreshment', rather than 'drink'. In order to determine whether or not there may be satisfaction where fulfillment fails, then, much knowledge and information is needed of a non-conceptual, "external," nature.

We may now pause once again to pose the question, what light does the above discussion throw on the internal nature of the intending relation. 'The intending relation', as we saw, is equivocal between the fulfillment relation and the satisfaction relation. The strong intuition about the internal nature of intention is captured by the fact that the relation between an intention and that which fulfills it remains, on the account offered here, a strictly internal relation. But I believe that we also have some pretty strong intuitions about the satisfaction (or lack thereof) of intentions. And with regard to the satisfaction relation we saw that it is a mixed relation: it has both internal and external elements. The precise sense in which an intention may be fulfilled yet unsatisfied was here exemplified by a case where the object of the intention is generic ('game'), and the intention is met by an item (gaming with dice) which falls under the relevant extension class—hence the fulfillment of the intention—but at the same time is a non-prototypical member of the relevant extension class—hence the non-satisfaction of the intention. The precise sense in which an intention may be unfulfilled yet satisfied was here exemplified by the case where the object of the intention is a specific item (water), and the intention is met by a relevantly different specific item (milk)—hence the non-fulfillment of the intention—which at the same time however is considered a prototypical member of the extension class identified as the class to which the object of the intention belongs—hence the satisfaction of the intention. And, as was pointed out, the evaluation of a member of a category as prototypical (central) or atypical (peripheral), as well as the judgment as to which category should be identified as that category *qua* member of which a specified item is intended, are based both on conceptual, intra-linguistic considerations and on external, extra-linguistic considerations. So, while intention and its fulfillment "make contact in language,"[16] the contact between intention and its satisfaction is made, at least in part, outside of language.

One last quibble on this issue: what about the so-called intensional nature

of intention? How can it be reconciled with the class-extension semantics which is here claimed to underlie the intention-fulfillment relation? The intensional nature of intention manifests itself, e.g., in the fact that even though both of the following statements may be true:

(1) I intend to watch *Secrets and Lies* tonight

and

(2) *Secrets and Lies* is Mike Leigh's most recent movie

it may not be true that I intend to watch Mike Leigh's most recent movie tonight. The context of intention, that is, may involve failure of substitutivity; it is thus an intensional, not an extensional, context. Still, the point is this: while the truth of the ascription to me of an intention is sensitive to the description of the object of my intention, once the description of the item under which it is truly the object of my intention is fixed—anything which falls under the extension of the item thus described will fulfill my intention.

III

Recall that the etymology of 'intend' has to do with drawing a bow while aiming an arrow. The natural direction of fit one thinks of, with regard to aiming, would be from the drawn arrow to the encircled target. But sometimes we operate with the opposite direction of fit: you hit a spot with your arrow, and you encircle it as the target at which you were aiming. By analogy, the first direction of fit would be from an intention (to get water) to that which strictly fulfills it (water). The second direction of fit would correspond to the situation where in light of what you get (milk) you redescribe the intention with which you set out to get it (a thirst-quenching drink, typified by water). And, as the discussion above was meant to bring out, for this sort of situations to occur no self-deception need be invoked. Rather, these situations suggest the potential fruitfulness of the distinction, from among the variety of possible ways in which an intention may in general be "met," between its being fulfilled on the one hand and its being satisfied on the other. The fulfillment relation was analyzed in terms of a homogenous-extension semantics, and was shown to remain an internal relation. The satisfaction relation was analyzed in terms of a non-homogenous-extension semantics and was consequently claimed to be neither purely internal, nor purely external either: it was shown to mix elements of both. If this analysis is correct, then the notion of intention may supply a principled support for Davidson's reasons-as-causes project.

In accounting for action, however, there is tension between the interpretative role of intention and its causal role. One aspect of this tension concerns the time dimension. When we consider propositions which stand in an interpretative relation to each other, this relation is a-temporal. When we consider events which stand in a causal relation to each other, this relation is temporal: the cause has to precede the effect, or, at the limit, to be simultaneous with it. Thus, to see intention as providing a redescription of an act, thereby interpreting it as an intentional action, is to operate in the a-temporal realm of propositions: the question which comes first does not come up. But to claim that intention may cause action implies a commitment as to the direction of the time arrow, which must fly from the intention to the action.

What Davidson recognizes is the possibility that an act may undergo a process of reinterpretation, in light of the intention with which it was carried out. What I have been arguing is that a further possibility should be recognized, namely, that the intention may undergo a process of reinterpretation, in light of the action which presumably carries it out and the attendant satisfaction or disappointment with it. The picture that emerges is the following: an event, one of whose descriptions is in terms of someone's intending something, may be the cause of another event—a motion, a movement—one of whose descriptions is in terms of that person's intentional action. This description of the action itself radiates back, so to speak, to the intention with which it was carried out, and it may change the way we describe, understand, or even determine, this intention. Indeed, we may carry this one step further and say that once the intention with which the action was carried out is redescribed, the ensuing action might once again be reinterpreted, because actions are liable to be reinterpreted in light of the intentions with which they are performed. There is, in other words, a sort of "reflective equilibrium" between intention and action, an interpretative process that goes back and forth, whereby each partially illuminates and partially determines the other.

Within the realm of propositional attitudes, belief is commonly assumed to be distinguished from intention, as well as from wish, expectation, hope, command, etc., with regard to the notion of the direction of fit alluded to above. For a belief to be true, the proposition expressing it has to fit the world. For an intention, wish, expectation, hope, and command to become true, the world has to fit the appropriate proposition. What I have here tried to show is that with intention (and its cognates), matters may be more complex, in that there may be a sort of "negotiation" process of going back and forth between the two directions of fit. And the upshot of this is that this process does not necessarily have to end before, or with, the acting: it may continue thereafter. In such cases we shall have to say that the action was carried out with a partial, or with an underdetermined, intention, and we shall

have to recognize that the story about the causal relation between intention and action may be even more baffling than we have come to know it to be.[17]

EDNA ULLMAN-MARGALIT

CENTER FOR RATIONALITY AND INTERACTIVE DECISION THEORY
HEBREW UNIVERSITY OF JERUSALEM
MAY 1997

NOTES

1. Ludwig Wittgenstein, *Zettel*, ed., G. E. M. Anscombe and G. H. Von Wright (Oxford: Basil Blackwell, 1967 [1981]), #7.

2. Note, however, that often an intention is a prelude to a deliberation process: you intend to go to the movies tonight, and then you have to decide to which movie to go.

3. For a further discussion of this and related issues see Edna Ullmann-Margalit, "Retroactive Intentions," in Hans Friedrich Fulda and Rolf-Peter Horstmann, eds., *Vernunft in der Moderne* (Stuttgarter Hegel-Kongress [1993], Klett-Cotta, 1994), pp. 691–703.

4. See Richard Rorty, "Relations, Internal and External," in the *Encyclopedia of Philosophy*, ed. Paul Edwards (New York: Macmillan, Inc., 1967), Vol. 7, pp. 125–33.

5. Simon Evnine, *Donald Davidson* (Great Britain: Polity Press, 1991), p. 47.

6. See A. I. Melden, *Free Action* (London: Routledge & Kegan Paul, 1961), p. 88.

7. Intentional action, for Davidson, seems adequately accounted for in terms of reasons, construed as beliefs and desires. However, the phenomenon of "pure intending," where one intends to do something but never does, forces Davidson to try to come up with an account of intending which goes beyond his account of acting intentionally—but which he hopes will, as he says, "mesh in a satisfactory way" with that account. The account he ultimately proposes is in terms of an unconditional judgment in favor of doing something: "—intending and wanting belong to the same genus of pro attitudes expressed by value judgments. Wants [] provide reasons for actions and intentions, and are expressed by prima facie judgements; intentions and the judgements that go with intentional actions are distinguished by their all-out or unconditional form." ("Intending," in *Essays on Actions and Events* [Oxford: Clarendon Press, 1980], pp. 101–2.)

8. See Bertrand Russell, *The Analysis of Mind* (London: Allen and Unwin, 1921); lecture III.

9. Wittgenstein, *Philosophical Remarks*, ed. R. Rhees (Oxford: Basil Blackwell, 1975), p. 64.

10. See the works of E. Rosch, starting with "On the Internal Structure of Perceptual and Semantic Categories," in T. E. Moore, ed., *Cognitive Development*

and the Acquisition of Language (New York: Academic Press, 1973), pp. 111–44, through "Human Categorization," in N. Warren, ed., *Advances in Cross-Cultural Psychology*, Vol. 1 (London: Academic Press, 1977).

11. See Herbert H. Clark and Eve V. Clark, *Psychology and Language* (New York: Harcourt Brace Jovanovich, Inc., 1977), pp. 462–68.

12. Ludwig Wittgenstein, *Philosophical Investigations* (Oxford: Basil Blackwell, 1953), p. 33e (un-numbered section after #70).

13. 'Game', as is well known, coheres as a category not because all members possess the defining features of games, but because each member shares a "family resemblance" with the other members of the category. Categories which do not possess defining (i.e. necessary and sufficient) features may still have prototypical members. In order for a member of this category to count as prototypical, or central, it has to possess a sufficient number of the prototypes's features. (See Clark and Clark, op. cit., n. 11, p. 467.)

14. I may have asked for apple-*qua*-ball-like object, for purposes other than eating (e.g. throwing and catching, explaining the earth's movement around the sun, etc.): here a pear will likely not satisfy my intention.

15. Table 12-2 in Clark and Clark, (op. cit., n. 11) p. 464, has 'apple' as the most prototypical member of the category of fruit. The studies they report also suggest that "the more typical a category member was, the more easily it could replace the category name," (p. 465). That is, 'fruit' is easily replaced by 'apple', and so an intention involving an apple is perhaps likely to be satisfied by other prototypical members of the same category. Or at least it is likelier to be satisfied by such members than by atypical members.

16. Ludwig Wittgenstein, *Philosophical Investigations* (op. cit., n. 12), #445.

17. I wish to thank Avishai Margalit for crucial help and support in writing this article.

REPLY TO EDNA ULLMANN-MARGALIT

The argument against holding that attitudes like beliefs and desires are the causes of actions which impressed Wittgenstein and some of his followers was that causal relations are contingent whereas the relations between reasons and the actions they explain is necessary or conceptual. My point against this argument was that it does not make sense to say of a relation that it is either contingent or necessary: it is statements or sentences or judgments that have these properties. Edna Ullmann-Margalit transposes the distinction to the supposed distinction between internal and external relations. I have said nothing about this distinction, but it seems to me equally suspect, at least as it is applied here. For it depends on the same confusion between things and their descriptions as the supposed distinction between contingent and necessary relations or between the essential and accidental properties of things. 7 is necessarily greater than 5, but it is a contingent fact that the number of eggs in my refrigerator is greater than the number of radishes. So I remain unimpressed with the assertion that there is a "genuine philosophical tangle" involved in saying actions, described in some ways, entail their causes, described in some ways. What some see as "playing with descriptions" I see as ignoring the difference between things and their descriptions.

There remains an interesting question about intentions which is raised by the suggestion that sometimes intentions are modified by what follows, not in the trivial sense that the intention one has in mind when acting may, and very often does, change as the intention is acted out, but retrospectively. And, of course, a person may not be satisfied when she gets what she asked for: as George Bernard Shaw remarked, "There are two tragedies in life. One is not to get your heart's desire. The other it to get it." Ullmann-Margalit rules such cases out. One of her examples involves buying a car. It's a little hard to be clear how it happens. She intends to buy a car of an unspecified model (or cost? or condition?) and somehow receives a jeep. Now the character of the intention is retroactively changed: it now explicitly excludes a jeep (or a car costing a million dollars? or a car that is inoperative?). I find I am not fully

satisfied that such a case does constitute a retroactive change. For while my intention could retrospectively be described simply as intending to buy a car in answer to the question why I went to the car dealer, I cannot imagine someone intending, even at the start, to buy *any* car. Even if it were wired to explode? Surely there are many things I could easily specify in advance, and would if I were ordering, say, from a catalogue. However, there is never a point at which I could completely specify the content of my intention (which is why it is impossible to draw up a foolproof contract). Even if I receive the make, model, and color of car I ordered, it may turn out to be a lemon. I didn't intend to get a lemon; does this show the original intention has turned out, retrospectively, to have included this caveat? I doubt that our intuitions (or lawyers) are clear enough always to settle such issues. If we attribute an intention to ourselves or others we normally use a fairly brief utterance to specify what is intended whereas the state of mind attributed may be both vaguer and more detailed than the utterance. But this doesn't show that either the meaning of the utterance or the actual state of mind when the attribution is made is subsequently changed by the outcome.

Of course, an externalist like me will happily agree that external factors enter into the determination of the correct description of any propositional state of mind, and states of intending are among these. Thus what a person has in mind when thinking of cars is apt to be determined, in part, by a history of perceptual encounters with cars. But this points to the past, not the future. There are entities which, though fixed in time, assume new properties and relations with the passage of time. Thus an act of aiming a gun and pulling the trigger, though finished before the bullet is out of the barrel, may sooner or later become an act of assassination (Davidson 1987). However, this is not a case of a change in the description of a propositional attitude.

This brings me to a complication I have been avoiding. I do not see how to think of the connection between an intention and its outcome (whether or not the outcome "fulfills" or "satisfies" the intention) as a relation, for I do not think intentions are entities nor that their "objects" are objects. When we act on an intention, we act on the basis of various beliefs and values. Where explicit reasoning takes place we may form an intention, which is a state of mind, and if the act takes time, we monitor our behavior in the light of the intention. But states of mind like beliefs, desires, wishes, valuings, and intentions are not entities, but modifications of a person. We describe these modifications by relating the person to a proposition, or, as I would rather say, a sentence, but I do not think it helps to say these abstract objects are "before the mind" of the person to whom the thought is attributed (Davidson 1989). And do intentions have objects? Not, I think, physical objects, not things like cars or apples. Nor can it be "generic objects", since there are no such things. We speak, it is true, of wanting or desiring a particular person or object, but

on reflection it becomes clear that we don't simply want or desire them; we want them to love us, or to eat them, or to drive them, or to have them at our disposal, and so on. In other words, we want or desire that some proposition be true; wants and desires and the other pro-attitudes, if they have "objects" at all, do not have physical objects. Neither of the "entities" related by the satisfying or fulfilling relations is a concrete particular and so the question of a causal relation is moot.

Intentions can, though, be called the causes of actions, and this is especially obvious when the intention is formed some time before it eventuates in action. What we mean, in my view, when we speak of beliefs, desires, and intentions as causes of actions is that they are significant causal *conditions* of actions. Often, but by no means always, it is a *change* in belief (for example perceiving that something is the case) that trips the action, or a sudden yen, or reaching a decision.

<div align="right">D. D.</div>

REFERENCES

Davidson, Donald. 1987. "Problems in the Explanation of Action." In *Metaphysics and Morality: Essays in Honour of J. J. C. Smart*, edited by P. Pettit, R. Sylvan and J. Norman. Oxford: Blackwell.
———. 1989. "What is Present to the Mind?" In *The Mind of Donald Davidson*, edited by J. Brandl and W. Gombocz. Amsterdam: Editions Rodopi.

22

John Collins

INDETERMINACY AND INTENTION

One of the main themes of Donald Davidson's work through the 1970s in the philosophy of mind and language is the conceptual inseparability of the theory of meaning from the theory of belief.[1] That a speaker holds a certain sentence true is a function of both that speaker's meanings, and of her beliefs. So if we are hoping to base a theory of interpretation on the evidence of the speaker's dispositions to assent to certain sentences and to reject others, then we shall have to, somehow, find a way to factor this resultant disposition into those component parts we are used to calling *belief* and *meaning*. We have one set of data, from which we have to solve simultaneously for two unknowns.

As Davidson himself has observed in several places, the problem is formally analogous to the one we face in decision theory when we attempt to disentangle the roles played by belief and desire in the rationalization of action. That an agent prefers one option to another is a function of both her beliefs and of her desires. So if we are hoping to base decision theory on the evidence of an agent's dispositions to prefer some options to others, then we shall have to, somehow, find a way to factor the resultant disposition that is preference into those component parts we are used to calling *belief* and *desire*. Again, we have one set of data, from which we have to solve simultaneously for two unknowns.

In more recent work, at least since the early 1980s, Davidson has repeatedly stressed that there is more than just a formal analogy here. In fact the two problems just mentioned—the problem of interpretation and the problem in decision theory—are themselves inseparable parts of one big problem. Neither one of the two issues should be taken to be conceptually prior to the other. Both decision theory and the theory of interpretation are guilty in this regard: decision theory of the unsupportable assumption that we may take the meanings of the agent's sentences as given before we start to

disentangle the roles played by belief and desire in rationalizing what she is disposed to prefer; the theory of interpretation of the unsupportable assumption that "holding true" is a conceptually unproblematic point from which to start disentangling the roles played by meaning and belief in assertion. The main theme of Davidson's more recent work is that there are not two problems here at all, but a single problem, which cannot easily be split into the traditional sub-tasks, since those sub-tasks must themselves be carried out simultaneously. What is required, Davidson says, is a "unified theory of meaning and action," what I shall here refer to as a *unified theory of intention*. Here is an early statement of the new Davidsonian manifesto:

> Theory of meaning as I see it, and Bayesian decision theory, are evidently made for each other. Decision theory must be freed from the assumption of an independently determined knowledge of meaning; theory of meaning calls for a theory of degree of belief in order to make serious use of relations of evidential support. But stating these mutual dependencies is not enough, for neither theory can be developed first as a basis for the other. What is wanted is a unified theory that yields degree of belief, utilities on an interval scale, and an interpretation of speech without assuming any of them.[2]

The data which are to provide our starting point in the unified theory of intention will be more austere than the material we began from in either decision theory or the theory of interpretation. Davidson suggests taking as our basic data facts of the form: the agent prefers the truth of this sentence to that sentence. It is not assumed that we know what those sentences of the agent's language mean, so this starting assumption is indeed less question-begging than that version of decision theory (Jeffrey's) that starts from the agent's preferences among propositions. From these facts about preferring (uninterpreted) sentences true, our task is now to solve simultaneously not for two unknowns, but for three: we have to figure out the agent's meanings, beliefs, and desires. I shall refer to this as solving the *intentional problem* for an agent.

A daunting task? Perhaps. Davidson himself seems somewhat equivocal about the prospects for the unified theory. In his more upbeat passages, as for example in the third of the Dewey Lectures for 1989, Davidson sounds confident that we already have at our disposal the conceptual techniques for seeing the whole task through. The optimistic line is that the unified theory will indeed amount to a method that combines Ramsey's approach to decision theory with the sort of approach to radical interpretation familiar from Quine and from Davidson's own work. Ramsey's great insight in the decision theoretic case was that there are certain propositions (those he called "ethically neutral") in which the agent's degree of belief could be determined

from preference quite independently of her degrees of desire. The trick amounts to showing how, in a special case, it is legitimate to hold one factor (belief) fixed while we work on determining the other (desire). Davidson sees the *principle of charity* as playing a conceptually similar role in the theory of interpretation. Here Quine's idea was that interpretation can be seen only to be possible at all if certain kinds of difference in belief between agent and interpreter are ruled out in advance. This trick too, if legitimate, would have the effect of enabling us, in certain special cases, to hold one factor fixed (belief) while we work on determining the other (meaning). In some places Davidson seems to suggest that the unified theory is simply just a matter of combining these two ideas. Thus, the punchline of the third Dewey Lecture is the proof (given in an appendix to the paper) that data about preferences among uninterpreted sentences enables us to identify the agent's truth-functional connectives. Davidson then comments:

> If we start with sentences instead of propositions, then our problem will be solved provided the truth-functional connectives have been identified, Jeffrey has shown how to fix, to the desired degree, the subjective desirabilities and probabilities of all sentences; and this, I have argued, suffices to yield a theory for interpreting the sentences.[3]

In other passages Davidson sounds somewhat less optimistic. For example:

> I would like a theory of meaning to be much like Ramsey's version of decision theory, but the best I know how to do falls seriously short of this goal.[4]

the reason being, apparently, that the Quine-Davidson approach to the problem of radical interpretation provides a solution to

> [a] problem . . . very like the problem in decision theory, but the solution is not as neat.[5]

In these less optimistic moments, Davidson suggests that we console ourselves with the (transcendental) thought that, even if we are unable to articulate it to ourselves, we can be absolutely sure such a theory is possible, since we can, and do, in fact, make sense of one another's words and actions.

My purpose in this paper is not to comment on the extent of Davidson's success in his sketch of the form that the unified theory of intention should take. Neither do I have my own version of a grand unified theory to offer. I am not in a position to present my own account of the proper method for the simultaneous elicitation of beliefs, meanings, and desires from the austere evidential base of preference among sentences.

My goal here is more modest. Let's imagine the theory is complete, the elicitation method arrived at to everyone's satisfaction. Then what, according

to this theory, would a solution to the intentional problem for an agent look like? There is, of course, a sense in which this question simply repeats the request for the details of the theory itself, or at least for an outline of an elicitation method. But I think that there's a less demanding interpretation of the question too, a way of thinking about the question of the form of a solution to the intentional problem that allows that one might get some way towards answering it even before the details of the theory itself were all in place.

I have in mind in particular the issue of indeterminacy. Should we expect our unified theory of intention to parse the resultant disposition that is sentence-preference unequivocally into determinate component parts: the belief component, the desire component, and the meaning component? Or should we expect even a perfect theory of intention to leave us with some slack, some indeterminacy in belief, desire, and meaning?

The second of the "pessimistic" passages from Davidson quoted above continues:

> Ramsey devised an ingenious trick for fixing a subjective probability of one event exactly without knowing anything but simple preferences; with this strategy, utilities can be assigned generally as uniquely as the theory demands. In a combined theory of meaning and belief there is no such precise trick, and so the data can be accommodated by various theories of interpretation provided these theories are paired with appropriate theories of belief. [footnote: This is a way of stating one lesson we learn from Quine's indeterminacy of translation thesis.] The consequent indeterminacy of interpretation is not on this account any more significant or troublesome than the fact that weight may be measured in grams or in ounces.[6]

In a similar vein, David Lewis has commented that "indeterminacy might come in more or less virulent forms,"[7] Lewis denies the conceptual possibility of the truly serious sort of indeterminacy that would obtain if there were two perfectly fitting but quite orthogonal solutions to the intentional problem for an agent: "*Credo*: if ever you prove to me that all the constraints we have yet found could permit two [such] perfect solutions. . . then you will have proved that we have not yet found all the constraints."[8] But Lewis also suggests that the more harmless forms of indeterminacy in interpretation are inescapable, gesturing here both towards Quine on the indeterminacy of translation, and to the phenomenon of "unsharp analyticity."

My topic here is precisely these non-virulent, and apparently inescapable, strains of indeterminacy. How will they affect the appearance of what counts as a total solution to the problem of intention for an agent? In the following sections I shall review the appearance of indeterminacy in the context of decision theory, in particular as it appears in the decision theory of Richard Jeffrey. In Jeffrey's theory degrees of belief as well as degrees of subjective

desirability are not uniquely determined, but only fixed up to transformations of a certain kind: those given by the *Bolker equations* to be described below. In section V I shall go on to discuss indeterminacy in interpretation and show how a certain kind of meaning-indeterminacy can always be reinterpreted as an indeterminacy about beliefs and desires (and vice-versa). The example discussed in section V generalizes to a result proved in section VI. The result is interesting for two reasons: (i) it provides a new heuristic model for thinking about the role of the Bolker transformations in Jeffrey's decision theory; (ii) it makes a deeply Davidsonian point. The Davidsonian point is this: not only will there always be some indeterminacy in the best story we can tell about the agent's intentions, but it will actually be indeterminate *what kind of indeterminacy it is!* That is, there will be no fact of the matter about whether, or to what extent, the indeterminacy is indeterminacy about meaning, or indeterminacy about belief, or indeterminacy about desire, or a mixture of some two, or all three, of these possibilities.

I. Equivalent Scales for Degrees of Desire

Multiplying all of the entries in a desirability matrix by the same positive number a, results in a new desirability matrix equivalent to the old one. The same is true when a single constant, positive or negative, is added to each entry in the matrix. We may sum these two facts up as follows: an agent's desirability function V is only uniquely determined up to a positive linear transformation. If V accurately reflects the agent's preferences, then so does any function V', where:

$$V'(X) = a \cdot V(X) + b, \quad \text{for } a > 0$$

The function V is supposed to describe the agent's degrees of desire. It might be more accurate to say that the agent's desirabilities are described by the whole family of functions related to one another by transformations of the above kind, a family of functions parametrized by $a > 0$ and b. That understood, there is nothing wrong with choosing a particular member of this family of functions to represent the agent's desires. It must be remembered, however, that there is no natural unit of desirability, and no natural zero point for the numerical scale on which degrees of desire are measured. Choosing any particular representative from the family of equivalent functions amounts to making an arbitrary choice of unit and zero point. The situation is quite analogous to the case of the measurement of temperature. It does not matter whether we choose to measure temperatures in degrees Celsius or in degrees Fahrenheit. The two temperature scales are equivalent, and related to one

another by a positive linear transformation. If C is today's maximum temperature given in degrees Celsius, then that temperature is F degrees Fahrenheit, where:

$$F = \frac{9}{5} C + 32$$

The existence of equivalent desirability scales has no more significance than does the fact that we can measure temperatures equally well on either the Celsius or the Fahrenheit scale. This fact about equivalent scales seems hardly to deserve to be thought of as an 'indeterminacy' in degrees of desire. If indeed this amounts to indeterminacy, then it is indeterminacy of a completely harmless kind.

II. COMPONENTS OF PREFERENCE

If mental states like belief are states of an organism which are individuated by functional role, then those functional roles appear to be interconnected. What is constitutive of the role of belief cannot be specified in a way that does not make reference to the role of, say, desire, nor can the concept of desire be explained without making reference to the concept of belief. Here are two representative passages. The first is by Robert Stalnaker:

> Belief and desire . . . are correlative dispositional states of a potentially rational agent. To desire that P is to be disposed to act in ways that would tend to bring it about that P in a world in which one's beliefs, whatever they are, were true. To believe that P is to be disposed to act in ways that would tend to satisfy one's desires, whatever they are, in a world in which P (together with one's other beliefs) were true.[9]

Daniel Dennett expresses a similar view in the second passage:

> The circularity of these interlocking specifications is no accident. Ascriptions of beliefs and desires must be interdependent . . . A man's standing under a tree is a behavioral indicator of his belief that it is raining, but only on the assumption that he desires to stay dry, and if we then look for evidence that he wants to stay dry, his standing under the tree will do, but only on the assumption that the tree will shelter him; if we ask him if he believes the tree will shelter him, his positive response is confirming evidence only on the assumption that he desires to tell us the truth, and so forth *ad infinitum*.[10]

The point being made by these two authors about the conceptual interconnection of the correlative notions of belief and desire would seem to indicate, for example, that it would be conceptually impossible for a creature to have beliefs if it was not also capable of having desires. What else is

involved here? Do the particular beliefs that an agent has depend on that agent's actual desires? If so, how? I would like to approach such questions by studying the quite precise ways in which the interrelation appears in the theory of degrees of belief and desire, i.e., the theory of subjective probability and value.

In Bayesian decision theory, the numerical values of degree of belief and desire are taken to be grounded in an agent's choices or preferences among options. For the time being I shall assume that the options in question are simply *propositions*. Now an agent's *actual* choices will certainly not suffice to fix her degrees of belief and desire. But the data from which we are to start is most often taken to include certain dispositional facts about the agent as well, namely her dispositions to express preferences between various outcomes. One might wonder why such dispositions are supposed to be acceptable as data. What makes them less suspect in this role than facts about belief and desire, which are no more dispositional. Dispositions to express preference are usually held to be "observable", or relatively more open to observation, than are beliefs and desires themselves. Beliefs and desires, on the other hand, are thought of as theoretical entities, which together provide a (non-observable) explanatory mechanism underlying preference. Why the difference? All these various facts are dispositional.

I think the answer is not hard to find. It is contained, in essence, in the thoughts expressed in the two passages quoted above in this section. I would put the point this way. Preference is relatively open to observation, despite being dispositional, because it is a *total disposition* of the agent. A total disposition to manifest M in circumstances C is the kind of disposition of an agent or a thing that corresponds to a simple counterfactual truth: if it were the case that C, then it would be the case that M. No such simple counterfactuals correspond to the having of the dispositions we call belief and desire. Beliefs and desires are not total dispositions, but rather partial, or, better, *component* dispositions of the total, resultant, disposition which is preference.

It is perhaps worth digressing here to point out just how widespread are the philosophical problems posed by those concepts of ours that are, on reflection, concepts of component dispositions. As well as the case of belief and desire here under discussion, we might mention the difficulties surrounding the notion of intrinsic desire. If intrinsic desires make sense at all, then they do so only as components of desire. Intrinsic desires are therefore doubly dubious, since they would be dispositional components of a dispositional component of a total behavioural disposition.[11]

The same holds true, I think, of the notion of *cognitive utility* required to make sense of the idea that *acceptance*, i.e., belief in the classificatory or nonquantitative sense, is to be thought of as a cognitive decision problem. The problem of giving a clear account of cognitive utility is exactly the problem

of separating this one component of utility from utility or desirability in general, when counterfactuals won't suffice to do the job.

Such problems are widespread indeed. The Kripkensteinian rejection of a dispositional response to the meaning-skeptic turns on an unquestioning acceptance of a counterfactual analysis of dispositions, that is, on the assumption that if my meaning *plus* rather than *quus* by '+' is a dispositional fact about me, then it has to be a fact about a total disposition, rather than, say, a fact about a component disposition to use the term competently, accompanied by another component disposition to make arithmetic mistakes.

Another example may be found in metaphysics: the main difficulties facing the counterfactual analysis of causation, problems of pre-emptive causes and causal over-determination, arise for a similar reason. Where there is a relation of cause and effect there is the manifestation of a disposition, but not necessarily of a total disposition. Cases of pre-empted causes and of causal over-determination show that the disposition in question may be a mere component. These problems would be avoided in a dispositional analysis of causation, but at a price that would, no doubt, seem unreasonably high to most philosophers. The notion of a component disposition seems as dubious today as the concept of counterfactual did forty years ago.

C. B. Martin has argued that a counterfactual analysis of dispositions must fail, since a disposition is the sort of property that can be gained or lost, and it might be the case that the circumstances in which a certain disposition would be lost are precisely the circumstances in which that disposition would have been manifested.[12]

Recognizing the possibility of component dispositions is another way of seeing the shortcomings of the counterfactual analysis, or, perhaps, a way of generalizing Martin's point. In fact, reversing the order of analysis, the prospects would appear to be better for a dispositional analysis of counterfactuals, according to which counterfactual truths are dispositions of a whole world.[13]

III. RAMSEY'S METHOD

How are we to make sense of degrees of belief and desire, if these two dispositions are inseparable components of the total behavioral disposition which is preference?

Frank Ramsey's insight was that there are certain propositions for which it is possible to discover an agent's degree of belief in the absence of any information about the agent's degrees of desire. Call a proposition N *ethically neutral* with respect to another proposition A for a particular agent if and only if the agent is indifferent between the propositions $A \& N$ and $A \& \neg N$. For

example, suppose a coin is to be tossed. Let N be the proposition that the coin lands heads. Suppose A is the proposition that I win \$20 on the coin toss. N is ethically neutral with respect to A since I don't care whether I win \$20 by betting on heads or by betting on tails.

Ramsey realized that there is a way of determining when an ethically neutral proposition has probability 1/2. Suppose that A and B are propositions between which the agent is not indifferent, and that N is ethically neutral with respect to A and B. Then the agent has degree of belief 1/2 in N if and only if she is in-different between the gamble [A if N, B if $\neg N$], and the gamble [B if N, A if $\neg N$].

Suppose, for example, that I prefer winning \$20 to losing \$20. As in the previous example, let N be the ethically neutral proposition that the coin will land heads. If I am indifferent between betting \$20 at even money that the coin lands heads, and betting \$20 at the same odds that the coin lands tails, then my degree of belief that the coin will land heads must be 1/2.

Suppose we choose A as the unit point and B as the zero point of our scale of degrees of desire. Using propositions like N whose probability is known to be 1/2, we may now proceed to calibrate the scale measuring the agent's desirabilities.

The midpoint of the scale must be the degree of desire assigned to the gamble: [A if N, B if $\neg N$]. Call this gamble C. Then C is desired to degree 1/2. We may then construct compound gambles whose desirabilities fix the 1/4 and 3/4 points on the scale. A compound gamble is a gamble at least one of whose prizes is another gamble. If N' is ethically neutral with respect to A, B, and N, and, furthermore, N' has probability 1/2, then the compound gamble D that yields B if N', and has the gamble C as a prize if N' is false must be desired to degree 1/4.

In theory at least, it seems possible that we might now continue in a similar way to divide the desirability scale into eighths, sixteenths, thirty-seconds, sixty-fourths, and so on, as long as the agent continues to manifest coherent preferences among multiply compound gambles whose structure will become increasingly complex. Call a simple gamble, a "zero-order gamble" and say that a gamble is "$(n + 1)$th-order" if the highest order of any gamble which is among its prizes is n. If the agent has dispositions to choose coherently between, say, any pair of seventh-order gambles, then that agent's desirability scale will be well-calibrated down to intervals of 1/128 (128 being the seventh power of 2). The agent's degrees of desire will be correspondingly well-defined: in this case to two decimal places.

Having thus calibrated the scale of degrees of desire, we may now elicit the agent's degree of belief in any given proposition H. Let G be the gamble [A if H, B if $\neg H$]. We may then establish the desirabilities of $A\&H$, $B\&\neg H$, and G, and since by definition:

$$V(G) = P(H) \cdot V(A\&H) + (1 - P(H)) \cdot V(B\&\neg H)$$

it follows that

$$P(H) = (V(G) - V(B\&\neg H)) / (V(A\&\neg H) - V(B\&\neg H))$$

But what is a gamble? A gamble is a kind of proposition, but which proposition? A gamble G of the form $[A$ if N, B if $\neg N]$ obtains if and only if there is a causal relationship of a particular kind between N, A, and B. It must be the case that N will cause A, and that $\neg N$ will cause B. If I offer to bet you $20 that this coin will land heads, and you agree to accept the bet, then we have established a causal relationship according to which the coin's landing heads will lead to you paying me $20, while the coin's landing tails will result in my giving you $20. The important point about a gamble like G above is that when I accept such a gamble, and update my beliefs to accommodate the information that the gamble is now in place, my probability for N remains fixed, while my probabilities for A and B are adjusted to reflect my new belief that N will cause A and $\neg N$ will cause B. So, for example, though I might initially have assigned a very low probability to your giving me $20 in the next few minutes, once we have agreed to bet on the outcome of the coin toss, my degree of belief in the proposition that you will soon pay me $20 becomes at least as great as the probability I assign to the coin's landing heads.

We see that the "if-then" in the statement of a gamble cannot be the material conditional. Accepting the gamble G is not equivalent to accepting the truth of the proposition $(N \rightarrow A)\&(\neg N \rightarrow B)$, i.e., the proposition $(A\&N) \vee (B\&\neg N)$. If it were, then the value of the gamble G would be

$$\begin{aligned} V(G) &= V((A\&N) \vee (B\&\neg N)) \\ &= \frac{(P(A\&N) \cdot V(A\&N) + P(B\&\neg N) \cdot V(B\&\neg N))}{(P(A\&N) + P(B\&\neg N))} \end{aligned}$$

which does not equal the correct value

$$P(N) \cdot V(A\&N) + P(\neg N) \cdot V(B\&\neg N)$$

unless $P(N) = P(A\&N)$ and $P(\neg N) = P(B\&\neg N)$.

Rather the conditional in question is a subjunctive conditional, and the gamble G is equivalent to the proposition: $(N \,\square\!\!\rightarrow A) \& (\neg N \,\square\!\!\rightarrow B)$.

We see now that Ramsey's method of constructing gambles, compound gambles, and so on, really amounts to expanding the domain of the preference ranking so as to include new propositions. These new propositions (the various "gambles") are not in the original algebra, since they are not simply Boolean combinations of the propositions we started from. Whenever A and B are propositions such that A is preferred to B, and N is ethically neutral with

respect to *A* and *B*, we must add a new proposition $(N \Box \rightarrow A) \& (\neg N \Box \rightarrow B)$. We want to finish up with a Boolean algebra that is closed under expansions of this kind, and then assume that the agent has a coherent preference ranking defined over this whole expanded set of propositions. This is a powerful assumption indeed, and ultimately a most implausible one, when we consider what dispositions it commits us to attributing to any agent to whom we wish to ascribe degrees of belief and desire.

Jeffrey makes this objection quite dramatically with the following example. Suppose I prefer *B*: fine weather next week to *A*: global thermonuclear war. In order to use the Ramsey method to calibrate my desirability scale between these two points *A* and *B*, I will need to compare my preferences for other intermediately ranked prospects (e.g., going to the dentist) with gambles which have the propositions *A* and *B* as "prizes". But am I really capable of contemplating a gamble like the following?

> There will be thermonuclear war next week if this coin lands heads, fine weather next week if it lands tails.

As Jeffrey puts it:

> for the agent to consider that this gamble might be in effect would require him so radically to revise his views of the causes of war and weather as to make nonsense of whatever judgment he might offer; and we are no more able than the agent, to say how he would rank such a gamble among the other propositions in the field of preference.[14]

IV. INDETERMINACY IN DEGREES OF BELIEF

The version of decision theory developed by Richard Jeffrey in *The Logic of Decision* dispenses with such causal notions. The objects of preference are taken to be simple propositions, and the algebra of these propositions is not expanded to include gambles. This simplification comes at a price. The price to be paid is a certain kind of indeterminacy in the assignment of degrees of belief. In the Ramsey theory, desirabilities were determined up to a positive linear transformation, while the agent's subjective probabilities were fixed uniquely. In Jeffrey's theory things are a little more complicated. The desirability function is unique only up to a certain bilinear transformation, and, what is perhaps more surprising, the agent's degrees of belief are no longer uniquely determined either.

In particular, if *(P, V)* is a pair of functions that accurately reflects the agent's preferences among propositions, then so does any other pair *(P′, V′)*, related to the original functions *P* and *V* by the following pair of equations, known as the *Bolker transformations*:

$$V'(A) = \frac{aV(A) + b}{cV(A) + d} \tag{1}$$

$$P'(A) = (cV(A) + d)P(A) \tag{2}$$

where a, b, c, and d are real numbers such that

$$ad - bc > 0 \tag{3}$$
$$cV(A) + d > 0 \tag{4}$$
$$cV(T) + d = 1 \tag{5}$$

whenever $P(A) > 0$.

The import of these equations may not be immediately obvious. It is clear from the form of the transformations that the agent's probabilities may not be uniquely determined. The values that we may assign as the agent's degrees of belief are somehow or other tangled up with the particular assignment of degrees of desire that we settle on. However, the precise form that this interconnection takes may not be immediately clear to the reader. For example, it is not hard to see that some variation is possible in the probability assigned to any particular proposition by a probability function that accurately reflects the agent's degrees of belief.[15] But it is not easy to see exactly how much leeway the Jeffrey theory gives us in this regard, and what, for example, is the maximum variation allowed by the theory in the allocation of probability values. How much indeterminacy can there be in degrees of belief on this account?

One of my aims in this paper is to give an alternative characterization of these transformations that may be more perspicuous for our purposes. To this end, it may help to make a couple of simplifying assumptions that do not involve any real loss of generality.

First of all, since our immediate concern here is with the kind of tradeoff between probability and desirability assignment that is unique to the Jeffrey theory, we need not concern ourselves with the sort of "indeterminacy" in degrees of desirability that was discussed in section I. That is to say, we need not concern ourselves here with the fact that desirabilities can always be recast on an equivalent scale by selection of a new unit and zero point, in an autonomous rescaling that has no effect at all on the numbers that are assigned as degrees of belief. Since that sort of arbitrariness in choice of desirability scale is common to all versions of the Bayesian scheme, we may ignore it here. Ignoring it amounts to setting $a = 1$ and $b = 0$ in the Bolker transformations.

Secondly, it will simplify matters further if we go ahead and make an (admittedly arbitrary) choice of zero point for the desirability scale, and then stick to it. Let's choose the zero point to be the utility assigned by the agent

to the necessary truth T. This choice has the nice feature that it enables us to divide all propositions easily into two classes, based on whether they are assigned positive or negative desirabilities, i.e., based on whether they are ranked above or below T in the agent's preference ranking of propositions. Call a proposition X *good* if it is preferred to T, and *bad* if T is preferred to X. Call propositions that are ranked with T *indifferent*. Then the suggested choice of zero point for the desirability scale will give the good propositions positive desirability, assign negative desirabilities to the bad propositions, while $V(X) = V(T) = 0$ for any indifferent proposition X that is ranked along with T.

Setting $V(T) = 0$ in equation (5) we see that making this choice of zero point amounts to setting $d = 1$. Our assumptions thus yield the following simplified version of the Bolker transformations:[16]

$$V'(A) = \frac{V(A)}{cV(A) + 1} \tag{6}$$

$$P'(A) = (cV(A) + 1)P(A) \tag{7}$$

where c is a real number such that $cV(A) > -1$ whenever $P(A) > 0$.

We have assumed that the agent's desirability function is bounded above and below, and in fact that it achieves maximum and minimum values *max* and *min* respectively. This means that the possible values of the parameter c are those allowed by the inequalities:

$$-\frac{1}{max} < c < -\frac{1}{min} \tag{8}$$

How much can the probability of a proposition A vary as the result of such transformation? Since c must be less than the value $-1/min$ it follows that $P'(A) > (1 - V(A)/min)P(A)$. And from the fact that c is always greater than $-1/max$ we may deduce that $P'(A) < (1 - V(A)/max)P(A)$. The difference between these values is

$$P(A) \cdot V(A) \left(\frac{1}{max} - \frac{1}{min} \right) \tag{9}$$

which sets an upper bound to the amount of variation possible in the assignment of a degree of belief to A.

Note in expression (9) the role played by the quantity $P(A) \cdot V(A)$, the product of the values assigned by P and V to the proposition A. This quantity will come up again in discussion a little further on. It will be useful to refer to it, in the same way Jeffrey does, as the quantity $INT(A)$. One thing that is clear from the form of the (simplified) Bolker equations (6) and (7) is that this quantity $INT(A)$ remains invariant under transformations of that kind.

It is now time to turn from this general discussion to a specific illustrative example. Suppose that our agent's degrees of belief and desire are represented by the following probability and desirability matrices:

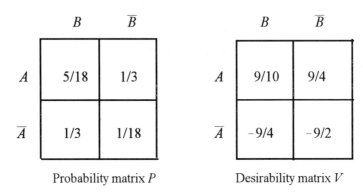

FIGURE 1

Here the maximum value of the desirability function is $V(A\&\neg B) = 9/4$. The minimum value is $V(\neg A\&\neg B) = -9/2$. Hence, in transforming these matrices via the Bolker equations, we may choose any value of the parameter c lying in the interval: $-4/9 < c < 2/9$. The choice $c = 0$ corresponds, of course, to the pair of matrices for P and V themselves. This value $c = 0$ lies 2/3 of the way along the range of possible values that c can take. So as to have a concrete (though quite arbitrary) example to think about, let's see what happens when we slide c halfway from its starting point to the negative end of the scale, i.e., to the value $c = -2/9$. Routing substitution into the Bolker equations yields the following pair of matrices, equivalent to the first pair.

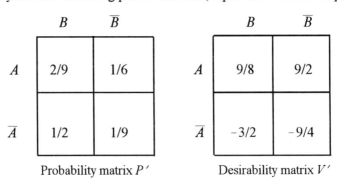

FIGURE 2

It is worthwhile pausing to observe several features of this example. First of all, the transformation of $\langle P, V \rangle$ to $\langle P', V' \rangle$ has indeed altered the probabilities assigned to various propositions in the algebra. For example, the probability assigned to $\neg A \& B$ by P was 1/3. The function P' raises this value to 1/2. Secondly, what is perhaps even more surprising, the transformation from one representation of the agent's degrees of beliefs to another, equivalent, representation has not even preserved the truth of statements of the form 'X and Y are equiprobable'. For example, according to the function P, the propositions $A \& \neg B$ and $\neg A \& B$ are equiprobable; while according to the function P' the latter is three times as likely as the former! This is true even though P and P' figure in equally good, and in fact completely equivalent, representations of what the agent believes. Thirdly, the transformation we have carried out has actually reversed the order of certain comparisons of probability. For example, $P(A \& B) < P(A \& \neg B)$, yet $P'(A \& B) > P'(A \& \neg B)$.

We can sum up these points by saying that, according to Jeffrey's version of decision theory, there are no determinate facts of the matter about an agent's degrees of belief, nor about her judgments of equiprobability, nor about her judgments of comparative probability.[17] These features are clearly enough advertised in *The Logic of Decision*, and not even only in the small print. Yet they do not always seem to be fully appreciated by philosophers discussing the matter.

Used as we are to thinking about subjective probability the way in which it is developed in theories like those of Ramsey and Savage, in which it *is* possible to specify an agent's degrees of belief independently of her degrees of desire, it is a little harder to see the considerable slack in probability assignment on the Jeffrey model as nothing more than a matter of change of scale. Part of the problem is, of course, that we are simply not used to thinking of everyday examples of rescaling in which two scales are reset simultaneously according to a coupled pair of transformation equations.

Here, though I would say it is fair to talk of a real indeterminacy in the agent's degrees of belief and desire. Of course if this is indeed to be thought of as indeterminacy in belief, it is assuredly not an indeterminacy of the "virulent" kind that would vitiate talk of intention completely. Odd these facts may be, yet we can live with them.

V. OR INDETERMINACY IN MEANING?

But is this really an indeterminacy about degrees of belief, or an indeterminacy about meaning? In this section we shall see how the previous example may be redescribed so that the indeterminacy characterized by the Bolker transformation appears as a matter of indeterminacy about correct interpretation of the agent's language.

In order to prepare for this shift in perspective we shall have to set things up a little differently. Up to this point we have assumed, with Jeffrey, that the objects of the agent's ordinal preference ranking were propositions. Now, following Davidson's suggestion, let us take the basic attitude to be this: the agent prefers one sentence true rather than another. Let the agent's language be \mathcal{L}, assumed for simplicity to be the language of the propositional calculus with the logical operators '¬' and '&' taken as primitive, along with a stock of sentence letters, here indicated by lower-case Greek letters 'α', 'β', etc. An interpretation of \mathcal{L} is a way of assigning a proposition to each sentence of the agent's language. In particular, we shall take an interpretation of the agent's language to be a function $M : \mathcal{L} \to P\ (\mathcal{I})$ that assigns a set of possible worlds to each sentence in \mathcal{L}. The function M is assumed to satisfy the following two conditions:

$$M(\neg\alpha) = \overline{M(\alpha)} \qquad\qquad (10)$$

$$M(\alpha\,\&\,\beta) = M(\alpha) \cap M(\beta) \qquad\qquad (11)$$

Interpretations of the kind just defined are *full* or completely determinate interpretations of the agent's language. But just as there may be indeterminacy in degrees of belief and desire, so there may be indeterminacy in interpretation. We shall represent this via a notion of *partial interpretation*. The definition of partial interpretation agrees with that of full interpretation in that a partial interpretation is also a map that assigns a proposition to each sentence of the language, and which maps a conjunction of two sentences to the intersection of the interpretation of the conjuncts. However, in the case of partial interpretations, it is not assumed that the proposition assigned to the negation of a sentence is the complement of the proposition assigned to the sentence itself. Rather we replace (10) with the weaker condition:

$$M(\neg\alpha) \subseteq \overline{M(\alpha)} \qquad\qquad (12)$$

If M is a partial interpretation of the agent's language, then M does not fully determine what proposition is being expressed by any given sentence α of \mathcal{L}. Call $M(\alpha)$ the *positive extension* of α. This can be thought of as the set of worlds of which the agent's sentence α is definitely true. The proposition $M(\neg\alpha)$ is the *negative extension* of α. The worlds in this set are all worlds of which α is definitely false. Condition (12) allows that there may also be worlds which are neither in the positive nor the negative extension of α according to the partial interpretation M. These are worlds for which there is no fact of the matter whether or not they are worlds of which the agent's sentence is true.

The indeterminacy due to a partial interpretation M may be thought of as an indeterminacy between the various possible ways of "sharpening" M to a

full interpretation. A sharpening of M will be defined to be a full interpretation that is consistent with the partial interpretation as far as it goes, extending the positive and negative extension that M assigns to each sentence. Usually it seems appropriate to impose a further condition on a sharpening as well. The idea is familiar from the use of this device in the supervaluational semantics for vague predicates. Consider a vague predicate like "is tall". An acceptable sharpening will not only have to enlarge the positive and negative extensions of the original vague predicate, it must do so in a way that respects the following fact about tallness: anyone taller than a tall person is tall. We shall suppose that for each proposition A we have a comparative similarity ordering $\leq A$ among worlds. When $v \leq A\ w$ we say that v is "closer to" A than w is. Then our final condition on a sharpening of M is that whenever the sharpening assigns some world w to the positive extension of the sentence α, all worlds closer to $M(\alpha)$ than w is get assigned to that positive extension as well. In summary, an interpretation $M^{\#}$ is called a *sharpening* of the partial interpretation M if and only if: (i) $M^{\#}$ is a full interpretation; (ii) $M(\alpha) \subset M^{\#}(\alpha)$; (iii) if $y \in M^{\#}(\alpha)$ and $x \leq M(\alpha)\ y$, then $x \in M^{\#}(\alpha)$, for all $\alpha \in \mathcal{L}$.

Now suppose that our agent's language \mathcal{L} contains two uninterpreted sentence letters α and β. There are two kinds of story we might tell about this agent.

(1) The first story is the traditional decision theoretic one. We take it for granted that the question of understanding the agent's language is unproblematic. We assume that we may take, as given, a correct and completely determinate inter-pretation of the sentences α and β. Perhaps we know, somehow or other, that the agent's sentence α expresses the proposition A, while the meaning of β is B. From this point on, arriving at a full intentional description of the agent is now simply a matter of figuring out the agent's beliefs and desires. This is the problem that was attacked and solved in various ways by Ramsey, Savage, and Jeffrey. Suppose that, following the method outlined by Jeffrey, we discover that the agent's degrees of belief and desire may be represented by any pair $\langle P, V \rangle$ Bolker equivalent to the pairs given in the matrices of figures 1 and 2. We have solved the intentional problem for the agent, but in a way that leaves some indeterminacy of the kind discussed in the previous section in the agent's degrees of belief and desire.

(2) The second story is purely imaginary, but the idea I have in mind should be clear enough. I am imagining a method which would be, in a sense, the direct opposite of the traditional decision theoretic approach. This second approach would start from the (equally implausible) assumption that questions of what an agent wants and believes are quite unproblematic. We would assume that we might take, as given, a correct and completely determinate account of the subjective probabilities and desirabilities the agent assigns to propositions (or, if you prefer, to sentences in our own language). The

problem of arriving at a full intentional description of the agent would then reduce to the problem of figuring out how to interpret the agent's language (or how to translate it into our own). If, somehow or other, we managed to do that, it seems likely that the solution we arrived at would also involve a certain amount of indeterminacy, though of course in this case an indeterminacy in meaning. Just as Jeffrey's version of the Ramsey method yields a family of pairs $\langle P,V \rangle$, so we might expect a method of this second kind to result in a partial interpretation of the agent's sentences, or, to put it another way, in a family of full interpretations related to one another by the fact that they were all acceptable sharpenings of the partial interpretation that characterizes all that is determinate about the agent's meanings. On this second approach, a solution to the intentional problem for an agent might take the form of a *single* pair of *partially* interpreted probability and desirability matrices (rather than a family of pairs of fully interpreted matrices). The single pair of partially interpreted matrices might, for example, look something like this:

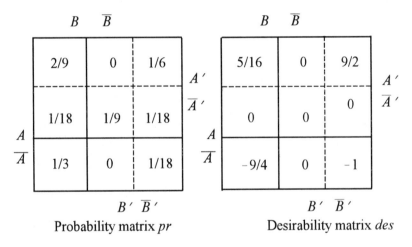

Probability matrix *pr* Desirability matrix *des*

FIGURE 3

Each of the matrices in figure 3 includes two hypotheses about what the agent means by the sentences α and β. Each of these hypotheses amounts to a full interpretation of those two sentences. Call these two full interpretations M and M'. According to interpretation M, when the agent asserts the sentences α and β, she expresses the propositions A and B respectively. This interpretation is indicated on the diagram by the solid lines. On the alternative interpretation, $M'(\alpha) = A'$ and $M'(\beta) = B'$. This alternative interpretation is indicated on the diagram by the dotted lines.

On the second imagined approach to solving the intentional problem,

assignment of degrees of belief and desire was assumed to be totally unprob-lematic and completely determinate. Thus within the cells of the two partially interpreted matrices in figure 3 the agent's probabilities and desirabilities over the space of possible worlds have been specified unequivocally. Figure 3 is to be read, for example, as maintaining that, as a quite determinate matter of fact, the agent assigns probability zero to the proposition $A' \cap \bar{B}$ and probability 1/18 to the proposition $\bar{A}' \cap B$, as is indifferent to the truth of each of those propositions, even though she quite clearly has no way of expressing either of those propositions in her own language! Is this an unrealistic assumption? Of course—but it is no more unrealistic than the corresponding assumption implicit in the approach of traditional decision theory. Further-more, by taking for granted determinacy in attitude though not in meaning, it is unrealistic in a way exactly opposite to the traditional approach, which takes for granted determinacy in meaning though not in attitude. Here I think it is actually an advantage that we have at our disposal two quite implausible models of the phenomenon of intention, since the truth of the matter can be seen to lie at a point somewhere between the extremes set by the two unrealistic idealizations.

And here is the punchline. The story told about an agent by the single pair of partially interpreted matrices in figure 3 is, at the level of the agent's total disposition to prefer one sentence rather than another true, a story about *exactly the same agent* described by figures 1 and 2. The A–B–interpretation of the agent's language corresponds exactly to the choice of the pair of functions $\langle P, V \rangle$ depicted in figure 1. The alternative A'–B'–interpretation of the agent's sentences yields the equivalent pair of functions $\langle P', V' \rangle$ shown in figure 2.

Readers may check the details of this claim for themselves from the diagrams; I will limit myself here to two illustrations of the point, from which the general idea should be clear. To see that the (non-primed) M interpretation yields the probabilities of figure 1, simply ignore the dotted lines on the left-hand matrix in figure 3, and sum the probabilities within each of the remaining four cells defined by the solid lines. For example: on this interpretation, the probability assigned to the sentence $\alpha \& \neg \beta$ is the probability assigned to the proposition $A \cap \bar{B}$, and:

$$
\begin{aligned}
pr(A \cap \bar{B}) &= pr(A' \cap B' \cap \bar{B}) + pr(A' \cap B') \\
&\quad + pr(A \cap \bar{A}' \cap \bar{B} \cap B') + pr(A \cap \bar{A}' \cap \bar{B}') \\
&= 0 + 1/6 + 1/9 + 1/18 \\
&= 1/3 \\
&= P(A \cap \bar{B})
\end{aligned}
$$

As a second example of the way to check the claim, let's calculate the desirability of the sentence $\neg\alpha\&\beta$ on the M' interpretation. This amounts to finding the *des*-values for the four sub-cells of the lower left dotted-lined cell of the desirability matrix in figure 3, and taking a weighted average of these numbers, the weights determined by the *pr*-assignments to the corresponding cells in the probability matrix. Thus, on the M' interpretation:

$$
\begin{aligned}
des(\neg\alpha\&\beta) &= des(\overline{A}' \cap B') \\
&= \frac{(1/18) \cdot 0 + (1/9) \cdot 0 + (1/3) \cdot (-9/4) + 0 \cdot 0}{1/18 + 1/9 + 1/3 + 0} \\
&= -3/2 \\
&= V'(\overline{A} \cap B)
\end{aligned}
$$

VI. GENERALIZATION

The foregoing would hardly be interesting if the possibility of reinterpreting belief-indeterminacy as meaning-indeterminacy was merely a feature of the particular example discussed above. But it is not. In this section we shall present a quite general recipe for the re-characterization of indeterminacy in degrees of belief and desire on the Jeffrey-Bolker theory as indeterminacy in meaning on an account that assumes completely determinate probabilities and desirabilities on the underlying algebra of propositions. The result extablished here represents both a new and rather revealing way of thinking about the Bolker transformations, and goes part of the way toward suggesting the form that any solution to the problem of intention must take, when cast in terms of Davidson's unified theory of meaning and action.

The recipe for this re-characterization will appeal to the notion of a *directed graph*. A graph consists of a set of points called *nodes* along with a set of *edges* connecting certain of those points. Considered set-theoretically, a graph G is simply an ordered pair $\langle N, E \rangle$ whose elements are a node set N, and an edge set E. Each edge $e \in E$ is a two-element set of nodes in N. In the case of a directed graph, each edge is an ordered pair of nodes $\langle m, n \rangle$, with m, $n \in N$. The node m is called the *source* of the edge $\langle m, n \rangle$, while n is referred to as its *target*. It is customary to depict a directed graph in a diagram in which each node appears as a point, and each edge $\langle m, n \rangle$ is represented by an arrow leading from the node m to the node n, as in the diagram below, which depicts a directed graph with five nodes and four edges.

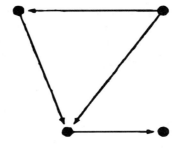

FIGURE 4

Suppose that M is the (full or partial) interpretation of \mathcal{L} that our method of radical interpretation (whatever it is) tells us captures all there is to know about the agent's meanings. We may then give a single, unified, representation of the agent's beliefs, desires, and meanings in terms of what I shall call an *interpreted graph*. An interpreted graph is a directed graph that satisfies the following conditions: (i) no node that is the source of some edge is also the target of any edge; (ii) each node is labelled with a sentence of \mathcal{L}; (iii) for any two nodes α and β, $M(\alpha)$ is inconsistent with $M(\beta)$; (iv) there is a probability function P that assigns probability to the nodes and edges; (v) exactly one source node, and exactly one target node receive zero probability.

Here is an example of such a graph:

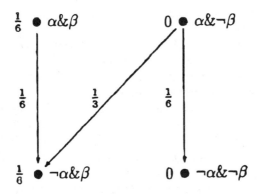

FIGURE 5

Given that we have either a full or partial interpretation of the agent's language, the graph of figure 5 displays, in a particularly succinct form, the same information that was given in different ways, by figures 1, 2, and 3. There are two ways of reading figure 5, depending on whether the associated interpretation M is full or partial. These two readings correspond to the two stories told about the agent in the previous section.

The first story is one in which our method of radical interpretation is assumed to have delivered a fully determinate interpretation M of the agent's language L. In this case only the nodes of the graph are interpreted as propositions. The probability assigned by the function P to an edge of the fully interpreted graph is, in this case, to be thought of as probability that can "slide" back and forth along the edge of the graph, so that some proportion k of it gets added to the probability assigned by P to the source node, while the remainder is added to the probability P assigns to the target node. In particular, the graph represents a whole family $\{P_k : 0 < k < 1\}$ of probability functions satisfying the following condition:

$$P_k(\alpha) = \begin{cases} P(\alpha) + k.P(E_\alpha) & \text{if } \alpha \text{ is a source node} \\ P(\alpha) + (1 - k).P(E_\alpha) & \text{if } \alpha \text{ is a target node} \\ P(\alpha) & \text{if } \alpha \text{ is an unconnected node} \end{cases}$$

Let's illustrate this definition by using it to calculate some probabilities from the graph given in figure 5. For example, setting $k = 2/3$, the definition tells us that the function $P_{2/3}$ will assign to the node $\alpha \& \neg \beta$ all of the probability that P assigned to that node (i.e. 0), plus 2/3 of the probability that P assigns to any edges leading away from that node. There are two such edges, and their probabilities are 1/3 and 1/6. Hence $P_{2/3}(\alpha \& \neg \beta) = 0 + (2/3) \cdot (1/3 + 1/6) = 1/3$. Similarly, $P_{2/3}(\alpha \& \beta) = 1/6 + (2/3) \cdot (1/6) = 5/18$. Note that these probabilities coincide with those displayed in the probability matrix in figure 1. That is no coincidence; the probability function depicted in figure 1 simply *is* $P_{2/3}$.

We next specify, for each node α, the value of $INT(\alpha)$. Since $INT(\alpha) = P_k(\alpha) \cdot V_k(\alpha)$ is constant as k varies, this will suffice to fix $V_k(\alpha)$ for each node of the graph. The idea behind the definition of INT is this. The INT values assigned to the source nodes will all be positive, will sum to unity, and will be assigned to each source node in proportion to the total amount of probability that P allocates to edges leading away from that node. The INT values for the target nodes, will all be negative, will sum to -1, and will be assigned to the target nodes in proportion to the total amount of probability that P allocates to edges leading in to that node. Finally, the INT value for each unconnected node will be zero.

That sounds a little complicated, so once again let's see how it works out for the example in figure 5. We shall calculate the *INT* values for the two source nodes $\alpha\&\beta$ and $\alpha\&\neg\beta$. The former node is the source of a single edge, to which P assigns probability 1/6. The latter node is the source of two edges, to which P assigns a total probability of 1/2. It follows that the *INT* values forthese two nodes will lie in the ratio 1 : 3. Since they are assumed to be positive, and to sum to 1, we see that it follows from our definition that $INT\,(\alpha\&\beta) = 1/4$ and that $INT\,(\alpha\&\neg\beta) = 3/4$.

The general definition of *INT*, stated more formally is:

$$INT\,(M\,(\alpha)) = \begin{cases} P\,(E_\alpha)\,/\,P\,(E) & \text{if } \alpha \text{ is a source node} \\ -P\,(E_\alpha)\,/\,P\,(E) & \text{if } \alpha \text{ is a target node} \\ 0 & \text{if } \alpha \text{ is an unconnected node} \end{cases}$$

Note that we have chosen to define *INT* so that all the source nodes turn out to be *good* nodes, while all the target nodes are *bad* nodes. (The agent is indifferent about unconnected nodes).

It is straightforward to check that the desirability matrix given back in figure 1 is actually $V_{2/3}$ for the graph of figure 5. For example: $V_{2/3}\,(\alpha\&\beta) = INT\,(\alpha\&\beta)\,/\,P_{2/3}(\alpha\&\beta) = (1/4)\cdot(18/5) = 9/10$ as required.

Theorem: Suppose that G is an intentional graph fully interpreted by M and with probability function P. Suppose that P_k and V_k are defined as above. Then the family $\{\langle\, P_k,\ V_k\,\rangle : 0 < k < 1\}$ is a complete set of probability-desirability pairs closed under the Bolker transformations.

Proof: The following illustrates the key step in the proof. Choose any j, k such that $0 < j < k < 1$. Suppose α is any good node of G and let $M\,(\alpha) = A$. Then

$$\frac{P_j(A)}{P_k(A)} = \frac{P(\alpha) + j\cdot P(E_\alpha)}{P(\alpha) + k\cdot P(E_\alpha)}$$

$$= \frac{(j - k)P(E_\alpha)}{P(\alpha) + k\cdot P(E_\alpha)} + \frac{P(\alpha) + k\cdot P(E_\alpha)}{P(\alpha) + k\cdot P(E_\alpha)}$$

$$= (j - k)\cdot P(E)\cdot \frac{P(E_\alpha)}{P(E)\cdot P(\alpha) + k\cdot P(E_\alpha))} + 1$$

$$= (j - k)\cdot P(E)\cdot V_k(A) + 1$$

and so

$$P_j(A) = (c \cdot V_k(A) + 1) \cdot P_k(A), \qquad \text{where } c = (j - k) \cdot P(E)$$

Hence P_j and P_k are Bolker equivalent. QED.

Let's turn secondly to the reading according to which the indeterminacy in intention is indeterminacy about meaning.

According to this story, the agent's probabilities are determinate, and herdesirabilities are fixed up to a positive linear transformation. The only indeterminacy lies in the interpretation of the agent's language, where the best we can do is to arrive at a partial interpretation of the sentences of L. Suppose that our elicitation method has given us this partial interpretation M. We can then use this partial interpretation to interpret each node and each edge in the graph as a proposition. First of all, each node is interpreted as the proposition that is the positive extension $M(\alpha)$ of the sentence α labelling that node. If that node is the source of some edge, then the worlds that make up that proposition will be called *source worlds*. Similarly, if the node is the target of some edge, the worlds in the proposition with which that node is identified will be called *target worlds*.

Then the edge $e = \langle \alpha, \beta \rangle$ is interpreted as the proposition $M(e)$ that contains all worlds w such that:

1. w is not an element of the positive extension of any sentence of L;

2. the closest source world to w is an $M(\alpha)$ world;

3. the closest target world to w is a $M(\beta)$ world.

The directed graph G so interpreted, can now be thought of as defining a family of sharpenings M_k, $0 < k < 1$ of the original partial interpretation M. The definition of M_k goes in two steps. First of all, if $e = \langle \alpha, \beta \rangle$ is any edge of G, then let $M_k(e)$ be the proposition such that:

1. $M_k(e) \subseteq M(e)$;

2. if $y \in M_k(e)$ and world x is no further from $M(\alpha)$ than y is, then $x \in M_k(e)$;

3. $P(M_k(e) / M(e)) = k$.

Secondly, if α is any node of the graph G, let E_α be the set of edges connected to α. Then:

$$M_k(E_\alpha) = \bigcup_{e \in E_\alpha} M_k(e), \qquad \text{if } \alpha \text{ is a source node}$$

and
$$M_k(E_\alpha) = \bigcup_{e \in E_\alpha} (M(e) - M_k(e)), \qquad \text{if } \alpha \text{ is a target node}$$

Finally, we complete the definition of M_k as follows.

$$M_k(\alpha) = M(\alpha) \cup M_k(E_\alpha)$$

This definition of M_k consciously mimics the definition of P_k so that

probability $(M_k(\alpha)) = P_k$ *(meaning* $(\alpha))$

where *probability* is the fully determinate probability function ascribed to the agent by the second kind of unrealistic story about the graph G, and *meaning* is the fully determinate interpretation of the agent's language that we are assumed to possess according to the first kind of unrealistic story about G.

We have established that the kind of indeterminacy in degrees of belief and desire characteristic of Jeffrey's version of decision theory, namely: uniqueness up to transformation under the Bolker equations, may be reinterpreted as a certain kind of indeterminacy in meaning. The family of Bolker-equivalent pairs $\langle P_k, V_k \rangle$ parametrized by k, corresponds to a family M_k of acceptable sharpenings of our partial interpretation of the agent's language, also parametrized by k. The Davidsonian moral of this is that from the point of view of the unified theory of intention, there is no fact of the matter whether the indeterminacy is really indeterminacy about belief and desire, or indeterminacy about meaning. Each of these sharpenings M_k simultaneously sharpens our partial interpretation of each of the agent's sentences. The sharpening takes place simultaneously—or *holistically*—over the whole of the language L. Recall how in the example of figure 3, the shift from the interpretation M to the interpretation M' involved a simultaneous re-interpretation of both the sentence α (re-interpreted from A to A') and of the sentence β (re-interpreted from B to B').

Of course the indeterminacy about meaning captured by the family of sharpenings M_k is of a special kind. In particular it was assumed that the agent was indifferent to all the worlds in the "penumbral" region whose elements get reassigned by various choices of M_k. Think of it this way: each particular choice of M_k amounts, in effect, to an acceptable precisification of what the agent means by "good" and "bad". This precisification is achieved indirectly by a holistic re-interpretation of a whole bunch of sentences of the agent's language; a re-interpretation that saves, of course, the evidential base of data about the agent's dispositions to prefer sentences true. While this is significant, I must remind the reader

that we have only considered one special case. I certainly cannot claim in this paper to have characterized the most general possible form of meaning-indeterminacy here, nor to have shown how that most general possible form of meaning-indeterminacy might be traded off conceptually with indeterminacy in the other two intentional components: belief and desire. That task could really only be achieved, I think, by producing a complete version of the unified theory of intention. Such a story would say something like the following:

> [Assuming that the agent's preferences are coherent in certain ways, and assuming certain structural conditions on the algebra of propositions], there is a triple of functions $\langle P, V, M \rangle$ that accurately reflects the agent's preference ranking over uninterpreted sentences of \mathcal{L}. P is a probability function, V a desirability function, and M a full interpretation of \mathcal{L}. Furthermore, if $\langle P', V', M' \rangle$ is any other such triple that accurately reflects the agent's preferences, then the functions P', V', and M' may be obtained from P, V, and M by transformation under the following three equations:
>
> $$P'(A) = [\text{some function of } P, V, \text{ and } M]$$
>
> $$V'(A) = [\text{some function of } P, V, \text{ and } M]$$
>
> $$M'(A) = [\text{some function of } P, V, \text{ and } M]$$

These three transformation equations, which generalize the Bolker equations in the unified theory, will show how tweaking any one of the three intentional components can be compensated for by adjustments to the other two, in a way that saves the phenomena of sentence-preference. That's the form that the central theorem of the unified theory of intention will take. Unfortunately I cannot, at the present moment, write down those transformation equations in their most general form.

JOHN COLLINS

DEPARTMENT OF PHILOSOPHY
COLUMBIA UNIVERSITY
OCTOBER 1996

NOTES

1. See, for example, Davidson [1], [2], [3].

2. Davidson [4] p.8. The passage is reproduced almost verbatim in the third of Davidson's 1989 Dewey Lectures [7] p.322. Related material may be found in [6].

3. Davidson [7] p.326.

4. Davidson [4] p.5.

5. Davidson [4] p.6.

6. Davidson [4] p.6.

7. Lewis [10] p.118.

8. Lewis [10] p.118.

9. Stalnaker [13] p.15.

10. Dennett [8] pp.8, 19.

11. I discuss this case at greater length in the paper 'Intrinsic Desire'.

12. Martin [11].

13. These ideas will be developed at greater length in 'The Parsing of the Possible: Dispositions and their Components,' to be read to the Princeton Philosophy Colloquium in March 1997.

14. Jeffrey [9] p.157.

15. Variation in probability assignment is possible provided that the agent's desirability function has either a finite upper bound or a finite lower bound. I shall assume throughout this paper that the agent's desirability function is bounded above and below, and that, in fact, it achieves maximum and minimum values.

16. Readers familiar with *The Logic of Decision* should be warned that the assumptions I am making here are not the same simplifying assumptions that Jeffrey makes there in Chapter 6. Jeffrey sets $b = 0$, $d = 1$ and $a = c + 1$, thus keeping both the zero point and the unit fixed. Here I am allowing the unit to float.

17. Nor, as Isaac Levi and Teddy Seidenfeld noticed long ago, are there determinate facts about probabilistic independence.

REFERENCES

Davidson, Donald. [1] 'Radical Interpretation,' in [5], pp. 125–39.

———. [2] 'Belief and the Basis of Meaning,' in [5], pp. 141–54.

———. [3] 'Thought and Talk,' in [5], pp. 155–70.

———. [4] 'Towards a Unified Theory of Meaning and Action.' *Grazer Philosophische Studien*, (1980), pp. 1–12.

———. [5] *Inquiries into Truth and Interpretation.* Oxford: Clarendon Press (1984).

———. [6] 'A New Basis for Decision Theory.' In *Recent Developments in the Foundations of Utility and Risk Theory*, edited by Daboni et. al. Reidel (1986), pp. 43–56.

———. [7] 'The Structure and Content of Truth,' (John Dewey Lectures 1989). *Journal of Philosophy*, (1990), pp. 279–328.

Dennett, Daniel. [8] 'Intentional Systems.' In *Brainstorms*, Bradford Books (1978).

Jeffrey, Richard. [9] *The Logic of Decision*, 2nd edition. Chicago: University of Chicago Press, (1983).

Lewis, David. [10] 'Radical Interpretation.' In *Philosophical Papers*, Vol. I. Oxford: Oxford University Press (1983), pp. 108–118.

Martin, C. B. [11] 'Dispositions and Conditionals.' *The Philosophical Quarterly*, (1994), pp. 1–8.

Ramsey, F. P. [12] 'Truth and Probability.' in *Philosophical Papers*, edited by D. H. Mellor. Cambridge University Press (1990).

Stalnaker, Robert. [13] *Inquiry*. Bradford Books, MIT Press (1987).

REPLY TO JOHN COLLINS

S etting aside the trivial indeterminacy (or inscrutability) of reference, many interesting cases of indeterminacy involve trade-offs among the attitudes. You and I, looking with unimpaired vision at the same tablecloth, do not agree on whether it is purple or blue. Or rather, one of us says "It's purple", and the other says, "It's blue". Do we disagree over the color or over the right use of the words? Further talk and mutual observations of samples may resolve the matter or they may not. There may be nothing to resolve; there may be no point in deciding. Every bit of available and counterfactual evidence may be consistent with either answer. We can arbitrarily decide the meaning and make the obvious adjustment in the belief, or the other way around.

John Collins lucidly retraces much of the course of my thinking on this matter since the mid fifties when I thought I had discovered how to determine degrees of belief and strengths of desire simultaneously from choices. I was, of course, wrong in thinking I had discovered the trick; Ramsey was there long before me. But the trick is impressive. It shows how to fix the subjective probability of one-half on the basis of simple preferences for gambles, and as Collins explains, this leads at once to the determination of so-called utilities (subjective values) on an interval scale, from which, in turn, other subjective probabilities can be deduced. It was years before it dawned on me that there was an analogue to this process in Quine's methodology for separating out meaning and belief on the basis of observed, honest utterances of sentences. In both cases, two richly detailed attitudes were derived from observable behavior (choice behavior in one case, honest utterances in the other). The strategy that made this possible in decision theory and theory of meaning alike was finding a way to hold one variable fixed while the other was determined (subjective probability in the first, the meaning of logical constants and of observation sentences in the second). In both disciplines the strategy could work only if one could plausibly postulate a powerful structure imposed on the observable base (Ramsey's postulates, a Tarski-type semantic theory of truth).

Neither of these theories seemed to me by itself to provide a comprehensive view of what makes the understanding of language and action possible, and each theory filled in the gaps in the other. The problem was to devise a way of combining the two. After a number of false starts, I found a way based on the single observable notion of valuing the truth of one sentence more than the truth of another, and using Richard Jeffrey's version of Bayesian decision theory rather than a more standard version. Collins doesn't explain how my way works; I'm sorry he doesn't only because he is so good at explaining technical machinery to those who find it daunting. In any case, the basic idea is set out in the appendix to the third of my Dewey Lectures, "The Structure and Content of Truth".

As I knew from the start, Jeffrey's version of Bayesian decision theory introduces a kind of indeterminacy not present in more standard versions. Collins explains this in a particularly clear way. I was not deterred, since I was committed to the Quinian doctrine of indeterminacy about meanings and beliefs in any case, and so it seemed natural that subjective probabilities would also be indeterminate. Collins gives us a sense of how the indeterminacy works in the unified theory. In the event, there is, of course, not just the indeterminacy introduced by the interdependence of meaning and belief, but a heightened indeterminacy due to the interdependence of meaning, belief, and valuing. The possible trade-offs involve all three elements. Collins is not able to state what he calls "the central theorem" which would map subjective probabilities, subjective values, and meanings onto all the sentences of an agent. I confess it never occurred to me that this would be possible, since I never thought one could state formally how to interpret the sentences of an idiolect on the basis of subjective probabilities. (This is why I said the theory of meaning falls seriously short of the theoretical neatness of decision theory.) But Collins has suggested a way of approaching the notion of degrees of indeterminacy of meaning which could no doubt be made to work. Whether the requisite regimentation would be realistic enough to be interesting I cannot guess. I very much hope Collins works this out.

D. D.

23

Isaac Levi

REPRESENTING PREFERENCES: DONALD DAVIDSON ON RATIONAL CHOICE

I

In 1955 Donald Davidson together with J. C. C. McKinsey and Patrick Suppes published an essay in *Philosophy of Science* with the title "Outlines of a Formal Theory of Value I".

> We take it as the general function of formal value theory to provide formal criteria for rational decision, choice and evaluation. Our conception of this aspect of value theory is in one way similar to Kant's, for like him we believe it possible to state in purely formal terms certain necessary conditions for rationality with respect to value. Unlike Kant, however, we do not suggest that any particular evaluations or value principles can be derived from purely formal considerations. Value theory, as here conceived, is associated with another venerable, and at present rather unfashionable, tradition, for it seems to us that there is a sense in which it is perfectly correct to say that just as logic can be used to define necessary formal conditions for rational belief, so it is a use of value theory to define necessary formal conditions for rational choice. (Davidson, McKinsey, and Suppes, 1955, pp. 140–41)

Ever since that time, Davidson has been preoccupied with understanding propositional attitudes of believing and desiring as motivating factors controlling deliberate decision making. Although there have been important changes in Davidson's views on the subject, the problematic which he and his colleagues addressed over forty years ago has remained an important stimulus to the development of the ideas that have shaped his later work.

Davidson, McKinsey, and Suppes argued that just as physics has advanced

without answering metaphysical questions and statistics has advanced without answering semantical questions, "substantial progress in the theory of value can be made independent of metaphysics and semantics" (1955, p. 140).

> just as logic can be used to define necessary formal conditions for rational belief, so it is a use of value theory to define necessary formal conditions for rational choice. (p. 140)

Formal conditions such as the transitivity of strict preference and of indifference (equipreference) over a domain of objects K together with a condition that for any pair of elements x and y in K, either x is strictly preferred to y, y strictly preferred to x, or x and y are indifferent define a set theoretic predicate "is a rational preference ranking" true (or false) of a triple consisting of a domain K, a binary relation of strict preference P and another binary relation of equipreference E (p. 143). The domain K could be any set of objects whatsoever. The relations could be any pair of relations that satisfy the conditions laid down by the axioms for the domain K.

Even when K is understood to be a set of objects of some agent's preference or indifference ranking, the formal theory of rational preference makes no descriptive claims. We know that the preferences of agents often violate such conditions. According to the formal theory, when such violations occur, the preferences over K do not constitute a *rational* preference ranking.

Nor does the formal characterization of a rational preference ranking allow us to derive recommendations from descriptive claims. Consider an analogy with the use of a formal deductive system as a set of norms regulating rational belief. Suppose that proposition Q is a deductive consequence of the proposition P:

> Logic does not say that we should reason in accordance with this truth, nor that if we believe the antecedent of the sample truth, we should believe the consequent. But we can *use* this truth of logic to explain what we mean in part by reasoning rationally, and when we do this we use a truth of logic normatively. (p. 144)

Formal value theory neither describes nor prescribes. It explicates a conception of rational choice which can then be used to characterize a standard for assessing the rationality of decisions. We may then ask whether agent X satisfies the standard and whether X ought to do so.

F. P. Ramsey (1990, ch. 4), whom Davidson, McKinsey, and Suppes acknowledge as an inspiration, did not think of principles of rational choice as merely explicating the concept of rational choice. He understood both deductive logic and principles of rational choice prescriptively as logics of consistency specifying consistency or coherence conditions that agent X's beliefs, probability judgments, values, and choices should satisfy at a given time. The difference between Ramsey's view and that of Davidson, McKinsey,

and Suppes reflects a difference in priorities. Ramsey thought that both deductive logic and principles of rational choice do make recommendations concerning what an agent ought to believe and choose. Agents ought to choose coherently in the sense that their choices ought to be what they judge to be best among their options given their goals and beliefs. Similarly, agents ought to have consistent beliefs. To the extent that they succeed, they will satisfy formal conditions of the sort considered by Davidson, McKinsey, and Suppes and manage to be rational decision makers and believers. For Ramsey, however, the primary applications of logic understood as formal structure is prescriptive. Davidson, McKinsey, and Suppes were more neutral as to the relative importance of the descriptive and prescriptive uses of such structures.

No matter what the emphasis, principles of rationality do not prescribe which coherent system of beliefs, goals, and choices ought to be embraced by an agent at a time. All that is demanded is consistency. We may look for more than consistency; but logic and principles of rational choice alone cannot give it to us.

Thirty years after his collaboration with McKinsey and Suppes, Davidson's view had moved closer to Ramsey's. He acknowledged that irrationality and rationality are both normative concepts. To act, reason, believe, or desire irrationally is to depart from a standard or norm. We often differ from one another in the standards we endorse and sometimes register our disapprovals of others for deviating from our standards by charging them with irrationality. Davidson is concerned with a less substantive notion of rationality. To be irrational is to deviate from one's own standards of what is reasonable (Davidson, 1985a, pp. 345–46). As with Ramsey, coherence or consistency is the focus of attention.

Davidson faces up to a question that he, McKinsey, and Suppes had earlier avoided: "Why must *inconsistency* be considered irrational?" Why should agents seek to be coherent according to an idea of coherence or consistency for which necessary conditions are supplied by a formal theory of value?

Why, for example, should the preferences that guide choice be transitive? It is not enough simply to offer a formal theory. And even if we take the extra step with Ramsey and declare adherence to a standard for coherent desire, belief and choice specified formally in a given way, how should we respond to the challenge of someone marching to a different drummer—perhaps, one embracing intransitive preferences as rationally coherent? Davidson responds as follows:

> I am strongly inclined to think my mistake in this imagined exchange came right at the start; I should never have tried to pin you down to an admission that you ought to subscribe to the principles of decision theory. For I think everyone does subscribe to those principles whether he knows it or not. This does not imply, of

course, that no one ever reasons, believes, chooses or acts contrary to those principles, but only that if someone does go against those principles, he goes against his own principles. (Davidson, 1985a, p. 351)

Here Davidson argues, in effect, that to demand a justification for being rationally coherent is to raise what Peirce would have called a "paper doubt". There is no need to justify being rationally coherent because no one doubts that one should (even though some may say that they do have doubts). But even if it is true that the injunction to be rationally coherent in one's deliberation is a noncontroversial prescription, it is, nonetheless, a prescription.

Davidson goes further than claiming that subscription to principles of rationality is noncontroversial. He writes: "it is a condition of having thoughts, judgments and intentions that the basic standards of rationality have application" (Davidson, 1985a, p. 351). Davidson no longer feels obliged to restrict attention, as Davidson, McKinsey, and Suppes did, to a formal theory of value. He is prepared to insist that every bearer of propositional attitudes should conform to the conditions of the formal theory in order to fulfill their own commitments. If they did not subscribe to principles of rational belief, desire, and decision, they would not be agents bearing propositional attitudes.

Davidson does not say that every bearer of propositional attitudes conforms to standards of rational belief, desire, and decision in their behavior or even in their dispositions to behavior. Satisfying conditions of rational coherence is not a necessary condition for having propositional attitudes. Clearly agents do not always believe, choose, or act rationally. But when an agent fails to meet the demands of rational consistency of coherence, Davidson insists that the agent "goes against" his own principles because subscribing to these principles (in contrast to conforming to them) is a necessary condition for being a bearer of propositional attitudes.

Propositional attitudes are, according to Davidson, dispositional properties of agents useful in explaining and predicting their conduct. The generalization "Any rational agent who faces a choice between options in a set of alternatives A maximizes expected utility among the members of A" is not a testable lawlike claim eligible for consideration as a covering law in reason explanations. Davidson has testified to his frustration in attempting to think of such generalizations as empirically testable during the course of the experimental work that he undertook in collaboration with Suppes and others in the 1950s and early 1960s (Davidson, 1980a, ch.14, pp. 267–72). Such experiments "*can* be taken, if we want, as testing whether decision theory is true. But it is at least as plausible to take them as testing how good one or another criterion of preference is, on the assumption that decision theory is true." (Davidson, 1980a, p. 272). So construed, we may think of the principles of decision theory as schemata for a family of covering laws. By plugging in various

hypotheses concerning the utility, probability, and expected utility judgments of an agent, one can predict or explain the choices of an agent on the assumption that the agent is rational. In effect, the generalization specified above becomes a characterization of a family of Carnapian reduction sentences for various specifications of belief and desire dispositions of the agent.

Davidson (1980a, chap. 14, p. 274) acknowledges that "reason explanations" resemble explanation by disposition illustrated by explanation as to why this cube dissolved. It was soluble. Soluble things dissolve in coffee. This cube was in coffee. This explanation tells us nothing about when, in general, cubes are soluble. It concerns *this* cube. Davidson insists, however, that the argument does do substantial explanatory work even though the attribution of the disposition to the particular cube is not made against a background of assumptions integrating solubility with a more comprehensive theory. He compares this kind of explanation with citing the beliefs and the desires when rationalizing agent X's behavior even though no explanatory laws link such beliefs and desires with the behavior to be explained except, of course, the reduction sentences derived from the principles of decision theory.

Consider, however, the old complaint against citing opium's dormitive virtue as an explanation of Y's going to sleep after taking opium. We can make this look like covering law explanation by declaring that anyone ingesting a soporific goes to sleep. This law specifies a necessary condition for dormitivity and does so axiomatically just as axioms of a decision theory implicitly characterize the primitive notions of preference among options and the notions of probability and utility defined in terms of preference among options. Objects that fail to induce sleep lack dormitive virtue and, hence, are not counterinstances to the reduction sentence.

To the extent that use of such principles as covering laws is unsatisfactory for explanatory purposes both in the case of dormitive virtue and in the case of rational decision making, so is the appeal to the dispositions they characterize. In the absence of more substantial covering laws for the purpose of explanation, we would not consider appeal to dormitive virtue in explanation here as anything other than the parody of scholastic science it was supposed to be.

To be sure, we might be prepared to regard the citation of the reduction sentence for dormitive virtue as a stopgap covering law pending future research that will either replace the disposition term with something more satisfactory or manage to integrate the term into an explanatorily adequate theory (Levi and Morgenbesser, 1964). Stopgap explanations may serve a useful purpose provided their status as stopgaps is well understood. Thus, the particularity of the predication of dormitive virtue to this particular dose of opium is not itself an obstacle to stopgap explanation—provided we can

expect through further inquiry to integrate the various instances of dormitive virtue into a more comprehensive theory.

It may be argued that we can do the same with "is a rational agent" or the specific belief and desire dispositions. Davidson, however, by implication denies that explanations using specific belief and desire dispositions or the disposition predicate "is a rational agent" are stopgap explanations in which the disposition predicates are placeholders for conceptions that will be better integrated into some framework scientific theory. Such denial is entailed by Davidson's commitment to anomalous monism. Anomalous monism precludes the integration into a broader framework. Explanations invoking belief and desire dispositions may look like stopgap explanations. But, on Davidson's view, they are not.

I agree with Davidson's suspicion of attempts to integrate psychology into biological and physical theory. But once one abandons attempts at integration and admits that the principles of rationality are often violated in practice, I fail to see a great advantage in insisting on the explanatory or predictive virtues of principles of rational belief, desire and decision making. Explanations appealing to opium's dormitive virtue may not be worth much; but they can with some charity be construed as stopgap explanations pending a deeper understanding of opium's chemical constitution and its effects on the human body. According to Davidson's anomalous monism, to look on belief and desire attributions as placeholders in generalizations used in stopgap covering law explanations in this sense is hopeless.

This hopelessness is predicated on the idea that the belief dispositions, etc. carry intensional content. If they do not, then Davidson's anomalous monism is no obstacle to treating such dispositions in the same way as "is magnetic" or "is soluble" is treated. But once the intensionality is sucked out of such dispositions, they no longer can be construed as propositional attitudes. How can we have both the propositional attitudes and the naturalizable dispositions whose use escapes the charges against dormitive virtue?

Let us think of believing that h (desiring that h, etc.) as being committed to having or displaying dispositions to motion of some kind or other. The dispositions in question are nonintensional and as "naturalizable" as solubility. When the having or manifesting of such dispositions is interpreted as carrying an intensional content, I suggest that the agent is understood to have undertaken a commitment or to have acquired or displayed a disposition that partially fulfills the commitment—a doxastic or other attitudinal commitment. The propositional attitude of believing that h understood as the doxastic commitment is then to be distinguished from the doxastic performances instantiated by doxastic dispositions and their manifestations. When an agent comes to believe that h, something describable as belonging in the natural order of things takes place. But the happening is also describable as an undertaking or commitment that incurs obligations. Belief that h as a

doxastic commitment is no more naturalizable than any other undertaking of an obligation provided we acknowledge the fallacious character of the naturalistic fallacy. But insofar as the dispositions that fulfill a doxastic commitment are considered without regard to their status as fulfillments, their intensionality has been removed and there is no a priori obstacle to naturalization (Levi, 1991, chap. 2).

I agree with Davidson that subscribing to principles of rationality is a condition of being an agent bearing propositional attitudes. One incurs obligations, thereby, to have coherent or consistent beliefs and desires and to make decisions consonant with such beliefs and desires. Davidson, however, does not think that believing that h or preferring that f be the case rather than g incurs any additional obligation. According to Davidson, if one believes at t that h, that belief incurs no obligation additional to the obligation to be consistent. Believing that h does not commit one to avoiding belief that ~h at that time although it prohibits believing the conjunction of h and ~h. The agent is committed neither to avoiding belief that ~h while believing that h at that time or believing that ~h while avoiding belief that h. The agent has no doxastic or conative commitments above and beyond the commitment to coherence. As a consequence, the intensionality of propositional attitudes must be given by supplying somehow a propositional content to each specific attitude. The principles of rationality are normative; but the specification of contents of propositional attitudes is not a normative issue.

According to the view I favor, spelling out the contents of propositional attitudes is tantamount to identifying the obligations the agent has incurred in endorsing them. In agreement with Peirce, I deny the demand that justification be given for beliefs currently endorsed; but changes in belief (i.e., doxastic commitment) call for justification; for such changes require abandonment of obligations already incurred.

Two advantages emerge from following the path I am suggesting: (1) We avoid introducing mystery-making dispositions in the sense of Levi and Morgenbesser (1964). (2) Two mysteries for naturalism are reduced to one (Levi, 1991, chap. 2). The two mysteries are the obstacles to naturalism presented by the naturalistic fallacy and the gap between nature and intensionality. By taking attitudes to be commitments, there is hope that the question of intensionality can be understood as a question about values. Perhaps, we can live with the fact-value dichotomy.

II

Urging upon Davidson a different understanding of the normative side of his muse does not undermine the importance of Davidson's preoccupation both in his early and in his later work with giving an account of how information

about the propositional attitudes of another agent might be elicited from "data" about the agent's choice and linguistic behavior. As Davidson, Suppes, and Siegel had emphasized, even if one is interested in principles of rational choice as prescriptive principles, ascertaining when they are and are not satisfied remains an important task.

Indeed, if principles of rationality are norms to which all bearers of propositional attitudes subscribe and if attitudes of belief, probability judgment, and value judgment incur commitments to have other attitudes coherent with those judgments, it is desirable to enhance the capacities of such agents to fulfill their commitments to belief, probability judgment, desire, and decision. Not only should we be in a position to judge what the commitments of others are and the extent to which they are living up to such commitments; but we should be able to police our own attitudes. A better understanding of the elicitation process enhances philosophical understanding of the attitudes and improves capacity for self-critical deliberation.

The explanations that will be sought here are explanations of the failures to conform to requirements of rationality and of mechanisms, technologies and therapies that may in certain classes of cases improve performance. No doubt a healthy scientific curiosity extends to explaining why agents who behave rationally act as they do. That curiosity is not gratified by rationalizations that cite the beliefs and desires that motivate such behavior even if we agree with Davidson that citing these beliefs and desires is citing the causes of such behavior.

The central use of theories of rationality, it seems to me, is in formulating the minimal standards to which, as Davidson claims, all bearers of propositional attitudes subscribe and are, therefore, under some obligation to observe. The theory of rational choice favored by Davidson in the 1950s and at present is the one whose fundamental principle is the recommendation that expected utility be maximized.

In order to ascertain whether deliberating agents are conforming to this maxim or not, some way of ascertaining what the probability and utility judgments are that motivate the choices such agents make must be in place. The pioneering work that Davidson and Suppes undertook in the 1950s on the question of elicitation as well as Davidson's more recent reflections on how to interpret the behavior of agents with reference to their motives remain relevant whether one understands the normative aspect of rational choice as Davidson and Suppes did, as Davidson now does or according to the commitment view I have been urging. The remainder of this essay will be given over to a discussion of Davidson's views on the question of the relation between belief and value to choice behavior. As a preliminary to this discussion, the next two sections will survey some issues concerning the question of deriving probability and utility judgments from choice behavior

that confront the projects of Ramsey (1990), von Neumann and Morgenstern (1947), Savage (1964), Anscombe and Aumann (1963), and Davidson and Suppes (1956).

III

Suppose that agent X is an ideal expected utility maximizer. Let X be confronted with a choice between a pair of options G_1 and G_2 such that if G_1 is realized and S is true, X receives \$1 and if S is false when G_1 is realized, X receives nothing. If G_2 is realized while S is true, X receives nothing and if G_2 is realized and S is false, X receives a dollar. The suppositions constituting decision problem #1 are summarized in table 1:

TABLE 1
Decision Problem #1

	S	~S
G_1	\$1	\$0
G_2	\$0	\$1

X might, in the situation, choose G_1 over G_2 or the other way around. In the first case, X is reasonably understood to judge G_1 at least as good as G_2. In the second, G_2 is judged at least as good as G_1. X's choice reveals something about X's preferences for these two options.[1] Because X cannot choose both G_1 over G_2 and G_2 over G_1, X's choice behavior cannot in this way reveal equipreference or indifference between these two options. The problem of how to disentangle both equipreference and strict preference from weak preference by appealing to choice behavior is a topic on which Davidson had written in collaboration with Marshak (Davidson and Marshak, 1959). It is not clear to me that the stochastic approach adopted by Davidson at that time or any other method of revealing equipreference by what might pass as publicly observable choice behavior will prove entirely satisfactory or superior to verbal expression of equipreference. In any case, I shall suppose that we can somehow empirically identify equipreference in terms of choice or linguistic behavior.

Suppose that X displays indifference between G_1 and G_2 when confronted with decision problem #1. From this information about X's choice behavior

and on the assumption (a) that X is maximizing expected utility, it is tempting to conclude that X is committed to judging S and ~S to be equally probable so that both states carry a probability of 0.5.

Such a conclusion would be too hasty. For example, we need to ascertain that X is not the kind of ascetic who is indifferent between winning a dollar and winning nothing. More precisely, we need to determine whether (b) the value to X of receiving $1 when S is true (false) is greater than the value to X of receiving $0 when S is true (false). Otherwise, we could not draw the conclusion that X's belief probability that S equals 0.5.

But even with assumption (b) in place, we also need the following assumption:

(c) *Probabilistic Independence of States on Acts*: X's subjective probability judgment that S conditional on G_1 is equal to the unconditional probability of S_1.

Finally, we need an assumption of the following kind:

(d) *State Independent Utility of Consequences*: (i) The value or utility of receiving $1 when the true state is S and the option chosen is G_1 is the same as the value or utility of receiving $1 when the true state is ~S and (ii) the option chosen is G_2 and the value of receiving nothing when G_1 is implemented and S is false is the same as the value of receiving nothing when G_2 is implemented and S is true.

Given these assumptions, we will have obtained information about X's subjective probabilities or degrees of belief from information about his choice behavior. The fact that we need assumptions such as (b) through (d) is not itself a difficulty. The question that needs to be settled is how to check whether the conditions specified by these assumptions obtain. In particular, can we discharge the three assumptions just listed for assumptions that are plausibly construed as claims about X's choice behavior?

We cannot do so if we focus exclusively on decision problem #1. Presumably we need to consider information about how X has or will choose in other contexts of choice X has or will face or how X would have chosen in contexts of choice X might have faced. When agent X faces decision problem #1, X is assumed to have commitments as to how options in other decision problems that X does not currently face and may not ever face should be evaluated.

This way of thinking is quite common. According to textbook accounts of consumers who decide which of a set of alternative commodity bundles to purchase, the consumer's options are restricted by the relative prices of the

commodities and the consumer's income—that is, by the consumer's budget. The consumer should, if he or she is rational, choose a commodity bundle that he or she most prefers from among the options allowed by the consumer's budget. In exploring the consumer's choice behavior at the time, we want to know not only what the consumer's purchases given his actual budget but also what the consumer commitments or dispositions to choose are in a wide variety of choice situations. Given information about such dispositions, we can then judge how the consumer would choose on various alternative suppositions about the relative prices and the consumer's wealth—that is to say, on various belief contravening suppositions about the consumer's budget. This type of information is representable by a function from sets of options available to the consumer given a budget (prices and income). If the function meets appropriate conditions, it can be used to define a weak ordering over all the commodity bundles that are options according to some budget or other.

It is tempting to call this weak ordering a representation of the consumer's preferences for the commodity bundles. This, in effect, is how matters are seen when the function is represented by an indifference map and budget lines. I have no objection to this way of speaking; but it is worthwhile pointing to an ambiguity in the interpretation of "preference" here that might on some occasions generate misunderstanding.

The rational consumer selects the commodity bundle the consumer most prefers from those available to him. But the indifference map tells us that there are commodity bundles the consumer prefers more than the one the consumer chooses.

Keep in mind, however, the consumer is convinced that he or she has no control over the acquisition of bundles unavailable given his or her budgetary constraints and, indeed, may be certain that he or she will not acquire that bundle. If the proposition representing the consumer's acquisition of such a bundle is inconsistent with the consumer's background information, that proposition does not represent an object of preference for the agent in the sense in which the agent, if rational, seeks an option the agent most prefers. This means that the preference ranking among option propositions whose truth is possible relative to what the consumer fully believes cannot be the same as the preference ranking represented by the indifference map. The indifference map represents a preference ranking over *potential options*. That is to say, the consumer whose attitudes are represented by the indifference map is claimed to have propensities to choose such that for any subset O of the set of potential options A, the subset $C(O)$ of optimal or most preferred options in O is defined relative to a preference ordering that is a restriction of the preference ranking over the potential options in A. These propensities to choose are preferences over A that consumer has in the setting of the decision problem the consumer is actually facing where the prices have been fixed and

the consumer's income is given. Not all options in **A** are available to the consumer. However, the consumer's propensity to choose is relevant to the choice the consumer actually faces. Given the range of commodity bundles accessible to the consumer according to the prices and the consumer's income, the preference over the options actually faced is a restriction of the preference ranking over **A**.

The indifference map is the paradigmatic characterization of a fragment of choice behavior. It specifies a weak ordering of propositions belonging to a set **A** of *potential* option propositions from which the decision maker's preferences for the options that agent actually confronts may be read off. The theories of decision making formulated by Ramsey, von Neumann and Morgenstern, Savage, Anscombe and Aumann, and Davidson and Suppes among many others all proceed by identifying a set **A** of potential option-propositions for which there is a preference. Given the preference ranking of the members of this set and given that the set of options actually available to the decision maker X is a subset of **A**, the preference among options actually faced is taken to be a restriction of the preference over **A** to the set of options actually available.

The important point to appreciate here is that the set **A** of potential options is identified in a manner that allows the probabilities and utilities needed to compute the expected utilities for the options actually available to the agent to be derived from the preference over **A** even though these probabilities and utilities cannot be derived from the preference over the subset of the potential options constituting the options actually available to the agent. At least that is the ambition of approaches like that of Ramsey, Savage, Anscombe and Aumann, and Davidson, Suppes et al. We can use decision problem #1 to provide an illustration and sketch of how the space of potential options used as the measuring apparatus for this purpose may be constructed from information about the decision problem actually faced.

In the context of decision problem #1, agent X is taken to have preferences over a set **A** of potential options or acts that include as members G_1 and G_2. Strictly speaking agent X faces only the two options G_1 and G_2. But the decision problem has extra structure. Let \underline{K} be a linguistic representation of X's state of full belief by a set of sentences closed under logical consequence. In decision problem #1, X's \underline{K} has the following properties:

(1) the logical consequences of \underline{K} and the information that G_1 is true and that S is true include that X receives \$1. The logical consequences of \underline{K} and the information that G_1 and ~S are both true include that X receives nothing.

(2) the logical consequences of \underline{K} and the information that G_2 and S are

true include that X receives nothing and the logical consequences of \underline{K} and the information that G_2 and ~S are both true include that X receives $1.

We may suppose for concreteness that G_1 is the proposition that X rings the bell and G_2 is the proposition that X presses the buzzer. They are not truth functional compounds of the propositions representing states (namely, S and ~S) and those representing consequences (that X receives $1, that X receives nothing). Nor are they constructed from these propositions by using causal connectives. However, since \underline{K} implies that either G_1 or G_2 is true (X is certain that X will either ring the bell or press the buzzer), \underline{K} entails that G_1 is equivalent in truth value with the disjunction of the proposition that X receives $1 when S is true and the proposition that X receives nothing when S is false. G_2 is equivalent in truth value with the disjunction of the proposition that X receives nothing when S is true and the proposition that X receives a dollar when S is false.

The other elements of **A** are not options that X is actually facing. Indeed, X is certain that the propositions asserting that they are implemented are all false. However, revising \underline{K} so that it becomes \underline{K}' relative to which all elements of **A** become consistent with \underline{K} (while remaining pairwise exclusive) yields the result that each element of **A** is equivalent given \underline{K}' with a disjunction where one of the disjuncts is a proposition that is a conjunction of S with a member of a certain stock of payoffs and the other is a conjunction of ~S with a member of the same stock of payoffs.

The agent X is not in a belief state \underline{K}' and may never be in such a belief state. As is the case with consumer demand, the set **A** of potential options is a product of a controlled fantasy. The options in the fantasy are constructed in a specific manner so that X's preferences among the potential options genuinely reflect X's commitments (or dispositions) to make choices when various subsets of **A** constitute the space of available options. If it can be ascertained how X would choose were he to face finite subsets of **A** as options, information could be ascertained that would shed light on X's probability and utility judgments in decision problem #1—the decision problem X actually does face. Not only would the equipreference between G_1 and G_2 be revealed; but so might the correctness of assumptions (b) to (d). We can look upon the preference ranking over **A** in the controlled fantasy as characterizing X's dispositions to choose among elements of finite subsets of **A** in contexts where the members of these subsets constitute the options available to X. X need never actually face such opportunities for making choices and, if and when X does, X's preferences (dispositions to choose) may have changed. But as long as we assume that X's dispositions to choose remain fixed, attempting to ascertain what they are and, hence, what X's

preference ranking over **A** is may enable us to determine what X's probability and utility judgments are for a certain class of propositions. In this sense, probabilities and utilities may be derived from choice behavior.

For which set of propositions did Ramsey assign probabilities and for which set of propositions did he assign utilities on the basis of the preference ranking over **A**?

Ramsey proposed to start with a set of potential options where, in general, if an option proposition is realized (if the option is implemented), the consequences that are of interest to the decision maker are a function of which of a finite set of exclusive and exhaustive hypotheses is true. Decision problem #1 illustrates a decision problem of this kind. By identifying the preference over the potential options, Ramsey sought to derive probabilities for the states (he called them "propositions") and utilities for the consequences (he called them "possible worlds") for each potential option so that the ranking of the potential options becomes a ranking with respect to expected utility.

There are many approaches taken to constructing **A**.[2] A common method is to start with a finite set **S** of propositions that count as states. These are the propositions for which probabilities conditional on the choice of options are sought. In our example, it is enough to consider S and ~S. In addition, a set **C** of consequence propositions is specified. Ramsey took this set to be infinite and, indeed, nondenumerable. Davidson and Suppes who followed Ramsey's approach fairly closely departed from it in this respect by keeping the consequences finite. Anscombe and Aumann also allowed for using finite consequence sets. But they were prepared to enlarge **C** to a noncountable set **L** of roulette lotteries whose payoffs are described by propositions in **C**.[3] Davidson and Suppes would have judged the Anscombe and Aumann approach to be of limited applicability because of the use of objective probabilities in roulette lotteries. However, the approach has several advantages for expository purposes and the questionable aspects of the approach will not prove relevant to the issues I propose to consider or do injustice to those aspects of Davidson's ideas I discuss. With this understood, we may then extend the pair {G_1, G_2} to a set **A** consisting of (1) the elements of **C** consisting of X's receiving \$1 and receiving nothing, (2) the set of roulette lotteries or mixtures **L** of these monetary payments, (3) all options representable by specifying a payoff in **C** or **L** for each state in **S**, and (4) all mixtures of items listed under (1), (2), and (3).

Recall that the challenge is to derive information about X's probability and utility judgments from information about X's choice behavior—that is to say, from the dispositions to choose that X has or is committed to have. As this problem is posed, it asks what X's preferences are not for the options X actually is facing in a given deliberation but for potential options in **A** that

include the options X actually has. The preference ordering whatever it might be is assumed to rank potential options according to expected utility.

To call these propositions potential option propositions is not to place them in some ontological limbo. It is merely to suggest that X's preference ordering is to be regarded as a multitrack disposition. Here the initiating conditions are opportunities for choosing that one of a subset (the set of available options) of the set of potential option propositions be true. (I suppose the subset of available options to be finite.) The outcome is a verdict as to what subset of members of the set of available options are to be admissible for choice. In this setting, I am assuming that admissible for choice is to be optimal in the choice set. The so-called "choice function" from input specifications of sets of available options to sets of admissible options represents the preference ordering as a multitrack disposition. The revealed preference thereby represented is then to be understood as an actual dispositional property of the agent.

Given these preferences X is supposed to be in a position to derive the probabilities assigned to members of S conditional on the choice of potential options from A and utilities for conjunctions of members of S and L that characterize results of implementing members of A pertinent to computing the expected utilities.

In our toy example, we are seeking to derive X's unconditional credal probabilities for S and ~S and X's utilities for receiving a dollar (nothing) when S is true (false). Given X's equipreference for the two options in decision problem #1, we can say that expected utility maximizer X assigns utility 1 to receiving $1 and 0 to receiving nothing and unconditional probability 0.5 to both S and ~S on assumptions (b) to (d). If we can state assumptions (b) to (d) so that they are constraints on the preferences over the set A, X's probability and utility judgments will have been derived from information about X's choice behavior.

Thus, methods for deriving information about X's probability and utility judgment from information about choice behavior have not required that the methods of elicitation to be deployed derive assumptions (b), (c), and (d) in decision problem #1 from X's preferences for the options actually available in decision problem #1. For example, since C consists of the two consequences represented by the propositions that X receives $1 and that X receives nothing, the set L consists of roulette lotteries over these two pure prizes. C and L are subsets of the set A and, hence, preferences over the union of these sets is part of the "data". Appeal can be made to information about X's preferences over L as well as information X's preferences relating G_1 and G_2 to each other and other potential options. The challenge now is to show, if it is possible to do so, that assumptions (b) to (d) are, indeed, claims about choice behavior in the sense just sketched. I do not believe this can be done.

IV

We can, to be sure, make some headway. We can state that X's receiving $1 for certain is better than X's receiving nothing for certain. Indeed, we might even try to check this out by offering X a dollar on a take it or leave it basis. As long as we can assume that X's preferences for the potential options is the same when this choice is offered as it was in decision problem #1, we have a check on X's preferences for what these propensities to choose were in the context of decision problem #1.

The preference ranking includes more than thus far mentioned. A includes propositions representable by any function from S to L. Moreover, the postulates for rationality constraining the preferences include constraints that allow us to say that X prefers a dollar when S is true (false) over receiving nothing when S is true (false) if and only if X prefers a dollar for sure over receiving nothing for certain.[4] Hence, we can represent assumption (b) by the claim that X prefers a dollar for certain to receiving nothing for certain and the method for checking whether X prefers a dollar to nothing will serve to check assumption (b).

Notice that assumption (b) is not a condition of rationality and nobody pretends that it is.

Let us now turn to assumption (c). It is well known that if states are probabilistically independent of acts in A, then whenever we are given two options a and b in A such that a is strictly preferred to b in every state, a is strictly preferred to b.

If we assume that any pair of acts that are representable as the same function from states to roulette lotteries over consequences are equipreferred, then the converse also holds.[5] If a is strictly preferred to b whenever a is strictly preferred to b in every state, acts are probabilistically independent of states. So we have a way of expressing the assumption (b) that states are probabilistically independent of acts in terms of preferences among elements of A.

Of course, for this method to be legitimate, we need to explain what it is for a potential option a to be strictly preferred to option b in a given state. To insure this, we need to invoke further postulates expressing some variant of the so-called "sure thing principle" to which advocates of the expected utility principle subscribe.

This approach to elicitation suffers from a serious limitation. Elicitation of probabilities and utilities from preferences among options is restricted to cases where options can be represented as functions from states to consequences or in some variant of this form. It is doubtful whether such representations are always available so that the method of elicitation lacks universal applicability. This does not itself imply a limitation on the applicability of the

principle of expected utility maximization. It can be formulated in a most general way (as, for example, P. Fishburn 1964 proposed). What is open to question is whether there is a uniform way to derive a Bayes-rational decision maker's probabilities and utilities from the decision maker's propensity to choose. No matter, however, how this question is settled, it is possible to formulate assumption (c) as a condition X's propensity to choose among options in **A** where this set of potential options is generated from information about X's current decision problem of a certain time.

Thus, given the assumption (a) that agent X is an expected utility maximizer and that X confronts decision problem #1 whose options G_1 and G_2 are evaluated in agreement with a preference ranking over a set **A** generated in a manner similar to the one outlined above, assumptions (b) and (c) can be expressed as conditions on the preference ranking over **A** on the basis of which probability and utility judgments are derived. Assumption (d), however, cannot be expressed so readily in terms of such preferences.

<div align="center">V</div>

Assumption (d) involves an evaluation on X's part of propositions that are conjunctions of states in **S** and elements of **L**. It asserts that the value of a dollar (nothing) is the same when S is true and when S is false. This assumption cannot be represented by a constraint on the preference ranking over **A**. This can be seen fairly quickly by supplying propositional contents for the states S and ~S in decision problem #1.

S asserts that the exchange rate for buying pounds sterling with dollars is one pound for $1.25. ~S asserts that the exchange rate is one pound for $1.50.

In decision problem #1, the payoffs are in dollars. There may be agents for whom a dollar is worth the same regardless of the exchange rate with sterling. Such agents would satisfy assumption (c). Indifference between G_1 and G_2 would imply that such agents assign equal subjective probability to S and ~S. But suppose that the agent X judged a dollar at the higher exchange rate (when S is false) to be worth less than at the lower exchange rate. Then if X is indifferent between the two options, X would judge S more probable than ~S. Equipreference between the two options cannot reveal which type of judgment is appropriate. The important and interesting point is that embedding the options G_1 and G_2 in the larger set **A** constructed as above cannot differentiate the two cases in terms of differences in the preferences over the larger set. So-called "constant acts" (acts for which the payoff is the same in all states) need not be constant in utility and there is no way to impose the assumption that they should be as a condition on the preferences over **A**.[6]

A casualty of this observation is a common exaggeration of the genuine

achievement of the approaches of Savage, Anscombe and Aumann, or Ramsey to measuring probability and utility. It is alleged that one can derive from revealed preference among potential options in a suitably specified set **A** an unconditional probability measure over states and a utility measure over consequences (and roulette lotteries) such that the expected utility ordering of potential options agrees with the preference ranking of these options, the probability is unique and the utility is unique up to a positive affine transformation. This claim is false. What is true is that there is a set of unconditional probability-*state independent* utility pairs representing the preference ranking where the probability is unique and the utility is unique up to a positive affine transformation. But there are other probability-utility pairs that represent the preference ranking just as well where the utilities are not state independent.[7]

Assumption (d) cannot be understood as a condition on preferences over the set of potential options **A** unless this set is extended to include as potential options choosing true that X receives \$1 when S is true, that X receives \$1 when S is false, that X receives nothing when S is true and that X receives nothing when S is false. Propositions constructed as conjunctions of state-consequence pairs are not taken to be potential options in the preference rankings deployed by Ramsey, Savage, Anscombe and Aumann, or Davidson and Suppes. That this is so is a fact of intellectual history. There are, however, serious obstacles to circumventing tradition.

Consider the following decision problems:

> *Decision Problem #2*: The decision maker faces a choice between receiving a dollar when S is true (option \$1&S) and receiving a dollar when S is false (option \$1&~S).
>
> *Decision Problem #3*: The decision maker faces a choice between receiving nothing when S is true (option \$0&S) and receiving nothing when S is false (\$0&~S).

Agent X who confronts decision problem #1 is invited to consider how X judges X should choose if confronted with one of these pairwise choices. In order for X's responses to be relevant to determining the correctness or incorrectness of condition (c) for decision problem #1, X's preferences for the act-consequence pairs \$1&S and \$1&~S in decision problem #1 are not altered when X considers the same propositions as options in decision problem #2. And the unconditional probability assignments to S and ~S appropriate in decision problem #1 must apply in the hypothesized setting of decision problem #2. Similar remarks should apply *mutatis mutandis* with respect to propositions \$0&S and \$1&~S and decision problem #3. The options faced in decision problems #2 and #3 must be added to the potential options in the set **A** constructed previously from G_1, G_2, and states S and ~S and the prizes of receiving \$1 and receiving nothing.

Observe, however, that these options cannot be represented as determining the prizes or lotteries on prizes conditional on whether S or ~S holds. In decision problem #2, for example, the option of receiving a dollar when S is true presupposes that the decision maker X has control over whether S is true or is false. The options are no longer representable given the informational available as functions from the states S and ~S to payoffs.

This circumstance would not constitute a serious objection to considering the choice between the options in decision problem #2 were it the case that a scenario (no matter how fantastic) in which X faces decision problem #2 could be envisaged coherently that holds fixed (1) the unconditional probabilities assigned to S and ~S, (2) the unconditional utilities assigned to receiving $1 and to receiving $0 and (3) the preferences over the potential options in the original set A. We might then consider transferring conclusions reached concerning decision problems #2 and #3 to decision problem #1.

Suppose then that in considering decision problems #2 and #3, X declares indifference between $1&S and $1&~S in decision problem #2 and indifference between $0&S and $0&~S in decision problem #3. This indifference by hypothesis carries over to decision problem #1 and insures assumption (d). As a consequence, X is committed in decision problems #1, #2, and #3 to assigning S an *unconditional* probability of 0.5. This means, however, that in decision problem #2, $1&S and 1~S receive unconditional probability of 0.5 and the same holds for $0&S and $0&~S in decision problem #3.

The important point to notice here is that in decision problems #2 and #3, the options carry unconditional probability and must do so given that they are embedded in the same preference ranking of potential options as are the options in decision problem #1. But when a decision maker X is deliberating about the options X judges available to him or her in a hypothetical opportunity for choice, X cannot coherently assign unconditional probabilities to the options judged to be available. Deliberation as to what to do precludes prediction as to what will be done (Balch 1974, Spohn 1976, 1977, Levi 1993). I shall elaborate further on this thesis in section IX.

If deliberation crowds out prediction, it is incoherent to include the options of decision problems #2 and #3 in a set of potential options including decision problem #1. And, if that is so, there can be no coherent way to endorse assumption (d) in terms of preferences over potential options understood as including conjunctions of states and consequences.

Karni, Schmeidler, and Vind (1983) and Karni (1985) suggested another way of expressing assumption (d): The proposal is explained with clarity by Schervish, Seidenfeld, and Kadane (1990). It has three elements:

(1) Instead of adding a new set of options to the potential options countenanced by Savage or by Anscombe and Aumann in the set **A**, the

preference ranking for **A** representing X's propensity to choose among subsets of the potential options is supplemented by additional rankings of the same set of potential options representing different judgments concerning what X's propensity to choose would be for various stipulations about X's probability distribution for the states in **S**. In particular, the data now include information about X's preferences over **A** on the supposition that s is true for each s in **S**.

(2) X is also supposed to be able to register cross fantasy comparisons between potential options according to the actual preference ranking of **A** and the many hypothetical rankings. For example, X is invited to pass judgment as to whether X would be indifferent between receiving a dollar from G_1 were X certain that S is true and receiving a dollar from G_2 were X certain that S is false.

(3) The cross fantasy comparisons are subjected to a consistency condition. In decision problem #1, for example, X should prefer G_1 to G_2 conditional on being certain that S is true if and only if X should prefer G_1^* to G_2^* in the actual preference ranking where G_1^* has the same payoffs as G_1 when S is true and G_2^* has the same payoff as G_2 when S is true but G_1^* and G_2^* share the same payoff when S is false. The comparison between G_1 and G_2 is a hypothetical preference on the supposition that payoffs when S is false can be ignored because the possibility that S is true has been ruled out for certain. The comparison between G_1^* and G_2^* in the actual preference ranking allows payoffs when S is false to be ignored because they are the same no matter which option is chosen. The condition proposed by Schervish, Seidenfeld, and Kadane (1990) states requires the correspondence between the two comparisons. They simplify the proposals made earlier by Karni, Schmeidler, and Vind.[8]

Use of cross fantasy comparisons allows for the formulation of assumption (d) or its negation at the expense of abandoning attempts to derive probabilities of states and utilities of consequences from choice behavior in the sense in which Ramsey, Savage, Davidson and Suppes, and Anscombe and Aumann sought to do. Even though the classical project of deriving probabilities and utilities from preferences over potential options involves registering preferences among potential options in controlled fantasy, such fantasies were restricted to cases where the unconditional probabilities on the states and the utilities on the consequences remain unchanged from what they are in the problem under consideration.

The cross fantasy comparisons involved in the method of elicitation proposed by Karni, Schmeidler and Vind calls for information about X's propensity to choose under conditions where X's full beliefs have been altered so that X becomes certain as to which state is true and to comparing that

propensity to choose with the propensity to choose is the one that X currently has. I do not object to the cross fantasy comparisons. They can be illuminating and suggestive. But we should be clear how far removed from the ambitions of those who sought to build on standard revealed preference theory.

Let us sum up where we have gotten thus far. Two approaches are entertainable on the assumption that deliberation crowds out prediction.

One can retain the ambition to derive probabilities and utilities from revealed preference over potential options and admit that the difference between adopting a state independent utility function and a probability of 0.5 for decision problem #1 and adopting a state dependent utility function and a probability different from 0.5 (there are uncountably infinite many ways to do this) is comparable to measuring length in meters and in yards. There is no "fact of the matter".

One can abandon the behaviorist ambition and concede that such derivations as can be achieved must appeal to information additional to current propensities to choose just as the proposal made by Karni, Schmeidler, and Vind does. The difference between versions of decision problem #1 where utilities for dollars are and are not state independent become "facts of the matter".

Of course, one can also deny that deliberation crowds out prediction, insist that it is coherent to assign unconditional probabilities to options and claim that state-consequence pairs can be included in the master preference ranking used for elicitation.

Such an approach is favored by R. C. Jeffrey (1965) who abandons the project of eliciting probability and utility judgments from preferences among the potential option propositions derived from the available options in a given context of choice in favor of a derivation of probabilities and utilities from a preference defined over all consistent propositions in a sufficiently rich conceptual space.

In contrast to the approaches of Ramsey, Savage, Anscombe-Aumann, Davidson-Suppes, et al., but like the approach of Karni, Schmeidler, and Vind, Jeffrey's approach allows for the expression of assumption (d) and for distinguishing state dependent from state independent utility.

But Jeffrey's approach has two features absent from the proposal of Karni, Schmeidler and Vind: (A) Jeffrey's theory does not allow for the expression of the assumption that agent X judges two propositions to be probabilistically independent and (B) as just noted, option propositions bear unconditional probabilities.

(A) Unlike the approaches of Ramsey, et al., Jeffrey's theory does not provide for expression of assumption (c) specifying the probabilistic independence of states from acts. Indeed, it is a property of Jeffrey's theory that a preference ranking over consistent propositions does not, in general,

secure a unique probability and that *at most* one probability can occur in a probability utility pair that assures probabilistic independence of S from the G_1's. There will be others that do not.[9] Consequently, even if we adopt assumption (c) for decision problem #1 according to one probability-utility pair representing the preference ranking of propositions, we cannot express assumption (c) within the framework of the theory and derive an assignment of 0.5 as the probability that S is true. At best, we can say that among the probability-utility pairs that represent the preference among propositions is a pair where the unconditional probability that S is 0.5. but there are other probability-utility pairs where the probability that S differs from 0.5 and these representations cannot be distinguished by the preference ranking among propositions. Either there is no fact of the matter as to whether the propositions in question are probabilistically independent as in the case of choosing between meters and feet or the information about preferences among propositions or sentences gives us incomplete information.

(B) Jeffrey's approach requires that the options available in a given decision problem be assigned unconditional probabilities.

Are these two features of Jeffrey's theory objectionable or not? In my judgment, any proposal that denies that there is a fact of the matter as to whether a pair of propositions are judged to be probabilistically independent is seriously defective. I also think that assigning unconditional probabilities to option propositions is objectionable. But in this essay, we are concerned with what Davidson thinks. In recent years, Davidson has exploited Jeffrey's proposal as a means to unify decision theory with his theory of meaning. In section VIII, the ramifications of his approach for feature (A) of Jeffrey's theory will be discussed. Section IX will focus on feature (B).

VI

The issues surveyed all too briefly in sections III through V concern a specific problem. Given suitable information about an expected utility maximizer's dispositions to choose (also known as "preferences") among options, can an interpreter of the behavior of such a maximizer disentangle the beliefs or probability judgments and the values or utility judgments that rationalize the decision maker's preferences on the assumption that the agent is, indeed, an expected utility maximizer?

This problem is explicitly discussed in the collaborations of Davidson with Suppes and others in the 1950s and credit is given to F. P. Ramsey for having shown the way to disentangle probability from utility. As late as 1976, Davidson continued to acknowledge Ramsey as being the first to "put

conditions on preferences between wagers while making no untestable assumptions about probabilities or utilities, and he outlined a method for testing the theory experimentally" (Davidson, 1980a, ch. 14, p. 270). He declared that "Ramsey had solved the problem of disentangling the roles of subjective probability and utility—of belief and desire—in decision making under uncertainty" (p. 270).

If Davidson's claim were true, Ramsey would have overcome the difficulties faced in examining decision problem #1. Ramsey did not overcome these difficulties. Nor did he, as far as I can make out, really pretend to have succeeded in doing so. It may be instructive here to consider what Ramsey actually said and compare it with what Davidson and his colleagues took him to be saying. I am not concerned here with the possible misreading that is involved. The confusion involved in the misreading has been widespread and is to some very considerable degree responsible for the longstanding neglect of the problem of state dependent utility found not only in the work of Davidson and his colleagues but also in the writings of Savage and Anscombe and Aumann.

Ramsey himself, however, did explicitly worry about state dependent utility. Ramsey acknowledged that prior to eliciting utilities and probabilities from preferences among options where payoffs are contingent on the truth of state propositions (propositions "which are used as conditions in the options offered") there was a difficulty to be dealt with:

> the propositions . . . which are used as conditions in the options offered may be such that their truth or falsity is an object of desire to the subject. This will be found to complicate the problem, and we have to assume that there are propositions for which this is not the case, which we shall call ethically neutral. (Ramsey, 1990, p. 73)

Ramsey offered a more precise definition in terms of Wittgenstein's tractarian theory of propositions but suggested that equivalent definitions probably could be given in terms of any other theory. It will not, however, be useful to attempt such formal precision; for it is clear that Ramsey's idea requires evaluation of what were called conjunctions of state-consequence pairs in section 3 as in Jeffrey's theory or resort to ideas of Karni, Schmeidler, and Vind. To embrace either approach is a clear departure from the ideas of Ramsey, Savage, or Davidson and Suppes.

Finally, Ramsey himself does not even pretend that his characterization of ethically neutral propositions is explicable in terms of preferences among options or potential options. To the contrary, he introduces the idea as a necessary concession to nonbehaviorist approaches. In point of fact, he does not declare that he has "begun" his effort to derive probabilities and utilities

from choice until he already has the notion of an ethically neutral proposition.

Having given himself the notion of an ethically neutral proposition, Ramsey goes on to assert that an ethically neutral proposition H carries unconditional subjective probability 0.5 if and only if given consequence propositions c and d such that c is strictly preferred to d, option F_1 paying c if H is true and d if H is false is equipreferred to option F_2 paying d if H is true and c if H is false.

Ramsey postulates the existence of an ethically neutral proposition and deploys it to derive a measure of utility over consequences from preferences among options. The difficulty with Ramsey's approach arises when he seeks to use the utility function just obtained to define the subjective probability of a proposition or condition as the fair betting rate for that proposition (p. 75).

Decision problem #1 illustrates that Ramsey's necessary concession does not get him past the problem of state dependent utility. The states S and ~S are not ethically neutral propositions and given their interpretation as specifications of exchange rates, they could not be. But Ramsey rightly did not restrict his definition of subjective probability to ethically neutral propositions. Unfortunately for Ramsey's definition, it presupposes the very state independent utility assumption enshrined in assumption (d) for decision problem #1 that has proven so vexing. If assumption (d) cannot be coherently expressed as a preference among potential options, Ramsey's necessary concession has failed to be sufficient to achieve the separation of probability and utility that was sought.

Davidson and Suppes and their associates postulate the existence of an event E* such that, for every c and d, two options such that one pays c when E* is true and d when it is false whereas the other pays d when E* is true and c when it is false are invariably equipreferred. They also assume that there is at least one pair of consequences c and d such that c is strictly preferred to d (Davidson, Suppes, Siegel, 1957, p. 13). Clearly state S cannot qualify as such an event E*. In virtue of decision problem #1 and the interpretation of S and ~S as exchange rates, letting c be a payoff in one pound sterling and d be nothing as before, cannot guarantee equipreference.

Suppose, however, that there is such a proposition E*. Davidson, Suppes, and Siegel assume that for expected utility maximizers, it will carry a subjective probability of 0.5. But it should by now be clear that this is a fallacy. Davidson, Suppes, and Siegel, like Savage and Anscombe and Aumann presuppose that the same payoffs carry the same utility in different states. They have no warrant for doing so if their aim is to derive probabilities for states and utilities for consequences from preferences among potential options.

Davidson continued to use this understanding of Ramsey's device in 1974

and endorsed it without explicitly using it as late as 1976. Around 1978, Davidson abandoned his endorsement of Ramsey's approach to separating probability and utility.

VII

I have been considering obstacles in the way of using information about preference for act or option propositions to derive judgments about probability and utility. Davidson had admired and endorsed Ramsey's project for using preferences revealed by choice to identify the probability and utility judgments motivating the choice.

Davidson thought Ramsey's program could be extended so as to illuminate the theory of meaning. According to Davidson, not only do beliefs and desires motivate the choices of rational agents and, hence, their revealed preferences; but the beliefs of rational agents together with the meanings they assign to the sentences they use to communicate their beliefs motivate the sentences to which they assent or hold true. Davidson closes his "Psychology as Philosophy" written in 1974 with the suggestion that a "theory of communication" should be incorporated into "decision theory" (Davidson, 1980a, ch. 12, p. 237ff). In the brief elaboration of his point offered in that essay, it becomes clear that he sees the problem of disentangling belief and meaning from data concerning acts of assertion as parallel to and implicated in the problem of separating utility and probability judgment.

In a paper delivered orally in 1978 but published in 1980, Davidson began pushing the analogy between the problem of separating out the probabilities (beliefs) and utilities (desires) of an agent on the basis of the agent's choice behavior and the problem of separating out the beliefs and the meanings of an agent on the basis of the agent's holdings true of sentences even further. For Davidson, there was more than analogy. Decision theorists seeking to elicit probabilities and utilities from choice behavior often took for granted an interpretation of the decision maker's activities as choosing that one proposition be true rather than others that also represented options in the given context of choice. Preference, that is to say, revealed preference, was regarded as a relation between propositions—the potential option propositions discussed previously.

> a Bayesian decision theory of the sort I have been discussing is open to the criticism that it presupposes that we can identify the propositions to which attitudes like belief and desire (or preference) are directed. But our ability to identify, and distinguish among, the propositions an agent entertains is not to be separated from our ability to understand what he says. We generally find out

exactly what someone wants, prefers or believes only by interpreting his speech. This is particularly obvious in the case of decision theory, where the objects of desire are often complex wagers, with outcomes described as contingent on specific events. Clearly, a theory that attempts to elicit the attitudes and beliefs which explain preferences or choices must include a theory of verbal interpretation if it is not to make crippling assumptions. (1980b, pp. 4–5)

Davidson proposed to avoid making crippling assumptions by taking the data of decision theory to be preference among *sentences* without presupposing interpretations of these sentences. Such data could be used to elicit probability judgments and utility judgments that take as "objects" sentences as well. Meanings are to be supplied to the sentences in part by a process of interpretation that looks to the way conditional probabilities that "show what the agent counts as evidence for the application of his more theoretical predicates" (Davidson, 1990, pp. 321–22). But the probabilistic dependencies that promote interpretation are probabilities of uninterpreted sentences. So if these probabilities can be derived (along with utility judgments for sentences) from data from preferences among sentences, Davidson thought the results could serve as a basis for interpreting the sentences held true to varying degrees.

Theory of meaning as I see it, and Bayesian decision theory, are evidently made for each other. Decision theory must be freed from the assumption of an independently determined knowledge of meaning; theory of meaning calls for a theory of degree of belief in order to make serious use of relations of evidential support. But stating these mutual dependencies is not enough, for neither theory can be developed first as the basis for the other. There is no way simply to add one to the other since in order to get started each requires an element drawn from the other. What is wanted is a unified theory that yields degree of belief, utilities on an interval scale, and an interpretation of speech without assuming any of them. (1980b, p. 8)

This idea of taking as the basic datum of decision theory the preferring true of one sentence rather than another has continued to be the basis of Davidson's effort to illuminate how probability judgment, utility judgment and meaning can be elicited by a single type of datum (see Davidson, 1990, p. 322).

Davidson already noticed in 1974 the parallels between separating probability and utility on the basis of revealed preference among options and separating belief and meaning in terms of holdings true or dispositions to assent, but at that point gave no hint that he found anything unsatisfactory in Ramsey's approach to separating probability and utility that would warrant replacing it. By 1978, Davidson felt obliged to abandon the approach to elicitation pioneered by Ramsey that Davidson himself had initially admired

so much. According to Davidson, there are two difficulties to confront here.

Davidson's program calls for starting with data about preferences among *sentences* from which information about probabilities and utilities may be derived without presupposing anything about the contents of the sentences that are the objects of preferences, probability judgment and utility judgment. Davidson does not deny that preference, probability judgment and utility judgment characterize propositional attitudes. But the data with which he begins yield information about preference for sentences being true without any specific propositional content being conferred on such sentences. Davidson does not think that Ramsey's theory (or, presumably cognate theories of von Neumann and Morgenstern, Savage, Davidson and Suppes, Anscombe and Aumann and others) allow for abstracting away propositional contents of sentences in this fashion.[10]

In his (to my knowledge) latest discussion of the subject, Davidson also raises for the first time (again to my knowledge) worries about state dependent utility of the sort I have sketched in the previous discussion.

> straightforward application of the theory [i.e., Ramsey's theory] depends also on the causing event (the coin coming up heads) having no value, negative or positive in itself. (1990, p. 323)

Davidson thinks that the proposals of R. C. Jeffrey (1965) and E. Bolker (1965, 1966) provide a way to overcome these obstacles and explicitly turned to Jeffrey's theory in 1978. For the purposes of this discussion, it is enough to consider that, according to Jeffrey's theory, probabilities are to be assigned to all propositions in an algebra of propositions and utilities to all consistent propositions in such an algebra and these probabilities and utilities are to be derived from a preference ranking over all consistent propositions in the algebra.

Jeffrey's proposal stands in marked contrast to classical approaches that restrict the data to preferences over a privileged subset **A** of the algebra—the set of potential option propositions. Since **A** is heavily structured according to the classical view, data about preferences among the potential option propositions presupposes a great deal of information that, so Davidson thinks, is not presupposed according to Jeffrey's theory. And because preferences are not restricted to a subset of the algebra of propositions (so that every consistent proposition could be regarded as a potential option proposition in **A** that finds a place in the preference ranking), assumptions like (d) in decision problem #1 can be expressed in terms of preferences among potential option propositions and so can their negations.

In section V, mention was made of two features of Jeffrey's theory I claim are unattractive. (A) Jeffrey's theory does not allow for the expression of the

assumption that agent X judges two propositions to be probabilistically independent and (B) Option propositions bear unconditional probabilities. How does the presence of these features bear on Davidson's attempt to use Jeffrey's theory to develop a unified theory of desire, belief, and meaning?

VIII

The fact that Jeffrey's theory does not allow for deriving a unique probability common to all probability-utility pairs does not, as it stands, seem to be more of a problem for Jeffrey's view than it is for the approaches of Ramsey, Savage, and Anscombe and Aumann. In any case, Davidson does not appear to be distressed by the result.

> These diminutions in determinacy are conceptually and practically appropriate: they amount, among other things, to permitting the same sort of indeterminacy in decision theory that we have come to expect in a theory of linguistic interpretation. Just as you can account for the same data in decision theory using various utility functions by making corresponding changes in the probability function, so you can change the meanings you attribute to a person's words (within limits) provided you make compensating changes in the beliefs you attribute to him. (Davidson, 1990, p. 324, n. 66)

Davidson seems to be suggesting that the selection of a probability-utility pair to represent a preference ranking from all of those that represent that ranking is a matter of convention like choosing between meters and feet to represent length. Davidson's claim regarding the conventionality of such a selection differs from a parallel claim that someone might make on Jeffrey's behalf in one important respect.

If the preference ranking is over propositions rather than sentences, then the choice of a probability-utility pair for propositions from among the many that represent the preference ranking is conventional. If sentences A and B express a pair of propositions that A and that B respectively under a given interpretation of an agent's language, it remains true that given the preference ranking for sentences under that interpretation, it is a matter of conventional choice which of the several representing probability-utility pairs defined over the sentences under the given interpretation (i.e., defined over the propositions) is selected.

If the preference ranking is over sentences, then the interpreter is free to choose by convention any probability-utility pair defined for sentences that represents the preference over sentences. But, if I understand Davidson correctly, that choice also selects an interpretation of the sentences in question in virtue of further data pertaining not only to the decision maker X's preference ranking over the sentences but the interpreter's beliefs and values

and the constraint of the principle of charity.[11] These extra data constrain the set of belief-meaning pairs for sentences and thereby impose restrictions on the set of probability (or belief) components that can figure in the probability-utility pairs for sentences additional to those imposed by the preference ranking over sentences.

Consider now the fact that the preference rankings over sentences or propositions according to Jeffrey's theory imply that if there is a probability-utility pair according to which A and B are probabilistically independent, there is at most one. Moreover, there are noncountably many other pairs representing the same preference ranking according to which A and B are probabilistically dependent.

On the interpretation of Jeffrey's proposal according to which preferences, probabilities, and utilities are defined for propositions, this means that in standard cases there is no "fact of the matter" as to whether agent X judges the propositions that A and that B to be probabilistically independent or not. That is because Jeffrey's proposal so construed assumes that the information establishing the interpretations of the sentences does not reduce the set of probability-utility representations of preference ranking for the sentences in the language from what Jeffrey's theory says it must be.

As I understand Davidson's transformation of Jeffrey's proposal, there may well be a fact of the matter as to whether agent X judges the sentences A and B to be probabilistically independent or not. There is no magic here. Davidson, as just noted, invokes more than the experimental subject X's preferences among sentences. He has the interpreter taking into account his own beliefs and values as well as invoking the principle of charity.

Of course, whether Davidson's idea can be made to work depends on a closer examination of how the "interanimation of sentences" reflected in the extent to which "a speaker counts the truth of one sentence as supporting the truth of others" (Davidson, 1990, p. 321) imposes structure upon preferences between sentences additional to what Jeffrey's theory has to offer. If the structure can be imposed in a plausible way, we can deny that the attribution of a judgment of probabilistic independence or dependence to propositions is a mere matter of convention. Given the specification of contents for sentences A and B, both the probability judgments and the utility judgments are determined just as given the utility function used, the probability judgments and contents are specified.

Davidson's idea that the theory of verbal interpretation and Bayesian decision theory are "made for each other" can thus be seen as pointing to a way of obtaining additional data that can reduce the lack of uniqueness in Jeffrey's approach to representing preferences by probability-utility pairs.

We have already noted that the failures of uniqueness associated with Ramsey, Savage, or Anscombe and Aumann might be remedied by deploying

the proposal of Karni, Schmeidler, and Vind to obtain data additional to that furnished by revealed preference. Davidson, if I understand him correctly, has pointed in another direction in which one might look for additional data to supplement the information about preferences among sentences deployed in Jeffrey's theory.

Thus, Davidson may have found a way to finesse a grave difficulty with Jeffrey's theory: the incapacity of that theory to distinguish between an agent who judges two propositions to be probabilistically independent and an agent who judges them to be probabilistically dependent. At the same time, his approach allows for separating probabilities and utilities. To be sure, the way the objection is finessed makes it clear how far removed Davidson's project is from the problem of eliciting probabilities and utilities from data about choice behavior with which he began. This, of course, parallels the direction away from extreme behaviorism favored by Karni, Schmeidler, and Vind.

Thus far, we have considered only one of the two main anxieties I have registered concerning Davidson's use of Jeffrey's theory. The second concerns the allowance of unconditional probabilities for potential options. In the next section, I shall argue that the second worry raises deeper philosophical concerns.

IX

Davidson's point of view as I explained it in section I claims that bearers of propositional attitudes "subscribe" to principles of rational coherence in the sense that they ought to conform to the requirements of such principles. The "ought" here is one that might be applied to any automaton that is designed either in its entirety or in part to conform to such requirements automatically so that the system's behavior could be explained and predicted by appealing to principles of rationality as general covering laws.

In designing such automata, the designer might wish to construct systems that are not merely coherent but that also meet other desiderata such as having true full beliefs or having full beliefs that are largely true in some sense of "largely". Probability judgments are neither true nor false but one might construct some standard for being "well calibrated" reflecting a sense in which probability judgment is well tuned to reality and utility judgments might reflect some core consensus on values. These ideas are problematic; but I do not want to go deeper into them here. The point is that one might envisage rational automata that meet requirements additional to rational coherence that reflect the idea that we are sufficiently alike that Davidson's principle of charity or some surrogate for it makes sense as part of a methodology for hermeneutics.

Such rational automata ought to conform to principles of rationality in virtue of the fact that some interpreter understands them to be bearers of propositional attitudes. But when they fail to fulfill the requirements of rationality, they are not obliged to take steps to remedy the defects in their design. In this sense, they are not responsible for meeting the demands of rationality.

I do not mean to suggest that Davidson thinks that bearers of propositional attitudes are themselves the product of intelligent design. Such systems may be the product of nature and nurture. Still the normative dimension of Davidson's view focuses almost exclusively on how interpreters of systems having propositional attitudes ought to understand the behavior of such agents. Even when the system interprets its own behavior, it does so from a third-person point of view. Just as Y may seek to predict what X will do from information about X's beliefs, desires and circumstances, X can make predictions about what X will do based on information about X's beliefs, desires, and circumstances.

For this reason, deliberation does not crowd out prediction as I have been insisting because deliberation amounts to nothing more than acting as the result having given beliefs and desires. The principles of rationally coherent belief, probability judgment, utility judgment, and decision have no application in self-critical examination on the part of agents seeking to assess the coherence of their own attitudes.

Rational agents as I understand them are not rational automata.[12] A rational agent is responsible for policing its beliefs and desires and determining what it is to do whereas a rational automaton is not. To avoid inconsistency in full belief, the rational agent X must be in a position to recognize whether the consequences of X's beliefs yield a consistent set. We all know, of course, that no one is logically omniscient. But as a rational agent, X is *committed* to judging the consequences of X's full beliefs to be true without contradiction even if X often fails miserably to fulfill this commitment.

X's responsibilities do not oblige X to do what X cannot do but only to recognize the implications of X's beliefs insofar as X is able. X's commitment to believing the logical consequences of X's beliefs generates other obligations as well. When X recognizes incoherence in these judgments, X is obliged to seek ways and means to remedy the defect. X's doxastic commitments resemble those of a novice monk who has taken a vow of chastity. The novice is committed to remaining chaste even if it is beyond his capacity to do so all the time. To be sure, he ought to do the best he can; but, in addition, he is obliged to improve his capacity. So, too, a rational agent is obliged not only to do the best the agent can with respect to recognizing the logical consequences of what the agent fully believes, but the agent should seek ways and means to do better whether this calls for improved training in logic and

mathematics, the acquisition of prosthetic devices such as sophisticated calculators and other rational automata or therapy to reduce the prospects of psychic disturbance upsetting a cool head (Levi, 1991, ch. 2, p. 7).

In the sense just sketched, a rational agent is committed to fully believing all the logical consequences of what it is committed to fully believing. It is also committed to making coherent judgments of probability and utility and to maximizing expected utility in choosing among the options available to it. To the very limited extent that such undertakings can be fulfilled, agent X must not only conform to the requirements of rational coherence but do so in a way that reflects the undertakings it has made in the way of full belief, probability judgment, and value judgment. If X's doxastic dispositions, for example, are inconsistent, X should modify X's behavior so as to retain those behaviors that are faithful to X's doxastic commitments and remove those that are not. That is to say, a rational agent not only has commitments to be coherent in its attitudes but, because of its responsibility as a self-critical agent, when a failure of coherence arises, it should make a distinction between behavioral dispositions that avow or fulfill its commitments (commitments to full belief, probability judgment, utility judgment, etc.) And those that purport to do so but fail. Making such a distinction is as much a precondition of being a bearer of propositional attitudes as "subscribing" to the principles of rationality.[13]

From this perspective, the most important application of principles of rationality is as a resource for self-criticism in deliberation.

There is thus an asymmetry between the first-person and third-person points of view. X is committed as a rational agent to fully believing that X fully believes that h if X is committed to fully believing that h. X is not committed to fully believing that Y fully believes that h if Y is committed to fully believing that h. I agree with Davidson among many others that X has no privileged access to whether X is fulfilling X's commitments; but unlike Davidson I suggest that X has special obligation regarding X's commitments.

According to this view, when X deliberates as to what to do in the context of a given decision problem, X seeks to use the principles of rationality to assess the coherence of X's attitudes and of X's assessments of the admissibility of options given such attitudes. X may fail to do an adequate job and, as a consequence, violate the canons of rationality. On the view I am advocating, principles of rationality are to be used to assess how well performance conforms with commitment.

To apply principles of rationality in this exercise in self-criticism, X must be informed as to what X's options are, what the probable consequences of their exercise are, and the values of such consequences so as to be in a position to assess their expected values and order them. To the extent that lack

of logical competence due to limitations of computational capacity, emotional instability, noise from the environment, etc. limit capacity to obtain and process such information with sufficient precision to render a clear verdict concerning the problem X is facing, X will find the principles inapplicable. But in many cases, X will have sufficient resources to bring the principles to bear with sufficient accuracy to confront the requirements of the problem. X does not have to fulfill X's commitments fully in order to fulfill them sufficiently to solve the problem being faced.

Suppose that in addition to having the requisite information as sketched above, X were also convinced when attempting to apply the principles of rationality that X will choose rationally. At the point at which X has the information available to evaluate X's options and identify the admissible or optimal options, X will presumably have sufficient capacity to draw the implications of the assumption of his rationality and become certain that only admissible options are available to X. X will be certain that X will not choose a suboptimal option. But no option that X is certain will not be implemented can be available to X. The only options open to X are the optimal or admissible ones. X can apply the principles of rationality to assess admissible options vacuously but not in order to reduce a set of available options to a proper subset of admissible ones.

As Schick (1979) pointed out, there is no inconsistency in this. At the moment that X is in a position to apply the principles of rationality to the evaluation of X's options, the application must be trivial. All the available options are admissible. According to Schick, there is nothing disturbing here. "No one has a commitment to full self-knowledge" (1979, p. 243).

Schick is advancing here what I take to be a perspective congenial to Davidson's. Principles of rationality are not primarily prescriptions that rational agents use to police their own coherence. As long as agents do not regulate their own deliberations self-critically, nothing prevents their predicting the rationality of their choices.

If principles of rationality are to be applied nontrivially to the self-policing of deliberation, X cannot take for granted that X will choose rationality. Can X assign probabilities short of certainty as to what X will do?

Two kinds of situations may be envisaged. (1) X might assign probabilities as to what X will do because what X will do is the outcome of some stochastic process. Perhaps, X has chosen to implement such a process such as tossing a coin. But then the option chosen is this "mixed" act and not the actions that are the outcomes of the process. (2) X might seek to predict what X will choose. But if probabilistic predictions are to be used in assessing risks, presumably, it is arguable that X should assign probability 1 to X's choosing an admissible option. The applicability of principles of rational

choice in self-policing has once more been trivialized.

I conclude from this that if principles of rational choice have a nonvacuous use as self-critical principles in deliberation, deliberation must crowd out prediction and assigning unconditional probabilities to options is incoherent.

Jeffrey's theory requires option propositions to have unconditional probabilities. I have been suggesting in this section that whether it is an objection to Jeffrey's theory or to Davidson's amendment of it depends on how one stands with respect to a controversy over the type of normativity that is carried by principles of rational choice. My concern here is not to convince Davidson or anyone else that the understanding of the normative dimension of rationality I am advocating is better than the view Davidson advocates. That is a debate for another occasion. I rest content here with suggesting that Davidson seems committed to a view of the normative aspect of rationality that fails to make good sense of the use of principles of rationality as principles of self-criticism in practical deliberation aimed at determining what to do. For those who take this use of such principles seriously as I do, the use of any approach to deriving probabilities and utilities from preference that mandates that the deliberating agent assign unconditional probabilities to the agent's options must be unacceptable.

Even though I am committed to a view of the normativity of rationality that implies that deliberation crowds out prediction, I do not mean to urge abandonment of Davidson's project of giving a unified account of belief, desire, and meaning. I am claiming that Jeffrey's approach to deriving probability and utility from preference even when it is modified in the ingenious manner proposed by Davidson remains unacceptable as a means for realizing Davidson's project because all consistent sentences are assigned unconditional probability.

The roadblocks confronting the strategy that Davidson has suggested for undertaking the project might be circumvented by following a different route. Perhaps, a unified approach to desire, belief, and meaning might be developed within the classical tradition pioneered by Ramsey et al. by borrowing a leaf from the suggestion of Karni, Schmeidler, and Vind. By allowing for cross fantasy comparisons among potential options under a consistency condition that imposes a minimal constraint on how full beliefs or evidence should bear on probability judgment (the condition of confirmational conditionalization mentioned in note 7), an agent's judgments at the time of interrogation concerning how his or her evaluation of options should be altered by the acquisition of certain kinds of information might be exploited to solve the problem of state independent utility. Davidson already seems prepared to interpret an agent's sentences by taking into account how judgments of probability are modified according to the agent's methods for assessing

evidence (Davidson, 1980b, p. 7). So perhaps the adjustments that might accommodate the worries about state independent utility also contribute to the interpretation of the decision maker's sentences.

I have no idea how well this suggestion will work. Interpreters would need to begin with information distinguishing sentences describing (according to the decision maker) options, states, and consequences. Such information will not determine specific contents for such sentences but may impose constraints on what they can be. Nor has a final word been said about the normative dimension of rationality. But Davidson's recognition of the centrality of principles of rationality and especially principles of rational choice to understanding propositional attitudes and his contributions to the appreciation of the interdependence of belief, desire, intentional action, and linguistic behavior place everyone who is interested in these matters in his debt.[14]

ISAAC LEVI

DEPARTMENT OF PHILOSOPHY
COLUMBIA UNIVERSITY
FEBRUARY 1997

NOTES

1. Strictly speaking choosing one option over the other does not reveal a weak preference for the option chosen over the alternative (i.e., that the chosen option is judged at least as good as the other). It is compatible with the choice that the option chosen is not comparable with the other. In that case both options are V-admissible in the sense of Levi, 1986. Davidson does not at any point contemplate the rationality of noncomparability due to unresolved conflict in values. Throughout this discussion, therefore, I shall restrict attention to a rational agent committed to having a system of preferences representable as a weak ordering of his options. Such an agent makes choices that satisfy choice consistency conditions. (See Herzberger 1973 and Sen 1971.) I do not think that rationality requires weakly ordered preferences (Levi, 1986).

2. See P. C. Fishburn (1981) for a comprehensive survey and careful presentation of different ways of relating acts, states, and consequences in seeking to elicit probabilities of states and utilities of consequences from preferences among acts.

3. A *roulette lottery* in the terminology of Anscombe and Aumann is a prize that stipulates that the recipient receives payoffs in **C** with definite objective chances or, for those who find the introduction of chances here inappropriate, with specific probabilities. Even when these stipulated probabilities are taken to be subjective belief probabilities, they are understood to be given. The elicitation process is not designed to derive them but to use them in deriving other belief probabilities. *Horse*

lotteries are the acts in **A** specified under (3) in what follows to be representable by functions from states to roulette lotteries in **L**. Elicitation seeks to derive the belief probabilities for states in horse lotteries.

4. L. J. Savage's (1954) postulate P3 secures this requirement on the assumption that P2 already holds.

5. The acts that might be the same function from states to consequences or roulette lotteries on consequences include acts that are themselves mixtures of acts (horse lotteries). So I am assuming the reversal or order postulate of Anscombe and Aumann (1963).

6. The importance of the distinction between acts with constant payoffs (in pure prizes or roulette lotteries) and acts with constant utility for payoffs is emphasized and illustrated in Schervish, Seidenfeld, and Kadane (1990) who also rehearse in some detail how the problem of state dependent utility surfaces in the approaches of Anscombe and Aumann, Savage, de Finetti, and Ramsey, and the relation of all of this to Savage's discussion of "small worlds". Schervish, Seidenfeld, and Kadane also make a positive proposal for eliciting both probabilities and utilities from an extended class of potential options that derives from suggestions of Karni, Schmeidler, and Vind (1983) and Karni (1985). I shall make reference to these ideas subsequently.

7. Although this point is not always as well understood as it ought to be, recognition of its importance in the postwar period goes back about forty years. An extended discussion appears in the doctoral dissertation by Dréze (1958). This work was published in revised form in Dréze (1987). Briefer discussions are found in Arrow (1965) and (1974) who makes reference to an unpublished lecture by H. Rubin in 1964. See also Rubin (1983). And, of course, there are the more recent references mentioned in note 5 as well as the recognition of the problem Schervish, Seidenfeld, and Kadane find in Savage's treatment of small worlds.

8. In Levi, 1980, ch. 4.3, I used the notion of a confirmational commitment to represent X's judgment at time t as to what his credal probabilities should be were his evidence or state of full belief representable by the deductively closed set of sentences or corpus *K* in a regimented language **L** for any member of a set of potential states of full belief expressible in **L**. A confirmational commitment was characterized by a function from potential corpora to states of probability judgment. Confirmational commitments were required to satisfy a condition of *confirmational conditionalization*. If an agent's confirmational commitment remains fixed over time except for the addition of some new sentence to the stock of certainties or full beliefs, X's state of probability judgment changes in accordance with temporal credal conditionalization. In Levi, 1980, ch. 10.4, I argued that the requirement of confirmational conditionalization could be defended by appealing to the assumption that it makes no difference to the evaluation of uncertain prospects whether some state is ignored because the agent is certain that it is false or because the payoffs expected in that state are the same in value no matter which option is chosen. This is essentially the condition of Schervish, Seidenfeld, and Kadane. Confirmational commitments involve tacit cross fantasy comparisons. It appears that if they are taken into account, something like the Karni-Schmeidler-Vind approach to state dependence may be developed.

9. Let us suppose that of the four parameters of the fractional linear transformation (6-1), (6-2) found in Jeffrey (1965, 6.1), $d = 1$ and $b = 0$ so that $a = c + 1$. Then taking any proposition (or sentence) ranking above or below the tautology T, PROB[X] = prob[X](cdes[X] + 1) and DES[X] = ades[X]/[cdes[X] + 1] is a probability-desirability pair representing the same ranking of consistent propositions as the pair <prob,des>. Let prob[AB] = prob[A]prob[B]. PROB[AB] = prob[A]prob[B][cdes[AB] + 1] and [PROB[A]]PROB[B]] = prob[A]prob[B][cdes[A] + 1][cdes[B] + 1]. Hence, PROB[AB] = PROB[A]PROB[B] iff cdes[AB] + 1 = [cdes[A] + 1][cdes[B] + 1]. In cases where des[AB], is different from 0, this condition of probabilistic independence holds for PROB if $c = 0$ in which case PROB = prob and otherwise for at most one value of c. But there will be infinitely many other values of c for which it fails. So, in general, probabilistic independence is not preserved under fractional linear independence. I thank T. Seidenfeld for reassuring me about this point.

10. Recall that a common feature of the approaches of Ramsey, von Neumann and Morgenstern, Savage, Davidson and Suppes, Anscombe and Aumann, and others is that the preference ranking that serves as the basis for elicitation is defined over a domain **A** that is related to the structure of the problem the decision maker faces. Thus, in decision problem #1, there are two option propositions, two state propositions, and two consequence propositions. Relative to the background information \underline{K} the decision maker either tacitly or explicitly takes for granted, the option propositions G_1 and G_2 are equivalent given \underline{K} to truth functional compounds of the state propositions and consequence propositions.

This does not mean that the option propositions are truth functional compounds of the state propositions and consequence propositions. Davidson thinks that G_1 and G_2 are (at least in the case of Ramsey) compounds formed by using non-truth-functional connectives—perhaps causal connectives of some kind. I think the evidence of Ramsey's own discussions of causality and law suggest that Ramsey would have dissented from such a view. (See Ramsey, 1990, pp. 154–55.) Whatever Ramsey may himself have thought, however, I have just offered an account of decision problem #1 where the option propositions are neither truth-functional compounds nor causal compounds of the state and consequence propositions. They are, however, equivalent, given what X knows, to truth-functional compounds.

Thus, if agent X registers indifference between G_1 and G_2, not only do we require that X be an expected utility maximizer as assumption (a) demands and that assumptions (b), (c), and (d) be in place but also that X be in a state of full belief that entails the truth-functionality condition if my reading of Ramsey is deployed or that X believes that there is a causal dependency between the act and possible state, on the one hand, and possible consequence on the other, if Davidson's reading is endorsed. No matter which way one interprets Ramsey, in stripping away the contents of the option sentences, we are abstracting away from the information about X's belief state (on my reading) or from the causal structure (on Davidson's reading). Once the contents of option sentences are ignored in this way, information about the contents of these sentences relevant to elicitation of probabilities and utilities from preferences is lost and Davidson's reformulated project for utility theory cannot get off the ground.

11. Davidson insists that what an agent means by his sentences, the value he sets on various possible and actual states of the world and the probabilities he sets on such states "can be abstracted from the pattern of . . . preferences among sentences" (1990, p. 322). This seems to mean that the sole data to be invoked consist of data about such preferences. This seems to indicate that Davidson denies that in selecting the belief-meaning pair, the decision maker invokes information additional to the preference ranking of sentences. But that cannot be right. The interpreter must understand his own sentences. And he must be in touch with his own beliefs and values. Such information is required in order to apply the principle of charity that Davidson famously invokes as prescription for interpretation. This information qualifies as data additional to the preference ranking of the agent whose views are being interpreted on the basis of which belief-meaning pairs can be identified. As I am interpreting Davidson, these extra data allow for the possibility of reducing the lack of uniqueness in Jeffrey's theory by appealing to the extra data used in interpretation via the principle of charity.

12. I have endorsed elements of this point of view in one form or another since the late 1960s; but especially in Levi (1980). A more elaborate understanding of commitment and the normative dimension of rationality appears in chapter 2 of Levi (1991). By that time, Akeel Bilgrami and I had been exchanging ideas for some time and, as a consequence, my ideas have been improved by interaction with his. Bilgrami's ideas on these matters are given a relatively early expression in Bilgrami (1992). An excellent statement appears in an, as yet, unpublished paper "Self-Knowledge and Resentment".

13. If X at t is committed to full belief that h or to judging that h is probable to some degree x or to judging that the truth of h is valuable to degree y, X has undertaken at t to fulfill that commitment (subject to the qualifications mentioned above) as long as X lacks a justification for changing that commitment. Commitments are open to revision with good reason. Thus, there are two types of changes in view (full belief, probability judgment, value judgment): changes in commitment and changes in performance (fulfillment of commitment). Corresponding to each there is an appropriate question of justification. Changes in performance may involve assenting to or acquiring a disposition to assent to h because h is a consequence of commitments one already has. Mario is certain that Albany is north of New York and that being north of is asymmetrical. At one stage Mario may fail to put two and two together and realize that he is committed to judging false that New York is not north of Albany. He is justified in changing his doxastic performances in keeping with this requirement. Implementing such a change incurs no change in commitment. Contrast this with a situation where Mario consults an atlas or a reliable authority and obtains reliable testimony to the effect that Montreal is north of Albany. Mario becomes committed to full belief that Montreal is north of Albany and also to full belief that Montreal is north of New York (because he is already committed to full belief that Albany is north of New York and to the transitivity of the relation of being north of. Here Mario changes doxastic commitments and does so for good reason.

Davidson does not countenance a distinction between change in commitment and change in performance. In the first scenario, Mario is no more obliged to come

to believe that New York is not north of Albany than he is to ceasing to believe that Albany is north of New York. Consistency requires he make one change or the other. No further commitments are in force.

14. Thanks are due to Akeel Bilgrami, John Collins, Carole Rovane, and Teddy Seidenfeld for insight, advice, and criticism.

REFERENCES

Anscombe, F. J., and R. J. Aumann. 1963. "A Definition of Subjective Probability." *Annals of Mathematical Statistics* 34: 199–205.

Balch, M. 1974. "On Recent Developments in Subjective Expected Utility." In *Essays in Economic Behavior Under Uncertainty*, edited by M. Balch, D. McFadden and S. Wu. Amsterdam: North Holland, pp. 45–54.

Bilgrami, A. 1992. *Belief and Meaning*. Oxford: Blackwell.

———. 1998. "Self Knowledge and Resentment." *Knowing Our Own Minds*, edited by C. Wright, Barry C. Smith, and C. Macdonald. Oxford: Oxford University Press, pp. 207–41.

Davidson, D., J.J.C. McKinsey, and P. Suppes. 1955. "Outlines of a Formal Theory of Value." *Philosophy of Science* 22: 140–60.

Davidson, D., and P. Suppes. 1956. "A Finitistic Axiomatization of Subjective Probability and Utility." *Econometrica* 24: 264–75.

Davidson, D., and P. Suppes, in collaboration with S. Siegel. 1957. *Decision Making: An Experimental Approach*. Stanford, Calif.: Stanford University Press.

Davidson, D., and J. Marshak. 1959. "Experimental Tests of a Stochastic Decision Theory." In *Measurement: Definitions and Theories*, edited by C. W. Churchman and P. Ratoosh. New York: Wiley, 233–69.

Davidson, D. 1980a. *Essays on Actions and Events*. Oxford: Clarendon Press.

———. 1980b. "Toward a Unified Theory of Meaning and Action." *Grazer Philosophischen Studien* 11: 1–12.

———. 1982. "Expressing Evaluations." *Freedom and Morality*, A volume of Lindley Lectures. Lawrence, Kans.: University of Kansas.

———. 1985a. "Incoherence and Irrationality." *Dialectica* 39: 345–54.

———. 1985b. "A New Basis for Decision Theory." *Theory and Decision* 18: 87–98.

———. 1990. "The Structure and Content of Truth." The John Dewey Lectures 1989. *Journal of Philosophy* 87: 279–328.

Fishburn, P. 1981. "Subjective Expected Utilities: A Review of Normative Theories." *Theory and Decision* 13: 139–99.

Herzberger, H. 1973. "Ordinal Preference and Rational Choice." *Econometrica* 41: 187–237.

Jeffrey, R. C. 1965. *The Logic of Decision*. New York: McGraw Hill.

Karni, E. 1985. *Decision Making Under Uncertainty*. Cambridge, Mass., Harvard University Press.

Karni, E., D. Schmeidler, and K. Vind. 1983. "On State Dependent Preferences and Subjective Probability." *Econometrica* 51: 1021–31.

Levi, I., and S. Morgenbesser. 1964. "Belief and Disposition." *American Philosophical Quarterly* 1: 221–32.

Levi, I. 1980. *The Enterprise of Knowledge.* Cambridge, Mass.: MIT Press.

———. 1986. *Hard Choices.* Cambridge: Cambridge University Press.

———. 1993. "Rationality, Prediction and Autonomous Choice." *Canadian Journal of Philosophy*, supplementary volume 19: 339–63.

———. 1991. *The Fixation of Belief and Its Undoing.* Cambridge: Cambridge University Press.

Ramsey, F. P. 1990. *Philosophical Papers*, edited by D. H. Mellor. Cambridge: Cambridge University Press.

Savage, L. J. 1954. *Foundations of Statistics.* New York: Wiley, 2nd ed. New York: Dover (1972).

Schervish, M. J., T. Seidenfeld, and J. Kadane. 1990. "State Dependent Utilities." *Journal of the American Statistical Association* 85: 840–847.

Schick, F. 1979. "Self Knowledge, Uncertainty and Choice." *British Journal for the Philosophy of Science* 30: 235–52.

Sen, A. K. 1971. "Choice Functions and Revealed Preference." *Review of Economic Studies* 38: 307–17.

Spohn, W. 1977. "Where Luce and Krantz do Really Generalize Savage's Decision Model." *Erkenntnis* 11: 113–34.

———. 1978. *Grundlagen der Entscheidungstheorie.* Copenhagen: Scriptor.

von Neumann, J. and O. Morgenstern. 1947. *Theory of Games and Economic Behavior.* Princeton: Princeton University Press.

REPLY TO ISAAC LEVI

Isaac Levi represents me as shifting from the view that rational choice theory describes the kind of consistency a rational agent will reveal in his attitudes and action to the view that such a theory is normative. He also thinks I at one time espoused Ramsey's version of such a theory but then "abandoned" it in favor of Jeffrey's version. Though I have changed my mind on many matters, these are not among them. I think, and always have, that to describe what is rational is to describe norms. I have not been in the business of recommending rationality, but I do think it is a good thing. I never abandoned Ramsey; I admire him as I did. We have a number of versions of rational choice theory, and I know that there has been much dispute over their relative merits. I am not a party to these disputes, since the use I have for formal theories of rationality is too abstract and speculative for the differences to matter much. I have in recent years adopted Jeffrey's theory (in modified form) because I saw a way to make a neat join with the theory of meaning, and I did not see how to do this with more traditional axiomatizations. I probably would have stayed with Ramsey if I had been ingenious enough to find a way of combining his theory with my approach to the interpretation of language.

It has always seemed obvious that any of these theories (which I call for short "decision theories") can be treated as either descriptive or normative. The two approaches do not rule one another out, since in asking to what extent people actually are rational in their preferences and choices, one is both asking whether the theories really do capture elements of rationality and investigating the extent to which the theories describe the patterns of real preferences and choices. But though the normative and descriptive approaches do not rule one another out, they are, it seems, clearly different. The difference becomes blurred, however, when one asks about the role of decision theory in interpretation, and it is here, as the essays of Lazar and Elster in this volume and my replies demonstrate, that I have said inconsistent things and shown myself to be confused.

An interpreter must take account of the logical and other formal relations among the attitudes of those he would understand simply as one condition of

understanding. Unless he can descry a considerable degree of consistency and coherence he cannot assign contents to the attitudes, since an essential key to identifying propositional attitudes is their interrelations. This point may be put: an interpretable agent is one who can be described as basically rational (i.e., as adhering to the norms of logic and induction and actions taken in the light of reasons). From the interpreter's point of view, these are norms in the sense that he accepts these ways of thinking and acting as reasonable given the values and beliefs of the agent. But here the descriptive and the normative are not so clearly distinguished: the interpreter understands the agent by being able to describe her as adhering (up to a point anyway) to his own norms.

But now, if it is a condition of having thoughts or of acting in the light of reasons that one can be described as adhering to the norms of rationality, does it make sense to say one must be *aware* of those norms or consciously *subscribe* to them or *reason* in accord with them? As Lazar convincingly argues, it is wrong to think of agents as taking the norms of rationality as premises in their reasoning, since one must then ask what the rules of inference are. To reason at all is to reason in accord with the norms of rationality. The moment we say to ourselves, "I must abide by these norms", we seem to have demoted the norms to premises about which we can reason well or badly. I do not suggest that we cannot reflect on our own rationality, or that we cannot make our norms explicit, or that such self-examination is to be avoided. Quite the contrary. But I think we can, and usually do, reason, and act in the light of reasons, and interpret others without being conscious of any norms of rationality and without taking them into account.

Because I think adherence to the norms of logic and decision theory are partly constitutive of thought and intentional action, I am not sure what it means to say people should adhere to those norms, or that they are obliged to try to conform. I see no harm in saying it would probably be better for them and for others if agents reasoned and acted more responsibly, and it is a mark of a certain sort of virtue that one attempts to improve one's deliberative methods. But I am not persuaded that just thinking that something is so commits me to anything further or incurs any obligations. Of course, if I say I believe something, I enter the world of public discourse with all its various obligations and consequences. But it is the social action, not the belief, that incurs the obligations and consequences.

Levi, if I understand him, thinks that only if we add the burden of commitment and obligation to the disposition of belief or other attitude do we get something with enough explanatory weight. I agree that to attribute dispositions is not in many cases to do as well as one might wish in giving explanations. And I agree, with Quine, Levi, and many others, that dispositions call out for further explanation where it can be had. Otherwise we are just positing an unexplained mechanism with a known power. But unlike Levi, I don't find such posits so empty. Why did Susan go to sleep? Because she

took this pill thinking it was an aspirin; in fact it was a sleeping pill. That really does explain why she went to sleep. The fact that it would explain more if we knew how the pill worked doesn't show that nothing has been explained. Beliefs and desires and intentions are powers, and the powers are, among other things, the power to cause the thoughts and actions they do. But if we wonder why someone has acted as he did, it is often just the explanation we want to learn what she wanted and what she thought. This is not something we could deduce from most descriptions of the action.

Formal systems say nothing, of course, either descriptively or normatively until they are interpreted, and it is here that the difficulties Levi discusses arise. His conditions (a) through (d) are conditions which must hold if a standard form of decision theory is to define rationality, given a certain interpretation. Whether he believes that, given the most natural interpretation, the formal system should somehow add these conditions to the axioms, or he thinks that because these conditions cannot be added to a standard theory the theory should be abandoned, he does not say. What is clear is that there is no plausible and testable interpretation of the standard theory under which it is descriptively true. (Even this is not quite correct. If the set of available choices is very small and other experimental conditions are carefully arranged, some people will probably satisfy the theory.) But thinking of the theory as a general theory of rational choice, there is no testable interpretation under which a person *ought* to satisfy the theory. This is obvious from the fact that any test of a *pattern* of choices must take time, while the theory is not even prima facie plausible except as placing constraints on simultaneously held preferences. Yet the beliefs of any rational agent will change due to changes in her situation, and her preferences will (rationally) change in consequence. So we can abandon at the outset any hope of determining whether or not an agent is rational in the sense of any of the definitions of rationality provided by the theories under consideration.

When Suppes and I tried testing various versions of Ramsey's theory we were, of course, aware of this difficulty as well as others that Levi stresses, and we attempted to design our experiments to minimize the factors that would falsify the theory. Several of the experiments involved bets where the payoffs were in money. We realized that if money changed hands during the experiments, the subjective value of prospective gains and losses would alter as actual gains and losses added up. We therefore postponed paying off the bets until the experiment was concluded. We knew that the theory could not be expected to hold if the "states" (i.e., events) on which payoffs were contingent were not, in Ramsey's words, "morally neutral". (For example, we discovered experimentally that heads and tails of a coin are not morally neutral for most people.) We created chance events by having special dice manufactured which had nonsense syllables on their faces in the hope that subjects would be indifferent to such events. And so on: for the number of ways in

which an experiment may fail to test a hypothesis is infinite. This does not mean one can never test a hypothesis, but that one is always testing the conjunction of a formal hypothesis and an experimental design.

I have often described the experiment which persuaded me to give up trying to test theories of rational choice. It was the sort of experiment on which one is taught to frown, for there was no hypothesis. I simply became curious as to how realistic the assumption was that preferences can be held fairly steady during an experiment. In a given session subjects were asked to choose between all possible pairings of eleven bets involving small amounts of money: that's fifty-five choices. Unnoticed by the subjects was the fact that all the options had the same actuarial value; the point of this arrangement was to invite intransitivities. And intransitivities there always were, though nowhere near as many as chance would predict. Again without the subjects noticing the fact, the very same fifty-five choices were again elicited in subsequent trials. (It was easy to conceal the repetition by altering the order of choices, the order in which the options were stated, and so on.) Every subject gradually reduced the number of intransitivities. Yet no subject noticed this, no two subjects ended up with the same ordering, and no subject was able to state a policy he or she had followed. Two things were demonstrated: even though no bets were paid off until all sessions were finished, preferences were not at all consistent over time; and all subjects became more consistent ("rational") as the experiment progressed. I decided that trying to test a static theory of rationality under dynamic conditions was bound to fail. But I also was impressed with the underlying consistency of preference that seemed to emerge over time.

The same doubts in a much more exaggerated form must arise if it is proposed to use some standard form of decision theory, or Jeffrey's alternative, as an interpretive device. This is why I have always stressed that my appeal to decision theory (and logic and the structures of languages) was not intended as an attempt to describe how we do or could come to understand the thoughts, speech, and actions of others. My purpose was rather to appeal to formal structures which seemed to me to capture conditions to which thought and speech and action must more or less conform if they are to count as thought and speech and action, and to sketch how the presence of the pattern so delineated makes it possible (in theory) for one person to understand another. I thought (and think) the fairy story I have told about how someone might, from preferences among sentences, figure out a person's beliefs, values, and meanings, illuminates what makes actual interpretation possible. Much fuller and more realistic theories are, I assume, possible. But even a relatively limited theory like Ramsey's demonstrates convincingly, to my mind, how simple input can, in the light of a theory, yield surprisingly sophisticated results.

D. D.

24

Richard Rorty

DAVIDSON'S MENTAL-PHYSICAL DISTINCTION

I. INTRODUCTORY

In 1971 my philosophical views were shaken up, and began to be transformed. That was the year in which Donald Davidson let me see the text of his 1970 Locke Lectures. These lectures included an early draft of his 1974 presidential address to the APA: "On the Very Idea of a Conceptual Scheme," a paper which still strikes me as epoch-making. It will, I think, be ranked with "Two Dogmas of Empiricism" and "Empiricism and the Philosophy of Mind" as one of the turning-points in the history of analytic philosophy.

In 1972 I published an article called "The World Well Lost"[1] which owed its central argument to Davidson's lectures. In that article, as in much that I have written since, I attempted to synthesize Davidson and Dewey. I pointed out that both philosophers were attacking the Kantian distinction between receptive sense and spontaneous intellect, and doing so for similar reasons. Furthermore, both were suggesting that all the links between mind and world are causal, and none representational. These suggestions, I claimed, dissolved a great many of the problems about the relation of mind or language to the world—problems which had been bequeathed to analytic philosophy by Russell, C. I. Lewis, and Carnap.

But in 1972 I also published an article criticizing Quine's claim that the indeterminacy of translation was different from the ordinary underdetermination of empirical theories.[2] I argued that Quine had never given a satisfactory sense to the term "fact of the matter," and that the contrast he invoked

between the factual and the nonfactual seemed to be the same contrast that he had been concerned to blur in the concluding paragraphs of "Two Dogmas of Empiricism."[3]

I had expected Davidson to concur on this point, and I was taken aback when it turned out that he heartily agreed with Quine about the indeterminacy of translation.[4] During the intervening quarter-century, we have continued to disagree over this point. I have persisted in thinking that the anti-dualist line of thought developed in "Two Dogmas," a line of thought which had led Davidson to reject the spontaneity-receptivity and scheme-content distinctions, should also lead him to reject the very idea of a distinction between the presence and absence of what Quine called "a fact of the matter." That idea is, of course, antithetical to the Deweyan pragmatism in whose embrace I keep trying to enfold Davidson.[5]

Quine's invidious distinction between the "baselessness of intentional idioms" and the better "based" idiom of physical science strikes pragmatists like me as a residue of the unfortunate positivist idea that we can divide culture into the part in which there is an attempt to correspond to reality and the part in which there is not. If you drop the idea that some of our sentences are distinguished by such correspondence, as Davidson has, it seems natural to say, as Dewey did, that all our idioms are tools for coping with the world. This means that there can be no philosophical interest in reducing one idiom to another, nor in asking whether and how a non-extensional language might be replaced with an extensional one.[6]

As pragmatists see it, we are equally in touch with reality when we describe a hunk of space-time in atomic, molecular, cellular, physiological, behavioral, intentional, political, or religious terms. We usually cannot state necessary and sufficient criteria of correct application for any of these terms in any of the other idioms, but there is no reason to demand such criteria, at least not for the sake of "conceptual clarity." For Wittgenstein has taught us that clarity is a matter of ease and fruitfulness of use, not of translation into a preferred vocabulary.

Looking for an ontological or epistemological gap between such idioms strikes pragmatists as like looking for such gaps between a small Phillips screwdriver and a large crescent wrench; there are all sorts of similarities and differences, but none of them have ontological or epistemological import. There is no invidious ontological or epistemological distinction to be made, for example, between physics and literary criticism. The only invidious distinctions which pragmatists allow themselves to draw are between the purposes various disciplines fulfill, and between the amounts of good done by fulfilling these various purposes. (For example, a pragmatist and a physicalist might agree that had natural science never gotten beyond Aristotle's *Physics* we should be worse off than if literary criticism had never gotten beyond his

Poetics.) So pragmatists are baffled by the claim that the gap between psychology and biology is somehow deeper than that between biology and chemistry—a claim Davidson and Quine both make.

Quine is explicitly anti-pragmatist when he propounds a physicalist ontology. He does this when he explicates his claim that translation is not simply underdetermined, but indeterminate, by saying that two incompatible translations, unlike two physical theories, are "compatible with all the same distributions of states and relations over elementary particles."[7] Quine did not explicitly endorse, but he did not object to, Roger Gibson's claim that the difference between the under-determination of theory and the indeterminacy of translation is a matter of ontology, rather than of epistemology or methodology, and that you have little reason to see a difference if you do not share his ontological views—unless you agree, as Gibson puts it, that "epistemology presupposes an ontology of nerve endings."[8]

What seems puzzling about Davidson's agreement with Quine about indeterminacy is that Davidson has no particular interest in elementary particles, nor much use for nerve endings. He thinks it best for translators to go straight from speakers' behavior to distal objects, and straight back again, skipping over neural stimulations. I suspect that Davidson may have the same doubts I do about Quine's claim that "information," rather than just electrical current, gets passed along from eye to brain.[9] Davidson has displayed no interest in epistemology, nor in a physicalistic ontology, nor, for that matter, in any other kind of ontology.[10] I see this lack of interest in ontological and epistemological questions as another of his laudable resemblances to Dewey.

Presumably Davidson would grant that Quine had several different motives for advancing his doctrine of the indeterminacy of translation. He might also grant that one or more of those motives (for example, what he once called "an adventitious philosophical puritanism") may have been misguided. But he holds that the doctrine itself is nevertheless sound and important. He is willing to restate it, but not to dismiss it. Davidson thinks that even anti-representationalists, people who believe (as he and I do) that our links with the world are merely causal, rather than representational or justificatory,[11] ought to recognize the importance of the difference between intentional and other idioms.

For my part, I am happy to grant that attributions of intentional states are far more holistic than any other attributions we make, but that is as far as I want to go. I cannot see why this holism is supposed to have ontological implications. I think of holism in the ascription of predicates as a matter of degree: some predicates signify, to use Putnam's terminology, "single-criterion concepts," others "multi-criterion concepts," and still others have conditions of correct application so incredibly complex that there seems little point in using the term "criterion" at all. But I do not see why greatly

increased complexity of conditions of application of predicates should be a symptom of philosophically interesting gaps between kinds of objects.

Davidson does see such an interesting gap, and in two recent papers he explains what makes the intentional-non-intentional distinction interestingly different from the cell-molecule or organ-cell distinction. These explanations are offered in "Three Varieties of Knowledge"[12] and "Could There Be a Science of Rationality?"[13] (hereafter "Varieties" and "Science"). In the former, he says that:

> Given the richness of structure represented by the set of one's own sentences, and the nature of the connections between the members of this set and the world, we should not be surprised if there are many ways of assigning our own sentences to the sentences and thoughts of someone else that capture everything of relevant significance. ("Varieties," p. 161)

In order to show why this plurality exhibits indeterminacy rather than mere underdetermination he says, in the next paragraph, that "the situation is analogous to the measurement of weight or temperature by assigning numbers to objects." Given all possible observations, " an assignment of numbers to objects that correctly registers their weights is not unique."

This analogy with measurement scales brings him to the following, somewhat half-hearted, restatement of Quine's indeterminacy doctrine:

> Because there are many different but equally acceptable ways of interpreting an agent, we may say, if we please, that interpretation or translation is indeterminate, or that there is no fact of the matter as to what someone means by his or her words. In the same way we could speak of the indeterminacy of weight or temperature. ("Varieties," p. 161)

I am inclined to reply: we *could* speak of the indeterminacy of weight or temperature, and to say that there is no fact of the matter about what temperature somebody has, but we do not. We do not because the possibility of using another scale of measurement seems to have nothing to do with factuality. Temperature seems as factual as ever, even after somebody points out that you could replace Fahrenheit with Centigrade.[14]

Analogously, what people mean strikes a lot of people as as determinate as ever, even after Quine shows them that translation could work beautifully if you translated certain native sentences using the term "rabbit-stage" instead of "rabbit" (along with various auxiliary modifications of your previous translation manual). They are no more inclined to speak of indeterminacy of meaning after reading Quine than they would be to speak of indeterminacy of atomic structure after reading a beautiful, but pointless, theory, empirically equivalent to our own, about how atoms really have three particles for every one we thought they had, with the extra two canceling out each other's effects.

Nobody is going to be moved by Davidson's analogy between translation

manuals and scales of measurement unless they are already convinced that there is a striking difference between ascribing intentional states and ascribing all other states. To show that meaning is a different sort of thing than temperature, and that speaking of the indeterminacy of translation is philosophically more enlightening than speaking of the indeterminacy of temperature, Davidson has to do more.

In the remainder of "Varieties" and in "Science" he does do more, but what he does seems to me to leave the notion of indeterminacy as dubious as ever. So I shall take up some of the things Davidson says in these recent articles in more detail, and argue that Davidson does not come up with any difference striking enough to produce the necessary conviction.

II. The Causal Character of Mental Concepts (1): Piecemeal Tinkering

In "Varieties," Davidson says that "most of the concepts that feature in common sense explanations are causal" because terms like "believes that . . ." and "is slippery" carry with them expectations about what will and will not happen, ceteris paribus. "Beliefs and desires are identified in part by the sorts of action they are prone to cause . . . something is slippery if it causes appropriate objects to slip under appropriate circumstances" ("Varieties," p. 162).

But, he goes on to say, there is a philosophically interesting difference between common sense explanations by reference to slipperiness or elasticity and common sense explanations by reference to beliefs. Both elasticity and belief are causal concepts, yet:

> in the case of causal properties like elasticity, slipperiness, malleability or solubility we tend to think, right or wrongly, that what they leave unexplained can be (or already has been) explained by the advance of science. We would not be changing the subject if we were to drop the concept of elasticity in favor of a specification of the microstructure of the materials in the airplane wing that cause it to return to its original shape when exposed to certain forces. Mental concepts are not like this. They appeal to causality because they are designed, like the concept of causality itself, to single out from the totality of circumstances which conspire to cause a given event just those factors that satisfy some particular explanatory interest. ("Varieties," p. 163)

It is not clear that an explanation by reference to elasticity leaves anything unexplained. Nor is it clear that the concept of elasticity is not designed to single out "just those factors that satisfy some particular explanatory interest." But we can waive both points, because, I take it, that Davidson's claim is that in the case of elasticity we have well-grounded hopes for a further explanation of a particular kind: we hope to have an explanation of how elasticity itself

works—of what makes some airplane wings more elastic than others, for example. Science can give, or has given, us that. So presumably the contrast with psychology is that we have no reason to hope for a parallel explanation of how mental states work.

There are two senses of "how mental states work." In one sense, of course, we already know this, because we know a lot about how each mental state is acquired, and about what effects it produces in the behavior of the person who is in it. But in the sense Davidson presumably has in mind you do not know "how things work" unless you can break macrostructure down into microstructure—unless you have the sort of knowledge that lets you alter things' behavior by tinkering with their insides, so to speak.

We cannot, of course, correlate the property of being elastic with a molecular arrangement common to each and every elastic thing, any more than we can correlate the property of being an airplane wing with such an arrangement. All we can do is give a fairly detailed molecular story about any given elastic thing. The disanalogy Davidson is suggesting between elasticity and belief is, I take it, that we do not expect neurology to provide a fairly detailed microstructural story about any given mental state. We do not expect to be able to change people's beliefs and desires by tinkering with their brains.

If this is the disanalogy Davidson is pointing to, then I think he is quite right. Tinkering with the brain might produce rather massive changes in desire—neurologists might be able to rewire you so as to make you lose interest in food, or sex, or maybe even politics. But changing beliefs seems harder, and changing a *very particular* belief or desire by neurological means is very hard to imagine. It does seem crazy to suggest that brain-tinkering could switch me over from believing that Madison was the fourth president to thinking that Jackson was, and that Madison came sixth, while leaving everything else alone. The same goes for switching from the desire that my neighbor turn down her radio to the desire that she turn it up, while leaving everything else alone.

Davidson would be right to insist that it is the holistic character of attributions of belief and desire that stands in the tinkerers' way. It is the "leaving everything else alone" clause that gives trouble. If you alter my beliefs about the sequence of presidents, you have to alter a lot of them at once. Since these beliefs interlock with a lot of my other beliefs about what happened in American history, and those with still other beliefs, your tinkering may never end.

This is the point that Dennett and others have invoked against type-type mind-body identity theories. Such identities might hold, they point out, for hunger, sexual desire, pains and moods—and maybe even for sensory images—but it is hard to see how they could work for particular sentential attitudes. These latter, however, are the only states which Davidson will

dignify with the name of "mental." If we assert token-token identity between sentential attitudes and neurological states, the latter will have to be states of an entire nervous system, rather than nicely specifiable bits of that system which could be zapped in order to alter beliefs and desires one at a time.[15]

Granted the point about tinkering, where does that leave Davidson's elasticity-belief disanalogy? What does non-tinkerability, inability to get down to microstructure, have to do with indeterminacy or factuality? I do not know how to answer that question without falling back on Quine's physicalistic ontology, a move which presumably Davidson does not want to make. So the passage I have been examining gives me no help in understanding why Davidson agrees with Quine about indeterminacy. For two questions are left unanswered: (1) why is microstructure such a big deal? (2) why is the gap between microstructure and biological explanations less significant than the gap between microstructure and the attribution of mental states?

II. THE CAUSAL CHARACTER OF MENTAL CONCEPTS (2): STRUCTURALITY AND STRICTNESS

I turn now to another passage, one in which Davidson explicates his notion of "causal concept" in a somewhat different way. In "Science" he uses "sunburn" as an example of a non-mental causal concept, and says that it is causal because:

> No completed physics would make use of the concept of sunburn, not only because part of the explanation is already built into the characterization of the state, but also because two states of the skin could be in every intrinsic way identical, and yet one be a case of sunburn and the other not.

This passage implicitly defines a "completed physics" as one which contains no functional predicates. In the relevant sense, a predicate is functional if two things could have the same predicate accurately applied to them even if they had different physical structures. Something can be a screwdriver no matter whether it is made of steel, platinum, or plastic. But something is platinum only if it has such and such an atomic structure. So in the relevant sense "screwdriver" is a functional term and "platinum" is not. Functional terms like "sunburn" and "screwdriver" are applied in the light of the causal history of the thing to which they are applied, but you do not have to know that history to know whether something is platinum. If nobody made it to drive screws, then an ancient artifact is not a screwdriver even if it looks just like one. But if it has the right atomic number it counts as platinum, even if it suddenly appeared in mid-air, apparently created out of nothing.

Now, however, we can ask the same question about structure in general as

I asked about microstructure earlier. Why is structure ontologically privileged, in respect of determinacy, over function? A possible answer is found in Davidson's explanation that "Descriptions of objects, states and events that are needed to instantiate strict, exceptionless laws, do not contain causal concepts" ("Varieties," p. 163). Perhaps determinacy is correlative with strictness—that is to say, with the absence of *ceteris paribus* clauses. The use of functional concepts in generalizations makes such clauses necessary. Sunburns are painful, but not if the person burned has been anesthetized. Banana peels are slippery, but not if they have first been burned to ashes. Yet some, though obviously not all, of the generalizations you can make about platinum do not require a *ceteris paribus* clause. Platinum is expensive, but only if there has been no recent discovery of huge and easily mined ore deposits in Alaska. Yet platinum is composed of atoms of such and such a kind, no matter what. If the availability of exceptionless generalizations is what matters for determinacy, then one can see why structure will, in this respect, be privileged over function, non-causal over causal concepts.

At this point, however, we pragmatists will object that the only cases in which we have exceptionless generalizations are those in which we are talking about ideal objects: objects such as pure samples of platinum, or point-masses, or a perfect vacuum. The only reason we never have to say "ceteris paribus" is that we have already said it, *sotto voce*, in the propaedeutic prose which leads up to the announcement of those admirably strict laws. Pragmatists think this because they see physics as a tool rather than a picture of the intrinsic nature of reality, and so see the physicists' use of non-causal, non-functional concepts as a gimmick, rather than an encounter with an ontologically privileged realm of being.

Pragmatists think that you can create a non-causal concept any time you want to, just by explaining that your use of a term will be governed by a single criterion. A non-causal concept is one whose application is governed by instructions like: Be strictly internalist! Don't look at causal histories! Avoid holism at all costs! That sort of definition of "non-causal concept" would avoid the realist suggestion that certain special things—the paradigms of determinacy, the things whose identity is especially sharp-edged, so to speak—demand a special kind of concept for their accurate representation.

Given the definition of "non-causal concept" I have just suggested, Fodor and the other anti-holist philosophers of mind who are attracted by internalism can be viewed as having dreamed up such a non-causal concept: that of an ideal object called "narrow content." Pragmatists will not say that Fodor, in deploying this concept, gets the mind wrong. For we pragmatists think that the mind is whatever psychologists manage to make of it. We shall say instead that Fodor's concept of narrow content is as coherent and clear as Leibniz's concept of a monad, or of the *petites perceptions* which link monads, but that, like them, it may serve no useful purpose.

All Fodor and his allies have done, on a pragmatist view, is urge psychologists to find something neither folk nor physiological—something with that distinctive Fodorian "psychological reality." Narrow content is an object tailor-made to provide explanations of behavior which are neither commonsensical, nor yet reductive, but just right. If psychologists do someday find something appropriate, if they turn out to be able to make good use of the concept of narrow content, then Fodor will be seen as a prophet. If they are not, then he will be looked back upon as we look back upon the Leibnizians who yearned to discover intrinsic properties of matter—properties which would explain what Newton's appeal to an occult force had left unexplained.[16]

I think that Davidson would lose nothing by replacing his distinction between causal and non-causal concepts with a distinction of degree. He could speak, as I did earlier, in terms of a spectrum of concepts: those are applied on the basis of very holistic considerations, of somewhat holistic considerations, and of considerations which are not very holistic at all. On this spectrum the concepts "believes that Madison was the fourth president" and "desires to eat a Bartlett pear" are off at the extreme holistic end. Concepts such as "gold," "electron," "point-mass" and "born in California" are off at the non-holistic end. Concepts like "typical suburbanite" and "genuine Vermeer" are somewhere in the middle.[17]

It may be that by changing the subject from kinds of objects to ways of applying terms I am simply missing the point of Davidson's distinction between causal and non-causal concepts. But it does seem useful to raise the question: does this thing called "determinacy" which molecules have and meanings lack come to anything more than the simplicity or complexity of our practices of description?

IV. NORMATIVITY AND RATIONALITY

In both "Varieties" and "Science," Davidson says that a further disanalogy between elasticity and belief is that there is a normative element in the ascription of the latter, but not in the ascription of the former. The relevant paragraph in "Science" reads as follows:

> There are several reasons for the irreducibility of the mental to the physical. One reason, appreciated by Quine, is the normative element in interpretation introduced by the necessity of appealing to charity in matching the sentences of others to our own. Such matching forces us to weigh the relative plausibilities of different deviations from coherence and truth (by our own lights). Nothing in physics corresponds to the way in which this feature of the mental shapes its categories. (p. 4)

I would rejoin that there is nothing especially normative about my effort to translate, since all I am doing is trying to find a pattern of resemblances

between my linguistic behavior and the native's. I am trying to mesh her behavior with mine by finding descriptions of what she is doing that also describe what I sometimes do. I cannot see that this attempt differs in kind from my attempts to find, for example, resemblances between the structure and behavior of an unfamiliar insect and those of familiar insects—resemblances which will permit me to assign the newcomer its proper place in the entomological scheme of things. Attributing species-membership to a new, strange, and ambiguous object is a matter of playing off a lot of considerations against a lot of other considerations, and so is figuring out how to translate a string of native noises.

I *can* of course describe myself as asking whether the native meets the norms of rationality, but all it will take for her to do so is to exhibit linguistic behavior that sufficiently parallels my own. The entomologist *could* turn Aristotelian, and describe his taxonomic inquiries as discovering whether the unfamiliar insect conforms to the norms set by the final and formal causes of a given species. But he might also drop the notion of specific essence and just say that the purposes of entomology seem best served by putting the new beetle in this box rather than that. Abandoning Aristotelian and essentialist language was the move recommended by Quine in "Two Dogmas," when he suggested that we stop talking about semantic rules and start talking about behavioral regularities. If we make the same move in the present case, what Davidson calls "the normative element in interpretation introduced by the necessity of appealing to charity" will appear as the need to see something's behavior as deviating only in minor and unimportant ways from the behavior of something else.

In short, I do not see that the notions of normativity and of rationality add anything to that of complexity of criteria of application of intentional predicates, any more than the notion of "causal concept" does. One can speak normatively—talk about conforming to rules and standards instead of talking about exhibiting regularities and similarities—whenever one wants to. But I do not see anything which distinguishes psychological from biological descriptions that makes it important to do so.

V. THE BIOLOGICAL AND THE PSYCHOLOGICAL

I turn now to the second of the questions I posed earlier: why is the gap between microstructure and psychological description supposed to be of a different order than that between microstructure and biological description?

Consider the following passage from "Varieties" in the light of this question:

The normative and the causal properties of mental concepts are related. If we were to drop the normative aspect from psychological explanations, they would no longer serve the purposes they do. We have such a keen interest in the reasons for actions and other psychological phenomena that we are willing to settle for explanations that cannot be made to fit perfectly with the laws of physics. Physics, on the other hand, has as an aim laws that are as complete and precise as we can make them: a different aim. ("Varieties," p. 163)

But do *biological* explanations fit perfectly with the laws of physics? What does "fit" mean? When we explain a bird's behavior by saying "it's migratory" or "it's monogamous," we do not hope to find microstructural conditions of applications for those predicates. So isn't perfect fit with the laws of physics absent here too? Isn't it enough to have a general idea of how macrostructural change in DNA molecules may be relevant to migration or monogamy, without demanding more? Is our sense of the relevance of DNA to animal behavior any looser or tighter than our sense of the relevance of neural processes to mental states?

My suggestion that biology and psychology are on a par in their relation to the laws of physics can be reinforced by noting that Davidson sometimes uses "physics" in a narrow sense to mean what the physicist, as opposed to the chemist and the biologist, does. Sometimes he uses it in a larger sense, synonymous with "natural science," in which physics extends all the way up through biology, though stopping short of psychology.[18] If we use the word "physics" in the latter sense, to mean "inquiry into everything save the intentional," Davidson is certainly right to say that "When we try to understand the world as physicists, we necessarily employ our own norms, but we do not aim to discover rationality in the phenomena" ("Varieties," p. 162). But read that way, the claim is tautologous and unhelpful, for Davidson believes that only rational beings exhibit intentionality.

Suppose, on the other hand, we use "physics" in a narrower sense, to mean "the discipline which, in order to pursue laws as precise and complete as we can make them, deploys only non-causal concepts." Then we can point out that when we try to understand the world as physicists, we do not aim to discover function in the phenomena, but only structure. As physicists in that narrower sense, we use no term which can be applied equally accurately to things with different make-ups. But then we shall not be able to do biology: we shall not be able to talk about avian migration and monogamy.

My point is that when Davidson uses "physics" or "natural science" in the wide sense, he simply excludes psychology by fiat. But when he says what is special about physics, he uses "physics" in a narrow sense—one which would exclude biology as well. So we still need an answer to the question why we are supposed to draw a line between psychology and biology.

Davidson deals with this point only once in the two articles I have been examining. In "Varieties," after discussing the normative and causal character of mental concepts, he says:

> Much of what I have said about what distinguishes mental concepts from the concepts of a developed physics could also be said to distinguish the concepts of many of the special sciences such as biology, geology and meteorology. So even if I am right that the normative and causal character of mental concepts divide them definitionally and nomologically from the concepts of a developed physics, it may seem that there must be something more basic or foundational that accounts for this division. I think there is. ("Varieties," p. 163)

But I find it hard to grasp the argument of the paragraphs which follow this one—the ones which ought to hold the answer to the questions of why biology counts as a natural science and psychology doesn't. For Davidson seems to change the subject. The passage which tells us what the "something more basic and foundational" is reads as follows:

> The fundamental difference between my knowledge of another mind and my knowledge of the shared physical world has a different source. Communication, and the knowledge of other minds that it presupposes, is the basis of our concept of objectivity, our recognition of the distinction between true and false belief. There is no going outside this standard to check whether we have things right. .
> . .
> It is here, I think, that we come to the ultimate springs of the difference between understanding minds and understanding the world as physical. A community of minds is the basis of knowledge; it provides the measure of all things. ("Varieties," p. 164)

I can only think of one construal which would make this passage relevant to the question of why the psychology-biology gap is different from the biology-chemistry gap. This is to read it as saying: because we can test our views of physics and biology against the standard provided by "a community of minds," but cannot test our knowledge of psychology against our knowledge of physics and biology, there is a gap between knowledge of mental states and knowledge of everything else.

That construal, however, is hard to reconcile with Davidson's doctrine of triangulation—the doctrine that "The ultimate source of both objectivity and communication is the triangle that, by relating speaker, interpreter, and the world, determines the contents of thought and speech."[19] This doctrine suggests an obvious sense in which we *do* test our knowledge of psychology against our knowledge of physics and biology. For example, after we realize that the native's habitat, unlike ours, contains poisonous frogs, we are more likely to accept what at first seemed a very implausible hypothesis: that a certain native utterance is translatable as "Watch out! That frog can kill you!"

The construal I have suggested is also hard to reconcile with a Davidsonian claim which, prima facie, seems a rejection of the very idea of a philosophically interesting gap between physics and psychology: the claim that "we have erased the boundary between knowing a language and knowing our way around in the world generally."[20] Once this boundary is erased, it is hard to see how we can still say that knowing our way around the beliefs of the community of human minds is the *basis* of the rest of our knowledge.

"Basis," indeed, seems exactly the wrong word. Knowing about other minds, Davidson has shown, is an inextricable part of our knowledge; if you don't know something about those minds, you don't know anything about anything. But the same goes, his doctrine of triangulation assures us, for our knowledge of the non-mental and of our own minds. A large body of Davidsonian doctrine suggests that it is hopeless to assign one apex of this triangle priority over the other two, in respect to basicness or standard-setting.

I may have misconstrued Davidson's point in the passage about standard-setting which I have quoted. Perhaps I also misconstrue him as attempting to respond, in "Varieties," to the question of whether there are any philosophically interesting differences between biology and psychology in respect to factuality or indeterminacy. But I have no alternative construals to offer.

VI. ESSENTIALISM AND FACTUALITY

So much for exegesis of what seem to me the most relevant passages in Davidson's most recent work, and for the reasons why I am still unable to see why there is something special about the plurality of possible translation manuals, something that makes this plurality different in kind from the plurality of scales of measurement, taxonomies of insects, or theories of elementary particles. I shall conclude with some free-wheeling speculations about the reasons why both Quine and Davidson seem to turn unpragmatic and metaphysical when they hit the topic of mental states.

I noted earlier that Quine had, circa 1985, seemed to agree with Gibson that the thesis of indeterminacy of translation presupposes a physicalistic ontology. But Quine seemed explicitly to reject that view when, circa 1990, he agreed with Dagfinn Føllesdal that the heart of the indeterminacy thesis was what Føllesdal had dubbed "the thesis of man-made meaning" or "MMM thesis" viz., "The meaning of a linguistic expression is the joint product of all the evidence that helps learners and users of the language determine that meaning." Føllesdal said that the "crux" of this latter thesis was that:

> The difference between translation and science . . . is that while in science we are exploring a realm that is not of our own making, or at least not totally of our own making, this is not so in translation. In science, unless we are idealists, we think

of the world as something that lies there waiting to be explored, even before we start out theorizing. With language, however, the situation is different. The various sounds and written marks in a language do not have a meaning before they become part of a language. And what makes them part of a language and gives them meaning is the use we make of them. . . .[21]

Quine responded by saying that "Dagfinn has illuminated the indeterminacy thesis by clearing away what does not pertain. What matters is just that linguistic meaning is a function of observable behavior in observable circumstances. . . . Broader behaviorism is irrelevant; *physicalism is irrelevant* [emphasis added]; monism is irrelevant. . . ."[22]

Looking back at his 1985 comment on Gibson in the light of this later dictum, we find him saying then that he is attracted by Føllesdal's earlier (1973) suggestion that "the indeterminacy of translation follows from holism and the verification theory of meaning."[23] Quine continues: "The statement of verificationism relevant to this purpose is that 'evidence for the truth of a sentence is identical with the meaning of the sentence'; and I submit that if sentences in general had meanings, their meanings would be just that. It is only holism itself that tells us that in general they do not have them."[24]

Sometimes, it seems, holism is enough to show that there is no matter of fact about the assignment of meanings; sometimes a physicalistic ontology seems required to show this. This oscillation seems to me to confirm Føllesdal's suggestion that Quine thinks of the indeterminacy doctrine as helping us divide things up into the found and the made. If the need for such a division is right, then Quine's oscillation can be explained by noting there are two different points at which such philosophers have been tempted to draw a line.

One such point is the gap between the elementary particles and everything else. If the division is made there, at the line where pure structure stops and function begins—or, as I would put it, the line between the ideal and the actual—the insects and the birds turn out to be as much "made" as the meanings. This point is the one preferred by David Lewis, who believes that "among all the countless things and classes that there are, most are miscellaneous, gerrymandered, ill-demarcated," and that physics, in the narrow sense, discovers elite, non-gerrymandered, properties, corresponding to the real joints in nature.[25] The other point is the one preferred by Davidson, the one at which functions describable in non-intentional terms are replaced by functions described in intentional terms—the line between biology and psychology.

I have been arguing that because holism is a matter of degree, the latter line is too fuzzy to be of any use in distinguishing the found from the made. If one insists on drawing such a line, I think one would be better advised to follow Lewis rather than Davidson. One should emphasize the physicalist passages in Quine—the passages in which he says that incompatible

translation manuals are compatible with "the same distributions of states and relations over the elementary particles." One can then add that incompatible assignments of a new insect to different species, or incompatible explanations of a bird's refusal to take a new mate are also compatible with those same distributions, and that that is the point of Lewis's claim that zoology deals with gerrymandered, non-elite, man-made, properties.

But if one wants to put avian monogamy under the heading of "the found" rather than "the made," while putting meanings and beliefs under "the made," things will be much harder. One will have to say that a unified science—a "completed physics" which extends up through biology—would show us how the states and distributions of the elementary particles determine whether, when a certain swan refuses to remarry, it is DNA-determined fidelity rather than idiosyncratic fatigue that is at work. I have no clear sense of what such a unified science would look like. I doubt that the idea of "a completed physics" can be sharpened up sufficiently to do the job Davidson wants it to do.

It seems to me that the popularity of the idea of unified science, and the notion that there is something called "the language of science," stem from philosophers' insistence that scientific inquiry must consist of the search for *laws*, together with their hunch that any law worthy of the name ought to be exceptionless. The identification of scientific progress with the discovery of laws seems to me to fly in the face of the fact that evolutionary biology, one of the great triumphs of modern science, is content with what Dennett calls "reverse engineering"—with constructing plausible narratives of how things came to be.

These narratives are not validated by reference to "laws of evolution," even though everybody agrees that evolutionary progress is made by successive modifications of DNA molecules. Learning more about these molecules will doubtless tell us, to use one of Dennett's examples, why we have spotted animals with monochrome tails but no monochrome animals with spotted tails. But it will not replace the usual functional explanations of individual animals' behavior, any more than learning more about neurons will replace the usual psychological explanations of individual humans' behavior. We can still say, with Laplace, that an omniscient being who knew the laws of physics and the distribution of the elementary particles at some earlier moment in history could have predicted both sorts of behavior. But that is like saying that a perfectly pure sample of a certain isotope of platinum which weighs exactly one gram will contain exactly so many atoms.[26] Both of these claims are doubtless true, but neither helps us synthesize the various vocabularies we need to deal with the world.

As I see it, only people concerned to divide culture into science and non-science, the good rational part and the bad less-than-rational part, would have made a big deal out of drawing a line between the found and the made.[27] Plato

was one such, and Carnap another. Both thought mathematics important because it promised a kind of strictness which they thought the rest of culture—or, at least, the part that purported to deal with the found rather than with the made—should imitate. The distinction between unified empirical science and the rest of culture was Carnap's way of taking the old Platonist division of culture away from the rationalists, and turning it over to the empiricists.

In the last paragraphs of "Two Dogmas," Quine helped to kill off the found-made distinction, and also helped facilitate Deweyan and Kuhnian attempts to fuzz up the distinction between science and non-science. But in chapter 2 of *Word and Object* he resuscitated the found-made distinction, in the form of the "matter of fact" vs. "no matter of fact" distinction. Davidson, in "On the Very Idea of a Conceptual Scheme," carried through on the good work begun by "Two Dogmas." His dissolution of the scheme-content distinction has made it easier for Deweyan fuzzies like me to criticize the Quinean idea that elementary particles are somehow more found, and less made, than the birds and the beliefs.

But Davidson seems to have retained a certain amount of sympathy with the impulses that led Plato and Carnap to find big epistemological gaps in culture, and big ontological gaps between the various things we talk about. My own Deweyan conviction, of course, is that these impulses should be firmly repressed, rather than sympathetically cultivated. I hope that my criticisms of his defense of the indeterminacy of translation may lead him to say a little more about what he thinks is living, and what dead, in the tradition which finds the found-made distinction important.[28]

<div align="right">RICHARD RORTY</div>

UNIVERSITY OF VIRGINIA
OCTOBER 1996

NOTES

1. "The World Well Lost," *Journal of Philosophy* 69 (26 October 1972): 649–65; reprinted in my *Consequences of Pragmatism* (Minneapolis: University of Minnesota Press, 1982).

2. "Indeterminacy of Translation and of Truth," *Synthese* 23 (March 1972): 443–62.

3. My arguments in that article paralleled, and borrowed from, Hilary Putnam's "The Refutation of Conventionalism." Putnam had said there that Quine seemed to be making "an essentialist maneuver" in arguing for indeterminacy. See Putnam, *Mind, Language and Reality* (Cambridge: Cambridge University Press, 1975), p. 174.

4. Davidson had made his agreement with Quine explicit in "Mental Events" (1970). There he says, for example, "The heteronomic character of general statements linking the mental and the physical traces back to the central role of translation in the description of all propositional attitudes, and to the indeterminacy of translation. . . ." Davidson, "Mental Events" in *Essays on Actions and Events* (Oxford: Oxford University Press, 1980), p. 222.

5. Davidson dislikes the term "pragmatism" because his definition of a pragmatist is somebody who identifies truth and assertability. I have tried to redefine pragmatism as anti-representationalism, arguing that what is essential to James's and Dewey's philosophical initiative is giving up the question "how accurately are we representing the world?" in favor of "how well are we getting what we want out of the world?" See the Introduction to my *Objectivity, Relativism and Truth* (Cambridge: Cambridge University Press, 1991).

6. At p. 176 in *Inquiries into Truth and Interpretation*, Davidson says "It seems to be the case, though the matter is not entirely simple or clear, that a theory of truth that satisfies anything like [Tarski's] Convention T cannot allow an intensional semantics, and this has prompted me to show how an extensional semantics can handle what is special about belief sentences, indirect discourse, and other such sentences."

It is not clear that Davidson is still interested in this latter attempt—the so-called "Davidsonian program." I do not see an easy way to combine his earlier claim that a learnable language must have a recursive structure, the sort of structure captured by a truth theory for the language, with his more recent view that since "we have discovered . . . no portable interpreting machine set to grind out the meaning of an arbitrary utterance," "we may say that linguistic ability is the ability to converge on a passing theory from time to time." "A Nice Derangement of Epitaphs" in *Truth and Interpretation: Perspectives on the Philosophy of Donald Davidson*, ed. Ernest LePore (New York and Oxford: Blackwell, 1986), p. 445. I should be happy to find that Davidson had lost interest in both recursivity and extensionality, but I am not sure whether he has or not.

7. Quine, *Theories and Things* (Cambridge, Mass.: Harvard University Press, 1981), p. 23.

8. Roger Gibson, "Translation, Physics, and Facts of the Matter," in *The Philosophy of W. V. Quine*, ed. Lewis E. Hahn and Paul A. Schilpp (La Salle, Ill.: Open Court, 1986), p. 150. For Quine's comments on Gibson, see pp. 155–57 in the same volume.

9. I discuss Quine's use of "information" at pp. 224–25 of *Philosophy and the Mirror of Nature*, arguing that Quine has no way to answer the question of when electricity is just electricity and when it is data, or information, or input. My point is that Quine's use of these latter notions presupposes what Daniel Dennett calls a "Cartesian Theatre," on whose screen data appear and are viewed by the theory-building mind. By contrast, Davidson's purely causal view of impacts on our sense organs permits him to ignore the question I claim Quine cannot answer.

10. In "The Method of Truth in Metaphysics" (1977) Davidson says that his metaphysics is that of events, persons, things, etc.—whatever you have to talk about to state a truth theory for English. But this is not the invidious sort of ontology which

Quine has in mind when he says that he does not want there to be more things in his ontology than there are in heaven and earth.

11. John McDowell says, correctly, that Davidson is "blandly confident" that "empirical content can be intelligibly in the picture even though we carefully stipulate that the world's impacts on our sense have nothing to do with justification." McDowell, *Mind and World* (Cambridge, Mass.: Harvard University Press, 1994), p. 15. As McDowell also says, "Rorty singles out for commendation precisely the aspects of Davidson's thinking that I have objected to." (Ibid., p. 146). What I commend is the idea that, in McDowell's terminology, the world has no "rational" control over our beliefs, but only causal control.

12. This article is in *A. J. Ayer: Memorial Essays*, ed. Griffiths (Cambridge: Cambridge University Press, 1991), at pp. 153–66.

13. *International Journal of Philosophical Studies* 3 (1995): 1–16.

14. Someone might rejoin at this point that there are two things, Fahrenheit temperature and Centigrade temperature. So two apparently conflicting reports of temperature, one for each scale, are not really contradictory. But there is only one way the world is, and so two conflicting physical theories really are contradictory. But that rejoinder would beg the question at issue: the question of whether it is all right to posit as many temperatures as scales, but not all right to posit as many worlds as theories. Pragmatists think that the question "which scale shall I use?" and the question "which theory shall I use?" are both questions about utility, and that the claim that there are *really* one (or many) temperatures is as pointless as the question whether there are *really* one (or many) worlds.

15. I do not have space to discuss Davidson's version of mind-body identity theory. Nor do I feel that I have a good grasp of it. Davidson's approach to the topic seems to many commentators to presuppose that unless there were such token-token identity there would be no causal efficacy to mental states—as if causal efficacy were something physically-described things, but not mentally-described things, could have. These commentators then proceed to accuse Davidson of a version of epiphenomenalism.

I am not sure that Davidson in fact has such a view of causal efficacy, but maybe he does. Conversation about this with Ken Taylor has suggested to me that there is a line of thought, stemming from "Actions, Reasons and Causes," which inclines Davidson to associate the non-mental with the causally efficacious, and another line of thought, stemming from "On the Very Idea of a Conceptual Scheme" which inclines him against it. The former line of thought seems to involve the premise that only where there are strict laws is there causal efficacy. If, as I do, one views strictness as an artifact of idealization, this claim is implausible.

16. Mark Johnson's quasi-Fodorian article "Why Having a Mind Matters" (in *Actions and Events: Perspectives on the Philosophy of Donald Davidson*, ed. Ernest LePore and Brian McLaughlin [New York and Oxford: Blackwell, 1985], pp. 408–26) is relevant here, because it is an explicit criticism of Davidson. Johnson insists that there just *must* be something in between the folk and the physiological for psychologists to find. He says that "anything that deserves to be regarded as a science of mind will talk about things amounting to entertaining a thought or going through a process of inference, that is entertaining and manipulating *contents*. Despite the

difficulties with the attitudes, a science of mind can accommodate this so long as it characterizes thought-processes in terms of contents which are wholly determined by intrinsic state of the thinker's mind." (p. 423). At p. 424 Johnson characterizes Davidson's "interpretive view"—i.e., his taking "the propositional attitudes as constitutive of the mental"—as "anti-psychologistic."

Maybe someday something will turn up to gratify Fodor's and Johnson's hopes for "a science of the mind." Maybe the next breakthrough in understanding how human beings work will be top down rather than neurological and bottom up. If so, we shall doubtless require some new concepts—some new tools—and we may see Fodor's "narrow content" and Johnson's "intrinsic states of the thinker's mind" as place-holders for these new concepts. But in the meantime Davidson is surely entitled to confine himself to folk psychology, since that is all we presently have. Davidson (and I) cannot see what a missing link between the folk and the psychological could look like, any more than Newtonians could imagine what would count as gravity-explaining "intrinsic properties of matter." But who knows? Something might turn up.

17. One advantage of this spectrum way of thinking of the matter is that it helps bring some recent, fairly abstruse controversies in the philosophy of psychology together with some of the fine old controversies between "absolutists" and "relativists"—the controversies we use to get people interested in philosophy in the first place. Consider, for example, Kant's absolutist view of the nature of moral goodness. Kant thought that nothing was morally good but a good will, and that there was a single criterion for goodness of will—namely being determined by the consciousness of the moral law alone. The effects brought about by the acts which that will performed were as irrelevant to the question of whether it was in fact good as are the effects brought about by the uses of gold to the one true criterion for the application of the term "gold"—its chemical constitution. Kant's was a non-holist and internalist about goodness.

Kant was, prudently, willing to be holist and external about prudence. Other moral philosophers have suggested that the difference between morality and prudence is not all that great, and that goodness is as causal a concept as elasticity. They have said that an action is good if it can be expected to lead, ceteris paribus, to a greater amount of human happiness than any alternative action. Still other moral philosophers have agreed that good is a causal concept, but have insisted that it is more multi-criterioned than the utilitarians thought.

These people tend to get criticized as "relativists." Some of them, the pragmatists among them—try to defend themselves by saying that nothing has an intrinsic nature anyway, and that it is as unprofitable to talk about intrinsic values as it is to talk about intrinsically mental properties or about the intrinsic essence of gold. "Intrinsic," on the pragmatist view is just a laudatory buzzword. We pragmatists think that all talk about anything is talk about its relations to other things. On our view, single- or few-criterioned concepts are not successful attempts to zero on in intrinsic properties, but rather the reflections of a sensible and tacit decision to keep some things simple so that the complexity of others can be better revealed—to close off some questions in order to keep others open.

18. See "Science," p. 3, where Davidson says, "Since for present purposes there is no point in distinguishing physiology from a special domain of physics, I'll talk from here on as if physics were the whole of natural science." Here, as at p. 15 of the

same article, he is using "natural science" in such a way as to exclude psychology.

19. Davidson, "The Structure and Content of Truth," *Journal of Philosophy* 87 (1990): 270.

20. "A Nice Derangement of Epitaphs," in *Truth and Interpretation: Perspectives on the Philosophy of Donald Davidson*, ed. E. LePore (Oxford: Blackwell, 1986), pp. 445–46.

21. Dagfinn Føllesdal, "Indeterminacy and Mental States," in *Perspectives on Quine*, ed. Robert B. Barrett and Roger F. Gibson (New York and Oxford: Blackwell, 1990), pp. 103–4.

22. "Comment on Føllesdal" in the volume cited in n. 16, p. 111.

23. The reference here is to Føllesdal's "Indeterminacy of Translation and Under-Determination of the Theory of Nature," *Dialectica* 27 (1973): 289–301.

24. Quine, "Reply to Roger F. Gibson, Jr.," cited in note 8 above. This passage confirms J. E. Malpas's suggestion that Quine thinks holism, all by itself, has ontological significance. See Malpas, *Donald Davidson and the Mirror of Meaning* (Cambridge: Cambridge University Press, 1992), p. 18 and 19n.

25. See Lewis, "Putnam's Paradox," *Australasian Journal of Philosophy* (1983): 226–28.

26. Janet Stemwedel helped me with the chemistry here.

27. It is instructive to compare the contributions (by Neurath, Bohr, Dewey, Russell, Carnap and Morris) to the preferatory section "Encyclopedia and Unified Science" of the volume *Foundations of the Unity of Science*, ed. Neurath, Carnap, and Morris (Chicago: University of Chicago Press, originally published in sections in 1938; republished in two volumes in 1955), pp. 1–75). Dewey was, predictably, the odd man out. He wanted to see a continuity between the particle physicist, the engineer, the farmer, and the chauffeur (p. 30), and to say that they were all using "the scientific method," because "the scientific attitude and method are at bottom but the method of free and effective intelligence," (p. 38). His idea of how to achieve "the linkage of the physico-chemical sciences with psychological and social fields of science through the intermediary of biology" was to "consider how various sciences may be brought together in common attack upon practical social problems" (p. 34).

By contrast, Carnap thought that he could show that "there is a common language to which both the biological and the physical laws belong so that they can be logically compared and connected" (p. 60). Morris thought that "the theory of signs gives the general background for the language of science" (p. 74). Russell, in a brief and dogmatic little piece called "On the importance of logical form," said that "The unity of science . . . is essentially a unity of method, and the method is one upon which modern logic throws much new light" (p. 41). Dewey would have had grave doubts about all three claims, and especially about the last clause of the passage quoted from Russell.

28. I am very grateful to Bjørn Ramberg for detailed and helpful comments on a draft of this paper.

REPLY TO RICHARD RORTY

I have always been grateful to Richard Rorty for his response to my thoughts about conceptual schemes. For a time it seemed to me almost no one else understood what I was getting at in "On the Very Idea of a Conceptual Scheme", and it mattered a good deal to me that Rorty not only grasped the main point but also endorsed it. Having found something he liked, he has ever since tried to improve my other views. This is generous of him, and I will reciprocate by trying to persuade him that some of those views are not as noxious as he fears.

In the present essay he is mainly concerned to wean me away from Quine's thesis of the indeterminacy of translation, or, as I translate it, the indeterminacy of interpretation. He associates this with my insistence that certain basic psychological concepts are irreducibly different from non-psychological concepts, and he finds this insistence equally wrong-headed. I start with the indeterminacy of translation and interpretation. Rorty is afraid indeterminacy implies that there is something mysterious, second rate, or even not quite real, about the mental, that there are no "facts of the matter" about meaning or the propositional attitudes. I want to put his mind at rest on this score. In my view, the mental is no more mysterious than molecular biology or cosmology. Our mental concepts are as essential to our understanding of the world as any others and we could not do without them. To have or acquire a propositional attitude, such as an intention, desire, belief, hope or fear, is to have or acquire a property in as objective a sense as can be, like a battery having or acquiring a charge or a car a coat of paint. How could there be a question about the *ontology* of mental entities for me if, as I hold, mental entities are identical with entities we also describe and explain, in different terms, in the natural sciences?

Rorty's trouble is partly based on an early mistake of mine. In "Mental Events" I did maintain that the irreducibility of mental concepts was due, among other things, to the indeterminacy of interpretation (Rorty quotes the

passage in note 4). This was wrong, as I have since admitted in "Three Varieties of Knowledge". The error is obvious: indeterminacy as I understand it is endemic in all disciplines. Indeterminacy is nothing more than the flip side of invariance. Indeterminacy occurs whenever a vocabulary is rich enough to describe a phenomenon in more than one way. It doesn't matter whether you say Sam is to the left of Susan, or that Susan is to the right of Sam. If you have the axioms that define some system of measurement, whether of weight, temperature, or subjective probability, you can represent the structures so defined in numbers in endless ways. What matters is what is *invariant*. With weight, an arbitrarily chosen positive number is assigned to some particular object; relative to that assignment, the numbers that measure the weights of all other objects are fixed. You get an equally good way of keeping track of weights by multiplying the original figures by any positive constant; it's the *ratios* that are invariant. Invariances are "facts of the matter".

This is how I understand the indeterminacy of translation and interpretation. Given the richness of all natural languages, it would be surprising if it were not always possible to describe the facts of any discipline in many ways. Such indeterminacy does not threaten the reality of what is described. Of course, confusion results if we do not take into account the relativity of some way of describing things to the appropriate scale or mode of description: it matters whether your numbers are Fahrenheit or Centigrade, your weights pounds or kilos, your distances miles or kilometers. The analogy with the case of sentences or the contents of propositional attitudes is this: Each of us can think of his own sentences (or their contents) as like the numbers; they have multiple relations to one another and to the world. Keeping these relations the same as far as possible, we can match up our sentences with those of a speaker, and with the attitudes of that speaker, in different ways without changing our minds about the facts. Just as endless sets of numbers allow us to keep track of the same complex structures in the world, so our sentences can be used in endless different ways to keep track of the attitudes of others, and of what they mean. Quine made this point in order to emphasize that there is no more to the identification of meanings than is involved in capturing these complex empirical relations. This can sound like a negative thesis, and it is; it is an attack on the idea that meanings can be captured in exactly one way, by pinning Platonic meanings on expressions. But this negative point does not entail that there are no facts of the matter; the facts are the empirical relations between a speaker, her sentences, and her environment. This pattern is invariant. Measurement is holistic in the plain sense that it is always a matter of placing something in a clearly defined pattern of other things. I agree with Rorty that the holism of the mental has no ontological implications.

If we actually employed more of the possible ways of reporting what

someone means and thinks, we would want to be explicit about the system we were using. In practice, we pretty much stick to one way; it's as if everyone spoke Centigrade or Miles or Kilograms. But for theoretical purposes, it is good to know what our assignments are relative to; they are relative to a language. Not our own language, of course, but the language of the speaker or agent. When in our ordinary dealings with others we make small adjustments in our reporting of what someone meant or thought, we silently change the language we take that person to be speaking. Quine calls this changing the translation manual, but this makes it seem that there is something in addition to the usual relativity of a theory of meaning to a language, while in fact only one relativization is required, and it is familiar.

Rorty says he discerns no distinction between the underdetermination of a theory and indeterminacy. I do. Theories are interesting and valuable mainly because they entail what hasn't been observed, particularly, though not only, in the future. It is an empirical question whether such a theory holds for the unobserved cases—a question to which we shall never know the whole answer. As Hume and Nelson Goodman have told us, there are endless things that may happen next, many of which would disconfirm our present theories. This is underdetermination. Indeterminacy is not like this; no amount of evidence, finite or infinite, would decide whether to measure areas in acres or hectares.

What I am expounding is my own view of indeterminacy and under-determination. It is clearly at odds with Roger Gibson's way of explaining Quine's view of the distinction, which does make it seem to have ontological implications, and give a peculiar twist to the phrase "facts of the matter". I don't know about Quine, but my way of taking the distinction has no ontological significance whatever, and so cannot imply that there is something slightly unreal, inferior, or underprivileged about mental phenomena.

In his sixth note Rorty suggests that there is a connection between my desire to give an extensional semantics for sentences that attribute propositional attitudes and dissatisfaction with intensional idioms. This is confused. One can reject correspondence theories of truth and representationalism, and agree with Dewey that all our idioms are tools for coping with the world without losing interest in having a satisfactory semantics. Promoting an extensional semantics has nothing to do with reducing psychological concepts to those of the natural sciences, something I am more certain cannot be done than Rorty is.

I am baffled by Rorty's distaste for formal semantics: it seems to me at odds with his generally tolerant attitude toward borderline enterprises. One is reminded of old battles over where to draw the lines between philosophy and, say, literature or mathematics or psychology. A philosopher may be interested

in many things while not giving a hoot about formal, or semi-formal, semantics as applied to natural languages. But why does Rorty mind if I happen to find formal semantics useful, interesting, and capable of throwing light on a number of concepts such as truth, the validity of logical inferences, the learnability of natural languages, and relations between a speaker and the world as mediated by language? I suspect that his distaste springs in part from the fear that by formulating this relation, normal semantics is in danger of encouraging the dread idea that language and thought *represent* or mirror the world. But there is no danger. Tarskian semantics introduces no entities to correspond to sentences, and it is only by introducing such entities that one can make serious sense of language mirroring or corresponding to or representing features of the world. The simple thesis that names and descriptions often refer to things, and that predicates often have an extension in the world of things, is obvious, and essential to the most elementary appreciation of the nature both of language and of the thoughts we express using language. Rorty is wrong if he holds it suspect.

Rorty likes "A Nice Derangement of Epitaphs" because it seems to break down the distinction between the sort of meaning that formal semantics deals with and the rest of what we know about the world. But he senses a conflict between the importance I assign to formal semantical theories and the "there is no such thing as a language" attitude of "A Nice Derangement of Epitaphs". I see no conflict. The Wittgensteinian and Tarskian modes can be reconciled by emphasizing the importance of a general institutionalized linguistic background against which deviant verbal behavior is understood. The members of a "speech community" share a host of overlapping, non-identical, habits of speech, and have corresponding expectations about what others in the community will mean by what they say (such a set of expectations is what is characterized by what I called a "prior theory"). It would be possible for each speaker to have a radically different language; then each hearer would have to extemporize a mode of interpretation. In practice this would be intolerable, perhaps humanly impossible: hence the survival value of conforming. The thesis of "A Nice Derangement of Epitaphs" is not that as philosophers we should abandon interest in formal theories, but rather that knowledge of some such theory is neither necessary nor sufficient for understanding a speaker. This is, after all, a Wittgensteinian point, and it suggests how Rorty might be persuaded to accept (while not applauding) my perverse interest in Tarskian semantics.

Does it make sense to speak of a theory in the case of Mrs. Malaprop? The idea I had in mind was simple. An interpreter in a particular conversational situation is prepared with a general set of expectations (which the "prior theory" describes). When expectation is thwarted, what is novel is (usually

automatically) accommodated (read "arrangement" for "derangement", "epithets" for "epitaphs"). If the speaker goes on like this, these substitutions in all possible contexts yield a new language, which can be delineated by a "passing theory". Slots in the "prior theory" have been filled in new ways. The apparatus of a "prior theory" and "passing theory" was an unnecessarily cumbersome way of expressing this thought.

I agree with Rorty that "we are equally in touch with reality when we describe a hunk of space-time in atomic, molecular, cellular, physiological, behavioral, intentional, political, or religious terms." Hunks of space-time are real enough, so whatever we say about them, we are "in touch with reality", even if we describe some hunks as witches, griffons, or gods. But saying this does not eliminate differences, and I persist in thinking that the intensional idioms of psychology (whatever their semantics) differ from the rest. The differences do not, I hope I have made clear, touch on ontology, nor are they invidious in the sense of downgrading the mental terms relative to vocabularies of the natural sciences. What I have chiefly emphasized is the irreducibility of our mental concepts. They are irreducible in two senses. First, they cannot be defined in the vocabularies of the natural sciences, nor are there empirical laws linking them with physical phenomena in such a way as to make them disposable. Second, they are not an optional part of our conceptual resources. They are just as important and indispensable as our common-sense means of talking and thinking about phenomena in non-psychological ways.

To speak of a difference between vocabularies is not to imply a "gap" large or small; our vocabularies mix freely. It is worth emphasizing the irreducibility of the mental, but only because the irreducibility springs from something more interesting than the indeterminacy of translation and interpretation, degree of complexity, clarity, or holism. What makes the difference is the constitutive role of normativity and rationality in psychological concepts, a role they do not play in the natural sciences.

Normativity is constitutive of the mental because the mental is built on a framework of attitudes which have a propositional content, and propositions have logical relations to one another. Reasoning, no matter how simple and unstudied, is a matter of putting thoughts together in ways that are assessable as reasonable both by the agent and by others. Every action is describable in terms of intentions, and intentions are based on reasons that are, again, judged as rational or not by the agent and others. All genuine speech is intentional, and can be understood only by interpreters equipped to grasp key intentions of speakers. The norms I am concerned with here are not the norms of responsibility, obligation, or morality. The basic "virtue" that sets mental concepts off from those of the natural sciences is the special sort of charity

required for understanding the thoughts, speech, and other actions of agents, and such charity is not a virtue, but simply a condition of understanding the thought and action and talk of thinking creatures.

Charity is a matter of finding enough rationality in those we would understand to make sense of what they say and do, for unless we succeed in this, we cannot identify the contents of their words and thoughts. Seeing rationality in others is a matter of recognizing our own norms of rationality in their speech and behavior. These norms include the norms of logical consistency, of action in reasonable accord with essential or basic interests of the agent, and the acceptance of views that are sensible in the light of evidence. Interpreting others is not like comparing one insect with another only in this respect: interpreting others is a matter of using (not looking at) my own values and thoughts, my norms and rationality, to understand someone else's. I do not expect to find propositional attitudes, or the kind of norms and rationality they entail, in a beetle. I cannot see the harm in pointing out this difference, nor point in arguing about its magnitude.

D. D.

25

Bjørn Ramberg

THE SIGNIFICANCE OF CHARITY

Davidson's view of the mental has drawn persistent fire from two quarters. There are those who hold that if mental predicates really are irreducible for the reasons that Davidson offers, then a vocabulary which employs them is in important ways deficient, second-rate, not suitable for serious accounts of the way the world is. So Davidson's view of the mental is not, contrary to his intentions, one that reconciles ingenuous, full-voice use of the categories of thought and agency with our faith in vocabularies of naturalistic enquiry. Then there are those, standing at a different angle, who find the irreducibility which Davidson attributes to our vocabulary of the mental not especially interesting, since it does not distinguish this vocabulary from others which stand in no particular relation to intentions, beliefs, desires, meanings, and the like. So Davidson's anomalous monism does not, contrary to his intentions, mark off the mental as one distinctive member of a contrasting pair of conceptual categories which jointly exhaust our ways of describing what there is.[1]

Forces from these two camps often join up, pressing upon Davidson a dilemma; either the mental is not very special, or it is not very real. You cannot, say these critics in unison, be a conceptual dualist and a naturalist at the same time. In what follows, I shall try to understand how Davidson takes the mind-body distinction to mark a fundamental divide in our picture of the universe. I shall wonder also how such a distinction can be maintained within a naturalistic framework, and why one would want to. Pursuing these questions, I shall be concerned mostly with the first horn of the alleged dilemma. Starting off from "Mental Events" (Davidson, 1970), I consider the significance of Davidson's irreducibility-claim for his conception of the mental. I come to think that, for all anomalous monism implies, mental predicates may or may not come to be incorporated into natural science, in which process they may or may not get "reduced" or dropped altogether. This may create the appearance that Davidson vastly overdramatizes the significance of the distinction he draws between the mental and the physical. But the

reality, I contend, is that the approach to Davidson's mental-physical contrast afforded by the argument for irreducibility cannot show the point of the distinction. In any case, whether predicates of mind are or are not reducible—in this or that sense of "reducible"—to terms of one or another non-mental variety, is not in my view the sort of question we should think of as having a substantive answer to be uncovered by philosophical argument. To think that it does, presupposes more faith in things like concepts and meanings than I am able to muster. Philosophical argument, rather, is about what sort of attitude we should take towards different possible developments within and among the vocabularies we discern at our disposal.

I should like, accordingly, to think of Davidson as engaged in a project of showing us that we need feel no pressure to bring about the reduction of the terms by which we typically characterize what is going on in people's minds. As I read him, he isn't constructing a priori arguments to the inconceivability of the reduction of our idiom of meaning and mind—rather, he is offering an antidote to the pangs of naturalist guilt that some of us—like good Protestants spending borrowed money—suffer as we continue to attribute intentional states before they are properly regimented through a psychology which lines them up with respectable predicates of natural science.

The argument for anomalous monism which Davidson offers in "Mental Events" and develops in later papers, plays an important part in this project.[2] The role, however, is largely a negative one. The positive import of Davidson's notion of mind lies in his familiar account of interpretation, which depicts it as tracking the patterns that reason makes in the events we are able to describe as actions. Here I have nothing new to say about the details of this account. The point I should like to make is that its real significance—which is to say, the import of Davidson's claim that our universe divides into two fundamental categories—emerges fully only against the background of Davidson's view of the physical. We must, I suggest, query Davidson's understanding of the physical if we are to tell whether the principle of charity really does spell ontological relief for the naturalist with attitude(s).

In section II of "Mental Events," Davidson argues that there can be no strict psycho-physical laws. The critical point is that "the attribution of mental phenomena must be responsible to the background of reasons, beliefs, and intentions of the individual"[3] (222). The application of the propositional-attitude scheme depends on constitutive principles which, as Davidson says in "Psychology as Philosophy" (1974), "have no echo in physical theory" (231). These are the principles which a radical interpreter must go by, in order to begin to get a theory about what the words of a speaker mean and what thoughts the speaker has; without them, observations of the linguistic and other behaviour of a speaker could not constrain interpretation. In order to have a theory based on evidence at all, the radical interpreter cannot but find

any language-user to be largely rational; "consistent, a believer of truths, and a lover of the good (all by our own lights, it goes without saying)" (222). It is thus the principle of charity, as constitutive of the vocabulary by which we describe thought-imbued, purposive agency, which underwrites Davidson's version of the claim that "there is a categorial difference between the mental and the physical" (223).

Davidson develops this difference in terms of the contrast between homonomic and heteronomic generalizations. The former "are generalizations whose positive instances give us reason to believe that the generalization itself could be improved by adding further provisos and conditions stated in the same general vocabulary as the original generalization. Such a generalization points to the form and vocabulary of the finished law" (219). Heteronomic generalizations, by contrast, of which "general statements linking the mental and the physical" (222) are examples, "may give us reason to believe that there is a precise law at work, but one that can be stated only by shifting to a different vocabulary" (219). Davidson introduces this distinction as one "to be made within the category of the rude rule of thumb" (219), but in fact it is hard to see how generalizations could qualify as homonomic unless they are embedded in developed empirical theory. For the refinement transforming homonomic generalization into "finished" law is to be brought about without modifications of a sort that would incline us to say that we were switching vocabularies in the process. So unless our notion of a vocabulary is very course-grained, or we are very liberal in what we count as "pointing to," it seems that homonomic generalizations are products of the sort of advanced empirical theory-construction that eventually issues in the formulation of laws.

In fact, this observation meshes well with Davidson's view. "Within the physical sciences," he says, "we do find homonomic generalizations, generalizations such that if the evidence supports them, we then have reason to believe they may be sharpened indefinitely by drawing on further physical concepts . . ." (219).

However, if homonomic generalizations are subject not just to "improvement" but to "indefinite sharpening" in terms of the vocabulary in which they are phrased, asymptotically approaching what Davidson calls a "finished law," then it appears that the latter must be laws that are maximally strict. After all, the relations captured in homonomic generalizations cannot, by stipulation, be stated more sharply by recourse to some other vocabulary. If this is the case, homonomic generalizations are available only in quite specialized terms, terms which "point to" the vocabulary in which we can formulate "a comprehensive closed theory," since only in such a vocabulary are maximally exceptionless laws a possibility. This vocabulary is made up of the predicates of physics, since on Davidson's conception of this subject its governing interest is to articulate maximally exceptionless laws. Homonomic

generalizations, then, turn out to be the sort of generalizations by which physics, or those sciences which can hope one day to be incorporated into physics, develops.

Since homonomic generalizations are available only in—or in the very close vicinity of—a vocabulary which holds out the promise of strict law, other generalizations, including, as Davidson acknowledges, most scientific ones, will be heteronomous. The heteronomy of psycho-physical generalizations, then, seems to encapsulate a relation between mental predicates and those of physics, a relation which is far from unique to these two sets of terms. The quality of being nomologically irreducible to physics is not a particularly distinguished or distinguishing property.

Perhaps, though, the heteronomy of generalizations in natural science is a kind of deficiency, an expression of our failure to have, as yet, achieved the sort of unity to which natural-scientific enquiry aspires? In that case, since the heteronomic nature of psycho-physical generalizations is, on Davidson's account, irremediable in principle, we may perhaps still draw the distinction we are after in terms of the potential for reducibility. However, I do not think this strategy can work. To see why, let us, taking a cue from Rorty (1996), consider biology.

In the opening chapter of *The Blind Watchmaker*, Richard Dawkins explains to the lay reader what he takes to be the constitutive purpose of biology, and how it differs from, and relates to, physics:

> The biologist's problem is the problem of complexity. The biologist tries to explain the workings, and the coming into existence, of complex things, in terms of simpler things. He can regard his task as done when he has arrived at entities so simple that they can safely be handed over to physicists. (Dawkins 1986: 15)

Dawkins's straightforward account of the external relations of biology is appealing. He labels it "hierarchical reductionism" (13), and takes pains to emphasize how benign this "reductionism" is. I would suggest, though, that the explanatory continuity which Dawkins rightly insists on doesn't require "reduction," in any clear or useful sense of the word, at all. For the "handing over" from the biologist to the physicists that Dawkins talks about is typically not a matter of applying bridging laws or definitionally linking predicates. As we know, there are numerous kinds invoked in the explanations produced by evolutionary theory that cannot be systematically replaced with chemical or other more basic predicates. What often is the case, however, is that the evolutionary mechanisms invoked by the biologist in explanation of why particular biological properties are distributed as they are, can be seen, in the particular case, to be the result of processes which the chemist and eventually the physicist has the resources to account for in terms of the laws of their

disciplines. We should take care not to fall into thinking of this kind of piece-meal "handing over" as a handing-over of the phenomena, as if the only one who gets to hold on to the things we talk about, and thus be really talking about things, about what there is, is the basic-account physicist. That a kind of thing is constituted, in its concrete instances, by diverse sets of other things, doesn't make it any more or any less useful or attention-worthy kind of a thing. Similarly, that an explanatory mechanism in its instances of effect runs by way of diverse and unrelated processes does not make it any less explana-tory or theoretically valuable. What gets passed along is the explanatory baton, the task of making evident to ourselves why things are as they are and go as they do. Being cautious, perhaps we shouldn't talk of handing over "entities," but rather the responsibility of accounting for mechanisms and processes. To pass this baton smoothly is to attain a contiguity of explanatory theory, which seems to me to provide all the unity that we might desire for natural science.

Clearly, achieving this kind of contiguity of theory is no small feat. When a mechanism appealed to in a special science is re-identified in the language of a more basic science as a process subject to explanation in its terms, this cannot be a matter of purely serendipitous token-by-token redescription. "Handings-over," explanatorily useful re-identification of mechanisms, will not be of literally individual instances, but of subclasses of instances, which are distinguishable, recognizable as kinds, in both vocabularies. So we must have developed at least a limited descriptive convergence, empirical and theoretical work will have developed local identities, limited and quali-fied—but diagnosable—coextensions of predicates of separate vocabularies. Such events are often great breakthroughs. The point here is that they can, and often do, occur without our developing links between scientific vocabularies that are general enough to qualify as nomological or definitional. This is enough to dissociate the ideal of unity and the ideal of reduction in natural science. Where there is unity, but not reduction, contiguous scientific vocabularies continue to differ in the role they assign to various ways of classifying phenomena. A simplifying and explanatorily powerful evolutionary mechanism will from the physicist's point of view consist in a theoretically pointless conjunction of physical processes, just as the physicist's classifica-tion of events would, if allowed to shape the biologist's kinds, result in a fragmentation of theory and diminished explanatory power.

Now the point is this. If this kind of conceptual diversity is compatible with explanatory unity, couldn't mental states, for all that anomalous monism rules out, be accommodated into natural-scientific enquiry? Could not scientific intentional psychology, regimenting and refining the vocabulary of folk psychology, aspire to the sort of conflict-free relation to the physical

sciences that biologists have achieved? And if so, what is the point of setting the mental off as a special category, in apparent contrast with other vocabularies not just in the way that these contrast with one another, by virtue of the special interests that shape their categories, but with all of them, taken together as some kind of unity?

Considerations like these are intended to deflect the impact of arguments for the irreducibility of mental predicates on various strategies for naturalizing mental states. Grant their irreducibility, why should this convince us that mental predicates are importantly different from those of various special sciences—or some other set of predicates designed to cut distinctions and kinds in accordance with some particular set of human needs or interests? Rorty has used this sort of reasoning to suspect that Davidson's "categorial difference" is just an anti-naturalistic hang-over, a spurious philosophical distinction. Fodor employs similar observations about obstacles to reduction of the key terms of special sciences to suggest that intentional psychology is no more recalcitrant—in principle, at least—to empirical theory than is geology or aerodynamics. Both conclude that Davidson's mental-physical distinction is seriously overblown, or over-billed.

Here's another line of thought that reaches the same diagnosis, by a converse route. There are, to be sure, some striking examples in the history of science where the achievement of descriptive convergence has provided not just piece-meal "handings-over," but has triggered massive theoretical breakthrough, allowing systematic redescription of the phenomena of a particular scientific vocabulary to the point where that vocabulary becomes explanatorily dispensable, a mere province of a more powerful vocabulary of greater generality. Perhaps philosophers sometimes over-emphasize the role of bridge laws and definitions in the actual unfolding of these breakthroughs. Then again, perhaps such devices are important when we try to make perspicuous the nature and significance of the transition. However that may be, there will in any case be an element of looseness in the laws and definitions that maps it out. So these cases do not constitute reduction in the sense that Davidson's anomalous monism rules out, namely reduction by strict law. This fact is exploited by Jaegwon Kim (1993), who argues that the conception of reduction at work in the argument for anomalous monism is "unrealistically stringent," and so to hold the mental to be irreducible in this sense has no bearing on our prospects for incorporating it into natural science. Granting non-strict psycho-physical laws, as Davidson (1993) explicitly does, raises a problem, argues Kim, which "Davidson and friends of A[nomalous] M[onism] seem not to have recognized" (Kim 1993: 26). Certainly, one can continue to deny the possibility of strict-law reduction. "But," Kim asks,

> why insist on reduction by strict laws only? *What's wrong with non-strict psycho-physical laws as 'bridge' laws?* If psychology is reducible by the same standards

that apply to the best cases of theory reduction in the sciences . . . why isn't that reduction enough? (Kim 1993: 26)

For all Davidson's anomalous monism implies, we have no reason to think that mental predicates are immune to reductive absorption into another vocabulary. So, again, we can grant the impossibility of strict psycho-physical laws, and still refuse to see the mental as an especially distinctive or fundamental category.

These lines of responses to anomalous monism domesticate the anomalousness of the mental by arguments from analogy. Their effectiveness turns on the fact that the premises of the argument for anomalous monism in effect set up the vocabulary of physics as the relevant contrast to the mental in Davidson's conceptual dualism. This is a result of the role of the notion of a strict law in the argument for monism which concludes "Mental Events." The argument turns on a principled distinction between the kinds of general statements that are required to back up singular causal relations, on the one hand, and the kinds of general statement that may unite mental and physical predicates, on the other. Davidson achieves this crucial contrast by requiring for causal relations the sort of law that is possible only in an ideal physics, a comprehensive, closed theory, which he calls strict, and by diagnosing psycho-physical generalizations as irremediably heteronomic, and therefore not absorbable into the domain of strict law. This seems to be quite clear; that with which the mental cannot be conceptually or nomologically united is physics.

What Davidson proposes is "a version of the identity theory that denies that there can be strict laws connecting the mental and the physical" (212). Our problem now is exactly how we are to take the sense of that with which the mental is intended to contrast. As Chomsky (1995) observes, a problem with the mind-body problem is that our concept of the physical is really in no better shape than our concept of the mental. If the conceptual category, "the physical," is taken expansively, to include predicates that we intuitively would class that way, but which have no prospect of making it into a closed system of strict law, then strict laws are anyway ruled out, and the denial Davidson offers seems pointless. Of course, it may still be interesting in this case to have established—if it could be established—that the mental is identical with something non-mental, however we conceive of that. If, by contrast, we take our notion of the physical to delineate the terms of a closed nomological system, then of course what is being denied of the mental can equally be denied of any set of predicates without prospects of incorporation into physics. In this case, however, it might still be useful to have been shown how something which is described in terms anomalously related to the predicates of physics might still also be captured by the latter. Speaking as if he is drawing a general mental-physical distinction, but arguing in fact only for the

irreducibility of the mental to the vocabulary of physics, and for the identity of mental events with events characterizable in terms of physics, perhaps Davidson tacitly assumes that all things physical "in principle" stand in an unproblematical relation to physics.

So then, is Davidson in "Mental Events" really talking about physics whenever he talks about the physical? Before we leap to an answer, we should bear in mind that the role of the irreducibility-claim, and indeed the point of the heteronomy-homonomy distinction, is quite specific; it has a dialectical part to play in the effort to establish that psycho-physical monism—in the form of the claim that mental predicates are true of events which are always also describable in terms of physics—*is implied by* the irreducibility of mental predicates to physical ones (in conjunction, naturally, with the other premises). It does no work in characterizing the distinctiveness of the mental. On the contrary, the principled heteronomy of general statements involving mental terms depends on an independent characterization of what it is that makes the mental distinctive. This, as we have seen, Davidson offers in "Mental Events" by invoking the principle of charity. From the point of view of the aim of the identity-argument, that the irreducibility of mental predicates upon which it rests is of an undistinguished sort is completely unimportant. Indeed, it indicates only that the argument for monism on offer is quite general, exportable to any set of predicates which permits statements of causal relations—whether general or singular—while being for some reason or other recalcitrant to the formulation of the sort of law which causal statements imply. If non-reducibility to physics is a widely-shared property, then anomalous monism turns out to be a doctrine which embraces a lot more than the mental. I take this to be one of Davidson's great achievements, that he has shown us how to dissociate reduction and ontology, thereby greatly reducing the philosophical significance of either pursuit. It would be a pity, from my perspective, if this liberation were confined to our talk of the propositional attitudes. Not with respect to the mental, nor any other vocabulary, is there a special, philosophical task which consists in tracing its conceptual relations to an ideal complete basic science, for then to pronounce upon its ontological legitimacy.

Taking the point of anomalous monism as I do, I must concede that anomalous monism *per se* leaves it an open question whether we should engage in serious efforts to incorporate ordinary mental terms into natural science. For I have to agree with Kim that the heteronomy of psycho-physical generalizations is not enough to show that such an effort must fail. But nor, of course, are such non-strict laws sufficient to show that reduction is a serious possibility, or an attractive alternative. Davidson acknowledges the distinctiveness of special sciences, and the irreducibility of their concepts to those of

physics. Yet, as he says, while "[t]he laws of many physical sciences are also not like the laws of physics . . . I do not know of important theoretical (as opposed to practical) reasons why they cannot be reduced to the laws of physics" (Davidson 1987: 45). What might this distinction mean? Actual cases of reduction in science, as Kim points out, are reductions by way of non-strict laws, where the slack in concepts is partly an expression, or symptom, of the greater power (strength, simplicity) of the one vocabulary, and partly of the fact that the categories of the narrower fragment are likely to reflect particular interests. Such interest-relativity also plays a part in those many cases where reduction is not achieved, or not sought after. What blocks reduction may well be, from the point of view of a particular science, theoretical concerns, having to do, for example, with its explanatory objectives. Still, perhaps there is some sense in which obstacles to such reduction are "practical," at least in many cases. It could be that the impor-tance to us of continuing to operate with descriptions of things that facilitate our interaction with them curtail more purely theoretical explanatory interests. But what would make the case of the mental any different? Clearly Davidson thinks that what is responsible for the anomalous nature of mental predicates is something that mental predicates share with neither geological, aerodynami-cal, biological nor any other set of terms, whether potentially absorbable by strict-law theory or not. Already in "Mental Events" he signals this in terms of the idea of distinct subjects, and in later writings he speaks of the uniqueness of the mental, and of switching from the vocabulary of the mental to physical vocabularies as a radical change of subject.[4] To get further here, to see how charity is intended to mark off the mental from all that is not, we need a way to understand the notion of the physical which can make talk of changing subject and switching vocabulary more than hand-waving. What is it about our diverse ways of describing phenomena as non-mental that joins these vocabularies together in contrast to the charity-structured predicates of meaning, thought, and action?

Twenty-five years after relying upon it in his argument for anomalous monism, Davidson revisits what he originally called "The Principle of the Nomological Character of Causality." When he does, this is not simply in order finally to patch up a neglected stretch of the reasoning in "Mental Events." "Laws and Cause" (1995) quickly moves to the core of Davidson's philosophical scheme of things, providing explicit articulation of views that make brief appearances in other papers, early and late, but which are never fully articulated. The explicit task of "Laws and Cause" is to give us reason to accept the cause-law thesis, as he now refers to the principle—that is, to give us a reason to think that singular causal statements imply the existence of a law covering the case. And this task Davidson carries out by elaborating

his view of the interests that give shape to our notion of the physical. Here, in a nutshell, is the connection Davidson sees between the cause-law thesis and the general category of physical object:

> The dispositions to which we advert to explain what happens to objects, or the things they do, encapsulate the relation between causality and laws. . . . The causal powers of physical objects are essential to determining what sorts of objects they are by defining what sorts of changes they can undergo while remaining the same object and what sorts of changes constitute their beginnings or ends. Our concept of a physical object is the concept of an object whose changes are governed by law. (Davidson 1995: 274)

If we accept this, Davidson suggests, then an event, what is recognized as a change, must be conceived so as to be capturable in terms of general relations. In that case,

> it is not surprising . . . that singular causal statements imply the existence of covering laws: events are changes that explain and require such explanations. This is not an empirical fact: nature does not care what we call a change, so we decide what counts as a change on the basis of what we want to explain, and what we think available as an explanation. In deciding what counts as a change, we also decide what generalizations to count as lawlike. (273)

I take the claim here to be that the whole point of our most general categories is to configure patterns that allow us to perceive events as tokens of general causal relations. The cause-law thesis, Davidson suggests, is built into the very application of the terms "object," "state," "change," and so forth.

Thus starkly put, the account of the principle undeniably has about it a whiff of stipulation. But even in the narrow context of the paper itself, this would not be a fair rendering. I discern two lines of thought in the paper, both of which I take to be intended to provide the account of the basic features of our vocabulary of the physical with plausibility. The main line brings that account to bear on the historical developments of physics. Davidson's examples show that theoretical changes which incontestably have greatly increased the power of physical theory, may be construed in a way that neatly fits his claim about the constitutive pressures that give point to our classifications both of physical objects and of the changes they undergo. The second line takes off from an allusion to Quine's conception of the continuum running from built-in similarity responses to abstract theoretical concepts. Davidson's point is that fundamental survival need ensures that we right from the start respond to our environment "as if we had learned crude laws." Together these lines illustrate Davidson's point. Both practical purposes and theoretical interest require that we perceive our environment in terms of generalities. And both may be sources of pressure that put the generalizations we at any one

time go by under strain. As Davidson says: "We then refine our classifications to improve our laws."

This last point is the critical one. What we count as an object and what we count as a state of an object, as well as what we count as a change, is governed by our fundamental interest in construing our environment in terms of generalities. This is an interest that we have, most fundamentally, as biological creatures. This point is what backs up the thesis. When we take two events as causally related, we thereby take them as nomologically related, because to recognize a change in the state of a physical object just is to recognize an event which is susceptible to explanation in terms of empirical law.

This summary of central points in "Laws and Cause," though brief, is enough to show that the discussion carries a trademark of Davidson's philosophical method; a key claim is defended by the elaboration of a view of the constitutive interests that give form to a vocabulary, and thereby is depicted as a truth which is built into the application of the terms of the vocabulary, giving them their point. If we are sufficiently attracted to Davidson's delineation of the vocabulary in question, and of how we do what we do with it, we will think of ourselves as inescapably committed to the claim, as a non-empirical principle. In this case, the vocabulary which Davidson is blocking out is a very general one, namely the vocabulary of physical objects, a vocabulary of which all our diverse ways of conceiving of physical objects are a part. Or perhaps it is better to say that he is depicting a constitutive feature which all physical vocabularies have in common. Either way, Davidson is providing us with his account of the proper contrast to the mental. Indeed, we can see how the quasi-aprioristic status Davidson assigns the cause-law thesis as a principle shaping our conception of the physical mirrors that of the principle of charity with regard to the mental. Just as our identification of the contents of people's minds and words implements and depends for its point on norms of rationality, so our identification of objects and the changes they undergo implements and is given point by the explanatory generalizations to which they yield, and by which we manage our dealings with them. Just as the interpreter cannot but find other minds largely rational, so the observer of physical events cannot but see them as, on the whole, instances of how things generally tend to go. We couldn't fail to discover general relations by which we understand the changes we perceive in the physical objects about us, because we are by nature disposed to count as changes and as persistent subjects of such changes whatever will yield general patterns allowing us to predict our environment.

What Davidson offers in "Laws and Cause" is a positive account of the physical which has room for non-reducible special sciences, but which has physics as its most highly theoretical and in an important sense most complete

project of characterization. In all physical vocabularies, on Davidson's picture, the very individuation of their characteristic kinds of objects, states, and changes is shaped by our biologically-rooted interest in generality. The special role of physics, in this scheme, stems from the fact that only for physics is this the all-governing concern; in physics, and only there, other constraints (I believe Davidson calls them "practical") on what we count as object, state, and change are always overridden by prospects of improved generality. This is the sense in which Davidson adheres to the Quinean dictum that it is uniquely the business of physics to strive for "full coverage"—that is, maximum generality, or maximum strictness of law. The application conditions of the terms of other physical vocabularies, by contrast, are fixed also and to varying degrees by whatever the special interests are that constrain their categories, and so to some extent or other limit their generality, impeding both the scope and the strictness of the general relations they enable us to articulate. Still, all physical characterizations are geared, within these constraints, to show up the general patterns in the changes that their objects undergo, general patterns the articulation of which amounts to providing a body of laws, or lawlike generalizations.

The view of the physical which is spelled out in "Laws and Cause" has informed Davidson's work for a long time. It is at work, for instance, in his treatment of Strawson's claim that the category of objects is conceptually prior to that of events, in "The Individuation of Events" (1969).[5] It seems reasonable, then, to think that this conception of the physical, and not physics, is what Davidson intends as the contrast to the mental, when he develops his distinction between the two. This, I think, makes it clear why Davidson considers the switch from the mental to the physical as a change in subject of a different order than one from one non-mental vocabulary to another. Special-science vocabularies may trace different patterns of events, and they may well, because we have interests in identifying events and objects of various kinds, remain forever distinct. The unity they offer, when we succeed, may be that of theoretical contiguity rather than merger. But the constitutive interest in generality, the inherent susceptibility to law of their terms, marks them as in an important sense a part of the same general descriptive project. This is true however distinct, and however diversely anchored in our explanatory interests, various theoretical structures of empirical law may remain. They contrast, as a body, with a vocabulary which depicts its objects as purposive, and in the realization of those purposes as subject to norms.

My purpose here has not been, evidently, to subject Davidson's conception of the physical to critical scrutiny, much less to question his account of the normative structure of our mental vocabulary. Indeed, with regard to the latter, I have simply helped myself to the principle of charity, and not even tried to suggest how we are to understand the normativity which it embodies.[6] Rather,

I have been concerned to show how Davidson recasts the mind-body distinction as a fundamental divide among our various descriptive strategies. It has turned out that Davidson rehabilitates the distinction against deflationary attacks; rather than relying on a more or less intuitive catch-all notion as contrast to his account of the mental, he provides a positive account of the most general features of our physical scheme.

It remains to see how this conception of the contrast between the mental and the physical bears on our naturalist aspirations. A preliminary point to make is that there is no reason to think Davidson's conceptual dualism precludes our doing any kind of serious empirical science that exploits mental events. It does not imply, contrary to, e.g., the reasoning in Rosenberg (1985), that the various social and behavioural sciences that incorporate mental attributions in their descriptions of data or in the mechanisms they postulate are not "properly scientific." For the purposes of much empirical science—even, I believe, for something as interpretatively delicate as the empirical investigation of our propensities to fall victim to cognitive illusions of various kinds—the actual attribution of propositional-attitude states is sufficiently robust that it will serve in induction and empirical generalization. Conversely, examples of successful empirical research programs which are unabashed about employing mentalistic descriptions does nothing to impugn the charity-account of the mental. Of course, any laws which theoretical endeavours involving such attribution may arrive at will remain non-strict. At this point, however, we may take it as beyond dispute that it would be unreasonable to view the irremediable non-strictness of its laws as sufficient grounds for considering a body of theory unscientific.

But this point is indeed preliminary—it does nothing to assuage naturalist worries. For what challenges our naturalist inclinations is that if we accept Davidson's account of the substantive and contrasting purposes of the vocabularies of the mental and the physical respectively, we will give up on the idea of a scientific intentional psychology conceived as the project of refining the folk-identification of mental states by developing a regimented and systematic classification of these states in terms that link them into non-intentional empirical science. Non-intentional science cannot give us better ways—better because integrated in natural-scientific theory—of identifying the states to which charity-driven predicates apply. So there is no hope of developing a better, more fundamental naturalistic understanding of what beliefs and desires really are, that would allow us to better predict and explain the actions of persons. This is worrisome. For in the normal case, our folk-vocabularies are subject to correction and reform as a result of our developing proper empirical theories about the phenomena they deal with. In the normal case, we take our claims and categories to depend for their legitimacy on their compatibility, at least, with what science reveals. In fact, we are now

confronted with the very point of the claim that the mental-physical distinction marks a fundamental divide. For it is exactly a feature of the physical as Davidson depicts it that we would expect our common physical sense to be correctable by empirical theory. And it is a feature of predicates structured by charity that they implement norms which, because of their role in the very individuation of states of mind, can be neither directly tested or assessed, nor, therefore, corrected, through empirical theories of mind. The very point of Davidson's distinction is to show how accounts of agents can "operate in a conceptual framework removed from the direct reach of physical law..." (1970, 225). To provide this space is what Davidson's category of the mental is for. The very purpose of his conception of it is to deny that its individuative principles could be revised or overridden as a result of empirical investigation of nomological relations obtaining between the kinds of things it recognizes.

But what is the import of a philosophical argument of this sort? It remains true that with regard to our current vocabulary of the mental, we could, as theorists, employ ordinary mental-state terms, incorporate them in specific theoretical projects, and in that process come to assign explicit state parameters that would permit smoother formulation of empirical laws linking these terms to descriptions of states and changes in lower, stupider, more modular levels of our cognitive machinery. We could do this and maybe learn much about the relation between brain and behaviour. And we would still be, as many cognitive-science oriented philosophers have stressed in response to Davidson, a very long way from, and perhaps utterly without interest in, physics. In doing this, though, in altering the application conditions of the terms of agency-description, we are relying on ordinary words to develop new conceptual tools; in Davidsonian terms, we are specifying a conception of what to count as states, events, and objects of a certain sort, in an effort to facilitate certain kinds of explanation. These regimented tools are suitable, if we succeed, for tracking interesting patterns in the causal connections that obtain between events. As we come to know these patterns, that knowledge might have great practical significance, perhaps trickling down into modifications of current common sense about why people do what they do (common sense being laudably eclectic). Still, what we would have succeeded in doing in this case, as we might put it in the terms of "Laws and Cause," is to take a mental vocabulary and transform it into a physical one. The patterns such a science reveals are not the very same patterns to which our non-scientific use of mental terms is sensitive, and the latter would not have been illuminated, or better understood, as a result of the transformation. Perhaps, if the discrepancy between the use of terms in such a scientific psychology and in ordinary psychological ascription becomes great, new terms would be brought in, either in the one domain or the other. For I doubt that the development of a nomothetic, non-charitable psychology, however scientifically fruitful,

would noticeably affect ordinary patterns of propositional-attitude attribution. Though it might well in time have an impact on some of our intuitions about where such attribution has a point and where it does not.

The reason for the likely persistence of the vocabulary of agency, as I see it, is not particularly metaphysical. Nor has it anything to do with an alleged performative contradiction befalling any attempt to abandon a conception of thought as a matter of following norms. The reason, rather, is that it looks like we are built to be sensitive to the sort of pattern that norm-tracking agency-predicates reveal. Speculations about the subpersonal mechanisms involved in our perceiving certain events as manifestations of agency are becoming increasingly well grounded in empirical research (see, e.g., Baron-Cohen, 1995). The vocabulary of agency, which Davidson characterizes as structured by the principle of charity, is probably not one we could choose to lose. Given the evident value of sensitivity to these patterns, perhaps we should, in a Humean spirit, be thankful that nature has not left it up to us to decide whether or not to preserve it.

Even if this were so, however, even if we cannot help, except when wearing our theoretical hats, being folk psychologists, we might still take the view that folk psychology is simply a heuristic device, a mere instrument. It may be a biological fact about us that we are not free to dispense with it, but that does not make the statements we produce when in its grips the least bit more respectable. In particular, we cannot use this instrument to make perspicuous those features of things that really are responsible for events, however described, unfolding as they do.

Is there anything in Davidson's account of the mental and the physical which might help us out of this perspective? Does he show us a way to be sanguine about the legitimacy of a vocabulary in which we make claims which neither are systematically correctable by, nor provide a basis for, empirical theory? Without claiming to have found a panacea for the naturalist's disease, I will conclude by suggesting that there may be considerable therapeutic power in Davidson's proposal.

On Davidson's account, the mental and the physical reveal distinctive sorts of pattern of events. For both general categories, Davidson provides an account of how the vocabularies come to reveal the particular sorts of pattern that they do allow us to depict. In each case, that account takes the form of an answer, at a high level of abstraction, to the question of what the point might be, for creatures like us, in being able to relate to the world in the ways made possible by our recognition of the particular sort of event-structure which that vocabulary is built to track. Both the mental and the physical then emerge as classifications of descriptive abilities which are accounted for in terms of our basic interests, and ultimately in terms of our biological natures—they appear as tools, in Rorty's words, of clever animals.

Davidson's manner of accounting for the most general features of the mental and the physical in effect naturalizes this distinction by placing mind and body on a metaphysical and ontological par—the legitimation of one in terms of the other no longer seems like a pressing objective. But there is unity in this tolerant dualism. For the diverse patterns tracked by our vocabularies are all causal patterns, and this, as Davidson says, "is what holds together our picture of the universe, a picture which would otherwise disintegrate into a diptych of the mental and the physical" (Davidson 1980: xi). The concept of causality, functioning as a unifying pivot, is the notion which ensures that our diverse ways of keeping track of and distinguishing events of various kinds can be brought to bear on one another. That is the point of monism. The notion of cause, in Davidson's monistic view of it, holds our various classifications of events together in a manner analogous to the way truth links interpreters speaking different languages. No insight into the essence of truth could help us improve our understanding of one another, yet if we did not know what truth was—or more generally, what rational thought was—there could be no understanding—no states, even, to understand. Similarly, while there is no insight to be had into the essence of causal power which will enable us to draw a distinction between vocabularies revealing genuine patterns of causation from those of merely heuristic value, if we did not know a cause when we met one, there would be no point to the individuation of events in any terms, whether physical or mental, at all.

BJØRN RAMBERG

DEPARTMENT OF PHILOSOPHY
UNIVERSITY OF OSLO
SEPTEMBER 1998

NOTES

1. Representatives of this second camp are e.g., Rorty (1999), Fodor (1990), Kim (1993), Chomsky (1995). In the former we find, for example, Rosenberg (1994), Stich (1991), and Kim (1993). Rosenberg and Stich make the point that the predicates of folk psychology are scientifically infertile. Kim elaborates his impression that, on Davidson's account, mental predicates fail to latch on to the causal powers of the states and events they denote. These two complaints are related, insofar as we take it that the laws uncovered in naturalistic enquiry lay bare the causal structure of the world. Membership in one camp does not, as we can see, exclude membership in the other.

2. "Thinking Causes" (1993) and "Laws and Cause" (1995) develop and explicate the argument.

3. Unless otherwise is noted, page numbers in parentheses after quotations from Davidson are from Donald Davidson, *Actions and Events* (Oxford: Oxford University Press, 1980).

4. For example, in Davidson (1991),

> We should not be changing the subject if we were to drop the concept of elasticity in favour of the microstructure of the materials in the airplane wing that cause it to return to its original shape when exposed to certain forces. Mental concepts are not like this. (163)

5. Compare also Davidson (1985):

> to identify an object as a physical object of a certain kind is already to have endowed it with certain causal dispositions; we cannot first classify an object and then discover that it has those causal properties. Thus the ground floor connection of causality with regularity is not made by experience, but is built into the idea of objects whose changes are causally tied to other changes. As this reference to changes suggests, events are as much caught up in this highly general net of concepts as objects. (227)

6. I have a stab at this in Ramberg (forthcoming).

REFERENCES

Baron-Cohen, Simon. 1995. *Mindblindness.* Cambridge, Mass.: MIT Press.

Chomsky, Noam. 1995. "Language and Nature." *Mind* 104.

Davidson, Donald. 1969. "The Individuation of Events." Reprinted in Davidson, 1980.

———. 1970. "Mental Events." Reprinted in Davidson, 1980.

———. 1974. "Psychology as Philosophy." Reprinted in Davidson, 1980.

———. 1980. *Essays on Actions and Events.* Oxford: Oxford University Press.

———. 1985. "Replies to Essays." In *Essays on Davidson's Actions & Events*, edited by Bruce Vermazen and Merrill B. Hintikka. Oxford: Oxford University Press.

———. 1987. "Problems in the Explanation of Action." In *Metaphysics and Morality: Essays in Honour of J.J.C. Smart*, edited by Philip Pettit, et al. Oxford: Blackwell.

———. 1991. "Three Varieties of Knowledge." In *A. J. Ayer Memorial Essays*, edited by A. Phillips Griffiths. Royal Institute of Philosophy, vol. 30.

———. 1993. "Thinking Causes." In *Mental Causation*, edited by John Heil and Alfred Mele. Oxford.: Clarendon Press.

———. 1995. "Laws and Cause." *Dialectica* 49: 2–4.

Dawkins, Richard. 1986. *The Blind Watchmaker.* Longman. (Penguin edition, 1988).

Fodor, Jerry. 1989. "Making Mind Matter More." Reprinted in *A Theory of Content and Other Essays.* Cambridge, Mass.: MIT Press, 1990.

Kim, Jaegwon. 1993. "Can Supervenience and 'Non-Strict Laws' Save Anomalous Monism?" In *Mental Causation*, edited by John Heil and Alfred Mele. Oxford: Clarendon Press.

McLaughlin, Brian. 1993. "On Davidson's Response to the Charge of Epiphenomenalism." In *Mental Causation*, edited by John Heil and Alfred Mele. Oxford: Clarendon Press.

Rosenberg, Alexander. 1985. "Davidson's Unintended Attack on Psychology." In *Actions and Events*, edited by Ernest LePore and Brian McLaughlin. Blackwell.

———. 1994. *Instrumental Biology or the Disunity of Science*. Chicago: University of Chicago Press.

Ramberg, Bjørn. forthcoming. "Post-Ontological Philosophy of Mind: Rorty *versus* Davidson." In *Rorty and his Critics*, edited by Robert Brandom. Oxford: Blackwell.

Rorty, Richard. 1996. "Davidson's Mental-Physical Distinction." This volume.

Stich, Stephen. 1990. *The Fragmentation of Reason: Preface to a Pragmatic Theory of Cognitive Evaluation*. Cambridge, Mass.: MIT Press.

REPLY TO BJØRN RAMBERG

This is the kind of criticism that makes doing philosophy worth the trouble. It is patient, sympathetic, and perceptive; it spots exaggerations and dead-end expeditions in papers I wrote over decades, all the while doing its best to follow the snake of thought when it leads to what may be interesting or even right. There is little in Bjørn Ramberg's essay with which I now disagree. He has shown me a better way to put together some of the strands in my thinking, and gently suggested what I would do well to leave out.

Ramberg, like Rorty, thinks I overdo the extent to which we can think of various scientific disciplines as reducible "in principle" to a perfected, though at present unknown, physics. The trouble is with that "in principle". What did I have in mind? Certainly nor that the terms of geology, biology, or aerodynamics could be defined in the vocabulary of quantum physics or general relativity theory or the dreamed-of theory that would combine or supplant them, perhaps some version of string theory. Ramberg is right to suggest that I had no clear concept of reduction in mind, and therefore definitional or nomological irreducibility to physics is not in itself a distinguishing feature of our mental vocabulary. Nor does it matter, he adds, so far as my argument for anomalous monism is concerned; that argument is an argument quite generally for monism, since it is designed to show that the ontology of any science that is not reducible to physics shares its ontology with physics.

"Laws and Cause" (Davidson 1995b), a paper I put off writing for many years, provides Ramberg with a theme that pulls together the whole continuum of non-mental sciences from our most primitive concepts of objects and their modifications to advanced physics. Evolution has shaped us to discriminate, and so find similar, bodies with certain familiar traits; thus evolution has handed us, so to speak, the rudiments of simple, rough inductions. Part of having the concept of an object is knowing what changes it undergoes under specific circumstances. Experience teaches us how to modify our classifications of objects and their changes in ways that improve our ability to control

and predict. Our rough inductions reflect habits which can be expressed as laws. The more these laws can be freed of caveats and the more universal they are seen to be in application, the more completely they can satisfy our curiosity about the ultimate constituents of matter and their behavior. There is also the associated thought that the better we understand the more we will be able to control and predict. But it would be a mistake to suppose that control and prediction have a single purpose. It is true that quantum physics and relativity theory have led to astonishing technological developments. But advanced physics, while it may enhance and lead to modifications in other sciences, is no substitute for them. We will never design automobiles and toasters from the quanta up, nor predict the weather particle by particle; aerodynamics and biology, though they have been and will be changed by what is known about basic physics, almost certainly will not be reduced in any strong sense to basic physics.

So far we have come across no reason not to include the many vastly important laws we know of human behavior along with the other practical lore we depend on in everyday life. As I have often remarked, there are endless things people do that we predict with far more confidence than we predict the weather. I think of logic and decision theory as rough but essential laws of thinking and action (Davidson 1995a), though of course these theories do not begin to exhaust the powers of folk psychology; they simply delineate aspects of rationality which thinking creatures must to a considerable extent exemplify. Further, as Ramberg points out, much of what we know about how people will behave depends on their causal relations to events we describe in purely physical terms. These terms are seldom those of advanced physics, of course, though as Pat Suppes once reminded me, the human eye can register the impact of a single photon.

I do not doubt that further knowledge of how the central nervous system works and the success of computer simulations of cognitive processes will throw ever more light on how the mind operates. I disagree with Ramberg on only one point. He believes it is possible that the difference between our mental vocabulary and our many vocabularies suited to describing and explaining the world in non-cognitive terms may shrink so much that we no longer think we "change the subject" as we shift from one to the other. I do not. Since we are thinkers, and it is we who devise these ways of talking and explaining, I am not abashed when I am told that for me the difference is "metaphysical" or "a priori", for I know no clear way of distinguishing metaphysical or a priori knowledge from other forms of knowledge. What I am convinced of is that when we treat animals as rational, the norms of rationality are in play, and such norms have no role in our other ways of thinking.

<div align="right">D. D.</div>

REFERENCES

Davidson, Donald. 1995a. "Could There Be a Science of Rationality?" *International Journal of Philosophical Studies* 3:1–16.

———. 1995b. "Laws and Cause." *Dialectica* 49:263–79.

26

Jennifer Hornsby

ANOMALOUSNESS IN ACTION

I shall begin in section I by scrutinizing two claims in the area of action. Both are claims of which Donald Davidson has persuaded a great many philosophers over the years. A: that we must be careful to distinguish between actions and their descriptions.[1a] B: that action explanation is causal explanation.[1b] These two claims, along with a claim about the nature of causation,[1c] can be the basis of the doctrine of anomalous monism.[1d] In bringing the doctrine to light, Davidson showed us how it is possible to achieve physicalism at the level of individuals, but not at the level of predication: he showed that one might embrace a thoroughly physicalist ontology even while one renounces all connections between everyday psychological concepts and scientific physical concepts.

Anomalous monism has set the terms of many debates. But such is the sway of reductionism in some quarters that a physicalist ontology has not been enough to satisfy everyone's 'physicalist' or 'naturalist' metaphysical cravings.[2] I think that there is considerable confusion about each of claims A and B, and that when this is set aside, we find that there is more space for doctrines which are both 'anomalous' and 'monist' than Davidson carved out for his own doctrine. My conclusion will not be welcome to the reductionists. But it may be of comfort to anyone whom Davidson persuaded on the subject of the mental's anomalousness, but who has been led by the literature critical of Davidson to doubt whether a reasonable anti-Cartesian anti-reductionist position is available.[3]

I. ACTION

Actions, Things Done, Descriptions

We can distinguish between anything and a description of that thing. Of course. On the face of it, it seems implausible that anyone should ever muddle

up the two: who would mistake Donald for 'Donald'? But in the realm of action, there is a very common confusion which corresponds to a confusion between actions and their descriptions, and I want to start with this before I bring descriptions in.

If the causal world includes events, and if one of our objectives is to understand the place of human agency in the causal world, then insofar as there are (to put it tentatively) events where there are human agents, we need to talk about these events explicitly.[4] There is thus good reason to reserve the word 'action' for a specific use in philosophy, so that it applies to things in the domain of events. In this use of 'action', the following are events that are (or may be) actions: Anna's writing of the word 'blue', Peter's setting light to the fuse, my eating of my breakfast.[5] In ordinary English, however, these things are not actions. For in ordinary English 'actions' is used for things that people do. And a person does not relate to what she does as she relates to her action (in the philosophers' sense just introduced): people do not do events. Anna does not do Anna's writing of the word 'blue', for instance; rather what Anna does is this—*[to] write the word 'blue'*.[6] Such a thing as *write the word blue*—or *set light to a fuse*, or *eat breakfast*—is repeatable; it is not a particular. Consider that someone other than Anna may write the word 'blue'; and that Anna may write the word 'blue' on several different occasions. But remember that Anna's writing of the word 'blue' at noon (say) is something to which no one other than Anna is related as Anna is, and that it is something that cannot happen more than once. Evidently enough, actions in the philosophers' sense must not be confused with things people do. I italicize phrases for the latter; and I use the word 'actions' only for actions in the philosophers' sense. Muddling up phrases of two different sorts,[7] and using 'action' ambiguously, can foster confusion, which these pieces of terminological policy are designed to guard against.

Davidson's own terminological policy is different. He thinks that in order to retain a correct conception of the particulars that are actions, we have to be clear about the difference between (say) Mary's flipping of the switch, and its description 'Mary's flipping of the switch'. Someone who conflated the action and its description would not be able to see that 'turning on the light' can also have application to Mary's flipping of the switch: the conflation obscures the fact that an action can be described in different ways. Now I think that taking account of different descriptions of Mary's action is simply a way of taking account of different things that Mary did— *flip the switch* and *turn on the light*. If that is so, Davidson's thought about the importance of distinguishing actions from descriptions might be put differently: we have to allow that there can be two different things that Mary does, and that Mary's doing one of them is (the same as) Mary's doing the other.

Davidson showed that keeping track of the distinction between actions and

descriptions enables us to keep track of the notion of *agency* itself. To have exhibited agency, a person has to have done something intentionally. But when it is recognized that a single event may be described as a person's doing one thing and described as her doing some other thing (and, perhaps, her doing some third and fourth things), then it must be allowed that she may have done one thing intentionally, another not. For instance, it might be that Peter intentionally set light to a wick but did not intentionally set light to the fuse of a bomb, even where his lighting the wick *is* his lighting the bomb's fuse. Davidson's way of putting this is to say that an action is an event which is intentional 'under some description'.[8] So, for instance, Peter's action, though it was intentional under the description 'setting light to a wick' was not intentional under the description 'setting light to a bomb's fuse'. But if the descriptions of actions correspond to things that people do, then we could say, more simply, that an action is a person's doing something (or other) intentionally. (The point that a person's doing something unintentionally may be an action is accommodated when it is seen that a person's doing one thing may be the same as her doing some other thing.)

If it is agreed that we can make all the necessary discriminations by thinking of the different descriptions that her actions fell under (on the one hand) or by thinking of the different things someone did (on the other hand), then there will be little to choose between Davidson's way of talking—using descriptions—and another way—using things the person did. We may prefer Davidson's way if we dislike mentioning things people do, e.g., on the nominalistic grounds that these things would come into a prohibited category of universals. But if we are prepared to introduce into theoretical generalizations about agency the locutions that are used every day, and to save it for another occasion to decide whether all mention of universals needs to be banished, then we do better, I think, to leave mention of actions' descriptions out of it. This can seem better for a pair of reasons. First, when we allow ourselves to speak of things done, we can understand how the confusions that Davidson is concerned to banish actually crop up, and we can be armed against them. Secondly, we can get rid of some of the wrong impressions that the 'description' way of talking has given rise to. The 'description' way of talking can even reintroduce the confusion it is intended to eliminate. People no sooner adopt the locution 'intentional under a description' than they talk about doing things under descriptions. It then seems as if the things that people do had various descriptions to which 'intentional' might or might not correctly be added. But of course things that people do are *not* redescribable things, they are repeatable things; when spoken of as if they were redescribable, they get confused with actions (which *are* redescribable particulars).

Avoiding the 'under a description' way of talking enables one to see more

clearly how it works out to use 'intentionally', as Davidson did, as a mark of agency. Davidson said, 'A person is an agent of an event if and only if there is a description of what he did that makes true a sentence that says he did it intentionally'.[9] One may say instead that an event is an action if and only if it is someone's intentionally doing something. But when this is said, attention is drawn to the fact that someone can do something intentionally without there being any *event* which is her doing it. For example, Bill might protest by intentionally failing to show up at the meeting; and here 'Bill's protesting' seems not to stand for any event.[10] If the application of 'intentionally' signals agency, then it looks as though examples of agency are not exhausted by events that are actions. We shall see shortly how this point may affect causal claims in the sphere of action.

Causal Explanation

If someone does something intentionally, then a distinctive kind of answer can be given to the question 'Why did she do that?'. The answer, as Davidson said, is of the rationalizing kind: it tells us enough about what the agent thought and wanted to show us what reason she had for doing the thing. And, as Davidson argued:

(CE) Rationalization is a species of causal explanation.

(CE) is the summary statement of Davidson's position which he sets off from in his 'Actions, Reasons and Causes'. But before the end of that paper, another summary is used:

(C) Reasons are causes.

There seem to me to be important differences between (C) and (CE); and I shall suggest here that only (CE) is warranted.

Much of Davidson's defense of his position was devoted to removing obstacles in its way; and some of these are removed by adopting the broadly Humean perspective on causation which is Davidson's own (on which more below). But there is also an important positive argument which Davidson gave, which is often overlooked, and which appears not to rely on settling on any particular account of causation. The argument asks us to consider a case in which someone did something and had a reason for doing it, yet cannot be said to have done it *because* she had the reason. We are to contrast such a case with another, in which we can actually explain why someone did the thing by mentioning this reason. 'Because' gets in now: she did it because she thought ———, and wanted ———. When the 'because' does get in, but not in the other case, we not only have an explanation of why she did what she did, we can see her having the reason she had as making the difference to her doing it.

When her having the reason can be cited in explanation, but not when the agent can be said only to have the reason, it is operative: the agent is moved by having it. All of the notions *making a difference, being operative, being moved* are causal notions. Thus causality comes to be seen to be at work when, but only when, the explanatory 'because' links 'She did it' and 'She had this reason'. Action explanations are causal explanations: the argument establishes (CE).

Now in order for this argument to work, 'She did it because ———' does not have to be true in virtue of the occurrence of an event. Suppose that both of Mary and Jane deliberately (and intentionally) failed to answer the question. And suppose that both of Mary and Jane thought the question to be a stupid one, and that both of them have a pro-attitude (in Davidson's sense) towards stupid questions' not receiving answers. Then Mary and Jane alike have a certain reason for not giving an answer. But suppose that it is true of Mary, but not of Jane, that she didn't answer the question because she thought it was stupid. (Although Jane thought that it was stupid, what actually ensured that the question didn't receive an answer from her was the fact that Jack was present: Jane, for reasons of her own, never participates in discussions if Jack is present.) Now the difference between Mary and Jane seems to be this: in Mary's case, her thinking that the question was stupid made the difference to whether she answered it. Where, but only where, there is a 'because'-statement linking the agent's doing something (here *not answering the question*) and the agent's having a reason to do it, the agent's having that reason is seen to be relevant causally to what she did—or didn't—do.

When it is clear that it is (CE) at which Davidson's positive argument is aimed, a difference between (CE) and (C) is evident . (CE) requires no more in the way of causal statements than the everyday ones that are found when *Why?*-questions about people's doing things are answered. (Some people think that such statements are not causal; but the argument has proved them wrong.) (C), on the other hand, requires statements recording the (putative) facts of reasons' being causes of actions—statements on the pattern of 'r caused a'. The cases in which there is a reason-explanation of someone's doing something but no event of her doing it make it doubtful that we could always find something on this pattern. For in these cases, there is nothing which mentions a particular to put at 'a's place in 'r caused a'.

Even if we stick to cases where there *is* an event of someone's doing something, it is not at all obvious that we can give any substance to (C). Notice first that if we are inclined to accept instances of 'r caused a', then it will not be a reason which is mentioned at 'r's place, but (rather) an agent's *having* a reason. This may seem to be a persnickety point about how the word 'reason' is used. But it is a point that assumes some importance when one remembers that Davidson's opponents, who deny that action explanation is causal, want

to insist that understanding in the space of reasons is never causal understanding. They may say: 'We can see that there is a reason for someone to cross the road when we know that there is something she wants on the other side. But seeing that there is a reason tells us nothing about happenings in the causal world.' Of course what is said here cannot show that action explanation is not causal. It cannot show this, because in order to be able to explain a person's doing something, we need not just to see 'X is a reason for a to Ø' but (as it might be) 'a Ø-d because she had reason X'. We need, that is, not only to be able to operate using what Davidson calls 'the constitutive ideal of rationality', but also to apply that ideal empirically, and to recognize actual dependencies between (say) a person's wanting something and her doing something. (Indeed the difference between the rational background and its actual application is what is revealed in Davidson's argument about the difference between 'She Ø-d and she had such and such reason' and 'She Ø-d because she had such and such reason'.)

Presumably, then, the claim (C), about reasons and causes, is intended as shorthand for 'People's havings of reasons causes actions'; and the sort of instance that would support it would be 'Mary's having a reason to cross the road caused action a'. But there is then a further complexity to notice. For on Davidson's account, a reason is not a simple thing, but is made up of a belief and a pro-attitude. Allowing for this, the sentences on the pattern of 'r caused a' that one should endorse now, if one favors (C), would go something like 'Mary's believing that p and Mary's wanting that q caused a'. But even a statement like this—which speaks of the agent's believing something *and* her wanting something, and speaks of these together as cause of her action—cannot be thought to provide the whole causal story in the case of any action. For there are typically various things an agent did when there is any action—as we saw. If Mary wanted it to be light enough to read, for example, then she may have done all of these things: *move her finger, flip the switch,* and *turn on the light*. Any of these is something about which it might be asked 'Why did she do *that*'?; and the correct response to such a request for explanation depends upon what exactly is asked (upon what replaces 'that'). It would be an error, then, to think that, for each action, there is one "belief-desire pair" which is mentioned whenever there is a request for explanation in respect of it. (This is an error fostered by using 'actions' sometimes for events, sometimes for things people do; one forgets that what is explained is not an event but [the fact of] an agent's doing something that she did.) If (C)'s proponents believe that there is just one statement on the 'r caused a' pattern in respect of any action, then they must allow that lengthy descriptions come at the place of 'r'. 'What caused Mary's action', they might say, 'was this: Mary's wanting it to be light enough to read and Mary's thinking that it would be light enough if the lamp was on and Mary's thinking that the lamp would

be on if she flipped the switch and Mary's thinking that she could flip the switch by moving her finger . . .'. We surely need not accept statements such as this in order to be persuaded that everyday answers to *Why?*-questions use a causal 'because'.

(CE) and (C) are often treated as equivalent. But if they were really equivalent, then we should expect statements on the '*r* caused *a*' pattern to be forthcoming as soon as we accept (CE). What these last points have shown is that simple examples on that pattern are hard to come by. There is a considerable distance between the statements which are made when action explanations are actually given—to whose causal character (CE) commits one—and those statements to whose acceptance (C) commits us.

A distinction between (CE) and (C) turns on a distinction between '*causally explains why*' and '*causes*'. And this is a distinction which Davidson would be the first to acknowledge—indeed to insist upon. Of course, then, Davidson appreciates the difference between the two. But he accepts them both. We may take him to assume that someone who acknowledges the causal character of action explanation automatically commits himself to causal statements of the relevant sort.[11]

The Argument for Monism

'Statements of the relevant sort' here is vague; and so is 'statements on the pattern of '*r* caused *a*''. I have not been very precise either about what we may actually extract from the thesis about causal explanation (CE), or about what a proponent of (C) thinks that he can extract. But this imprecision may not matter in the context of a discussion of Davidson. The important question here is whether we can extract what Davidson needs in his argument. I shall suggest now that (CE) may not be enough to give Davidson the premise that he uses in his argument for monism.

Davidson's argument might be thought of as bringing two kinds of statement into a certain sort of relation—into such a relation that it can be established that statements of both sorts import the same ontology. The first kind of statement is an everyday "mental" kind got from such claims as we make when, e.g., we explain why people do things. Statements of the second kind are far from everyday: they record exceptionless physical laws. Using a rough and ready schema for each kind of statement, we could represent them thus:

(1) An A caused a B.
(2) Ns cause Qs.

Here 'A''s and 'B''s instances are the everyday predicates that occur in rationalizing explanations, whereas 'N''s and 'Q''s instances are nomological

predicates—bits of vocabulary in which exceptionless physical laws are framed. Davidson's Principle of Causal Interaction ensures the truth of statements like (1): 'at least some mental events interact causally with some physical events'. Davidson's Principle of the Nomological Character of Causality ensures in turn that the truth of something like (1) requires the truth of something like (2): 'events related as cause and effect fall under strict deterministic law'. Davidson's Principle of the Anomalousness of the Mental then tells us that mental vocabulary does not feature in laws; so it assures us that whenever there is an instance of (1) in which the place of 'an A' is occupied by a piece of mental vocabulary, it will be a piece of physical vocabulary that occupies the place of 'N' in the required instance of (2) (i.e., in the particular law covering the particular case). But this means that whatever we have picked out using mental vocabulary, we know that a piece of nomological, physical vocabulary would be applicable to it. That is to say that the mental thing is a physical thing: we arrive at monism.

If this account of the argument for monism is acceptable, then the role of the Principle of Causal Interaction in it is to assure us of statements like (1). The Principle, in that case, is not just any old claim to the effect that 'there is mental-physical causal interaction', but requires endorsement of causal statements of a certain sort. Where action is the phenomenon of concern, what I have suggested is that, despite what the slogan 'Reasons are causes' might have made us think, no simple statements of that sort are in fact available. From (CE), we cannot get statements (like (1)) standing in the sort of relation to nomological statements (like (2)) which the argument demands.

The best kind of candidate we can find, for a statement recording a causal interaction in accordance with the Principle in the needed sense, will be something like 'Mary's believing that she could get to the other side by crossing and Mary's wanting to be on the other side caused Mary's crossing of the road'.[12] It is not obvious that we accept this statement. But even if we do accept it, it is hard to treat it as relating to statements like (2) in the way that Davidson's argument requires.[13] One obstacle to treating 'Mary's believing ——— and Mary's wanting ——— caused such-and-such action' in the way we should need to stems from the presence of the 'and' in it (in what precedes 'cause'). Should we say that wherever x and y caused a, there is something x-and-y which caused a? Or should we say that wherever x and y caused a, each of x and y caused a? It seems that unless we say one or other of these things, we shall not have the kind of causal statement which asserts a relation between two items, and which can thus be brought into such a relation to a statement of law that nomological vocabulary can be seen as applicable to the same things as mental vocabulary applies to.

The difficulties about finding the needed statements multiply when we notice not only that there can be causal explanations of what someone does where there is not an event of her doing it (as we noticed above), but also that

there can be causal explanations of a person's doing something in which the fact that the person did *not* believe something, is crucial. Are we then to say that her *not* believing that *p* is "a cause"? Is her not believing that *p* an item that could be subsumed under a law?

Questions like these will not seem pressing to those who are in the habit of talking of 'beliefs and desires as causes of actions'. But here I am trying to challenge that habit.[14] The habitual way of talking derives from a certain model of causal explanations in the case of action—a model according to which explanations go hand in hand with statements in which pairs of particulars are related to one another by 'cause'. The model does not apply across the board, and it seems to be unsupported by any examples of actually accepted statements.

II. ANOMALOUSNESS

Rationalization and Anomalousness

Anomalous monism is a general doctrine about the mental, not confined to the area of action. But if any feature of human beings really did pose a threat to physicalism, then agency would surely do so.[15] The case of action then seems a useful one to take if one is investigating how dualism should be avoided. Moreover the phenomenon of action can seem peculiarly tractable ontologically speaking: there are actions, and we can inquire into their etiology.

We should remember, however, that the Davidsonian thesis that reason explanation is causal explanation has application outside the domain of action—that it is not only where human beings are agents that reason is at work. Action explanation, one might say, is one species of reason explanation, where reason explanation is something of which we find examples not only when we ask (for instance) 'Why did she look in the cupboard?', but also when we ask 'What made her think that the cornflakes were in the cupboard?'. In 'Actions, Reasons and Causes', Davidson's concern was explanation of people's doing things, and not explanation of their thinking things. But if one is concerned about the repercussions of Davidson's causal thesis for the philosophy of mind generally, then one must take account of the pervasiveness of rational-causal-explanation. In whatever sense we expect to see someone as rational in learning why she did what she did, we expect to see her as rational again in learning why she thought what she did. We must attend to the *general* significance of the fact that (as Davidson put it) 'rationalization is a species of causal explanation'. When we contemplate the wider picture, we may find that there is much less pressure to accept the model of causal statements which has become so popular in the philosophy of action.

Considering what it is for someone to operate as a rational perceiver, and

as a rational thinker, as well as an agent, it becomes even clearer that acquiring the kind of causal understanding got from rational explanation is not a matter of finding pairs of particulars related by 'cause'. One who seeks understanding of a person's thinking something does not look for states and events that occur in the region where the person is. It can be found intelligible (for example) that someone came to believe that r, having believed that p and that q, when it is seen that r is a reasonable thing to believe given that p and that q. Appreciating what is reasonable in such a case is not a matter of judging that individuals' states of belief that p and individuals' states of belief that q have a causal tendency jointly (where they are inside the same head) to produce a state of belief that r. To suppose that reasonableness as such amounted to causal tendencies would be to ignore the normative character of rational relations; and it is the normativeness of these relations which, on Davidson's account, is at the root of the mental's anomalousness, and which reveals the unsuitability of concepts like 'belief' to be incorporated into strict laws.[16]

Accepting the anomalous of the mental, and *some* version of a principle of causal interaction, we allow that rational thinkers are causally complex beings. But we do not have to think of their causal complexity as a matter of connections between self-standing states "interacting" inside them.

Monism

I presented the argument of Davidson's 'Mental Events' as encouraging us to say that a common domain provides for the truth of two kinds of statement—everyday psychological statements, and statements of laws. It now seems that everyday psychology does not deliver causal statements which can be brought into the kind of relation with statements of law which the argument requires. So we appear to be left without an argument for monism.

The problem, as I see it, with Davidson's argument, is that our use of the language of the mental does not supply us with any items that are candidates for being identified with things mentioned in laws' instantiations. It is easy to be under the illusion that there are such items: when reasons are spoken of as causes, they seem themselves to be such items. But we saw that reasons are in fact quite the wrong sort of things to be causes. Reasons are not encountered in the *causal* world when rational explanations are found: what are encountered there are people who have reasons. If, then, we want to show, as Davidson wanted to, that a common domain provides for the truth both of statements containing everyday mental vocabulary and of statements containing physical vocabulary, we must advert to persons (who have reasons).

The suggestion that persons could be items in a monist's ontology might seem absurd: it was surely the presence in the world of persons (or of other

conscious beings) that gave rise to the metaphysical problem of mind in the first place. Still, it is not absurd to say that persons are things having both mental and physical properties, which is the conclusion reached, in respect of events, by Davidson's own argument. So there is a version of monism here. Moreover it is an anti-Cartesian version. For on a Cartesian view of human agents, there are non-physical things possessed of causal powers to be found in the spatiotemporal world. (These non-physical things are either persons or proper parts of persons, depending upon your interpretation of Descartes.) We turn our back on a Cartesian ontology as soon as we acknowledge that persons are causally complex physical beings.

The only thing that I have taken issue with Davidson about here is the gloss that he puts on the causal interaction of mental with physical. Without this gloss, one may be satisfied with a monistic doctrine from which claims about mental events are missing. But even if one wishes to quarrel with Davidson, as I do, about what mental-physical causal interaction consists in, one can still take oneself to have learned from him that a philosophy of mind that endorses the obvious facts about causal interaction need make no ontological concessions to Descartes, nor any metaphysical concessions to those reductionists who refuse to accept the mental's anomalousness.

JENNIFER HORNSBY

DEPARTMENT OF PHILOSOPHY
BIRKBECK COLLEGE, UNIVERSITY OF LONDON
NOVEMBER 1998

NOTES

1. All papers by Davidson referred to here, are reprinted in his *Essays on Actions and Events* (Oxford: Clarendon Press, 1980). **a.** 'Agency', **b.** 'Actions, Reasons, and Causes', **c.** 'Causal Relations', **d.** 'Mental Events'.

2. I am thinking of the fact that eliminative materialism and functionalism (in one or another version) remain such popular positions.

3. I am thinking of the literature suggesting that Davidson's position is epiphenomenalist. There is a discussion of that suggestion in my 'Agency and Causal Explanation', in *Mental Causation*, ed. J. Heil and A. Mele (Oxford: Clarendon Press, 1993), reprinted in J. Hornsby, *Simple Mindedness: In Defence of Naïve Naturalism in the Philosophy of Mind* (Harvard University Press, 1997).

4. For further defense of the event ontology (not concerned specifically with introducing it where *action* is the topic), see Davidson's 'The Individuation of Events' and 'Events as Particulars' (in op. cit. n. 1).

5. Each of these three nominals is true of events. It is easy to slip between these

and nominals in a different category. And there are many philosophers, who, although they are explicit about believing that some nominals are true of events, seldom explicitly use nominals which are plausibly so: they are more likely to say [i] 'Anna's eating the apple' than [ii] 'Anna's eating of the apple'. Notice that of these two nominals, only [ii] (which I use) has any of the following three properties (a) it can be pluralized; (b) 'Anna's' in it can be replaced by an article, (C) the residual verbal element in it can be modified with adjectives (not adverbs). The fact that [i] has none of these properties makes it implausible that it stands for any particular, for any event.

6. The square-bracketed 'to' is optional. The context 'What she did was ————' can in fact be inhabited by phrases of three different kinds: at least I find it okay to put in any of the forms: 'write' (infinitival), 'to write' (a true infinitive), 'writing' (which behaves sometimes like an imperfect infinitival).

7. The muddles are introduced, for instance, with use of verbal '-ing' forms. These can either be shortened nominals (and then they may or may not denote events: see n. 5 above) or can behave like infinitives (in which case they denote things people do: see n. 6 above). One finds philosophers using (say) 'eating' intending to denote an event, but using it in a construction in which it cannot be true of an event.

8. G.E.M. Anscombe had used the phrase in *Intention* (Oxford University Press, 1957). For Anscombe's own misgivings about the uses to which it has subsequently been put, see her 'Under a Description', *Nous* 13 (1979).

9. P. 46, op. cit., n. 1. In this formulation (as in many others in Davidson) the 'it' is required to make back-reference to an event, yet the 'it' occurs in 'he did it' —as if people did events.

10. I rely here on a conception of an event as something which is such as to trigger or to be triggered by another event. And I should suggest that such a conception is relied on in the understanding of 'cause' as a relation between events which Davidson's argument introduces. Notice that it would be wrong to think that whenever there is something 'negative' someone did (i.e., when for some instance of 'Ø', she did not Ø), there is no event of her doing it. This must be wrong, since an event which is someone's doing one thing may be the same as her not doing some other thing. In the example here (and in the different example in the text below), where I claim that there is no event of someone's not Ø-ing, I do not rely on the fact that we have something that she did not do, but on a conception of an event which I have gestured towards with the notion of a "trigger". (I take it to be one merit of giving *things done* priority over *action descriptions* that we can more easily see our way through the tangle of issues surrounding so-called negative action. But I cannot explore this here.)

11. For an instructive discussion of different conceptions of causal explanation, see William Child, *Causality, Interpretation and the Mind* (Oxford: Clarendon Press, 1994), ch. 3, sec. 2.

12. If we treat such relatively simple statements as this as a candidate, then (since, in respect of any one action, there will be many such statements: see above) we must allow that any action has many causes.

13. The mere occurrence of the verb 'cause' is not enough to ensure that there is a statement expressing a simple causal relation between events. Often '*a* X-d because *b* Y-d' can be paraphrased with '*b*'s Y-ing caused *a*'s X-ing'; but the gerunds in such paraphrases are not event-denoting nominals, so that the 'caused' in them is not a

relation between events. In the example sentence considered in the text, I have introduced the word 'of' so that we have 'Mary's crossing of the road': this ensures that we have an event-denoting nominal following 'cause' (see n. 5 above); but it may also ensure that the sentence is unacceptable (people's intuitions vary).

14. This habit is reinforced by recurrent talk of "token states" (not introduced by Davidson, however). "Token states" are meant to be particulars on a par with "token events". But (a) it is extremely doubtful whether the relation between things-called-'events'-which-are-not-in-the-category-of-particulars and things-called-'events'-which-are-in-the-category-of-particulars is rightly conceived as relation of type to token; (b) it is extremely doubtful whether the distinction between non-particulars and particulars which is correctly made between two different categories of things that are all called 'events' is a distinction that has any counterpart for things called 'states'. See Helen Steward, *The Ontology of Mind: Events, States, and Processes* (Oxford: Clarendon Press, 1997), esp. ch. 4, for a detailed account of what is wrong with assumptions that there are "token states".

15. It has become common to think that there are two separable problems about mind: problems about intentionality and problems about consciousness. Even if it were granted that this is a correct way of thinking, it would have to be acknowledged that we find both sorts of problems together with the phenomenon of agency. In fact I think that the problems are erroneously taken to be separable, and that part of what is responsible for the error is that conscious beings are lost sight of when questions about intentionality are translated into questions about relations between states and events. Evidently they are not lost sight of when persons are treated as the topic of a monistic doctrine: see below.

16. See Davidson's 'Replies to Essays X–XII' in *Essays on Davidson: Actions and Events,* ed. Bruce Vermazen and Merrill Hintikka (Oxford: Clarendon Press, 1985), especially his remarks on Lewis, Smart and Suppes) for the way in which normative considerations enter. See also John McDowell, 'Functionalism and Anomalous Monism', in *Actions and Events: Perspective on the Philosophy of Donald Davidson*, ed. E. LePore and B. McLaughlin (Oxford: Basil Blackwell, 1985).

REPLY TO JENNIFER HORNSBY

This essay presents an interesting challenge. Jennifer Hornsby wants to cling not only to the distinctions we usefully make in ordinary language, but also to its surface ontology, whereas I am somewhat cavalier about departures from our common idioms when I think such departures make for semantic clarity. Most of her points depend on taking locutions like "what Susan did" as literally referring to entities of some sort, and these are far more numerous than actions. This enables her to say that perhaps the action of aiming the gun and pulling the trigger is the same action as firing the gun and frightening the dog, so that there are (at least) three things she did: aimed the gun and pulled the trigger, fired the gun, and frightened the dog. She balks at saying the action (taken as a single event) is something Susan did, since "She did an action", or "She did an event", or "She did Susan's firing of the gun" are not acceptable sentences of English.

Leaving aside for the moment the further advantages Hornsby thinks follow from abandoning my talk of "actions under a description" in favor of her preferred locutions and ontology, let's try to get her idea straight. As she recognizes, the multiplicity of descriptions which I say apply to an action "corresponds" to the multiplicity of things a person does in performing a single action. But the two ways of introducing multiplicity are clearly different, since my talk of descriptions doesn't introduce descriptions into the ontology of ordinary sentences about actions, while things done are things mentioned by such sentences according to Hornsby. This is, of course, one of the reasons I took the line I did. But is there any harm in doing it her way? Well, first of all there is the question what sort of entities these doings are. The only suggestion Hornsby makes is that they are universals, *sorts* of actions. This makes sense of the "correspondence" between descriptions and doings: on my account our descriptions bring an action under a universal by *using* a predicate; Hornsby does it by *mentioning* the universal. She suggests that avoiding talk of universals may be a motive of mine in talking of descriptions, but this is not the case. I have no objection to referring to universals

when it promotes some explanatory or semantic project. But does it here?

There is something strange in the suggestion that when we ask what someone did we are asking for the *naming* of a universal. We don't say "She did an action", but neither do we say "She did a universal". The things people do are in this world; they are not Platonic abstractions. Nor will it help to try "She did something that instantiated the universal [firing a gun]". Whichever way we go, we depart from standard usage as soon as we try to make sense of what I call the logical form of action sentences, which necessarily involves specifying what expressions are referring expressions and what they refer to. Clearly expressions like "set light to a fuse" or "eat breakfast" are not referring expressions in English. Hornsby says these phrases refer to actions, but if so we need much more help than she gives us to see how to convert them to recognizable names or descriptions of anything, actions, kinds of action, or universals. But even setting this problem aside, there seems a difficulty. Hornsby says "we have to allow that there can be two different things that Mary does, and that Mary's doing one of them is (the same as) Mary's doing the other". (Shouldn't this read "Mary's doing *of* one of them is (the same as) Mary's doing *of* the other" according to Hornsby's regimentation of usage?) Here we have at least three entities (besides Mary): the two "things" she does and the one thing differently referred to by the phrases starting "Mary's doing of". What are the first two things? If they are universals, they are not actions by anyone's account, for they could not accomplish anything in this world.

Hornsby tells us that "the things people do are *not* redescribable things, they are repeatable things". But *any* entity is redescribable, and *no* entity, as far as I know, is repeatable. A universal can be repeatedly instantiated, but the universal itself is not repeatable. And Hornsby allows that the events I call actions are redescribable, since she gives examples of such alternative descriptions of the same action.

There are a number of problems any serious analysis of the semantic and logical properties of actions sentences must solve: the analysis must explain the semantic role of adverbs and why we can infer "Susan fired the gun on Friday" from "Susan's firing of the gun took place on Friday" but not vice versa, for example. Take adverbs. Why, according to Hornsby, does "Susan fired the gun on Friday" entail "Susan fired the gun"? The temporal modifier can't apply to a universal or a kind of action. It's no answer to say it modifies what she did, since so far we have no idea what kind of an entity is referred to by a phrase like "fire a gun". There is a closely connected problem with the inference from "Susan's firing of the gun took place on Friday" to "Susan fired the gun". According to Hornsby these sentences refer to entirely different sorts of entity. Why then, is the inference valid? These, and many other problems about actions and action sentences, have straightforward solutions

if we take all these sentences to be about particular actions, the sort of entities we can pick out with phrases like "Susan's firing of the gun". On my analysis, "Susan fired the gun" says there was an event which was a firing of the gun and Susan was its agent. Note that there is no description of or reference to an action here, since the sentence does not imply there was only one firing of the gun by Susan. This *explains* why we may be inclined to say what she did was "repeatable". Of course no action, in this sense, is repeatable, but Susan can fire that gun again and again for all our sentence says; it just records the fact that there was at least one action which was a firing of the gun by Susan. "Susan fired the gun on Friday" says there was at least one event which was a firing of the gun by Susan, and it (the event) was on Friday. Ordinary quantification theory endorses the inference to (my analysis of) "Susan fired the gun". Up to this point, so far as I can see, my proposal takes care of all the problems Hornsby mentions in her first section on actions, and it does so without mysterious "things done" in addition to ordinary events.

Hornsby has two objections to my saying reasons are causes. One, as she seems to realize, is terminological. We use the word "reason" in a great many ways, and I have always tried to make clear which one I had in mind. The sorts of reasons that can be causes are Susan's desire to shoot somebody and her belief that by firing the gun she might succeed. These are propositional attitudes which can cause actions under the right circumstances; to say they caused her to fire the gun is to imply, among other things, that the circumstances were right. I do not think this is an unusual way to speak of reasons. "The reason he did it was that he thought this and wanted that." Hornsby's other objection is that even if we take attitudes to be reasons they can't be causes because sometimes there is no resulting event we can call an action. Normally propositional attitudes are not events but rather states of a person which provide some of the conditions that explain why someone acted as they did, and so they are causal conditions. Sometimes there is clearly a change in attitude, such as perceiving that something is the case or having a sudden urge or remembering something, which is the causal event. Sometimes we cannot say what change brought about the action, perhaps just a shift in attention. Similarly we often speak of a condition as the result of a cause: if it had not been for the causing event and conditions, the effected condition would not have resulted. In none of these cases can I see what is wrong in speaking of reasons as causes. At worst the objection is to my use of the words, not to how I plainly intended them to be understood.

But is my causal account compromised by the existence of "things" people do intentionally which do not seem to be events, such as staying away from a meeting or not answering a question? From what I said in the last paragraph it is clear that I do not think so. But it is also possible to defend the claim that actions are always events. Actions reflect choices among options. It simplifies

things to speak just of what we do and our reasons for doing it. But the same sort of explanations, though often more detailed and subtle, apply to choices. Whenever we act we fail to act in endless ways that are ruled out by what we do. To the extent that we recognize the existence of the potential but rejected options, we can say we rejected those options. Deliberately failing to go to a meeting or answer a question is a matter of choosing to do something else. So here again we have a multiplicity of "things done"; in staying home with a book and a drink we also declined to go to the meeting, decided not to take a walk, and thought better of visiting a friend. Think of how many things we do when we choose a can of soup from among the hundreds on display in the supermarket! In each case not doing one thing is doing another. So the action can be described in all these ways, and always as a positive doing, an event. Of course, we may give different answers to the question "Why did you not come to the meeting?" and the question "Why did you stay home with a book and a drink?" This is because the appropriate response depends on how the action was described in the question, which gives a clue to what puzzles the questioner. This multiplicity of answers, and so of causes, is not surprising. We explain, here as generally, by mentioning the items appropriate to the sort of explanation requested and what we take to be the items the questioner may not know about. There are endless causes (including both events and conditions) for any event, and no listing of attitudes and their changes can possibly give a "full" explanation.

I am afraid I do not understand Hornsby's reasons for holding that there is no saying how a strict law could apply to the situation in which it is true to say "Mary's believing that she could get to the other side by crossing and Mary's wanting to be on [the] other side caused Mary's crossing of the road". She makes two tries: "Should we say wherever x and y caused a, there is something x-and-y which caused a? Or should we say that wherever x and y caused a, each of x and y caused a?" Putting it this way misses the point. It is part of why psychological talk is irreducible to the terms of advanced physics that there is no hope of systematically matching up items in one vocabulary with items in the other: if this were possible, psychology wouldn't be irreducible to physics. Here is how I see it. I have no hope that anyone will discover how to describe a state of mind or an action in physical terms that are suitable for strict laws; what I assume is that where there is a singular causal relation, there exists a strict law that applies to the case. The sort of law that I have in mind will say (and this is very rough indeed) that whenever there is a certain distribution of forces and matter in a field of a certain size at time t, it will be followed by a certain distribution of forces and matter in a field of a certain size at time t'. In Mary's case the second field will have to include Mary and the entire region through which the crossing passed. The "cause" must embrace everything in the universe within the sphere defined by the

distance light travels in the interval from t to t' from the region of the cause to the region of the action. There is no reason for such laws to mention causality, since we use the language of causality only when we are selecting causal factors. Strict laws don't select; that's what makes them strict (as exceptionless as nature permits). Presumably a strict law of the sort I just hinted at will be a special case of the general laws of physics. What the Principle of the Nomological Character of Causality says in effect is that events correctly said to be related as cause and effect would be seen to be covered by the laws of physics if the cause and effect were identified in the vocabulary of physics. It should be evident that the plausibility of this claim is not affected by vagueness about the exact boundaries of the events concerned.

D. D.

27

Bruce Vermazen

ESTABLISHING TOKEN-TOKEN PSYCHOPHYSICAL IDENTITIES

The conclusion of Donald Davidson's argument for anomalous monism in "Mental Events" is that "every mental event that is causally related to a physical event is a physical event."[1] Under the assumption that every mental event is causally related—that is, related as cause or effect—to some physical event, he could draw the further conclusion that every mental event is a physical event. Later on the same page, he remarks that "we see that it is possible to know that a mental event is identical with some physical event without knowing which one (in the sense of being able to give it a unique physical description that brings it under a relevant law)." I think that a stronger conclusion can be drawn from certain broad features of radical interpretation, namely, that if radical interpretation is our method for knowing the minds of others, it is not generally possible to know which physical event a given mental event is identical with.[2] My argument has two stages, corresponding to two ways a radical interpreter might go about discovering or deciding what events are going on in his subject's mind.

FIRST STAGE

Start with the ascription of a mental economy. This is part of what Davidson's radical interpreter[3] struggles to construct. Such an ascription consists of a list of sentences attributing propositional attitudes to the subject—at least the subject's beliefs and desires. The balance of the interpreter's goal is a truth theory for the subject's language. I call what is ascribed an "economy" because of the way in which the ascription of one item on the list constrains the ascription of the other items.[4] There are two kinds of evidence for such an ascription: the first kind is a comprehensive ranking of uninterpreted sentences

of the subject's language, ordered according to the subject's pairwise preferences as to the truth of those sentences; the second kind consists of correlations between holdings-true of uninterpreted sentences and external circumstance-types, that is, correlations expressed in sentences like "Subject holds 'Gavagai' true when and only when there is a rabbit in his sight."[5] The first kind of evidence is used as a basis for applying a modified version of Richard Jeffrey's decision-theoretical method of eliciting from the subject's merely ordinal preferences among sentences a complete listing of the subject's cardinal assignments of desirabilities (which Davidson, unlike Jeffrey,[6] equates with degrees of desire) and subjective probabilities (which he equates with degrees of belief) to those same sentences. The second kind is used as a basis for assigning truth conditions to all those so far uninterpreted sentences.[7]

Davidson, following Quine in *Word and Object*,[8] says that the totality of possible evidence for a combined mental economy ascription and truth theory fails to determine a unique outcome for the radical interpreter. Consequently, two mental economy ascriptions, equally well confirmed, may differ from each other in what constellation of quantified and contentful beliefs and desires they ascribe to the subject.[9] In *addition* to this problem, the two ascriptions may differ in the ways that result from the two sources of indeterminacy Davidson recognizes: the inscrutability of reference and "the blurring of the distinction between the analytic and the synthetic."[10] Nothing in the present paper depends on these latter differences.

Although complete assignments of desirabilities-plus-probabilities using Jeffrey's method may differ from each other, any two assignments beginning from the same preference ranking will be related to each other in a precisely expressible way,[11] so that one can determine that they are at bottom the same despite such local facts as that on the first assignment the subject gives a probability of .35 to a certain proposition (or sentence, in Davidson's modification of the method), while on the second he gives it a probability of .5. Variations of this sort will be mirrored by variations in the desirability and probability assignments to other propositions in such a way as to preserve the preference ranking the interpreter began with. Davidson says "the differences do not matter to the prediction or explanation of choice behavior, nor do they matter to the interpretation of language by the method under discussion,"[12] that is, to radical interpretation.

Consider three features of Davidson's view. First, the interpreter ends up with an assignment of propositional attitudes and a truth theory; so far, he has not picked out even one mental event as a candidate for being the same as some physical event, because he has said nothing to indicate the existence of any *events*, but only states: beliefs, desires, and preferences among sentences.[13] Second, there are very many economy ascriptions compatible with the evidence, and there is no fact of the matter about which one is correct, although for a static ascription, "the differences do not matter."[14] Here, I

think, is where Davidson's comparison with the measurement of temperature or of weight enters. Different ascriptions of numbers representing temperature may correspond to the same average kinetic energy in a volume of molecules. Different economy ascriptions may correctly characterize the same total, static mind-at-a-moment. Finally, the view does not include any way of ascribing intentions. Since Davidson argues forcefully that intentions cannot be reduced to complexes of belief and desire,[15] it would seem that intentions would have to be added to the picture a radical interpreter attempts to draw, if the mental background of the subject's actions is to be understood.[16]

It is helpful, if not exactly Davidsonian, to think of a mind, in this connection, as an input-output device. The inputs are perceptions; the outputs are actions, including utterances; and the ascription of a particular mental economy is one of many possible characterizations of the input-output device as a mental economy.[17] Such an ascription must honor a number of constraints besides those imposed by the input-output data, but the totality of constraints falls short of determining a unique acceptable characterization. Why isn't this way of conceiving a mind Davidsonian? Because for Davidson, even actions and perceptions aren't data; only preferences among uninterpreted sentences and holdings-true-in-such-and-such-circumstances are. Perceivings would, I think, have to be ascribed to the subject of a radical interpreter partly on the basis of how his degrees of belief in various propositions change in the perceiving. What actions an interpreter interprets a subject as performing will depend on what desires, beliefs, and intentions the interpreter thinks caused the relevant bodily movements. Still, the distorted picture is useful in understanding the analogy with temperature: it is the total device that is characterized by the mental economy ascription, just as it is the entire volume of molecules that is characterized by the temperature ascription. And different mental economy ascriptions may be equally correct because they serve equally well the end of understanding the input-output device, just as different numbers (relative to different scales) may be equally correct ascriptions of temperature, just because they serve equally well the ends we have in measuring temperature.

However, the picture of the mind as an input-output device goes substantially beyond the picture a radical interpreter gets, for perceivings and actions are events, while an interpretation subject's mental economy so far consists entirely of states. Perhaps then we could use an economy ascription to *construct* mental events. For example, couldn't we detect comings-to-believe and beginnings-to-desire from information about what a subject believes or desires at successive moments? At first I lack a belief, and a moment later I have it; so I must have come to believe something. We could think of a momentary ascription for Joe as telling us of Joe's static mental properties, and of sequences of ascriptions as telling us about events, like *Joe's coming to believe, Joe's coming to desire*, and the like. We would be taking static,

momentary, synchronic economy ascriptions and turning them into dynamic, time-extended, diachronic event-ascriptions. Let's say that if in economy-ascription n Joe doesn't believe that p and in temporally adjacent and subsequent economy-ascription $n+1$ Joe believes that p, there has been a Joe's-coming-to-believe-that-p event. We could then look for a physical event to identify it with.

I think this method of construction could work for the acquisition of beliefs, if we conceive of the acquisition as the subject's going from assigning zero probability to a sentence to his assigning it some probability. For it is a consequence of Jeffrey's method that if a proposition has zero probability on one assignment, it has zero probability on all assignments.[18] Thus there could not be a pair of two-moment sequences of interpretations (starting from the same two-moment sequence of preference rankings) such that on one the subject acquired a belief and on the other the subject did not. But something more refined is needed for constructing the acquisition of a desire, since there is no true zero desirability. Acquisition of desire would have to be represented as a change from some very low desirability assignment to a higher one, that is, as a change in the strength of the desire. Changes of that sort (as well as changes in the assignment of probabilities) could be detected and distinguished from merely apparent changes (due to the indeterminacy of Jeffrey's assignments) by taking the assignments to some sentences as constant across short stretches of time (for example, assignments of probabilities to the contents of basic beliefs and of desirabilities to the contents of basic desires) and normalizing the rest of the assignment to them.[19] Normalizing in this way would be like reconciling two sets of temperature measurements (using different scales) by determining what numbers the two sets assigned to boiling water and freezing water and then applying the appropriate transformation.

But though acquisitions of beliefs and desires could be constructed from sequences of states, acquisitions of intentions can't. The problem lies in the autonomy of intention with respect to belief and desire. Because Davidson seems to require of intentions in a subject's economy only that they be rationalized by *some* belief-desire pair, two different economy ascriptions for the same moment could be such that the first contained an intention directed at a certain sentence and the second did not, no matter what the two ascriptions said about the subject's beliefs and desires. Using those two ascriptions as the later members of two two-moment sequences, and using as the earlier member of both an ascription according to which the subject lacks the intention, we would detect the acquisition of an intention in one sequence, but not in the other. Unlike the case of belief and desire, there would be no way to tell which of the two later members used the same "system of measurement" as the first; in fact, there would be no answer to the question, for there would be a real indeterminacy as to whether an intention had been acquired or not. Now suppose that we choose the first sequence, the one according to which

the subject has acquired an intention, and somehow find a physical event to identify with that acquisition. Even if we had chosen the second sequence, that same *physical* event would still be hanging around in the subject's brain. This seems to show that, if we construct events out of states, it is possible at best to identify intention-acquisitions with physical events relative to an arbitrarily chosen sequence out of the many possible sequences of economy ascriptions. We might say: for a radical interpreter, intention-acquisitions so constructed exist, or at any rate are detectable, only relative to an arbitrary sequence of interpretations. This first stage of my argument touches only a single sort of mental event and so throws into doubt the possibility of establishing token-token psychophysical identities only for one sort of mental event.[20] The second stage will be an attempt to include more sorts of mental event.

The first stage depends on what looks like a very austere view of what mental events there are: only those events are allowed that can be constructed out of beliefs, desires, intentions, and the transitions from a particular belief, etc., to another. Perhaps some event-types other than coming-to-believe, coming-to-desire, and their easy cousins can be constructed from such materials. For example, drawing a conclusion might be represented in a sequence whose first member included belief in certain premises, but not in a corresponding conclusion, and whose second member included beliefs both in premises and conclusion, plus an indexical belief that this very conclusion follows from these very premises. But I doubt that, even if that worked, we could do the same for mental events like thinking of Vienna, struggling to come up with an argument, stewing about the quick comeback you failed to make yesterday, or trying to remember the name of your first piano teacher. We could approach mental acts of this sort through desire, at least when they were voluntary, for then we could say that the subject *wants* to think of Vienna, to come up with an argument, to remember the teacher's name, and that the subject desires that he had done something yesterday. But the gap between so desiring and actually setting about doing it, together with the fact that such mental actions are not always voluntary, keeps them from being recoverable from ascriptions of desires.

However, it may seem obvious that they will be recoverable from beliefs, namely, the subject's beliefs about his own current mental life. And that brings me to the second stage of my argument.

SECOND STAGE

It seems that a radical interpreter who had finished ascribing beliefs and desires to a subject and writing a truth theory for the subject's language could easily enliven his static portrait of the subject's mind by an appeal to first-person authority. He will find, among the ascribed beliefs, ones whose objects

are episodes in the subject's current mental life: subject believes that he is thinking of Vienna; subject believes that he is trying to remember the name of his childhood piano teacher; and so on. By appealing to first-person authority, the interpreter can then add to the portrait details like: subject is thinking of Vienna; subject is trying to remember the name of his childhood piano teacher; and so on. Of course, first-person authority has its limits. Although, as Davidson argues, it is incoherent to suppose we could interpret a subject as making mistakes about all, or even many, of his belief contents, no incoherence threatens an interpretation that counts the vast majority of the subject's self-ascriptions of mental episodes true while taking exception to a handful of them. He thinks he is trying to remember the name of his piano teacher, but he never took a lesson in his life. He thinks he is thinking of Vienna, but Lake Michigan is not in Austria. So any particular ascription could be wrong. Episodes in a subject's mental life can't be read off one by one from his beliefs about his mental life.[21] But such beliefs are a prime source of *evidence* for what's going on in his mind. So, if a radical interpreter can detect a subject's beliefs about the subject's own mental contents,[22] he need not rely wholly on the kind of construction of mental activity proposed in the first stage of my argument. Yet another limitation is that perhaps not every mental episode will be accompanied by a belief that it is going on. I may be in doubt, for example, whether I heard something just now (rather than imagined hearing something); yet it may be a fact that I did (or did not).

With these second-stage ascriptions of mental episodes, we undercut the strategy of the first-stage argument against token-token identities involving intention-acquisitions. Since second-stage ascriptions, once made, are parts of a single, momentary ascription, their reality can't be impugned by a problem about how to choose a sequence of ascriptions. But how can we match up the mental events so discovered with physical events?

We might for a moment entertain a picture of the mind as a private inner theatre[23] in which mental events (whether detected by the first-stage or second-stage method) correspond to performances on the theatre's stage, to turns. If there is only one such turn during a given stretch of time, and if there is only one physical event going on in one's brain at the same time, then, it seems obvious, nothing could be easier than establishing a psychophysical identity between those (apparently) two tokens: that mental event is identical with that physical event. Or, a little more narrowly, the theatre has two descriptions, one mental and one physical, and the active or eventful portion of the mental description picks out the same event as the dynamic portion of the physical description. But that won't do the trick.

First, consider that there is no very clear criterion for distinguishing or counting mental acts. If I am thinking that Vienna is a lovely city except for those cold Midwestern winters, clearly I am also thinking that there are cold

Midwestern winters in Vienna. Two thinkings or one? Or consider Tyler Burge's view that "When one knows that one is thinking that p, . . . one is thinking that p in the very event of thinking knowledgeably that one is thinking it. It is thought and thought about in the same mental act."[24] Are we so sure he is right? Aren't there perhaps two mental acts on stage: my thinking that p and my thinking that I am thinking that p?

Second, even supposing that we could satisfy ourselves that there was a single turn on the mental stage on a certain occasion, and that we could produce a physical description of the theatre on that occasion, there is a problem about picking out that portion of the physical description that corresponds to the turn. Two paragraphs back, I suggested that the relevant portion would just be the dynamic portion, but that suggestion collapses under scrutiny. We have no reason to think that, if we could discover what part of the physical description corresponded to mental-*state* ascriptions like those picking out the subject's beliefs and desires, that part would be *physically* speaking static. It could be that what underlies a mental state is something dynamic, some vibration or transfer of electrical charge from neuron to neuron. If that's so (and I suppose that neurobiologists must think something like that), then our task involves separating the part of the physical description corresponding to the mental event from the part corresponding to the whole background of beliefs, desires, and intentions. It may seem obvious how, in principle, that is to be done. We look at the subject's brain at a number of different times when he has the same beliefs, intentions, and desires, but when different turns are occupying his mental stage. What is constant in the physical description will then describe the mental background, and what isn't will describe the mental episodes, the turns. Such a solution isn't available to a Davidsonian, however, since the assumption that constancy of a partial physical description across different occasions corresponds to mental constancy is just the assumption of type-type psychophysical identity, although both the mental-state type (the whole intentional background in front of which the turn occurs) and the physical-event (or -state) type here will both be very encompassing. A Davidsonian should be open to the possibility that the portion of a physical total-brain description corresponding to a mental state (or event, but states are in question at the moment) on one occasion could differ from the portion of such a physical description corresponding to a type-identical mental state on another occasion. For example, she should be open to the possibility that my believing *now* that Vienna is in Illinois is a different physical state (different not just with respect to its time) from my believing *last Wednesday* that Vienna is (or, as we say, was) in Illinois.[25]

Finally, one's mental life is not very much like turns on a stage. Consider perception, in which numberless new beliefs about the here and now flood one's economy simultaneously, joining whatever currents of ongoing thought

are already present. Consider ruminative thought, on the basis of which, at any moment, very many different self-ascriptions with an active, rather than static, character can be made. Because of the way we ascribe thinkings, and therefore probably for deeper reasons as well, we can separate what is ascribed into different strands. I am constantly reminding myself of what lap I am swimming at the same time that I am doing long division problems in my head. The problem of distinguishing portions, corresponding to those strands, of the physical description of my brain is pretty much the same problem we faced in the preceding paragraph: distinguishing seems to call for finding similarities between physical descriptions at different times, and a Davidsonian should be open to the possibility that what is merely similar physically speaking is not what underlies what is merely similar mentally speaking.[26]

The conclusion of the second stage of the argument complements and extends the conclusion of the first: neither a radical interpreter who relies on first-person authority to discern a subject's mental life in the content of the subject's beliefs about himself, nor one who constructs acquisitions of beliefs and desires from sequences of economy ascriptions, will be able in general to establish token-token psychophysical identities.

WHAT'S LEFT OF MONISM?

My thesis and a broad kind of monism are compatible under some hypothesis like this: the totality of a person's mental events is identical with some subset of the events in that person's central nervous system (not including, for instance, the circulation of blood there, or the movement of the whole system, or parts of it, from place to place). Or more narrowly, the totality of a person's mental states at a moment is identical with some subset of the states of that person's central nervous system at that same moment (not including, for instance, the temperature of the person's blood at that moment). But my thesis is not obviously incompatible with the narrower monism Davidson espouses; what exactly is wrong with saying that each particular mental event is identical with a particular physical event, though it is impossible in principle to say which one?

Perhaps someone would call on us to convince him that the Principle of (mental-physical) Causal Interaction[27] is true by showing him that a particular physical event caused a particular mental event; and the challenge might include a demand that we show that the two events can be brought under a law. On Davidson's assumption that the law would have to be physical, we would be obliged to produce a physical description of that mental event, that is, to produce a token-token identity of the sort I am pessimistic about. But

that amounts to saying only that we can't convince the doubter in this fashion. We need some more philosophical argument. Or, to put the point another way, the starting point of Davidson's argument for anomalous monism is not empirical, but itself philosophical. It is part of the way we think about perception and action that there is physical-mental interaction; it isn't something we figured out by examining cases of perception and action.

So perhaps we can't coherently talk about one-by-one identifications of mental states with physical states, any more than we can about one-by-one identifications of mental events with physical events. We may be able to slice individuals only this finely: a person's mental economy is identical with that ensemble of physical states of the person that accounts for the person as an input-output device (or as one who has a certain preference ranking for the totality of the sentences of his language and holds certain sentences true in certain circumstances). But no less-than-global mental state resulting from a dissection of the economy into the person's having various particular propositional attitudes is identical with any particular physical state within the ensemble.[28]

BRUCE VERMAZEN

DEPARTMENT OF PHILOSOPHY
UNIVERSITY OF CALIFORNIA, BERKELEY
MARCH 1995

NOTES

1. *Essays on Actions and Events* (cited below as *EAE*) (Oxford: Oxford University Press, 1980), p. 224. In "Indeterminism and Anti-Realism" (forthcoming), he speaks of mental "objects" being identical with physical objects as well.

2. This stronger conclusion would seem to contradict a claim Davidson makes in "Mental Events": "For if anomalous monism is correct, not only can every mental event be uniquely singled out using only physical concepts" (*EAE*, p. 215). But the claim is offered to show that one of its consequences doesn't matter. The claim plays no role in any of Davidson's further arguments to positive conclusions.

3. At different stages of his evolving thought, Davidson refers to different enterprises as "radical interpretation." In early papers like "Radical Interpretation" (*Inquiries into Truth and Interpretation* (cited below as *ITI*) (Oxford: Oxford University Press, 1984), pp. 125–39; originally published 1973) and "Belief and the Basis of Meaning" (*ITI*, pp. 141–54; originally published 1974), the radical interpreter aims only at a complete ascription of beliefs to the subject and a truth theory for the subject's language. In "Thought and Talk" (*ITI*, pp. 155–70; originally published 1977), Davidson explicitly distinguishes radical interpretation from the project of producing a "more comprehensive theory of action and thought" that would

also include ascriptions of desire and intention (*ITI*, p. 162, n. 5). But by the time of *Expressing Evaluations* ([monograph] Lawrence, KS: University of Kansas, 1984; lecture delivered in 1982), he had begun referring to the process of ascribing the whole economy as "radical interpretation" (ib., pp. 8 and 13) and to the ascriber as a "radical interpreter" (ib., p. 17).

4. Davidson uses the term "economies" in this way in "Judging Interpersonal Interests," in *Foundations of Social Choice Theory*, ed. J. Elster and A. Hylland (Cambridge: Cambridge University Press, 1986), p. 207.

5. Such a correlation is already at one level of abstraction or generalization above another sort of thing that might be considered the prime evidence, namely, the subject's holding true a certain sentence on a particular occasion when a rabbit is in his sight. But an interpreter may find it difficult to appreciate just what complex of features of the particular situation is salient until he is in a position to formulate a generalization over a number of situations in which an apparently single utterance-type has been tokened: was it the rabbit, or was it the subtle fragrance of the subject's own aftershave?

6. *The Logic of Decision*, 2d edition, (Chicago: University of Chicago Press, 1983), p. 63. Jeffrey took a stronger view of the non-identity of desirability and degrees of desire in the first edition of the book (New York and other cities: McGraw-Hill, 1965), where he says that "Subjective desirability is not related to desire as simply as subjective probability is related to belief" and that "the theory of preference is concerned not with desire, but with subjective *desirability*" (p. 52). One reason for not identifying desirabilities with degrees of desire, not given in Jeffrey's book, is that since desirability has no *true* zero (though any degree of desirability *could* be assigned the number zero), Davidson's view can't allow that a subject has no desire at all directed toward a sentence, that is, no desire at all for some particular state of affairs; everybody has at least some minuscule degree of desire for absolutely every way the world might turn out.

7. It is not always clear in Davidson's writings that there are these two kinds of evidence with separate roles, but the claim is explicit in "A New Basis for Decision Theory," *Theory and Decision* 18 (1985), p. 97.

8. *Word and Object* (Cambridge, MA: The M.I.T. Press, 1960), chapter 2.

9. The individual stars in these constellations will be sentences of the interpreter's language (to express the contents of the subject's attitudes) together with the degrees of subjective probability and (initial) desirability assigned to each one. Two constellations might differ from one another either in the sentences they contain (since the interpreter may be free to include or exclude certain of his own predicates when building the truth theory) or in degrees of probability or of desirability assigned to individual sentences. "Or" here is inclusive. Whether these differences are "real" or only prima facie is an important question, but not one directly relevant to my argument.

10. "Indeterminism and Anti-Realism," p. 5.

11. See Jeffrey, *Logic of Decision*, 2d edition, chapter 6.

12. "A New Basis For Decision Theory," p. 96.

13. Someone might try to liven things up by pointing out that the attitudes come in two varieties, the occurrent and the standing, and that only the latter are states. But

there is a way to regard so-called occurrent beliefs, desires, and intentions other than as states that, for the moment, *become* events, or perhaps as state/event twins, namely as events that are *not* themselves beliefs, desires, or intentions, but in which a person's beliefs, desires, or intentions are felt, reflected on, thought about, formed, remembered, revealed, attended to, and the like. Such events are sometimes also attitudes, for example, realizing that one wants to drink a can of paint or remembering that one intends to build a squirrel house. But building a bridge from belief and desire to attitudes like realizing or remembering is neither an easy task nor one assigned to the radical interpreter. Nor, given Davidson's description of the radical interpreter's task, does it seem to be part of the task to ascribe occurrent believings and desirings. Even the result of discovering that the subject's "Gavagai" indicated that he *was thinking* (an occurrent belief, on the usual view) that there was a rabbit in his sight primarily adds to the mental economy ascription the subject's belief (static) that at that moment a rabbit was in his sight. For that is the belief that combines with the subject's desires to produce intentions or actions. (See Bruce Vermazen, "Occurrent and Standing Wants," in *Action and Responsibility*, vol. 2 (Bowling Green, Ohio, 1980), pp. 48–54.) And that is the belief that is altered when the interpreter reveals that it was a false bunny. To put it another way, if the beliefs and desires ascribed by an interpreter are to play decision-theoretic roles, they must be conceived as states (or dispositions) of the subject. If the interpreter wanted to add to the ascription the occurrent belief, the thinking or mental rehearsal, he could; I discuss adding such ascriptions in the second stage of the argument. But occurrent beliefs would not play an important role as such in the subject's mental economy.

14. I think this statement represents a change from what Davidson thought at the time of writing "Judging Interpersonal Interests": "If more than one interpretation of a speaker's words is possible, it is even more obvious that a theory that interprets his beliefs and desires along with his words has more degrees of freedom" (p. 209). Behind this remark seems to lie the idea that appears in "Thought and Talk," that "where one constellation of beliefs and desires will rationalize an action, it is always possible to find a quite different constellation that will do as well" (p. 160). That is, Davidson seems once to have thought that there could be differences between ascriptions that would matter. His appreciation and adaptation of Jeffrey's method seems to have changed his mind on the point. See also "Mental Events," p. 222: "For we could not begin to decode a man's sayings if we could not make out his attitudes towards his sentences, such as holding, wishing, or wanting them to be true. Beginning from these attitudes, we must work out a theory of what he means, thus simultaneously giving content to his attitudes and to his words. In our need to make him make sense, we will try for a theory that finds him consistent, a believer of truths, and a lover of the good (all by our own lights, it goes without saying). Life being what it is, there will be no simple theory that fully meets these demands. Many theories will effect a more or less acceptable compromise, and between these theories there may be no objective grounds for choice."

15. See "How Is Weakness of the Will Possible?" (*EAE*, pp. 21–42) and "Intending" (*EAE*, pp. 83–102).

16. Note also that in "Mental Events," Davidson says, "Just as we cannot intelligibly assign a length to any object unless a comprehensive theory holds of

objects of that sort, we cannot intelligibly attribute any propositional attitude to an agent except within the framework of a viable theory of his beliefs, desires, intentions, and decisions." (*EAE*, p. 221)

17. There may be ways of characterizing the input-output device that do not involve ascription of a mental economy. But molecular or neurobiological characterizations are poor candidates unless the inputs and outputs can somehow be characterized in those terms as well.

18. Jeffrey, *Logic of Decision*, 2d edition, p. 107.

19. Here I assume that basic belief and desire contents have been identified in constructing the truth theory. It wouldn't comport with what we think we know about human subjects to suppose that the truth theory could change from moment to moment.

20. Although the argument given concerns only the acquisition of intentions, I think it would apply also to the acquisition of any other mental state that was autonomous with respect to the well-behaved rational beliefs and desires discoverable by Davidson's version of Jeffrey's method, for example, to irrational beliefs and desires.

21. Perhaps there is a "purely intentional" level of beliefs with a special "narrow content," for which first-person authority is infallible. Something like that is suggested by Tyler Burge in "Individualism and Self-Knowledge," *Journal of Philosophy* 1988, pp. 649–63, specifically in footnote 8 to p. 658. But since Davidson does not adopt this position, my argument still applies to his views on occurrent mental events.

22. But can he? Given Davidson's paratactic analysis of indirect discourse in "On Saying That" (*ITI*, pp. 93–108), perhaps the believed uninterpreted sentence corresponding to the content of a subject's belief about his own beliefs will turn out, on interpretation, to be simply "I believe that."

23. I borrow the image from Gilbert Ryle, *Concept of Mind* (Oxford: Oxford University Press, 1949).

24. "Individualism and Self-Knowledge," p. 654.

25. For the same reason, it is clear that a Davidsonian can't use comparisons between physical descriptions of a subject's brain at different times to distinguish between the portion of the description corresponding to one mental *event* and the portion corresponding to another. I base my claim about what a Davidsonian should think on Davidson's discussion of the "nomological slack between the mental and the physical" in "Mental Events," *EAE*, pp. 215–23.

26. This point holds even if mental characteristics supervene on physical characteristics in the sense "that there cannot be two events alike in all physical respects but differing in some mental respect, or that an object cannot alter in some mental respect without altering in some physical respect." (*EAE*, p. 214) For in the sort of case I am citing, there would be no reason to expect any two events (e.g., two events identified mentally as "doing long division in one's head") to be alike in *all* physical respects.

27. See *EAE*, p. 208, Davidson's statement and discussion of the Principle.

28. I wish to thank Donald Davidson, Martin Jones, Ernie LePore, Stephen Neale, Brendan O'Sullivan, and Jamie Tappenden for comments on earlier versions of this essay.

REPLY TO BRUCE VERMAZEN

Years ago I had in my hands a book the title and author of which I do not remember. It was written, I think, by a neurosurgeon. He had performed many operations on the brains of people part of whose brains had been damaged. Before operating he needed to know what cognitive functions were performed by the parts of the brain in or near the wound. He opened up a generous flap of scalp and skull, exposing the top of the brain of the fully conscious patient (this is said not to be painful: there are no nerves in the brain). In the book there was a full-color photograph of exposed brain, covered with a scatter of single letters typed on tiny squares of paper. Alongside was a code describing the reactions of the patient when these spots had been lightly touched with an electric probe. I remember that when one spot was touched the patient suddenly remembered the words of a tune he had learned in his youth, and as far as he knew, had completely forgotten. When I read this, I thought I saw how in practice it might sometimes be possible to identify a physical event with a mental event: measure the length of time from the electric stimulus to the verbal response, trace the firing of the neurons as the effect spread through the brain, and consider some stretch of that spreading as the physical event identical with remembering the tune. Today, of course, there are more subtle methods using non-invasive techniques which can identify all the areas in the brain that come on line when a subject solves a certain sort of problem or is exposed to one or another sort of stimulus.

Although such phenomena may make it plausible that there is a physical event which is identical with each mental event, they do not come close to really picking out a precise physical event, nor is it likely they ever will. I agree with Bruce Vermazen that this is a hopeless project. Contrary to what he suggests, I don't think I ever seriously thought it was possible. The phrase he quotes from "Mental Events" to the effect that if anomalous monism is correct "every mental event [can] be uniquely singled out using only physical concepts" seems, in its context, to no more than state one of the features of

anomalous monism: mental events are physical events, and so some physical description applies to each mental event. I don't think I was saying anyone could say what the physical description is in particular cases, but if I did mean this I was wrong.

Vermazen has a much stronger thesis: we can't coherently talk of there *being* physical events that correspond to most (or any?) of the sort of mental phenomena with which radical interpretation deals: particular preferences, beliefs, intentions, and the like. One difficulty he sees is that radical interpretation aims to attribute *states* to agents, not events. I'm not sure what the difficulty is. Anomalous monism says that mental entities add nothing to the furniture of the world that is not treated in physics (though, of course, they do add a different way of describing and explaining what certain entities do). But states aren't entities. When we ascribe an attitude to a person we describe the person as having a certain trait. It is to such traits that we mainly appeal when we explain why someone acted as he did. The action is an event, but we can't infer from this that the beliefs and values that prompt the action are events (or entities of any kind). But neither can we infer from the fact that what we typically think of as the reasons for an action are not events that there aren't events that are essential to the causing of the action. These events may or may not be mental in an ordinary sense.

As interpreters we actually depend on actions as evidence of the explaining attitudes and it is also actions we want to explain. The interpretation of the simplest sentences depends on noting the reactions of an agent as the environment changes. So it is natural to think of radical interpretation as taking for data not attitudes but the observed ways the agent changes (acts) as the environment changes. Since I count events described as actions as mental, this perspective does not remove us from the domain of the mental. Given such data, partly mental, partly physical, we then hypothesize a set of attitudes to explain what we have observed, attitudes which will help predict how people will act in the future. Beliefs, desires, and intentions belong to no ontology, and so cannot pose a problem for anomalous monism. When we ascribe attitudes we are using the mental vocabulary to describe people. Beliefs and intentions are not (in my opinion) little entities lodged in the brain.

There are, of course, mental events besides actions. We change our minds, solutions to problems occur to us, and perception changes what we believe every second of our waking lives. Can these events be identified in a way that makes it theoretically plausible that they can be described in a physical vocabulary geared to strict laws? Again we should reflect on the ontological issue. Since beliefs, desires, and intentions aren't entities, it is a metaphor to speak of their changing, and hence an extension of that metaphor to speak of them as causes and effects. What happens is that the descriptions of the agent

change over time. The relevant entity that changes is the person, and there seems no difficulty in supposing that these changes have a physical description. Vermazen is right that mental events, at least those that involve the propositional attitudes, are global changes that apply to the whole person. But the reason for this is not that there is some special difficulty about identifying the appropriate location for such events. The reason is that the only thing there is that changes when our attitudes change is us.

D. D.

28

Stephen Neale

ON REPRESENTING

I. THE END OF REPRESENTATION

Our thoughts, utterances, and inscriptions are taken by many philosophers to have content in virtue of being *representations* of reality. Such representations can be accurate or inaccurate: those that are accurate are said to be true, to correspond to the facts, to mirror reality (nature, the world).

Donald Davidson finds such talk unfortunate: it is thoroughly intertwined with talk of facts, counterfactual states-of-affairs, and correspondence theories of truth, and it lures us into fruitless discussions about scepticism, realism and anti-realism, the subjective-objective distinction, representational theories of mind, and alternative conceptual schemes that represent reality in different ways.[1] The time has come, Davidson suggests, to see only folly in the idea of mental and linguistic representations of reality; and with this realization philosophy will be transformed as many of its staple problems and posits evaporate.

A proper examination of Davidson's case against representations must include an examination of his case against *facts,* for Davidson's position boils down to this: in order to give any substance to the idea of representations of reality, reciprocal substance must be given to the idea that there are facts (which true utterances and beliefs represent). Once the case against facts is made, the case against representations (and, with it, the case against correspondence theories of truth) comes more or less for free:

The correct objection to correspondence theories [of truth] is . . . that such theories fail to provide entities to which truth vehicles (whether we take these to be statements, sentences, or utterances) can be said to correspond. If this is right, and I am convinced it is, we ought also to question the popular assumption that sentences, or their spoken tokens, or sentence-like entities or configurations in our brains, can properly be called "representations," since there is nothing for them to represent. If we give up facts as entities that make sentences true, we ought to give up representations at the same time, for the legitimacy of each depends on the legitimacy of the other.[2]

If there are no facts to which true sentences correspond, then such entities cannot function (as some have suggested) as truth-makers, causal relata, or objects of knowledge or perception. And if there are no representations, there is no sense to be made of (e.g.) 'conceptual relativism': "Beliefs are true or false, but they represent nothing. It is good to be rid of representations, and with them the correspondence theory of truth, for it is thinking that there are representations that engenders thoughts of relativism."[3]

The idea here is that talk of relativism is encouraged by the idea that a viable distinction can be made between representations and things represented, a distinction that is supposed to be untenable. In the framework of Davidson's landmark paper 'On the Very Idea of a Conceptual Scheme', the intelligibility of relativism presupposes a dualism of 'conceptual scheme' and 'empirical content'.[4] His central argument against this dualism comprises four parallel sub-arguments which are meant jointly to undermine the *four and only* ways of making the dualism viable. A premise in one of the sub-arguments—the one against *schemes fitting reality*—is that there are no (distinct) *facts* to which true utterances (or thoughts) correspond.[5] In short, the success of Davidson's central argument against the scheme-content distinction, representations, and correspondence theories of truth depends on the success of an independent argument against *facts*. I shall return to this.

According to Richard Rorty, by undermining the scheme-content distinction Davidson has made it all but impossible to formulate many of the traditional problems of philosophy.[6] The only useful application of the phrase "the problems of philosophy", says Rorty, is to "the set of interlinked problems posed by representationalist theories of knowledge . . . problems about the relation between mind and reality, or language and reality, viewed as the relation between a medium of representation and what is purportedly represented."[7] And,

[i]f one gives up thinking that there are representations, then one will have little interest in the relation between mind and the world or language and the world. So one will lack interest in either the old disputes between realists and idealists or the contemporary quarrels within analytic philosophy about "realism" and "anti-realism." For the latter quarrels presuppose that bits of the world "make sentences

true," and that these sentences in turn represent those bits. Without these presuppositions, we would not be interested in trying to distinguish between those true sentences which correspond to "facts of the matter" and those which do not (the distinction around which the realist-vs.-antirealist controversies revolve.[8]

Once we give up *tertia*, we give up (or trivialise) the notions of representation and correspondence, and thereby give up the possibility of epistemological scepticism.[9]

It is one of the virtues of Davidson's work, says Rorty, that it shows us "how to give up" truth-makers and representations. Rorty sees Davidson as an "anti-representationalist" philosopher in the tradition of Dewey, Heidegger, Wittgenstein, Quine, and Sellars. The attack on the distinction between scheme and content, says Rorty, "summarizes and synthesizes Wittgenstein's mockery of his own *Tractatus,* Quine's criticism of Carnap, and Sellars's attack on the empiricist 'Myth of the Given'."[10] These philosophers are said to be linked by a rejection of the "reciprocal relations" of *making true* and *representing* that are central to so-called "representationalism." But there is more to anti-representationalism than this. According to Rorty, it is "the attempt to eschew discussion of realism by denying that the notion of 'representation,' or that of 'fact of the matter,' has any useful role in philosophy."[11] Davidson is meant to be an anti-representationalist because he is committed to the thesis that "there is no point to debates between realism and antirealism, for such debates presuppose the empty and misleading idea of beliefs 'being made true'."[12] And it is precisely the idea that sentences are made true by non-linguistic entities, i.e. *facts*, that Davidson is meant to have discredited and which has led to the rejection of the scheme-content distinction. In short, Rorty's Davidson is someone whose philosophy transcends "pointless" controversies about 'realism' and 'scepticism'.

There is a revolutionary tone to Rorty's claims: once we see that we should give up representations, we will realize that we are no longer confronted with many, perhaps any, of the standard problems of philosophy. The demise of representations renders the stock problems "obsolete" and presents a challenge for philosophers to find a new place for themselves within the academy. Debates between 'realists' and 'antirealists' and between 'sceptics' and 'antisceptics', to name just two, are "pointless. . . . the results of being held captive by a picture, a picture from which we should by now have wriggled free."[13]

I want to revisit Davidson's original argument against scheme-content dualism, explain fully its dependence on a separate argument against facts, and then establish precisely what Davidson is claiming about representation, for it seems to me that Rorty has got Davidson very wrong.

II. SCHEME AND CONTENT

Davidson argues that no good sense can be made of (a) 'conceptual rela-tivism'—the idea that different people, communities, cultures, or periods view, conceptualize, or make the world (or their worlds) in different ways—or (b) the idea of a distinction between 'scheme' and 'content', i.e., a distinction between conceptual scheme (representational system) and empirical content ("something neutral and common that lies outside all schemes"[14]).

Davidson's main argument against relativism is intertwined in subtle ways with one of two arguments he deploys against scheme-content dualism, which relativism is meant to presuppose. For concreteness, Davidson associates conceptual schemes with sets of intertranslatable languages (some people find this problematic, but for my purposes here it is not). His first argument against scheme-content dualism proceeds by way of undermining the notion of a scheme; his second proceeds by way of undermining the (relevant) notion of content. The anti-scheme argument involves an appeal to the conditions something must satisfy in order to qualify as a conceptual scheme, conditions that some have found too stringent. I shall not discuss that argument here. I want to look at the anti-content argument and explain precisely why its ultimate success depends upon the rejection of facts. I shall then explain the relevance of this for talk of "anti-representationalism".

Davidson detects two contenders for the role of "content" in writings advocating forms of relativism: (1) *reality*, (the world, the universe, nature) and (2) *uninterpreted experience*. And since we find talk of conceptual schemes (languages/systems of representation) either (a) *organizing* (*systematizing, dividing up*) or (b) *fitting* (*describing/matching*) reality or experience, there are four distinct ways of characterizing the relationship between scheme and content: schemes organize reality, organize experience, fit reality, or fit experience.

None of the four possibilities is meant to be viable. For the concerns of this essay, it is Davidson's argument against *schemes fitting reality* that is important as it connects in a direct way with talk of an ontology of facts. According to Davidson,

> When we turn from talk of organization to talk of fitting, we turn our attention from the referential apparatus of language—predicates, quantifiers, variables, and singular terms—to whole sentences. It is sentences that predict (or are used to predict), sentences that cope or deal with things, that can be compared or confronted with the evidence. It is sentences also that face the tribunal of expe-rience, though of course they must face it together.[15]

A sentence or a theory (i.e., a set of sentences) "successfully faces the tribunal of experience . . . provided that it is borne out by the evidence," by which

Davidson means "the totality of possible sensory evidence past, present, and future."[16] And for a set of sentences to fit the totality of possible evidence is for each of the sentences in the set to be true. If the sentences involve reference to, or quantification over, say, material objects and events, numbers, sets, or whatever, then what those sentences say about these entities is true provided the set of sentences as a whole "fits the sensory evidence."[17] Davidson then adds that "[o]ne can see how, from this point of view, such entities might be called posits. It is reasonable to call something a posit if it can be contrasted with something that is not. Here the something that is not is sensory experience—at least that is the idea."[18] There is definite allusion to the theory of meaning here. A set of sentences involves reference to, or quantification over, material objects, events, numbers, sets, or whatever, only if a successful truth theory for the language as a whole must appeal to such entities in delivering T-sentences for the sentences in the set in question. And the entities in question are part of our ontology: they are the posits of our 'scheme' and can be contrasted with (sensory) experience, i.e., 'uninterpreted content'.

But now Davidson makes what I take to be an important move, a move against schemes fitting either experience or reality. There is no alternative to quoting the relevant passage in close to its entirety:

> The trouble is that the notion of fitting the totality of experience, like the notion of fitting the facts, or of being true to the facts, adds nothing intelligible to the simple concept of being true. To speak of sensory experience rather than the evidence, or just the facts, expresses a view about the source or nature of evidence, but *it does not add a new entity* [my italics, SN] to the universe against which to test conceptual schemes . . . [A]ll the evidence there is is just what it takes to make our sentences or theories true. Nothing, however, no *thing*, makes sentences or theories true: not experience, not surface irritations, not the world, can make a sentence true. *That* experience takes a certain course, that our skin is warmed or punctured, that the universe is finite, these facts, if we like to talk that way, make sentences and theories true. But this point is put better without mention of facts. The sentence 'my skin is warm' [as uttered by me, here, now] is true if and only if my skin is warm [here and now]. Here there is no reference to a fact, a world, an experience, or piece of evidence. *Footnote:* See Essay 3 [i.e., "True to the Facts," SN].[19]

Here there is allusion both to the theory of meaning and to a collapsing argument (slingshot) against the viability of *facts*. The theory of meaning doesn't need facts, and the collapsing argument is meant to show that we can't have them anyway. Davidson is surely right that on his conception of a scheme—which I am not going to contest here—if the *schemes-fitting-reality* story is to succeed, there must be something extralinguistic for a true sentence

(or belief) to fit or match up to. And surely there are just two plausible candidates: the world itself or an individual fact. Davidson is claiming that neither will work because each trades on the idea that the entity in question "makes the sentence true."

The reason he thinks that individual facts will not do the job is that he has confidence in his collapsing argument, which shows that there is at most one fact (this is surely part of what is suggested by his back-reference to "True to the Facts" in the footnote quoted above). I have discussed this type of argument in detail elsewhere, so I can be brief here.[20] Those who have waived aside slingshot arguments as formal tricks that have no bearing on theories of facts, and those who have seen the same arguments as ruling out facts (and nonextensional logics) are both wrong. Slingshot arguments are extremely valuable: they impose very definite constraints on what theories of facts (and nonextensional logics) must look like, constraints that many proposed theories are incapable of satisfying. (Russell's theory of facts passes—assuming his Theory of Descriptions and his idea that facts contain universals as components—but the theories of Wittgenstein and Austin appear to fail.) There is, then, some room for the fact theorist to maneuver, but it may not be room enough to produce a theory of facts of the sort that initially motivated the postulation of such entities.

Now what of the alternative position, that individual true sentences are made true not by facts but by *the world*? There is nothing in Davidson's attitude to facts, his general approach to truth and meaning, or his argument against scheme-content dualism that requires him to reject the idea of a world existing independently of our thought and language. So why does he suggest, in the passage quoted above, that not even *the world* can make a sentence true? In the course of rejecting the idea of schemes *organizing* the world, he points out that such a story presupposes distinct entities in the world to be organized. Distinct entities in the world are called for by the meaning and use of the word 'organize' (you cannot organize a closet without organizing the things in it). But they do not appear to be called for by the meaning and use of the word 'fit'. And, interestingly, on occasion Davidson seems to suggest that the world is, in fact, one of two things that does make a (true) sentence true, as in the following passage:

> What Convention T, and the trite sentences it declares true, like "'Grass is green' spoken by an English speaker, is true if and only if grass is green' reveal is that the truth of an utterance depends on just two things: what the words as spoken mean, and how the world is arranged. There is no further relativism to a conceptual scheme, a way of viewing things, a perspective. Two interpreters, as unlike in culture, language, and point of view as you please, can disagree over whether an utterance is true, but only if they differ on how things are in the world they share, or what the utterance means.[21]

Suppose that a simple sentence 'Smith is sitting' is true. Then surely, given the meaning of the sentence, it is true because of "how the world is arranged": one of the entities in the world, Smith, is sitting. Indeed, this much is given by a Davidsonian truth theory (and no appeal to an alternative set of axioms will alter this fact). So the world makes the sentence true in at least this sense: if the world had been arranged differently—i.e., if the things in the world had been arranged differently (for a world to be arranged, the things in it must be arranged)—if Smith were, say, standing, the sentence 'Smith is sitting' would not be true. Denying this would drain all content from the concept of truth that permeates Davidson's writings.

There might seem to be no barrier, then, to making the scheme-content distinction viable by thinking of schemes fitting reality, for it is still open to pursue the idea that a true sentence fits the world without endorsing the (possibly hopeless) idea that it fits a particular fact. But of course there is nothing here to console the correspondence theorist. It is no more illuminating to be told that a sentence is true if and only if it corresponds to the world than it is to be told that a sentence is true if and only if it is true, states a truth, says the world is as the world is, or fits the facts. For the last of these phrases, perfectly ordinary as it is—unlike the philosopher's invention 'corresponds to a fact'—is just an idiom meaning 'is true'. Indeed it is hard to resist the point that all talk of 'facts' is idiomatic and that the logical forms of sentences do not quantify over facts ('it is a fact that p' = 'it is true that p'; 'that's a fact' = 'that's true'; 'the fact that p caused it to be the case that q' involves quantification over events, and so on.[22]

III. Representations

If there are no individual facts, then we cannot say with any felicity that a true sentence (or belief) corresponds to, or represents a fact. When Davidson says that neither "sentences, [n]or their spoken tokens, [n]or sentence-like entities [n]or configurations in our brains can properly be called 'representations', since there is nothing for them to represent,"[23] he is proposing an injunction against statements of the form 'a represents b' wherever 'b' is meant to refer to or describe a *fact (situation, state of affairs, circumstance)*. In this vein, no sentence, statement, utterance, mental state, computer state, painting, or photograph can be said to represent a fact.

It is important to see—as I think Rorty does not—that Davidson is not explicitly claiming that there can be no representations of *objects* or *events*. Without any charge of inconsistency, Davidson can accept the truth of many sentences of the form 'a represents b' where a is (e.g.) a painting or a sculpture and b is (e.g.) a person, a place, or an event (e.g., a battle). He can say

that a map of San Francisco represents San Francisco, that various marks on the map represent its streets, coastline, parks, and so on. Similar remarks apply to remarks one might make about wind-tunnel and computer-generated models of objects (e.g., aircraft and automobiles) or events (e.g., hurricanes and earthquakes). So anyone seeking an explicit argument against the existence of representations of objects and events had better look elsewhere; no such argument is to be found in Davidson's work.

I mention this because Rorty appears to want to draw more from Davidson's rejection of facts, for example when he says that 'anti-representationalism'—to which he sees Davidson as subscribing—is "the claim that *no* linguistic items represent *any* non-linguistic items".[24] If we are meant to take this at face value—the italics are Rorty's—then Rorty is drawing a conclusion that Davidson is not. Schematically, Rorty is ascribing to Davidson the view that there are no true sentences of the form '*a* represents *b*' where *a* is a linguistic item and *b* a non-linguistic item. But Davidson's explicit position is that there are no true sentences of this form where *a* is *anything whatsoever* and *b* is a *fact* (*situation, state-of-affairs, circumstance*); and this entails only that no linguistic items represent *facts* (etc.), not that no linguistic items represent *any* non-linguistic items. Davidson holds there are no true sentences of the form '*a* represents *b*' where '*b*' is of the form 'the fact that so-and-so' (or some similar form designed to describe a fact) because he believes he can show (by way of his collapsing argument) that there are no entities to serve as values of '*b*'; nothing can be said to represent a fact since there are no facts to be represented. It's that straightforward, and there is no overt reason to ascribe a stronger injunction to Davidson.

It is possible that Rorty wants to draw the stronger conclusion about linguistic representations because the only viable linguistic contenders for values of '*a*' are sentences and singular terms (including variables under assignments) and the only viable non-linguistic contenders for values of '*b*' are objects, events, and facts. If sentences and singular terms cannot represent facts (because there aren't any) then the only way for linguistic entities to represent non-linguistic entities is for sentences or singular terms to represent objects or events.

Davidson's collapsing argument is meant to show that any two true sentences will represent the same entity (by whatever name); so there is still no merit to the idea that sentences are representations. We are left, then, with the task of making sense of singular terms representing objects or events. One can only presume that Rorty thinks this impossible because as far as Davidsonian truth theories are concerned, no particular set of reference (i.e., satisfaction) axioms for singular terms is privileged—on Davidson's account, no complete set of truth-theoretic axioms is privileged; so the reference relation cannot be considered usefully representational.

It might be countered that the theoretical ineliminability of reference (i.e. satisfaction) within Davidsonian truth theories threatens to take the sting out of this conclusion. For while it is true that no particular set of working reference axioms is privileged, and while it is true that no philosophical account of the reference relation is invoked beyond the idea of a pairing between singular terms and objects (and events)—Davidson does not have to see reference as determined by (e.g.) description, baptism, or causal or informational chains—on his account reference is theoretically ineliminable in the sense that any adequate axiomatization for a natural language will treat names and variables (relative to sequences, and via axioms of satisfaction) as "standing for" particular objects and events. Thus the theory of meaning reveals an ontology of objects and events. We should not, I think, infer from Davidson's faith in the existence of alternative axiomatizations (containing different singular term axioms) that he means to be claiming that there is no interesting sense in which a singular term can be said to stand for, or represent an object or event. Relative to a particular axiomatization (and assignment) that is precisely what a singular term is doing.

STEPHEN NEALE

RUTGERS UNIVERSITY
MARCH 1999

NOTES

1. See Davidson, "The Structure and Content of Truth," *Journal of Philosophy* 87 (1990): 279–328.
2. Davidson, "The Structure and Content of Truth," p. 304. In his earlier paper "True to the Facts," *Journal of Philosophy* 66 (1969): 748–64, Davidson uses "correspondence theory" in application to theories of truth capable of serving as theories of meaning. At the same time he argues against facts by providing an argument deemed to show that all facts, if there are any, collapse into a single Great Fact. This might seem initially puzzling: if there are no facts, to what do true sentences correspond? Davidson neatly dispels puzzlement in the preface to *Inquiries into Truth and Interpretation* (Oxford: Clarendon, 1984): truth theories are correspondence theories only in the "unassuming" sense that their internal workings "require that a relation between entities and expressions be characterized ('satisfaction')" (ibid. p. xv), and not in the sense that they presuppose any entities (facts) to which true sentences correspond. So a truth theory might be called a correspondence theory because of the roles played by (sequences of) *objects* and *events*: we find correspondence in the axioms, through satisfaction, but not in the theorems. We must be careful to distinguish this unassuming sense of correspondence from the sense used in

characterizing theories that appeal to *facts*. Abbreviating somewhat: we must be careful to distinguish correspondence theories that appeal to the concepts of *satisfaction by* (sequences of) individual objects and events from those theories that appeal to the concept of correspondence to facts.

In "The Structure and Content of Truth," Davidson views his earlier use of the word 'correspondence' as somewhat unfortunate and potentially misleading, and proposes, in effect, to reserve the term 'correspondence' for use in application to sentential correspondence theories. I shall follow suit. The hallmark of a 'correspondence' theory of truth, then, is the idea that a sentence (or statement) is true if there is some particular fact (state-of-affairs, situation, circumstance, or other non-linguistic entity) to which the sentence, if true, corresponds. Some correspondence theories will also involve structural correspondence between constituents of sentences and components of facts; but this is not an essential feature of correspondence theories.

3. Davidson, "The Myth of the Subjective", in *Relativism: Interpretation and Confrontation*, ed. M. Krausz (Notre Dame: University of Notre Dame Press), pp. 159–72; quotation from pp. 162–63.

4. Davidson, "On the Very Idea of a Conceptual Scheme", *Proceedings and Addresses of the American Philosophical Association* 47 (1974). Reprinted in *Inquiries into Truth and Interpretation* (Oxford: Clarendon, 1984), pp. 183–98; page references to reprinted version.

5. Ibid., 193–94.

6. R. Rorty, *Objectivity, Relativism, and Truth* (Cambridge: Cambridge University Press, 1991) 1991; "Twenty-Five Years After", in *The Linguistic Turn*, 2nd edition, ed. R. Rorty (London: Hackett, 1992), pp. 371–74.

7. Rorty, "Twenty-Five Years After", p. 371.

8. Ibid., p. 372.

9. Rorty, *Objectivity, Relativism, and Truth*, p. 139.

10. Ibid., p. 5.

11. Ibid., p. 2.

12. Ibid., p. 128.

13. Ibid., pp. 2–3.

14. Davidson, "On the Very Idea of Conceptual Scheme", p. 190.

15. Ibid., p. 193.

16. Ibid.

17. Ibid.

18. Ibid.

19. Ibid.

20. S. Neale, "The Philosophical Significance of Gödel's Slingshot", *Mind* no. 104 (1995), pp. 761–825; *Facing Facts* (Oxford: Oxford University Press, forthcoming).

21. Davidson, "The Structure and Content of Truth", p. 309.

22. See P. F. Strawson, "Truth", *Proceedings of the Aristotelian Society* (1950), suppl. vol. no. 24 (reprinted in *Logico-Linguistic Papers* (London: Methuen, 1971), pp. 190–213; and Davidson, "Causal Relations", *Journal of Philosophy* 64 (1967): 691–703.

23. Ibid., p. 304.

24. Rorty, *Objectivity, Relativism, and Truth*, p. 2.

REPLY TO STEPHEN NEALE

Stephen Neale is right that my rejection of facts as entities correspondence to which can explain truth is central to my views of truth and meaning, to my rejection of the scheme-content distinction, representationalism, and much more. I am therefore grateful to him for exploring the argument against facts on which I have rested so much. His essay, "The Philosophical Significance of Gödel's Slingshot" (Neale 1995), shows in convincing detail how awkward it is to evade the argument. It can be done, as Russell's semantics did it, by making properties parts of facts and so the entities that correspond to predicates. This is a course against which I have argued on the grounds that it cannot be incorporated into a satisfactory theory or definition of truth, and entities that are made up in part of abstract entities can hardly be thought of as empirical truth-makers. Gödel's argument (an analogue of which Alonzo Church attributed to Frege) provides the best and clearest reason to abandon facts. It can be said to make explicit arguments to be found in C. I. Lewis, Strawson, and others who had no such formal considerations in mind.

The Slingshot (given its assumptions) doesn't prove there are no facts; it proves that there is at most one fact. It is this that makes appeal to facts useless for explaining truth, since the predicate "corresponds to The One Fact" might as well be considered an unstructured word, and we already have an appropriate predicate: "is true". The same can be said about representation. If there is only one thing to represent there is nothing interesting to do the representing, nor can the notion of representation allow us to make distinctions among the items that do the representing. Of course, the entities I am talking about here are sentences or utterances or beliefs, because these are the propositional entities that are most naturally thought to present, or re-present, something. Maps and pictures, as Neale remarks, can legitimately be said to represent what they picture or map. Many philosophers and others also speak of words as representing the things they name or describe. I have no strong objection to this use of the word, though "naming" and "describing" seem better ways to express the relation between names and descriptions and what

they name or describe. I do, however, bridle at the idea that any expression *re-*presents any object or event. The only direct manifestations of language are utterances and inscriptions, and it is we who imbue them with significance. So language is at best an abstraction, and cannot be a medium through which we take in the world nor an intermediary between us and reality. It is like a sense organ, an organizational feature of people which allows them to perceive things as objects with a location in a public space and time, or as events with causes and effects (Davidson 1997).

The Slingshot argument concludes that there is one fact at most, but it says nothing about that one. Frege called it The True, and took true sentences to name it. Many of us don't like the idea that sentences are names. But can't we say that true sentences represent, or better, correspond to, or are made true by, the world, as Neale suggests? As long as this way of talking isn't thought to explain anything about the concept of truth, it is harmless and may even make those happy who want to be sure that the truth of empirical sentences depends on something more than words and speakers. I'll come back to this point in a moment. Meanwhile there is the question raised by Neale: why isn't the fact that the world can be said to make our sentences true or false enough to justify the scheme-content distinction and conceptual relativism? Why, he asks, did I say in "The Very Idea of a Conceptual Scheme" that "Nothing, . . . no *thing*, makes our sentences or theories true: not experience, not surface irritations, not the world, can make a sentence true"? That was a mistake. I was right about experience and surface irritations, but I gave no argument against saying the world makes some sentences true. After all, this is exactly as harmless as saying a sentence is true because it corresponds to The One Fact, and just as empty. But isn't the pair, language (meaning the sentences of a language) and world, a fair version of the scheme and content pair? Maybe we can't locate a part of the world that makes an individual sentence true, but the world itself makes the true sentences true and is in some imprecise sense the subject matter of empirical sentences. Still harmless and trivial. The catch is that different languages vary, so if we consider such totalities of sentences as conceptual schemes, we seem to have reinstituted conceptual relativism (and we get a lot of schemes if languages are construed as idiolects that differ from person to person and time to time). This is correct. But it reinstitutes conceptual relativism of a mild sort that I have always accepted. Schemes differ, but very little in their basic conceptual resources (see my reply to Evnine). Neale is right, though, that this requires a separate argument: the essential sameness of schemes does not follow from the Slingshot.

I find nothing to disagree with in what Neale says about my views on the need, in a theory of truth or meaning, to map some expressions onto objects and events in the world. This is one of the clear lessons of Tarski's truth definitions. Tarski's definitions of truth also bring out in a special way the

relation between such mappings and truth. Tarski introduces the notion of a sequence, which is a mapping of all variables (infinite in number) on to entities in the universe of discourse. He then gives a recursive account of the circumstances under which open sentences of any degree of complexity are satisfied by a sequence; in effect satisfaction is a fancy version of reference under an interpretation. The definition of the concept of a sequence can easily be extended to include names, in which case it maps each name on to some entitity. Sequences thus distinguish clearly among predicates (except those that are coreferring) and between names (except those that name the same thing). These distinctions are preserved through the recursion on open sentences. But true (closed) sentences are defined as those satisfied by every sequence; all distinctions made by individual words disappear. Since every language has, in effect, general quantifiers, names, and predicates, what we learn is that if we follow Tarski's methodology, the functions of these expressions can be explained only by relating expressions to things. There is not, as Quine has shown, a unique interpretation of the concept of reference (or satisfaction), but this does not affect the conclusion that we cannot explain how language works without invoking an ontology and assigning objects to singular terms. There cannot in my opinion be a language that does not deal with particular entities (Davidson 1995). This is one reason I long ago asked Quine whether his language, which did away with the notation of quantifiers and variables ("Variables Explained Away", Quine 1966), could be given a semantics that dispensed with ontology. The answer was that it could not. Rorty has misunderstood me if he believes I ever thought otherwise, though I confess those three little words ("not the world") were seriously misleading.

D. D.

REFERENCES

Davidson, D. 1995. "Pursuit of the Concept of Truth." In *On Quine*, edited by P. Leonardi and M. Santambrogio. Cambridge: Cambridge University Press.
———. 1997. "Seeing Through Language." In *Thought and Language*, edited by J. M. Preston: Cambridge: Cambridge University Press.
Neale, Stephen. 1995. "The Philosophical Significance of Gödel's Slingshot." *Mind* 104:761–825.
Quine, W. V. 1966. "Variables Explained Away." In *Selected Logic Papers*. New York: Random House.

29

James Higginbotham

A PERSPECTIVE ON TRUTH AND MEANING

Donald Davidson's article "Truth and Meaning" (Davidson 1967), and several others that followed it, were major instruments in clearing the way for a scientific and philosophical project that continues to this day, of attempting to account systematically for the combinatorial semantic properties of given human languages: to show, in his words, how the meaning of a construction in a language depends upon the meanings of its parts. (The lexicon, comprising the meanings of the primitive parts, or more precisely of those that have separately stated meanings rather than being taken up syncategorematically, comes in only for minor discussion.) For this purpose, Davidson argued, the construction of a theory of truth for a language was both necessary and sufficient. And not just for this purpose, indeed; for he argued also that knowing possession of a correct theory of truth for a language would enable one to understand its speakers.

Davidson's path to his conclusions is widely known, and I will not review it here. But it will be important for my discussion to distinguish the purely analytical project of exposing the combinatorial structure of language from the more philosophical issue of the relations of a successful theory of language, however arrived at, to the understanding exhibited by its speakers. In each case there is a question of necessity, and a question of sufficiency. We thus have four theses linking meaning and truth: is a theory of truth a necessary component of a theory of meaning? is it sufficient? is a theory of truth a necessary component of a theory of understanding? and, is it sufficient?

Over the years, all four of these theses have been criticized, refined, and criticized again; and it would be unfortunate if nothing had been learned in the process. In this article I will take them up, in a particular order, concentrating upon the more abstract considerations. I will argue that the position of referential semantics, in the current state of the subject, is undiminished. At

the same time, as the role of contextual information in human communication has come to be better appreciated and understood, and as the lexical and combinatorial devices of human language have been more deeply explored, we are, I believe, in a much better position than we were some years ago to see what a full theory of the workings of language might look like, and how far it may, even must, draw upon resources that are not themselves linguistic.

On the question of the relations of the deliverances of semantic theory to the psychological states of speakers, a possible answer, which I will assume here, is that the theory gives the knowledge that speakers actually have, in virtue of which they are able to understand what is said to them, or plan their own speech, or engage in any of the myriad applications that are available to any normal native speaker of a human language. The things that native speakers know, and that they know them, enter explanations of their behavior (and not just linguistic behavior) in the usual way; that is, they serve as premises from which deductive or defeasible inferences are drawn, given other knowledge and other psychological states. In short, I am supposing that semantic theory aspires to be a theory of semantic competence in the sense of that notion derived from Chomsky.

Theories of competence have been regarded with deep misgiving; but I will not here enter upon the issues that have grown up around conceptions of tacit, implicit, or even unconscious knowledge. Davidson himself did not say that a person, to whom a correct theory of meaning applies, knows that, or any other theory. Rather, as he remarks in the introduction to Davidson (1984), there may be for all that we can tell nothing at all such that we are linguistically competent because we know it. In another formulation, he remarks that a correct semantic theory for S should have the property that one who did know it, and knew that it was correct, could (in principle) use it to interpret S; but nothing is said about the relation of the theory to any knowledge on the part of some actual interpreter of S. Of course, if the theory is correct, then as Davidson puts it in (1986:438), "some mechanism in the interpreter must correspond to the theory;" but in Davidson's view this remark would add nothing to the thesis that the theory is in fact correct.

If we assume a specific view of the nature of our semantic capacities (that they derive from knowledge), the questions of the necessity and the sufficiency of a theory of truth for a theory of understanding take on a particular form, and it is natural to ask whether this form may prejudice the issues, perhaps in favor of assigning a significant role to the referential conception; but such prejudice as there is may equally attend Davidson's more modest formulation above. I hope, therefore, that making the assumption will not sacrifice generality. Finally, instead of speaking exclusively of truth, I will generally use the wider vocabulary of reference.

I. Is Reference Necessary?

If conditions on reference and truth are necessary for the exposition of the lexicon and the combinatorics of a language, then they must be necessary for understanding as well; for by hypothesis it is in virtue of knowing the lexicon and combinatorics that speakers achieve understanding. The converse does not follow; that is, it may be possible to give the interpretation of the lexicon and the interpretations of the various combinatorial devices of a language without recourse to the concepts of reference and truth, and still not possible that a grasp of these interpretations should confer understanding on a speaker. Theories of meaning that are not finitely axiomatizable, for example those that state outright the meaning of every sentence by using that very sentence, already illustrate the point.

Some care is required in setting up our questions, because we possess a ready-made vocabulary for the phenomenon of understanding itself, namely the very vocabulary that uses conceptions such as "knowing what was meant," "getting the point," and so on. In this vocabulary, we can express pseudo-theories of understanding, saying for instance that to understand the sentence 'Connecticut is south of Massachusetts' you need to know precisely that it means that Connecticut is south of Massachusetts, or that it is used, or to be used, to say that Connecticut is south of Massachusetts; and in these formulations there is no intrusion of the concept of truth, or the other concepts of the theory of reference. Moreover, empirical manifestations of understanding, or misunderstanding, can be described in the same vocabulary. There remains the truism that expressions that diverge in the referential dimension must also diverge in meaning: but this observation of itself does not advance the issue.

As Davidson observed, however, a significant entering wedge appears when we ask what a humanly manageable theory of understanding must involve. If it must have a finite basis, comprising a finite lexicon and a finite set of combinatorial principles, with each of which are associated meanings, or conditions on meaning, then, given the unbounded nature of lexical and phrasal combinations, what is assigned as meaning or condition of understanding of a lexical item or combinatorial mode will have the following properties:

First, the meaning of a lexical item (a word, or a part of words appearing as an affix, a "bound morpheme" in the classical sense) must accompany it through each of the infinitely many sentences in which it appears. A single item may have many meanings, but their totality must be finite (in practice, not very large), so that the relevant conception of meaning must respect the finiteness condition in any case.

Second, whatever is advanced as meaning or condition of understanding must be sufficiently flexible as to apply to all categories of expression. In this regard one may think of the different types of meaning attached to predicates, singular terms, quantifiers, connectives; but the scope extends to tenses, aspectual morphemes, adverbials of various sorts, and many others.

Third, it must be possible to express the combinatorics of the language in terms of the relevant concept of meaning; and this combinatorics must have the property that whoever knows the meanings of the parts and the combinatorial principle is in a position to derive the meaning of the whole.

Fourth, it must have the property that reasoning that speakers engage in within the language can be shown to be generally correct, and their knowledge of its correctness stems from their understanding of the language.

Referential semantics, as customarily practiced, can satisfy all of the above, over a fairly wide stretch of human language. The elements to which reference is relative, the parameters of evaluation, have undergone various expansions, notably including the parameter of possible worlds, and the idea, originally due to Robert Stalnaker, that the active context of a discourse (represented, for him, by a set of possible worlds, constituting the assumptions of the participants) should be a parameter as well, for the determination of presuppositions and even the nature of the proposition uttered. These expansions in no way alter the fundamental dimensions of the referential theory.

The assumption that semantics is referential, however, can be, and has been, questioned on the grounds that reference, satisfaction, and truth should be understood in a way that is "minimalist" in the sense of Horwich (1990) or "deflationist" in the sense of Field (1994) (so that they tell us nothing about meaning), and that meaning is constituted, not by conditions on reference, but by concepts expressed (where what concept a linguistic item expresses is derived in some way from its use, manifesting our practical abilities). A recent locus of this alternative is work by Paul Horwich that is, as I write, on the eve of publication. I will relay what I take to be Horwich's position, based on discussion with him, and convey where, if my summary is correct, my disagreement would come. Whether I have him right or not, I think that the view that I will consider, and the rejoinder to it, deserve to be spelled out.

Assume, then, that concepts are associated with expressions, and that combinations of concepts give rise to other concepts, where some features of use determine what concept a lexical element expresses, and the effect of a given mode of combination. Assume that the lexicon and set of combinatorial modes is finite, and that concepts are sufficiently well described as to type that they may cover all of the various categories of a language. As for reasoning within the language, Horwich (1990) argues that the minimalist position can generalize over patterns of inference in the standard way. There remains an

obscurity at the beginning, since we are not told very much about what concepts are (they are not, for example, individuated in terms of reference). But the crucial issue is whether the combinatorics is forthcoming.

Meaning, however understood, must be compositional; that is, it must be seen to satisfy the general principle that the meaning of an expression is a function of the meanings of its parts and their mode of combination. The combinatorics of meaning is concerned with interpreting the notion of a "mode of combination," and with spelling out the cases that actually occur. Without loss of generality we can assume a version of compositionality that may be called *strictly local*; whether it is generally true or not, it certainly marks the default case.

Suppose that we are looking at a syntactic structure $Z=X-Y$, and that the meaning of whatever occupies X (the conditions on X's reference, on the referential conception) and of whatever occupies Y are known. The points X, Y, and Z will come with certain formal information (in the form, for instance, of syntactic features). Then the thesis of strict locality is that the meaning, or range of possible meanings, of Z is strictly determined once for all by the formal information at X, Y, and Z, and the meanings of X and Y. The thesis implies, then, that further information about how the meanings of X and Y were arrived at is not relevant to the meaning of Z; and furthermore that the contribution of Z to any larger structure W within which it may occur is independent of the nature of W.

The configuration $Z=X-Y$, together with the formal features (identifying, say, X as a Noun, Y as a Verb, and Z as a Sentence) constitutes a syntactic *schema*, to which a condition on interpretation is attached, by hypothesis. An *instance* of the schema is obtained by filling in X and Y with appropriate linguistic material. Let the schema be that of predication, illustrated by simple sentences such as 'Fido barks'. We know how to associate truth conditions with expressions falling under this schema, but the interest here is whether, by simply endowing the schema with a meaning of its own, we can express the combinatorics of this simple, and strictly local, case of compositionality without bringing truth conditions into it.

Suppose that (in virtue of whatever phenomena) we have fixed on the concepts expressed by the subject and predicate; say, that 'Fido' expresses FIDO (a certain individual concept) and 'barks' expresses BARKS. Then, the thought is, the meaning of the predication schema yields as the meaning of Z, the sequence 'Fido barks' with grammatical description as given by the syntax, the proposition FIDO BARKS. More generally:

if **S** is an instance 'a Vs' of the predication schema, the concept c_1 is the meaning of the instance of a, and c_2 is the meaning of the instance of **V**, then the meaning of **S** is (the proposition that) $c_1\ c_2$

What we have just said for predication would be applied *mutatis mutandis* across the board, throughout the various types of constructions: the meaning GREEN DOOR of 'green door' will be the result of applying the schema governing Adjective+Noun to GREEN and DOOR; and so on. Compositionality, in the strictly local form, is therefore satisfied.

Notice that Horwich (or at least my version of his views) does not deny the thesis that the theory of meaning may be studied as the theory of a human competence. As such, this theory would have to explain how one may know the meaning of a complex expression given that one knows the meanings of its parts and their mode of combination; and in fact it purports to do just that, by means of the general condition above, for example, on combining concepts under the schema of predication.

However, as a theory of how you know what 'Fido barks' means, what that condition gives is unsatisfactory, since it does not determine what the meaning of the predication schema, or any of its instances, in fact is. This can be seen from the fact that a person who knew that 'Fido' means FIDO and 'barks' means BARKS, and apprehended the general statement above governing the predication schema would not in virtue of that come to know what the meaning of 'Fido barks' is, unless he already grasped that the latter is to be predicated of the former, which it was precisely the intention by means of that formula to convey. (The schema was *called* 'predication' in the formula, but that it *was* predication played no role in the formula.) But the meaning of 'Fido barks' must be specified as involving c_2 in the role of predicate of c_1, for we are juxtaposing names of concepts not by way of listing them, but by way of indicating certain propositions, in which c_2 is predicated of c_1.

In sum, one cannot bring another to understand the semantic effect that a mode of combination has on an ensemble of concepts simply by reproducing the linguistic specification of that mode. We know that FIDO BARKS is the proposition delivered by applying the predication schema to FIDO and BARKS (in that order); or alternatively, by applying BARKS to FIDO. But about the meaning of 'Fido barks' we know only that the schema yields FIDO BARKS as value, given FIDO and BARKS; and that does not tell us what proposition FIDO BARKS may be.

The above disquisition is intended as an echo of a swift remark in Davidson (1967), rejecting the proposal that the meaning of the sentence 'Theaetetus flies' can be given as the value of the meaning of 'flies' for the meaning of 'Theaetetus' as argument. Davidson writes:

> The vacuity of this answer is obvious. We wanted to know what the meaning of 'Theaetetus flies' is; it is no good to be told that it is the meaning of 'Theaetetus flies'. (Davidson (1967: 20).

—or, we may add, that it is THEAETETUS FLIES.

By way of contrast, compare how the interpretation of modes of combination, and the schema of predication in particular, proceed according to the account of meaning in terms of knowledge of reference. We assume that the native speaker knows

'Fido' refers to Fido;
'barks' is true of x <-> x barks; and
If **S** is an instance of 'a **V**s', the instance of 'a'
refers to y, and the instance of **V** is true of x <-> $F(x)$,
then **S** is true if and only if $F(y)$.

Knowledge of all these (and of the fact that 'Fido barks' is an instance of 'a **V**s', where the instance of 'a' is 'Fido' and that of **V** is 'barks') is sufficient to enable the deduction concluding that 'Fido barks' is true if and only if Fido barks—which, on the referential conception, is part of what the native speaker knows in knowing the meaning of the sentence.

I have spoken in terms of knowledge of reference rather than meaning; but this was not essential. Thus one could conceive an account whose principles were

'Fido' means FIDO;
'barks' means $^\wedge \lambda x$ (BARKS(x));
(where the carat '$^\wedge$' marks intensional abstraction), and
If **S** is an instance of 'a **V**s', the instance of 'a'
means y, and the instance of **V** means $^\wedge \lambda x$ $(F(x))$
then **S** means
$^\wedge F(y)$

Since the context 'means . . . ' is not extensional, more would have to be said in order to enable the derivation of

'Fido barks' means that Fido barks

but it should be clear that there is a difference even between this formulation and the trivial account that we are considering: the configuration that yielded the proposition that Fido barks as the meaning of 'Fido barks' was not called 'the predication schema', but that it served *as* the predication schema follows from the principle governing it (and of course makes our calling it the predication schema redundant).[1]

I conclude that attempts such as that I am attributing to Horwich have obscured the point that a combinatorial semantic principle, if it is to confer knowledge of the meaning of an expression on the basis of knowledge of the meanings of its parts, cannot take the form envisaged. It is like an equation in two unknowns; we know that the meaning of the predication schema is such

that it delivers FIDO BARKS given FIDO and BARKS; and we know that FIDO BARKS is the value of the predication schema for those arguments; but from this single principle we don't know what the predication schema signifies, or what proposition FIDO BARKS may be.

I have dwelt at length on one "minimalist" attempt to state a theory of understanding meeting the conditions that I have identified. If only a referential conception of meaning can satisfy these conditions, then grasp of reference and truth is a necessary condition for understanding. But a demonstration of this necessity is by its nature forbidding, because it would have to be shown that nothing at all that does not incorporate reference and truth could in principle be satisfactory.

I remarked above that expansions of referential semantics to include parameters such as possible worlds or context sets in the sense of Stalnaker are not a departure from referential semantics. (Davidson has expressed scruples about possible worlds semantics, but with respect to the matter we are now considering, that is a side issue.) Reliance on reference can be apparent behind a terminology whose interpretation depends upon it. If, for example, one's explication of the notion of a concept identifies concepts that are cointensional or necessarily coextensive, then it's clear that nothing but (parameterized) referential semantics is at stake, as in a view stemming from Rudolf Carnap and taken up in much of contemporary semantics. But otherwise the notion of a concept is left obscure, even apart from the difficulty of combining concepts productively so as to specify propositions.

The situation is different with respect to the alternative, suggested for instance in Schiffer (1987) that would associate with each expression of the lexicon and each mode of combination a "processing role," amounting in the case of modes of combination that produce sentences to what he calls a "saying potential." To use the example above, what is the saying potential of the schema 'a V's? The natural thing to say its saying potential consists in its suitability for saying that the reference of the instance of 'a' is among the things of which the instance of V is true. But this is to bring reference in by the back door. And once reference is brought in, then, with the concept of truth at our disposal, we can explain why it has the saying potential that it has.

The necessity of the referential concepts for a theory of understanding survives, if I am right, both the advent of a "minimalist" approach to reference, and the extensions of simple referential semantics that have occupied an important position in recent research. If so, then whether a theory of the combinatorics of language that does not rely on reference can be constructed in abstraction from the question whether it can be used as a theory of understanding is a question that loses interest, at least on the assumptions in force here.

II. Is Reference Sufficient?

I turn now to the questions of sufficiency, where the order of consideration is inverse to that of section I. Whatever is sufficient for understanding is also sufficient for semantic description; so if there is a humanly usable body of knowledge, sufficient for understanding, that does not extend the semantic notions beyond the referential, then the whole of the lexicon and combinatorics can be given in its terms. On the other hand, it may be that whereas the lexicon and combinatorics need deploy only referential concepts, understanding requires more. I will argue here that meeting the requirements of understanding does take us in an important sense outside the realm of reference, by adding a contextual dimension whose significance has emerged in part as a result of continued empirical research; but it does not do so in a way that vindicates the chief considerations that have been advanced against the truth conditional theory of meaning.

The point of order that I have just sketched calls for some winnowing of the data if we can see right off that the interpretation of the lexicon and combinatorics of a human language cannot be confined to referential concepts (plus, of course, those that occur in the course of stating what reference or truth conditions are to be). And indeed it cannot. There is a variety of linguistic devices whose functions are not referential, but reflect other communicative interests. Simple examples include euphemism, and insulting language (Frege's "coloration," which he recognized as a third ingredient in meaning). Then there is phatic speech, whose point is to emphasize social solidarity. There are divergences in usage, reflecting social distinctions or level of conversation, from vernacular to formal. And there is arch speech (as in 'I met a certain man yesterday'), partly revealing and partly concealing the speaker's belief state.[2] These elements should not be viewed as mere intrusions or extras added on to the otherwise cognitive component of language, but rather as intrinsic parts of its operation, including its cognitive operation, because their use influences the context (e.g., the common beliefs of the participants) with respect to which subsequent utterances are evaluated. In general, however, all of the non-referential devices lean upon reference for their effectiveness. The recognition of euphemism, for instance, involves the knowledge that the euphemism and the common expression do indeed have the same reference, and euphemism is therefore understood only in the light of reference. The same may be said of several figures of speech, as noted in Goodman (1976). Hilary Putnam (1978: 99) once wrote that meaning should be viewed as a "coarse grid laid over use." What is right about this appealing image, if reference is the core of meaning, is the reverse of what it suggests. Meaning is not laid over use: use is a refinement of the grid laid down by

reference. Having noted some of the non-referential aspects of speech, I will put them aside, except for the point that they influence the context, as indeed all speech does.

A number of authors, perhaps most forcefully Scott Soames in Soames (1989), following in part John Foster's remarks in Foster (1976), have argued that the sufficiency of a theory of truth, either for lexical and combinatorial semantics or for language understanding, is undermined by the observation that a correct account of truth for a whole language need not deliver the meanings of the sentences of the language. The reason is that the goal, of formulating a theory that yields a true statement of truth conditions for every sentence of the language, can be met in many ways if in any way at all (for instance, by adding any irrelevant logical truth to the axioms). If so, then a person in possession of a correct account of truth may combine it with a misapprehension of meaning, and so fail to understand its speakers.

Davidson's original exposition was entirely in terms of simple referential axioms and combinatorial principles, and it is to this conception first of all that the argument is directed. But, as Soames remarks, the situation does not change in any essential way when further parameters—possible worlds, situations, properties, etc.—are added. Any theory of truth (or truth with respect to various parameters) that draws upon familiar combinatorial apparatus and lexical axioms will make use of various statements governing that apparatus, or the lexical entries, equivalent in the theorist's language. Substitution, therefore, of one statement for another will not affect the theory of truth, however much it may distort meaning.

Part of the force of Foster-Soames objections stems from taking the notion of meaning, or the content of a speech act, as *given*, at least to the extent that we can see that some ascriptions of meaning are distortions. Davidson's own exposition invites this attitude as well, inasmuch as he advanced the project of constructing a theory of truth, whose consequences were the familiar biconditional statements of truth conditions, as a replacement for the project of constructing that theory that would directly employ the concept of meaning, issuing in theorems giving the meanings of whole sentences, in the form 's means that p'. But of course the problem is not to be avoided by discarding talk of meaning. Any theory of meaning will have to expound the combinatorics of complement clauses in conjunction with expressions for speech acts: 'He warned me that p', 'She asserted that q', and so forth. Since the discriminations marked by these clauses cut far more finely than the statements of truth conditions for 'p' and 'q' themselves, in the sense that among correct (i.e., true) statements of truth conditions only some are appropriately characterized as giving the content of the warning, assertion, or other act, it follows that a correct theory of truth alone is not sufficient for the specification of content.

At this notorious point there are various remedies. One possibility is to embellish the notion of a correct theory of truth in terms of attendance to conditions under which it might be arrived at, or in terms of a canonical derivation from axioms empirically established, to single out as it were a target statement that, in giving truth conditions, also gives meaning. The latter suggestion raises the question what reality the restriction on derivations answers to, and the former I must confess to finding unclear in the details. Another consists in discriminating the semantics of sentences not only according to where they end up (say, true or false in this or that possible world) but also according to how they got there: David Lewis's suggestion in Lewis (1970) that sentences be discriminated according to their compositional intensions, and other, more recent views that endow propositions with an internal structure, belong here. Still more refined methods might include taking the notation itself as crucial to the semantics. However, the ability mechanically to mark distinctions amongst truth conditionally equivalent sentences can hardly be a satisfactory procedure by itself. What is missing from accounts in terms, for example, of structured propositions, is an understanding of how the distinctions correlate with the cognitive capacities of speakers and hearers. It is not just a matter of being able to make enough distinctions, but also a matter of knowing which distinctions are not to be made.[3]

In Higginbotham (1991), I suggested that we could discriminate what gave the content of a sentence from what merely gave correct truth conditions by asking what the native speaker was, or was justifiably, expected to know about truth conditions. I still think that this response is adequate as far as it goes, although it comes at the (potential) cost of endorsing an account of linguistic mastery in terms of tacit knowledge. But the response glosses over a distinction between the case of sentences used as complements on the one hand and those same sentences as said in isolation on the other. To put it another way, it moves too quickly to a simple version of Frege's thesis, that the sense of a sentence is its indirect reference.

Let me illustrate the issue with reference to Davidson's paratactic account of indirect discourse; an alternative that I and others have advanced, that differs fundamentally in taking the type of the embedded sentence to be crucial; and the modal theory of sentential embedding, pioneered by Jaakko Hintikka. I will argue that the same issue arises for each.

On the view advanced in Davidson's "On Saying That" (Davidson 1969), the English written as 'He said (that) the earth moves' consists of a subject, 'he', with whatever reference it has, a transitive verb, and a demonstrative object, which by the principles governing our speech is constrained to refer to the following utterance of 'the earth moves'. The whole is then true if the reference of the subject did indeed say something or another having the same

import as that utterance as said by the speaker—something that makes the subject and the speaker "samesayers," to use Davidson's formulation. The theory carries over straightforwardly to contexts of belief and others.

Alternatively, taking the apparently embedded clause 'the earth moves' not as a true part of a single utterance, it may be suggested that the whole is true if the reference of the subject did indeed say that very type, *understood as it would be if uttered by the speaker*, this last condition taking over the role of sameness of import in Davidson's account.

Finally, on the modal theory, the speaker's utterance of 'He said that the earth moves' is true if the reference of the subject said the very proposition that the speaker expresses, as determined by the spectrum of possible worlds in which the embedded sentence is true. This last account demands supplementation, not only because of widely appreciated counterintuitive results, but also because there are locutions of embedding whose very point would be undermined by the modal treatment. Examples like

It is transparently obvious to John that p

can hardly be understood as meaning that the proposition $^\wedge p$ holds in every possible world in which everything transparently obvious to John is true; for many propositions will be true in all such worlds that are not transparently obvious to John, and it is precisely the point of saying that something is transparently obvious to discriminate among items of belief or knowledge. The supplementation, whatever form it takes, will induce a notion of sameness of import far finer than that afforded by the truth conditional semantics alone.

From the remarks just made about the modal theory, it follows that even if the paratactic account or the sentence-embedding account of the reference of complement clauses were to give the semantics of the complement in terms of possible worlds, the relevant notions of sameness of import, or of how the embedded clause is to be understood, would still not be captured.

Of the suggestions just canvassed, the modal theory most directly incorporates Frege's thesis equating sense with indirect reference, because in that theory the proposition expressed by a sentence in isolation is precisely the one to which it refers when embedded. But the other accounts incorporate it too, if we but take the small step of supposing—and how can we not?—that the import of a sentence, or how it is to be understood, is determined by its canonical truth conditions, as given by applying the theory of truth, or of what the speaker is expected to know about truth conditions, to that sentence in isolation.

But this last step need not, and should not, be taken, for it conceals the fact that the interpretation of the contents of our speech acts, or reports of speech and thought, are sensitive to our very capacity to deploy what we tacitly know. Consider the extent of the abstraction from our actual speech and understanding that a theory of competence makes. We are supposing, as is customary,

that grasp of truth conditions, and for that matter of other features of speech not involving reference, as illustrated above, is the outcome of a system that, given appropriate features of the context, is deductive; and overall, since the assignment of the appropriate context and the disentangling of the syntax must go together, a process of defeasible reasoning. The semantic theory that we deploy, capable as it is of deriving what we do know and can use more or less immediately, is of course capable of deriving many things that we do not know in any sense, the remoter or more difficult, for us, consequences of what we know. Hence the performance of the semantically competent will diverge from that of a hypothetical ideal engine in any number of ways, and in ways that differ from speaker to speaker, and from time to time. In sum, what holds for our explicit knowledge and beliefs holds likewise for tacit or implicit knowledge and beliefs.

But now, our competence in reporting with whole sentences the speech or thoughts of another, and in giving the contents of speech acts, engages our sensitivity to the gap between competence and performance in the use of those sentences themselves. For this reason first of all, the notion of sameness of import, or of how an utterance of a sentence is to be understood, cannot attend only to what the semantic theory delivers as the truth conditions of that utterance as a sentence of English. In interpreting these notions, we find that they draw upon features of the relations of the theory of semantic competence to the characteristic powers and limitations of speakers of the language. Roughly speaking, the semantic theory should allow the interchange of obvious equivalents, for example of 'the soup grew cooler' for 'the soup cooled': but which equivalents are obvious is a matter of the interaction of underlying competence with our actual capacities for deploying it.

There is a further context-sensitivity to be noted. As Stalnaker (1991) has emphasized, it is not merely that in attributing knowledge and belief we are sensitive to whether what we express is available to the agent in guiding her behavior, but also to which specific projects the agent may be up to. I know, for example, that the cupboard above my sink is approximately level with my forehead; but this knowledge is not properly accessed or available to me when I am concentrating on doing the dishes, with the result that I bump my head on the cupboard.

Can the modal theory of sentential embedding be supplemented so as to incorporate an appropriate notion of sameness of content? A recent suggestion in Stalnaker (1998) is that it can in principle, if the context of an utterance, expressing a proposition in the modal sense, includes standardly the information that it was that very utterance that expressed it. Apart from technical issues in working out the modal, or another, account of matters, the general point, I believe, remains.

Frege's view was that the sense of a sentence was also its indirect reference, and now we have said that the indirect reference is sensitive to a

number of contextual matters, whereas the sense (i.e., what one is expected to know about its truth conditions) is not. In fact, the divergence is inevitable, and not an essential departure from Frege. As Michael Dummett has noted (Dummett 1973), the Fregean thesis that sense determines reference calls for modification in a context-dependent language, and is to be replaced by the thesis that sense together with context determines reference. I would offer as a corollary that the Fregean thesis that sense is indirect reference is likewise to be replaced, for a context-dependent language, by the thesis that sense together with context *constitutes* indirect reference.

Contexts are not very well-behaved creatures. Hence, the project of explicating our notion of sameness of sense, now elaborated as explicating the notion that a potential assertive utterance u in context c comes to the same thing as u' in c', is not one where we should expect formalism to accomplish everything, particularly as the contexts themselves will make reference to the psychological states of speakers and hearers, including their implicit knowledge of language. But pieces can be extracted, and the basis for our comprehension of language thereby clarified.

I have advocated the view that the Foster-Soames problem is to be resolved (or, perhaps, dismissed in virtue of changing the subject), not by constraints anterior to the construction of a theory of truth conditions, but rather by frankly endorsing the thesis that truth conditional semantics should be conceived as a theory of what speakers know, and by an appropriate modification of the thesis that sense is indirect reference. An analogous modification is available also on Davidson's more cautious view. It isn't the case that any old correct theory of truth will enable communication: one must understand, in the context and with the powers and limitations of those one is interpreting in mind, what sameness of import between utterances in fact comes to, and this will involve attributing to them a sophisticated grasp (possibly different from our own) of how they access and deploy information linguistically expressed. There is no reason to believe that a purely formal solution to this problem exists, and good reason to believe otherwise: we are quick and accurate in some things, slow and mistake-prone in others, in ways that are not measurable except in terms of the local features of human psychology. In any case, whether the views that I have advanced are "Davidsonian" or not, I see the role of reference and truth in philosophical reflection upon meaning as undiminished, even wholly unobstructed, by the issues considered above.

<div align="right">JAMES HIGGINBOTHAM</div>

SOMERVILLE COLLEGE, OXFORD
NOVEMBER 1998

NOTES

1. The above is a simplification, if intensional abstraction is understood in the sense of intensional logic. In that setting we would have

'Fido' means $^\wedge$ Fido;

'barks' means $^\wedge \lambda x$ bark(x); and

'Fido barks' means $^\wedge$ barks(Fido).

this being an application of the general schema that, if the instance of a means α, and the instance of **V** means ß, then **S** means $^\wedge (^\vee \alpha) (^\vee ß)$, where the upside-down carat gives the extension of the intension upon which it operates.

2. For elaboration of the meaning of 'a certain', and its link with assertion, see Higginbotham (1994).

3. On this point, see Scheffler (1955).

REFERENCES

Davidson, Donald (1967). "Truth and Meaning." *Synthese*. Reprinted in Davidson (1984), pp. 17–36.

———— (1969). "On Saying That." In *Words and Objections: Essays on the Work of W. V. Quine*, edited by Donald Davidson and Jaakko Hintikka. Dordrecht, Holland: D. Reidel. Reprinted in Davidson (1984), pp. 93–108.

———— (1984). *Inquiries Into Truth and Interpretation*. Oxford: Clarendon Press.

———— (1986). "A Nice Derangement of Epitaphs." In *Truth and Interpretation: Perspectives on the Philosophy of Donald Davidson*, edited by Ernest LePore. Oxford: Basil Blackwell, pp. 433–46.

Dummett, Michael (1973). *Frege: Philosophy of Language*. London: Duckworth.

Field, Hartry (1994). "Deflationist Views of Meaning and Content." *Mind* 103: 249–85.

Foster, John (1976). "Meaning and Truth Theory." In *Truth and Meaning: Essays in Semantics*, edited by Gareth Evans and John McDowell. Oxford: Clarendon Press, pp. 1–32.

Goodman, Nelson (1976). *Languages of Art*. Indianapolis: Hackett Publishing Company.

Higginbotham, James (1991). "Truth and Understanding." *Iyyun* 40: 271–88.

———— (1994). "Priorities in the Philosophy of Thought." *Proceedings of the Aristotelian Society Supplementary Volume 1994*: 85–106.

Horwich, Paul (1990). *Truth*. Oxford: Basil Blackwell.

Lewis, David (1970). "General Semantics." *Synthese* 22. Reprinted in *Philosophical Papers, Vol. I*, edited by Lewis. Oxford University Press, Oxford, 1983, pp. 189–232.

Putnam, Hilary (1978). *Meaning and the Moral Sciences*. London: Routledge and Kegan Paul.

Scheffler, Israel (1955). "On Synonymy and Indirect Discourse." *Philosophy of Science* 22: 39–44.

Schiffer, Stephen (1987). *Remnants of Meaning*. Cambridge, Mass.: MIT Press. A Bradford book.

Soames, Scott (1989). "Semantics and Semantic Competence." In *Philosophical Perspectives 3: Philosophy of Mind and Action Theory*, edited by James Tomberlin. Altascadero, Calif.: Ridgeview Publishing Company. Reprinted in Steele, S. and Schiffer, S. (1988), *Cognition and Representation*. Boulder, Colo., Westview Press, pp. 185–208.

Stalnaker, Robert (1991). "The Problem of Logical Omniscience, I." *Synthese* 89: 425–40. Reprinted in Stalnaker (1999).

——— (1998). "On the Representation of Context." *Journal of Logic, Language, and Information* 7: 3–19.

——— (1999). *Content and Context*. Oxford: Oxford University Press.

REPLY TO JAMES HIGGINBOTHAM

Meaningful linguistic utterances involve many nesting intentions on the part of a speaker. Here are some of the most obvious: the speaker must intend to produce certain sounds with the intention of uttering a certain string of words with the intention of uttering words that will be interpreted by an audience in an intended way with the intention of making an assertion (or asking a question or giving an order, etc.) with the intention of conveying certain information (or specifying the information wanted, etc.) with the intention of warning someone, or obtaining information, with the intention of accomplishing something further. Several of these intentions exhibit the Gricean reflexion: there is the intention that the intention be recognized by the audience. The first intention in this list that has to do with meaning is the intention that one's utterance be interpreted in a certain way. This is what could be called the intended literal meaning. It could be, but it usually is not. Literal meaning more often refers to the meaning that is thought to be good standard usage, whatever that is. I don't think this concept is useful in understanding how language works because 1) it is ill defined, 2) if it is given a sharp definition, that definition will exclude large numbers of speakers, and 3) communication succeeds when, and only when, the speaker is interpreted as he or she intended, and it is neither necessary nor sufficient that any particular social norms of speaking be followed for communication to succeed. Speakers can often understand each other even though they do not use the same words to mean the same thing.

Since the word "literal" is so often understood in a way for which I have no use, I have sometimes simply spoken of first meaning: it corresponds to the first intention which has to do with meaning of any sort. This is the level at which a systematic recursive characterization of truth conditions can hope to characterize an aspect of linguistic understanding. James Higginbotham has done a masterful job of explaining how meaning at this level cannot do without the concepts of truth and reference, and how all further levels of meaning depend on this level. He also makes clear that there is much more to

a "full theory of the workings of language" than can be treated at the level of first meaning. I completely agree that there is much more to understanding a speaker than a theory of first meaning supplies. I doubt, however, that there can be a satisfactory theory which can be formally specified for very much of what lies beyond.

Higginbotham raises the familiar worry that there is no satisfactory way to guarantee that a theory of truth which yields correct T-sentences will reflect meaning. I think this worry can be overcome by reflecting on the fact that when such a theory is treated as an empirical theory, T-sentences are laws which state the truth conditions not only of actual utterances but also of unspoken sentences. Laws formulated as universally quantified biconditionals convey far more than identity of truth value. This consideration, and the constraints that follow from the logical relations among sentences should, when coupled with the usual pressure for simplicity, ensure that contrived, gerrymandered theories are weeded out. There remain, however, plenty of doubts whether a "canonical" theory is sufficient to describe what an interpreter needs to know about first meaning. The most obvious question is what conceptual resources a theory of meaning can legitimately employ. I prize Tarski's general way of defining truth because the T-sentences it entails give the truth conditions of sentences using (on the right side) no more than the conceptual resources of the language for which it gives the semantics: no set theoretical or intensional concepts are employed at the T-sentence level unless, of course, they are employed by the sentence whose truth conditions are being stated. But cleaving to these resources means all the usual idioms of a natural language must be shown to be amenable to such treatment. I have seen no convincing proof that this is impossible, but it well may be impossible. Meanwhile, much is learned by trying (see the essay of Ernie Lepore).

If I follow his argument, Higginbotham rejects my paratactic account of indirect discourse and sentences that attribute propositional attitudes on the grounds that a truth-conditional semantics cannot yield the fine-grained distinctions needed to explain when two speakers are samesayers. I think it is true that a truth-conditional semantics cannot do this, but I can't imagine that any semantic theory could. There surely is no set of rules, no matter how complex, that will specify when reports of what someone believes or intends or said are accurate. Our standards in this matter are highly flexible, and depend on the overall point of such reports. This is the reason I put problem into the undefined (and, in my opinion, undefinable) relational predicate "samesays".

Higginbotham does an excellent job of pointing out the futility of a semantics that maps each expression on to some entity, concrete or abstract, but fails, within the theory, to explain how the entities are related. Russell's simplest "propositions", made up of an object and a universal, are an example.

Frege saw the problem, but couldn't solve it. (Two entities one of which is called "unsaturated" serve no better unless their relation is explained in the semantics.) Paul Horwich falls into the same trap.

As is clear from Higginbotham's essay, part of the solution requires use of the concept of truth. The rest of the solution devised by Tarski is to abandon the search for entities to correspond to predicates. I'm not sure there is a viable alternative. In any case, it is interesting to note how the problem of providing facts appropriate to explaining the truth of sentences and the problem of giving the semantics of predication can merge. Richard Schanz once suggested that Barwise and Perry's "situations" might serve as the entities that would satisfy the demands of a correspondence theory. Barwise and Perry's situations are set-theoretical constructs. Called "abstract situations", they are defined in terms of (real) objects and properties and relations. Truth can't be explained by reference to abstract situations, for abstract situations correspond to false sentences as well as true. Among the abstract situations are "actual" situations, which do correspond in some sense to true sentences. So far this defines actual situations in terms of truth and not vice versa. Actual situations, however, "represent" real situations, which are said to be "parts" of the world. Barwise and Perry never try to define "real situation"; they say that if you don't think there are such things, they admit they don't see how to persuade you. It is easy to specify when a particular abstract situation is actual: the abstract situation that I will call "Sam, mortality" is actual if and only if Sam is mortal (that is, Sam instantiates mortality). Having determined what makes [Sam, mortality] actual, we can now "explain" what makes the sentence "Sam is mortal" true by saying it is true because "Sam is mortal" corresponds to an actual situation. That situation is actual because Sam is mortal. It is obvious that we can retain the contents of this explanation, everything that "relates language to the real world", by saying "Sam is mortal" is true if and only if Sam is mortal; the apparatus of situations has done no work. The reason it has done no work is that truth must be brought in to explain the relation between Sam and mortality, something the semantics of situations fails to do.[1]

D. D.

NOTE

1. I have simplified the story in *Situations and Attitudes*, J. Barwise and J. Perry. Cambridge, Mass.: MIT Press, 1983. Barwise and Perry do not attempt to define truth in terms of situations, but they do suggest a kind of correspondence theory of truth. Some of the material in the last paragraph of this reply is based on my "Reply to Richard Schanz" in *Reflecting Davidson*, edited by R. Stoecker. Berlin: de Gruyter, 1993. Pp. 36–39.

30

Ernie Lepore

THE SCOPE AND LIMITS
OF QUOTATION[1]

Astandard view about quotation is that 'the result of enclosing *any* expression . . . in quotation marks is a constant singular term' (Wallace 1972, p. 237). There is little sense in treating the entire complex of an expression flanked by a right and left quotation mark, a *quotation term* for short, as a 'constant singular term' of a language L *if* that complex is not, in some sense, itself a constituent of L. So, just as (1) contains twenty-seven tokened symbols (including twenty-three roman letters, three spaces, and a period), so too, on the standard view about quotation terms, (2) contains twenty-nine tokened symbols (including twenty-two roman letters, four spaces, a left and right quotation mark, and a period).

1. That president runs slowly.
2. 'lobster' is an English word.

In this paper, I will defend the intriguing thesis (IT) that whatever is tokened between quotation marks within quotation sentences (QS) like (2) is in no sense a constituent of that QS.[2] Tipping my cards just a bit, I will argue that whatever (e.g., letters, symbols, shapes) is tokened within quotation marks in (2) is no more *in* (2) than whoever is indicated by a true utterance of (1) is in that sentence.

Once (IT) is established, I will argue it has surprising consequences for the semantics of quotation; in particular, I will argue that if (IT) is correct, then something like Davidson's demonstrative account (1979; Cappelen and Lepore 1997a) for the logical form of QS must be correct.

Professor Lepore assures us that the proper spelling of his name is 'Lepore' and unhappily we discovered after sending copy to the press that in other parts of the book the 'p' is erroneously capitalized. —L.E.H.

I. Problems with Syntax

Sentences like (3) clarify that we do *not* always want to countenance what appears within quotation marks as a meaningful or grammatical component of the sentence.

 3. 'klfgh' is not an expression of any natural language.

But even if what is tokened within quotation marks in (3) is no significant part of (3), mustn't it *in some sense* still be some sort of component of (3)? How else could (3) be a grammatical sentence of English?

 In a relatively recent paper, Richard (1986) attempts to develop a view of grammar consistent with the intuition that sentences like (3) are grammatical English sentences. A grammar for a language should list basic components (e.g., letters, digits, the space, punctuation marks, and concatenates of such components) of lexical items and operations on those components to generate lexical items. Richard emphasizes that,

> some constraints concerning *finitude* are appropriate as constraints on the form of a grammar for a natural language. . . . A lexical construction which generates vocabulary from an initial set must either operate on a *finite initial set* or, at least, *there must be an effective procedure for determining membership in the initial set*. None of these restraints, of course, require that the output of lexical constructions be finite. (1986, p. 402, fn.12, my emphasis)

So, given a set of building blocks, say, letters of an alphabet and some finite list of punctuation symbols, what Richard is noting is that quotation permits the construction of quotation terms of unlimited complexity. Examples (4) to (6) show how one such infinite series of increasing complexity can get started.

 4. 'aa' isn't an English word.
 5. 'aaa' isn't an English word.
 6. 'aaaa' isn't an English word.

 In order to account for *this* source of unboundedness, assume that 'for each concatenate e of letters of the Roman alphabet, lq followed by e followed by rq is a singular term' (1986, p. 389, where 'lq' and 'rq' stand for the left quote and the right quote respectively). A specification of the lexicon of English can then build upon an inductive definition of the quotable items of English, where a quotation term of English is what issues from concatenating a left quotation mark together with a quotable item of English together with a right quotation mark. More formally, suppose that 'Alphabet(1)', 'Alphabet(2)', . . . , 'Alphabet(n)' is a finite list of primitive quotable items of English (corresponding, e.g., to the letters 'a', 'b', . . . , 'z', together perhaps with other symbols for the digits, the space and punctuation marks), then an

inductive definition of a quotable item in English is:

(Base$_1$) Alphabet(1) is an English quotable item.
(Base$_2$) Alphabet(2) is an English quotable item.

...

(Base$_n$) Alphabet(n) is an English quotable item.

(Ind) $(\forall x)(\forall y)$(if x and y are English quotable items, then Concat(x,y) is an English quotable item.

With this inductive definition, we can characterize the quotation terms of English as follows:

(Quoterm) $(\forall x)$(if x is an English quotable item, then Concat(lq,x,rq) is a quotation term of English)

This sort of inductive definition (together with ordinary apparatus for other expressions) licenses the well-formedness of sentences like (3) and (7):

3. 'klfgh' is not a word of any natural language.
7. 'carne' is an Italian word; not an English one.

On this strategy "carne" and "klfgh" are English expressions (and therefore can be legitimate subjects, e.g., of English sentences), while 'carne' and 'klfgh' are not.

So far so good, but there still is a serious problem facing the Richard strategy for inductively defining the class of quotable items of English. The problem arises because there is another source of unboundedness that Richard ignores, and thus he errs when he writes:

> It is *easy enough* to come up with a *finite* list of elements (the letters, punctuation symbols, the digits, the space, etc.) and an operation (concatenation) with which one can generate all of the concatenates. . . . If we are formalizing a grammar for a language with quotation names, we would include, as part of the specification of the lexicon, a proviso to the effect that, for each concatenate *e*, the left quote (lq), followed by *e*, followed by the right quote (rq) is a singular term. (1986, pp. 386–89, my emphasis)

What Richard surprisingly neglects, as does just about everyone else who writes on quotation, is just how liberal our quotation practice is. In (8), quotation is used to mention a sign that may be new to us, but nonetheless is already in an extant notation, the Greek alphabet. Similarly, sentences like (9) and (10) are pretty ordinary.[3]

8. 'φ' is a letter of Greek, not English.
9. '@' is used in every email address.
10. '↔' is a sign for the material bi-conditional in propositional logic.

Anyone who thinks that (8) through (10) are grammatical sentences of English and who insists upon pursuing Richard's strategy for inductively defining the set of quotable items of English has his work cut out for him. In quotation, we have indefinitely many possible signs to draw from. If this is right, then there is no reason to believe that an inductive definition exists for specifying the quotable items in English. This is particularly clear if one considers the wide variety of sign systems in *actual* use (other alphabets, sundry icons like the heart-sign, the hatch-sign, and the at-sign, coined mathematical notation, all of the zapf-dingbats, and lots lots more). And, of course, natural language is not only written but voiced, signed, and even felt for those who use Braille.

In English (and every other natural language), we can employ quotation to mention items of these various sign systems. Surprising results issue from such ordinary facts. On the one hand, if there is no reason to believe that the set of basic (or primitive) items from which the set of concatenates can be inductively generated is recursively definable, then if quotation terms are constant singular terms, it follows that the class of quotation terms is not recursively definable, and therefore that English syntax *is not recursively definable*. On the other hand, the more one peruses the troublesome sorts of data the more one begins to wonder how wise it was in the first place to consider the esoteric quotable items as a part of English in any sense. Consider an English sentence like (11):

11. 'ϱ' is not a symbol of English; nor indeed of any other language.

(11) seems grammatcal; yet it also seems to insist upon not being fed into any inductive base for generating the set of quotable items *of English*, on the assumption that the distinct parts of a singular term of English are themselves a part of English.

II. HOW NOT TO ACCOMMODATE THE UNBOUNDEDNESS OF QUOTATION

i. It would be desperate, in the face of such considerations, to deny that quotation marks are really a part of English or of natural language in general. Partee expresses doubt about whether 'quotation is part of natural language' (1973, p. 410). It's true, as Partee notes, that quotation indicators are not always phonetically realized (say, with devices such as 'quote-unquote' or finger dancing); and it's also true, as Washington (1992) notes, that even in writing indicators of quotation are sometimes dropped. But it does not follow from such considerations that quotation is not part of natural language. There is a difference between saying that the president of the United States has five words and 'the president of the United States' has five words. The former is

usually never true, whereas the latter is obviously true. If one can effect the latter without invoking devices to indicate where quotation occurs, that must be because audiences can figure out where quotation is intended to occur, not because quotation doesn't exist. I'm not even sure I know what it means to suggest otherwise.

ii. Alternatively, one might grant that there are indefinitely many primitive quotable items, but then deny that at any point in time there is an indefinite set of such items *in English*. Otherwise, we seem to be requiring that every quotable item is a constituent of every language that shares our quotation resources. No matter how sanguine one might be about universal grammar, surely no one thinks that natural languages share all their primitive constituents. On this alternative way of thinking about things, with the introduction of each new primitive symbol, the language expands (right before one's eyes, so to speak). This would permit the set of primitives in an expanded language to remain recursively specifiable. When and only when a novel sign is tokened does it thereby enter the language, and the inductive base expands accordingly.

Here there is no breach of finiteness. So, either we can do what Richard proposes—for stages in the evolution of the language—or we must give up the program of a recursively specifiable grammar.

In response, first of all, I'm not sure how this strategy helps us with sentences like (11), whose truth seem to refuse incorporation into the language *à la* Richard. Secondly, it's a brute fact that when we encounter a QS for the first time, provided we understand the materials outside the quotation marks, we understand that sentence immediately. This would be quite odd, indeed, bordering on the mystical, if (a) the quotable items must be a (specifiable) part of the language in order for the sentence to be true, but (b) they are not part of the language until actually tokened.

(Someone who does think that quotation terms are part of the language might think we have internalized a semantic rule which enables us to interpret quotation terms with novel constituents when we encounter them. I believe this rejoinder is confused, and I'll return to it when we take up the semantic rule DQR for interpreting quotation terms below.)

iii. A third strategy would be to try to live with the fact that the syntax for a language with quotation terms cannot be recursively defined.[4] Of course, this is not an option for a syntactician who seeks to recursively define the set of well-formed strings of English. But, also, if quotable items alone forced this result on us, it would certainly seem wiser to find an alternative strategy for dealing with their unboundedness, especially given sentences like (11).

Before considering a fourth option, I want to consider complications the data we have been examining about quotation provoke for the semantics of quotation. Looking ahead, I will be arguing that these complications cry out for (IT).

III. WHAT ABOUT THE SEMANTICS?

How does one reconcile the issues (and various interpretations about the role of quotation in our language) we have been discussing about the syntax of quotation with its semantics? Richard, *inter alii*,[5] endorses a disquotational rule (DQR) of semantic interpretation:

> For any expression *e*, the left quote (lq) followed by *e* followed by the right quote (rq) denotes *e*. (1986, p. 397)

How does (DQR) apply to ordinary quotation terms? Conventional recommendations like the following are common-place:

> one of the most convenient ways of forming a name of a given linguistic expression is that of placing the expression within quotation marks. For example,
> 'The Iliad'
> denotes the title
> The Iliad,
> which in turn denotes the great epic poem. . . . (Mates 1972, p. 21)

Because the quoted expression (the title) in this passage is tokened on a separate line, one might be tempted to reason that variable-tokens in DQR are replaceable with expressions themselves in its instantiatons. Following this temptation results in ill-formedness:

> *12. lq followed by happy followed by rq denotes happy.
> *13. lq followed by carrot followed by rq denotes carrot.
> *14. lq followed by happy people followed by rq denotes happy carrot.[6]

(12) to (14) are *illegitimate* instantiations of DQR; legitimate instantiations require singular terms as substituends for variables, singular terms that denote expressions. A more plausible application, one that DQR proponents' illustrations recommend, is to restrict the substituends of DQR's variables to quotation terms themselves. Substituends for variables in DQR include "happy", "carrot", and "happy people". Instantiations of DQR so constrained are well-formed and true, as in (15) to (17).

> 15. lq followed by 'happy' followed by rq denotes 'happy'.
> 16. lq followed by 'carrot' followed by rq denotes 'carrot'.
> 17. lq followed by 'happy carrot' followed by rq denotes 'happy carrot'.

Now, of course, as these examples make plain, the statements of these instantiations use quotation on the right as well as on the left (doubled). One might think that whatever such a maneuver gains in well formedness it loses in informativeness. If a sentence like (15), in which quotation marks are both mentioned and used, is an intended instance of DQR, in what sense does the rule help us to understand, or provide an analysis of, quotation?

Disquotational theories want to disclaim there's anything to analyze or inform about. But, if not an analysis of quotation, what then is the aim of a semantic rule like DQR? For proponents of DQR an adequate semantic rule for quotation is one that can be implemented in interpreting QS (Richard 1986, p. 397; Wallace 1972, p. 224; Ludwig and Ray 1998): what might speakers know that enables them to understand QS when confronted with their tokens? What might they know that enables them when confronted with a token of (2) to infer that the speaker asserted that 'lobster' is a word, or know which word (2) is about?

Suppose, just for the purposes of discussion, we adopt a Davidsonian approach to specifying linguistic competence. Then an adequate treatment of quotation minimally requires of an adequate semantic theory for English that it entail for each (indicative) QS sentence φ of English, an interpretive T-sentence of the form:

φ is true in English iff p.

In order to prove an interpretive T-sentence for any of indefinitely many QS, say, from English, we need an axiom or a theorem from which, for each QS like (2), a T-sentence like (18) is provable:

18. The sentence beginning with lq followed by 'lobster' followed by rq followed by the space followed by the ninth letter of the roman alphabet followed by . . . followed by the fourth letter of the roman alphabet is true in English iff 'lobster' is a word.

A sequence s satisfies the left-hand side of (18) iff the denotation of the singular term beginning with lq followed by 'lobster' followed by rq satisfies the predicate 'is a word', i.e., just in case 'lobster' is a word.

So, inasmuch as a semantic rule like DQR enables us to prove (18), and if knowing what's expressed by (18) suffices for understanding (2), it would seem that DQR has earned its keep.

IV. Is There a Problem about Semantic Primitives?

DQR has other benefits as well, for example, it shows how it's possible for quotation terms to be constant singular terms without requiring, contrary to what Davidson argued against Tarski and Quine, infinitely many semantic primitives.

An expression is a semantic primitive 'provided that the rules which give the meaning for sentences in which it does not appear do not suffice to determine the meaning of the sentences in which it does appear . . .' (Davidson 1967, p. 9). Davidson argued that any semantic theory with infinitely many

semantical primitives is inadequate. Richard and Wallace concur with Davidson that any such theory would be unlearnable or unteachable (Wallace 1972, p. 224; Richard 1986, p. 397). Davidson, however, goes further, arguing that if quotation terms were treated as constant singular terms, it would follow that every quotation term ends up being a semantic primitive.

So, consider (19) and (20), with their distinct quotation terms; and also consider, we'll assume, two provable T-sentences (21) and (22), corresponding to (19) and (20) respectively:

19. 'happy' is an English expression.
20. 'carrot' is an English expression.

21. The sentence beginning with lq followed by 'happy' followed by rq followed by the space followed by the ninth letter of the roman alphabet . . . followed by the nineteenth letter of the roman alphabet is true iff 'happy' is an English expression.
22. The sentence beginning with lq followed by 'carrot' followed by rq followed by the space followed by the ninth letter of the roman alphabet . . . followed by the nineteenth letter of the roman alphabet is true iff 'carrot' is an English expression.

Now consider (23), in which a quotation term distinct from those in (19) and (20) occurs.

23. 'happy carrot' is an English expression.

The denotations determined by DQR of quotation terms in (19) and (20) do not *by themselves* determine the denotation of the quotation term in (23). The fact is that one might have denotation clauses for "happy" (and "carrot" and the quotation of the space) without having one for "happy carrot". On this basis, Davidson concludes that if quotation terms are constant singular terms, then all quotation terms are *semantically* primitive.

Richard recognizes that treating quotation terms as singular terms does not all by itself suffice to establish that English has infinitely many semantic primitives. A language might have finitely many semantical primitives, even though the semantic values of indefinitely many expressions are not determined by the semantic values of any others. This is because all that Davidson's definition of *semantic primitiveness* requires is that:

> As long as there is an effective procedure for determining, for each member of the lexicon what its interpretation is to be, there is no need that . . . the semantics for the grammar work off of the interpretations of productively occurring expressions in specifying the interpretation of the grammatically complex expressions of the language. (Richard 1986, p. 392)

Since DQR is intended to assign denotations to every quotation term, once

we master DQR we can understand (interpret, identify the denotation of) novel quotation terms. So, given the sort of inductive definition of a quotation term sketched above and DQR (and whatever standard Tarskian apparatus is needed for the semantics of unquoted expressions), a T-sentence for each English QS is derivable. DQR doesn't *require* that the semantic value of an arbitrarily long quotation term is determined by the semantic values of its parts since the grammar need not assign a grammatical category to any part of a part of a quotation term.[7]

V. WHAT THEN IS WRONG WITH DQR?

Inasmuch as DQR seems to tell us just what we need to know about quotation in order to interpret QS, and inasmuch as it seems to show how we can continue to innocently treat quotation terms like constant singular terms, what then is wrong, if anything, with DQR? It would seem that it has done all that we could expect from a semantic rule. Unfortunately, one rather large problem naggingly persists.

We begin with a simple question: what are legitimate instantiations of DQR? The answer is obvious: since the quantifier in DQR ranges over expressions, the legitimate substituends of its variables must be singular terms of English that pick out only expressions. But since DQR presupposes that quotation terms are constant singular terms, unless the class of quotable items which are their constituents were recursively definable, it would be impossible to recursively specify a semantic theory, e.g., a Tarski-like truth theory, for English QS.

Suppose, for example, DQR were a semantic axiom in a *finitely axiomatizable* Tarski-like truth theory for English QS. Since the substituends for its variables are quotable items, the class of its substituends would have to be recursively definable; otherwise, for any truth theory of English it could not be proven *of* every sentence φ a corresponding T-sentence since the set of T-sentences could not be recursively specified.[8] So, we must be able to provide a complete list of base clauses in order to guarantee that the theory licenses each legitimate substitution DQR warrants. Richard and Wallace agree that one goal for a semantic theorist is to devise a finitely axiomatizable truth theory for (at least) the English QS fragment (Wallace 1972, p. 225; Richard 1986, p. 397). So, we know beforehand this goal is unobtainable *if what occurs within the quotation marks are constituents of the QS.*

This problem is independent of reservations one might have about the formalizability of English or any other natural language. Begin with the set of English QS. So restrict this set as to exclude *any* features of natural language (short of single non-iterable quotation marks) that prevents English from

being formalizable. My point is that there is no reason to believe that this restricted fragment is recursively definable.

VI. A Semantic Theory *WITHOUT* Quotation for a Language with Quotation

Of course, the criticism of this last section seems pretty parochial insofar as it assumes that the semantics for a language *with* quotation must itself have quotation. Denying this assumption won't help to solve the problem of recursively defining the syntax of English, but it might solve the semanticist's worry.

The semanticist wants a theory that assigns truth conditions to each English QS sentence. For convenience, we have been allowing that whatever metalanguage we use to describe that language contains the same sort of quotation device. (Indeed, we are allowing that metalanguage to be that object language.) I don't see this as a problem, however, anymore than there's a problem with a rule that issues in statements like,

'Socrates' names Socrates.

which uses on the right the very word being mentioned on the left. But this is accidental. We could imagine the metalanguage being different, and having a different sort of device to refer to expressions in the object language, or even having no way to refer to such expressions, but only to describe them. The point being that from the fact that a language L has QS doesn't require that its metalanguage L′ (in which a semantic theory for L is to be devised) also have QS. Why not exclude from L′ the troublesome quotation marks *of* L by merely describing in L′ whatever L uses quotation marks to mention. Suppose that 'φ' denotes the twenty-first letter of the Greek alphabet. Then, for example, a true T-sentence for (8) is (24), and a true T-sentence for (9) would be (25):

8. 'φ' is a letter of Greek, not English.

9. '@' is used in every email address.

24. The sentence beginning with lq followed by the twenty-first letter of the Greek alphabet followed by rq followed by the space followed by the ninth letter of the Roman alphabet followed by . . . followed by the twentieth letter of the Roman alphabet is true in English iff the twenty-first letter of the Greek alphabet is a letter of Greek, not English.

25. The sentence beginning with lq followed by the at-sign followed by rq followed by the space followed by the ninth letter of the Roman alphabet

followed by . . . followed by the nineteenth letter of the Roman alphabet is true in English iff the at-sign is used in every email address.

The assumption in play here is that whatever a quotation term designates is *describable*. Does this suffice to avoid what I claim is a major stumbling block for finitely axiomatizing a truth theory for L, namely, that the set of quotation terms is not recursively definable? Even if the set of English QS is not recursively definable, can't we still devise a finitely axiomatizable truth theory for this fragment in metalanguage without quotation marks? I believe the answer is no; at least two substantial problems remain.

Suppose, as seems natural, the set of quotation mark–free descriptions is recursive. It doesn't follow that there is a recursively definable predicate which denotes the proper subset of descriptions of quotable items. Indeed, if the set of descriptions that denote quotable items were recursive, and if the reference function from descriptions to their referents were also recursive, then the set of referents, i.e., quotable items, would be, contrary to assumption, recursively enumerable.[9]

There is another problem with the description strategy; understanding what it is enables us to present an elegant dilemma for anyone who *rejects* (IT).

Both Davidson's and Wallace's interest in Tarski-like truth theories is to inquire into what *would* suffice for an interpreter to know in order to understand a speaker (Davidson 1967; 1973; Wallace 1972). Suppose the set of descriptions denoting quotable items were recursive. If the rest of the truth theory is as it should be, then it would be finitely axiomatizable. But this theory need not be an adequate tool for *interpretation*, because it may require further *empirical* non-linguistic knowledge for an interpreter to determine which quotable item a particular description denotes. Why?

It's obvious that no such theory can be *homophonic*. The sentence used on the right-hand side of a T-sentence cannot be identical to the QS mentioned on the left-hand side because the sentence on the right doesn't use quotation marks. Still, if the sentence used on the right (semantically) *interprets* the QS mentioned on the left, non-homophony poses no problem. But how *could* it interpret the QS mentioned on the left? If, as Richard and Wallace presume, quotation terms are constant singular terms, it follows that they must be rigid singular terms. That seems right, inasmuch as "a" can't mention anything other than 'a'. But the descriptions used in the metalanguage need not be rigid. 'the twenty-first letter of the Greek alphabet' might not have denoted 'φ'. For example, the Greek letters might have been alphabetized differently. It follows immediately that truth theories which utilize these particular descriptions can't be interpretive.

An analogy might help. Any truth theory that issues in T-sentence (26) for the English sentence (27) is *not* interpretive.

26. Bill Clinton is from Arkansas.

27. 'Bill Clinton is tall' is true in English iff the 41st president of the United States is from Arkansas.

One need not know that Bill Clinton is the 41st president of the United States in order to understand (26). Analogously, one need not know that 'φ' is the twenty-first letter of the Greek alphabet in order to understand (8). A lot more empirical information seems to be required to identify 'φ' as the twenty-first letter of the Greek alphabet than is required to recognize what 'φ' denotes.

One way out might be to assume that every quotable item has a distinct shape rigidly describable by equations (Wallace 1972, p. 225). Suppose we artificially restrict ourselves to graphemic marks. There are fine differences between curves and between patterns which the human eye cannot detect and which we cannot detect even with good instruments. But, given a fixed space, there seems to be a limit to how many quotable items there can be in that space. It might seem plausible that most of what we by ordinary standards consider as a graphemically quotable item can be represented on a black and white 640 by 480 pixels computer screen.[10] There are only finitely many such symbols. Add millions of colors; still only finitely many symbols. Moreover, we can generate a list of them, in the shape of sequences of zeros and ones. If you think there is some figure that cannot be represented on the screen, pick a larger screen. In fact, think of an unbounded sequence of screens, with more pixels and more colors. If we give, for each, a list of all possible sequences of zeros and ones, then whatever is two-dimensional and visual must be representable somewhere in this sequence. If this is right, then we can assign a description to each two-dimensional quotable item. This syntax is recursively specifiable. Now imagine a metalanguage for written English QS in which all quotation terms are replaced by descriptions utilizing these sequences of zeros and ones. We can generate, using this strategy, true T-sentences corresponding to indefinitely many QS English sentences. The relationship between the descriptions and the quoted graphemic shapes is, unlike the relationship between 'φ' and 'the twenty-first letter of the Greek alphabet', not contingent. Presumably any shape denoted by a description using equations is necessarily denoted by that description.[11] But will it issue in correct interpretations?

This depends on whether understanding a sentence like (8) *requires* knowing that this sentence is true just in case the shape of such and such dimensions is a letter of the Greek alphabet. So, even if an interpreter knew a correct truth theory for the speaker's language, and knew that the theory was correct, his knowledge might not suffice for interpreting the speaker. If all that is required of the truth theory is that it denotes the syntactic objects of the speaker's language and ascribes the appropriate semantic properties to them, then one can denote those expressions without *displaying* them. If a theory

doesn't display them, then the interpreter might not be able to identify those expressions in the speaker's mouth as the very denotations of the theory's descriptions for his expressions.

We seem to have backed ourselves into a dilemma, namely:

> If the quoted string is part of the quotation term, then we must choose between *axiomatizability without the interpretation property* (i.e., take the description alternative) or the *interpretation property without axiomatizability* (i.e., go for the displays).[12]

Neither alternative is acceptable for anyone who accepts as a goal for a semantic theory for a language L the finite specification of information sufficient for understanding L.

Confronted with this dilemma, must one give up that goal, or deny that quotation is a part of natural language (options [*iii*] and [*i*] above)? No. Instead, I want the reader to consider *seriously* (IT), the proposal that symbols within quotation marks in a QS are in no sense a constituent of that sentence.

What occurs inside quotation marks in 'klfgh', 'carne', 'φ', '@', and '↔' are, of course, no part of the English *lexicon*; how else could we make sense of true English QS like (3) and (7) through (10)?

3. 'klfgh' is not a word of any natural language.
7. 'carne' is an Italian word; not an English one.
8. 'φ' is a letter of Greek, not English.
9. '@' is in every email address.
10. '↔' is a sign for the material bi-conditional in propositional logic.

Richard agrees if by 'part of English' we mean 'must be a member of a *grammatical* category', as every lexical item must be. But this doesn't imply that what's in between quotation marks isn't part of a productive class of symbols from which English is constructable; it follows only that not every member of this class will be a member of some *grammatical* category. But why think this productive class has a finite or recursively definable basis? If it does not, and only one's own limited imagination could make one think otherwise, then there is no good reason to demand that what's within quotation marks in QS sentences like (3) and (7) through (10) are *any part* of these English QS.

But how can one both devise an adequate semantics for English and simultaneously endorse (IT)? Though I have remained relatively silent about what sort of referring expression a quotation term is, there are a good number of choices available in the literature: e.g., proper names (e.g., Quine 1961 p. 140 and Tarski 1956, p. 159), descriptions (e.g., Quine 1960 p. 202, Tarski 1956, p. 160, Geach 1957, p. 79, and 1970), self-referring expressions (minus the quotation marks) (Frege 1970, pp. 58–59; Washington 1992). The real

moral to draw from my discussion is that none of these alternatives *can* be right since each is incompatible with (IT). However, so I will argue, a demonstrative theory of quotation (Davidson 1979), suitably modified (Cappelen and Lepore 1997a), can respect (IT). Let me remind the reader of Davidson's version of a demonstrative theory, introduce some refinements, and then summon what I take to be the chief virtues of a demonstrative theory, which, *inter alia*, includes its capacity to respect (IT).

VII. THE DEMONSTRATIVE THEORY OF QUOTATION

According to Davidson, the result of flanking a token of a sign by quotation marks is neither a name nor a description of that sign. Instead, the quotation marks in QS function like a displaced demonstrative-like expression, and, on an ordinary occasion of use, they can be used to demonstrate the token of the expression within the quotation marks, a token which might well have been placed elsewhere. In this sense, what's between quotation marks is tagged on merely to be displayed as a demonstrated object. So, on Davidson's semantic account, 'we have to give up the notion that quoted material is part of the *semantically significant syntax* of a sentence' (1979, p. 90, my emphasis).[13]

From a logico-semantical perspective, Davidson construes (2) as (28),

2. 'lobster' is an English word.
28. lobster. The pattern (shape) of which this is a token is an English word.

where an utterance of the sentence in (28) is accompanied by a demonstration of an utterance of the expression that precedes it. In effect, what Davidson is recommending (though these are not his words) is that we replace a quotation term, in logical form, with a restricted quantifier, namely, 'The shape of which this is a token'. So, what might be called standard English QS would map on to canonical forms, e.g., (2) would map on to (29):

29. [The x: x is a pattern (shape) of which this is a token](x is an English word)

Indeed, fixing the predicate in (2), regardless of what we enclose within the quotation marks, every such QS would have (29) as its logico-semantical form. On any particular occasion of use, for any such QS, inasmuch as (29) is its logical form, the token within the quotation marks would be demonstrated, and the definite description would denote whatever pattern is instantiated by that demonstrated token.

Of the various ways to avoid the problem of English syntax being recursively non-specifiable, (*ii*) above concedes that there are infinitely many

primitive *quotable* items, and therefore there exist, as types, infinitely many abstract entities consisting of the quotable item enclosed with quotation marks, but denies that all of them are already part of English. A quotable item becomes a constituent of an English quotation term only if it is either part of an extant inductive domain or else is actually used or actually mentioned.

Part of the motivation behind this move was that merely drawing a figure on a page and enclosing it within quotation marks is *in*sufficient to token an already extant type. There is no type until it's determined what counts as another token of that type. Until we decide what the intended relevant equivalence relation between such tokens is, it's unsettled whether we have a quotation term, as opposed to mere marks on paper. So, on this view, quotation terms do not already exist, only the possibility of defining them, and that amounts to *extending* English syntax. Behind these claims is an assumption shared both by Davidson and proponents of DQR, an assumption I wish to reject, namely, that in quotation an abstract expression (shape) is denoted (whether by a quotation term or descriptionally *à la* Davidson).

Consider (2_1) through (2_3), graphemic variants of (2):

2_1. 'lobster' is an English word.
2_2. 'LOBSTER' is an English word.
2_3. `lobster´ is an English word.

According to Davidson, from a semantical point of view, each of (2) through (2_3) has the logical form of (29). Which of these particular inscriptions is true on Davidson's account is contingent upon whether the demonstrated object in each tokens a certain *shape* that is an English word. Since English speakers would evaluate all four as true, the differences among these four distinct inscriptions are apparently semantically (or linguistically) irrelevant. Indeed, *phonetically realized* tokens of (2) through (2_3), where the demonstrated object in each would be phonetically indistinguishable from every other, are also obviously true. But, in what sense, does any such utterance token the same shape as the above inscriptions of (2) through (2_3)? Such considerations raise doubts about the plausibility of there being shapes denoted in inscribed QS like (2) through (2_3); and they also challenge the plausibility of the pixel strategy considered above.

Since Davidson, however, only says 'we *may* take [an expression] to be an abstract shape' (1979, p. 85, my emphasis), his theory is compatible with expressions being something else. We need only find something that can be instantiated by radically differently shaped objects. Whatever it is must be such that written tokens, spoken tokens, signed tokens, Braille tokens, Semaphore tokens, finger language tokens, and any other way in which words can be produced, can be instantiated by it. Moreover, since we can, and

constantly do, develop new ways of producing words (we develop sign systems for blind people, for computer languages, etc.), this object must be instantiable by tokens not yet conceived.

Such entities might exist; if they do, they might ultimately play some role in the metaphysics of language. However, Davidson's account can be modified so as *not* to quantify over expressions. We could replace quotation terms in logical form with a restricted universal quantifier over tokens that stand in a certain relation, say, *the same-tokening relation*, to the demonstrated token. This suggests we construe the QS (2) in logical form not as (28) but as (29),

29. [Every x: x same-tokens that](x is an English word)

where an utterance of (2) demonstrates the exhibited token. So, instead of replacing a quotation term (in logical form) with the restricted quantifier expression 'The shape of which that is a token', we replace it with 'Everything which same-tokens that';[15] and so rather than *demonstrating* a token in order to *denote* some abstract object it instantiates, when we assert a QS, we *quantify* over tokens that stand in a same-tokening relation to the demonstrated quoted token.[16]

Whether two entities stand in a same-tokening relation is *not* (and should not be) settled by the semantics, any more than whether two objects are similar in color or shape or size.[17] Once we abandon the idea that quotations make reference to abstract shapes and embrace the idea of same-tokening, it's easy to respond to worries that on the basis of a single confrontation with a blot on a pad we are not yet ready to quote it in English, since we do not yet have identity conditions for what type it is.[18] Recall, this move permitted proponents of DQR to reject (IT) (namely, (*ii*) above), since even if there are no a priori constraints on what a primitive quot*able* item is (barring the constraints of note 13), still these items do not exist as components of *actual* English quotation terms since to do so requires identity conditions for when two tokens of a quotable item are of the same type.

If this were correct, then, at any given moment, English syntax would be finitely specifiable, since, at any such moment, there would be no more than finitely many primitive quotable items.

This sort of ad hoc gerrymandering of natural language, and the concern that engenders it, is thwarted once same-tokening is brought into play. Every quotable item exemplifies countless features. Which determine whether one such item same-tokens another depends on all sorts of non-linguistic considerations; and therefore, it should not be part of a semantic program to legislate or 'figure out' a priori which ones can and which ones cannot be relevant. Unlike Bennett (1988, p. 403), I doubt we can a priori delimit which of these countless features fix the extension of a same-tokening relation.

The displayed tokens in (2) through (2_3) differ with respect to all sorts of

features. Whether such differences are relevant for adjudicating the truth of a given QS is surely contextually determined. In (2) through (2₃) differences in (size of) font and case are *ir*relevant to the extension of the same-tokening relation. But, because (30) is obviously well-formed and true (*contra* Bennett 1988, p. 402), differences in case, e.g., can be relevant in fixing the extension of a same-tokening relation.

30. 'L' is in upper class; while 'l' is in lower-case.

Here, again, I disagree with Bennett, who says quotation is sensitive *only* to 'linguistically significant' features, i.e., those concerning 'syntax and semantics, excluding anything that bears only upon typographic manner and the like' (Bennett 1988, p. 404), where by 'linguistically significant' he means 'language relative'; so, quotation (at least in English) is blind to differences in print, font, case, size, script, and so forth (Bennett 1988, p. 403).[19] This just isn't right. In order to understand (31) one need not know whether the quoted item is nonsense, a single word, or an entire sentence:

31. 'ηψαϖονηιπθ' is Greek.

Indeed, one may know so little about Greek he has no idea whether the quoted item in (31) should be read from left to right, or right to left; he needn't know how many symbols are quoted; nor whether the thickness of what appear to be individual items (nor any other dimension of size) is relevant in Greek. None of this matters for linguistic comprehension. As long as one understands the predicate 'is Greek' and is able to *see* what's on display in (31), one has grasped all that's relevant from a linguistic point of view. Grasping this basic (but apparently elusive, at least to philosophers) fact about quotation, highlights the sheer elegance of a demonstrative account.[20]

Bennett backed himself into a position where he felt obliged to elaborate on which features of a quoted item can be relevant to the truth of a QS because he is struggling to locate identity conditions for whatever objects are denoted in quotation. Appeal to same-tokening not only sidesteps positing any such identity conditions; it pushes such questions outside of semantics, where they belong.[21] As contexts shift, which features of a demonstrated token determine whether it participates in the same-tokening relationship shift as well. This isn't a philosophical invention. It emerges from closely attending to our actual practice of quotation.[22]

VIII. Virtues of the Demonstrative Account

Understanding quotation is understanding the expression 'everything which same-tokens that'. There is no mystery about how to account for this capacity

in a *finitely axiomatized* semantic theory. Obviously, there is no upper bound on what can be quoted on this account, since there is no upper bound on demonstrable tokens. Still, on this account, quotation is not *semantically* productive. Every QS ascribing a metalinguistic feature α to some quoted item β asserts the same thing, namely, that whatever same-tokens the demonstrated object (i.e., β) is α.

On this account, quotation is, contrary to a common view, not semantically iterative (*contra*, Boolos 1995). What's within quotation marks is *exhibited* or *displayed* so that speakers can talk about properties of whatever same-tokens it. Since semantic properties of tokens need *not* be in active use (they may be semantically inert; see below), quotation marks within quotation marks are semantically inert. Reapplying Davidson's account to the referenced token in (32) results in gibberish like (33):

32. "oswerk" is not a quoted expression in some language.
*33. Everything that same-tokens that is not a quoted expression in some language:
Everything that same-tokens that: Oswerk

The displayed (bold) token in (33), what follows the first colon, is not at all what's quoted in (32).

An additional virtue is that the account preserves *semantic* innocence. An account T for a language L is semantically innocent just in case what an expression of L means according to T does not vary according to context (see Davidson 1968, p. 106; 1975, p. 166). Semantic innocence is preserved because the account does not assume the well-formed expressions receive new semantic values when tokened within quotation marks. Semantic innocence so construed, however, is compatible with there being contexts in which what an expression means is *not in active use*. Even though 'the United States' denotes the United States, the expression is *semantically inert* in (34):

34. 'the United States' is a definite description.

Also, the demonstrative account provides an adequate explanation for why quotational contexts seem *opaque*, indeed, hyper-opaque. Sentences containing demonstratives need not preserve their truth-value when different objects are demonstrated. If you substitute a word-token of one type for another of a different type as a demonstrated object, since different objects are demonstrated, the truth-value of the (utterance of the) original sentence may change, even if the two word-tokens are synonymous.

Lastly, the demonstrative account explains why *quantifying into* quotes in QS produces gibberish. '(\existsy)('apply' is a word)' cannot be inferred from "apple' is a word' nor can '(\existsx)('x' is a word)'. The account explains why

these inferences fail; since it makes no sense to quantify into a demonstrated object, it makes no sense to quantify within quotation marks on this account.[23]

CONCLUSION

Why, with these virtues, has the demonstrative account not won anything like a sweeping endorsement? The main worry, often voiced in discussions of Davidson's accounts both of ordinary quotation and indirect quotation, is that the accounts are not *syntactically* innocent.[24] On our demonstrative account, 'lobster' is in no sense a component of (2):

2. 'lobster' is an English word.

For years I thought I was speaking intelligibly when I said, echoing Davidson (cf., note 13), that a demonstrative account is committed only to 'lobster' not being a *semantically* significant constituent of (2), thereby suggesting *syntactic* significance was not in jeopardy. But if (IT) is right, what occurs within quotation marks in (2) does not itself occur in (2), *appearances to the contrary*, semantically, syntactically, lexically or in any other sense. One of my reasons for holding a demonstrative account of quotation should by now be obvious. If, with me, you accept that the scope of our practice of quotation is not a priori delimitable, then unless you excise items inside quotation marks from the sentences in which they seem to occur, neither the syntax nor the semantics nor the lexicon of English is recursively specifiable. Moreover, you wind up positing that there is an intelligible sense in which all languages that share our quotation practices share their primitive linguistic items, in other words, every quotable item exists in every language which permits quotation. These are costs way too high to pay for what once passed as innocence.

ERNIE LEPORE

DEPARTMENT OF PHILOSOPHY
RUTGERS UNIVERSITY
MARCH 1998

NOTES

1. I would like to thank Josh Dever, Ray Elugardo, Jerry Fodor, Mario Gomez-Torrente, Kent Johnson, Lou Goble, Jim Higginbotham, Helen Lauer, Barry Loewer,

Kirk Ludwig, Mark Richard, Peter Pagin, Terry Parsons, Paul Pietroski and Rob Stainton for generous and insightful comments in discussion of the topics of this paper. Herman Cappelen and Donald Davidson require special thanks. Herman Cappelen and I have collaborated on papers about quotation. Had we not I would never have come to believe some of what I endorse in the current paper. Donald Davidson I don't know how to thank. We all tend to get caught up in our own projects and careers and forget or minimize the contributions others have made in one way or another to whatever it is we produce. Without Donald Davidson I sincerely doubt I would have stayed in philosophy this long and I suspect that my life would have been much less rich. I am very lucky first to have found his writings, and even luckier to have come to know the person behind those writings.

2. There are various devices for indicating quotation in written English in addition to inverted commas: e.g., some uses of italicized, bold, or underlined print; other languages differ. There are no particular conventions for spoken quotation except what we can cull from context. Also, quotation works its way into all sorts of contexts: direct speech reports, scare quotes, and mixed quotation, as in:

John said that he had a 'very good time'.

I intend my comments to extend to all forms of quotation, but won't argue for that here (Cappelen and Lepore 1997a).

3. Richard shows some sensitivity to my concern when he writes, 'some constraints concerning finitude are appropriate as constraints on the form of a grammar for a natural language. "Mere lists" must be finite; the set of lexical and grammatical constructions must be finite. A lexical construction which generates vocabulary from an initial set must either operate on a *finite initial set, or, at the least, there must be an effective procedure for determining membership in the initial set*' (1986, p. 402, my emphasis). What I have to assume is that Richard, for reasons he never articulates, either rejects the sort of data I'm advancing against his account, or simply never thought about it. Bennett, however, explicitly rejects much of the data I'm advancing, without offering any reason to do so (1988, p. 400, p. 405). Throughout his paper, Bennett seems to be legislating how quotation should go, rather than attempting to account for actual practice.

4. On the non-recursiveness of English syntax, see Postal and Landgendon (1984).

5. See also, for example, Wallace, 'the denotation of the result of enclosing anything in quotes is the thing itself' (1972, p. 237); Salmon, '[t]he result of enclosing any expression within quotation marks refers . . . to the enclosed expression itself' (1986, p. 6); and Smullyan (1957). Washington writes, 'The lexicon of the language above [i.e., a very simple fragment of English] would contain "Otto", "big", "very" and a rule of interpretation would be added: Quote (φ) mentions φ, for all φ' (1992, p. 602). I will ignore this formulation in what follows because there is not enough to go on in Washington's discussion to say for certain how he is using the expression 'Quote'. See also Ludwig and Ray (1998).

6. Of course, someone Plato-friendly might find the deviance of (12) through (14) provocative. Consider 'tall' denotes tall. We frequently see such sentences from those who think predicates denote. Better to say, perhaps that 'tall' denotes tallness, or to play with some other device, to say that 'tall' denotes *tall*. The former forces one into Platonism; the latter needs explication. The use of italics is probably a sneaky form

of quotation (see note 1), but the claim that 'tall' denotes 'tall', though grammatical, isn't what we were trying to get at.

7. DQR is still compatible with giving a compositional semantics for quotation terms.

(Base) $(\forall x)$(if x is a simple quotable item, then Ref[Concat(lq,x,rq)] = x)

(Rec) $(\forall x)(\forall y)$(if x and y are quotable items, then Ref[Concat(lq,x,y,rq)] = Concat[Ref(Concat[lq,x,rq]),Ref(Concat[lq,y,rq])])

The reference function is a homomorphism from a syntactic/morphological algebra to a semantic algebra. In this case, those algebras are virtually the same, as they should be, since we are dealing with quotation. The semantic value of a quotation term is a function of the semantic values of its parts, and the parts are subterms which themselves are quotation terms. Furthermore, with (base) and (rec) one can trivially prove by induction that:

(Gen) $(\forall x)$(if x is a quotable item, then Ref[Concat(lq,x,rq)] = x),

which corresponds to DQR. To the extent that we can give an inductive specification of all quotable material, DQR reduces to (Gen). Moreover, given (Gen), the validity of (Base) and (Rec) are also provable. Therefore, DQR, as restricted to an inductive domain, is equivalent to the possibility of a compositional semantics for quotation terms. (Thanks to Peter Pagin)

8. It might, however, be possible to prove:

$(\forall s)$(if s is T-sentence in T, then s is true)

without being able to prove, for *each* T-sentence s in T:

s is true.

If we cannot recursively specify the syntax of an object language, then we cannot specify each sentence of this object language, and so we cannot do the second kind of proof for each T-sentence, and so, the truth theory isn't finitely axiomatizable. But it doesn't follow that we can't do the first kind of proof. We may, with the help of DQR, be able to prove *that* every T-sentence is true, since there are common properties of quotation terms and hence of QS that we can exploit in giving a proof. Why being able to provide this sort of proof is still insufficient for semantic adequacy I'll take up below.

9. But not necessarily recursive. The difference doesn't matter much here. The conclusion that the set is recursively enumerable is still inconsistent with the claim that there is no finite specification of the elements of that infinite set.

10. I say 'presumably' since it is quite unlikely that each and every linguistic symbol can be specified using a pixel matrix. There remains a problem about multiple realizability: the same letter, e.g., can exhibit vastly different shapes. I'll return to this worry below.

11. There are other even less obviously remediable problems. If the range of quotation really isn't a priori constrainable, then there is no reason to believe that every quotable sign can be uniquely described by a sequence of zeros and ones. To think otherwise is to place a priori constraints on, e.g., which medium we can quote in.

12. This dilemma would stand up even if the set of quotable items is effectively specifiable in one sense, in the sense of being recursively enumerable.

13. Note how cautious Davidson's wording is vis-à-vis (IT). He also writes, 'for

the demonstrative theory, the quoted material [is] not part, *semantically*, of the quoting sentence' (1979, p. 91, my emphasis]. Presumably, the contrast Davidson intends to draw is between a linguistic item being a *syntactically* significant part of a sentence from its being a *semantically* significant part. I now believe this contrast is bogus; I'll return to it below.

14. This may not be exactly right. My concern is over matters of type and token. We might, at the very least, have to limit the class of quotable objects to objects of which there can be multiple tokens of the same type. In this sense, even the quo*table* doesn't behave like Kaplan's pointy brackets [Kaplan 1986, pp. 272ff].

15. There is a rather trivial objection that arises sufficiently often it's probably best to respond to it. A number of commentators complain that since the 'that' in (29) is a bare demonstrative, it can demonstrate anything, so there can be no guarantee it will demonstrate the quoted item. After all, I might utter (2) with a demonstrative intention to demonstrate my uncle and not the token between the quotation marks. Let's amend (29) so that the restricted quantifier reads 'Everything which same-tokens that *quoted item*'. ('quoted item' doesn't make reference to quotation marks; there are many ways to quote an item.) There is still a problem about multiple quotations in the same QS, as in: 'lobster' has more letters than 'table'. But this is a general problem about how best to accommodate multiple demonstratives, a topic I take up elsewhere. See Lepore and Ludwig, forthcoming.

16. As quotation is represented as involving quantification, one cost might be the creation of scoped readings where there don't seem to be any. So, e.g., on the Davidson account, a sentence like, 'A' is not a word, would, on a natural Russellian reading of definite descriptions, seem to be ambiguous between the two readings:

The shape of which this is a token is NOT a word.

NOT[The shape of which this is a token is a word].

and on the modified account it would seem to be ambiguous between,

Everything which same-tokens that is NOT a word.

NOT[Everything which same-tokens that is a word].

These pairs are not logically equivalent. However, unlike explicit quantification, quantification in quotation can be treated as lexically internal, and as always taking narrow scope with respect to explicit quantifiers and with respect to any other linguistic element that can take scope. See Lepore and Ludwig, 1998, for a related discussion about tense and lexically internal quantifiers.

17. For elaboration on same-tokening, see Cappelen and Lepore (1997a) and (1997b).

18. Mark Richard thinks that on the modified Davidsonian account,

'lob' begins with 'l'.

will be false, because it's not true that everything which same-tokens that *begins with* everything which same-tokens that. I don't think this is a special problem for the modified account. In the original sentence, no one thinks 'begins with' is to be interpreted spatial-temporally. Indeed, it's not clear what it means. Think about a sentence like:

'Lolita' has two 'l'-s.

Suppose you think quotation terms are constant singular terms, and you don't think they refer to or quantify over tokens. What on earth then does this sentence mean? See

Peter Simons (1982). The point is that everyone worried about the semantics of quotation has their work cut out for them. How best to interpret ordinary predicates when attributed to whatever quotation terms are about is not a straightforward affair. Thanks to Herman Cappelen for getting me to see this.

19. Imagine someone being taught that 'L' is a capital letter by being presented with a token of (30). If (30) were not a legitimate use of quotation, how then would we explain why anyone can generalize from (30) to other tokens of the same capital letter?

20. It *may* be true that the more one knows about the language the quoted expression is from, the better positioned one will be to say which variations on the displayed item are compatible with a QS remaining true. But this has less to do with quotation, and more to do with familiarity with the language from which the quoted items are being drawn.

21. Despite its label, same-tokening is not an equivalence relationship. The label is inspired by Davidson's samesaying relationship, which also is not an equivalence relationship. See my and Cappelen's papers referenced in the bibliography, for arguments and data in support of these seemingly perverse claims.

22. The same sort of issue arises in indirect reports. What counts as a successful indirect report of another's words is contextually dependent. The idea that we fail to correctly indirectly report another unless we use words that express the exact same *proposition* as his words is hopelessly flawed. See Cappelen and Lepore (1997b).

23. I'm not claiming it's illegitimate to introduce a quotation-like device into English that allows quantification in. The point is rather that 'ordinary' quotation doesn't allow such quantification. Here I agree with Quine (1961) and Davidson (1979).

24. See both Segal and Washington, among many others.

REFERENCES

Bennett, J. 1988. 'Quotation', *Nous* 22: 399–418.

Boolos, G. 1995. 'Quotational Ambiguity'. In *On Quine*, edited by P. Leonardi and M. Santambrogio. Cambridge: Cambridge University Press, pp. 283–96.

Cappelen, H., and E. Lepore. 1997a. 'Varieties of Quotation'. *Mind* 106 (July): 429–50.

———. 1997b. 'On an Alleged Connection between Semantic Theory and Indirect Quotation'. *Mind and Language* 12: 278–96.

Davidson, D. 1965. 'Theories of Meaning and Learnable Languages'. In *Inquiries Into Truth and Interpretation*. Oxford: Oxford University Press, 1984, pp. 3–16.

———. 1967. 'Truth and Meaning'. In *Inquiries into Truth and Interpretation*. Oxford: Oxford University Press, 1984, pp. 17–36.

———. 1968. 'On Saying That'. In *Inquiries into Truth and Interpretation*. Oxford: Oxford University Press, 1984, pp. 93–108.

———. 1973. 'Radical Interpretation'. *Inquiries into Truth and Interpretation*. Oxford: Oxford University Press, 1984, pp. 125–40.

————. 1975. 'Thought and Talk'. In *Inquiries into Truth and Interpretation*. Oxford: Oxford University Press, pp. 155–70.

————. 1979. 'Quotation'. In *Inquiries Into Truth and Interpretation*. Oxford: Oxford University Press, 1984, pp. 79–92.

Frege, G. 1892. 'On Sense and Reference'. In *Translations from the Philosophical Writings of Gottlob Frege*, edited by P. Geach and M. Black. Oxford: Basil Blackwell, 1970.

Geach, P. 1957. *Mental Acts*. London: Routledge Kegan Paul.

Geach, P. 1970. 'Quotation and Quantification'. In *Logic Matters*. Oxford: Basil Blackwell.

Kaplan, D. 1986. 'Opacity'. *The Philosophy of W.V. Quine*, edited by L. E. Hahn and P. A. Schilpp. La Salle, Illinois: Open Court, pp. 229–88.

Lepore, E., and K. Ludwig. 'The Semantics and Pragmatics of Complex Demonstratives', manuscript.

Lepore, E., and K. Ludwig. 1998. 'Outline of a Truth Conditional Semantics for Tense.' In *Tense, Time and Reference*, edited by Q. Smith. New York: Oxford.

Ludwig, K., and G. Ray. 1998. 'The Semantics of Opaque Contexts'. *Philosophical Perspectives* 12, *Language, Mind, and Ontology*, edited by James E. Tomberlin, pp. 141–66.

Mates, B. 1972. *Elementary Logic*. 2nd edition. Oxford: Oxford University Press.

Partee, B. 1973. 'The Syntax and Semantics of Quotation'. In *A Festschrift for Morris Halle*, edited by S. R. Anderson and P. Kiparsky. New York: Holt, Rinehart and Winston, pp.410–18.

Postal, P., and T. Landgendon. 1984. *The Vastness of Natural Language*. Oxford: Basil Blackwell.

Quine, W.V. 1956. 'Quantifiers and Propositional Attitudes'. *Journal of Philosophy*.

————. 1960. *Word and Object*. Cambridge, Mass.: MIT Press.

Quine, W.V. 1961. *From a Logical Point of View*. Cambridge, Mass.: Harvard University Press.

Quine, W.V. 1961. 'Reference and Modality'. In *From a Logical Point of View*, pp. 139–59.

Richard, Mark. 1986. 'Quotation, Grammar, and Opacity'. *Linguistics and Philosophy* 9: 383–403.

Salmon, N. 1986. *Frege's Puzzle*. Cambridge, Mass.: MIT Press.

Segal, G. 1989. 'A Preference for Sense and Reference'. *Journal of Philosophy* 86: 73–86.

Simons, Peter. 1982. 'Token Resistance.' *Analysis*.

Smullyan, R.M. 1957. 'Languages in which Self Reference is Possible'. *Journal of Symbolic Logic* 22: 55–67.

Tarski, A. 1956. 'The Concept of Truth in Formalized Languages'. Reprinted in *Logic, Semantics and Metamathematics*. New York: Oxford.

Wallace, J. 1972. 'On the Frame of Reference'. In *Semantics of Natural Language*, edited by D. Davidson and G. Harman. Boston: D. Reidel, pp. 219–52.

Washington, C. 1992. 'The Identity Theory of Quotation'. *Journal of Philosophy* 89: 63–84.

REPLY TO ERNIE LEPORE

At one time there was said to be a program, for which I was held partly responsible. I had proposed to adapt Tarski's method of defining truth for a purpose foreign to Tarski's interests. Where Tarski had shown how to make the concept of truth respectable by giving it an explicit definition in non-semantic terms, I wanted to use features of the method to throw light on the semantics of natural languages by assuming truth was as respectable a concept as we have in philosophy of language. This meant foregoing the possibility of defining truth in favor of an axiomatized theory, thus treating the truth predicate as primitive. Tarski had claimed that natural languages are unsuited for formal treatment, partly because of their messy grammar, and partly because they are capable of predicating truth of their own sentences and hence awash with paradox and contradiction. I decided one could ignore the latter difficulty, assuming that in the process of formalizing a natural language one would in any case have only a rough sketch of the semantics of any actual idiolect in use. The "program" was to see how many of the common idioms of English could plausibly be put into a shape a Tarski-type theory could handle. I thought, and think, that to the extent that we are able to carry out the program, it helps unravel important confusions which have plagued various fields of philosophy. By prompting us to decide on the logical form of sentences it can reveal our basic ontological commitments, it can tell us where inferences are truly logical and where they are not, and it can reveal problems we had barely appreciated. This is by no means the whole of philosophy, nor is it the only way to approach the philosophy of language. But as one enterprise among others, some of us find it unusually satisfying, for there can be genuine progress, and many issues can be appreciably sharpened.

A small group joined me in this enterprise, at first among some of my students at Stanford, and then, to my surprise, in England. The way of thinking that comes with taking this sort of semantics seriously has not died out. It has taken hold to some extent in linguistics (see the essay by Higginbotham in this volume), and it has become more common for

philosophers to worry about the logical form of sentences. But no one, I think, has proven as assiduous and productive in working with truth-conditional semantics as Ernie Lepore. He has done great things with complex demonstratives, tenses, the semantics of action, events and causal sentences, and indirect discourse. Now we have his ideas about quotation. When the idea of trying to fit truth-conditional semantics into a formal theory of truth dawned on me, I naturally started teaching it to my students at Stanford. I soon found that a good way to get started was to ask my students to explain quotation to me. It seems so easy: a quotation refers to the expression between the quotation marks. That's more or less right, but how does it work? Everybody has a theory (in this respect the topic is almost as fecund as akrasia). But Lepore demonstrates that none of the natural answers (and most of the fancy ones) really works the way quotation works in natural languages. Reading Lepore's present essay, and the earlier one he published with Hermann Cappelen have brought to my attention the astonishing number of articles on this subject.

Lepore's essay is a fine demonstration of the truth-conditional semantic approach at work. I find little with which to disagree. There is one point, though, where he has misunderstood me. He quotes two remarks of mine from my early "Quotation" (first published in 1979). One reads, "for the demonstrative theory [of quotation], the quoted material [is] not part, semantically, of the quoting sentence", and the other says "we have to give up the notion that quoted material is part of the semantically significant syntax of a sentence". He reads these passages as implying that the quoted material is part of the syntax of a sentence in which it appears, and so part of the syntax of English if the quoting sentence is English. But I had no such idea, as can be inferred from my insistence on such uses of quotation as to introduce new symbols (which therefore could not be part of the syntax when introduced), or to discuss foreign languages. In fact I say the inscription inside quotation marks "does not refer to anything at all, nor is it part of any expression that does". I go on to compare the function of what is inside the quotation marks with that of a fish when I say "I caught that fish". Neither the fish nor the material that is typically in quotes is part of the sentence or utterance.

So far, Lepore and I are in agreement, though he is not aware of it. But he doesn't like another aspect of my theory, for I think quotation is a kind of deferred ostension, and he does not. ("Deferred ostension" is Quine's term for such cases as pointing at an equation on the blackboard and saying "This number must be even". Here we point to an inscription, which is a token of a numeral, which names or describes a number.) My idea was simple: we point to an actual inscription or squiggle, but we want to refer to the type of which it is a token. Typically, though by no means always, what we want to pick out

is an expression, and expressions are abstract entities we cannot directly pick out by pointing. The most common use of words like "word", "sentence", and "predicate" is to refer to abstract types; utterances and inscriptions provide physical tokens in the form of acoustic events and thin deposits of ink (or indentations in stone, etc.) with a location in space and time. Since I wanted quotations to lead us (by deferred ostension) not only to the expressions of languages but also to anything a token of which could appear inside quotation marks, I interpreted quotation marks as picking out the shape of which an instantiation was physically present inside the quotation marks. The tokens of expressions have shapes, but so, of course, do lots of other things. Since the tokens of expressions have shapes, there is no reason not to take expressions to be shapes: shape is what the various tokens share.

Lepore is apparently worried that some tokens of the same expression have different shapes. But there are no clear directions for deciding when two objects have the same shape, and I took this fact to reflect what Lepore calls the context sensitivity of the right understanding of what a quotation covers. I claim for my same-shape relation exactly the rights and duties of Lepore's same-tokening relation; same-tokening tokens have the same shape. My interpretation of quotations is a bit simpler than his, and is more natural in that it allows quotations to direct us to words and other expressions as well as exotica. (Notice that Lepore's (29) treats a word as a token, not as an expression.)

D. D.

31

Dagfinn Føllesdal

TRIANGULATION

In 1986 Stanford's Center for the Study of Language and Information sponsored a meeting where Donald Davidson, Burton Dreben, and I spent a week together with Quine discussing Quine's philosophy. One of the major themes that we discussed was the proximal versus the distal view in language learning. The discussion has later been pursued in many publications and is a main theme in many of Davidson's papers in the 1990s. One should think that it would be easy for philosophers who have a common philosophical outlook and who know one another's writings well to come to agreement on an issue that seems to be clear and simple. However, while the issue is clear, it is not at all simple. The public nature of language is more complex than is often thought.

I. The Public Nature of Language

Philosophers and linguists have always said that language is a social institution. They have, however, immediately forgotten this and have adopted notions of meaning that are not publicly accessible and where it remains unclear how such entities are grasped by us.

Quine seems to have been the first to take the public nature of language seriously and explore its consequences for meaning and communication.[1] He begins with a situation where two people, each with their own language and view of the world, attempt to communicate. They have no previous translation manual to fall back on, no grammar or dictionary, but must carry out "radical translation," where they try to establish a grammar and a dictionary that they test out by observing one another's behavior.

Quine specifies two constraints that translation manuals have to satisfy. First, a condition on observation sentences, that is, sentences which the other person assents to or dissents from only in certain observational circumstances.

Such sentences should be translated into sentences that we assent to or dissent from in similar circumstances. Secondly, a principle of charity. Sentences which the other person accepts should not be translated into sentences which we regard as absurd, and sentences which the other person dissents from, should not be translated into sentences that we regard as banal.

As Quine points out, several different translation manuals can satisfy these constraints. Given that these two constraints are all the evidence there is for correct translation, Quine concludes that translation is indeterminate; there are several translation manuals between two languages, and they are all correct.

I shall not here discuss indeterminacy of translation, which Davidson and I both accept, but I will concentrate on Quine's constraints on translation and the proximal-distal issue.

II. PROBLEMS WITH PERCEPTION

I find the second of Quine's constraints, the principle of charity, well justified. It reflects an old and well-established hermeneutic principle and Quine supports it with good arguments. The first constraint, however, the observation constraint, both Davidson and I find very problematic. Not because observations are irrelevant to understanding and translation—their relevance will be a main theme of this paper—but because Quine defines observations in terms of the behaviorist notions of stimulus and response. Our problem is not the usual arguments against behaviorism, such as those of Chomsky against Skinner. Chomsky's arguments are pretty irrelevant against Quine's more discerning behaviorism.

Our problem is that we find that Quine through his focus on stimulus and response has forsaken the public nature of language. Stimuli can be *empirically* studied, but they are not *publicly* accessible. And according to Quine's fundamental insight, the emergence and development of language, the learning of language, and the use of language in communication must all be founded on publicly available evidence. In my daily life, where I learn and use language, I cannot observe the sensory stimuli of others. And I have never observed my own. How can I then compare the stimuli of others with those of my own, as Quine requires? The stimuli are encumbered by the same problem as Frege's "Sinne," they are not publicly accessible. What the child learns to associate with words, are neither "Sinne" nor stimuli, but things in the surrounding world.

Quine developed his view on stimuli further in *Ontological Relativity* (1969)[2] and ended the book with the open problem of "saying in general what it means for two subjects to get the same stimulation or, failing that, what it means for two subjects to get more nearly the same stimulation than two

others". In a lecture series in Oxford in 1974 where Quine and Davidson also participated, I criticized Quine's emphasis on stimulations thus:

> In criticism of this proposal of Quine's, I would like to suggest that identifying stimulations with triggering of nerve endings sets us off on a wrong track. By talking about the triggering of the sensory receptors we are already going too deeply inside the skin. Language being a social phenomenon, the basis for language learning and communication should also be publicly accessible without the aid of neurophysiology. This is a point repeatedly emphasized by Quine himself. In fact, on page 157 of *Ontological Relativity* he says that homology of receptors 'ought not to matter'.[3]

Also, already in the very opening sentences of *Word and Object* Quine stressed how language learning builds on distal objects, the objects that we perceive and talk about:

> Each of us learns his language from other people, through the observable mouthing of words under conspicuously intersubjective circumstances. Linguistically, and hence conceptually, the things in sharpest focus are the things that are public enough to be talked of publicly, common and conspicuous enough to be talked of often, and near enough to sense to be quickly identified and learned by name; it is to these that words apply first and foremost. (*Word and Object*, p. 1)

Why, then, did Quine turn to stimuli? He saw, I think, clearer than it had ever been seen before, how intricate the notion of an object is. We cannot determine through observation which objects other people perceive; what others perceive is dependent upon how they conceive of the world and structure it, and that is just what we are trying to find out. When we study communication and understanding, we should not uncritically assume that the other shares our conception of the world and our ontology. If we do, we will not discover how we understand other people, and we will not notice the important phenomena of indeterminacy of translation and of reference. Already in chapter 3 of *Word and Object*, the chapter following the chapter where he introduces stimuli, Quine discusses the ontogenesis of reference, and the discussion of this topic takes up several of the following chapters.

III. THE EARLY DAVIDSON: "MAXIMIZE AGREEMENT"

Davidson's theory of radical interpretation is similar to, but also interestingly different from Quine's theory of radical translation. One highly important contribution of Davidson to the whole theory of understanding, understanding language as well as understanding action and the mind, is his idea of comparing the problem of separating belief from meaning in the understanding of language to the problem of separating belief from value—or desire, or

generally, pro-attitude—in the explanation of action. Since one component in each pair, that of belief, is the same, Davidson is able to add observation of actions to our evidential basis for interpretation and translating of language.

I will, however, here concentrate on that part of Davidson's theory that has a counterpart in Quine's theory of translation. In order to compare the two theories let us transform Davidson's theory into a theory of the conditions a correlation between two languages must satisfy in order to be a translation. There are various reasons why Davidson prefers a theory of interpretation to a theory of translation manuals, but they are not pertinent to my aim in this paper.[4]

I shall argue that there is an early and a late version of Davidson's theory, and I will discuss the two in turn. Davidson may not agree that his theory has developed in two stages, and he may very well have conceived of the second stage theory from the very beginning, although the important characteristics of the second stage did not appear in print from the beginning. As I see it, Davidson held his early theory up to 1973. This early theory differs from Quine's on the following two points:

(1) Davidson replaces Quine's systematization via grammar with a systematization by means of Tarski's theory of truth. This change reflects the fact that the systematization concerns semantics: one wants to see how the semantic features of complex expressions depend upon the semantic features of their component expressions. More accurately: given that one knows, through behavioral evidence, which sentences a person assents to—that is, regards as true—and which sentences he dissents from—regards as false—we try to segment these sentences into recurrent parts, that is words, and to find extensions and references for these words that make most of the sentences that the person assents to true and most of the ones he dissents from false.

This proposal by Davidson could be looked upon as applying Tarski upside down. While Tarski assumed that we knew the extensions and references of the smallest components and build up from there, Davidson starts with the truth and falsehood of sentences and tries to determine the parts and their semantic features from there.[5]

I regard this first proposal of Davidson's as an improvement upon Quine. And Quine has accepted it.

(2) Davidson's second proposal is to fuse Quine's two constraints on translation that I outlined above into one single constraint, a sweeping principle of charity that he expresses as a maxim: *maximize agreement*. That is: try to correlate the two languages in such a way that the sentences to which the other person assents are correlated with sentences to which we assent, and sentences from which he dissents are correlated with sentences from which we dissent.[6]

This simple constraint was the only condition Davidson put on translation

in his early writings. He had recognized Quine's problems in connection with perception, and he formulates his constraint without any appeal to perception. In Davidson's early writings there is no mention of perception as one of the factors one has to take into account when one interprets somebody else.

It would certainly simplify matters if perception did not have to enter the picture. However, I found Davidson's maxim problematic, and in 1973, on a walk in the hills near Biel, Switzerland, I discussed with Davidson the indispensability of perception for interpretation. I used the following example of a rabbit behind a tree, and was curious as to how he would handle it:

I am together with a person who speaks a language which I do not know, but would like to learn. He frequently uses the phrase 'Gavagai' and I have formed an hypothesis that it has to do with rabbits. While we are in a forest and I note a rabbit I try out the phrase 'Gavagai'. However, my friend dissents. According to Davidson's maxim of maximizing agreement this would be a reason against my hypothesis that 'Gavagai' should be translated by 'Rabbit'. If I now discover that there is a big tree between my friend and the rabbit, I immediately have an explanation for our disagreement: I take it for granted that my friend, like me, is not able to see through trees and that he therefore does not think that there is a rabbit there. I even take my friend's dissent as confirming my hypothesis; I do not expect him to believe that there is a rabbit there.[7]

The maxim of maximizing agreement hence has to be modified into *maximize agreement where you expect to find agreement*. Here both of Quine's constraints on translation come in, the observational and the principle of charity. Interpretation recapitulates epistemology, and Quine's two principles reflect the two main ingredients in epistemology: perception and reason.

The rabbit-behind-the-tree example illustrates how the perceptual situation which we assume the other to be in may be decisive for the beliefs we ascribe to him and thereby for how we interpret and translate what he says. When Davidson was confronted with this example, he agreed that perception is important for translation and interpretation. Of course, he must have been aware of it all the time, but it never was mentioned in his writings, and the problems concerning perception that were raised by Quine were therefore not addressed. In his later writings Davidson gives prominence to perception.

IV. The Later Davidson: Triangulation

How then has Davidson incorporated perception in his theory of meaning? He does it with the help of a process that he calls 'triangulation'. 'Triangulation' was a word Donald Davidson introduced in 1982, in the second to the last

paragraph of *Rational Animals*, for the process of language learning.[8] From 1989 on he has developed the idea further in a number of articles.[9] He depicts this process as a triangle where one line connects the learner and the object, one the teacher and the object, and one the learner and the teacher:

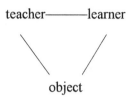

teacher————learner

object

This triangulation process was exactly what Quine argued for in *Ontological Relativity* from 1969, where the triangle is spelled out in detail:

> The learner has now not only to learn the word phonetically, by hearing it from another speaker; he also has to see the object; and in addition to this, in order to capture the relevance of the object to the word, he has to see that the speaker also sees the object.[10]

As we noted earlier, Quine stressed from the very beginning of *Word and Object* (1960) the importance for language learning of publicly observable uttering of words in the presence of things and events that we observe and take our fellow users of language to observe. The problem is how one shall find out what it is that others observe.

V. DAVIDSON'S CAUSAL THEORY OF PERCEPTION

How does Davidson solve the problems of perception? He turns to a causal theory of perception and says that the object, event, or situation an expression relates to is the last common cause in the two infinite causal chains that lead to the sense organs of the teacher and learner in the learning situation.

I have great problems with this solution. Generally, I feel unease when adherents of causal theories of perception or of reference speak as if causality can individuate objects. Thus, for example, when Gareth Evans developed his causal theory of reference, I was in Oxford and I gave a talk on reference with Evans as commentator. I took the opportunity to include in my talk some objections to his view that a name refers to the object which is the main cause of the information that I connect with the name. Alfred Ayer, who was in the audience, said in the discussion that if Evans's theory were true, the reference of most of Ayer's names would be his nurse. She was the main source of the information he connected with these names.

The problems become even worse when one speaks of causal chains, as does Davidson. The events with which I am familiar have a multitude of causes. One should rather talk about causal trees, branching out from the teacher and learner. One then sees immediately that the notion of the last common cause makes little sense. Which of the many junctions between our two causal trees is the last one?

VI. AN "INTENTIONAL" THEORY OF PERCEPTION

I contend that in order to talk about objects one needs complex mental structures, such as Husserl's noemata, which are closely connected with linguistic meaning. Perception has propositional content and can thereby serve as evidence for judgments. Perception and language are jointly dependent upon intersubjective adaptation. Husserl studied this adaptation in great detail and concluded that "even what is straightforwardly perceptual is communal."[11]

Since 1986, Quine has relinquished his "proximal" approach to translation. He has seen that the stimuli do not play a central role, and he has now a "distal" theory, a theory of triangulation, such as he originally conceived of it at the beginning of *Word and Object*. Quine has not written much about this new theory. However, already in his Paul Carus lectures in 1973 he observed the social nature of perception: "Perception being such a private business, I find it ironical that the best evidence of what counts as perceptual should be social conformity. I shall not pause over the lesson, but there is surely one there."[12]

In his later writings Quine stresses the importance of reification. Thus he writes in a manuscript from 1990 that he has permitted me to quote: "Our sophisticated concept of recurrent objects, qualitatively indistinguishable but nevertheless distinct, involves our elaborate schematism of intersecting trajectories in three-dimensional space, out of sight, trajectories traversed with the elapse of time."[13]

Reification is a process which is fundamental for our theories and at the same time depends upon them. It is in my opinion also crucial to language learning and communication. When we try to understand another person, we have to make assumptions concerning which objects he perceives and which properties he takes them to have, and thereby concerning his theories and the structure of what he perceives, his expectations, or his noema, to speak with Husserl. As the process of understanding progresses, these assumptions may be modified in the light of publicly accessible evidence, the way Neurath modified his ship. Our understanding always remains tentative. There is no dry dock, where we can build up our understanding from a firm, non-intensional basis, such as stimuli or causality. We are hence moving in a

circle, we use assumptions concerning perception to understand language, and we use our tentative understanding of language to improve our assumptions concerning perception. However, this is no vicious circle. We are just extending Neurath's boat simile from science to translation and interpretation.

There are many encouraging signs of such a "circular" approach to perception and meaning in Quine's later writings, notably in his discussion of reification in "From Stimulus to Science" and other recent articles, and also in many of Davidson's later articles. In particular, I like Davidson's illuminating discussion of the social nature of perception, which, as I mentioned above, was a prominent theme in Husserl and was also noted by Quine. However, Davidson still relies heavily on causation. He insists that "the stimulus that matters, is the nearest mutual cause of the joint reaction"[14] and "the relevant cause . . . is the cause common to both creatures, the cause that prompts their distinctive responses."[15] Davidson also insists, like the early Quine, that "if one wants to add to the evidence, one should be sure that it meets the standard of extensionality. Otherwise there will almost certainly be a circle."[16]

Of course, causation matters in perception and language learning. But causation alone does not get us anywhere. Causation is only one among very many important factors that are needed. And both causation and many of the other factors are intimately intertwined with a theory of individuation, or reification, that to a large extent is undeveloped. I see no way of developing such a theory without bringing in non-extensional notions. Of course, we should not move in a small circle, as when one defines meaning in terms of analyticity or conversely, or defines meaning on the basis of intentions, to use Davidson's example. However, like Neurath, I think that when the circle is very large, it is unobjectionable—and unavoidable.

DAGFINN FØLLESDAL

STANFORD UNIVERSITY
 AND
UNIVERSITY OF OSLO
JUNE 1999

NOTES

1. W. V. Quine, *Word and Object* (Cambridge, Mass.: M.I.T. Press; and New York: Wiley, 1960).

2. W. V. Quine, *Ontological Relativity and Other Essays* (New York: Columbia University Press, 1969).

3. "Meaning and Experience," in Samuel Guttenplan, ed., *Mind and Language: Wolfson College Lectures 1974* (Oxford: Oxford University Press, 1975), pp. 34–35.

4. See Davidson, "Radical Interpretation," *Dialectica* 27 (1973): 313–28, esp. pp. 316–17.

5. See, e.g., Davidson, "Belief and the Basis of Meaning," *Synthese* 27 (1974): 318.

6. The expression "maximize agreement" recurs in many of Davidson's papers from this period, for example in "Truth and Meaning" (1967), where it is explained as follows: "The linguist will then attempt to construct a characterization of truth-for-the-alien which yields, so far as possible, a mapping of sentences held true (or false) by the alien on to sentences held true by the linguist." (Page 27 of the reprint in Davidson's *Truth and Interpretation*.)

7. I repeated the example in my lecture "Meaning and Experience" in Oxford the following year (p. 39). The example is discussed by Davidson in his reply to David Lewis's paper "Radical Interpretation," in *Synthese* 27 (1974): 345–47. However, Lewis's paper, in that same issue, does not contain this example nor any other similar example. It may be that Davidson recalled my example and associated it with Lewis, since Lewis makes the following general point, with which I agree: "In our opinion, he ought to believe what we believe, or perhaps what we would have believed in his place; and he ought to desire what we desire, or perhaps what we would have desired in his place" (p. 336). The phrase "in his place" is crucial here, and it is just this phrase Quine is striving to spell out. Also Quine, in his comment on Davidson's paper "Belief and the Basis of Meaning" in the same issue, feels the want of perception: "Towards the end of his paper Davidson proposed assuming that the speaker is always right, in order to separate belief from meaning, until we have enough of a system so we can start including error. I'm wondering how he means that system to develop: according to applied psychology? The T-sentence for Karl's example 'Es schneit' hinges on observationality. We can settle the truth of that T-sentence as well as we can settle the translation of 'Es schneit' into 'It's snowing': we find the circumstances in which the thing will be said" (p. 328).

8. Donald Davidson, "Rational Animals," *Dialectica* 36 (1982): 317–27; reprinted in E. LePore and B. McLaughlin, eds., *Actions and Events: Perspectives on the Philosophy of Donald Davidson* (Oxford: Blackwell, 1985), pp. 473–80, and several other anthologies.

9. "The Conditions of Thought," *Le Cahier du Collège International de Philosophie* (Paris: Éditions Osiris, 1989), pp. 165–71. "Meaning, Truth and Evidence," in R. Barrett and R. Gibson, eds., *Perspectives on Quine* (Oxford: Blackwell, 1990), pp. 68–79. "Epistemology Externalized," *Dialectica* 45 (1991): 191–202 (originally in Spanish, 1990). "Three Varieties of Knowledge," in A. Phillips Griffiths, ed., *A.J. Ayer: Memorial Essays: Royal Institute of Philosophy Supplement*, vol. 30, (Cambridge: Cambridge University Press, 1991), pp. 153–66. "The Second Person," *Midwest Studies in Philosophy* 17 (1992): 255–67. "Locating Literary Language," in R.W. Dasenbrock, ed., *Literary Theory After Davidson* (University Park, Pa: Pennsylvania University Press, 1993), pp. 295–308.

10. W. V. Quine, *Ontological Relativity and Other Essays*, p. 28.

11. Edmund Husserl, *Crisis of the European Sciences*, §47, Husserliana VI, 166: 19–22 = Carr's translation, p. 163.

12. W. V. Quine, *The Roots of Reference* (La Salle, Ill.: Open Court, 1974), p. 23.

13. W. V. Quine "From Stimulus to Science," lecture at Lehigh University Oct. 15, 1990, page 21 of the manuscript. See also Quine's book *From Stimulus to Science* (Cambridge, Mass.: Harvard University Press, 1995), pp. 35–40. Similar observations are found also in other of Quine's later writings, for example in his "Reactions," in Paolo Leonardi and Marco Santambrogio, eds., *On Quine* (Cambridge: Cambridge University Press, 1995), p. 350.

14. "Interpretation: Hard in Theory, Easy in Practice," to appear in the proceedings of a conference on Meaning and Interpretation at the University of Stockholm.

15. "Externalisms," to appear in the proceedings of the 1996 Karlovy Vary Conference on Interpreting Davidson.

16. "Quine's Externalism," unpublished paper.

REPLY TO DAGFINN FØLLESDAL

Quine's "Two Dogmas of Empiricism" was a heady mixture of philosophy of language and epistemology. When I read it in manuscript in 1950 I had one misgiving: for all its revolutionary criticism of reductionism and the synthetic/analytic distinction, it seemed to me to retain the equally untenable empiricist dualism of "the tribunal of experience" and conceptual scheme. This third idea underwent a change in *Word and Object*, but it survived throughout Quine's writing to his most recent book, *From Stimulus to Science* (Quine 1995), where he speaks of the "unvarnished input" from which we construct our common sense view of the world and our science. In the summer of 1997 Quine and I had a taped discussion on this issue (Davidson 1997). His first question was, in effect, "What is this third dogma of empiricism you accuse me of?" Despite his principled insistence on the public nature of language, Quine's epistemology from beginning to end remained based on private, pre-conceptualized, data. My difference with Quine on the question of whether linguistic communication should depend on the proximal or the distal stimulus was a relatively minor corollary of a deeper disagreement about epistemology.

Quine's way of approaching language by way of the radical translator transformed the philosophy of language. It made the public aspect of language do the fundamental work it should and in the process permanently altered the way we think of meaning. I borrowed the approach and the method from Quine as soon as I thought I understood them. From the start, though, I made three related changes which reflected my different epistemology. The first was to make responses to the external world, that is, distal stimuli, the basic data for interpreting empirical sentences. The second was to substitute interpretation for translation in order to emphasize the semantic structure of language and to highlight the role of truth. The third was to claim that Quine's way of detecting the truth functional sentential connectives by observing patterns of inference could be extended to the patterns of quantificational logic. This meant that the radical interpreter was able to spot the roles of singular terms

and predicates and whatever did the work of quantifiers and variables in natural languages from the start. These three changes gave up Quine's doctrine that predication and the ontology that goes with it are a provincial trait of our home language which we read into the languages we understand rather than a fundamental feature of anything we would call a language.

As Dagfinn Føllesdal says, Quine often wrote as if he accepted the first of these modifications himself. I ch urted how he went back and forth between proximal and distal theories at a Quine conference in 1988, and urged Quine to give up the former in favor of the latter (Davidson 1990). In reply he said, with characteristic generosity, that "our agreement runs pretty deep" and noted that he had arrived at a compromise position (Quine 1990a). He decided simply to do away with the matching of neural patterns as the key to translation, but he "remained unswerved in locating stimulation at the neural input" because he wanted to explain how we arrive at the reification of objects. He was interested in "the flow of evidence from the triggering of the senses to the pronouncements of science". He also, like Føllesdal, questioned whether appealing to shared causes, as I did, could in itself single out objects. He stressed, again like Føllesdal, the role of empathy in teaching language and in radical translation: we see how the learner or speaker is located, and what she seems to be attending to, and then imagine what proximal stimulations we would have if we were in her shoes (Quine 1990b, p. 3).

It was clear to me that by not appealing to Quine's concept of stimulus meaning as what needed to be matched for translation (or, in my case, for interpretation) I was creating a problem for myself, the problem of error. Quine's substitute for stimulus meaning was empathy, which is also a way of bypassing the problem of error on the principle that translation will succeed if errors match. If you can't see the rabbit and I can, our proximal stimuli don't match, but neither would I say there was a rabbit (or "Gavagai!") if I were in your shoes.

This was perhaps a solution to Quine's problem of translation, but it wouldn't work for interpretation, since interpretation aimed to assign truth conditions to an informant's utterances, and nothing in Quine's approach seemed to me suited to explaining how the concept of truth was to be introduced. It is not enough for the interpreter to share the verbal habits of a speaker, since both might be wrong and both might simply be programmed or conditioned to act similarly when exposed to similar stimuli. To put the same point another way: where, in the matching of verbal behaviors, does a sense of *objectivity* come in? What is the difference between being trained to follow others and understanding that one might be wrong? Perception cannot answer these questions in any direct way, since perception operates within the ambit of propositional thought, and so assumes that the perceiver is armed with the idea of an objective world and the concepts of truth and error.

Triangulation does not answer these questions either, but it helps fix some of the conditions under which propositional thought can emerge. In its simplest form, triangulation does not require language or propositional thought. All animals react selectively to their environment. We, who have the relevant concepts, say they distinguish hot from cold, moist from dry, infrared from other colors, male from female, lion from giraffe. When we say they distinguish these things, we mean they behave in ways we distinguish when exposed to changes in environment we distinguish. Animals of the same species share the same discriminative abilities, and of course there are endless such abilities we share with many other animals. Many animals can learn to make new responses to what they can distinguish and to correlate things observed repeatedly in conjunction. The cases I am interested in are cases where animals associate events and objects sensed with the responses of other members of the herd. This is triangulation in its pure state: two or more animals equipped to correlate the responses of the others with events and situations they jointly distinguish. This is common in the animal world, and does not require propositional thought. My thesis is that this arrangement is essential to both language and propositional thought.

My reasons are two. First, a community provides a check on first reactions. Most of the time, one assumes, the reactions of the troop to a threat or a treat are simultaneous. The exceptions provide the entering wedge for correction and the dawning of a sense of an independent reality and of the possibility of error. There is nothing inevitable about this progression: the thesis is that these are the only plausible conditions under which private responses can generate thoughts of a shared and public world (Davidson 1991). Second, triangulating helps sharpen, by locating, the source of the relevant reactions, for it is a shared source. This observation, like the first one, has no clear application until there is propositional thought. Triangulation does not explain the transition from complex behavior which does not require thought to behavior mediated by propositional thought, but the claim is that triangulation supplies some of the necessary conditions. The transition takes place when the base line of communication between agents becomes as thick as language. Propositional thought depends on language, and, of course, language depends on thought. But if I am right, there can be no propositional thought without language.

Føllesdal is certainly right that no simple causal theory of perception can explain our concepts of objects, events, and their properties. We are built to discriminate objects, to keep track of them, expect them to emerge from their holes or from behind trees, and in some cases to feed or eat us. But these finely tuned abilities are not the same as thinking of things as objects and events. This demands the apparatus of propositional thoughts with truth conditions and the awareness of possible error. I don't think of the awareness

of possible error as an abstract cautionary warning; it takes shape rather in the light of the reasons we have and can give for our beliefs, and therefore the explanations we can give of specific mistakes. Perception is propositional: when we look or feel or hear we believe. What we are caused by our senses to believe is often true, which in the simplest cases it could not fail to be, since the content of our simplest beliefs is necessarily fixed by the history of past perceivings.

Triangulation emphasizes the importance of shared experiences where the fact of sharing registers on the sharers. Quine came to think that it was because evolution had shaped our discriminative abilities to be much alike (rather than the details of our personal neural wirings) that linguistic communication was possible, and I am sure he was right (Quine 1996). But there was a final step that much of his thinking suggested, but that his epistemological leanings kept him from making. This is the step that recognizes that what determines the contents of our thoughts and utterances is not confined to what is within the skin. Our thoughts neither create the world nor simply picture it; they are tied to their external sources from the beginning, those sources being the community and the environment we know we jointly occupy.

D. D.

REFERENCES

Davidson, Donald. 1990. "Meaning, Truth and Evidence." In *Perspectives on Quine*, edited by R. B. Barrett and R. F. Gibson. Oxford: Blackwell.
———. 1991. "Three Varieties of Knowledge." In *A.J. Ayer Memorial Essays: Royal Institute of Philosophy Supplement 30*, edited by A. P. Griffiths. Cambridge: Cambridge University Press.
———. 1997. The Quine tape, in *In Conversation: Donald Davidson*. Videotapes organized, introduced, and edited by R. Fara. Preface by R. Fara and summaries by M. Fara. London: Philosophy International.
Quine, W. V. 1990a. "Comment on Davidson." In *Perspectives on Quine*, edited by R. Barrett and R. Gibson. Oxford: Blackwell.
———. 1990b. "Three Indeterminacies." In *Perspectives on Quine*, edited by R. Barrett and R. Gibson. Oxford: Oxford University Press.
———. 1995. *From Stimulus to Science*. Cambridge, Mass.: Harvard University Press.
———. 1996. "Progress on Two Fronts." *Journal of Philosophy* 93 (April 1996): 159–63.

PART THREE

BIBLIOGRAPHY OF THE WRITINGS OF DONALD DAVIDSON

Compiled by

DONALD DAVIDSON

BIBLIOGRAPHY OF THE WRITINGS OF DONALD DAVIDSON

A. PUBLICATIONS

1. "Why Study Philosophy?" *View Point* 2 (1952): 22–24.

2. "Outlines of a Formal Theory of Value." *Philosophy of Science* 22 (1955): 140–60. (With J. J. C. McKinsey and Patrick Suppes.)

3. "The Return of Reason in Ethics." *Analysis of the American Way of Thinking.* Edited by T. Kimura. Tokyo University Press, 1955. (In Japanese.)

4. "A Finitistic Axiomatization of Subjective Probability and Utility." *Econometrica* 24 (1956): 264–75. (With Patrick Suppes.)

5. "Experimental Measurement of Utility by Use of a Linear Programming Model." *Econometrica* 24 (1956). (Abstract, with Patrick Suppes.)

6. *Decision-Making: An Experimental Approach.* Stanford University Press, 1957. (With Patrick Suppes.) Reprinted, University of Chicago Press, Midway Reprint Series, 1977. Parts reprinted in:
 Decision Making. Edited by W. Edwards and A. Tversky. Harmondsworth, G.B.: Penguin Modem Psychology Series, 1967.

7. "Experimental Tests of a Stochastic Decision Theory." *Measurement: Definitions and Theories.* Edited by C. W. Churchman and P. Ratoosh. New York: John Wiley & Sons, 1959, 233–69. (With J. Marschak.) Also published as Cowles Foundation Paper No. 137, New Haven, 1959. Reprinted in:
 Marschak, Jacob. *Economic Information, Decision, and Prediction: Selected Essays.* Dordrecht: D. Reidel, 1974.

8. "Actions, Reasons and Causes." *Journal of Philosophy* 60 (1963): 685–700. Reprinted in:
 Free Will and Determinism. Edited by B. Berofsky. New York: Harper and Row, 1966.
 The Philosophy of Action. Edited by A. R. White. Oxford University Press, 1967. Second edition, 1970.
 Readings in the Theory of Action. Edited by N. S. Care and C. Landesman. Bloomington, IN: Indiana University Press, 1968.
 Readings in the Philosophy of the Social Sciences. Edited by M. Brodbeck. New York: Macmillan, 1968.
 An Introduction to Philosophical Inquiry. Edited by J. Margolis. New York: Knopf, 1968. Second edition, 1977.
 Bobbs-Merrill reprint series, 1969.
 The Nature of Human Actions. Edited by M. Brand, Scott. Glenview, Illinois: Foresman, 1970.

Introduction to Philosophy: A Contemporary Perspective. Edited by S. Gendin and R. Hoffinan. New York: Scribner's, 1970.
Philosophical Dimensions of Educational Research. Edited by Harry S. Broudy. AERA Readings in Educational Research. New York: John Wiley and Sons, 1971.
Theorie, Handeln und Geschichte. Edited by B. Giesen and M. Schmid. Hamburg: Hoffinan und Campe, 1974. (In German.)
Gründe und Ursachen gesellschaftlichen Handelns. Edited by J. Ritsert. Frankfurt: Campus Verlag, 1975. (In German.)
La Filosofía de la Acción. Edited by A. R. White. Mexico City, Madrid: Fondo de Cultura Economica, 1976. (In Spanish.)
Seminar: Freies Handeln und Determinisms. Edited by U. Pothast. Frankfurt am Main: Suhrkamp Verlag, 1978. (In German.)
Filosofin Genom Tiderna. Edited by K. Marc-Wogau. Stockholm: Albert Bonniers Förlag, 1980. (In Swedish.)
Essays on Actions and Events. Oxford University Press, 1980.
Dometi 14 (1981). (Translated into Slovenian by T. Paskvan.)
Causal Theories of Mind. Edited by S. Davis. Berlin: Walter de Gruyter, 1983.
La Spiegazione Storica. Edited by R. Simili. Parma: Pratiche Editrice, 1984. (Translated into Italian by A. Artosi.)
Théorie de L'Action, 61–78. Edited and translated into French by M. Neuberg. Liège: Mardaga, 1991.
Readings in the Philosophy of Social Science. Edited by M. Martin and L. E. McIntyre. Cambridge, MA: MIT Press, 1994.
Filozofia 8 (1994). (Translated into Slovakian by E. Višňovský.)
Metafizički Ogledi. Belgrade: Radionica Sic (Edicija Teorija), 1995. (Translated into Serbo-Croatian by Živan Lazović.)
The Philosophy of Action. Edited by A. R. Mele. Oxford University Press, 1997.
Čin Mysel Jazyk. Edited by E. Višňovský. Bratislava: Archa, 1997. (Translated into Slovakian by E. Višňovský.)

9. "The Method of Extension and Intension." *The Philosophy of Rudolf Carnap*, 311–50. The Library of Living Philosophers, vol. XI. La Salle: Open Court, 1963.

10. "On Mental Concepts and Physical Concepts." *Annals of the Japan Association for Philosophy of Science* 2 (1964): 226–31.

11. "Theories of Meaning and Learnable Languages." *Proceedings of the 1964 International Congress for Logic, Methodology and Philosophy of Science*, 383–94. Amsterdam: North Holland Publishing Co., 1966. Reprinted in:
 Semantica filosofica: problemas y discussiones. Edited and translated into Spanish by T. M. Simpson. Siglo Veintiuno Editores, 1973.
 Deucalion 31 (1980): 285–300. (In Greek.)
 Inquiries into Truth and Interpretation. Oxford University Press, 1984.

12. Review of *The Logic of Preference*, Georg Henrik von Wright. *Philosophical Review* 2 (1966): 233–35.

13. "Emeroses by Other Names." *Journal of Philosophy* 63 (1966): 778–80.
Reprinted in:
Essays on Actions and Events. Oxford University Press, 1980.
Filosofia de la psicologia. Barcelona: Anthropos, 1994. (Introduction and translation into Spanish by M. Candel.)
The Philosophy of Nelson Goodman: Selected Essays. Vol. 2. Nelson Goodman's New Riddle of Induction. Edited by C. Elgin. New York: Garland Publishing, 1997.

14. "The Logical Form of Action Sentences." *The Logic of Decision and Action,* 81–95; 115–20. Edited by N. Rescher. University of Pittsburgh Press, 1967.
Reprinted in:
The Logic of Grammar, 18–24. Edited by D. Davidson and G. Harman. Encino, CA: Dickenson Press, 1975.
Analytische Handlungstheorie, Band I. Edited by G. Meggle. Frankfurt am Main: Suhrkamp Verlag, 1977. (In German.)
Essays on Actions and Events. Oxford University Press, 1980.
Metafizički Ogledi. Belgrade: Radionica Sic (Edicija Teorija), 1995. (Translated into Serbo-Croatian by Živan Lazović.)
Readings in the Philosophy of Language, 217–33. Edited by P. Ludlow. Cambridge, MA: MIT Press, 1997.

15. "Causal Relations." *Journal of Philosophy* 64 (1967): 691–703.
Reprinted in: Bobbs-Merrill reprint series, 1967.
Philosophical Problems of Causation. Edited by T. L. Beauchamp. Encino, CA: Dickenson Press, 1974.
Causation and Conditionals, 82–94. Edited by E. Sosa. Oxford University Press, 1974.
The Nature of Causation. Edited by M. Brand. Urbana: University of Illinois Press, 1974.
The Logic of Grammar. Edited by D. Davidson and G. Harman. Encino, CA: Dickenson Press, 1975.
Neue Texte zum Kausalitätsproblem. Edited by G. Posch. Stuttgart: Reclam Verlag, 1979. (In German.)
Essays on Actions and Events. Oxford University Press, 1980.
Causation, 75–87. Edited by E. Sosa and M. Tooley. Oxford University Press, 1993.
Metafizički Ogledi. Belgrade: Radionica Sic (Edicija Teorija), 1995. (Translated into Serbo-Croatian by Živan Lazović.)
Metaphysics: An Anthology. Edited by J. Kim and E. Sosa. Oxford: Blackwell, 1999. 428–35.
Laws of Nature, Causation, and Supervenience. Edited by M. Tooley. New York: Garland, 1999. 351–57.

16. "Truth and Meaning." *Synthese* 17 (1967): 304–23. Reprinted in:
Studies in Philosophical Logic. Edited by J. W. Davis, D. J. Hockney, and W. K. Wilson. Dordrecht: D. Reidel, 1969.
Bobbs-Merrill reprint series, 1969.

Philosophy of Language, 450–65. Edited by J.F. Rosenberg and C. Travis. Englewood Cliffs, NJ: Prentice-Hall, 1971.

New Readings in Philosophical Analysis, 196–207. Edited by H. Feigl, W. Sellars, and K. Lehrer. New York: Appleton-Century-Crofts, 1972.

La Strutturo Logic del Linguaggio, 433–54. Edited by Andreas Bonomi. Milan: Valentino Bompiani, 1973. (In Italian.)

Raziskave o Resnici in Interpretaciji. Ljubljana: SKUC, Filozofska Faculteta, 1975.

Moderne Sprachphilosophie. Edited by M. Sukale. Hamburg: Hoffinann und Campe, 1976. (In German.)

Deucalion 27/28 (1979): 183–205. (In Greek.)

Sêmantica, Vol. III. Fundamentos Metodológicos da Lingüística, 145–80. Edited by M. Dascal. Campinas: Instituto de Estudos da Linguagem, 1982. (In Portuguese.)

Inquiries into Truth and Interpretation. Oxford University Press, 1984.

The Philosophy of Language, 72–83. Edited by A. P. Martinich. Oxford University Press, 1985. Second edition, 1990; third edition, 1996.

New Work Abroad on Language, 99–120. Edited by V. V. Petrova. Moscow: Progress, 1986. (In Russian.)

Kontekst i Znacenje. Edited by N. Miščević and M. Potrc. Izdavacki Centar Rijeka, 1987. (Translated into Slovenian by D. Jutronić-Tihomirović.)

Philosophy, Language, and Artificial Intelligence. Edited by J. Kulas, J. Fetzer, and T. Rankin. Dordrecht: Kluwer, 1988.

Meaning and Truth. Edited by J. Garfield and M. Kiteley. New York: Paragon House, 1990.

La Búsqueda del Significado. Edited by L. M.V. Villanueva. Tecnos, Universidad de Murcia, 1991. (In Spanish.)

Essays on Truth, Language and Mind. Warsaw: Wydawnictwo Naukowe, 1992. (Translated into Polish by J. Gryz.)

Meaning and Reference, 92–110. Edited by A. W. Moore. Oxford University Press, 1993.

Metafizički Ogledi. Belgrade: Radionica Sic (Edicija Teorija), 1995. (Translated into Serbo-Croatian by Živan Lazović.)

Readings in Language and Mind, 64–77. Edited by H. Geirsson and M. Losonsky. Oxford: Blackwell, 1996.

Meaning, Truth, Method: Introduction to Analytical Philosophy I. Edited by J. Kangilaski and M. Laasberg. Tartu University Press, 1997. (Translated into Estonian by M. Laasberg.)

Ajattelu, Kieli, Merkitys: Analyyttisen Filosofian, 320–35. Edited by P. Raatikainen. Helsinki: Finnish University Press, 1997. (Translated into Finnish by P. Raatikainen.)

Readings in the Philosophy of Language, 89–107. Edited by P. Ludow. Cambridge, MA: MIT Press, 1997.

17. Double number of *Synthese* devoted to essays on Quine's *Word and Object*. Edited by D. Davidson and J. Hintikka. *Synthese* 19 (1968–69). Issued as a book, *Words and Objections, Essays on the Work of W. V Quine*. Dordrecht: D. Reidel,

1969. 2nd printing and papercover edition, 1975.

18. "On Saying That." *Synthese* 19 (1968–69): 130–46. (158–74 in book). Reprinted in:
> *The Logic of Grammar*, 143–52. Edited by D. Davidson and G. Harman. Encino, CA: Dickenson Press, 1975.
> *Inquiries into Truth and Interpretation.* Oxford University Press, 1984.
> *The Philosophy of Language.* Edited by A. P. Martinich. Oxford University Press, 1985. Second edition, 1990, 337–46.
> *Meaning and Truth.* Edited by J. Garfield and M. Kiteley. New York: Paragon House, 1990.
> *Readings in the Philosophy of Language*, 817–32. Edited by P. Ludow. Cambridge, MA: MIT Press, 1997.

19. "Facts and Events." *Fact and Existence.* Edited by J. Margolis. Oxford: Blackwell, 1969, 74–84. Reprinted in:
> *Essays on Actions and Events.* Oxford University Press, 1980.

20. "How is Weakness of the Will Possible?" *Moral Concepts.* Edited by J. Feinberg. Oxford University Press, 1969, 93–113. Reprinted in:
> *Raziskave o Resnici in Interpretaciji.* Ljubljana: SKUC, Filozofsks Faculteta, 1975.
> *Essays on Actions and Events.* Oxford University Press, 1980.
> *Philosophie* 3 (1984): 21–46. (Translated into French by P. Engel.)
> *Metafizički Ogledi.* Belgrade: Radionica Sic (Edicija Teorija), 1995. (Translated into Serbo-Croatian by Živan Lazovič.)
> *Filozofia Moralności.* Edited by J. Holowka. Warsaw: Wyd. SPACJA, 1997, 81–106. (Translated into Polish by W.J. Popowski.)

21. "The Individuation of Events." *Essays in Honor of Carl G. Hempel.* Edited by N. Rescher. Dordrecht: D. Reidel, 1969, 216–34. Reprinted in:
> *Essays on Actions and Events.* Oxford University Press, 1980.
> *Metafizički Ogledi.* Belgrade: Radionica Sic (Edicija Teorija), 1995. (Translated into Serbo-Croatian by Živan Lazović.)

22. "True to the Facts." *Journal of Philosophy* 21 (1969): 748–64. Reprinted in:
> *Readings in Semantics.* Edited by F. Zabeeh, E. D. Slemke, and F. A. Jacobsen. Urbana: University of Illinois Press, 1974.
> *Inquiries into Truth and Interpretation.* Oxford University Press, 1984.
> *Essays on Truth, Language and Mind* Warsaw: Wydawnictwo Naukowe, 1992. (Translated into Polish by M. Szczubiałka.)

23. "Semantics for Natural Languages." *Linguaggi nella Società e nella Tecnica.* Milan: Communità, 1970, 177–88. Reprinted in:
> *The Logic of Grammar.* Edited by D. Davidson and G. Harman. Encina, CA: Dickenson Press, 1975.
> *Noam Chomsky.* Edited by G. Harman. Modern Studies in Philosophy Series. Garden City, NY: Doubleday-Anchor, 1974.

Bedeutungstheorien. Edited and translated into German by J. Schulte. Stuttgart: Reclam Verlag, 1980.

Inquiries into Truth and Interpretation. Oxford University Press, 1984.

Gramatika, Semantika, Znacenje. Edited by M. Suško. Sarajevo: Svjetlost, 1987.

Literatura na Świecie. 2 (1988): 335–45. (Translated into Polish by Marek Witkowski.)

Essays on Truth, Language and Mind. Edited by B. Stanosz. Warsaw: Wydawnictwo Naukowe, 1992, 60–76. (In Polish.)

24. "Mental Events." *Experience and Theory.* Edited by Lawrence Foster and J. W. Swanson. Amherst: University of Massachusetts Press, 1970, 79–101. Book reissued by Duckworth, 1977. Reprinted in:

Raziskave o Resnici in Interpretaciji. Ljubljana: SKUC, Filozofsks Faculteta, 1975.

Philosophy As It Is. Edited by T. Honderich and M. Burnyeat. London: Penguin, 1979.

Readings in Philosophy of Psychology. Edited by N. Block. Harvard University Press, 1980.

Analytische Philosophie des Geistes. Edited by P. Bieri. Meisenheim: Anton Hain, 1981. (Translated into German by M. Gebauer.)

Essays on Actions and Events. Oxford Unversity Press, 1980.

Cuadernos de Crítica II. Mexico City: University of Mexico, 1981. (In Spanish.)

The Nature of Mind. Edited by D. Rosenthal. Oxford University Press, 1991, 247–56.

Théorie de L'Action. Edited and translated into French by M. Neuberg. Mardaga, 1991, 121–40.

Essays on Truth, Language and Mind. Edited by B. Stanosz. Warsaw: Wydawnictwo Naukowe, 1992. (Translated into Polish by T. Baszniak.)

Filosofii de la psicología. Barcelona: Anthropos, 1994. (Introduction and translation into Spanish by M. Candel.)

The Philosophy of Mind: Classical Problems/Contemporary Issues. Edited by B. Beakley and P. Ludlow. Cambridge, MA: MIT Press, 1994, 137–49.

Metafizički Ogledi. Belgrade: Radionica Sic (EdiciJa Teorija), 1995. (Translated into Serbo-Croatian by Živan Lazović.)

Contemporary Materialism. Edited by P.K. Moser and J.D. Trout. London: Routledge and Kegan Paul, 1995, 107–21.

Čin Mysel Jazyk. Edited by E. Višňiovský. Bratislava, Archa, 1997. (Translated into Slovakian by M. Popper.)

The Way Things Are, 263–82. Edited by W.R. Carter. Boston: McGraw-Hill, 1998.

25. "Events as Particulars." *Noûs* 4 (1970): 25–32. Reprinted in:
Essays on Actions and Events. Oxford University Press, 1980.

26. "Action and Reaction." *Inquiry* 13 (1970): 140–48. Reprinted in:
Essays on Actions and Events. Oxford University press, 1980.

27. "Agency." *Agent, Action and Reason*. Edited by Robert Binkley. University of Toronto Press, 1971, 4–25. Reprinted in:
 Analytische Handlungstheorie. Edited by G. Meggle. Frankfurt am Main: Suhrkamp Verlag, 1976. (In German.)
 Essays on Actions and Events. Oxford University Press, 1980.
 Théorie de L'Action. Edited and translated into French by M. Neuberg. Mardaga, 1991, 205–24.

28. "Semantics of Natural Language, I." *Synthese* 21 nos. 3/4 (1970). Edited by D. Davidson and G. Harman.

29. "Semantics of Natural Language, II." *Synthese* 22 nos. 1/2 (1971). Edited by D. Davidson and G. Harman.

30. *Semantics of Natural Language*. Edited by D. Davidson and G. Harman. Dordrecht: D. Reidel, 1971. Hardcover version of *Synthese* 21, nos. 3/4 and *Synthese* nos. 1/2, with additional material. 2nd printing and papercover edition, 1974.

31. "Eternal Events vs. Ephemeral Events." *Noûs* 5 (1971): 335–49. Reprinted in:
 Essays on Actions and Events. Oxford University Press, 1980.

32. "In Defense of Convention T." *Truth, Syntax and Modality*. Edited by H. Leblanc. Amsterdam: North Holland Publishing Company, 1973, 76–86. Reprinted in:
 Inquiries into Truth and Interpretation. Oxford University Press, 1984.
 Essays on Truth, Language and Mind. Edited by B. Stanosz. Warsaw: Wydawnictwo Naukowe, 1992. (Translated into Polish by M. Szczubialka.)

33. "Freedom to Act." *Essays on Freedom of Action*. Edited by T. Honderich. London: Routledge and Kegan Paul, 1973, 139–56. Book reprinted with corrections and first published as a paperback, 1978. Article reprinted in:
 Essays on Actions and Events. Oxford University Press, 1980.
 Metafizički Ogledi. Belgrade: Radionica Sic (Edicija Teorija), 1995. (Translated into Serbo-Croatian by Živan Lazović.)

34. "Radical Interpretation." *Dialectica* 27 (1973): 313–28. Reprinted in:
 Inquiries into Truth and Interpretation. Oxford University Press, 1984.
 La Búsqueda del Significado. Edited by L.MV. Villanueva. Tecnos, Universidad de Murcia, 1991. (In Spanish.)
 Dicionário do Pensamento Contemporâneo. Edited by M. M. Carrilho. Lisbon: Publicações dom Quixote, 1991, 199–210. (In Portuguese.)
 Essays on Truth, Language and Mind. Edited by B. Stanosz. Warsaw: Wydawnictwo Naukowe, 1992. (Translated into Polish by P. Józefowicz.)
 Metafizički Ogledi. Belgrade: Radionica Sic (Edicija Teorija), 1995. (Translated into Serbo-Croatian by Živan Lazović.)
 Contemporary Analytic Philosophy. Edited by J. Baillie. Upper Saddle River, NJ: Prentice Hall, 1997, 382–93.
 Čin Myseĺ Jazyk. Edited by E. Višňiovský. Bratislava: Archa, 1997. (Translated into Slovakian by T. Sedoá and E. Višňiovský.)

35. "The Material Mind." *Logic, Methodology and Philosophy of Science IV.* Edited
 by P. Suppes et al. Amsterdam: North Holland Publishing Company, 1973,
 709–22. Reprinted in:
 Mind Design. Edited by J. Haugeland. Montgomery, Vermont: Bradford
 Books, 1981.
 Essays on Actions and Events. Oxford University Press, 1980.
 Mentes y Máquinas. Madrid: Tecnos, 1985. (In Spanish.)
 Essays on Truth, Language and Mind. Edited by B. Stanosz. Warsaw:
 Wydawnictwo Naukowe, 1992. (Translated into Polish by T. Baszniak.)
 Analytic Philosophy. Edited by A.F. Griaznov. Moscow University Press,
 1993. (In Russian.)
 Filosofía de la psicología Barcelona: Anthropos, 1994. (Introduction and
 translation into Spanish by M. Candel.)

36. "Psychology as Philosophy." *Philosophy of Psychology.* Edited by S. Brown.
 New York: Macmillan, 1973, 41–52; 60–67. Reprinted in:
 Philosophy of Mind. Edited by J. Glover. Oxford University Press, 1976.
 Essays on Actions and Events. Oxford University Press, 1980.
 Nemjera i Cin. Edited by N. Miščević and N. Smokrović. Izdavacki Centar
 Rijeka, 1983. (Translated into Slovenian by D. Miščević.)
 Essays on Truth, Language and Mind. Warsaw: Wydawnictwo Naukowe,
 1992. (Translated into Polish by C. Cieśliński.)
 Readings in the Philosophy of Social Science. Edited by M. Martin and L.E.
 McIntyre. Cambridge, MA: MIT Press, 1994.
 Filosophía de la psicología. Barcelona: Anthropos, 1994. (Introduction and
 translation into Spanish by M. Candel.)
 Metafizički Ogledi. Belgrade: Radionica Sic (Edicija Teorija), 1995. (Trans-
 lated into Serbo-Croatian by Živan Lazović.)
 Modern Philosophy of Mind. Edited by W. Lyons. London: J. M. Dent
 (Everyman edition), 1995.

37. "On the Very Idea of a Conceptual Scheme." *Proceedings and Addresses of the
 American Philosophical Association* 47 (1974): 5–20. Reprinted in:
 Relativism, Cognitive and Moral. Edited by M. Krausz and J. W. Meiland.
 University of Notre Dame Press, 1982, 66–80.
 Inquiries into Truth and Interpretation. Oxford University Press, 1984.
 Post-Analytic Philosophy. Edited by J. Rajchman and C. West. New York:
 Columbia University Press, 1985. (Japanese edition. Tokyo: Tuttle-Mori
 Agency, 1990.)
 *Razionalita, e relativismo epistemologico nella filosofia della scienza
 contemporanea.* Edited by R. Egidi. Rome: Edizioni Theoria, 1985. (In
 Italian.)
 Analytische Philosophie der Erkenntnis. Edited by P. Bieri. Athenäum, 1986.
 (In German.)
 Human Knowledge: Classical and Contemporary Approaches. Edited by P.
 Moser and A. vander Nat. Oxford University Press, 1987, 254–62.
 Also in Japanese, Gendai Shiso Press, Tokyo.

La Svolta Relativistica nell'Epistemologia Contemporanea. Edited by R.
Egidi. Milan: Franco Angeli Libri, 1988. (In Italian.)
Literatura na Świecie. 5, no. 238 (1991): 100–19. (Translated into Polish by
J. Gryz.)
Empiryzm Współczesny. Edited by B. Stanosz. Warsaw University Press,
1991.
Philosophia 22 (1993): 11–24. University of Aarhus. (Translated into Danish
by Lars Bo Bondesen.)
Analytic Philosophy. Edited by A. F. Griaznov. Moscow University Press,
1993. (In Russian.)
Metafizički Ogledi. Belgrade: Radionica Sic (Edicija Teorija), 1995. (Trans-
lated into Serbo-Croatian by Živan Lazović.)
Organon F, (1996): 368–82. (Translated into Slovakian by Emil Višňiovský.)
Čin Myse l Jazyk. Edited by E. Višňovský. Bratislava: Archa, 1997. (Translated
into Slovakian by Emil Višňovský.)
Obrat Jazyku: Druhé Kolo. Edited and translated into Czech by J. Peregrin.
Prague: Philosophia, 1998. 107–25.

38. "Paradoxes of Irrationality." *Philosophical Essays on Freud.* Edited by R.
Wollheim and J. Hopkins. Cambridge University Press, 1982. 289–305.
Reprinted in:
Raziskave o Resnici in Interpretaciji. Ljubljana: SKUC, Filozofska Faculteta,
1975.
Análisis Filosófico. 1 (1981): 1–18. (Translated into Spanish by G. Carrió and
E. Rabossi.)
Philosophical Essays on Freud. Edited by R. Wollheim and J. Hopkins.
Cambridge University Press, 1982, 289–305.
Filozofsko Čitanje Frojda. Edited and translated into Serbo-Croatian by Obrad
Savić. Belgrade: IIC SSO Srbije, 1988.
Lettera Internazionale.
Paradoxes de L'Irrationalité. Combas: Éditions de L'Éclat, 1991. (Translated
into French by Pascal Engel.)

39. "Belief and the Basis of Meaning." *Synthese* 27 (1974): 309–23. Reprinted in:
Inquiries into Truth and Interpretation. Oxford University Press, 1984.
Literatura na Świecie. 2, no. 199 (1988): 346–60. (Translated into Polish by
Barbara Stanosz.)
Essays on Truth, Language and Mind. Edited by B. Stanosz. Warsaw:
Wydawnictwo Naukowe, 1992. (In Polish.)
Understanding and Sense. Edited by C. Peacocke. Aldershot: Dartmouth,
1993.

40. "Replies to David Lewis and W.V. Quine." *Synthese* 27 (1974): 345–49.

41. *The Logic of Grammar.* Edited by D. Davidson and G. Harman. Encina, CA:
Dickenson Press, 1975.

42. *Raziskave o Resnici in Interpretaciji.* Ljubljana: SKUC, Filozofska Faculteta,

1975. (A collection of six essays by D. Davidson, translated into Slovenian.)

43. "Thought and Talk." *Mind and Language.* Edited by S. Guttenplan. Oxford University Press, 1975, 7–23. Book reprinted in paperback, 1977. Article reprinted in:

 Raziskave o Resnici in Interpretaciji. Ljubljana: SKUC, Filozofska Faculteta, 1975.

 Bedeutungstheorien. Edited and translated into German by J. Schulte. Stuttgart: Reclam Verlag, 1980.

 Inquiries into Truth and Interpretation. Oxford University Press, 1984.

 Język w Świetle Nauki. Edited by B. Stanosz. Warsaw University Press, 1980, 340–62. (In Polish.)

 The Nature of Mind. Edited by D. Rosenthal. Oxford University Press, 1991, 363–71.

 Readings in Language and Mind. Edited by H. Geirsson and M. Losonsky. Oxford: Blackwell, 1996, 64–77.

44. "Reply to Foster." *Essays in Semantics.* Edited by M.G.J. Evans and J. McDowell. Oxford University Press, 1976, 33–41. Book reprinted in 1978. Article reprinted in:

 Inquiries into Truth and Interpretation. Oxford University Press, 1984.

45. "Hempel on Explaining Action." *Erkenntnis* 10 (1976): 239–53. Reprinted in: *Essays on Actions and Events.* Oxford University Press, 1980.

46. "Hume's Cognitive Theory of Pride." *Journal of Philosophy* 73 (1976): 744–57. Reprinted in:

 Essays on Actions and Events. Oxford University Press, 1980.

 Hume (Vol. 1). Edited by J. Dunn and I. Harris. An Elgar Reference Collection. Cheltenham U.K.: 436–49.

47. Introduction and Discussion. *Origins and Evolution of Language and Speech.* Annals of the New York Academy of Sciences 280 (1976): 18–19; 42–45.

48. "The Method of Truth in Metaphysics." *Midwest Studies in Philosophy* 2 (1977): 244–54. Edited by P. A. French, T. E. Uehling, Jr., and H. K. Wettstein. Reprinted in:

 Contemporary Perspectives in the Philosophy of Language. Edited by P. A. French, T. E. Uehling, Jr., and H. K. Wettstein. Minneapolis: University of Minnesota Press, 1979.

 Revue de Metaphysique et de Morale. 2 (1979): 209–24. (In French.)

 Inquiries into Truth and Interpretation. Oxford University Press, 1984.

 Prospettive sul significato. Edited by C. Penco and A. Bottani. Milan: Franco Angeli Editore, 1984. (In Italian.)

 After Philosophy. Edited by K. Baynes, J. Bohman, and T. McCarthy, Cambridge, MA: MIT Press, 1987.

 Anthology on Logic and Ontology. Lisbon: Editorial Presenca, 1987. (In Portuguese.)

Metfizyka w Filozofii Analitycznej. Edited by Tadeusz Szubka. Lublin: Towarzystwo Naukowe KUL, 1996, 79–94. (Translated into Polish by T. Szubka.)

Twentieth-Century Philosophy. Edited by F. E. Baird and W. Kaufmann. Upper Saddle River, NJ: Prentice Hall, 1997. 330–40.

49. "Reality without Reference." *Dialectica* 31 (1977): 247–58. Reprinted in:
Reference, Truth and Reality. Edited by M. Platts. London: Routledge and Kegan Paul, 1980.
Inquiries into Truth and Interpretation. Oxford University Press, 1984.

50. "What Metaphors Mean." *Critical Inquiry* 5 (1978): 31–47. Reprinted in:
Reference, Truth and Reality. Edited by M. Platts. London: Routledge and Kegan Paul, 1980.
On Metaphor. Edited by Sheldon Sacks. University of Chicago Press, 1979.
Philosophical Perspectives on Metaphor. Edited by M. Johnson. Minneapolis: University of Minnesota Press, 1981.
Inquiries into Truth and Interpretation. Oxford University Press, 1984.
The Philosophy of Language. Edited by A.P. Martinich. Oxford University Press, 1985, 438–48.
Anthropos, Filozofija in Kultura 5/6 (1985). (Translated into Slovenian by B. Kante.)
Theories of Metaphor. Moscow: Progress Publishing, 1990. (Translated into Russian by by Vasily Petrov.)
Helikon 4 (1990). Budapest: Argumentum . (In Hungarian.)
Pragmatics. Edited by S. Davis. Oxford University Press, 1991.
The Philosophy of Nelson Goodman: Selected Essays. Vol. 2. *Nelson Goodman's New Riddle of Induction.* Edited by C. Elgin. New York: Garland Publishing, 1997.

51. "Intending." *Philosophy of History and Action: Papers Presented at the First Jerusalem Philosophical Encounter.* Edited by Y. Yovel. Dordrecht: D. Reidel and Jerusalem: The Magnes Press, The Hebrew University, 1978. Reprinted in:
Essays on Actions and Events. Oxford University Press, 1980.
Čin Mysel Jazyk. Edited by E. Višňovský. Bratislava: Archa, 1997. (Translated into Slovakian by E. Višňovský.)

52. "Moods and Performances." *Meaning and Use.* Edited by A. Margalit. Dordrecht: D. Reidel, 1979. Reprinted in:
Inquiries into Truth and Interpretation. Oxford University Press, 1984.
Pragmatics: Critical Concepts. Vol. II. *Speech Act Theory.* Edited by A. Kasher. London: Routledge. 1998. 69–80.

53. "Quotation." *Theory and Decision II* (1979): 27–40. Reprinted in:
Inquiries into Truth and Interpretation. Oxford University Press, 1984.

54. "The Inscrutability of Reference." *Southwestern Journal of Philosophy* 10 (1979): 7–19. Reprinted in:

Raziskave o Resnici in Interpretaciji. Ljubljana: SKUC, Filozofska Faculteta, 1975.

Inquiries into Truth and Interpretation. Oxford University Press, 1984.

Understanding and Sense. Edited by C. Peacocke. Aldershot: Dartmouth, 1993.

55. *Essays on Actions and Events*. Oxford University Press, 1980. Reprinted with corrections, 1982, 1985, 1986, 1989.

 German edition: *Handlung und Ereignis*. Frankfurt am Main: Suhrkamp Verlag, 1985. (Translated by J. Schulte.) Paperback edition, 1990. (Suhrkamp Taschenbucher Wissenschaft Series.)

 Japanese edition: Essays 1, 2, 3, 5, 6, 7, 8, 11, 12. Tokyo: Keiso Shobo, 1991. (Translated by Hiroyuki Hattori.)

 Italian edition: *Azioni ed Eventi*. Bologna: Il Molino, 1992. (Translated by R. Brigati; Introduction by Eva Picardi.)

 French edition: *Actions et Événements*. Paris: Presses Universitaires de France, 1994. (Translated by P. Engel.)

 Spanish edition: *Ensayos sobre Acciones y Sucesos*. Mexico City: Instituto de Investigaciones Filosóficas, UNAM, and Barcelona: Crítica, 1995. (Translated by O. Hansberg, J.A. Robles, and M. Valdés. Coordination and revision of the translation, O. Hansberg.)

56. "Toward a Unified Theory of Meaning and Action." *Grazer Philosophische Studien II* (1980): 1–12. Reprinted in:

 Essays on Truth, Language and Mind. Edited and translated into Polish by B. Stanosz. Warsaw: Wydawnictwo Naukowe, 1992.

57. "Rational Animals." *Dialectica* 36 (1982): 317–27. Reprinted in:

 Actions and Events: Perspectives on the Philosophy of Donald Davidson. Edited by E. LePore and B. McLaughlin. Oxford: Blackwell, 1985, 473–80.

 Revista de Filosofia 31–32 (1988): 15–25. (Translated into Spanish by L. Estrella.)

 Paradoxes de L'Irrationalité. Combas: Éditions de L'Éclat, 1991. (Translated into French by Pascal Engel.)

 Essays on Truth, Language and Mind. Edited by B. Stanosz. Warsaw: Wydawnictwo Naukowe, 1992. (Translated into Polish by C. Cieśliński.)

 Metafizički Ogledi. Belgrade: Radionica Sic (Edicija Teorija), 1995. (Translated into Serbo-Croatian by Živan Lazović.)

58. "Empirical Content." *Grazer Philosophische Studien* 16/17 (1982): 471–89; special issue on *Schlick und Neurath—Ein Symposium*. Edited by R. Haller. Amsterdam: Rodopi. Reprinted in:

 Truth and Interpretation: Perspectives on the Philosophy of Donald Davidson. Edited by E. LePore. Oxford: Blackwell, 1986.

59. "A Coherence Theory of Truth and Knowledge." *Kant oder Hegel*. Edited by D. Henrich. Stuttgart: Klett-Cotta, Stuttgart, 1983, 423–38. Reprinted in:

Primer Simposio International de Filosofía, Vol. I. Edited and translated into Spanish by E. Villanueva. Mexico City: UNAM, 1985, 15–36.

Truth and Interpretation: Perspectives on the Philosophy of Donald Davidson. Edited by E. LePore. Oxford: Blackwell, 1986.

Analytische Philosophie der Erkenntnis. Edited by P. Bieri. Athenäum, 1986. (In German.)

Analisis Filosofico 8 (1988). (Translated into Spanish by E. Rabossi.)

Significato e Teorie del Linguaggio. Edited by A. Bottani and C. Penco. Milan: Franco Angeli Libri, 1991. (In Italian.)

Reading Rorty. Edited by A. Malichowski. Oxford: Blackwell, 1990, 120–38. Includes "Afterthoughts, 1987".

Epistemologia: Posições e Críticas. Edited and translated into Portuguese by M. M. Carrilho. Lisbon: Fundação Calouste Gulbenlcian, 1991.

Mente, Mundo y Acción. Barcelona: Ediciones Paidós, 1992. (In Spanish.)

Metafizički Ogledi. Belgrade: Radionica Sic (Edicija Teorija), 1995. (Translated into Serbo-Croatian by Živan Lazović.)

Philosophie der Skepsis. Edited and translated into German by T. Grundmann and K. Stüber. Munich: Ferdinand Schöningh, 1996.

Čn Mysel Jazyk. Edited by E. Višňovský. Bratislava: Archa, 1997. (Translated into Slovakian by D. Kamhal.)

60. *Inquiries into Truth and Interpretation.* Oxford University Press, 1984. Reprinted with corrections, 1985, 1986.

> German Edition: *Wahrheit und Interpretation.* Frankfurt am Main: Suhrkamp Verlag, 1986. Translated by Joachim Schulte. Paperback edition, 1990. (Suhrkamp Verlag Taschenbucher Wissenschaft Series.)
>
> Japanese Edition: Essays 2, 3, 7, 8, 9, 10, 11, 13, 14, 16, 17, 18. Tokyo: Keiso Shobo, 1991. Translated by Kazuyuki Nomoto.
>
> Spanish Edition: *De la Verdad y de la Interpretation.* Barcelona: Editorial Gedisa, 1990. Translated by Guido Filippi.
>
> Italian Edition: *Verità e Interpretazion.* Bologna: Il Molino, 1994. Translated by Roberto Brigati; Introduction by Eva Picardi.
>
> Chinese Edition: *Truth, Meaning, Actions and Events—Selections from the Philosophical Writings of Donald Davidson.* Essays 2, 5, 7, 9, 10, 12, 13, 14, 15, 17, along with "Mental Events", "The Logical Form of Action Sentences", "A Coherence Theory of Truth and Knowledge", and "Afterthoughts", 1987. Beijing: Shangwu Publishing House, The Commercial Press, 1993. Introduction and translation by Bo Mou.
>
> French Edition: *Enquêtes sur la Vérité et L'Interprétation.* Nîmes: Jacqueline Chambon, 1994. Translated by Pascal Engel.

61. "Communication and Convention." *Synthese* 59 (1984): 3–17. (Proceedings of the Institute International de Philosophie, Oslo, September 3–5, 1979.) Reprinted in:

> *Journal of Indian Council of Philosophical Research* 1, no. 1 (1983): 13–25.
>
> *Inqiries into Truth and Interpretation.* Oxford University Press, 1984.
>
> *Dialogue—an Interdisciplinary Approach.* Edited by M. Dascal. Amsterdam: John Benjamins, 1985.

Cadernos de Estudos Lingüísticos: Encontro International de Filosofia da Linguagen Conferecias e Comunicacoes, Parte I. Translated into Portuguese by M. Dascal, 1986.

Philosophy, Logic and Language. Moscow: Progress, 1987, 213–33. (In Russian.)

62. "First Person Authority. " *Dialectica* 38 (1984): 101–11. Reprinted in:
 Revista de Filosofia, 1988. (In Spanish.)
 Cuarto Simposio International de Filosophia, Vol. II. Mexico City: UNAM, 1989. (In Spanish.)
 Analytische Theorie des Selbstbewusstseins. Edited by M. Frank. Frankfurt am Main: Suhrkamp Verlag, 1994. (Translated by Heinz-Dieter Heckmann.)

63. *Expressing Evaluations.* The Lindley Lecture (monograph), University of Kansas, 1984.

64. "Replies to Essays by Bratman, Grice and Baker, Peacocke, Pears, Bennett, Vermazen, Chisholm, Strawson, and Thalberg, Harry Lewis, Smart, and Suppes"; "Postscript." *Essays on Davidson: Actions and Events.* Edited by B. Vermazen and M. Hintikka. Oxford University Press, 1985, 195–229; 242–54.

65. "Adverbs of Action." *Essays on Davidson: Actions and Events.* Edited by B. Vermazen and M. Hintikka. Oxford University Press, 1985, 230–41. Reprinted in:
 Segundo Simposio International de Filosfia, Vol. II. Edited by E. Villanueva. Mexico City: UNAM, 1987, 85–98. (Translated into Spanish by O. Hansberg.)

66. "Reply to Quine on Events." *Actions and Events: Perspectives on the Philosophy of Donald Davidson.* Edited by E. LePore and B. McLaughlin. Oxford: Blackwell, 1985, 172–76.

67. "Incoherence and Irrationality." *Dialectica* 39 (1985): 345–54. (Entretiens d'Oxford, 3–9 September, 1984, Institut International de Philosophie.)

68. "Plato's Philosopher." *The London Review of Books* 7, no. 14 (1985): 15–17. (The S. V. Keeling Memorial Lecture in Greek Philosophy, given at University College, London, March 1985.) Reprinted in:
 Les Paradoxes de la Connaissance: Essais sur le Ménon de Platon. Edited and translated into French by Monique Canto-Sperber. Paris: Editions Odile Jacob, 1991, 89–105.
 Modern Thinkers and Ancient Thinkers. Edited by R. W. Sharples. University College London Press, 1993, 99–116.
 Virtue, Love & Form: Essays in Memory of Gregory Vlastos. Edited by T. Irwin and M. Nussbaum. Edmonton, Alberta: Academic Printing & Publishing, 1993, 179–94.

69. "A New Basis for Decision Theory." *Theory and Decision* 18 (1985): 87–98. Reprinted in:

Recent Developments in the Foundations of Utility and Risk Theory. Edited by L. Daboni, A. Montesano, and M. Lines. Dordrecht: D. Reidel, 1986.

70. "Judging Interpersonal Interests." *Foundations of Social Choice Theory.* Edited by J. Elster and A. Hylland. Cambridge University Press, 1986, 195–211.

71. "Deception and Division." *The Multiple Self.* Edited by J. Elster. Cambridge University Press, 1986, 79–92. Reprinted in:
 Actions and Events: Perspectives on the Philosophy of Donald Davidson. Edited by E. LePore and B. McLaughlin. Oxford: Blackwell, 1985, 138–48.
 Paradoxes de L'Irrationalité. Combas: Éditions de L'Éclat, 1991. (Translated into French by Pascal Engel.)
 Mente, Mundo y Acción. Barcelona: Ediciones Paidós, 1992. (In Spanish.)
 Metafizički Ogledi. Belgrade: Radionica Sic (Edicija Teorija), 1995. (Translated into Serbo-Croatian by Živan Lazović.)

72. "A Nice Derangement of Epitaphs." *Philosophical Grounds of Rationality.* Edited by R. Grandy and R. Warner. Oxford University Press, 1986, 156–74. Reprinted in:
 Truth and Interpretation: Perspectives on the Philosophy of Donald Davidson. Edited by E. LePore. Oxford: Blackwell, 1986.
 Die Wahrheit der Interpretation: Beiträge zur Philosophie Donald D Davidsons. Frankfurt am Main: Suhrkamp Verlag, 1990. (Translated into German by E. Picardi and J. Schulte.)
 Metafizički Ogledi. Belgrade: Radionica Sic (Edicija Teorija), 1995. (Translated into Serbo-Croatian by Živan Lazović.)
 The Philosophy of Language. 3rd edition. Edited by A. P. Martinich. Oxford University Press, 1996, 465–75.

73. "Knowing One's Own Mind." Proceedings and Addresses of the American Philosophical Association 60 (1987): 441–58. Reprinted in:
 Mente, Mundo y Acción. Barcelona: Ediciones Paidós, 1992. (In Spanish.)
 Analytische Theorien des Selbstbewusstseins. Edited by M. Frank. Frankfurt am Main: Suhrkamp Verlag, 1994. (Translated into German by Heintz-Dieter Heckmann.)
 Self-Knowledge. Edited by Q. Cassam. Oxford University Press (Oxford Readings in Philosophy), 1994.
 The Twin Earth Chronicles. Edited by A. Pessin and S. Goldberg. New York: Paragon House, 1995, 323–41.
 Externalism and Self-Knowledge. Edited by P. Ludlow and N. Martin. Stanford Center for the Study of Learning and Information (distributed by Cambridge University Press), 1996.

74. "Problems in the Explanation of Action." *Metaphysics and Morality: Essays in Honour of J. J. C. Smart.* Edited by P. Pettit, R. Sylvan, and J. Norman. Oxford: Blackwell, 1987, 35–49.

75. Reply to "Semantic Content and Cognitive Meaning" by Hans Sluga. *Cuarto Simposio International de Filosofía*, Vol. I. Edited by E. Villanueva. Mexico City: UNAM, 1988, 39–44. (In Spanish.)

76. Review of *The Time of My Life: An Autobiography*, W.V. Quine, M. I. T. Press, 1985. *Journal of Symbolic Logic* 53 (1988): 293–95.

77. Reply to Burge. *Journal of Philosophy* 85 (1988): 664–66. Reprinted in:
 Analytische Theorien des Selbstbewussyseins. Edited by M. Frank. Frankfurt am Main: Suhrkamp Verlag, 1994. (Translated into German by Heinz-Dieter Heckmann.)

78. "The Myth of the Subjective." *Bewustsein, Sprache und die Kunst*. Edited by M. Benedikt and R. Burger.Vienna: Edition S. Verlag der Österreichischen Staatsdruckerei, 1988, 45–54. Reprinted in:
 Relativism: Interpretation and Confrontation. Edited by M. Krausz. University of Notre Dame Press, 1989.
 Filosofía del Lenguaje, de la Ciencia, de los Derechos Humanos y Problemas de su Enseñanza. Edited by L.Valdivia and E. Villanueva. Mexico City: UNAM, 1987, 13–29. (In Spanish.)
 Dijalog 3/4 (1989): 63–74. Sarajevo. (In Serbian.)
 Mente, Mundo y Acción. Barcelona: Ediciones Paidós, 1992. (In Spanish.)
 Der Mythos des Subjektiven. Stuttgart: Philipp Reclam, 1993. (Translated into German by J. Schulte.)

79. "Epistemology and Truth." *Proceedings of the Fourth Panamerican Philosophy Conference*. Cordoba, Argentina, 1988. Reprinted in:
 Iride. 9, nuova serie (1992): 7–21. Ponte alle Grazie, Florence. (Translated into Italian by M. Salucci.)

80. "The Conditions of Thought." *Le Cahier du Collège International de Philosophie*. Paris: Éditions Osiris, 1989, 165–71. Reprinted in:
 The Mind of Donald Davidson. Edited by J. Brandl and W. Gombocz. Amsterdam: Editions Rodopi *(Grazer Philosophische Studien, Band 36)*, 1989, 193–200.
 Mente, Mundo y Acción. Barcelona: Ediciones Paidós, 1992. (In Spanish.)
 Der Mythos des Subjektiven. Stuttgart: Philipp Reclam, 1993. (Translated into German by J. Schulte.)

81. "James Joyce and Humpty Dumpty." *Proceedings of the Norwegian Academy of Science and Letters*, 1989, 54–66. Reprinted in:
 Midwest Studies in Philosophy 16 (1991): 1–12. Edited by P. French, T. E. Uehling and H. Wettstein. (University of Notre Dame Press.)

82. "What is Present to the Mind?" *The Mind of Donald Davidson*. Edited by J. Brandl and W. Gombocz. Amsterdam: Editions Rodopi. *(Grazer Philosophische Studien, Band 36)*, 1989. 3–18. Reprinted in:

Lieux et Transformations de la Philosophie, Les Cahiers de Paris VIII.
Presses Universitaires de Vincennes, 1991, 109–26. (Translated into
French by P. Sauret.)

Consciousness. Edited by E. Villanueva. Ridgeway Publishing Company,
1991, 197–213.

Der Mythos des Subjektiven. Stuttgart: Philipp Reclam, 1993. (Translated into
German by J. Schulte.)

Pensamiento y Lenguaje. Edited by Margarita M. Valdés. Mexico City:
Universidad Nacional Autónoma de México, 1996, 145–62. (Translated
into Spanish by O. Hansberg.)

83. "Turing's Test." *Modelling the Mind.* Edited by W. H. Newton-Smith and K. V.
Wilkes. Oxford University Press, 1990, 1–11.

84. "Representation and Interpretation." *Modelling the Mind.* Edited by W. H.
Newton-Smith and K. V. Wilkes, Oxford University Press, 1990, 13–26.

85. *Plato's PHILEBUS.* New York: Garland Publishing Inc., 1990, 1–458.

86. "Meaning, Truth and Evidence." *Perspectives on Quine.* Edited by R. Barrett and
R. Gibson. Oxford: Basil Blackwell, 1990, 68–79. Reprinted in:
Der Mythos des Subjektiven. Stuttgart: Philipp Reclam, 1993. (Translated into
German by J. Schulte.)

87. "The Structure and Content of Truth." *Journal of Philosophy* 87 (1990):
279–328. (The John Dewey Lectures.) Reprinted in:
The Philosopher's Annual. Edited by P. Grim, G. Mar and P. Williams.
Independence, OH: Ridgeview Publishing Co., 1992.
Understanding and Sense. Edited by C. Peacocke. Aldershot: Dartmouth,
1993. (Except pages 282–95.)
Teorias de la Verdad. Edited by N. Frápoli. Madrid: Editorial Tecnos, 1997.

88. "Epistemology Externalized." *Análisis Filosófico* 10 (1990): 1–13. (Translated
into Spanish by E. Rabossi.) Also printed in:
Dialectica 45 (1991): 191–202. (In English.)
Der Mythos des Subjektiven. Stuttgart: Philipp Reclam, 1993. (Translated into
German by J. Schulte.)

89. "Three Varieties of Knowledge." *A. J. Ayer: Memorial Essays. Royal Institute of
Philosophy Supplement: 30.* Edited by A. Phillips Griffiths. Cambridge
University Press, 1991, 153–66.

90. "Subjective, Intersubjective, Objective." *Merkur* 512 (1991): 999–1014.
(Translated into German by J. Schulte.) This is a slightly modified version of
"Three Varieties of Knowledge." Reprinted in:
Dialektik und Dialog. Frankfurt am Main: Suhrkamp Verlag, 1993.
Current Issues in Idealism. Edited by D. Hutto and P. Coates. Bristol:
Thoemmes Press, 1996.

91. Paradoxes de L'Irrationalité. Combas: Éditions de L'Éclat, 1991. (Translated into French by Pascal Engel.)

92. "Jusqu'où va le caractère public d'une langue?" *Wittgenstein et la Philosophie aujourd'hui.* Edited and translated into French by J. Sebestik and A. Soulez. Paris: Méridiens Klincksiek, 1992, 241–59.

93. "The Second Person." *Midwest Studies in Philosophy* 17 (1992): 255–67. Edited by P. French, T. E. Uehling, and H. Wettstein. (University of Notre Dame Press.) This is a modified, English, version of the above.

94. *Eseje o Prawdzie, Jezyku i Umyśle* [Essays on Truth, Language and Mind]. Edited, With an introduction, by B. Stanosz. Warsaw: Wydawnictwo Naukowe, 1992. (Translated into Polish by Barbara Stanosz and others.)

95. *Mente, Mundo y Acción.* Introduction and translation into Spanish by Carlos Moya. Barcelona: Ediciones Paidós, 1992.

96. "The Socratic Concept of Truth." *The Philosophy of Socrates: Elenchus, Ethics and Truth.* Edited by K. J. Boudouris. Athens, 1992, 51–58.

97. "The Third Man." Catalogue for *Robert Morris: Blind Time Drawings with Davidson.* Allentown, PA: The Frank Martin Gallery, Mühlenberg College, 1992. Reprinted (with response by Morris) in:
 Critical Inquiry 19 (1993): 607–27.
 La Balsa de la Medusa 32 (1994): 3–10. (Translated into Spanish by M. H. Iglesias.)
 Les Cahiers du Musée D'Art Moderne (Centre Georges Pompidou) 53 (1995): 25–31. (Translated into French by Pascal Engel.)

98. *Der Mythos des Subjektiven.* Stuttgart: Philipp Reclam, 1993. (Translated into German by J. Schulte.)

99. "Method and Metaphysics." *Deucalion* 11, 1993, 239–48.

100. "Thinking Causes". *Mental Causation.* Edited by J. Heil and A. Mele. Oxford University Press, 1993, 3–17. Reprinted in:
 Analisis Filosofico 15 (1995): 57–72. (Translated into Spanish by D. Pérez.)

101. "Locating Literary Language." *Literary Theory After Davidson.* Edited by R. W. Dasenbrock. University Park, PA: Pennsylvania University Press, 1993, 295–308.

102. *Dialektik und Dialog: Rede von Donald Davidson anlässlich der Verleihung des Hegel-Preises 1992.* Frankfurt am Main: Suhrkamp Verlag, 1993. (Translated into German by J. Schulte.) Also printed (in English) in:
 Language, Mind and Epistemology: On Donald Davidson's Philosophy. Edited by G. Preyer, F. Siebelt, and A. Ulfig. A special volume of

ProtoSoziologie. Dordrecht: Kluwer Academic Publishers, 1994,
429–37. Also in book form.
Filosofický Časopsis 47 (1999): 181–89. (Translated into Polish by T.
Marvan.)

103. Replies to seventeen essays. *Reflecting Davidson: Donald Davidson Respond-
ing to an International Forum of Philosophers.* Edited by R. Stoecker. Berlin:
de Gruyter, 1993.

104. "Radical Interpretation Interpreted." *Philosophical Perspectives: Logic and
Language* 8 (1994): 121–28. Edited by J. E. Tomberlin. Also printed in:
 *Reflecting Davidson: Donald Davidson Responding to an International
 Forum of Philosophers.* Edited by R. Stoecker. Berlin: de Gruyter, 1993,
 77–84.

105. "The Social Aspect of Language." *The Philosophy of Michael Dummett.* Edited
by B. McGuinness and G. Oliveri. Dordrecht: Kluwer, 1994, 1–16.

106. *Filosofía de la Psicología.* Barcelona: Anthropos, 1994. (In Spanish and English.
Introduction and translation into Spanish by M. Candel.)

107. "On Quine's Philosophy" and "Exchange between Donald Davidson and W. V.
Quine following Davidson's Lecture." *Theoria* 60 (1994): 184–92; 226–31.

108. "La Mesure du Mental." *Lire Davidson: Interprétation el Holisme.* Edited and
translated into French by Pascal Engel. Paris: Éditions de L'Éclat, 1994, 31–49.
This essay contains parts of "Thinking Causes" and "Epistemology Exter-
nalized". Reprinted in:
 *L'Intentionalité en Question: Entre Phénoménologie et Recherches
 Cognitives.* Edited by D. Janicaud. Paris: J. Vrin, 1995, 329–36.

109. Entry on Donald Davidson, *A Companion to the Philosophy of Mind.* Edited by
S. Guttenplan. Oxford: Blackwell, 1994, 231–36.

110. Foreword to *The Philosophical Papers of Alan Donagan* Vol. II, *Action, Rea-
son, and Value.* Edited by J. Malpas. University of Chicago Press, 1994, vii–ix.

111. "What is Quine's View of Truth?" *Inquiry* 37 (1994): 437–40. Edited by D.
Føllesdal and A. Hannay. Also in: *Theoria* 60 (1994): 184–192. (A special issue
on the philosophy of W. V. Quine edited by Dag Prawitz.)

112. *Metafizički Ogledi.* Belgrade: Radionica Sic (Edicija Teorija), 1995. (Translated
into Serbo-Croatian by Živan Lazović.)

113. "Could There Be a Science of Rationality?" *International Journal of Philosophi-
cal Studies* 3 (1995): 1–16. Reprinted in:
 La Rationalidad. Su Poder y sus Límites. Edited by O. Nudler. Buenos
 Aires: Paidós, 1996, 273–93. (Translated into Spanish by A. Nudler and
 S. Romaniuk.)

114. "Pursuit of the Concept of Truth." *On Quine.* Edited by P. Leonardi and M. Santambrogio. Cambridge University Press, 1995, 7–21.

115. "The Problem of Objectiviy." *Tijdschrift voor Filosofie* (Leuven) June (1995): 203–20.

116. "Laws and Cause." *Dialectica* 49 (1995): 263–79.

117. "The Objectivity of Values." *El Trabajo Filosófico de Hoy en el Continente.* Edited by Carlos Gutiérrez. Bogatá: Editorial ABC, 1995, 59–69. Reprinted in:
 Belgrade Circle 1-2 (1995): 177–88. (In English and Serbian. Translated by Dušan Đorđević Mileusnić.)

118. "Replies" to eleven essays, and "Concluding Remarks." *Dyskusje z Donaldem Davidsonem o Prawdzie Języku i Umyśle [Discussions with Donald Davidson about Truth, Language and Mind].* Edited by U. Żegleń. Lublin: Towarzystwo Naukowe KUL, 1996, 333–55. (Translated into Polish by A. Grobler.)

119. "The Folly of Trying to Define Truth." *Dialogue and Universalism* 6 (1996): 39–53. (Special issue on Truth after Tarski. Edited by M. Hempoliński). Also printed in:
 Dyskusje z Donaldem Davidsonem o Prawdzie Języku i Umyśle. Edited by U. Żegleń. Lublin: Towarzystwo Naukowe KUL, 1996, 333–55. (Translated into Polish by P. Luków.)
 Przegląd Filozoficzny 5, no. 1 (1996): 111–27. (Translated into Polish by P. Luków.)
 The Journal of Philosophy 94 (1997): 263–78.

120. "Indeterminism and Antirealism." *Realism/Antirealism and Epistemology.* Edited by C.B. Kulp. Lanham, Maryland: Rowman & Littlefield, 1997, 109–22. Reprinted in:
 Davidsons Philosophie des Mentalen. Edited by W. R. Köhler. Paderborn: Ferdinand Schöningh, 1997. (Translated into German by Peter Niesen.)

121. "Gadamer and Plato's **Philebus**." *The Philosophy of Hans-Georg Gadamer.* Edited by L. Hahn. Chicago and La Salle: Open Court, 1997, 421–32.

122. "Die Emergenz des Denkens." *Die Erfindung des Universums? Neue Überleggungen zur philosophischen Kosmologie.* Edited by W.G. Saltzer, P. Eisenhardt, D. Kurth, and R.E. Zimmermann. Frankfurt am Main: Insel Verlag, 1997, 152–67. (Translated into German by Thomas Marschner.)

123. "The Centrality of Truth." *The Nature of Truth, Proceedings of the International Colloquium, Prague, 17–20 September, 1996.* Edited by J. Peregrin. Prague: Filosofia, 1997, 3–14. Reprinted in:
 Truth and its Nature (if any). Edited by J. Peregrin. Dordrecht: Kluwer, 1999. 105–15.

124. *Čin MyseľJazyk.* Edited by, Bratislava: Archa, 1997. (Translated into Slovakian by E. Višňovský and others.)

125. "Who is Fooled?" *Self-Deception and Paradoxes of Rationality.* Edited by J.-P. Dupuy. Stanford: CSLI, 1997, 15–27.

126. "In Conversation: Donald Davidson." Videotapes organized, introduced, and edited by R. Fara. Preface by R. Fara and summaries by M. Fara. London: Philosophy International, 1997. Nineteen videotapes of Davidson discussing his views with W.V. Quine, Sir Peter Strawson, Nancy Cartwright, Tim Crane, Martin Davies, Michael Dummett, Stuart Hampshire, Jim Hopkins, Jennifer Hornsby, Michael Martin, John McDowell, David Papineau, Richard Rorty, Mark Sainsbury, Gabriel Segal, Barry Smith, Barry Stroud.

127. "Seeing Through Language." *Thought and Language.* Edited by J. M. Preston. Cambridge: Cambridge University Press, 1997. 15–27.

128. "Replies to my Critics." *Critica* 30 (1998): 97–112. Replies to articles by Barry Stroud, John McDowell, Richard Rorty, and Carlos Pereda in *Critica* 28 (1998).

129. "Replies to Kirk Ludwig, Gabriel Segal, Stephen Neale, Ernie Lepore and Herman Cappelen, Reinaldo Elugardo, Rogen Gibson, Anita Avramides, and Richard Rorty. *Donald Davidson: Truth, Meaning and Knowledge.* Edited by U. Zeglen. London: Routledge, 1999.

130. "Is Truth a Goal of Inquiry?" and "General Comments." *Donald Davidson. Truth, Meaning and Knowledge.* Edited by Urzula Zeglen. London: Routledge, 1999. 15–17, 157–61.

B. BOOKS ON THE WORK OF DONALD DAVIDSON

1. *Essays on Davidson: Actions andEvents.* Edited by B. Vermazen and M. Hintikka. Oxford University Press, 1985.

2. *A Study of Davidsonian Events.* Wan-Chuan Fang. Nanking, Taipei: Institute of American Culture, 1985.

3. *Actions and Events: Perspectives on the Philosophy of Donald Davidson.* Edited by E. LePore and B. McLaughlin. Oxford: Blackwell, 1985.

4. *Truth and Interpretation: Perspectives on the Philosophy of Donald Davidson.* Edited by E. LePore. Oxford: Blackwell, 1986.

5. *Donald Davidson's Philosophy of Language.* Bjørn Ramberg. Oxford: Blackwell, 1989.

6. *The Mind of Donald Davidson.* Edited by J. Brandl and W. Gombocz. Amsterdam: Rodopi, 1989.

7. *Die Wahrheit der Interpretation: Beiträge zur Philosophie Donald Davidsons.* Edited by E. Picardi and J. Schulte. Frankfurt am Main: Suhrkamp, 1990.

8. *La Semántica de Davidson.* Manuel Hernandez Iglesias. Madrid: Visor, 1990.

9. *Donald Davidson.* Simon Evnine. Oxford: Polity Press/Stanford University Press, 1991. Japanese translation, 1996.

10. *Donald Davidson and The Mirror of Meaning: Holism, Truth, Interpretation.* Jeffrey Malpas. Cambridge University Press, 1992.

11. *Reflecting Davidson: Donald Davidson Responding to an International Forum of Philosophers.* Edited by Ralf Stoecker. Berlin: de Gruyter, 1993.

12. *Donald Davidsons Theorie sprachlichen Verstehens.* Karsten Stüber. Frankfurt am Main, Anton Hain, 1993.

13. *Literary Theory After Davidson.* Edited by Reed W. Dasenbrock. University Park, PA: Penn State University Press, 1993.

14. *Donald Davidson zur Einfürung.* Kathrin Glüer. Hamburg: Junius Verlag, 1993.

15. *Language, Mind, & Epistemology: On Donald Davidson's Philosophy.* A special volume of *ProtoSoziologie.* Edited by G. Preyer, F. Siebelt, and A. Ulfig. Dordrecht:, Kluwer Academic Publishers, 1994.

16. *Davidson et la Philosophie du Language.* Pascal Engel. Paris: Presses Universitaires de France, 1994.

17. *Lire Davidson: Interprétation et Holisme.* Edited and translated into French by Pascal Engel. Paris: Éditions de L'Eclat, 1994.

18. *Mind & Language.* 11 (1996). Forum on Swampman. Edited by Samuel Guttenplan and Sarah Patterson. 68–132.

19. *Davidson Analysé.* Actes du Colloque de Caen (13 Juin 1996) publiés sous la direction de Pascal Engel. Cetre de Philosophie de l'Université de Caen, 1996.

20. *Semantyka Donalda Davidsona.* Andre Nowakowski. Lublin: Wydawnictwo Uniwersytetu Marii Curie-Sklokowskiej, 1997. (Introduction by Urszula Zeglen.)

21. *Davidsons Philosophie des Mentalen.* Edited by W. R. Köhler. Paderborn: Ferdinand Schöningh, 1997.

22. *Der sozial Charakter sprachlicher Bedeutung und propositionaler Einstellungen: Eine Untersuchung zu Donald Davidsons Theorie der radikalen Interpretation.* M. Schaedler-Om. Würzburg: Königshausen & Neumann, 1997.

23. *Verstehen ohne Sprache: Zu Donald Davidsons Szenario der radikalen Interpretation.* Urs Bruderer. Bern: Haupt, 1997.

24. *Critica.* 88 (1998). Papers by Barry Stroud, John McDowell, Richard Rorty, Carlos Pereda, and Akeel Bilgrami presented at the XVI International Symposium of Philosophy on the Philosophy of Donald Davidson.

25. *Donald Davidson. Truth, Meaning and Knowledge.* Edited by Urszula Zeglen. London: Routledge, 1999.

26. *Ensayos sobre Davidson.* Edited by c. E. Caorsi. Montevideo: Fundación de Cultura Universitaria, 1999.

C. INTERVIEWS WITH DONALD DAVIDSON

1. Koppelberg, Dirk, "Analytic Philosophy without Empirical Dogmas: Interview with Donald Davidson", in *Information Philosophie,* Moser & Scheuermeier Verlag, Basel, Feb. 1983. Reprinted in:
 Filosojie Magazine 2 (1993): 18–24. Translated into Dutch by F. Buekins.

2. Potrč, Matjaž, "Stroj je hitrejši kot človek", in *Dnevnik,* October 5, 1988, 37, p. 13. (In Slovenian.)

3. Miller, Jacques-Alain, "Une Coversation avec Donald Davidson", in *L'Âne,* 39 (1989): 28–34. (In French.)

4. Borradori, Giovanna, in *Conversazioni Americane,* Editori Laterza, 1991. (In Italian.) English edition, University of Chicago Press, 1994.

5. Edward Abrams, Sandy Goldberg, and Eric Hetherington, "A Conversation with Donald Davidson". Interview with authors. *Conference* 4, no. 2 (1993): 3–15.

6. Glüer, Kathrin, "Ein Interview mit Donald Davidson", in *Donald Davidson: zur Einfführung.* Hamburg: Junius, 1993, 153–76. Reprinted in:
 Dialectica, 49 (1995): 75–86. (In English.)

7. Kent, Thomas, "Language, Philosophy, Writing, and Reading; A Conversation with Donald Davidson", in *Journal of Advanced Composition* 13, no. 1 (1993): 1–20. Comments on this: Susan Wells, "The Malaprop in Spite of Herself A Desperate Reading of Donald Davidson", and Reed Way Dasenbrock, "A Response to 'Language, Philosophy, Writing, and Reading: A Conversation with Donald Davidson'," *Journal of Advanced Composition* 13, no. 2 (1993): 517–28. Reprinted in:
 Philosophy, Rhetoric, Literary Criticism: (Inter)views. Edited by G.A. Olson. Carbondale, IL: Southern Illinois University Press, 1994, 7–28.

8. Christian Delacampagne, "Un entretien avec Donald Davidson", in *Le Monde,* 28 June 1994, 2.

9. Lars Bergströrn and Dagfinn Føllesdal, "Interview with Donald Davidson in November 1993", *Theoria* 60 (1994): 207–25.

10. Interview, "Tot pensament té una base social", in *El Punt,* Diumenge, 19 de juny de 1994, p. 30. (in Catalan.)

11. *Theoria,* Yugoslav Philosophy Association, Belgrade, 1995.

12. Ernie Lepore, *Iride,* 8, 1995, 295–322. (In Italian.)

13. Roberta Pires de Oliera, "Metaphor, Logical Form, and Event: a Linguist Talking to the Philosopher Donald Davidson", *Cadernos de Estudos Lingidsticos,* 31, Campinas, 1996, 91–107.

D. CONFERENCES ON DAVIDSON'S WORK

Alicante, Spain	September 6–9, 1981
Rutgers University, New Brunswick	April 28–May 1, 1984
Bad Radkersburg, Austria and Yugoslavia	November 11–13, 1988
NEH Summer Institute on Heidegger and	
Davidson, Santa Cruz, CA	July 9–August 17, 1990
Bielefeld, Germany	February 25–March 1, 1991
CREA, Paris	May 21, 1992
University of Rome (La Sapienza)	April 2, 1993
Bad Homburg, Germany	May 14–16, 1993
Royal Irish Academy, Dublin	May 19–20, 1994
Girona, Spain	June 6–17, 1994
Utrecht, Netherlands	November 10–12, 1994
Leuven, Belgium	December 2–3, 1994
Lublin, Poland	October 2–6, 1995
Karlovy Vary, Czech Republic	September 9–13, 1996
Mexico City	October 6–10, 1997

INDEX

(by Kathleen League)